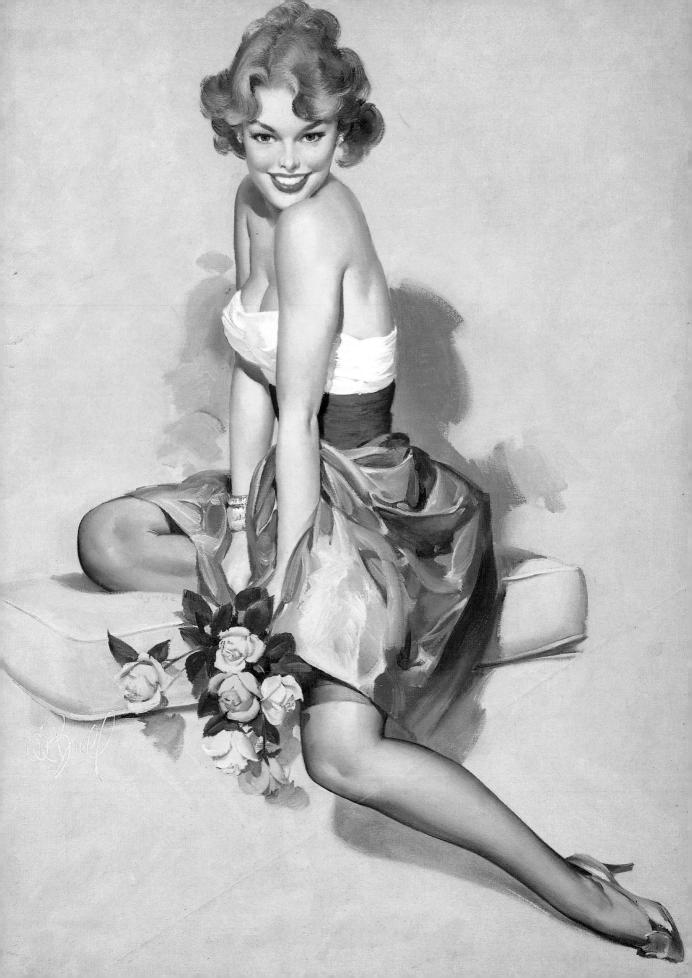

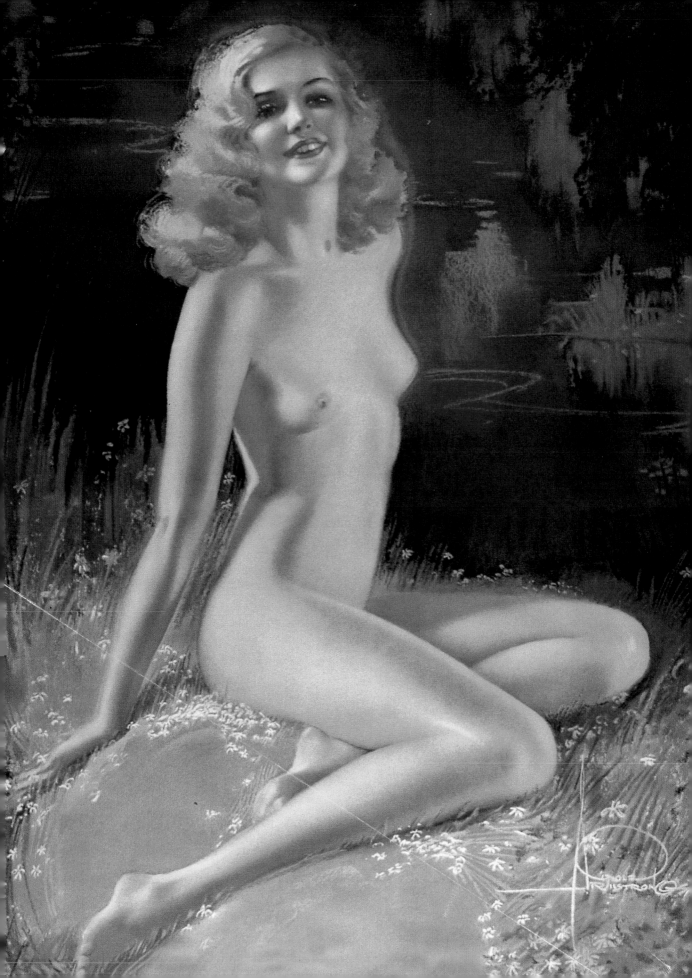

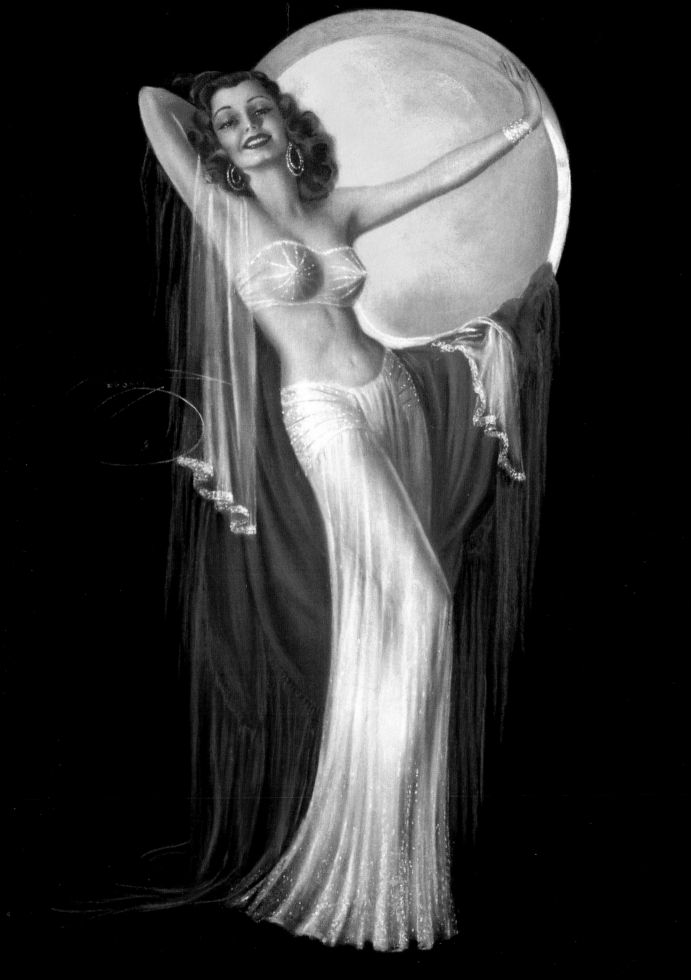

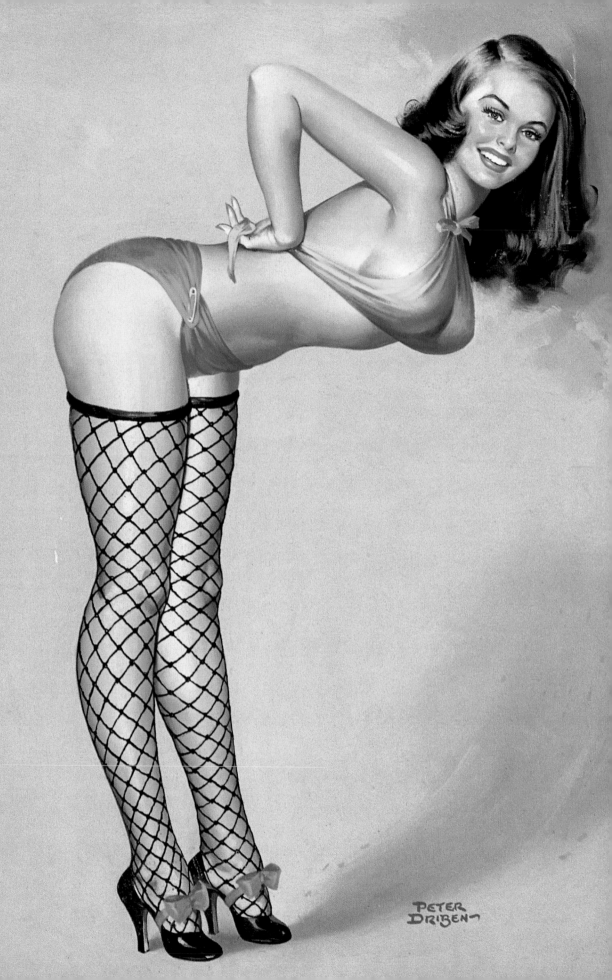

PETER
DRIBEN

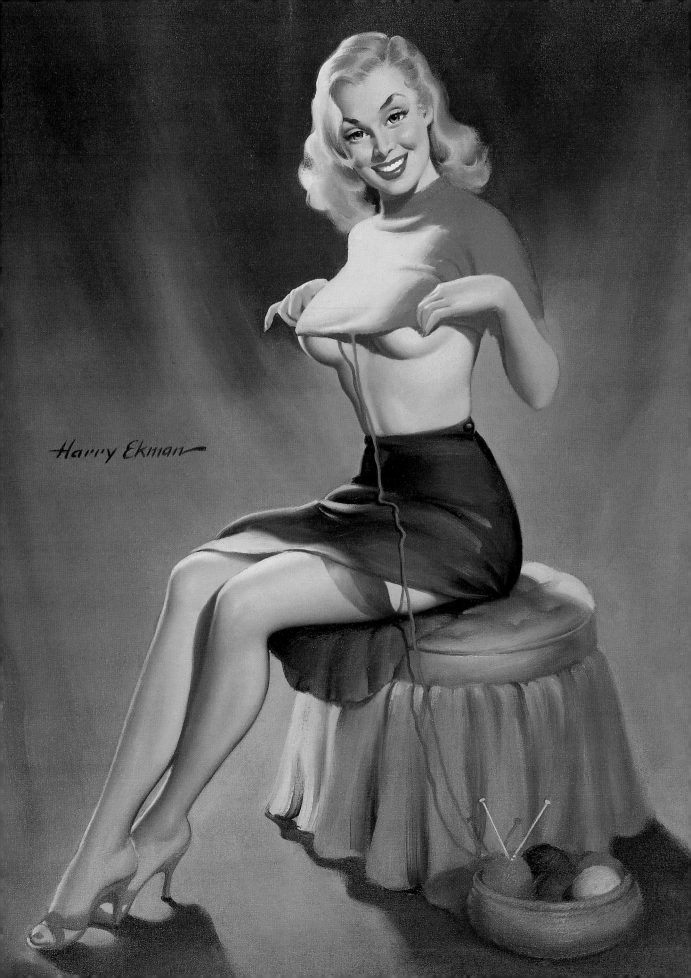

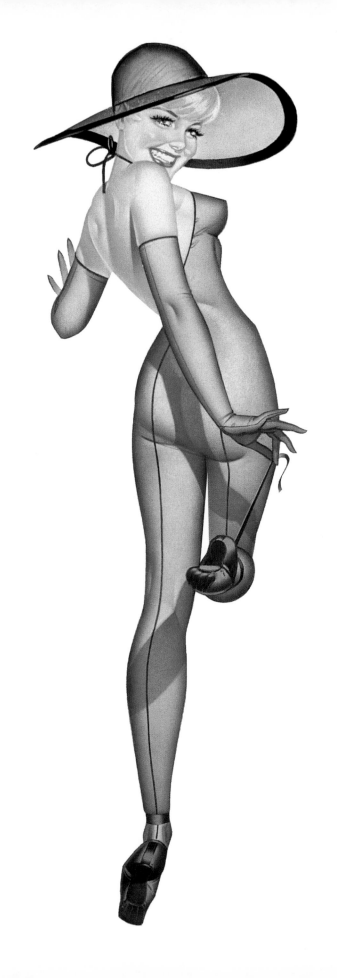

Charles G. Martignette / Louis K. Meisel

The Great American Pin-Up

TASCHEN

KÖLN LONDON LOS ANGELES MADRID PARIS TOKYO

To the eternal memory of my mother, Marie Della Femina, and to my father, Charles G. Martignette, Sr., who, as the best of catholic parents, unselfishly supported all of my ideas, interests, and dreams from the day I was born. Without their love and encouragement, there would be no glamour in my life.
Charles G. Martignette

My part of this book is dedicated to the memory of Grace Elizabeth Moak, my mother, who at twenty-one in 1941 was, and continued to be, the all-American girl this book is about. It is also in celebration of Susan Pear, whom I immediately recognized in 1964 as my Femlin, my Pin-Up, my Wife.
Louis K. Meisel

Dem Andenken an meine Mutter, Marie Della Femina, und meinen Vater, Charles G. Martignette, Sr. gewidmet, den besten katholischen Eltern überhaupt, die vom Tag meiner Geburt an immer selbstlos all meine Ideen, Interessen und Träume unterstützt haben. Ohne ihre Liebe und Unterstützung gäbe es keinen Glamour in meinem Leben.
Charles G. Martignette

Meinen Part des vorliegenden Buches widme ich dem Andenken an meine Mutter, Grace Elizabeth Moak, die 1941 mit 21 Jahren das All American Girl war, von dem dieses Buch handelt, und die es bis heute geblieben ist. Und ich widme dieses Buch meiner Frau Susan Pear, in der ich 1961 auf Anhieb mein Pin-up erkannte.
Louis K. Meisel

A la mémoire éternelle de ma mère, Marie Della Femina, et de mon père, Charles G. Martignette Sr. qui, en excellents parents catholiques, ont généreusement soutenu toutes mes idées, mes centres d'intérêts, et mes rêves depuis le jour où je suis né. Sans leur affection et leurs encouragements, ma vie serait totalement dépourvue de glamour.
Charles G. Martignette

Je dédie ma participation dans cet ouvrage à la mémoire de ma mère, Grace Elizabeth Moak, qui était à vingt et un ans (c'était en 1941) l'image même de la belle fille «made in USA» que nous célébrons ici. Je dédie également cet ouvrage à Susan Pear, rencontrée en 1964 et en qui j'ai immédiatement reconnu ma «Femlin», ma pin up,
Louis K. Meisel

Contents / Inhalt / Sommaire

Author's Notes

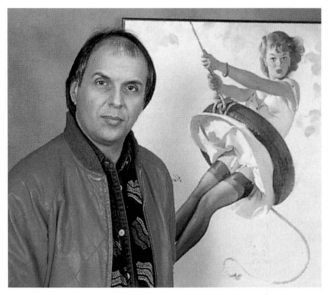

CHARLES G. MARTIGNETTE DEVANT «A REAL SWINGING
SWEETIE», UNE HUILE DE GIL ELVGREN, VERS 1965
PHOTO: TOM THURSTON, APOGEE, FT. LAUDERDALE, FLORIDE
CHARLES G. MARTIGNETTE MIT „A REAL SWINGING SWEETIE",
EINEM ORIGINALÖLGEMÄLDE VON GIL ELVGREN, UM 1965
FOTO: TOM THURSTON, APOGEE, FT. LAUDERDALE, FLORIDA
CHARLES G. MARTIGNETTE DEVANT «A REAL SWINGING
SWEETIE», UNE HUILE DE GIL ELVGREN, VERS 1965
PHOTO: TOM THURSTON, APOGEE, FT. LAUDERDALE, FLORIDE

It was about 1955 when I saw my first pin-up. My Aunt Anna would sometimes baby-sit with me, and one of our regular activities during those special nights was to read the day's newspaper together. Being five years old, I obviously couldn't understand the words, but I would cry out with delight every time I saw a pretty girl in an ad for ladies' shoes. At the end of the evening, we would both count together how many shoe ads we had seen.

When I was eight, my Uncle Mike began taking me for my haircuts. There, on the wall of the barbershop in Somerville, Massachusetts, I saw my first pin-up calendar. I began looking for pictures of pin-up girls everywhere I went. In 1960, at the grand old age of ten, I started to accompany Uncle Mike on Saturday mornings when he went to a local doughnut shop for coffee and doughnuts. There I discovered an entire wall decorated with pin-up and glamour art calendars, many of which, according to the owner of the shop, Mr. Rose, dated back almost to World War I.

It wasn't until December 1978 that I saw my first original pin-up painting – *A Refreshing Lift* by Gil Elvgren. I bought the work, which became my new prized possession: an oil on canvas, measuring 30 x 24 inches (76.2 x 61 cm), that had been published by Brown and Bigelow in 1969. I was in love. I was in heaven. And I was smitten with the idea of collecting more originals.

During the last fifteen years, I have been fortunate to have found and bought most of the original pin-up art in existence. I have shared that material with fellow collectors, both in the United States and abroad. This book presents the best of my pin-up and glamour art paintings, by both major and lesser-known artists in the field.

I feel strongly that the time has come for American pin-up and glamour art to be recognized worldwide for its special place in the history of American art. I have joined forces with Louis Meisel to produce numerous exhibitions of this art as well as a series of informative and, we hope, entertaining books, of which this is the first.

While I searched for artwork and information on pin-ups, I also discovered other illustrators who worked in a broad range of subjects for magazines and advertisers in the "mainstream" sector. I found myself loving the work of these contemporaries of Norman Rockwell as much as I loved my glamorous pin-ups, for they were all the *real* art of America.

I firmly believe that time and history will recognize the hundreds of American illustrators as truly significant artists of the twentieth century. It was their art that recorded for all of us the social and cultural development of our country. And pin-ups and glamour art played a key role in that process.

Charles G. Martignette

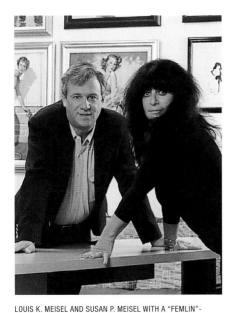

LOUIS K. MEISEL AND SUSAN P. MEISEL WITH A "FEMLIN"-
PAINTING BY LEROY NEIMAN AND TWO PAINTINGS BY GIL
ELVGREN. PHOTO: STEVEN LOPEZ
*LOUIS K. MEISEL UND SUSAN P. MEISEL MIT EINEM „FEMLIN"-
GEMÄLDE VON LEROY NEIMAN UND ZWEI GEMÄLDEN VON GIL
ELVGREN. FOTO: STEVEN LOPEZ*
LOUIS K. MEISEL ET SUSAN P. MEISEL AVEC UNE PEINTURE DE
LEROY NEIMAN ET DEUX PEINTURES DE GIL ELVGREN. PHOTO:
STEVEN LOPEZ

When the Fabulous Fifties arrived, I was eight years old. For the first three years of the decade, I was entirely absorbed in airplanes, specifically the Sabre jet. I wrote to all the airplane manufacturers for promotional pictures and built a terrific collection to adorn my room. I always preferred the pictures that showed paintings of airplanes to those that were merely photographs.

I was a teenager by the middle of the decade, and my interest turned to girls. Again, I was more drawn to paintings of girls than to photographs of them. My favorites were the kinds that showed girls who looked like the prettiest of my high school classmates in Tenafly, New Jersey. Whenever I got a copy of *Wink*, *Whisper*, or *Beauty Parade*, I was happy with the Peter Driben pin-up on the cover, while my friends were more turned on by the photographs inside, showing girls in their underwear who were to me tacky, unattractive, and sloppy. Nothing illustrated the ideal American girl better than the Brown and Bigelow calendars of that period painted by Gil Elvgren, Earl Moran, Rolf Armstrong, and Zoë Mozert.

At the end of the decade, I began to meet the artists of the New York School, or the Abstract Expressionists, as they were called. My attention was diverted to the field of fine art. Then, in 1963 or 1964, I discovered the Pop artist Mel Ramos. The sole link between the so-called fine-art world and that of pin-up illustration, Ramos acknowledged Elvgren as an inspiration and was himself a collector of pin-up art.

In 1972, I began to represent Mel and to seriously collect his art. At the same time, I began a search, which proved largely unsuccessful, for original pin-up art. In 1982, my wife, Susan, and I presented an exhibition of works by Elvgren, Mozert, and Armstrong at Susan P. Meisel Decorative Arts. The paintings we showed were primarily from the collection of our friend Marvin Oshansky. For the rest of the 1980s, we always had a pin-up or two on exhibition.

By the 1990s, I had acquired a good deal of pin-up art and had rekindled my relationship with Charles Martignette. I felt ready to act on an idea I had thought about for a long time. Charles and I joined together to present these artists and their work in a serious way, to proclaim and promote them as the fine artists they are.

Louis K. Meisel

Anmerkungen
der Autoren

FRANK HOFFMAN, EARL MORAN, ZOË MOZERT, NORMAN ROCKWELL

Mitte der 50er Jahre kam meine Tante Anna manchmal als „Babysitterin" zu uns. Für mich waren das immer ganz besondere Abende, denn zu unserem Ritual bei ihren Besuchen gehörte die gemeinsame „Lektüre" der Tageszeitung (ich war erst fünf Jahre alt und konnte natürlich noch nicht lesen). Aber jedesmal, wenn ich in einer Damenschuhreklame ein hübsches Mädchen entdeckte, stieß ich einen Freudenschrei aus. Zum Schluß zählten Tante Anna und ich dann, wieviele Schuhreklamen wir gesehen hatten.

Von meinem achten Lebensjahr an begleitete ich meinen Onkel Mike zum Haareschneiden. Bei einem Friseur in Somerville, Massachusetts, sah ich zum erstenmal einen Pin-up-Kalender, der mich so sehr beeindruckte, daß ich von da an überall nach Bildern von Pin-up-Girls Ausschau hielt. 1960, ich war zehn Jahre alt, durfte ich mit Onkel Mike an den Samstagen morgens zu Kaffee und Doughnuts ins Café in der Nachbarschaft gehen. Dort entdeckte ich eine ganze Wand voller Pin-up- und Glamour-Kunst-Kalender, von denen viele – so erzählte uns der Besitzer – noch aus der Zeit des Ersten Weltkriegs stammten.

Das erste originale Pin-up, A Refreshing Lift von Gil Elvgren, sah ich 1987. Ich kaufte es, und es war fortan mein wertvollster Besitz: Öl auf Leinwand, ca. 76 x 61 cm, 1969 von Brown and Bigelow in einem ihrer Kalender reproduziert. Ich war begeistert und ganz versessen darauf, noch mehr Originale mein eigen zu nennen.

Ich habe das Glück gehabt, in den letzten 15 Jahren den größten Teil der noch existierenden Originale der Pin-up-Kunst entdecken und erwerben zu können. Das Material habe ich auch anderen Sammlern in den USA und im Ausland zugänglich gemacht. In dem vorliegenden Buch finden sich die besten Gemälde aus meiner Sammlung: Pin-up- und Glamour-Kunst bedeutender, aber auch weniger bekannter Vertreter dieses Genres.

Es liegt mir sehr am Herzen, daß die Pin-up- und Glamour-Kunst endlich weltweit als eigenständige Richtung innerhalb der Geschichte der amerikanischen Kunst anerkannt wird. Louis K. Meisel und ich planen zahlreiche Ausstellungen sowie eine Reihe von informativen und, wie wir hoffen, auch unterhaltsamen Büchern über das amerikanische Pin-up. Mit diesem Buch machen wir den Anfang.

Bei meiner Suche nach Pin-up-Kunst und Informationen über diese Kunstrichtung stieß ich auch auf andere Illustratoren: Künstler, die für „seriöse" Zeitschriften oder für die Werbung tätig waren. Ich stellte fest, daß mir die Werke dieser Zeitgenossen Norman Rockwells genauso lieb waren wie meine Pin-ups, denn diese Werke verkörpern die wahre amerikanische Kunst.

Ich bin der festen Überzeugung, daß die meisten amerikanischen Illustratoren mit der Zeit als wirklich bedeutende Künstler des 20. Jahrhunderts anerkannt werden. In ihrer Kunst spiegelt sich die soziale und kulturelle Entwicklung unseres Landes wider – und dabei haben Pin-ups und Glamour-Girls eine äußerst wichtige Rolle gespielt.

Charles G. Martignette

1950, zu Beginn der sogenannten Fabulous Fifties, der fabelhaften Fünfziger, war ich acht Jahre alt. Zuerst einmal interessierte ich mich während der ersten drei Jahre des Jahrzehnts ausschließlich für Flugzeuge. Bei allen Flugzeugbauern orderte ich Werbebilder und legte nach und nach eine großartige Sammlung an, mit der ich mein Zimmer dekorierte. Aber bereits damals zog ich Illustrationen von Flugzeugen den Fotos vor.

Mitte der 50er Jahre begann ich, mich für Mädchen zu interessieren und sammelte nun Bilder von schönen Frauen. Am besten gefielen mir die Illustrationen, auf denen die Mädchen so aussahen wie die hübschesten meiner Mitschülerinnen in Tenafly, New Jersey. Wenn mir ein Exemplar von Wink (Augenzwinkern), Whisper (Geflüster), oder Beauty Parade (Schöne Frauen) in die Hände fiel, begeisterte ich mich für das Pin-up-Girl von Peter Driben auf der Titelseite, während meine Freunde mehr auf die Fotos in den Zeitschriften abfuhren: Mädchen in Unterwäsche, die ich geschmacklos, unattraktiv und schlampig fand. Meiner Meinung nach wurde die ideale junge Amerikanerin dieser Zeit nirgendwo besser dargestellt als in den Brown-and-Bigelow-Kalendern mit Pin-ups von Gil Elvgren, Earl Moran, Rolf Armstrong und Zoë Mozert.

Als mir Ende der 50er Jahre zum ersten Mal die sogenannten Abstrakten Expressionisten, Künstler der New Yorker Schule, begegneten, wechselte ich zur „hohen" Kunst, bis ich 1963 oder 1964 den Pop-Art-Künstler Mel Ramos entdeckte. Ramos war das einzige Bindeglied zwischen der „hohen" und der Pin-up-Kunst. Er gab nicht nur zu, daß er sich von Elvgren inspirieren ließ, sondern sammelte auch selbst Pin-up-Kunst.

Ich selbst sammelte Mels Werke und stellte ihn 1972 auch aus. Zur gleichen Zeit begann meine – weitgehend vergebliche – Suche nach Pin-up-Originalen. 1982 zeigten meine Frau Susan und ich in der Galerie Susan P. Meisel Decorative Arts Werke von Elvgren, Mozert und Armstrong, die hauptsächlich aus der Sammlung meines Freundes Marvin Oshansky stammten. Von da an stellten wir während der gesamten 80er Jahre in unserer Galerie immer mindestens ein Werk der Pin-up-Kunst aus.

Anfang der 90er Jahre war meine Sammlung beträchtlich gewachsen. Ich nahm die Verbindung zu Charles G. Martignette auf und hielt den Zeitpunkt für gekommen, einen lange gehegten Plan in die Tat umzusetzen. Charles und ich wollen gemeinsam diese Künstler und ihre Werke einem breiten Publikum präsentieren und ihnen so zu der gebührenden Anerkennung als großartige Künstler verhelfen.

Louis K. Meisel

Notes des auteurs

J'ai vu ma première pin up en 1955. Ma tante Anna me gardait parfois le soir quand mes parents étaient de sortie et l'une de nos occupations favorites lors de ces soirées spéciales consistait à feuilleter le journal ensemble. Alors âgé de cinq ans, je ne savais naturellement pas lire, mais chaque fois que j'apercevais une jolie dame dans une publicité pour chaussures, je laissais échapper un cri de joie. A la fin de la soirée, nous comptions ensemble le nombre de publicités pour chaussures que nous avions vues.

Lorsque j'atteignis huit ans, mon oncle Mike fut chargé de m'emmener régulièrement me faire couper les cheveux. C'est là, sur un des murs du salon de coiffure pour hommes de Sommerville, dans le Massachusetts, que j'ai vu mon premier calendrier de pin up. Dès lors, je me suis mis à chercher des pin up partout où j'allais. En 1960, à l'âge de dix ans, j'obtins le privilège d'accompagner tous les samedis matins l'oncle Mike dans un café du quartier. Le propriétaire, M. Rose, avait recouvert un mur entier de calendriers d'art glamour et de pin up dont un grand nombre, m'assura-t-il, remontaient presque à la Première Guerre mondiale.

Ce n'est qu'en décembre 1978 que je suis tombé sur ma première peinture originale de pin up : *A Refreshing Lift*, de Gil Elvgren. Je l'ai achetée, le cœur battant. C'était une huile sur toile, de 76,2 x 61 cm, publiée en 1969 par Brown and Bigelow. J'étais aux anges. J'étais amoureux. Et j'étais bien décidé à commencer une collection.

Au cours des quinze dernières années, j'ai eu la chance de retrouver et de pouvoir acquérir la plupart des œuvres originales existantes. J'ai partagé ce trésor avec d'autres collectionneurs, aux Etats-Unis et à l'étranger. Cet ouvrage présente les plus belles pièces de ma collection, réalisées par des artistes célèbres et d'autres, moins connus.

Je pense sincèrement que le moment est venu pour l'art glamour et les pin up de prendre enfin leur juste place dans l'histoire de l'art américain. Je ne doute pas qu'ils finiront par être reconnus dans le monde entier comme une forme d'art à part entière. Louis Meisel et moi-même avons uni nos efforts afin d'organiser de nombreuses expositions et de publier une série de livres instructifs et, nous l'espérons, agréables à regarder, dont vous tenez le premier exemple entre vos mains.

Tout en recherchant des œuvres et des informations sur les pin up, j'ai découvert d'autres illustrateurs ayant travaillé sur un large éventail de sujets pour des magazines ou des publicités plus traditionnels. Je me suis surpris à aimer l'œuvre de ces contemporains de Norman Rockwell autant que mes séduisantes pin up, car tous représentent le *véritable* art américain.

Je suis intimement persuadé que le temps et l'histoire reconnaîtront ces centaines d'illustrateurs américains comme des artistes importants du vingtième siècle. Leur art a enregistré pour nous l'évolution sociale et culturelle de l'Amérique, une évolution dans laquelle les pin up et l'art glamour ont joué un rôle essentiel.

Charles G. Martignette

J'ai eu huit ans en 1950. J'ai passé les trois premières années de cette glorieuse décennie fasciné par les avions, et plus particulièrement par le Sabre jet. J'écrivais à tous les avionneurs pour obtenir des images publicitaires et assemblais ainsi une formidable collection qui ornait les murs de ma chambre. Je préférais nettement les peintures et les dessins d'avions aux simples photos.

J'ai atteint l'adolescence vers le milieu des années cinquante, et mon attention s'est tout naturellement tournée vers les filles. Là encore, j'avais une certaine prédilection pour les dessins. Mes pin up préférées ressemblaient aux plus jolies filles de mon lycée de Tenafly, dans le New Jersey. Chaque fois que j'achetais un numéro de *Wink, Whisper* ou de *Beauty Parade*, je me régalais avec la pin up de Peter Driben qui faisait la couverture, tandis que mes camarades s'intéressaient davantage aux photos de filles en petite culotte qu'on trouvait à l'intérieur, trop ringardes, laides et maladroites à mon goût. Rien n'illustre mieux l'idéal de la beauté américaine que les calendriers Brown and Bigelow de cette époque, peints par Gil Elvgren, Earl Moran, Rolf Armstrong et Zoë Mozert.

Vers la fin des années 50, j'ai commencé à fréquenter les artistes de l'école de New York, qu'on appelait également les expressionnistes abstraits. Je me suis alors intéressé aux beaux-arts. Puis, en 1963 ou 64, j'ai fait la connaissance de Mel Ramos et du Pop Art. Seul lien entre le monde des arts dits «beaux» et celui des illustrateurs de pin up, Ramos reconnaissait s'inspirer d'Elvgren et était lui-même collectionneur de peintures de pin up.

A partir de 1972, je suis devenu l'agent de Mel et me suis mis à collectionner ses œuvres. Parallèlement, j'ai entamé une recherche, largement infructueuse, d'œuvres originales de pin up. En 1982, ma femme Susan et moi-même avons organisé une exposition de peintures d'Elvgren, de Mozert et d'Armstrong à la galerie d'arts décoratifs Susan P. Meisel. Les tableaux provenaient en grande partie de la collection de notre ami Marvin Oshansky. Depuis, nous avons toujours une ou deux pin up accrochées dans notre galerie.

Au début des années 90, j'avais réussi à rassembler un bon nombre de peintures originales de pin up et renoué mes relations avec Charles Martignette. Je me sentais prêt à mener à bien un projet qui me tenaillait depuis longtemps. Charles et moi nous sommes alors associés pour présenter ces artistes et leurs œuvres sérieusement, afin de les faire connaître et aimer comme les grand artistes qu'ils sont.

Louis K. Meisel

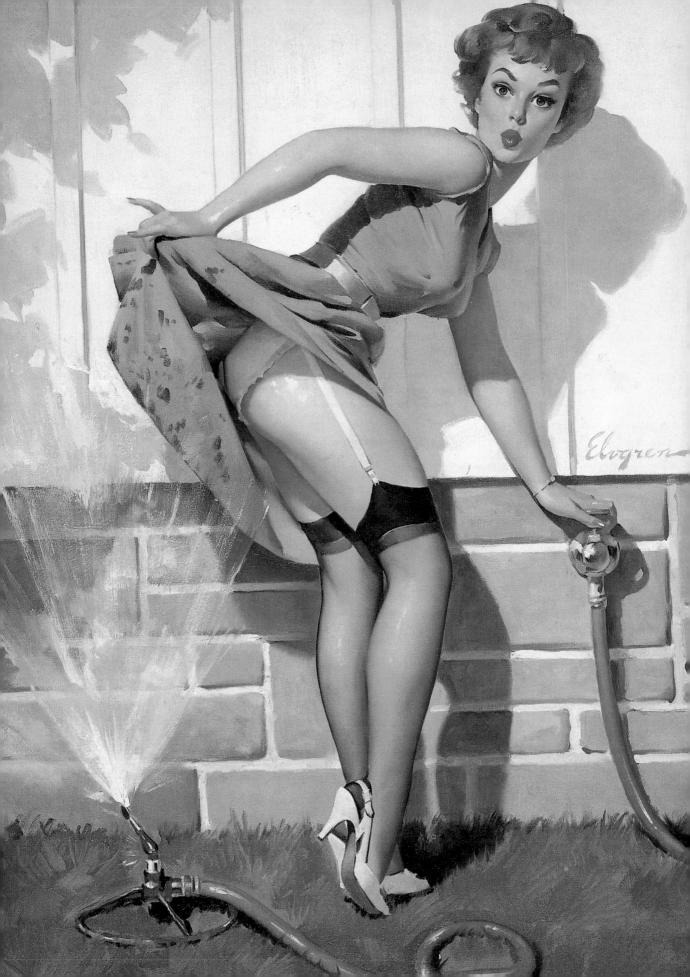

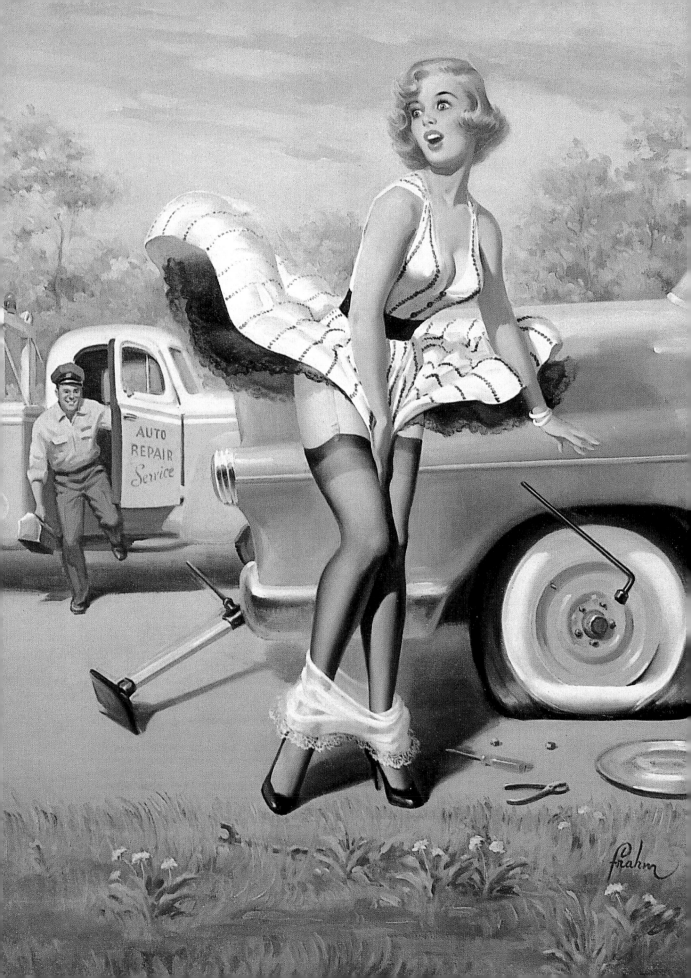

Pin-Up Art:
A Historical Commentary

Walt A. Reed

At the turn of the century, "family values" ran rampant. Still under the repressed and cloistered mores of the Victorian era, women were corseted, petticoated, and so covered from head to toe that the glimpse of an ankle was a racy titillation. The unmentionable word was spelled "s_x" and any books relating to that subject in the public library were kept under lock and key behind glass cases. It's a wonder that the population rate didn't fall precipitously.

Somehow Mother Nature persevered, and if the printed word was being policed by the Boston-based Anthony B. Comstock Society, magazine publishers were risking censure or confiscation by printing pictures of scantily clad maidens under the more-difficult-to-censor guise of art. Or, as in the case of *The Police Gazette*, should the peccadilloes of vaudevillians involve murder or mayhem, it was perfectly legitimate to illustrate the story by showing the leading lady in her tights, in the interests of news.

Nor did art museum attendance languish. Academic painters found great public favor by depicting Grecian maidens in diaphanous robes or innocently emerging from ornate pools covered only by a strategic lily pad. If the figures were of Greek or Roman mythology, the public was historically and safely removed from contemporary temptation.

A few more subversive influences were looming. D.H. Lawrence railed against sexual repression in his infamous novel *Lady Chatterley's Lover*. Certainly any library with a copy kept it locked up! The aftermath of World War I brought back a generation of lusty young soldiers from Europe, where the population was much less inhibited and French postcards were the ultimate in sensuality.

The 1920s became a revolt against everything the older generation stood for, and young women as well as men sought emancipation. The illustrator John Held, Jr., portrayed the leggy, short-skirted "flappers" who were accompanied by the bell-bottomed, saxophone-playing "sheiks" with pomaded hair à la Rudolph Valentino whose manners were as sullen as their fathers' had been gallant.

The magazines *Judge*, *Life*, and *College Humor* enthusiastically published the flappers of Held and Russell Patterson and the bathing beauties of Coles Phillips and Rolf Armstrong.

Publishers of "pulp" magazines like *Spicy Detective*, *Weird Tales*, and *The Mysterious Wu Fang* saw no reason to withhold lurid paintings, showing heroines in bondage or mortal danger from the "yellow peril," from an eager public. Renegade illustrators, including Jerome and George Rozen, John Newton Howitt, and H.J. Ward, lent their considerable talents to this risqué genre and were later joined by the daring Margaret Brundage. Even as far back as "Little Egypt" at the 1898 World's Fair, pin-ups have had an exotic ancestry. A "nice girl" wouldn't display her figure, but it was all right for sloe-eyed Eurasians or Belly Dancers to cavort about and inspire naughty pictures.

Some publishers developed a specialized niche in the nudist magazines reflecting that new fad. Others, like *Captain Billy's Whiz Bang*, *Snappy Stories*, and *Film Fun*, needed no excuse to combine sex with humor. As with the adventure pulps, the main expense was for cover art. Many of these early magazines operated with very slim budgets – some did not survive beyond the first printing. The artwork reflected this lack of funds, and their covers were necessarily done by second-rate performers. The social standing of such magazines was so low that few self-respecting illustrators would touch them. Even later, with improvement in magazine budgets and content, pin-up art was considered a lowbrow specialty. There was little crossover between mainstream magazine illustrators and those in the pin-up field. Unabashed, pin-up artists such as Earle Bergey, Enoch Bolles, and George Quintana raised the artistic level of the art and came to dominate the covers of this budding branch of pathfinding publications.

Brown and Bigelow, the earliest and biggest of the calendar publishers, began using bathing beauties as an important part of their line early in the century. After the 1920s, nearly every garage in the country had a sultry beauty by Rolf Armstrong, Earl Moran, Earl Mac Pherson, or Billy DeVorss on display over the workbench.

Esquire magazine in the Depression 1930s brought a monthly relief from the bad economic outlook with morale-boosting centerfolds, featuring first the George Petty Girl and then Antonio Vargas's airbrushed beauties. As a lavish slick-paper magazine, *Esquire* could attract more established artists, and later *Esquire* artists included Gilbert Bundy, Mike Ludlow, Fritz Willis, Joe DeMers, Al Moore, Ben-Hur Baz, and many other talents.

World War II turned the pin-up into a major industry. It was to become the golden age of the art, with room for any artist who could paint an enticing figure. Girls by artists such as Gil Elvgren, Zoë Mozert, Joyce Ballantyne, and Earl Moran vied for space in the GIs' lockers along with photographic images of movie actresses, such as Betty Grable, Rita Hayworth, and Veronica Lake, and a host of starlets.

The returning veterans of World War II wanted only to settle down, to build houses and raise families. A few efforts to push the sexual frontiers, such as the lavish *Eros* magazine, were quickly quashed by the postal authorities. While the garage calendar was still the thriving mainstay format, a group of younger artists led by Gil Elvgren and his protégés Art Frahm, Ed Runci, Al Buell, and Harry Ekman were taking over the pin-up genre. And, not to be taken too seriously, subgroups of "plump" pin-ups, "dropped-panty" pin-ups, male pin-ups, and other fragmented specializations found their enthusiastic partisans.

During this time, the newest showcase for pin-up art was on the covers of the paperbacks. Born of a need for cheap, pocket-sized reading matter for GI's and restricted by paper shortages, the pent-up postwar public response was seemingly without limit. Every kind of subject was published in a ten-cent format with an illustrated cover. Even titles by such classic authors as William Faulkner, Emily Brontë, and John Steinbeck could be illustrated by the artists with a lot of leg. Hundreds of artists were involved in painting the covers; among the best were James Avati, Rudy Belarski, Baryé Phillips, and Bob McGinnis. Some had been recruited from the pulps, others from the ranks of the dwindling major "slicks," which were falling right and left. Among these were such publications as *American*, *Collier's*, *Liberty*, and *Woman's Home Companion*; later on even the mighty *Saturday Evening Post* folded in competition with T.V. and the paperback.

It was the baby boomers of the 1960s who brought down the sexual barriers with the availability of the Pill. Hugh Hefner became the new guru through *Playboy*, which directly confronted censorship rules for use of the mails. Under legal challenges, the Supreme Court waffled about how to rule on obscenity within the vague definition of "prurient and with no redeeming social value." Consequently, the gates came down and many other magazines rushed into competition. The "skin" magazines became an international phenomenon.

By the 1970s, photography had taken over the pin-up genre, with graphics that tended to take the fun out of the subject and to put the emphasis on literal examination of sexual parts more appropriate to the medical profession.

The subject having been pursued about as far as it can go, an inevitable reaction may be in the offing. Excesses of freedom without taste or responsibility, AIDS, and increasing public concern about lost standards of behavior are certainly adding to the clamor for a return to "family values." Will the pendulum swing back to its original extreme in the next century? Will we return to that errant ankle?

Die Geschichte der Pin-up-Kunst

Walt A. Reed

Die Jahrhundertwende war die Zeit der „traditionellen Werte", in der Frauen noch den strengen Sitten des viktorianischen Zeitalters unterworfen waren. Sie trugen Korsetts, voluminöse Unterröcke und waren von Kopf bis Fuß so verhüllt, daß bereits der Anblick einer weiblichen Fessel als erotischer Kitzel galt. Das Wort, das man nicht in den Mund nehmen durfte, schrieb sich „Sex". In den Bibliotheken wurden alle Bücher zu diesem Thema hinter Schloß und Riegel verwahrt. Eigentlich ein Wunder, daß die Bevölkerung sich nicht dramatisch verringerte!

Trotz der scharfen Überwachung durch die staatliche Zensurbehörde, der Bostoner Anthony B. Comstock Society, wurden unter dem Deckmantel „Kunst" Bilder von spärlich bekleideten Jungfrauen gedruckt. Bei der Police Gazette stand beispielsweise das Recht auf Information im Vordergrund: Wenn sich unter Varietékünstlern ein Mord oder eine schwere Körperverletzung ereignete, war es völlig legitim, die Story mit einem Bild der Hauptakteurin in enger Trikothose zu illustrieren – immer im Interesse der Information der Öffentlichkeit.

Auch die Museen trugen ihren Teil bei. Sofern es sich um Gestalten aus der antiken Mythologie handelte, befand sich der Betrachter in den Augen der Zensur in „sicherem" Abstand und war keinerlei erotischen Versuchungen im Hier und Jetzt ausgesetzt. Beliebt waren Akademiemaler, die griechische Jungfrauen darstellten, die in aller Unschuld dem Wasser entstiegen und nur von einer an strategisch wichtiger Stelle plazierten Seerose bedeckt wurden.

Weitere subversive Einflüsse zeichneten sich ab. In seinem berüchtigten Roman Lady Chatterley's Lover wetterte D. H. Lawrence gegen die sexuelle Repression. Wenn eine Bibliothek ein Exemplar besaß, hielt sie das ganz bestimmt unter Verschluß!

Nach dem Ersten Weltkrieg kehrte eine Generation lebenslustiger junger Soldaten aus Europa zurück, wo die Menschen viel weniger prüde waren. Im Gepäck hatten sie französische Postkarten, die das Nonplusultra an Sinnlichkeit darstellten.

Die 20er Jahre waren geprägt vom Emanzipationsbestreben der Jugend, die gegen alles revoltierte. Der Illustrator John Held jr. malte die langbeinigen „Flappers" in kurzen Röckchen neben saxophonspielenden „Sheiks", die Hosen mit Schlag und das Haar pomadisiert à la Rudolph Valentino trugen und deren blasiertes Gehabe in krassem Gegensatz zu den galanten Umgangsformen ihrer Väter stand. Die Zeitschriften Judge, Life und College Humor druckten die „Flappers" von Held und Russell Patterson ab oder die Badenixen von Coles Phillips und Rolf Armstrong, wobei sie sich der Gunst des Publikums sicher sein konnten.

Für die Verleger von Groschenheften, den sogenannten pulps, wie z. B. Spicy Detective, Weird Tales oder The Mysterious Wu Fang, gab es keinen Grund, einer begierigen Leserschaft reißerische Bilder der Heldinnen vorzuenthalten. Manche Illustratoren, unter ihnen auch Jerome und George Rozen, John Newton Howitt und H. J. Ward, wurden zu Verrätern an der „hohen" Kunst und stellten ihr beachtliches Können in den Dienst dieses Genres; später gesellte sich noch Margaret Brundage dazu.

Die exotischsten Vorfahren der Pin-ups kann man bis zur Weltausstellung von 1898 zurückverfolgen, wo die Bauchtänzerin „Little Egypt" viel bewundert wurde. Eine wohlerzogene junge Dame hätte nie ihre Figur zur Schau stellen dürfen, aber niemand fand etwas dabei, wenn mandeläugige Eurasierinnen als Bauchtänzerinnen auf der Bühne agierten.

Einige Verleger machten sich die neue FKK-Masche zunutze und brachten Nudistenmagazine auf den Markt. Andere Zeitschriften, wie Captain Billy's Whiz Bang, Snappy Stories oder Film Fun wiederum verbanden unbefangen Sex und Humor. Der größte Teil des Etats floß in die Illustration der Titelseite. Da die meisten dieser frühen Magazine nur über ein sehr schmales Budget verfügten, gingen manche bereits nach der ersten Auflage wieder ein. Der Geldmangel schlug sich vor allem in der Qualität der Illustrationen nieder: Oft wurden zweitrangige Künstler mit der Gestaltung der Titelseiten beauftragt. Zudem galten viele der Magazine als zweit- oder drittklassig, so daß kaum ein Illustrator für sie arbeiten wollte. Aber auch nachdem die Magazine finanziell und inhaltlich solider geworden waren, haftete der Pin-up-Kunst weiterhin das Vorurteil an, etwas für Anspruchslose zu sein. Es gab kaum Illustratoren, die gleichzeitig für „seriöse" und für Pin-up-Zeitschriften arbeiteten. Allerdings ließen sich Pin-up-Künstler wie Earle Bergey, Enoch Bolles oder George Quintana davon nicht beirren, sie blieben auf dem einmal eingeschlagenen Weg und beherrschten schließlich die Titelseiten.

Brown and Bigelow, der größte US-Kalenderverlag, bildete bereits Anfang des Jahrhunderts Badenixen ab. Ab 1930 hing praktisch in sämtlichen Autowerkstätten des Landes eine sinnliche Schöne von Rolf Armstrong, Earl Moran, Earl Mac Pherson oder Billy DeVorss.

Anfang der 30er Jahre, während der Weltwirtschaftskrise, sorgten die sogenannten Centerfolds, die doppelseitigen Bilder in der Mitte der Zeitschrift Esquire, für wohltuende Ablenkung von der miserablen Lage. Anfangs war es das „George Petty Girl", später trugen die von Antonio Vargas in der Airbrush-Technik gemalten „Varga-Girls" zur Hebung der allgemeinen Stimmung bei. Dem aufwendig gestalteten Hochglanzmagazin Esquire gelang es, auch etabliertere Künstler an sich zu binden: Künstler wie Gilbert Bundy, Mike Ludlow, Fritz Willis, Joe DeMers, Al Moore oder Ben-Hur Baz standen bei Esquire unter Vertrag.

Während des Zweiten Weltkriegs entwickelte sich die Pin-up-Kunst zu einem bedeutenden Industriezweig. In den Spinden der GIs teilten sich die Pin-ups von Gil Elvgren, Zoë Mozert, Joyce Ballantyne oder Earl Moran den Platz mit Fotos von Filmschauspielerinnen wie Betty Grable, Rita Hayworth, Veronica Lake und anderen.

Nach dem Krieg wollten die Veteranen jedoch wieder seßhaft werden, eine Familie gründen und ein Haus bauen. Die 50er Jahre waren in den USA eine Zeit, in der kein Mensch über Sex redete oder, unvorstellbarer noch, Spaß daran hatte. Zwar versuchten einige ambitionierte Zeitschriften, wie etwa das üppig aufgemachte Magazin Eros, die engen sexuellen Grenzen zu sprengen; aber die Zensur setzte dem schnell ein Ende. Die Pin-up-Kalender in der Autowerkstatt, die sich nach wie vor am besten verkauften, blieben das am häufigsten benutzte Format für Pin-up-Kunst. Allmählich bemächtigten sich jüngere Künstler des Genres, an der Spitze Gil Elvgren und seine Protégés Art Frahm, Ed Runci, Al Buell und Harry Ekman.

Ein weiteres wichtiges Medium für die Verbreitung der Pin-ups sollten Taschenbücher werden. Das kleinformatige Taschenbuch war enstanden, weil man der kriegsbedingten Papierknappheit begegnen wollte, und weil man für die GIs Lesestoff im Taschenformat brauchte. Der aufgestaute Lesehunger war scheinbar grenzenlos, und jedes Thema oder Sachgebiet taugte zur Veröffentlichung mit einem Bild auf der Umschlagseite. Sogar die Titel von Klassikern wie William Faulkner, Emily Brontë oder John Steinbeck ließen sich mit viel Bein illustrieren. Hunderte von Künstlern, als die Besten unter ihnen galten James Avati, Rudy Belarski, Baryé Phillips und Bob McGinnis, waren mit der Illustration von Buchumschlägen beschäftigt. Manche hatten vorher für Groschenhefte gearbeitet, andere für Hochglanzmagazine, von denen aber immer mehr ihr Erscheinen einstellen mußten, wie z. B. American, Collier's, Liberty und Woman's Home Companion. Später war sogar die mächtige Saturday Evening Post der Konkurrenz von Fernsehen und Taschenbüchern nicht mehr gewachsen und ging ein.

Als in den 60er Jahren die Antibabypille überall zu haben war, wuchs die sexuelle Freiheit. Der neue Guru wurde Hugh Hefner, der mit seinem Playboy die Postzensur geradezu herausforderte. Es kam zu unzähligen Prozessen, und der Oberste Gerichtshof der USA diskutierte lang und breit, was der offiziellen Definition „schlüpfrig und ohne jeden gesellschaftlichen Wert" folgend, denn nun eigentlich obszön zu nennen und damit zu verbieten sei. Nach mehreren Musterprozessen fielen alle Schranken. Eine Unzahl neuer Zeitschriften drängte auf den Markt, und Pornomagazine wurden zum internationalen Phänomen.

Zu Beginn der 70er Jahre bemächtigte sich schließlich die Fotografie des Pin-up-Genres. Die Gestaltung ließ jeden Spaß an der Sache vermissen. Es drehte sich alles nur noch um die genaue Darstellung der Geschlechtsorgane, und die Illustrationen hätten jedem anatomischen Lehrbuch zur Ehre gereicht.

Das „goldene Zeitalter" des amerikanischen Pin-ups ist vorbei; vielleicht wird demnächst die unvermeidliche Reaktion einsetzen. Exzesse, grenzenlose „Freiheit" ohne guten Geschmack oder Verantwortlichkeit, AIDS und die zunehmende Besorgnis um verlorengegangene Umgangsformen und alle Regeln des guten Benehmens tragen dazu bei, daß der Ruf nach einer Rückkehr zu den „traditionellen Werten" immer lauter wird. Wird das Pendel im nächsten Jahrhundert wieder in die entgegengesetzte Richtung ausschlagen? Werden wir wieder dahin kommen, daß schon das Zeigen des weiblichen Fußgelenks als erotisch gilt?

L'art des pin up : Commentaire historique

Walt A. Reed

Au début du siècle, les «valeurs familiales» étaient toutes-puissantes. Encore sous le joug des mœurs réprimées et cloisonnées de l'époque victorienne, les femmes étaient corsetées, juponnées, couvertes des pieds à la tête, au point que le simple entr'aperçu d'une pudique cheville constituait une incitation à la débauche. Le mot imprononçable s'écrivait «s.e» et tout ouvrage traitant du sujet de près ou de loin était soigneusement gardé sous clef dans les bibliothèques publiques. On peut s'étonner de ce que le taux de natalité n'ait pas subi un déclin vertigineux.

Néanmoins, l'espèce humaine survécut et si toutes les publications étaient sévèrement contrôlées par la très prude Anthony B. Comstock Society de Boston, il se trouvait toujours des revues pour braver la censure et risquer d'être confisquées en publiant des images de jeunes filles légèrement vêtues sous couvert «d'œuvres d'art», plus difficiles à censurer. De même, dans les journaux à sensation tels que The Police Gazette, lorsqu'un meurtre ou un fait divers quelconque venait troubler les vicissitudes des artistes de vaudeville, il était parfaitement légitime d'illustrer l'article avec une image de l'héroïne en collants, dans l'intérêt de l'information.

Les musées, eux, n'étaient pas en manque de public. Les peintres académiques remportaient un grand succès en montrant de jeunes Grecques drapées dans des tuniques diaphanes ou sortant innocemment de leur bain avec, pour seul vêtement, un nénuphar stratégique. Tant qu'il s'agissait de mythologie grecque ou romaine, le contexte historique semblait protéger le public de toute tentation malsaine.

Mais d'autres influences subversives pointaient. Dans son sulfureux roman, L'Amant de lady Chatterley, D. H. Lawrence s'insurgea contre la répression sexuelle. Il va sans dire que les bibliothèques qui en possédaient un exemplaire le cachaient soigneusement! La fin de la Grande Guerre ramena au bercail une armée de vigoureux jeunes hommes après plusieurs années passées en Europe, où la population était beaucoup moins inhibée et où les cartes postales «légères» étaient le dernier cri en matière d'érotisme.

Les années 20 virent la rébellion de la jeunesse contre tout ce qui était cher au cœur de ses aînés. Les jeunes des deux sexes revendiquaient leur émancipation.

L'illustrateur John Held Jr. montrait ces jeunes femmes «délurées», aux jupes courtes et aux jambes interminables, aux côtés de leurs «jules» saxophonistes, aux pantalons évasés, aux cheveux gominés à la Rudolph Valentino, et aux manières aussi directes que celles de leurs aînés étaient policées.

Les revues Judge, Life et College Humor publièrent avec enthousiasme les garçonnes effrontées de Held et de Russel Paterson ainsi que les belles baigneuses de Coles Phillips et de Rolf Armstrong. Les éditeurs de «pulp fiction», des revues de littérature de gare telles que Spicy Detective, Weird Tales et The Mysterious Wu Fang, ne virent plus aucune raison de priver leur public ravi d'images lubriques montrant des héroïnes enchaînées ou mortellement menacées par le «péril jaune». Des frondeurs de l'illustration, dont Jerome et George Rozen, John Newton Howitt et H.J. Ward, prêtèrent leur talent considérable à ce genre osé, plus tard rejoints par l'intrépide Margaret Brundage. Il faut dire que depuis la «Petite Egypte» de l'Exposition universelle de 1898, les pin up avaient des ancêtres exotiques. Si une «fille bien» ne pouvait décemment pas montrer ses dessous en public, il paraissait tout naturel qu'une Eurasienne aux yeux de biche ou une danseuse du ventre batifolent à moitié nues et inspirent des images polissonnes.

Certains éditeurs développèrent un créneau spécial à travers les revues de nudisme, répondant ainsi à ce nouvel engouement du public. D'autres, comme Captain Billy's Whiz Bang, Snappy Stories et Film Fun, n'avaient pas besoin d'un prétexte pour conjuguer érotisme et humour. Comme pour les journaux à sensation, le souci principal était d'avoir des couvertures attirantes. Un grand nombre de ces publications disposaient d'un budget très serré et certaines ne survécurent pas à leur premier numéro. La médiocrité des illustrations reflétait leurs faibles moyens et les couvertures étaient nécessairement réalisées par des artistes de second ordre. Socialement, ces revues étaient si mal vues que les illustrateurs dignes de ce nom ne voulaient pas en entendre parler. Même plus tard, lorsque les moyens et le contenu de ces revues s'améliorèrent, l'art des pin up continua à être considéré comme une spécialité de bas étage. Un gouffre séparait les illustrateurs des magazines à grande diffusion de ceux qui donnaient dans la pin up. Sans se démonter pour autant, certains artistes spécialisés dans ce domaine comme Earle Bergey, Enoch Bolles et George Quintana haussèrent la qualité artis-

tique de leur travail à un tel niveau qu'ils finirent par dominer les couvertures de cette branche naissante et innovatrice de l'édition.

Dès le début du siècle, Brown and Bigelow – les premiers et principaux éditeurs de calendriers – consacrèrent une bonne partie de leurs publications aux belles baigneuses. A partir des années 20, rares étaient les garages où il n'y avait pas une beauté voluptueuse de Rolf Armstrong, d'Earl Moran, d'Earl Mac Pherson ou de Billy DeVorss punaisée au-dessus de l'établi. Tout au long de la grande dépression des années 30, le magazine *Esquire* égaya chaque mois la grisaille ambiante avec son poster central où figurait d'abord une *Petty Girl* puis une des beautés aérographées d'Antonio Vargas. En tant que revue luxueuse sur papier glacé, *Esquire* pouvait attirer des artistes plus établis – Gilbert Bundy, Mike Ludlow, Fritz Willis, Joe DeMers, Al More, Ben-Hur Baz et de nombreux autres talents.

La Deuxième Guerre mondiale transforma la pin up en industrie florissante. Elle devait marquer l'âge d'or de cet art, offrant du travail à tout artiste capable de dessiner une silhouette aguichante. Dans les casiers des G.I.'s., les filles de Gil Elvgren, de Zoë Mozert, de Joyce Ballantyne et d'Earl Moran se disputaient l'espace avec Betty Grable, Rita Hayworth, Veronica Lake et une pléthore de starlettes.

Les soldats qui rentrèrent de la Deuxième Guerre mondiale n'aspiraient qu'à retrouver une vie normale, à fonder un foyer et à élever leurs enfants. Les quelques tentatives pour repousser plus loin les frontières de l'érotisme, comme la luxueuse revue *Eros*, furent vite écrasées par les autorités postales. Tandis que le calendrier des garagistes continuait d'être le principal pourvoyeur de pin up, un groupe de jeunes artistes, menés par Gil Elvgren et ses protégés Art Frahm, Ed Runci, Al Buell et Harry Ekman, s'empara du genre. Parallèlement apparut une série de sous-groupes: pin up «dodues», pin up «Ciel! J'ai perdu ma culotte!», hommes pin up, et autres fantaisies qui trouvèrent chacune leur public d'amateurs enthousiastes.

Durant cette époque, les pin up trouvèrent un nouveau débouché, et non des moindres, dans les livres de poche, apparus pendant la guerre afin de faire face aux restrictions de papier et d'offrir aux G.I.'s. des lectures bon marché et faciles à transporter. Une fois la paix retrouvée, la demande du public semblait sans limite. Pratiquement tout était publié en format à deux sous et sous couverture illustrée. Même les grands classiques de William Faulkner, d'Emily Brontë ou de John Steinbeck pouvaient se retrouver avec une jolie fille en couverture. Des centaines d'artistes furent appelés à la rescousse. Certains venaient des journaux à sensation, d'autres des revues de luxe en plein déclin, dont *American, Collier's, Liberty* et *Woman's Home Companion.* Plus tard, même le très respectable et puissant *The Saturday Evening Post* dut capituler devant la concurrence de la télévision et des livres de poche.

Avec l'avènement de la pilule, les baby boomers des années 60 firent tomber les dernières barrières sexuelles. Hugh Hefner devint le nouveau gourou avec *Playboy* et défia ouvertement la censure pour le droit d'utiliser les services postaux. Confrontée à la nécessité de légiférer sur le sujet, la Cour Suprême tergiversa en adoptant une définition de l'obscénité des plus vagues: «d'une lubricité qu'aucune valeur sociale ne peut racheter». Par conséquent, une multitude de publications s'engouffrèrent dans le créneau. Les revues «de charme» devinrent un phénomène international.

Dans les années 70, la photographie remplaça progressivement les peintures de pin up, avec des images le plus souvent dénuées d'humour et proposant un examen approfondi des parties intimes qui conviendrait davantage à un traité de gynécologie.

Le sujet ayant été désormais poussé aussi loin que possible, une réaction inverse ne tardera sans doute pas à se faire sentir. L'excès de liberté sans goût ni responsabilité, le sida, l'inquiétude croissante de l'opinion devant le laisser-aller des comportements sont autant d'arguments dans la bouche de ceux qui revendiquent un retour aux «valeurs familiales». Le vingt et unième siècle renouera-t-il avec la pudibonderie du siècle passé? Serons-nous de nouveau réduits à guetter la «cheville impudique»?

The 'Fine' Art of Illustration

Louis K. Meisel

Where is the line between illustration and fine art, between illustrator and artist? More to the point, why in the 1990s is there still such a line?

Until the camera was invented in the middle of the nineteenth century, all artists essentially illustrated – for their contemporaries and for posterity – the faces (portraits), places (landscapes), and objects (still lifes) of their time. Artists were commissioned to paint portraits of pharaohs, emperors, kings, nobles, and wealthy patrons and their families; later, commercial enterprises gave them similar "assignments." They traveled the world, for a myriad of reasons, recording places and historical events, and they created still lifes as decorative ornament since the earliest eras of human life. (And speaking of subject matter, I would venture to suggest that, in the thirty thousand years or so since the "Venus" of Willendorf, the female form has been more popular than any other theme as a subject for artists.)

In theory, the introduction of the camera and the photograph was to take over the artists' responsibility for recording and illustrating, thus freeing them to pursue more "intellectual" concerns and challenges. In reality, however, a long chain of events – beginning with the Impressionists' questioning of the conventions by which earlier artists had been bound – has led to the utter rejection of the "illustrative" function of art and the disparagement of those who make realism the core of their art.

Sometime during the 1980s, I realized that there was in fact a vast universe of artists out there who, by the very nature of their careers, have always addressed the general public, not the infinitesimally small "art world," and who have consistently been required to be disciplined craftsmen with the ability to communicate effectively through their art. In fact, these artists' works have always been so clear and communicative that no critic has ever needed to interpret and evaluate them for the public. The level of quality, craftsmanship, and discipline in their work has been monitored by editors and other professionals, not by critics. Perhaps because they perform in such a "real" world rather than in the confines of the art community, it has been thought necessary to label these artists "illustrators."

The word *illustrator* has been used to describe many kinds of artists, but it has usually carried a derogatory connotation. There are, to be sure, several different ways in which illustrators have approached their work. Some, who may be called the technicians, obviously accept assignments with nothing more in mind than taking a series of dictated ideas and realizing them on paper. For example, Pan Am wants a picture of an airline pilot in the cockpit; he's in the left seat, with his jacket off, is graying at the temples, shows three small children the gauges and controls of the 747, and so on. Then there are those illustrators who, given a story, book, or film to contemplate, can distill its essence into a single picture for a book cover, magazine page, or poster. Still others can create appealing images (pretty girls being classic examples) which, because they catch and retain the attention of a great number of people, can be used to mass-market and advertise products. And, to go even further, there are those whose work, created independently, can be used to transform concepts and words into stunning visual communications.

Somewhere along this continuum, we probably cross the line between the job of illustrating and the creation of fine art, but the question is whether it is really worth trying to pinpoint that place exactly. I have found that practically every artist who created what we now call pin-ups in the vintage years from 1920 to 1970 was closer to the creative side of the spectrum – a fine artist whose work happened to be employed by others in various commercial enterprises.

Of course, some artists in the genre were better than others, but all loved doing their work. All shared the same inspiration and communicated the same truths about their time and place, as artists have always done. The girls and women they all portrayed were free from the influence of a warped fashion world or a distorted feminism. They looked the way most women of the time wanted to look and certainly the way men (particularly those returning from World War II) wanted them to look: sexy but chaste and all-American.

It is interesting to note that virtually none of the artists documented here ever had an exhibition of his or her work in a gallery or museum. Almost none sold paintings as collectible works of art, and all but two or three are no longer here to keep their names and reputations alive. Yet over the decades, a handful of serious art collectors (including the authors) have collected and preserved between one and two thousand originals of their works.

Let's look at some of the factors that have led to the wholesale rejection of such artists as "illustrators." For one thing, illustrators belong to the category of commercial artists, who as the name suggests conduct their activities for financial gain in the world of business. To argue that commerce should have no place in the sphere of art is to engage, I think, in a basically hypocritical discourse. In thirty years of art dealing, I have rarely, if ever, come upon an artist who was not hoping for a monetary reward for his or her efforts. (It is true, of course, that Earthwork and Conceptual artists had no product to sell, but they certainly did capitalize on the documentation, photographs, and artifacts spun off from their main work.)

Taking the same "holier-than-thou" attitude are the artists who speak exaltedly of their noncommercial, intellectual, dedicated work. Usually fueled by some sort of political agenda, the work of such artists is generally inept, poorly executed, undisciplined, and lacking in aesthetic qualities. Yet, despite their protestations of the sacredness of their mission and their creations, these artists have all placed price tags on their works. Their sanctimonious attitudes are gladly reinforced by critics, museum curators, and art school administrators who glorify ineptitude and mediocrity in their search for the novel, the trendy, and the lucrative.

Another factor diminishing the status of the illustrator has been the antirealist trend in modernist art. For almost half a century now, we have been led to believe that Abstract Expressionism is the true American modernist movement — the movement that wrested artistic preeminence from Europe and firmly planted it in New York City. But one could argue just as strongly that the true American art form has always been, and still is, entrenched in realism and that this strain has affected European art forcefully for more than two hundred and fifty years. Early American, Primitive, Hudson River School, Ashcan, The Eight, WPA art, Magic Realism, to list only a few, all had clear counterparts on the other side of the Atlantic.

In this great American realist tradition, Hopper followed Eakins and Homer, and was in turn followed by Andrew Wyeth. As some of the finest realist painters of the twentieth century, these artists had colleagues — just over a very blurry line — in illustrators like N. C. Wyeth, J. C. Leyendecker, Rolf Armstrong, Howard Chandler Christy, and Norman Rockwell. They were all fine realists — period.

Furthermore, the American modernists' rejection of realism in favor of abstraction was responsible, in part, for a gradual but insidious deterioration of artistic standards. When Abstract Expressionism and its progeny threw out the rules and the discipline that had traditionally governed realist art, the flood gates were opened for anyone who sought an easy path to being an artist. By the late 1980s, in fact, this trend had gone so far that some in the art world began an attack on the word *quality*. They labeled the word, which represented a set of standards established over thousands of years, sexist, racist, and otherwise severely limiting to the masses of would-be artists who might ordinarily be thought unqualified and unworthy of the name. When they evaluate the work of contemporary artists, today's art schools, museums, critics, and magazines deem it necessary to give more weight to such matters as race, gender, and political content than to the appearance of the art itself. This tendency has gathered such strength in the past decade that nowadays the artist's ability to make art, and the viewer's to recognize it, has been severely compromised.

Of course, such license to be undisciplined does not hold for doctors, lawyers, engineers, scientists, or the many other professionals who, if they perform unsatisfactorily, are subject to swift identification and disqualification, regardless of the political consequences. Only in the area of the arts (and I mean all the arts) are clear-cut criteria for excellence lacking, and the possibility that the public may be deceived is therefore quite real. Multitudes of aspiring artists have entered the field in recent years and found some measure of success, if only for a while. Time will judge their true worth, although I am convinced that many of them will be forgotten before we proceed very far into the new century.

Allied to the snobbism about commercial and realist art, and stemming directly from the lowering of contemporary standards, is the elevation of the political content of art above the aesthetic. Real, valid issues of social concern — racism, sexism, homophobia, disease, war — have been allowed to overshadow the primary importance of aesthetics and discipline in making art. In the interests of conformity and multiculturalism, a strange and disturbing sort of reversal has occurred: art that is aesthetically pleasing, technically refined, craftsmanlike, and communica-

EARL MAC PHERSON

tive is valued less than art that is ugly, obscure, impermanent, and driven by anger and hatred.

Not content merely to move in such a direction itself, the art world also has to ignore or disparage the efforts and products of those who do not go along. Among the rejected are all realists, including the Photo-Realists who, while cherishing the standards set by previous generations, have still found ways to discover new artistic approaches and tools. But, today as in the golden age of the pin-up, the largest group of outcasts from the art world are those branded "illustrators," no matter how skilled.

The amusing paradox is that these artists, while shunned by the traditional gallery system, found themselves in great demand. First called upon in the late nineteenth century by the fast-growing publishing industry, American illustrators went on to be infinitely better remunerated, recognized, and appreciated than their "fine-art" contemporaries. Charles Dana Gibson earned more than $25,000 a year at the turn of the century and, in his time, was the most famous artist in the world. Master pin-up artists like Rolf Armstrong, Zoë Mozert, Gil Elvgren, and Earl Moran had the satisfaction of successful careers as well as the joy of working as dedicated and disciplined artists. The century's top illustrators, artists like N.C. Wyeth, J.C. Leyendecker, and of course Norman Rockwell, are more widely known and loved than all but a handful of their contemporaries in the sphere of fine art.

Why do so many factions in today's art world feel that a universally appealing, popular art that speaks to masses of people cannot be also challenging, innovative, intelligent, and worthy of inclusion in museums and art-history books? Hilton Kramer, in a review of the 1995 Hopper show at the Whitney Museum, tellingly addresses some of the issues that such a question raises:

In part, this prejudice against painting – for that is what it often amounts to – is a reflection of the bureaucratic mindset that now reigns at the Whitney. And in part, it is a reflection of what has happened to the study of painting in the academy, where connoisseurship has been largely abandoned in favor of dealing with art as just another form of what is called material culture. From that perspective, painting is seen as a "text" in urgent need of one or another context if it is to have any meaning at all.

Among 20th-century American painters, Edward Hopper (1882–1967) strikes me, as he has long struck other people, as the one whose art is least in need of this kind of contextual clarification. Hopper was a realist – a realist in his attitude toward his medium as well as in his attitude toward life. There is nothing esoteric or hermetic in his art. Everything about his painting is deliberately and programmatically explicit. That is one reason why it has always been so popular. For his immediate contemporaries, he painted subjects that were instantly recognizable because they were so familiar. For posterity, many of these subjects have now become historical, but they nonetheless remain triumphantly accessible. They may now be touched by an element of nostalgia, and thus somewhat distorted in the way that nostalgia always distorts our understanding of the past. But the clarity of Hopper's work remains intact all the same. That is one reason why Hopper continues to be so popular.

Clarity of any kind, however, is intolerable to the mindset that now prevails at the Whitney. Clarity of Hopper's sort, anyway, is looked upon as an intellectual embarrassment. Clarity, after all, is not where the intellectual action is at the moment. Clarity lacks chic. And at the Whitney, clarity is thought to be almost as boring as painting itself.

Hopper is therefore a vexing problem for the geniuses that now run the Whitney, which owns more of Hopper's work than any other museum in the world. To be made intellectually respectable – which is to say, more marketable – these geniuses obviously thought Hopper was in need of a little obfuscation. Something that would make him look a little more current, a little more fashionable, a little less like an old-fogey American realist.

("Those Whitney Geniuses Hop Up Edward Hopper," *The New York Observer*, July 17, 1995)

As a matter of fact, I question the entire concept that art must be challenging and innovative in order to be respected. Most of the works created and shown by the "high-art world" in the last twenty years have, unfortunately, been nothing but innovation for the sake of innovation, showing no respect for the foundations, skills, and disciplines that were required in the past to make art of quality. Most of

this art has indeed been challenging in an intimidating, aggressive, and hostile way. But the challenge is not at the intellectual level, as critics would have us believe (the level at which their services are needed to lead us to the more exalted kinds of understanding). No, the challenge is at a much baser, street-fighting level – to be more disgusting, more shocking, more destructive than the latest "hot" artist of three months ago.

When all is said and done, I believe that the great "illustrators" of the twentieth century – and particularly the masters of the American pin-up – deserve, as much as any other artists of quality, to have their works appear in galleries, museums, and history books. The best of the pin-up artists were, in fact, innovative; their experiments centered around finding new and interesting variations on how to present the human figure in two dimensions. Elvgren, in particular, was renowned for his daring, tongue-in-cheek situation images, in which an accidentally sexy event happened to an absolutely innocent all-American girl.

Practically every one of the artists discussed herein was rigorously trained, in the same schools and at or above the same levels as their colleagues in "fine" art. The contemporary artists to whom I have shown Elvgren's work have been deeply impressed by its compositional genius and rich painting technique. And few "fine" artists have mastered the art of pastels as well as the best pin-up artists.

The paintings of these men and women, as they exist today, triumphantly meet all the traditional standards of fine art. And in fact, if viewed without prejudice and preconception, pin-up art commands much attention and imparts much pleasure – certainly more than most of the "fine art" produced during the last twenty-five years in the increasingly distorted contemporary art world.

Die ‚schöne' Kunst der Illustration

Louis K. Meisel

Wo verläuft die Grenze zwischen Illustration und Kunst, zwischen Illustrator und Künstler? Ist diese Unterscheidung am Ende des 20. Jahrhunderts überhaupt noch sinnvoll?

Bis Mitte des 19. Jahrhunderts die Kamera erfunden wurde, waren praktisch alle Künstler Illustratoren, die für ihre Zeitgenossen oder für die Nachwelt malten: Gesichter (Porträtmalerei), Orte (Landschaftsmalerei) oder Gegenstände (Stilleben). Herrscher und andere wohlhabende Mäzene ließen sich für kommende Generationen porträtieren. Künstler bereisten die Welt und hielten Orte und historische Ereignisse für die Daheimgebliebenen mit dem Pinsel fest. Die ältesten und bekanntesten dekorativen Stilleben stammen aus der frühesten Epoche der Menschheitsgeschichte. Apropos Sujet: Ich möchte behaupten, daß in den circa 30000 Jahren seit der Entstehung der „Venus von Willendorf" die bildenden Künstler den weiblichen Körper öfter als jedes andere Sujet gewählt haben.

Durch die Einführung von Kamera und Foto sollte den Künstlern die Verantwortung für das Dokumentieren und Illustrieren abgenommen werden. Es begann damit, daß die Impressionisten jegliche bis dahin geltende künstlerische Konvention in Frage stellten, und es endete mit der totalen Ablehnung der „illustrativen" Funktion der Kunst und der Herabwürdigung aller Künstler, die sich dem Realismus verschrieben hatten.

Irgendwann im Laufe der 80er Jahre wurde mir klar, daß es eine große Schar von Künstlern gibt, deren Kunst für die Allgemeinheit gedacht ist und nicht für die vergleichsweise winzige Gruppe von Zeitgenossen, die sich zur „Kunstszene" zählt. Es sind Künstler, die ihr Handwerk beherrschen und deren Kunst allgemein verständlich ist. Ja, diese Künstler teilen sich immer so eindeutig mit, daß das Publikum keine Kritiker zur Interpretation und Bewertung ihrer Werke braucht. Redakteure und andere Fachleute, nicht Kritiker, beurteilen die Qualität ihrer Arbeiten und sorgen für ein gleichbleibend hohes Niveau. Vielleicht sah man sich bemüßigt, diesen Künstlern das Etikett „Illustratoren" anzuheften, weil sie in einer „realen" Welt arbeiten und nicht in der eng begrenzten Kunstszene.

Mit „Illustrator" bezeichnet man ganz unterschiedliche Typen von Künstlern, aber meistens ist diese Bezeichnung abschätzig gemeint. Natürlich unterscheiden sich die Arbeitsweisen und die Arbeiten verschiedener Illustratoren voneinander. Manche – die „Techniker" – nehmen Auftragsarbeiten an, lassen sich die Ideen zu den gewünschten Bildern vorgeben und bringen dann das Gewünschte zu Papier. Andere wiederum haben sich darauf spezialisiert, das Wesentliche einer Geschichte, eines Buches oder eines Films zu erfassen und es auf ein Umschlagbild, eine Zeitschriftenseite oder ein Plakat zu bannen, während wieder andere sich in ansprechenden und anziehenden Bildern des klassischen Sujets hübscher Mädchen angenommen haben. Solche Illustrationen sind natürlich vor allem für die Produktwerbung gedacht.

Auf diesem weiten Feld der Illustration verläuft irgendwo die Grenze zwischen bloßem „Job" und freiem künstlerischen Gestalten. Ist es notwendig, diese Grenze genau zu lokalisieren? Ich habe festgestellt, daß jeder Künstler, der sich in der Blütezeit des Pin-up-Kunst (1920–1970) des Sujets annahm, am kreativen Ende des Spektrums anzusiedeln ist – ein wahrer Künstler, der eher zufällig auch Aufträge für Wirtschaftsunternehmen ausführte.

Natürlich waren manche besser als andere; aber ihnen allen gemeinsam war der Spaß an ihrer Arbeit. Ihre Kunst legt ein beredtes Zeugnis über die Zeit ab, in der sie lebten. Die Frauen, die sie malten, sahen so aus, wie die meisten Frauen damals gern ausgesehen hätten, und ganz bestimmt so, wie die meisten Männer (besonders diejenigen, die gerade aus dem Krieg heimgekehrt waren) sie gern haben wollten: sexy, aber gleichzeitig keusch und natürlich typisch amerikanisch.

Es ist erstaunlich, daß die Arbeiten der hier besprochenen Künstlerinnen und Künstler fast nie in Galerien oder Museen ausgestellt wurden, und kaum einer

konnte seine Werke an Kunstsammler oder Galeristen verkaufen. Die meisten von ihnen leben mittlerweile nicht mehr und können nichts mehr dazu beitragen, daß sie und ihre Werke nicht in Vergessenheit geraten. Aber im Laufe von Jahrzehnten haben einige Zeitgenossen 1000 bis 2000 ihrer Bilder gesammelt und so der Nachwelt erhalten.

Was hat dazu geführt, daß diese Künstler in Bausch und Bogen als „Illustratoren" abqualifiziert werden? Nun, Illustratoren liefern „Gebrauchskunst", das heißt, sie sind Teil der Geschäftswelt und wollen verdienen. In meinen 30 Jahren als Kunsthändler ist mir aber auch so gut wie nie ein Künstler begegnet, der nicht auf finanzielle Vergütung für die Früchte seiner Arbeit hoffte. Natürlich hatten die Earthwork- und Concept-Art-Künstler kein Kunstwerk zu verkaufen; aber sie schlugen doch nicht wenig Kapital aus den Nebenprodukten ihrer Arbeiten: Dokumentationen, Fotos und Artefakte.

Nicht wenige der Künstler, die in hohen Tönen von ihren nichtkommerziellen, intellektuellen und engagierten Arbeiten reden, wollen mit ihrer Kunst irgendwelche politischen Ideologien propagieren. Ihre Arbeiten sind oft wenig überzeugend in der Ausführung, schlecht strukturiert und ästhetisch unbefriedigend. Und obwohl diese Künstler ständig die Heiligkeit ihrer Mission und ihrer Kunst im Munde führen, haben sie jedes ihrer Werke mit einem Preisschild versehen. Ebenso salbungsvoll wie sie selbst äußern sich auch Kritiker, Museumskuratoren und Mitglieder der Akademien. Die ständige Jagd nach den neuesten, lukrativsten „Trends" verleitet sie zur Glorifizierung von Unfähigkeit und Mittelmäßigkeit.

Ein weiterer Faktor, der dazu beigetragen hat, den Status des Illustrators herabzuwürdigen, sind die antirealistischen Tendenzen in der zeitgenössischen Kunst. Seit einem halben Jahrhundert versucht man uns davon zu überzeugen, daß der Abstrakte Expressionismus die wahre Kunstrichtung der amerikanischen Moderne sei – eine Bewegung, welche die Vorrangstellung der europäischen Kunst gebrochen und New York zur neuen Kunstmetropole gemacht habe. Ebensogut könnte man den Standpunkt vertreten, daß die eigentlich amerikanische Kunst im Realismus gründet und die europäische Kunst seit fast 250 Jahren davon beeinflußt wird. Nennen wir nur ein paar Beispiele: Early American, Primitive, Hudson River School, Ashcan, The Eight, WPA-Kunst, Magic Realism – sie alle haben ihre Entsprechung jenseits des Atlantiks.

In dieser großen amerikanischen Tradition folgte Andrew Wyeth auf Edward Hopper und dieser wiederum auf Eakins und Homer. Sie alle zählen zu den besten realistischen Malern des 20. Jahrhunderts, und ihre Kollegen waren Illustratoren wie N. C. Wyeth, J. C. Leyendecker, Rolf Armstrong, Howard Chandler Christy und Norman Rockwell.

Darüber hinaus war die Absage der amerikanischen Modernisten an den Realismus zugunsten der Abstraktion mitschuldig daran, daß alle bis dahin in der Kunst gültigen Maßstäbe allmählich fallengelassen wurden. Als die Abstrakten Expressionisten und ihre Nachkommen die Regeln, die bis dato in der realistischen Kunst gegolten hatten, aufgaben, stand für jeden, der auf leichte Weise Künstler werden wollte, die Tür weit offen. Dieser Trend führte dazu, daß in den späten 80er Jahren manche Angehörige der amerikanischen Kunstszene sogar gegen den Begriff „Qualität" zu Felde zogen. Obwohl seit Tausenden von Jahren als Werturteil bewährt, hieß es nun, das Wort sei sexistisch und rassistisch und schränke die Künstler zu sehr ein – unqualifizierte Möchtegern-Künstler, die man normalerweise der Bezeichnung „Künstler" für nicht würdig erachtet hätte. Bei der Beurteilung zeitgenössischer Kunst legen Kunstakademien, Museen, Kritiker und Zeitschriften mehr Wert auf Rasse und Geschlecht der Künstler oder die politischen Inhalte als auf das Kunstwerk selbst. Kein Wunder, daß heute die Fähigkeit des Künstlers, Kunst herzustellen, und die des Betrachters, Kunst zu erkennen, ganz verkümmert ist.

Bei keiner anderen Berufsgruppe gibt es eine vergleichbare „Lizenz zur Miß-

achtung aller Regeln". Wenn Ärzte, Juristen oder Naturwissenschaftler ihre Arbeit nicht zufriedenstellend ausführen, wird man sie, ungeachtet aller politischen oder sozialen Konsequenzen, disqualifizieren. Nur auf künstlerischem Gebiet gibt es keinen exakten Maßstab für Qualität. In den letzten Jahren betrat eine wahre Heerschar aufstrebender junger Künstler die Bühne und konnte auch, zumindest für bestimmte Zeit, Erfolge verbuchen. Ihr wahrer Wert wird sich erst mit der Zeit erweisen. Allerdings bin ich davon überzeugt, daß die meisten schon vergessen sein werden, bevor das nächste Jahrhundert beginnt.

Mit der snobistischen Einstellung gegenüber „Gebrauchskunst" und realistischer Kunst geht eine andere Einstellung einher, die sehr viel mit dem gesunkenen Niveau heutzutage zu tun hat: Zumindest in den USA wird der politische Inhalt der Kunst höher bewertet als ihr ästhetischer Gehalt. Die brennenden sozialen Probleme – Rassismus, Sexismus, Krankheiten und Kriege – haben es vermocht, Ästhetik und Sachverstand in der Kunst in den Hintergrund zu drängen. Im Interesse einer konformistischen und multikulturellen Gesellschaft hat sich eine beunruhigende Umkehrung der Werte ergeben: ästhetisch ansprechende, technisch ausgefeilte Kunst, die von den Menschen verstanden wird, gilt weniger als Kunst, die häßlich, schwer verständlich, vergänglich und aus Wut und Haß entstanden ist.

Die Kunstszene begnügt sich aber nicht damit, diesem Trend zu folgen; nein, sie muß auch noch die Arbeiten derjenigen Künstler, die sich dieser Tendenz widersetzen, mit Nichtachtung strafen und herabwürdigen. Davon betroffen sind alle Realisten, einschließlich der Vertreter des Fotorealismus, die traditionelle Maßstäbe in der Kunst durchaus nicht ablehnten, aber dennoch neue künstlerische Ansätze und Mittel fanden. Genau wie während des „Goldenen Zeitalters" der Pin-up-Kunst, so besteht auch heute die größte Gruppe von Außenseitern der „Kunstgesellschaft" aus den als „Illustratoren" gebrandmarkten Künstlern, ganz gleich, wie gut ihre Arbeiten sind. Es ist ein amüsantes Paradox, daß gerade diese Künstler, obwohl sie von den traditionellen Galerien gemieden wurden, beim Publikum so großen Anklang finden.

Die große Zeit der amerikanischen Illustratoren begann Ende des 19. Jahrhunderts, sie ging einher mit der Zunahme der Verlagsgründungen. Die Illustratoren genossen damals ein hohes Ansehen und wurden erheblich besser bezahlt als ihre Kollegen von der „hohen" Kunst. Um die Jahrhundertwende verdiente z.B. Charles Dana Gibson $25.000,– pro Jahr. Auch die anderen Meister der Pin-up-Kunst wie Rolf Armstrong, Zoë Mozert, Gil Elvgren und Earl Moran waren sehr erfolgreich. Illustratoren wie N.C. Wyeth, J.C. Leyendecker und natürlich Norman Rockwell werden von sehr viel mehr Menschen geschätzt als fast alle ihre Zeitgenossen, deren Werke zur „hohen" Kunst zählen.

Und dennoch herrscht heutzutage allgemein die Meinung vor, populäre Kunst, die wirklich eine große Zahl von Menschen anspricht, könne nicht anspruchsvoll, innovativ und intelligent sein und verdiene es nicht, in Museen ausgestellt und in Kunstgeschichtsbüchern berücksichtigt zu werden. In seiner Besprechung der Hopper-Ausstellung von 1995 im Whitney Museum geht Hilton Kramer auf einige der mit dieser Frage zusammenhängenden Probleme ein:

Dieses Vorurteil gegenüber der Malerei – denn darum handelt es sich zumeist – beweist eigentlich nur die im Whitney Museum gegenwärtig vorherrschende bürokratische Haltung. Außerdem läßt es erkennen, was aus dem Studium der Malerei an den Kunstakademien geworden ist: Dort ist nicht mehr Können gefragt, sondern Kunst gilt nur als eine unter vielen Ausprägungen der sogenannten „materiellen Kultur." Aus dieser Perspektive sieht man die Malerei lediglich als „Text", der dringend einen Kontext braucht, damit er verständlich wird.

Edward Hopper (1882–1967) gehört zu denjenigen amerikanischen Malern,

deren Kunst, wie ich und viele andere finden, am wenigsten einer solchen „kontextuellen Klärung" bedarf. Hopper war Realist, und zwar seinem Medium gegenüber und auch in seiner Lebenseinstellung. Seine Kunst hat nichts Esoterisches oder Hermetisches. Alles in seiner Malerei ist explizit und programmatisch. Das ist einer der Gründe dafür, warum sie so populär war und ist. Seine Sujets waren seinen Zeitgenossen sofort verständlich, weil sie ihnen vertraut waren. Für uns sind viele dieser Sujets schon historisch, aber unzugänglich sind sie uns deshalb keineswegs. Sie mögen heute etwas nostalgisch wirken und daher ein wenig verzerrt, wie Nostalgie ja immer unsere Sicht der Vergangenheit verzerrt. Die Klarheit in Hoppers Werk wird davon aber nicht berührt. Das ist einer der Gründe dafür, warum Hopper immer noch so populär ist.

Hopper ist deshalb ein ärgerliches Problem für die Genies, die jetzt im Whitney Museum das Sagen haben. Und dieses Museum besitzt mehr Werke Hoppers als irgendein anderes Museum der Welt. Um Hopper zu größerem intellektuellen Ansehen zu verhelfen – das heißt, um ihn besser vermarkten zu können –, mußten ihm diese Genies offenbar ein bißchen Vernebelung angedeihen lassen. Etwas, das ihn ein bißchen gängiger, ein bißchen modischer erscheinen lassen sollte, damit er nicht gar so sehr wie ein alter amerikanischer Realistenopa wirkte. („Wie die Genies im Whitney Museum Edward Hopper aufmotzen", Hilton Kramer in The New York Observer, 17. Juli 1995)

Ich bezweifle übrigens, daß Kunst unverständlich und originell sein muß, damit man sie respektiert. Die meisten Kunstwerke, die in den letzten 20 Jahren entstanden sind und als „hohe Kunst" ausgestellt wurden, waren oft nichts als Innovation um der Innovation willen. Es fehlte ihnen jeglicher Respekt vor den Grundlagen, den Fertigkeiten und dem fundierten Sachverstand, vor allem, was man früher für nötig erachtete, damit eine Kunst entstehen kann, die überdauert. Viele dieser Kunstwerke kamen tatsächlich als Herausforderung daher: Sie wirkten einschüchternd, aggressiv und feindselig. Die Provokation spielt sich allerdings nicht auf intellektuellem Niveau ab, wie die Kunstkritiker uns weismachen wollen; nein, es geht darum, noch widerlicher, noch schockierender, noch zerstörerischer zu sein als der Künstler, der drei Monate vorher „in" war.

Die großen „Illustratoren" des 20. Jahrhunderts – und besonders die Meister der amerikanischen Pin-up-Kunst – verdienen es, daß ihre Werke ebenso wie die anderer großer Künstler in Galerien und Museen ausgestellt und in Büchern erwähnt werden, denn die besten unter den Pin-up-Künstlern waren innovative Genies. Ihre Experimente drehten sich darum, neue und interessante Variationen der zweidimensionalen Darstellung der menschlichen Gestalt zu finden. Insbesondere Elvgren war bekannt für seine gewagten und raffinierten Situationsbilder, auf denen einem absolut unschuldigen, „typisch amerikanischen" Mädchen ganz zufällig etwas widerfuhr, das „sexy" war.

Praktisch jeder der hier besprochenen Künstler hat eine strenge Ausbildung genossen, und zwar in den gleichen Akademien und auf mindestens dem gleichen Niveau wie seine Kollegen von der „hohen" Kunst. Alle zeitgenössischen Künstler, denen ich Elvgrens Arbeiten gezeigt habe, waren tief beeindruckt von seiner Meisterschaft der Komposition und seiner großartigen Maltechnik. Und nur wenige Vertreter der „hohen" Kunst beherrschen die Pastellmalerei so perfekt wie die besten Pin-up-Künstler.

Die Bilder dieser Männer und Frauen werden mit Bravour allen traditionellen Anforderungen an „hohe Kunst" gerecht. Wenn man Pin-up-Kunst vorurteilsfrei und unvoreingenommen betrachtet, merkt man, wie interessant sie ist und wieviel Vergnügen sie bereitet – mehr jedenfalls als die meiste „hohe" Kunst, die in den letzten 25 Jahren in der mehr und mehr überdrehten Kunstszene produziert worden ist.

Le ‹bel› art de l'illustration

Louis K. Meisel

Quelle est la frontière entre l'illustration et les beaux-arts, entre l'illustrateur et l'artiste? Ou plutôt, comment se fait-il que cette frontière existe encore dans les années 90?

Jusqu'à l'invention de l'appareil-photo au milieu du dix-neuvième siècle, les artistes transcrivaient – pour leurs contemporains et la postérité – les visages, les lieux et les objets de leur époque. Pharaons, empereurs, rois, notables et riches mécènes leur commandaient leur portrait et celui de leurs proches. Plus tard, les entreprises commerciales leur confièrent des «missions» similaires. Les artistes parcouraient le monde, enregistrant les lieux et les événements historiques. Ils créaient également des natures mortes à des fins décoratives (tout au long des trente mille ans qui nous séparent de la Vénus de Willendorf, le corps de la femme a toujours été le sujet de prédilection des peintres et sculpteurs).

En théorie, l'apparition de l'appareil-photo et de la photographie aurait dû libérer l'artiste de la responsabilité de transcrire et d'illustrer, et lui permettre de s'attaquer à des questions et des préoccupations plus «intellectuelles». Toutefois, dans la pratique, une longue série d'événements, à commencer par la remise en question par les impressionnistes des conventions qui conditionnaient le travail de leurs prédécesseurs, a conduit à un rejet absolu de la fonction «illustratrice» de l'art et au dénigrement de ceux qui plaçaient le réalisme au cœur de leur travail.

Au cours des années 80, je me suis rendu compte qu'il existait un vaste univers d'artistes qui n'avaient jamais cessé de s'adresser au grand public – et non au monde infiniment petit des milieux artistiques – et desquels on attendait qu'ils soient de rigoureux artisans capables de communiquer avec efficacité à travers leur art. De fait, les œuvres de ces artistes ont toujours été si claires et communicatives qu'aucun critique n'a jamais eu besoin de les interpréter et de les évaluer pour le public. La qualité, la dextérité et la rigueur du travail étaient contrôlées par les éditeurs et d'autres professionnels. C'est sans doute parce qu'ils œuvraient dans le domaine du «réel» qu'on leur a accolé l'étiquette d'«illustrateurs».

Le terme d'illustrateur a servi à définir de nombreux types d'artistes, mais il porte généralement une connotation péjorative. Les illustrateurs eux-mêmes abordent leur travail de différentes manières. Il y a les techniciens, qui prennent des commandes sans autre idée que celle d'appliquer des consignes précises sur le papier. Par exemple, la Pan Am veut une image représentant un pilote dans un cockpit: il sera assis sur le siège de gauche, en chemise, les tempes grisonnantes, et montrera le tableau de bord du 747 à trois charmants bambins, etc. Puis, il y a ceux qui, après avoir pris connaissance d'une histoire, d'un livre ou d'un film, en distillent l'essence en une seule image pour la couverture d'un roman, une page de revue ou une affiche. D'autres encore créent des images attirantes (les jolies filles en sont l'exemple type) qui, parce qu'elles captent et retiennent l'attention, peuvent être utilisées à des fins publicitaires. Enfin, pour aller encore plus loin, il y a ceux qui créent en toute indépendance et transforment des concepts et des mots en communications visuelles extraordinaires.

Quelque part dans cet inventaire, nous avons probablement franchi la ligne de démarcation entre l'«illustration» et l'«art», mais est-il vraiment utile de mettre le doigt sur son emplacement? Pratiquement tous les artistes qui ont créé une pin up entre 1920 et 1970 étaient des créateurs: de véritables artistes dont le talent s'est trouvé être utilisé par d'autres dans diverses entreprises commerciales. Naturellement, certains artistes du genre étaient meilleurs que d'autres, mais tous adoraient leur travail. Tous partageaient la même inspiration et communiquaient les mêmes vérités à propos de leur époque et de leur environnement. Les jeunes filles et les femmes qu'ils représentaient étaient libérées de l'influence du monde artificiel de la mode ou des déformations féministes. Elles correspondaient à l'idéal de la plupart des femmes de l'époque mais aussi aux rêves des hommes: sexy mais chastes et typiquement américaines.

On notera au passage que pratiquement aucun des artistes présentés dans ce livre n'a été exposé dans une galerie ou un musée. Pratiquement aucun n'a vendu ses peintures à des collectionneurs et aucun, sauf deux ou trois, n'est encore de ce monde pour défendre sa réputation. Néanmoins, au fil des ans, quelques collectionneurs (dont les auteurs de cet ouvrage) sont parvenus à rassembler entre mille et deux mille de leurs œuvres originales.

Examinons à présent quelques-uns des facteurs qui ont entraîné le rejet absolu de ces artistes en tant qu'illustrateurs. D'une part, les illustrateurs appartiennent à la catégorie des graphistes ou artistes «commerciaux» qui, comme leur nom l'indique, exercent leur activité pour le commerce moyennant une rémunération. Or, prétendre que le commerce n'a pas sa place dans le monde de l'art relève de l'hypocrisie. En trente ans d'activité de galeriste, j'ai rarement rencontré un artiste qui n'espérait pas être récompensé de ses efforts par une rétribution financière. (Il est vrai que les artistes conceptuels n'avaient à proprement parler aucun produit à vendre, mais ils ne se sont pas privés de capitaliser sur la documentation, les photographies et les objets découlant de leur travail principal.)

Les artistes qui parlent avec exaltation de leur œuvre non commerciale, intellectuelle et désintéressée sont les principaux tenants de cette «sanctification» de leur statut. Souvent chargé de connotations socio-politiques, leur travail est en général inepte, mal exécuté, dépourvu de rigueur et de qualités esthétiques. Pourtant, ils attachent tous un prix on ne peut plus «palpable» à leurs œuvres. Leur attitude de supériorité vertueuse a été encouragée par les critiques, les conservateurs de musée et les administrateurs d'écoles d'art qui glorifient l'incompétence et la médiocrité dans leur quête de la nouveauté, du «moderne» et du lucratif.

Le parti pris anti-réaliste de l'art moderniste est un autre facteur qui a contribué à rabaisser le statut des illustrateurs. Depuis près d'un demi-siècle, on nous rabâche que l'expressionnisme abstrait est le véritable mouvement moderniste américain, celui qui a arraché à l'Europe sa primauté artistique. Toutefois, on pourrait affirmer avec autant de force que le vrai art américain a toujours été, et est encore, fermement enraciné dans le réalisme et que cette caractéristique a considérablement marqué l'art européen pendant plus de deux cents ans. Les premiers primitifs américains, l'école de Hudson, Ashcan, les Huit, l'art WPA, le réalisme magique, pour n'en citer que quelques-uns, avaient tous leur contrepartie évidente de l'autre côté de l'Atlantique. Dans cette grande tradition réaliste américaine, Hopper a emboîté le pas à Eakins et à Homer, pour être suivi à son tour par Andrew Wyeth. Ces peintres réalistes américains du vingtième siècle étaient proches d'illustrateurs tels que N. C. Wyeth, J. C. Leyendecker, Rolf Armstrong, Howard Chandler Christy et Norman Rockwell. Tous étaient de grands réalistes, un point c'est tout.

Les modernistes américains sont en partie responsables de la détérioration progressive et insidieuse des critères artistiques. En détruisant les règles et la rigueur qui avaient régi l'art réaliste, l'expressionnisme abstrait et ses successeurs ont considérablement facilité l'accès au statut d'artiste. Vers la fin des années 80, cette tendance a été portée si loin que le monde de l'art s'en est pris au sens même de « qualité ». Le mot, qui incarnait une série de critères établis sur des milliers d'années, fut qualifié de sexiste, de raciste et plus généralement d'inique par rapport aux légions de prétendus artistes qui auraient normalement été considérés comme incompétents et indignes de cette appellation. Les écoles d'art, les musées, les critiques et les revues donnent désormais davantage de poids aux critères de race, de sexe et de contenu politique qu'à l'aspect des œuvres elles-mêmes. Cette tendance a pris une telle ampleur ces dix dernières années que, désormais, la capacité de l'artiste à faire de l'art, et celle du spectateur à le reconnaître en tant que tel, est gravement compromise.

Naturellement, cette incitation à l'indiscipline ne s'applique pas aux médecins, aux avocats, aux ingénieurs, aux scientifiques ou aux nombreuses autres professions qui, lorsqu'elles font preuve d'incompétence, sont vite décriées et mises à l'index. Il n'y a que dans le monde de l'art (sous toutes ses formes) qu'on observe l'absence de toute exigence de qualité et que le public court un tel risque d'être dupé. Ces dernières années, une multitude d'aspirants artistes ont envahi la scène de l'art, nombre d'entre eux avec un certain succès – un succès de courte durée parfois. Le temps jugera de leur véritable valeur mais il y a fort à parier que la plupart d'entre eux seront oubliés assez rapidement.

Au snobisme anti-art commercial et réaliste vient s'ajouter l'élévation du contenu politique des œuvres au-dessus de leurs qualités esthétiques, directement issue du déclin des critères de l'art contemporain. Les thèmes, respectables et réels, qui reflètent des préoccupations sociales telles que le racisme, le sexisme, l'homophobie, la maladie ou la guerre, occultent désormais l'importance primordiale de l'esthétique et de la discipline dans l'art. Au nom du conformisme et du multiculturalisme, il s'est produit un étrange et troublant renversement: un art esthétiquement plaisant, techniquement raffiné et communicatif a moins de valeur qu'un art laid, obscur, provisoire et inspiré par la colère et la haine. Non contents de se laisser entraîner dans cette voie, les milieux artistiques se sont cru obligés de mépriser les efforts et les œuvres de ceux qui avaient choisi une autre direction. Les réalistes font partie du lot des exclus, y compris les photo-réalistes qui, tout en respectant les critères imposés par les générations précédentes, ont su découvrir de nouvelles approches artistiques et de nouveaux outils. Mais aujourd'hui, comme pendant l'âge d'or de la pin up, le plus grand groupe d'artistes bannis du monde de l'art se trouve être celui des «illustrateurs».

L'ironie du sort est que ces artistes, tout en étant rejetés par le circuit traditionnel des galeries, sont très recherchés. D'abord sollicités à la fin du siècle dernier par le secteur en pleine expansion de la publicité, les illustrateurs américains devinrent rapidement infiniment mieux rémunérés, reconnus et appréciés que leurs contemporains des «beaux-arts». Au début du siècle, Charles Dana Gibson gagnait plus de 25000 dollars par an et était, de son vivant, l'artiste le plus célèbre du monde. Des maîtres tels que Rolf Armstrong, Zoë Mozert, Gil Elvgren et Earl Moran eurent la satisfaction de faire de belles carrières tout en exerçant leur art avec rigueur. Les plus grands illustrateurs du vingtième siècle, des artistes tels que N.C. Wyeth, J.C. Leyendecker, et naturellement Norman Rockwell, sont aujourd'hui plus connus et appréciés qu'un bon nombre de leurs contemporains des beaux-arts.

Comment se fait-il que tant de factions des milieux artistiques actuels estiment qu'un art populaire et universellement attirant ne peut être également excitant, innovateur, intelligent et digne d'entrer dans les musées et les livres d'histoire de l'art? Hilton Kramer, dans un article consacré à l'exposition Hopper du Whitney Museum en 1995, aborde quelques-uns des thèmes que cette question soulève:

(…) Ce préjugé contre la peinture – car c'est souvent de cela qu'il s'agit – reflète en partie la mentalité de bureaucrate qui règne aujourd'hui au Whitney Museum. Il reflète également ce qui est arrivé à l'étude académique de la peinture, où l'apprentissage de l'histoire de l'art a été largement abandonné en faveur du traitement de l'art comme une simple manifestation de ce qu'on appelle la «culture matérielle». De ce point de vue, la peinture est considérée comme un «texte» qui n'aurait de sens que si on le replace dans un contexte quelconque.
Parmi les peintres américains du vingtième siècle, Edward Hopper (1882–1967) m'apparaît, comme il est apparu à bien d'autres avant moi, comme étant celui dont l'art a le moins besoin de cette clarification contextuelle. Hopper était un réaliste, tant dans son attitude face à sa toile que dans la vie. Son art n'a

rien d'ésotérique ni d'hermétique. Tout dans sa peinture est délibérément et sciemment explicite. C'est une des raisons de sa grande popularité. Pour ses contemporains, ses sujets étaient immédiatement reconnaissables parce qu'éminemment familiers. Pour la postérité, un grand nombre de ses sujets sont désormais devenus historiques, mais ils restent néanmoins triomphalement accessibles. Certes, ils peuvent aujourd'hui être teintés d'une certaine nostalgie, et être ainsi déformés de cette manière dont la nostalgie déforme toujours notre compréhension du passé. Mais la clarté du travail de Hopper n'en reste pas moins intacte.
Malheureusement, la clarté sous toutes ses formes est intolérable à l'esprit qui prévaut aujourd'hui au Whitney Museum. La clarté, du moins telle que la pratiquait Hopper, est considérée comme une sorte d'infériorité intellectuelle. Après tout, l'intellectualisme actuel ne donne pas dans la clarté. La clarté manque de chic. Et au Whitney Museum, la clarté est considérée comme aussi ennuyeuse que la peinture elle-même. Hopper pose donc un problème embarrassant aux petits génies qui dirigent actuellement le Whitney Museum (qui se trouve posséder plus d'œuvres de Hopper que tout autre musée au monde!). Pour le rendre intellectuellement acceptable, c'est-à-dire plus commercialisable, ces messieurs ont manifestement pensé que Hopper avait besoin d'être un peu obscurci. Il fallait bien le rendre un peu plus actuel, dans le vent, et donc lui ôter ce côté «vieux ringard de réaliste américain».
Those Whitney Geniuses Hop Up Edward Hopper (Ces génies du Whitney Museum qui piétinent Edward Hopper), *The New York Observer*, 17 juillet 1995.

Je ne pense pas que l'art doive être provocant et innovateur pour être respecté. La plupart des œuvres de «grand» art de ces vingt dernières années ne sont que des innovations pour le plaisir d'innover, sans le moindre respect pour les fondations, les compétences et la rigueur autrefois requises pour faire de l'art de qualité.

Le plus souvent, cet art n'est provocant que d'une manière intimidante, agressive et hostile. Mais cette provocation ne se situe pas au niveau intellectuel comme voudraient nous le faire croire les critiques (ce niveau de compréhension supérieure vers lequel ils sont censés nous guider). Non, la provocation se situe à un niveau nettement inférieur, celui du caniveau: il s'agit d'être plus répugnant, plus choquant et plus destructeur que le dernier artiste «branché» d'il y a trois mois.

Tout ceci pour dire que je crois que les grands «illustrateurs» du vingtième siècle, et notamment les maîtres de la pin up américaine, méritent tout autant que les autres artistes de qualité de voir leur œuvres présentées dans les galeries, les musées et les livres d'histoire. Les meilleurs peintres de pin up étaient, de fait, des innovateurs: ils cherchaient sans cesse de nouvelles variantes pour présenter la silhouette humaine en deux dimensions. Elvgren, surtout, était connu pour ses scènes joliment troublantes, où une jeune ingénue était surprise dans des circonstances fortuitement érotiques.

Pratiquement tous les artistes présentés ici ont été formés dans les mêmes écoles et au même niveau, quand il n'était pas supérieur, que leurs confrères des «beaux»-arts. Les artistes contemporains à qui j'ai montré le travail d'Elvgren ont tous été impressionnés par son génie de la composition et par sa technique picturale. Rares sont les artistes des «beaux»-arts qui maîtrisent l'art du pastel aussi bien que les meilleurs peintres de pin up.

Les tableaux de ces hommes et de ces femmes, tels qu'on peut les voir aujourd'hui, satisfont triomphalement à tous les critères traditionnels des beaux-arts. De fait, quand on l'examine sans idées préconçues, l'art des pin up inspire un grand respect tout en donnant beaucoup de plaisir – certainement plus que la plupart des «œuvres» produites au cours des vingt-cinq dernières années dans le monde de plus en plus dénaturé de l'art contemporain.

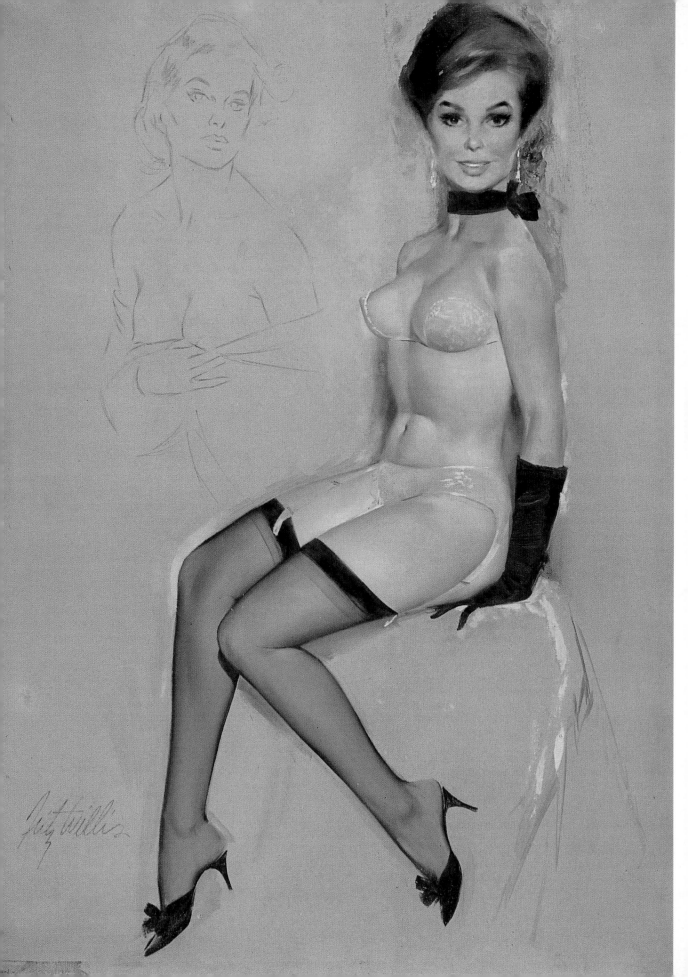

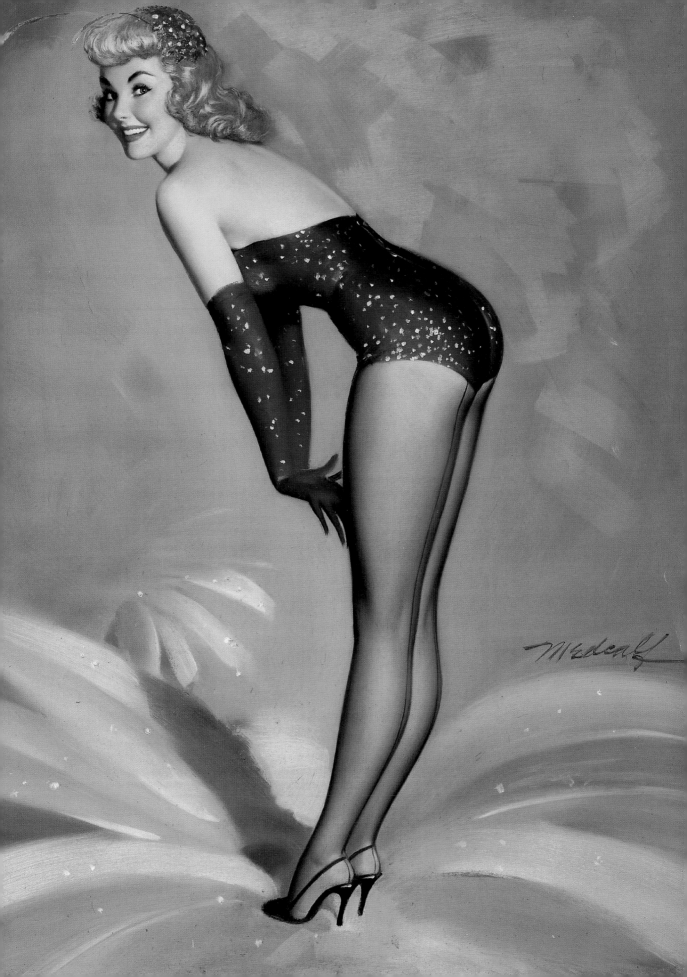

The Great American Pin-Up

Charles G. Martignette

Most Americans who lived during the last quarter of the nineteenth century and the first half of the twentieth were not able to visit museums or purchase art books. The only art they saw on a regular basis was illustration art. In all their varied forms, illustrations infiltrated every aspect of American existence and wove their images into the very fabric of everyday life. In this sense, illustration art may be said to be the real art of the American public.

The history of American illustration closely parallels the growth and development of the nation. As the population began to expand rapidly about 1875, so too did the need for additional means of communication. Advances in existing printing techniques also contributed to an increase in the number of local and regional newspapers. National magazines and periodicals like *Scribner's*, *The Century*, *Puck*, *Harper's Weekly*, and *The Saturday Evening Post* primarily served their new audiences by acting as vehicles for the transfer of news, information, ideas, and services. In addition, their fiction articles (featuring tales of romance, adventure, crime, and the like) and their reports on social happenings, politics, and sports were tremendously entertaining.

The magazine publishers soon learned that if an article or story was accompanied by a picture, people were more likely to read it. They also realized that the artwork reproduced on their front covers was an important point-of-sale factor at newspaper stands which directly affected their subscription rates. By 1920, the competition for readers had become an all-out battle among the publishers of magazines and other periodicals. And it was this ferment that ushered in the Golden Age of American Illustration, which was to last until 1970.

In reviewing the history of the American pin-up, it is necessary to understand that such images were by no means limited to a specialized audience. Almost all the leading "mainstream" magazines commissioned scores of artists to paint pictures of attractive men, women, and children, singly or in groups, to decorate their weekly or monthly covers. The publishers knew only too well that, in the highly competitive marketplace, one sure way to secure new readers was to have either captivating people or highly dramatic narratives adorn their covers. And among the most captivating people to portray were attractive women, who were present-

ed in three general categories of illustrations: the "pin-up," the "glamour art" image, and the "pretty girl" subject.

A definition of terms would be helpful here. A "pin-up" image is one that shows a full-length view of its subject and characteristically has an element of a theme or some kind of story. The woman in a pin-up is usually dressed in a form-revealing outfit, either one that may be worn in public, such as a bathing suit, sunsuit, or skimpy dress, or one that is more provocative and intimate, such as lingerie. Sometimes, a pin-up may be shown as a nude, but this is more the exception than the rule.

A "glamour art" image may be either a full-length view or a presentation of only the head and shoulders of the subject. The "glamour" woman is generally attired in an evening gown, fancy dress, or some other attire that is less revealing than that in a pin-up. "Pretty girl" art is a term used to refer to painting of a glamour art nature that was done by mainstream illustrators. It found its audience among popular magazines like *The Saturday Evening Post* and *Cosmopolitan* and in the world of advertising. Thus, the terms "pin-up art" and "glamour art" generally refer directly to works by artists concentrating in these genres, while "pretty girl art" almost always means the "glamour" work of the mainstream illustration community. Most of the important mainstream illustrators chose to paint "pretty girl" subjects at one time or another, since these images seemed to have widespread public appeal. Some of these illustrators' pictures had the qualities of pin-ups, but most focused on the "glamour" aspects of feminine beauty.

Among the major magazines that heartily supported pin-up and glamour themes when artists submitted them for front-cover publication were *The Saturday Evening Post*, *Collier's*, *Liberty*, *Ladies' Home Journal*, *Cosmopolitan*, *Woman's Home Companion*, *Life*, *Judge*, *McCall's*, *Redbook*, *American Weekly*, *Vogue*, *Esquire*, and *True*. Even *Time*, which billed itself as "America's Weekly Newsmagazine," published original pin-up art paintings on its front cover: its November 10, 1941, issue reproduced a pin-up of Rita Hayworth painted by George Petty, the father of twentieth-century American pin-up and glamour art.

Of the hundreds of artists and illustrators contributing to periodicals in the years from 1920 to 1970, approximately fifty worked almost exclusively in the pin-up and glamour fields. (Some did accept other editorial assignments, but limit-

12. CHARLES DANA GIBSON
THE GIBSON GIRL
DRAWING, C. 1887–1894
KREIDEZEICHNUNG, UM 1887–1894
DESSIN AU CRAYON, VERS 1887–1894

12

ed them mostly to advertising, which often used such themes.) By and large, these artists chose to paint pin-ups because they wanted to capture and celebrate the femininity of American women. The approximately five hundred artists who worked in the other major fields of illustration generally painted narrative, sentimental, romantic, and patriotic images of American life. Yet they would also often incorporate glamour themes into their pictures since, as time went on, the pin-up artists were increasingly monopolized by the major calendar companies.

As the demand for pin-up and glamour illustrations grew, enterprises other than mainstream magazines beckoned: advertising, calendars, pin-up and pulp magazines, art cards, and advertising specialty products. The leading ad agencies and corporations often employed pin-up and glamour art to sell and promote products and ideas. Companies like Kodak, Coca-Cola, and General Motors frequently used such subjects to build national advertising campaigns, which sometimes spanned several decades and therefore influenced generations of Americans. Of the various ways in which pin-up and glamour art images were reproduced, the primary and most widespread was as calendars. Calendar art prints, ranging in size from approximately 2 x 3 inches (5.1 x 7.6 cm) to 20 x 30 inches (50.8 x 76.2 cm), would be attached or mounted to a one-sheet calendar background. Then color-coordinated matting and ribbons would be added so that the calendar could be hung on the wall. The largest of these one-image calendars, called "hangers," were usually placed in factories or other work areas where hundreds of employees could see the picture and date high above their work space. Also very popular was the twelve-page, spiral-bound appointment calendar, which featured a different pin-up or glamour image on each page. In time, such calendars – and their pin-up and glamour images – came to permeate the American home and workplace, to become an integral part of daily life.

The next most popular use for pin-up art was as the front covers of pin-up magazines. In the 1920s and 1930s, such titles as *Film Fun*, *Movie Humor*, *High Heel*, *Silk Stocking Stories*, and *Gay Book* featured photographs of scantily clad movie starlets, Ziegfeld Follies showgirls, New York models, and Mack Sennett's famous Bathing Beauties. In the 1940s and 1950s, most of the magazines with

pin-up paintings on their covers came out of Robert Harrison's New York publishing headquarters; his *Beauty Parade*, *Whisper*, *Wink*, *Eyeful*, *Titter*, *Flirt*, *Giggles*, and *Joker* were seen on newsstands from coast to coast. Inside were photographs similar to those of the 1920s and 1930s, but supplemented with pictures of unknown models or "cult" figures like Betty Page, Irish McCalla ("Sheena, Queen of the Jungle"), and a host of others, all aspiring to stardom and fame.

The centerfolds in pin-up magazines were crucial in giving widespread visibility to pin-up and glamour art worldwide. They had appeared as early as the 1880s, when *Life* magazine published drawings of the Gibson Girl in the format. Positioned in the center of a magazine, these two-page pullout lithos were either secured by staples or bound into the magazine on the left-hand side of the artwork. The reader could thus remove the centerfold from a magazine so that it could be "pinned-up" on a wall, framed, glued into a scrapbook, or perhaps even cut out like a paper doll. Although centerfolds were published in many magazines over the years, they were most important to several mainstream publishers, particularly *Esquire*, *True*, and *Playboy*. At *Esquire*, the centerfold (called a gatefold) was introduced in the late 1930s, and by the end of the decade the magazine had published several three-page pin-ups featuring the famous Petty Girl.

Another area of illustration art that drew heavily on pin-up imagery was the pulp magazine. Of lower price and lesser quality than mainstream magazines, the pulps were exceedingly prolific and popular in their heyday, which dated from 1920 to the early 1950s. Their subject matter was wide-ranging – detective stories, science fiction, horror, adventure, crime, romance, Westerns – and their front covers frequently employed suggestive, provocative, and often explicit pin-ups. The stable of artists who concentrated solely on pulp magazines began to disperse about 1952, when digest and paperback-novel publishers began soliciting their talents to execute more toned-down images for their new and rapidly expanding audience.

Also disseminating pin-up imagery to a wide audience were "art cards," sold through millions of arcade vending machines. These pictures, slightly smaller than postcards, were also called "mutoscope cards." Published from the mid-1930s to the mid-1950s, they increased in cost during that period from one cent each to as

13. CHARLES DANA GIBSON
ILLUSTRATION FOR "THE BLUE BUTTERFLY", PUBLISHED IN
WOMAN'S HOME COMPANION, JANUARY 1913
ILLUSTRATION FÜR „THE BLUE BUTTERFLY", NEU ABGEBILDET
IN WOMAN'S HOME COMPANION, JANUAR 1913
ILLUSTRATION POUR «THE BLUE BUTTERFLY», NOUVELLE
PUBLIÉE DANS WOMAN'S HOME COMPANION, JANVIER 1913

13

much as a nickel each. Both young people and adults collected these full-color, brightly printed pin-ups, in much the same manner as children collected baseball cards and comic books. All told, at least several million mutoscope arcade cards were manufactured and sold around the world.

The final major way in which pin-up and glamour art found its audience was by means of advertising specialty products. Extremely diverse in their forms, these included, but were not limited to, decks of playing cards, ink blotters, note pads, pocket mirrors, drinking glasses, ashtrays, key chains, pens, pencils, cigarette lighters, neckties, plates, and – more than any other item – matchbook covers. The tens of millions of these products that have circulated the globe for more than seventy-five years have made pin-up and glamour art truly universal in its scope and appeal.

The development of the pin-up is closely linked with that of the American calendar industry. Benjamin Franklin is generally credited with introducing the first calendar into America, in his 1752 edition of *Poor Richard's Almanac*. The version he published was the one that had been adopted by the entire English-speaking world that same year. Having undergone many changes throughout the centuries, the calendar was thus stabilized in its current form by dropping eleven days from the year.

About 1850, a new business began to develop in America – single-sheet calendars used for advertising purposes. These almost primitive sheets, seen as "modern-day" inventions, advertised either the name of the firms that printed them or associated lithographers, engravers, and newspaper publishers.

The first commercial calendar to be published as an advertising tool came in 1889, when two newspaper publishers in Red Oak, Iowa, Edmund B. Osborne and Thomas D. Murphy, printed a wall calendar and sold advertising space to a dozen local merchants. They positioned the merchants' ads around a woodcut of the new town courthouse. Originally, the two had wanted to commission a woodcut of the courthouse for publication in their paper, but the cost had proved prohibitive. Planning it as the center of a business calendar not only gave them the money they needed to have the woodcut made, but also generated a profit of $300, a huge sum at the time. More than a thousand copies of that first advertising calen-

dar were sold, and it represented the launching of an industry that would go forward for more than a hundred years to produce billions of dollars in revenue.

The first salesman Osborne and Murphy hired for their new advertising-calendar business was a man named Herbert Huse Bigelow. After working for them for five years, Bigelow moved to St. Paul, Minnesota, where he met a printer, Hiram D. Brown. The two became friends and eventually decided to form a partnership. Bigelow had accumulated savings of $1,500 and Brown agreed to contribute twice that amount to their new venture – a calendar-publishing company. Brown's only stipulation was that his name was to come first in the corporate title.

Brown and Bigelow was officially born on February 7, 1896. Six months later, the company had settled into their first one-room "plant" and published their first calendar – a one-color print on cardboard showing George Washington along with an advertisement for a coal and wood business in St. Paul. Within three years, Brown and Bigelow had a burgeoning business. They had moved into a three-story building in 1899, and by 1902 had opened their first regional sales office, in Boston. Only one year later, the firm had to relocate to a ten-story plant, and this pattern of growth has never really ended. From the outset, Brown and Bigelow was destined to be the largest, most important, and most successful calendar-publishing company in the world. Known as "The House of Quality" until 1920, the company registered their famous trademark, "Remembrance Advertising," in 1921.

As years went by, other companies were successful in creating and selling calendars with pin-up and glamour art: the Shaw-Barton Calendar Company in Ohio, the Joseph C. Hoover and Sons Company in Philadelphia, McCleery-Cummings in Iowa, Kemper-Thomas in Cincinnati, John Baumgarth in Chicago, Gerlach-Barklow in Illinois, the Louis F. Dow Company in St. Paul, Skinner-Kennedy in St. Louis, the Forbes Company in Boston, C. Moss in Philadelphia, and the Thomas D. Murphy Company in Red Oak, Iowa. But none attained the preeminence of Brown and Bigelow. As the dominant company in the field, the firm was the single most influential force behind the development of the American pin-up. Most of the original paintings in this book were created for and published by the firm. It was Brown and Bigelow that commissioned the best pin-up and glamour artists in America to create the tremendously varied and potent images that were to grace billions of

14

15

their calendars; in so doing, the company helped to bring pin-up and glamour art to its highest level.

The growth of Brown and Bigelow during the last decade of the nineteenth century laid the groundwork for the major market in which the great American pin-up appeared. At nearly the same time, a young artist from Boston, Charles Dana Gibson (1867–1944), was beginning a career that was to give birth to the most famous pin-up girl of all time – the legendary Gibson Girl. In the spring of 1885, armed with a portfolio of his pen-and-ink drawings, Gibson made the rounds of New York's magazine and book publishers to try his luck with their art directors. The market proved inhospitable to the aspiring artist, and it was not until the autumn of 1886 that he found any success. A new, humor-oriented magazine called *Life* paid Gibson for a drawing and commissioned more illustrations for future issues.

The year 1887 marked the first published appearance of the Gibson Girl. Without question, she was both the first true American pin-up and the first true American glamour girl. Her popularity surpassed that of any contemporary or future rival, including the Christy Girl, the Fisher Girl, the Crandell Girl, and later the Varga Girl and the Petty Girl. Within a few years of her debut, the Gibson Girl had become the nation's sweetheart, the ideal of American femininity. Her popularity had also spread overseas: millions of foreign admirers constituted something of an international fan club.

Perhaps the most notable aspect of the Gibson Girl's popularity was that she was idolized not only by American men, but by an equal if not greater number of American women. Self-assured, independent, and strong-willed, she was seen as a "modern" American girl, socially adept in every situation. Although often portrayed as upper class, she had equal appeal to both rich and poor, young and old, from all walks of life.

At the height of her popularity, the Gibson Girl influenced contemporary fashions, life-styles, manners, and even morals. Songs were written praising her charms, and Broadway shows paid tribute to her beauty. Her likeness appeared on all sorts of everyday objects: postcards, porcelain plates, candy boxes, sou-

venir spoons, fans, handkerchiefs, and, of course, calendars and magazines.

One of Gibson's favorite drawings was a glamour portrait (figure 12) that became closely identified with his name. This work was so popular, in fact, that it was featured in a series of art books that *Collier*'s magazine published from 1894 onward. It was even chosen as the basis of a special wallpaper design.

By 1900, the Gibson Girl craze had grown to such an extent that *Collier*'s offered the artist the unheard-of sum of $100,000 to create one hundred drawings over a four-year period. These illustrations would appear (as they had a decade earlier in *Life*) as centerfolds, which made the Gibson Girl the first real centerfold in American pin-up history. Gibson's work was featured in many magazines other than *Life* and *Collier*'s, and he was a frequent contributor to the three other leading periodicals of the era – *Scribner*'s, *The Century*, and *Harper's Weekly*.

Gibson also created the first true male pin-up in America. Like the Gibson Girl, the Gibson Man appealed equally to women and men: his strong features, distinguished mode of dress, and honorable character made him everyone's ideal. When he appeared in a drawing with the Gibson Girl, it was usually in a narrative scene with a self-explanatory title or caption commenting on contemporary American life in a humorous or satirical tone. The Gibson Man and Girl are paired in a classic pen-and-ink drawing depicting one of the artist's favorite subjects – the eternal triangle – in a characteristically brilliant style (figure 13).

As the original great American pin-up, the Gibson Girl holds a unique place in the history of American art. Her importance as an influence on later pin-up and glamour artists cannot be overestimated. She was the ultimate image of American beauty, sophistication, and freedom which was to inspire generations of artists to come.

While the Gibson Girl captivated Europe at the turn of the century, the creations of an Italian artist had a similar phenomenal success in America. Angelo Asti captured much of the new American calendar-art market when his first published picture was reproduced in 1904 by Brown and Bigelow. The first "pretty girl" subject ever accepted by the firm, this image of a long-haired lady in the Art Nouveau style sold a total of more than one and a half million calendars. (Within five years, "pretty girl" and "glamour" illustrations would became major categories in the calendar-art business.)

Another Asti painting that was published about 1910 by the Shaw-Barton Calendar Company enjoyed widespread popularity in Europe and the United States (figure 14). Asti's beauties had their likenesses reproduced in many forms, most notably as postcards and bone-china plates. The "fine-art" maiden seen in Hy Whitroy's painting *Biruté* (figure 15) was published about 1915 on a calendar by the Joseph C. Hoover and Sons Company.

The pin-up flourished on both sides of the Atlantic before, during, and after World War I. Dominating the entire European market for sensual and provocative artwork was the painter Raphael Kirchner. Kirchner's Girls appeared regularly in *La Vie Parisienne*, France's most daring magazine. They became household names on the Continent and eventually crossed the ocean to America in reproductions on prints, postcards, and calendars. A watercolor and gouache original that was published as both a calendar and postcard reveals Kirchner's typically delicate, soft style (figure 16). The cigarette was a taboo prop, forbidden in a depiction of a woman in an intimate moment. The freedom demonstrated in Kirchner's works reflected the liberation that was sweeping through all phases of society during the Belle Epoque. Through the example of his art, Kirchner acted as a catalyst to encourage artists throughout the world to be spontaneous and bold.

Alberto Vargas, an artist who was to be central to the history of the American pin-up, began his career strongly influenced by the European style. A young Peruvian, Vargas had studied art in Switzerland before coming to New York in 1916. Kirchner's Girls had served as his inspiration in Europe and continued to do so in America during the 1920s and 1930s.

Vargas's uncanny ability to capture an air of dreamlike sensuality may be seen in an exquisite watercolor dating from between 1922 and 1924 (figure 17). During those years, Vargas was working full time in New York on a commission by the Ziegfeld Follies to paint the company's showgirls. Occasionally, he would ask one of the Follies stars to pose for him privately during her time off; the results were often spectacular, perhaps because these paintings were not done under the usual constraints of time and commercial dictates.

In another exceptional painting of a Ziegfeld Follies star (figure 18), the show-girl wears an extraordinary Art Deco costume made of a beautiful fabric printed with scenes from children's fairy tales. Vargas's delicate handling of these intricate patterns, coupled with the brilliant watercolor technique, clearly illustrates important facets of the artist's genius.

Vargas experimented with many different styles before he found his characteristic "look," often in the process drawing upon his extraordinary talent as a designer, which is frequently underestimated. The highly stylized Art Deco *Robe d'Après-Midi* (figure 19) is one of Vargas's most important advertising images. A fashion illustration with a design that Vargas modeled after the covers of *Vogue* magazine, this original watercolor measures a substantial 30 x 22 inches (76.2 x 55.9 cm).

Vargas created another important advertising work in 1927 for Paramount Pictures (figure 19). The artist signed it "Albert Vargas," as he did other works from the 1920s that he felt would have widespread commercial exposure. Reproductions of this watercolor appeared as posters and full-page advertisements for *Glorifying the American Girl*, a movie about the Ziegfeld Follies, which Vargas's work had helped to publicize around the world for much of the 1920s. The title of the movie actually summarizes quite nicely the only goal Vargas ever wanted to achieve. And it was one he accomplished with few rivals among twentieth-century American artists.

The first major expansion of the American calendar business occurred directly after the close of World War I. Soldiers who had left the States as teenagers and young men returned as seasoned "men of the world." Along with their memories of the European women they had met, the soldiers carried home untold numbers of risqué French postcards. Produced either from original artwork or photographs, these cards depicted nude or provocatively posed French and Italian flappers. Prints of French glamour girls were also popular with the returning soldiers.

American calendar companies soon began large-scale production of pin-ups based on these new, liberated images imported from the Continent. These American versions of the liberated European female, who were to be called "flappers" charlestoned their way into the 1920s. Their likes had never before been seen on

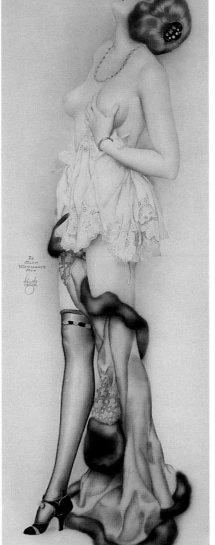

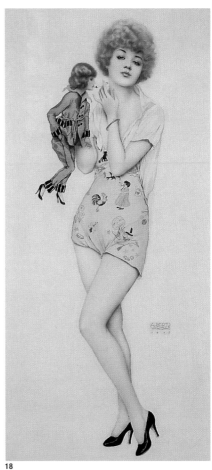

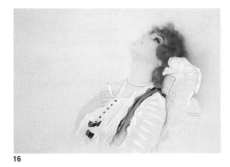

16

17

18

published calendar imagery: the Gibson Girl had entered the Jazz Age.

In the magazine and advertising markets, many of the leading mainstream illustrators of the day painted "pretty girl" subjects (with a strong "glamour" component) as crossover images. Norman Rockwell was among the numerous important illustrators who, throughout their careers, regularly painted "pretty," "glamour," and "pin-up" images, employing models, starlets, and movie stars as subjects. This trend in American illustration art actually started at the turn of the century and lasted to the mid-1970s.

One of the most admired of such mainstream artists was Joseph Christian Leyendecker (1874–1951), who created America's second famous male pin-up, the Arrow Collar Man. Following in the footsteps of the popular Gibson Man, Leyendecker's dapper hero so intrigued American women that, in the early 1920s, he received hundreds of weekly marriage proposals in the mail. The artist's brilliant designs and meticulously executed images appeared in several massively successful advertising campaigns, most notably those for Arrow Collar shirts, made by Cluett Peabody and Company; Hart, Schaffner, and Marx; and the clothier Kuppenheimer.

Whenever Leyendecker had the opportunity to paint a beautiful girl, he would respond with an accomplished painting, as he did in a painting executed for Chesterfield cigarettes, produced by the Liggett and Meyers Company (figure 20). Here, Leyendecker displays his characteristic painting technique, in which brush-

strokes are applied in such a way that areas of bare canvas are incorporated into the design. The figure portrayed in this advertising piece suggests what the "Leyendecker Girl" might have looked like, had the artist worked on campaigns for women's rather than men's fashions.

Matching Leyendecker's stature in the world of illustration was his contemporary Howard Chandler Christy (1873–1952). A hardworking artist who also loved people and enjoyed the good life, Christy excelled at everything he did. From the time his formal art education began, in 1892 at the Art Students League and the National Academy in New York, Christy impressed his teachers with his talent. One of them, the artist William Merritt Chase, even agreed to give him private lessons – a particular honor at the time.

After only three years of study, Christy entered the field of commercial illustration on a full-time basis: in 1895, he began supplying work to *Life*, as Charles Dana Gibson had before him. Also like Gibson, Christy was to specialize in creating elegant images which celebrated female beauty and which were identified by his name, the Christy Girls.

Christy's name became known to every household in America in the first twenty years of his career. In 1900, within five years of his first illustration for *Life*, the Christy Girls were the subject of a best-selling art book, and six more volumes were to follow in the next twelve years. Christy's signature became widely recognized, while he himself attained celebrity status. His charming, warm personality

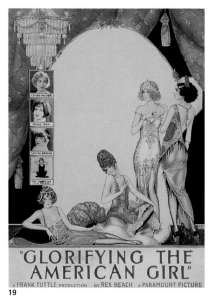

"GLORIFYING THE
AMERICAN GIRL"
A FRANK TUTTLE PRODUCTION BY REX BEACH A PARAMOUNT PICTURE
19

20

attracted many people, particularly members of the press, with whom he developed a jovial, playful relationship.

In 1921, at the peak of his success as an illustrator, Christy decided to "retire" and devote himself exclusively to painting "fine-art" easel works, most especially portrait nudes and landscapes. Occasionally, he would accept a special commission if the project was tempting or challenging. Such was the case when Christy agreed, in the early 1920s, to create a series of murals for the famous Café des Artistes in New York.

From 1915 to his death in 1952, Christy both lived and worked at the Hotel des Artistes, where the Café was located, just off the lobby; his studio in the hotel was one of the most elegant in the world. When the commissioned work was finished, all the walls of the Café were splendidly adorned with Christy's life-size nudes frolicking in a lush forested landscape.

Later, about 1925, the artist received another commission, from a private patron, for a work of almost mural size. The painting Christy created in response (figure 21) might be thought of as a sort of fifth wall for the Café. The work features three nudes in a dreamlike Garden of Eden, and to underscore the special nature of the scene, Christy chose twenty-four-carat gold paint for the sky and the setting sun.

Christy's murals may still be seen at the Café des Artistes. Like all his masterly images of feminine beauty, they remain as a permanent testimony to his art, to the brilliance of his brushstrokes, and to the sensuality and eroticism of his female nudes.

Harrison Fisher (1875–1934) was another Art Deco artist who, like Gibson and Christy, had such talent and attained such fame that his creations were known by his name. The son and grandson of painters, Fisher was a native of New York who later moved with his parents to San Francisco. He studied art in that city's Mark Hopkins Institute of Art. After further art education in England and France and jobs with the Hearst newspapers in San Francisco, Fisher returned to New York in 1897. He soon became known for his work as a staff artist at *Puck*, especially for his front-cover pen-and-ink drawings (to which color was later added).

Working primarily in gouache and pastel for most of his career, Fisher expressed his vision of the ideal American girl in an extraordinarily long-lasting series of images – the front covers that he created from 1912 to 1934 for Cosmopolitan magazine. That publication described the Fisher Girl in these words: "healthy, well poised, clear-eyed, … neither slob nor sloven, … who wins by the sheer charm of her personality, who is genuine, gracious, tender when need be, buoyant when occasion calls, and feminine always."

In addition to his special relationship with Cosmopolitan, Fisher provided work to other mainstream publications like *The Saturday Evening Post*, *McClure's*, *Ladies' Home Journal*, and *Scribner*'s; a gouache entitled *Dear Sweetheart* that was published in 1914 as a front cover for *American Sunday Monthly Magazine* is typical of such work (figure 22). Fisher was also well known for his illustrations of popular romantic novels.

Like the other prominent illustrators of his day, Fisher became a wealthy man who was much sought after by models seeking to pose for him. He, too, had books published that featured his pictures of American beauties. And, in a final parallel to Gibson and Christy, Fisher turned to easel painting and portraiture toward the end of his life.

It is clear from the preceding examples that Art Deco artists quite often either incorporated pin-up and glamour images into their work or used them as starting points for many different kinds of illustrations. The examples we have seen come from the most famous of the mainstream illustrators working in the early decades of the twentieth century. Although one of the works was a "glamour-art" image used in a national advertising campaign (see figure 20), it was not a true pin-up.

For a real pin-up image, we must turn to a superb watercolor by Coles Phillips that was first published in 1922 as a full-page advertisement for Holeproof Hosiery (figures 23 and 24). Virtually all the leading mainstream magazines, including *The Saturday Evening Post*, *Cosmopolitan*, and even *Good Housekeeping*, carried the advertisement, and many readers wrote to request prints of the image. Obviously, the tranquil pose of the model, coupled with Phillips's sophisticated composition and design, allowed the pin-up subject here to work with grace, elegance, and sensuality.

Coles Phillips had a short-lived but successful career that spanned just under twenty years (1908–1927). Like Christy and Gibson before him, he received his first assignments from *Life*. Unlike his two peers, however, Phillips graduated to front-cover assignments a few months afterwards and continued to produce them until his death. His designs also graced the front covers of most of the major magazines – *Ladies' Home Journal*, *Collier's*, *McCall's*, *Liberty*, and *Woman's Home Companion*, in addition to the ones already mentioned – and the great majority of such images were designed and painted with a pin-up or glamour theme. His art was eventually featured in a popular book entitled *A Gallery of Girls*.

Phillips was particularly concerned with the design element of his work, seeing it as his first and primary tool in creating an image. In fact, he became famous for his inventive use of the "fade-away" method of design, in which one element of the picture, a man's overcoat, for instance, is blended into the background while his figure and face are defined by the skillful use of highlights.

Coles Philips accomplished much during his brief life, and both the art world and the general public were saddened by his untimely death in 1927. At his funeral, his friend J. C. Leyendecker eulogized Phillips as "an artist unique in his field, one with a highly developed sense of decoration and color … he was ahead of his time [in] depicting the American type of womanhood."

Of all the successful mainstream artists of "pretty girl" subjects, James Montgomery Flagg (1877–1960) was the most flamboyant. A natural "rebel," Flagg was one of those rare individuals who achieved both public acclaim and the respect of his peers in the art world. His life-style was often compared to that of Howard Chandler Christy: both men loved traveling around the world with the "jet set" of their day. Flagg spent a great deal of time in Hollywood, where he socialized with a colorful assortment of writers, actors, and bohemian characters, among them his longtime friend John Barrymore.

Flagg grew up, worked, and died in New York City. Again, like many other great illustrators of the time, he got his start working for *Life* and continued to do so for many years. As his career flourished, his paintings and drawings appeared as illustrations for magazine covers, calendars, advertisements, and stories. Almost every magazine of consequence during the first half of the century published

Flagg's work. In a glamour painting reproduced about 1930 as a magazine cover, probably for *Life* or *Judge*, the artist captures an Art Deco beauty in a sensual, sophisticated pose as she applies her lipstick (figure 25).

As an artist, Flagg was supremely versatile and skillful. Often working with incredible speed, he was at home in many mediums, including oils, pen and ink, opaque and transparent watercolor, charcoal, and graphite; he was also a fine sculptor. In addition, his numerous recruitment posters during World War II – especially the depiction of Uncle Sam entitled *I Want You* – brought him much fame.

Flagg most particularly loved painting beautiful women, who played a large part in his personal as well as his social life. Like other famous illustrators of the 1920s and 1930s, he was a connoisseur of the female form. He and his artist friends partied quite often at the private clubs they had formed and at various gathering places for the Dutch Treat Club's annual soirées. A wash drawing done about 1930 for the Club's yearbook (figure 26) shows a bare-breasted model in bed answering the phone and saying, "No, madam – you have the wrong number – This is the Museum of Natural History!" The man in the background is the artist's friend the illustrator John LaGatta, whom Flagg liked to tease as often as possible.

Another important mainstream illustrator who employed pin-up and glamour themes was Dean Cornwell (1892–1960). In an original charcoal drawing done about 1935 for the Dutch Treat Club, Cornwell illustrates the extremely popular subject of an artist and his model (figure 27). This theme was one that artists certainly were familiar with and that the public appreciated for its hints of glamour and naughtiness. In recognition of Cornwell's artistic skill, his fellow artists called him the "Dean of Illustrators."

William Reusswig (1902–1978) was an illustrator who regularly employed pin-up themes in his work for major magazines as well as in his advertising assignments for prominent clients. Like his friends Flagg and Cornwell, Reusswig contributed regularly to the yearbooks of the Dutch Treat Club. One of his illustrations shows a nude model seated at a bar that could be in a corner of the 21 Club, the Lotos Club, or any of the other nightspots in New York where artists regularly

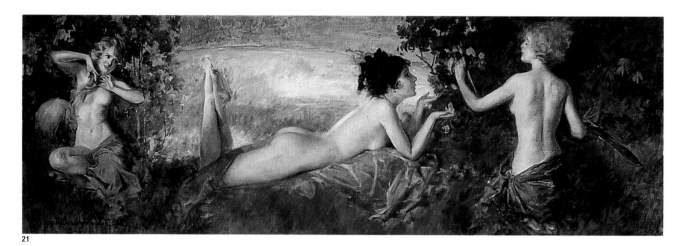

21

gathered (figure 28). Both the sauciness of her pose and her unashamed nudity convey something of the playfulness of the artist-model relationship at that time.

Bradshaw Crandell (1896–1966) was the last of the "pretty girl" artists of the 1920s and 1930s to become so popular with the American public that his name was regularly linked to his creations. Crandell did some work for the calendar pin-up market, but was best known for the pastel front-cover images he delivered every month to *Cosmopolitan* for more than twelve years starting in the mid-1930s (he took over this assignment from Harrison Fisher). One of these works is the typical "glamour-art" pastel that was reproduced as a front cover for *Cosmopolitan* in August 1940 (figures 29 and 30).

Crandell devoted most of his artistic career to painting pictures of attractive women – an activity that was greatly aided by his membership in the Dutch Treat Club and other artists' groups in Manhattan. In 1952, a clever Crandell painting was used as the endsheets for the Dutch Treat Club's yearbook (figure 31). The names and phone numbers on the wall behind the model are those of Club members, and each name bears a humorous notation supposedly made by the model. If ever there was a "mainstream" pin-up, this Crandell work is it!

One kind of pin-up art that spanned both the Art Deco period and the years after World War II was the pulp-magazine illustration, which had its own "golden age" from the 1920s through the 1940s. Focusing on subjects like crime, science fiction, horror, and adventure, the provocative pulps featured sexy pin-up girls depicted in perilous – and usually highly erotic – situations.

The pulps relied on their own stable of artists who basically specialized in either color front covers or black-and-white illustrations of stories. Many pin-up and glamour artists in the 1920s and 1930s had their early work published on the covers of pulp magazines, including Earle K. Bergey, Enoch Bolles, Peter Driben, George Quintana, Arthur Sarnoff, and William Fulton Soare. A classic science-fiction glamour subject by Bergey, for example, was published as a front cover for *Thrilling Wonder Stories* (figure 32).

Similarly, many artists who restricted their careers to pulps incorporated pin-up and glamour themes into their subjects, as in Howard McCauley's vintage pulp

from 1940 (figure 33). Even *Weird Tales* published pin-up themes, like the spectacular nude by Virgil Finlay, the "grand-daddy" of pulp art (figures 34 and 35). A few artists enjoyed moving regularly between the two genres as well as branching out to other areas of illustration art; among these were the versatile Bergey; George Rozen, the creator of the famous *Shadow* magazine covers; Jerome Rozen, George's brother; John Newton Howitt; and Harry T. Fisk.

Devoting their time and talent primarily to pulp-magazine pin-up covers were Margaret Brundage, who provided pastel pin-ups for the covers of *Weird Tales*, and Hugh J. Ward and Harry Parkhurst, both of whom worked on covers for *Spicy* magazine (although Ward sometimes illustrated such mainstream magazines as *Liberty* and *Collier's*). How much the front covers of the spicy pulps were oriented toward pin-ups can be seen from the magnificent Ward cover that so effectively combines pin-up and horror themes (figure 36). In addition, illustrations for detective pulps, like the ones by Raphael DeSoto and George Gross (figures 37 through 40), regularly placed their heroes and villains in the company of pin-up girls.

As we have seen, both the publishing and the calendar business burgeoned during the period from after the end of World War I to 1940. In both of these fields, pin-up and glamour themes were among the biggest sellers – so much so that many mainstream illustrators, from Gibson to Flagg, incorporated them into their art. There was a group of artists, however, who focused their attention on such themes as the very basis for their work, finding calendars and men's magazines among their most lucrative markets.

The most prolific and visible of the Art Deco pin-up artists who specialized in magazine covers was Enoch Bolles. Bolles's campy, playful, and seductive pin-ups appeared on the covers of such men's magazines as *Film Fun* and *Gay Book*, while his more provocative designs were seen on spicy pulp magazines like *Bedtime Stories*, *Tattle Tales*, and *Pep Stories*. Equaling Bolles, in both talent and success, were two other important pin-up artists whose magazine covers were seen on newsstands from coast to coast, Earl K. Bergey and George Quintana. Both worked primarily for the spicy pulp magazines but also for other men's magazines like *Real Screen Fun*, *Movie Humor*, and *Reel Humor*.

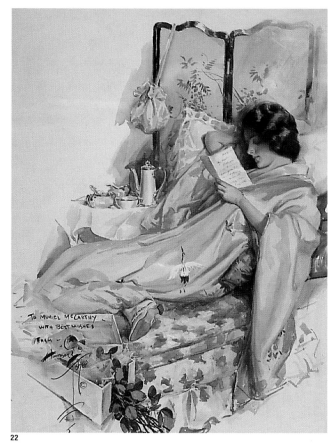

22

Of those artists who provided pin-up and glamour-art images to calendars, Edward M. Eggleston, Henry Clive, and Gene Pressler were clearly the most talented working during the 1920s and 1930s. All three were proficient in many mediums, although Eggleston and Clive favored oil on canvas and Pressler pastels on canvas. Each of these artists was an academic painter who could easily have been influenced by John Singer Sargent.

Peter Driben, who would become one of the giants of pin-up cover art in the 1940s and 1950s, began his career during the Deco years: while in Paris during the 1920s, he started providing risqué drawings and paintings to the American pin-up pulp-magazine market. (Interestingly, Driben was not the only major pin-up artist whose career spanned the decades both before and after World War II. Those whose works were equally important in both periods include Rolf Armstrong, Bradshaw Crandell, Billy DeVorss, Gil Elvgren, Jules Erbit, Earl Moran, Zoë Mozert, George Petty, and Alberto Vargas.)

Three other pin-up artists who began their careers during the Deco period are Charles Sheldon, Billy DeVorss, and Jules Erbit. During the 1920s and 1930s, Sheldon's fashion drawings inspired a series of famous ads for women's shoes, stockings, and lingerie which appeared in *Ladies' Home Journal* and *Woman's Home Companion*. In 1937, he created the first of his legendary Breck Girl Shampoo ads, a campaign that was to be one of the most successful in the history of American advertising. Sheldon's images of the Breck Girl are considered by many to be the ultimate examples of the "glamour art" type of pin-up.

Mainly pastel artists, DeVorss and Erbit were both extremely prolific, working in large formats that averaged 40 x 30 inches (101.6 x 76.2 cm). DeVorss's glamorous women often looked as if they had just walked off the set of a swank 1930s Hollywood movie. Erbit's, on the other hand, were a bit less sophisticated and, more often than not, portrayed the sort of girl that every young man of the 1930s wanted to bring home to mom and dad.

There were four women artists in the Art Deco era whose pin-ups and glamour girls were part of the American scene for more than two decades: Mabel Rollins Harris, Laurette Patten, Irene Patten, and Pearl Frush. Harris had an exceptional command of and flair for the medium of pastels, which she used to conjure up an

extraordinary range of images and moods. Also accomplished in pastels, the Pattens were sisters whose styles were so similar that their works at times seemed interchangeable. Frush is truly an undiscovered artistic treasure. Her original works, painted in gouache on illustration board, often have the look of tightly executed oils. In fact, Frush's technical brilliance was such that, upon close examination, her works even begin to take on a photographic clarity. Those knowledgeable collectors who have studied her paintings have often judged her the equal of Alberto Vargas in artistic excellence.

In the late 1930s and early 1940s, as America worked its way out of the Depression, a new concern developed about the perilous situation in Europe. With the thought that their country could become involved in war at any moment, American men and women experienced a sense of anxiety that touched every person's life in one way or another. As people always have, many sought escape from their worries in entertainment – listening to the radio, going to the movies, and reading magazines, books, and novels. Spurred by this increased interest, the taste for pin-ups, and for the magazines and calendars that featured them, only grew.

By the fall of 1940, *Esquire* had become one of the most important literary publications in America. Drawing upon the nation's leading writers, artists, and photographers, the magazine also employed a top-notch staff, which was under the vigorous direction of publisher David Smart. In the environment of excellence fostered by *Esquire*, the American pin-up was to experience an elevation in status. Taking the pin-up out of locker rooms, garages, dormitories, barracks, and clubhouses, where it had been surreptitiously enjoyed by generations of American men, the magazine had begun to give it a new stature as early as 1933, when its first issue appeared on newsstands.

Rather than sales at newsstands, however, it was *Esquire*'s massive subscription list that was responsible for the pin-up's new status. Every month, American families welcomed the magazine into their living rooms, where everyone enjoyed its brilliant articles and fiction as well as its dazzling display of humor, photography, and art. Without *Esquire*'s determination to deliver to its readers the best tal-

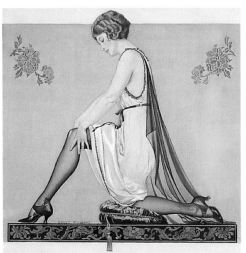

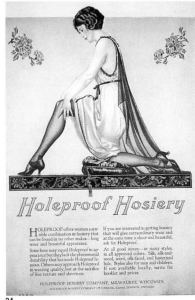

23–24. COLES PHILLIPS
ORIGINAL (WATERCOLOR) AND (RIGHT) REPRODUCTION AS
AN ADVERTISEMENT FOR HOLEPROOF HOSIERY, 1922
*ORIGINAL (AQUARELL) UND REPRODUKTION IN FORM EINER
ANZEIGE FÜR „HOLEPROOF HOSIERY" (EIN MARKENNAME
FÜR DAMENUNTERWÄSCHE), 1922*
ORIGINAL (AQUARELLE) ET REPRODUCTION SOUS FORME
DE PUBLICITÉ POUR HOLEPROOF HOSIERY (UNE MARQUE
DE SOUS-VÊTEMENTS FÉMININS), 1922

23

24

ent that money could buy, the American public might never have accepted quality pin-ups as readily as they did just prior to the war.

The October 1940 issue of *Esquire* featured centerfold pin-ups by two artists who were significant both to the magazine itself and to the place of the pin-up in American society. One was George Petty, who had attained fame as the creator of the Petty Girl, the first modern pin-up image to emerge from the lean years of the Depression. *Esquire* had done much to foster Petty's career, making a major commitment to the artist by publishing at least one of his images every month throughout the 1930s. The other was Alberto Vargas, who had specialized in the 1920s in portraits and promotional artwork for the Ziegfeld Follies and in the 1930s in works portraying and publicizing the Hollywood motion picture industry.

The appearance of Vargas's first pin-up in *Esquire* marked the beginning of worldwide fame for the artist. His dreamlike Varga Girls (the magazine had taken the liberty of dropping the "s" from his name) were promoted by *Esquire* again, just two months later, when it published its first calendar by the artist. The 1941 calendar was followed by seven more, and each of them made publishing history as the best-selling calendar of any kind worldwide; the Varga Girl became part of American society. Within a year of the Varga Girl's introduction, the country was preparing to go off to war.

When American soldiers boarded the transport ships for their destinations overseas, they carried not only their guns, their gear, and pictures of their loved ones but also their favorite pin-ups. Besides photographic prints themselves, the soldiers might have playing cards, calendars, and notepads decorated with pin-up and glamour themes. Such images boosted morale by giving many a soldier something to dream about during the hours, days, and weeks of wartime. Both General Eisenhower and General MacArthur commented publicly on this phenomenon, citing the help that such images afforded to their men.

Although Vargas is perhaps the most well known of the World War II pin-up artists, there were many others who specialized in the field during this era, which constituted the second major boom in the pin-up and glamour art industry. The most important of these artists was undoubtedly Gil Elvgren. Since the late 1930s,

Elvgren's work had been published by the Louis F. Dow Calendar Company in St. Paul. As demand for his images increased during the war years, Dow produced Elvgren's pin-ups in booklets measuring 8 x 10 inches (20.3 x 25.4 cm) – a format that was suitable for mailing overseas and for "pinning up" on all kinds of surfaces. After the war, Elvgren's popularity increased even more; his work for Brown and Bigelow from the late 1940s through the early 1970s was reproduced so extensively that it is estimated that there were more than a billion images of Elvgren Girls in circulation throughout the world.

Elvgren's pin-ups had that extraordinary, undefinable "something extra" that made him not only enormously popular with the public but the envy of his artistic contemporaries as well. One part of his unique talent was his skillful employment of the "situation" picture, and Elvgren seemed capable of inventing an endless variety of clever scenarios to delight his audience. Whether victims of an unexpected wind or ambushed by a pesky tree branch, his girls were invariably involved in interestingly revealing escapades. Another important element of Elvgren's pin-up mastery was his rich, painterly technique. His style, with its creamy brushstrokes and deep colors comparable to John Singer Sargent's, was imitated by many fellow artists – not only because they admired it for itself but also because art directors in search of a best-selling image often ordered them to paint like him.

Another major pin-up and glamour-art artist of this period was Earl Moran. Beginning in the mid-1930s, Moran established a name equal to Elvgren's, although their styles were basically different. Often more moody than Elvgren's images, Moran's pastel pin-ups became enormously popular during the war. So much so that an article on popular calendar art in the 1940 New Year's issue of *Life* magazine was illustrated mostly with his work, as well as with a photograph of him working in the studio with his daughter, who often posed for him.

Rolf Armstrong was already a major pin-up artist by the time the war started. During the 1920s and 1930s, his glamorous beauties, drawn in pastels, had appeared on magazines and sheet music, in advertising displays, and of course on calendars. However, most of his earlier images had been glamour art depictions, showing only the head of his model; now, in the wartime world of the

1940s, Armstrong turned to the more traditional full-length pin-up. Armstrong's pin-ups of the 1940s and 1950s, like those of Elvgren and Moran, were published by Brown and Bigelow. During World War II, this firm continued to be the single most significant calendar-publishing company in America, as it is today.

Two women pin-up artists became superstars in the 1940s and 1950s: Zoë Mozert and Pearl Frush. Mozert often used herself as the model for her pastel pin-ups, posing in front of a mirror as she worked. Her pin-ups and glamour images, also published by Brown and Bigelow, were extremely popular – because of their quality and sometimes because of the artist's gender. Pearl Frush shared the spotlight with Mozert, her exquisite gouaches being published by the Gerlach-Barklow Company. Both women regularly drew pin-ups for calendar companies and for glamour magazines, where countless young American boys first encountered and came to love their art.

In 1942, Betty Grable's famous "million-dollar legs" publicity photo for the movie *Pin-Up Girl* was released, and the studio received more than twenty thousand letters a week, from both soldiers and men at home, all clamoring for pictures to pin up on their walls. When the movie debuted two years later, it played to sold-out houses all over the United States. Americans seemed to respond with as much enthusiasm to real-life pin-up girls as to the creations of the master pin-up artists!

Other icons of the pin-up contributed to boosting the morale of the troops abroad: Lana Turner, who had been known as The Sweater Girl since 1938, and Ann Sheridan, who was dubbed The Oomph Girl. In a 1942 contest for the most popular American pin-up, Grable unsurprisingly won first place – she had, after all, been selected earlier as "The Queen of the Pin-up Girls" by *Movie Stars Parade*. The runner-up was Rita Hayworth, who had caused a furor by being photographed in a sexy black slip on the cover of *Life*, while Sheridan came in third.

During the war, thousands of American and Allied aircraft sported pin-up "nose art." The best artist at each airbase was selected for the prestigious job of painting the front of the plane with these provocative pin-ups, which the pilot and crew thought of as good luck charms to help them get through tough missions. Fliers often decorated their leather jackets with such images for the same purpose.

As the war continued, all of the major calendar companies stepped up production of pin-ups, which became more and more patriotic. While the Andrews Sisters sang on the radio and the Pin-up Stars performed at the USO Hollywood Canteen, artists like Elvgren, Moran, Armstrong, and Mozert contributed what they could to the war effort. Publishers employed pin-up and glamour art in every conceivable way to help boost the spirits of America's fighting troops and of the citizens who supported them at home. *Esquire* featured Varga Girls on its front covers during the war, and *Yank* magazine (figure 41) brought pin-up distribution right up to the front lines. Such popular mainstays as *Life* and *Look* proudly carried pin-ups on their covers (figure 42). Original pin-up and glamour art was even given away as raffle prizes at War Bond rallies: Curtis Publishing Company, which owned *The Saturday Evening Post, Ladies' Home Journal*, and *Country Gentleman*, regularly donated art that had been used for its front covers for this purpose. From Betty Grable to *Esquire* to Brown and Bigelow, the entire country was flooded with patriotic American pin-up girls. They too played a part in winning the war.

In 1950, both America and the pin-up were poised on the brink of an exciting new decade. Rita Hayworth had emerged as the new queen of the pin-up girls, and her movies drew huge audiences. When the Korean War began, she was "called back into service" by the government, which received more than 2,500 requests a week from servicemen for her photo. In 1950, Columbia Pictures released a movie starring Joan Caulfield entitled The Petty Girl, and the film was a smash hit. Pin-ups of all kinds were not only socially acceptable – they were embedded into the very fabric of the nation.

Although the pin-ups and glamour girls created by American illustrators in the 1940s and 1950s were distinctly American, they found a wider audience as well. They were full of sex appeal, not sex. The slightly flirtatious facial expressions and suggestive provocative situations were sources of innocent amusement: people responded readily to the fun inherent in these works.

From the late 1930s well into the 1950s, a popular format for showing off pin-ups was the "punch board" game (figure 43). Available in every corner variety store, barber shop, barroom, clubhouse, and service station, punch boards were self-contained games of chance. Some were made with die-cut designs to feature

the pin-up as prominently as possible. By 1951, punch boards had become a billion dollar a year business, with pin-up and glamour images constituting most of their illustrations.

Pin-up and glamour images appeared in the advertisements of many American companies during and after the war; the firms saw them as a way to promote their products while also raising the spirits of the public. Coca-Cola was the largest of such companies to feature pin-ups prominently; the firm was actually responsible for an informal stable of pin-up illustrators that grew up around the artist Haddon Sundblom. Sundblom, who had established his own studio in Chicago in the 1920s, went on to become the mentor of many important pin-up and glamour illustrators. He himself created the tremendously popular, classic image of Santa Claus that was the center of many Coca-Cola advertisements throughout the years.

The Sundblom Circle, as the group around the artist was called, included many of the leading lights of the contemporary American pin-up – artists like Joyce Ballantyne, Al Buell, Bill Medcalf, Robert Skemp, Al Moore, Thornton Utz, Jack Whittrup, Al Kortner, Euclid Shook, Harry Ekman, Walt Otto, Vaughn Bass, and, most prominently, Gil Elvgren. The works of the Sundblom Circle artists were, by and large, marked by a painterly technique. In fact, their brushstrokes were so rich, thick, and creamy that eventually their painting style came to be informally termed "the mayonnaise school." Their styles were actually so alike that telling one from the other was hard even for the artists themselves. Yet the artistry of the Sundblom Circle was so great that Norman Rockwell often spoke of his desire to know Sundblom's secret – how, in Rockwell's words, his paintings achieved their characteristic "sunlight glow." This group was also noted for its truly generous spirit, for the artists inspired each other naturally, without conscious effort, as a response to the good will that Sundblom engendered.

The Sundblom style of advertising art is clearly evident in Gil Elvgren's 1950 advertisement for Coca-Cola (figure 44). William Dolwick, another member of the Sundblom Circle, painted an imaginative Coke ad in which two sailors drinking sodas flirt with a pin-up girl just outside the picture (figure 45). Like all the works inspired by Sundblom, this picture is brilliantly composed – only the end of the

mysterious pin-up girl's pink scarf, seen in the lower right-hand corner, teasingly suggests her presence.

Ed Runci, Joyce Ballantyne, and Al Buell were three important pin-up illustrators who had both a format and an artistic influence in common. All worked in oil, on canvases measuring 30 x 24 inches (76.2 x 61 cm), and all were products of the Sundblom Circle early in their careers. Like Elvgren, Runci often set his pin-ups in narrative situations, but his thin application of paint set him apart from other members of the group. Ballantyne is most often compared with Elvgren in style, color, and the use of situation poses, and the two did in fact work quite closely together in Chicago. Adding to Art Frahm's preliminary sketch ideas, she created the well-known Coppertone billboard ad showing a little girl whose dog is pulling at her bathing suit. Buell's style of painting was tighter than that of the other two, although his work resembled theirs in many respects.

Two other Sundblom students, Harry Ekman and Vaughn Bass, were greatly influenced by working with Elvgren and went on to have successful careers of their own. Bass began his working life with a commission to redo some of Elvgren's paintings. In the late 1930s, the Louis F. Dow Company hired him to rework many of the pin-ups that Elvgren had done for the firm in order that the works could be used again. Drawing upon the same creamy painting technique as Elvgren, Bass tried to work mainly on the backgrounds and clothing of the figures, leaving their faces and bodies as Elvgren had originally painted them. (Fortunately, a few of the Elvgren originals that were not overpainted survive intact.)

Shortly after the war ended, so too did the reign of Alberto Vargas at *Esquire*; the magazine's 1947 calendar did contain twelve of the artist's creations, but neither his name nor his signature appeared on it. *Esquire* soon found a replacement for Vargas in Al Moore, one of Sundblom's talented group. For almost the next ten years, Moore's collegiate pin-up girls – a far cry from Vargas's – appeared as the central two-page gatefold of the magazine. Moore's pin-ups were also seen on *Esquire*'s calendars, which continued to sell every year (although not as well as Vargas's) until 1958, when photographs replaced paintings as the artwork.

During the 1950s, *Esquire* continued to be the biggest promoter of pin-ups and glamour art on a worldwide scale. Supplementing Moore's work for the magazine

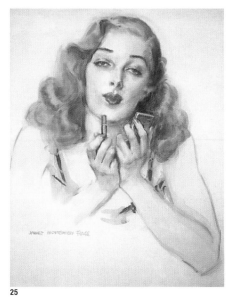

25. JAMES MONTGOMERY FLAGG
GLAMOUR GIRL WITH LIPSTICK,
REPRODUCED AS COVER FOR "LIFE" OR "JUDGE", C. 1930
GLAMOURSCHÖNE MIT LIPPENROT,
VERÖFFENTLICHT AUF DER TITELSEITE VON „LIFE" ODER
„JUDGE", 1930
BEAUTÉ GLAMOUR AVEC ROUGE À LÈVRES,
REPRODUITE EN COUVERTURE DE «LIFE» OU DE «JUDGE», 1930

25

was a group of talented artists that included Fritz Willis, Joe DeMers, Ernest Chiriaka, Thornton Utz, Frederick Varady, Eddie Chan, Euclid Shook, and Ben-Hur Baz. Interestingly enough, every one of these illustrators also enjoyed a highly successful career painting front covers and illustrating stories for the national mainstream magazines, the most prominent among those using such work being *The Saturday Evening Post*. Yet, these *Esquire* artists were the only pin-up and glamour art illustrators who managed to have two lucrative full-time careers; most of the others, like Elvgren, Moran, and Mozert, limited themselves to working in one genre only.

During the postwar years, *True* magazine sought to follow in the footsteps of *Esquire*. Originally carrying features on adventure, sports, travel, fashion, and the outdoors for a mostly male audience, the magazine began to publish Petty Girl centerfolds every month. It soon added works by Vargas, which were often accompanied by photographs of the artist painting or photographing a model in his studio. In 1947 and 1948, Fawcett, the parent company of *True*, issued two special Petty Girl calendars that duplicated exactly the size and format of Esquire's Vargas calendars.

As it had in every decade of the century, Brown and Bigelow in the 1950s commissioned, produced, sold, and distributed more pin-up art than any other company. Impressed, like many others in the illustration world, by the talent of the Sundblom Circle, the firm made many of these artists – including Elvgren, Ballantyne, and Buell – into the stars of its roster.

At the same time, Brown and Bigelow introduced a best-selling series of calendars called the Artist's Sketch Pad, first developed by Earl Mac Pherson in 1942. Although several different artists were later responsible for this series – K.O. Munson, Ted Withers, Joyce Ballantyne, Freeman Elliot, and Fritz Willis – the fact that it had the same basic format gave a unified look to the results. There was always a main subject, primarily a pin-up, at the center of the calendar image, surrounded by two or three separate sketches that were preliminary to the larger picture. Mac Pherson later devised a highly successful version of the format for the Shaw-Barton company that was eventually taken over by his assistant, T.N. Thompson.

There is no question that the pin-up world of the 1950s was dominated, as it had been in the 1940s, by the work of Gil Elvgren. Elvgren remained preeminent in the calendar and advertising fields for those two decades, and his "girls" continued to be the most popular pin-ups even throughout the 1960s. Art Frahm was the artist who perhaps came closest, at this time, to Elvgren's popularity. Although Frahm had been active as an artist for more than a decade before, he had his heyday in the 1950s, when he came up with an idea for a series of pin-ups with a common theme: a girl caught in some ordinarily innocent everyday situation that causes her panties to somehow fall down around her ankles. Frahm's girls with errant underwear – variations on Elvgren's adroit use of situations – sold millions of calendars and advertising-specialty products. His publisher, the Joseph C. Hoover and Sons calendar company, kept Frahm's images in their line for many years, and they proved to be the most durable and successful theme-oriented pin-up series of the century.

Billy DeVorss, who had been prominent since the late 1930s, produced many wonderful pin-up and glamour images in the 1950s. He worked mostly in pastels, sometimes in oil, and his calendar girls were reproduced and published so widely that one estimate put their number at more than fifty million worldwide. The pin-up artist Edward D'Ancona was known primarily for his calendar subjects, which were also reproduced on products like paperweights, key chains, and men's wallets.

Bill Medcalf was another accomplished pin-up artist who reached his peak in the 1960s. His work for Brown and Bigelow displayed a beautiful creaminess reminiscent of the work of the Sundblom Circle "mayo boys," but the texture of his painting surface was uniquely smooth. Since Medcalf received many special assignments through Brown and Bigelow from companies in the automobile industry, his pin-ups often contain cars and automotive accessories.

Another master of the "slick" style of the Sundblom Circle, Walt Otto, built a successful career in advertising with a subject that became his specialty – the wholesome farm girl. Whether fishing by a stream or stacking hay, the Otto girl reveled in the country. She was usually smiling and wearing shorts and a straw hat, and her trusty dog was beside her, as best friend and protector.

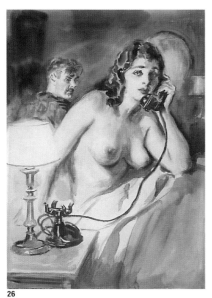

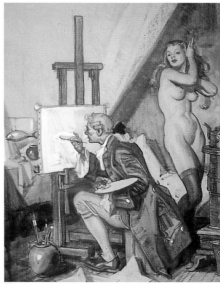

26 27

Arthur Sarnoff was probably the most versatile of the pin-up artists working during these years. He was primarily a mainstream illustrator, and his work was regularly published from 1935 to 1975 in the major American magazines, particularly *The Saturday Evening Post*. Yet Sarnoff also produced so much significant pin-up and glamour art, working within the field itself, that he was alone among the artists of the era in being a major name both in the pin-up field and in the world of advertising and magazines. He was so much in demand that many of the calendar companies for which he worked would book his time years in advance.

One business that had particularly grown and flourished during the war was the paperback novel industry. The armed forces had supplied soldiers with these small-format books, and when the troops came home, they – and many other Americans – had learned to appreciate paperbacks. Publishers knew that the quality of cover art often determined how well a title would sell. They therefore recruited the top illustrators of the day, hoping that these artists' pictures would boost sales of paperbacks at newsstands, drugstores, and bookstores. In the early days of the paperback, "digest" books – which were a little bit bigger than the traditional paperback, closer to the size of today's *TV Guide* – were extremely popular (figures 46 and 47). An illustration by pin-up artist Paul Radar appeared on a novel entitled *Teacher's Pet* in 1958 (figures 48 and 49). Sometimes the pin-up painting would actually include the text for the front cover of the book, as in *Just Like a Dame* (figure 50), which is a classic example of how pin-ups were used on the covers of paperback novels.

At the height of their postwar popularity, pin-ups could even be seen on the covers of such venerable mainstream magazines as *The Saturday Evening Post*. Artists like Norman Rockwell and his contemporaries often acknowledged the power of such images by incorporating pin-up themes into works that were basically of a very different nature. In the 1950s and 1960s, even the most sentimental and traditional calendars might flirt with the idea of the pin-up. A calendar on safety by Edward D'Ancona, for instance, draws on many aspects of the idealized, Rockwellian vision of American life. Yet D'Ancona can't resist including one little *Miss Me* pin-up among all the homespun imagery (figure 51).

It was not until the mid-1960s that production of the artist-rendered pin-up calendar began to be phased out. Although most of the leading American calendar companies had introduced photography for other kinds of subjects starting in the late 1940s, they continued to illustrate pin-up themes with artwork. A significant step in the final switch to photography occurred in England in January 1964, when the tire manufacturer Pirelli published the firm's first photographic pin-up calendar. Robert Freeman (who had worked as a photographer with the Beatles) joined art director Derek Forsyth and designer Derek Birdsall in creating a calendar that was to be instrumental in shifting the balance over to photographed pin-ups.

One pin-up and glamour-art artist did, however, remain popular well into the 1970s. Fritz Willis had first come to the public's notice in the 1940s, with his work for *Esquire*. When the magazine lost Vargas's services after the war, Willis was one of the artists it drew on most heavily to fill the void; the magazine also selected him in 1946 as the first artist to contribute to the prestigious *Esquire* Gallery Series. Willis continued his brilliant work for *Esquire* during the 1950s and began to emerge as a superstar in 1962, with his first Artist's Sketch Book and Memo Calendar for Brown and Bigelow.

Willis's women both looked sexy and created a sexy atmosphere around themselves. They were extremely sophisticated and provocative, whether overtly or covertly. Willis often portrayed them wearing revealing lingerie or stockings and subtly touching their breasts. Many of his pin-ups included a lushly painted bowl of fruit, and he might playfully add a bottle of wine or a pack of cigarettes as another suggestive touch. Willis's pin-up creations were special – classy, elegant, and erotic women of the world – and they had a special way of interacting with the viewer. His fame will continue to grow as he is increasingly recognized as one of the giants in the field.

By the time of Willis's last Artist's Sketch Book and Memo Calendar, in 1975, there was only one other pin-up and glamour art illustrator who consistently delighted the American public – and satisfied Brown and Bigelow's art directors as well. Mayo Olmstead had worked for America's premier calendar company for more than twenty-five years. In the early and mid-1970s, Olmstead's female fig-

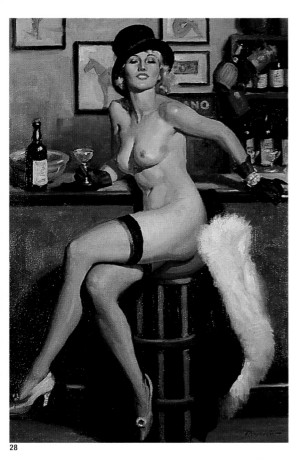

28

ures became more contemporary, responding to modern tastes and paving the way for Brown and Bigelow to enter the era of the photographic pin-up and glamour calendar.

By the mid-1970s, almost all of the American calendar publishers were using fashion and commercial photographers rather than painters to illustrate their calendars with pin-up or glamour motifs. Offering top fashion models and exotic locations, these calendars evolved into a popular art form that has continued up to the present. When artist-rendered pin-up and glamour girls disappeared from calendars, most of those who specialized in such themes either turned to portraiture or other kinds of fine-art easel painting, or retired altogether. The advent of photographic illustration also cut short the careers of many mainstream illustrators who worked in the fields of advertising and magazine publishing. Whatever their field of interest, many of these artist-illustrators are only now being recognized for their real contributions to the history of American art.

In the nearly one hundred years from the first Gibson Girl to the last Willis Girl, pin-up and glamour art served as a powerful testament to the beauty, vitality, and appeal of the American woman. Embraced by generations of Americans, of both sexes, pin-ups became a significant and rich part of the nation's art, society, and culture during the twentieth century.

note: *The pages that follow are divided into three sections. The first contains artists whose work relates to the Art Deco style, prevalent during the early years of the twentieth century. The second, comprising the major body of pin-up and glamour art, contains artists whose careers were almost entirely devoted to this genre and who made important contributions to the field. In the third section, we include for historical purposes artists who did in fact create work in the genre but not in significant numbers.*

Until recently, originals of pin-up and glamour art had never been handled or distributed through the customary art-world channels. The art illustrated herein was therefore never accurately documented, measured, or described. Created for publication, pin-up and glamour art originals were turned over to publishers in exchange for fees. The artists rarely asked for, or got, the originals back, and the *publishers disposed of them in various, undocumented ways. The artists also did not title their works; instead, titles were assigned by copyrighters, advertising people, and even salesmen. The same image could appear in different formats, in different years, and with different titles (sometimes as many as three or four). The originals were never measured, and publishers did not record mediums. Artists did not usually date originals, which were sometimes published years after they were finished, and so dates of completion can be determined within a few years only.*

In light of these circumstances, we have simply assigned a number to each work illustrated, in order to facilitate future reference. In the essays on the individual artists, we have endeavored, whenever possible, to indicate a range of dates and the typical medium and size for important series or types of images.

Die amerikanische Pin-up-Kunst

Charles G. Martignette

Im letzten Viertel des 19. und in der ersten Hälfte des 20. Jahrhunderts hatten die meisten Amerikaner weder Zeit noch Geld, Museen zu besuchen, und sie konnten sich auch keine Kunstbücher leisten. Die einzige Kunstform, die ihnen regelmäßig begegnete, war die Illustration. Diese behandelte jeden Aspekt des amerikanischen Alltagslebens. In diesem Sinne könnte man behaupten, die Illustration sei die wahre Kunst der Amerikaner.

Die Geschichte der amerikanischen Illustration läuft parallel zur Entwicklung der amerikanischen Nation. Als ab etwa 1875 die Bevölkerungszahl rapide anstieg, wuchs auch der Bedarf an zusätzlichen Kommunikationsmitteln. Fortschritte in der Drucktechnik trugen zu enormen Auflagensteigerungen lokaler und regionaler Zeitungen und Magazine bei. Zeitschriften mit landesweiter Verbreitung, wie Scribner's, The Century, Puck, Harper's Weekly und The Saturday Evening Post versorgten ihre wachsende Leserschaft mit aktuellen Nachrichten und vermittelten Ideen und Informationen. Außerdem boten sie erstklassige Unterhaltung in Form von Kurzromanen (romantische Liebes-, Abenteuer- und Kriminalgeschichten) und Berichten über gesellschaftliche Ereignisse, Kultur und Sport.

Die Verleger der Zeitschriften merkten schnell, daß ihre Artikel leichter eine Leserschaft fanden, wenn sie illustriert waren. Sie stellten auch fest, daß die Umschlagillustrationen wichtig für den Umsatz an den Zeitungsständern waren, was wiederum die Abonnementspreise unmittelbar beeinflußte. Bis 1920 war das Werben um die Lesergunst in regelrechte Kämpfe unter den Magazin- und Zeitschriftenverlegern ausgeartet. Das war zugleich die Geburtsstunde des „Goldenen Zeitalters" der amerikanischen Illustration, das bis 1970 andauern sollte.

Betrachtet man die Geschichte der amerikanischen Pin-ups, muß man sich klarmachen, daß die Bilder keineswegs nur auf eine bestimmte Leserschaft abzielten. Fast alle führenden „seriösen" Magazine beauftragten Heerscharen von Künstlern, für die Titelseiten ihrer wöchentlich oder monatlich erscheinenden Publikationen attraktive Männer, Frauen oder Kinder zu malen. Die Verleger wußten nur zu gut, daß sie auf dem heiß umkämpften Markt neue Leser am ehesten gewinnen konnten, wenn sie auf der Titelseite interessante Menschen oder hochdramatische Situationen zeigten. Und zu den faszinierendsten Menschen, die man abbilden konnte, gehörten schöne Frauen.

Die Illustrationen lassen sich in drei Kategorien unterteilen: „Pin-up", „Glamour" und „Pretty Girls". Ein „Pin-up" ist ein Ganzfigurenbild mit einem erzählerischen Element. Auf einem Pin-up-Bild trägt die Frau ein figurbetontes Kleidungsstück: entweder eins, in dem sie sich außer Haus zeigen könnte, zum Beispiel einen Badeanzug, einen Strandanzug oder ein knappes Kleidchen; oder sie trägt provokant Intimes, wie zum Beispiel Dessous oder gar ein Negligé. Es gibt auch nackte Pin-up-Girls, aber die sind die Ausnahme.

Ein der „Glamour-Kunst" zuzurechnendes Bild ist entweder ein Ganzfiguren- oder ein Brustbild. Die „Glamour-Frau" trägt gewöhnlich ein Abendkleid, ein Kostüm oder irgendein anderes Kleidungsstück, das in der Regel weniger „offenherzig" ist.

Als „Pretty Girls" bezeichnet man von Illustratoren „seriöser" Zeitschriften im „Glamour"-Stil gemalte Frauenporträts. Die Abnehmer waren die großen und populären Magazine, wie The Saturday Evening Post oder Cosmopolitan und die Werbung. Die Bezeichnungen „Pin-up-Kunst" und „Glamour-Kunst" beziehen sich also auf die Werke von Künstlern, die sich auf diese Sparte spezialisiert hatten. Unter „Pretty-Girl-Kunst" versteht man fast immer Motive von Illustratoren, die sich normalerweise auf andere Genres konzentrierten. Die meisten bekannten Illustratoren malten irgendwann im Laufe ihrer Karriere Bilder der Kategorie „Pretty Girl", ein breites Publikum ansprachen. Manchmal waren es auch Pin-up-Bilder, aber meistens konzentrierten sich die Illustratoren doch auf den „Glamour"-Aspekt der weiblichen Schönheit.

Zu den bekannten Magazinen, die sehr gern „Pin-up"- oder „Glamour"-Sujets auf die Titelseiten setzten, gehörten The Saturday Evening Post, Collier's, Liberty, Ladies' Home Journal, Cosmopolitan, Woman's Home Companion, Life, Judge, McCall's, Redbook, American Weekly, Vogue, Esquire und True. Sogar Time, das sich selbst als „Amerikas Nachrichtenmagazin" bezeichnete, reproduzierte Original Pin-up-Gemälde auf der Titelseite: Das Cover der Ausgabe vom 10. November 1941 zeigt Rita Hayworth als Pin-up-Girl, gemalt von George Petty, dem Vater der amerikanischen Pin-up- und Glamour-Kunst des 20. Jahrhunderts.

Unter den Hunderten von Künstlern und Illustratoren, die zwischen 1920 und 1970 für Zeitschriften arbeiteten, waren etwa 50, die sich fast ausschließlich auf

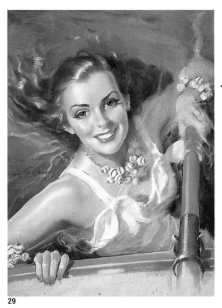

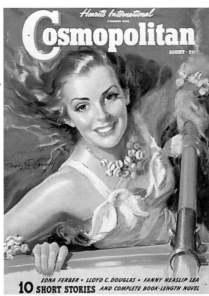

29

30

29–30. BRADSHAW CRANDELL
"GLAMOUR ART" IMAGE, ORIGINAL (LEFT, PASTEL) AND
REPRODUCTION (BELOW) AS COVER OF "COSMOPOLITAN",
AUGUST 1940
*GLAMOURBILD, ORIGINAL (PASTELL, LINKS) UND REPRODUKTION
ALS UMSCHLAG FÜR „COSMOPOLITAN", AUGUST 1940*
IMAGE GLAMOUR, ORIGINAL (PASTEL, À GAUCHE) ET REPRODUC-
TION EN COUVERTURE DE «COSMOPOLITAN», JANVIER 1940

„Pin-up" oder „Glamour" spezialisiert hatten. Manche von ihnen arbeiteten auch gelegentlich für andere Auftraggeber, hauptsächlich für die Werbebranche. Im großen und ganzen ging es den Künstlern, die Pin-up-Bilder malten, um eine Huldigung an das „ewig Weibliche" der amerikanischen Frauen. Die annähernd 500 Künstler gaben in ihren Bildern gewöhnlich erzählende, sentimentale, romantische oder patriotische Aspekte des amerikanischen Alltags wieder. Aber auch ihre Bilder enthielten Glamour-Elemente, besonders später, als die Pin-up-Künstler fast ausschließlich für die großen Kalenderverlage arbeiteten.

Da sich Pin-up- und Glamour-Illustrationen einer regen Nachfrage beim Publikum erfreuten, winkten neben den Zeitschriften neue Auftraggeber: Werbung, Kalenderverlage, Pin-up-Magazine, Groschenhefte, Postkarten und Werbeartikel. Führende Werbeagenturen und Unternehmen benutzten Pin-up- und Glamour-Kunst, um für ihre Ideen und Produkte Reklame zu machen. Unternehmen wie Kodak, Coca-Cola und General Motors bedienten sich solcher Bilder bei landesweiten Werbekampagnen und beeinflußten so Generationen von Amerikanern.

Pin-up- und Glamour-Bilder wurden auf vielfache Weise reproduziert, meistens in Form von Kalendern im Format 5 x 7,5 cm bis ca. 50 x 75 cm. Diese Kalender bestanden anfangs nur aus einem Blatt mit dem Überblick über alle zwölf Monate darunter. Das Ganze wurde mit einem farblich passenden Rahmen und mit einem Bändchen versehen, damit man den Kalender an der Wand aufhängen konnte. Die größten dieser Kalender, die sogenannten Hangers, hingen gewöhnlich in Fabriken oder Werkstätten so hoch an der Wand, daß Hunderte von Arbeitern sie von ihrem Arbeitsplatz aus sehen konnten. Sehr beliebt waren auch zwölfseitige Terminkalender in Spiralheftform, mit einem Pin-up- oder Glamour-Bild auf jeder Seite. Im Laufe der Zeit eroberten diese Kalender immer mehr Wohnungen und Arbeitsplätze und waren aus dem amerikanischen Alltag nicht mehr wegzudenken.

Auf Platz zwei der Beliebtheitsskala rangierten Pin-ups auf den Titelseiten von Magazinen. In den 20er und 30er Jahren zierten Fotos von spärlich bekleideten Filmsternchen, Ziegfeld-Follies-Girls, New Yorker Models und Mack Senetts berühmte Badenixen die Cover von Film Fun, Movie Humor, High Heel, Silk Stocking Stories und Gay Books. In den 40er und 50er Jahren sah man Pin-up-Bilder

vor allem auf den Magazincovern des New Yorker Verlagshauses Robert Harrison. Es gab im ganzen Land keinen Zeitungskiosk ohne Harrisons Beauty Parade, Whisper, Wink, Eyeful, Titter, Flirt, Giggles und Joker. Die Fotos in den Magazinen ähnelten den Bildern aus den 20er und 30er Jahren, aber zusätzlich gab es noch Fotos von unbekannten Models oder „Kultfiguren" wie Betty Page, Irish McCalla („Sheena, die Königin des Dschungels") und zahlreichen anderen, nach Starruhm strebenden Schönheiten.

Die doppelseitigen Bilder in der Mitte der Pin-up-Magazine, die „Centerfolds" bescherten der Pin-up- und Glamour-Kunst weltweite Verbreitung. Centerfolds gab es schon seit 1880, als das Magazin Life das „Gibson Girl" herausgebracht hatte. Sie waren entweder mit Heftklammern befestigt oder am linken Bildrand in das Magazin eingebunden. Man konnte sie aus dem Magazin heraustrennen und an der Wand aufhängen („pin up!"), sie rahmen oder in ein Sammelalbum kleben. Manche Pin-ups konnten ausgeschnitten werden. Obwohl im Laufe der Jahre viele Magazine Centerfolds herausbrachten, trugen vor allem die seriösen Zeitschriften, insbesondere True und Playboy, zur Verbreitung der Pin-ups bei. In den späten 30er Jahren brachte Esquire das erste Centerfold heraus (und nannte es „Gatefold"), und bis 1940 druckte Esquire auf diesen dreiseitigen Pin-ups mehrmals das berühmte „Petty Girl".

Ein weiterer Bereich der Illustrationskunst waren die Groschenhefte. Sie waren billiger als seriöse Zeitschriften und von minderer Qualität, aber in ihrer Blütezeit – zwischen 1920 und 1950 – ungeheuer zahlreich und populär. Es gab Groschenhefte zu allen erdenklichen Themen: Science-fiction, Horror, Abenteuer, Verbrechen, Liebes-, Wildwest- und Detektivgeschichten. Die Pin-ups auf ihren Titelseiten waren oft gewagt und überließen nur wenig der Phantasie des Betrachters. Bis etwa 1952 arbeiteten viele Illustratoren ausschließlich für Groschenhefte. Danach wechselten sie häufig zu den Verlegern von Digests und Taschenbüchern, für deren schnell wachsende Leserschaft sie weniger provozierende Pin-ups malten.

Auch die „art cards" (Kunstbildchen) oder „mutoscope cards", die man aus ungezählten Automaten ziehen konnte, brachten die Pin-ups unters Volk. Sie waren etwas kleiner als Postkarten und von Mitte der 30er bis Mitte der 50er Jahre auf dem Markt. Sie kosteten zunächst einen Cent, später bis zu fünf Cents.

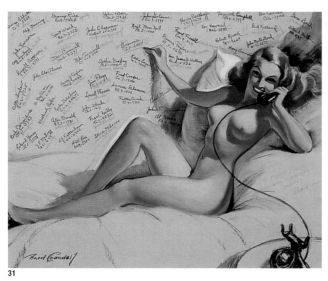
31

Junge Leute und Erwachsene sammelten diese bunten Pin-up-Bilder, genauso wie Kinder Baseball-Bilder oder Comic-Hefte. Weltweit wurden mehrere Millionen dieser Bildchen abgesetzt.

Pin-up- und Glamour-Girls wurden darüber hinaus ein wichtiger Werbeträger und fanden sich auf Kartenspielen, Löschern, Notizblöcken, Taschenspiegeln, Trinkgläsern, Aschenbechern, Schlüsselanhängern, Kugelschreibern, Bleistiften, Feuerzeugen, Krawatten, Tellern und Streichholzbriefchen. Seit über 75 Jahren in der ganzen Welt verbreitet, haben sie Pin-ups und Glamour-Girls zu einer wahrhaft universellen Kunstgattung gemacht.

Pin-up-Kunst ist untrennbar verbunden mit der Entwicklung des amerikanischen Kalenders. Benjamin Franklin gilt als derjenige, der den ersten Kalender in Amerika eingeführt hat, und zwar 1752 mit seiner Ausgabe von Poor Richard's Almanac. Seine Version wurde zunächst von der gesamten englischsprachigen Welt übernommen. Jahrhundertelang wurde der Kalender immer wieder variiert, bis er schließlich seine endgültige Fassung erhielt.

Um 1850 begann in Amerika die Entwicklung eines neuen Geschäftskalenders, der nur aus einem Blatt bestand und Werbezwecken diente. Diese heute primitiv anmutenden Blätter machten entweder Reklame für die Firma, die sie druckte, oder für ihre Geschäftspartner, zum Beispiel Lithographen, Graveure oder Zeitungsverleger.

Der erste für Werbezwecke konzipierte Kalender erschien 1889: Zwei Zeitungsverleger, Edmund B. Osborne und Thomas D. Murphy aus Red Oak, Iowa, druckten einen Wandkalender, in dem ortsansässige Händler Anzeigen schalteten. Die Anzeigen wurden um einen Holzschnitt gruppiert, der das neue Verwaltungs- und Gerichtsgebäude der Stadt zeigte. Ursprünglich hatten die beiden diesen Holzschnitt in Auftrag geben wollen, um ihn in ihrer Zeitung zu reproduzieren; aber die Kosten hatten sich als untragbar erwiesen. Als Herzstück des Werbekalenders brachte er nicht nur die Herstellungskosten ein, sondern einen zusätzlichen Profit von $ 300 – für damalige Verhältnisse eine gewaltige Summe. Von diesem ersten Werbekalender wurden mehr als 1000 Exemplare verkauft. Damit wurde ein Wirtschaftszweig ins Leben gerufen, der in gut 100 Jahren mehrere Milliarden Dollar an Profit einbrachte.

Der erste Vertreter, den Osborne und Murphy für ihre neue Kalenderproduktion einstellten, hieß Herbert Huse Bigelow. Er arbeitete fünf Jahre lang für Osborne und Murphy und zog dann nach St. Paul, Minnesota. Dort lernte er Hiram D. Brown, einen Drucker, kennen. Sie freundeten sich an und faßten eines Tages den Entschluß, eine eigene Firma aufzubauen. Bigelow hatte ein Sparguthaben von $ 1500 – und Brown war bereit, den doppelten Betrag in ihr neues Unternehmen zu stecken: einen Kalenderverlag. Browns einzige Bedingung war, daß „Brown" an erster Stelle in dem Firmennamen stehen sollte.

Das offizielle Gründungsdatum von Brown and Bigelow ist der 7. Februar 1896. Ein halbes Jahr später hatte sich die Firma in ihrer ersten „Produktionsstätte" – die nur aus einem Raum bestand – etabliert und ihren ersten Kalender herausgebracht: Der Einfarbendruck auf Pappe zeigte George Washington und die Anzeige einer lokalen Holz- und Kohlenhandlung. Nach drei Jahren florierte das Geschäft. 1899 bezog die Firma ein dreistöckiges Gebäude, und 1902 wurde in Boston die erste regionale Vertriebsstelle eröffnet. Ein Jahr später benötigte das Unternehmen bereits ein zehnstöckiges Gebäude. Ziemlich bald zeichnete sich ab, daß Brown and Bigelow der größte und erfolgreichste Kalenderverlag der Welt werden sollte. Bis 1920 war der Verlag als „The House of Quality" bekannt. Erst seit 1921 lautet ihr berühmtes Firmenmotto „Remembrance Advertising".

Im Laufe der Jahre entstanden weitere Firmen, die mit Erfolg Pin-up- und Glamour-Kalender absetzten: die Shaw-Barton Calendar Company in Ohio, die Joseph C. Hoover and Sons Company in Philadelphia, McCleery-Cummings in Iowa, Kemper-Thomas in Cincinnatti, John Baumgarth in Chicago, Gerlach-Barklow in Illinois, die Louis F. Dow Company in St. Paul, Skinner-Kennedy in St. Louis, die Forbes Company in Boston, C. Moss in Philadelphia und die Thomas D. Murphy Company in Red Oak, Iowa. Aber keine erlangte eine so marktbeherrschende Stellung wie Brown and Bigelow. Als Marktführer hatten Brown and Bigelow ungeahnten Einfluß auf die Entwicklung des amerikanischen Pin-ups. Die meisten der in diesem Buch abgebildeten Illustrationen waren Auftragsarbeiten für Brown and Bigelow oder erschienen erstmals bei ihnen. Die besten Pin-up- und Glamour-Künstler Amerikas standen bei ihnen unter Vertrag und gestalteten jene hinreißenden Bilder, die Milliarden ihrer Kalender zieren

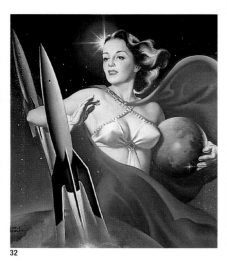

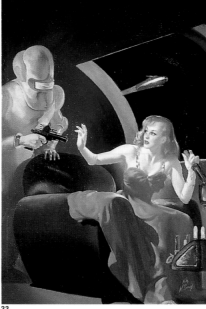

32 33

sollten. Brown and Bigelow verhalfen der Pin-up- und Glamour-Kunst zu höch-
ster Blüte.

Ungefähr zur gleichen Zeit stand ein Künstler aus Boston, Charles Dana Gibson
(1867–1944), am Beginn seiner Karriere. Er schuf das berühmteste Pin-up-Girl
aller Zeiten: das legendäre Gibson Girl. Im Frühling 1885 klapperte Gibson, mit
einer Mappe voller Federzeichnungen bewaffnet, die New Yorker Zeitschriften-
und Buchverlage ab, um in ihren Kunstabteilungen sein Glück zu versuchen. Aber
der Markt zeigte sich dem aufstrebenden jungen Künstler gegenüber abweisend,
und erst im Herbst 1886 war ihm Erfolg beschieden. Ein neues, humoristisch aus-
gerichtetes Magazin namens Life kaufte Gibson eine Zeichnung ab und erteilte
ihm Folgeaufträge für künftige Nummern der Zeitschrift.

1887 erschien das erste Gibson Girl. Es war zweifellos das erste echte ameri-
kanische Pin-up-Girl oder Glamour-Girl. Seine Popularität übertraf bei weitem die
aller damaligen und zukünftigen Rivalinnen, einschließlich des Christy Girl, des
Fisher Girl, des Crandell Girl und später auch des Varga Girl und des Petty Girl.
Schon wenige Jahre nach seinem ersten Erscheinen war das Gibson Girl zum
Liebling der Nation geworden, zum Inbegriff amerikanischer Weiblichkeit. Auch im
Ausland war das Gibson Girl populär: Ein internationaler Fanclub hätte mehrere
Millionen Mitglieder gehabt.

Der bemerkenswerteste Aspekt dieser Popularität war vielleicht die Tatsache,
daß das Gibson Girl nicht nur das Idol amerikanischer Männer war, sondern daß
mindestens ebenso viele Frauen es vergötterten. Selbstbewußt, unabhängig und
willensstark verkörperte das Gibson Girl die „moderne" amerikanische Frau.
Obwohl das Gibson Girl offensichtlich zur Oberschicht gehörte, waren alle – ob
reich, ob arm, jung oder alt – von ihm angetan.

Zu Zeiten seiner größten Popularität beeinflußte das Gibson Girl die Mode, den
Lebensstil, die Umgangsformen und sogar die Moralvorstellungen. Seine Reize
wurden in Liedern gepriesen und in Broadway-Shows gefeiert. Sein Bild war auf
allen möglichen Alltagsgegenständen zu finden: Postkarten, Porzellantellern, Pra-
linenschachteln, Souvenirlöffeln, Fächern, Taschentüchern und natürlich in Zeit-
schriften und Magazinen. Eine von Gibsons Lieblingszeichnungen war ein Gla-
mour-Porträt (Abb.12), das bald als „typischer Gibson" galt. Dieses Bild war so

populär, daß es sogar in Kunstbüchern erschien. Schließlich fand sich das Konter-
fei des Gibson Girl sogar als Tapetenmuster wieder! Um 1900 hatte die Begeiste-
rung für das Gibson Girl derartige Ausmaße angenommen, daß Collier's Gibson
die damals unerhörte Summe von 100000 Dollar bot, für die er innerhalb von vier
Jahren 100 Zeichnungen (wie schon ein Jahrzehnt zuvor in Life) für Centerfolds
liefern sollte. Gibsons Arbeiten erschienen außer in Life und Collier's auch noch in
vielen anderen Magazinen, und er arbeitete häufig für die drei anderen führenden
Zeitschriften jener Zeit, nämlich Scribner's, The Century und Harper's Weekly.

Gibson schuf auch das erste echte männliche Pin-up Amerikas. Genau wie das
Gibson Girl, sprach auch der Gibson Man Frauen wie Männer gleichermaßen an.
Der elegant gekleidete Gentleman mit den markanten Gesichtszügen verkörperte
den idealen Mann. Zusammen mit dem Gibson Girl (Abb. 13) erschien er in Bild-
geschichten mit leicht verständlichen, humorvollen oder satirischen Unterschrif-
ten, die vom amerikanischen Alltag erzählten. In seinen klassischen Federzeich-
nungen, auf denen man den Gibson Man zusammen mit dem Gibson Girl sieht,
erfaßt Gibson auf brillante Weise eines seiner Lieblingssujets – das amouröse
Dreiecksverhältnis.

Als erstes „Great American Pin-up" hat das Gibson Girl eine einzigartige Stel-
lung in der Geschichte der amerikanischen Kunst inne. Sein Einfluß auf spätere
Pin-up- und Glamour-Künstler kann gar nicht hoch genug bewertet werden. Das
Gibson Girl war der Inbegriff der amerikanischen Schönheit, die die Inspiration für
kommende Künstlergenerationen wurde.

Während das Gibson Girl um die Jahrhundertwende Europa im Sturm eroberte,
konnte ein italienischer Künstler einen ähnlich phänomenalen Erfolg in Amerika
verbuchen. Angelo Asti beherrschte einen großen Teil des jungen amerikanischen
Kalenderkunstmarktes, nachdem Brown and Bigelow 1904 erstmalig ein Bild von
ihm gedruckt hatten. Für das Unternehmen war die langhaarige Frau in Jugend-
stilmanier das erste „Pretty Girl"-Bild, das sich als Kalendermotiv mehr als andert-
halb millionenmal verkaufte. Um 1910 brachte die Shaw-Barton Calendar Compa-
ny ein Bild von Asti heraus, das sich in Europa und Amerika großer Beliebtheit
erfreute (Abb. 14). Abbildungen von Astis schönen Frauen fanden sich hauptsäch-
lich auf Postkarten und Porzellantellern. Das Mädchen in Hy Whitroys Gemälde

Biruté *prangte 1915 auf einem Kalender der Joseph C. Hoover and Sons Company (Abb. 15).*

Diesseits und jenseits des Atlantiks florierte die Pin-up-Kunst in der Zeit vor dem Ersten Weltkrieg, während des Krieges und auch nach dem Krieg. Den gesamten europäischen Markt für sinnliche Kunst beherrschte damals der Maler Raphaël Kirchner. Seine „Girls" erschienen regelmäßig in La Vie Parisienne, *Frankreichs gewagtester Zeitschrift. In ganz Europa waren sie ein Begriff, und schließlich kamen sie als Drucke, Postkarten oder Kalenderbild auch nach Amerika. Ein Aquarell- und Gouache-Original (Abb. 16), das als Postkarte und als Kalenderbild reproduziert wurde, zeigt den für Kirchner charakteristischen zarten, weichen Stil. Die Zigarette als Requisit war eigentlich tabu, undenkbar bei der Darstellung einer Frau in einem intimen Augenblick. Die Freiheit, die Kirchner sich in seiner Kunst nahm, spiegelt das Gefühl der Ungezwungenheit wider, das in der Belle Époque allenthalben zu spüren war. Kirchner war gleichsam ein Katalysator, der Künstler in der ganzen Welt zu Spontaneität und Kühnheit animierte.*

Alberto Vargas, eine zentrale Figur in der Geschichte der amerikanischen Pin-up-Kunst, war zu Beginn seiner Karriere deutlich vom europäischen Stil beeinflußt. Der gebürtige Peruaner hatte, bevor er 1916 nach New York kam, in der Schweiz Kunst studiert. Dort war er auch mit Kirchners „Girls" in Berührung gekommen, und er ließ sich bis in die 20er und 30er Jahre in Amerika von ihnen inspirieren.

Vargas hatte die fast unheimliche Fähigkeit, auf seinen Bildern einen Ausdruck träumerischer Sinnlichkeit festzuhalten. Das sieht man zum Beispiel an einem bezaubernden Aquarell (Abb. 17), das zwischen 1922 und 1924 entstand. Während dieser Jahre arbeitete Vargas hauptberuflich für die Ziegfeld Follies Company, in deren Auftrag er die Showgirls malte. Gelegentlich bat er eine der Startänzerinnen der Follies, ihm privat Modell zu stehen. Das Ergebnis war oft sensationell – vielleicht, weil diese Bilder nicht unter Zeitdruck oder zu kommerziellen Zwecken entstanden.

Auf einem außergewöhnlichen Bild, das ebenfalls eine Startänzerin der Ziegfeld Follies darstellt (Abb. 18), trägt das Showgirl ein wunderschönes Gewand im Art-deco-Stil aus herrlichem Stoff, der mit Märchenfiguren bedruckt ist. Auch hier

bestechen Vargas' brillante Aquarelltechnik und die Leichtigkeit, mit der er die zarten, komplizierten Muster wiedergibt.

Vargas experimentierte mit vielen verschiedenen Stilen, bis er den für ihn so charakteristischen Vargas-„Look" fand. Dabei griff er oft auf sein außergewöhnliches Talent als Designer zurück, das häufig unterschätzt wird. Das äußerst stilisierte Art-deco-Bild Robe d' Après-Midi *ist eines der wichtigsten Werke, die Vargas für die Werbung schuf. Für ein Aquarell hat das Original mit seinen 76 x 56 cm ungewöhnliche Ausmaße. Vargas hatte sich von den Titelbildern des Modemagazins* Vogue *zu diesem Bild eines Nachmittagskleides inspirieren lassen.*

1927 malte Vargas für Paramount Pictures (Abb. 19) ein Werbeplakat, das er mit „Albert Vargas" signierte. Das tat er auch bei seinen anderen Bildern aus den 20er Jahren, wenn er glaubte, daß sie ein großer kommerzieller Erfolg werden würden. Reproduktionen des Paramount-Aquarells erschienen als Plakate und ganzseitige Anzeigen für Glorifying the American Girl, *ein Film über die Ziegfeld Follies, die er ja schon seit Jahren mit seinen Bildern in der ganzen Welt bekannt gemacht hatte. Der Titel (etwa: Verherrlichung der amerikanischen Frau) drückt genau das aus, was Vargas mit seiner Kunst erreichen wollte, und was ihm besser gelang als vielen anderen amerikanischen Künstlern des 20. Jahrhunderts.*

Unmittelbar nach dem Ersten Weltkrieg expandierten die amerikanischen Kalenderverlage. Soldaten, die Amerika als Teenager oder junge Männer verlassen hatten, kehrten als erfahrene „Männer von Welt" zurück. Außer ihren Erinnerungen an europäische Frauen brachten sie auch unzählige „pikante" französische Postkarten mit nach Hause. Diese zeigten junge französische oder italienische Frauen nackt oder in aufreizenden Posen. Bei den Soldaten gleichermaßen beliebt waren Bilder von französischen Glamour-Girls. Die amerikanischen Kalenderverlage begannen schon bald damit, Pin-ups zu publizieren, die auf diesen neuen, freizügigen, aus Europa importierten Bildern basierten. Diese amerikanischen Versionen emanzipierter europäischer Frauen wurden „Flappers" genannt und tanzten im Charlestonschritt in die 20er Jahre. So etwas wie sie war noch nie auf einem Kalender abgebildet worden: Das Gibson Girl war in das Jazz-(Zeit-) Alter gekommen.

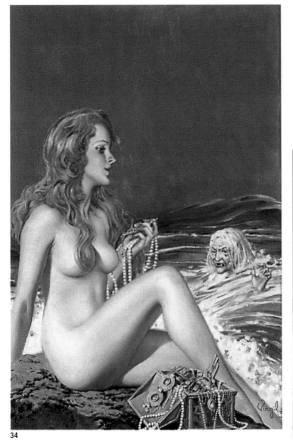

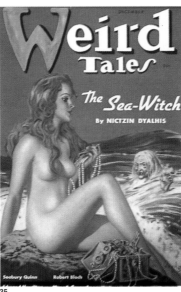

34

35

Für den Zeitschriftenmarkt und die Werbung malten viele der führenden „seriösen" Illustratoren jener Zeit „Pretty Girls" mit einem kräftigen Schuß Glamour. Norman Rockwell war einer der zahlreichen bedeutenden Illustratoren, denen im Laufe ihres Lebens immer wieder Filmsternchen und Filmstars für „Pretty Girl"-, „Glamour"- und „Pin-up"-Bilder Modell standen. Dieser Trend, der sich bis in die Mitte der 70er Jahre fortsetzte, ist in der amerikanischen Illustrationskunst schon am Anfang unseres Jahrhunderts auszumachen.

Einer der am meisten bewunderten unter diesen „seriösen" Künstlern war Joseph Christian Leyendecker (1874–1951), der Amerikas zweiten berühmten Pin-up-Mann kreierte, den „Arrow Collar Man". Leyendeckers gepflegter, gut gekleideter Held trat in die Fußstapfen des beliebten Gibson Man und faszinierte die amerikanischen Frauen dermaßen, daß er jede Woche Hunderte Heiratsanträge per Post erhielt. Leyendeckers brillant komponierte und sorgfältig ausgeführte Bilder erschienen in mehreren überaus erfolgreichen Werbekampagnen, besonders für „Arrow Collar"- Hemden der Cluett Peabody Company sowie für Hart, Schaffner and Marx und die Herrenbekleidungsfirma Kuppenheimer.

Wenn Leyendecker die Gelegenheit erhielt, eine schöne junge Frau zu malen, wartete er jedesmal mit einem vollendet gemalten Bild auf. Ein Beispiel dafür ist das Bild, das er für den Zigarettenhersteller Chesterfield malte und das von der Ligett and Meyers Company reproduziert wurde (Abb. 20). Deutlich erkennt man die für Leyendecker so charakteristische Malweise: Er bedeckt beim Malen nicht die gesamte Leinwand mit Farbe, sondern bezieht die weißen Flächen in die Komposition ein. Die weibliche Figur auf diesem Reklamebild läßt erahnen, wie das „Leyendecker Girl" ausgesehen haben könnte, wenn der Künstler an Werbekampagnen für Damen- statt für Herrenmode mitgearbeitet hätte.

Ein Illustrator von gleichem Format wie Leyendecker war sein Zeitgenosse Howard Chandler Christy (1873–1952). Christy malte mit großem Fleiß, und alles, was er tat, gelang ihm hervorragend. Schon zu Beginn seiner künstlerischen Ausbildung – 1892 an der Art Students League und der National Academy in New York – waren seine Lehrer von seiner Begabung tief beeindruckt. Einer von ihnen, der Künstler William Merritt Chase, erbot sich sogar, ihm Privatunterricht zu geben – zu der Zeit eine ganz besondere Ehre.

Nach einem nur dreijährigen Studium begann Christy seine Laufbahn als hauptberuflicher Illustrator: Von 1895 an arbeitete er, wie Charles Dana Gibson vor ihm, für Life. Und genau wie Gibson, sollte sich auch Christy darauf spezialisieren, der weiblichen Schönheit in eleganten Bildern zu huldigen. Diese schönen Geschöpfe trugen auch seinen Namen: Es waren die „Christy Girls".

Innerhalb von 20 Jahren kannte jeder in Amerika Christys Namen. 1900, fünf Jahre nach Christys erster Illustration für Life, kam ein Kunstbuch über die Christy Girls heraus, das zu einem Bestseller wurde, und im Laufe der nächsten zwölf Jahre erschienen noch sechs weitere Bände. Christys Signatur wurde weithin bekannt und er selbst ein gefeierter Star. Viele Menschen fühlten sich von seinem Charme und seiner Warmherzigkeit angezogen, insbesondere auch Journalisten. Zwischen ihm und den Vertretern der Presse entwickelte sich ein herzliches Verhältnis, und sie scherzten gern miteinander.

1921, auf dem Gipfel seines Erfolgs als Illustrator, faßte Christy den Entschluß, „sich aus dem Geschäftsleben zurückzuziehen" und nur noch Staffeleibilder „seriöser" Art zu malen. Nur wenn ein Projekt ihn reizte, nahm er gelegentlich einen Sonderauftrag an. Das war zum Beispiel in den frühen 20er Jahren der Fall, als Christy sich bereit erklärte, für das berühmte Café des Artistes in New York eine Reihe von Wandgemälden auszuführen.

Von 1915 bis zu seinem Tod im Jahre 1952 lebte und arbeitete Christy im Hotel des Artistes, zu dem auch das Café gehörte. Seine Wohnung und sein Atelier befanden sich neben der Eingangshalle. Sein Atelier gehörte zu den elegantesten der Welt. Als er seine Arbeit dort beendet hatte, waren alle Wände des Cafés prächtig dekoriert: In einer üppig bewaldeten Landschaft tummelten sich Christys lebensgroße Aktfiguren.

1925 beauftragte ein privater Gönner Christy mit einem weiteren Wandgemälde. Was daraufhin entstand, könnte man als fünfte Wand des Cafés bezeichnen. Das Gemälde zeigt drei Aktfiguren im Garten Eden, so wie er einem im Traum erscheinen mag (Abb. 21). Um das Besondere der Szene noch besser herauszustellen, malte Christy den Himmel und die untergehende Sonne mit einer Goldfarbe. Christys Wandgemälde kann man noch heute im Café des Artistes bewundern. Wie alle seine meisterhaften Darstellungen weiblicher Schönheit, sind sie

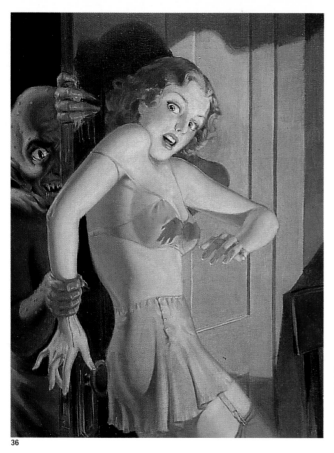

36. HUGH J. WARD
BUG-EYED MONSTER,
OIL ON CANVAS, C. 1930
UNGEHEUER MIT INSEKTENAUGEN
ÖL AUF LEINWAND, UM 1930
MONSTRE AUX YEUX D'INSECTE
HUILE SUR TOILE, VERS 1930

ein bleibendes Zeugnis seiner brillanten Pinselführung und der Sinnlichkeit und erotischen Ausstrahlung seiner weiblichen Akte.

Harrison Fisher (1875–1934) war ein weiterer Art-deco-Künstler, der wie Gibson und Christy so berühmt wurde, daß seine „Geschöpfe" seinen Namen trugen. Fisher wurde in New York geboren, die Familie zog aber später nach San Francisco. Er trat in die Fußstapfen seines Vaters und Großvaters, die beide Maler gewesen waren und studierte Kunst am Mark Hopkins Institute of Art. Er setzte sein Studium in England und Frankreich fort, arbeitete dann in San Francisco für diverse Hearst-Zeitungen und zog 1897 wieder nach New York, wo er eine Anstellung bei der Zeitschrift Puck fand und sich schon bald einen Namen machte, besonders wegen seiner eleganten Federzeichnungen für die Titelseiten von Puck.

Fisher arbeitete fast ausschließlich in Gouache und Pastell. Seiner Vision der idealen amerikanischen Frau verlieh er in den Bildern, die er 1912 bis 1934 für die Titelseite des Magazins Cosmopolitan malte, Ausdruck. Das Magazin beschrieb das „Fisher Girl" mit folgenden Worten: „gesund, gelassen-selbstsicher, mit klarem Blick (…) nie schlampig, gewinnend, charmant, ungekünstelt, liebenswürdig, liebevoll-zärtlich, da, wo es angebracht ist, voller Elan bei anderen Gelegenheiten – und stets weiblich".

Obwohl Fisher Cosmopolitan besonders eng verbunden war, arbeitete er außerdem noch für andere Zeitschriften, wie zum Beispiel The Saturday Evening Post, McClure's, Ladies' Home Journal und Scribner's. Typisch für diese Arbeiten ist eine 1914 als Titelbild für das American Sunday Monthly Magazine gemalte Gouache mit dem Titel Dear Sweetheart (Abb. 22). Auch als Illustrator populärer Liebesromane wurde Fisher bekannt.

Wie andere prominente Illustratoren seiner Zeit, wurde auch Fisher ein reicher Mann. Modelle rissen sich darum, ihm zu sitzen und seine amerikanischen Schönheiten erschienen sogar in Bildbänden. Eine weitere Parallele besteht zwischen ihm, Gibson und Christy: Gegen Ende seines Lebens malte auch Fisher Porträts und andere Staffeleibilder.

Aus diesen Beispielen geht hervor, daß Art-deco-Künstler oft auch Pin-up- und Glamour-Bilder malten oder sie als Ausgangsmotive für andere Illustrationen

benutzten. Die bisher beschriebenen Bilder stammen von den berühmtesten unter den „seriösen" Illustratoren der ersten Jahrzehnte des 20. Jahrhunderts. Obwohl eines dieser Werke ein Bild der „Glamour-Kunst" war, das in einer landesweiten Werbekampagne Verwendung fand (vgl. Abb. 20), handelte es sich doch nicht um ein echtes Pin-up.

Ein „echtes" Pin-up-Bild ist das großartige Aquarell von Coles Phillips, das 1922 als ganzseitige Reklame für Damenunterwäsche erschien (Abb. 23 und 24). Praktisch alle führenden seriösen Magazine, darunter auch The Saturday Evening Post, Cosmopolitan und sogar Good Housekeeping druckten die Anzeige, und viele Leser baten um ein Exemplar des Bildes. Dank der ruhig-gelassenen Pose des Modells und Phillips' raffinierter Komposition strahlte dieses Pin-up Grazie, Eleganz und Sinnlichkeit aus.

Coles Phillips' Karriere, die sich über einen Zeitraum von nur knapp 20 Jahren (1908–1927) erstreckte, war ebenso kurz wie erfolgreich. Wie schon Christy und Gibson, erhielt auch Phillips seinen ersten Auftrag von Life. Aber im Gegensatz zu den beiden anderen durfte Phillips schon nach wenigen Monaten Titelbilder für Life malen, und dabei blieb es bis zu seinem Tod. Seine Bilder, die meistens Pin-ups oder Glamourmotive zeigten, zierten auch die Cover der meisten anderen großen Magazine – Ladies' Home Journal, Collier's, McCall's, Liberty und Woman's Home Companion. Seine Werke wurden später als Bildband unter dem Titel A Gallery of Girls herausgebracht.

Phillips' Hauptaugenmerk galt der Komposition, denn er maß dem Zusammenhang zwischen dargestellter Person und Hintergrund große Bedeutung bei. Berühmt wurde die von ihm praktizierte Methode des „fade-away" (Verschwindens), bei der ein Element des Bildes mit dem Hintergrund gleichsam verschmilzt, während Gesicht und Gestalt durch geschicktes Setzen von Glanzlichtern klar herausgearbeitet werden. Coles Phillips hat in der kurzen Zeit seines Wirkens viel geleistet, und sein früher Tod im Jahre 1927 war ein großer Verlust für die Kunst und die breite Öffentlichkeit. Bei seiner Beerdigung pries ihn sein Freund J. C. Leyendecker als „einen Künstler, der auf seinem Gebiet einmalig war, der ein hochentwickeltes Gespür für Dekor und Farbe hatte (…). In seiner Darstellung der typisch amerikanischen Frau war er seiner Zeit voraus".

Von allen erfolgreichen „Pretty-Girl"-Malern war James Montgomery Flagg (1877–1960) der extravaganteste. Der geborene Rebell gehörte zu den seltenen Menschen, die gleichzeitig populär und in der Fachwelt geachtet waren. Man hat seinen Lebensstil oft mit dem Howard Chandler Christys verglichen: Beiden machte es Spaß, mit dem Jet-set ihrer Zeit durch die Gegend zu ziehen. Flagg verbrachte lange Zeit in Hollywood, wo er mit einem bunten Völkchen verkehrte: mit Schriftstellern, Schauspielern und Bohemiens, darunter auch sein langjähriger Freund John Barrymore.

Flagg lebte, arbeitete und starb in New York. Und ebenso wie bei vielen anderen großen Illustratoren seiner Zeit stand am Anfang seiner Karriere ein Auftrag des Magazins Life, für das er noch viele Jahre tätig war. Seine Bilder erschienen auf den Titelseiten von Zeitschriften, in Kalendern oder als Illustrationen von Anzeigen und Geschichten und sicherten seinen Erfolg. Fast jedes Magazin, das in der ersten Hälfte des 20. Jahrhunderts von Bedeutung war, veröffentlichte Flaggs Arbeiten. Auf einem Glamour-Bild, das um 1930 wahrscheinlich bei Life oder Judge als Cover reproduziert wurde, zeigt er eine Art-deco-Schönheit in sinnlicher, raffinierter Pose, die gerade Lippenstift aufträgt (Abb. 25).

Als Künstler war Flagg überaus vielseitig und sehr geschickt. Er arbeitete unglaublich schnell und beherrschte viele Techniken: Öl, Tusche, opake und transparente Aquarelle, Kohle und Graphit. Außerdem war er ein guter Bildhauer. Während des Zweiten Weltkriegs brachten ihm seine Werbeplakate für die Armee – besonders das Uncle-Sam-Plakat I Want You – noch zusätzlichen Ruhm ein.

Flagg malte besonders gern schöne Frauen, die auch in seinem Privatleben eine wichtige Rolle spielten. Gleich anderen berühmten Illustratoren der 20er und 30er Jahre war er ein Connaisseur. Seine Freunde und er feierten oft Parties in Privatclubs oder anderswo, zum Beispiel anläßlich der alljährlichen Soirée des „Dutch Treat Club". Für das Jahrbuch des Clubs fertigte Flagg um 1930 eine lavierte Zeichnung an (Abb. 26), die ein barbusiges Modell im Bett mit dem Telefonhörer in der Hand zeigte. Das Modell sagt gerade: „Nein, gnädige Frau, sie haben sich verwählt. Hier ist das Naturhistorische Museum". Der Mann im Hintergrund des Bildes ist der Illustrator John LaGatta, ein Freund Flaggs, mit dem er sich gern einen Spaß erlaubte.

Ein weiterer bedeutender „seriöser" Illustrator, der ebenfalls Pin-ups und Glamour-Girls produzierte, war Dean Cornwell (1892–1960). In einer Kohlezeichnung, die er um 1935 für den „Dutch Treat Club" anfertigte, greift er das äußerst beliebte Sujet „Künstler mit Modell" auf (Abb. 27). Dieses Thema kam beim Publikum an, weil es einen Hauch von Glamour und Lasterleben bot. Sein außergewöhnliches Talent trug ihm den Spitznamen „Dean of Illustrators" (König der Illustratoren; ein Wortspiel mit seinem Namen: Dean bedeutet im Englischen ,Dekan').

Der Illustrator William Reusswig (1902–1978) nutzte regelmäßig Pin-up-Elemente in seinen Werbeaufträgen für bekannte Magazine. Wie seine Freunde Flagg und Cornwell lieferte auch Reusswig regelmäßig Illustrationen für die Jahrbücher des „Dutch Treat Club". Eins seiner Bilder zeigt ein nacktes Modell an einer Bar, vielleicht in einer Ecke des Club 21 oder des Lotus Club oder irgendeines anderen New Yorker Nachtclubs, in denen die Künstler Stammgäste waren (Abb. 28). Die kesse Pose und die ungenierte Nacktheit lassen etwas von der Verspieltheit ahnen, die das Verhältnis Künstler-Modell damals hatte.

Bradshaw Crandell (1896–1966) war der letzte der „Pretty Girl"-Künstler der 20er und 30er Jahre, der in Amerika so populär war, daß seine Geschöpfe unter seinem Namen bekannt waren. Zwar arbeitete Crandell auch für den Pin-up-Kalendermarkt, bekannt war er aber durch die Pastellzeichnungen auf den Titelseiten des Cosmopolitan, die er ab Mitte der 30er Jahre zwölf Jahre lang Monat für Monat lieferte (als Nachfolger von Harrison Fisher).

Eine dieser Arbeiten ist das typische Glamour-Kunst-Pastell, das im August 1940 die Titelseite des Cosmopolitan zierte (Abb. 29 und 30).

Crandell malte am liebsten attraktive Frauen – eine Tätigkeit, der seine Mitgliedschaft im „Dutch Treat Club" und anderen Künstlervereinigungen in Manhattan sehr förderlich war. 1952 zierte ein witziges Crandell-Bild das Vorsatzblatt für das Jahrbuch des „Dutch Treat Club" (Abb. 31). An der Wand hinter dem Modell stehen Namen und Telefonnummern von Clubmitgliedern, und bei jedem Namen steht ein launiger Kommentar, der angeblich von dem Modell stammt. Wenn es je ein „seriöses" Pin-up gegeben hat, dann ist es dieses Werk von Crandell!

Von Art deco bis in die Zeit nach dem Zweiten Weltkrieg illustrierten die Pin-ups auch die Groschenhefte, deren „goldenes Zeitalter" von den 20er Jahren bis

Ende der 40er Jahre reichte. Die gängigen Themen der Groschenhefte waren Verbrechen, Science-fiction, Horror und Abenteuer. Die Illustrationen sollten provozieren; sie stellten gewöhnlich attraktive Pin-up-Girls in gefährlichen – und häufig höchst erotischen – Situationen dar. Die Groschenhefte hatten ihren eigenen Künstlerstab, der sich entweder auf farbige Umschlagseiten oder Schwarz-Weiß-Illustrationen der Texte spezialisiert hatte. Die frühen Werke vieler Pin-up und Glamour-Künstler erschienen in den 20er und 30er Jahren auf den Titelseiten von Groschenheften. Zu ihnen gehörten Earle K. Bergey, Enoch Bolles, Peter Driben, George Quintana, Arthur Sarnoff und William Fulton Soare. Ein klassisches Science-fiction-Sujet im Glamour-Stil von Bergey erschien zum Beispiel als Cover der Thrilling Wonder Stories (Abb. 32).

Auch Künstler, die ausschließlich für Groschenhefte („Pulps") arbeiteten, nahmen Pin-up- und Glamour-Motive in ihre Bilder auf, wie es bei dem schon klassischen „Pulp" von Howard McCauley aus dem Jahr 1940 der Fall war. Sogar Weird Tales brachte Pin-up-Bilder, beispielsweise den aufsehenerregenden Akt von Virgil Finlay, dem „Großvater" der Pulp-Kunst (Abb. 35 und 36). Manchen Künstlern machte es Spaß, abwechselnd in beiden Genres – Pin-up und „Pulp" – zu arbeiten und sich zusätzlich noch in anderen Bereichen zu versuchen. Zu dieser Gruppe gehörten der vielseitige Bergey, George Rozen, der die berühmten Titelbilder für das Magazin Shadow gestaltete, sein Bruder Jerome Rozen, John Newton Howitt und Harry T. Fisk.

Hauptsächlich als Coverillustratoren für Groschenhefte arbeiteten Margaret Brundage, die für Weird Tales Pastellzeichnungen von Pin-ups lieferte, sowie Hugh J. Ward und Harry Parkhurst, die beide die Titelbilder des Magazins Spicy gestalteten. (Allerdings arbeitete Ward auch für „seriöse" Magazine wie Liberty und Collier's). Wie sehr die Umschlagseiten der „pikanten" Groschenhefte („spicy pulps") auf Pin-ups eingestellt waren, kann man an dem Titelbild von Ward sehen, das wirkungsvoll Pin-up und Horror miteinander verbindet (Abb. 36). Außerdem befanden sich meist Helden und Bösewichte der Detektivheftchen in Begleitung von Pin-up-Girls, wie zum Beispiel auf den Bildern von Raphael DeSoto und George Gross (Abb. 37 bis 40).

Wie wir gesehen haben, florierte sowohl das Verlags- als auch das Kalendergeschäft zwischen 1918 und 1940. In beiden Branchen verkauften sich Pin-up-

und Glamour-Sujets glänzend. Deshalb griffen auch viele „seriöse" Illustratoren – von Gibson bis Flagg – dieses Thema auf. Darüber hinaus gab es eine Gruppe von Künstlern, die sich auf Pin-ups und Glamour-Girls spezialisiert hatten, nachdem sie Kalender und Männermagazine als lukrative Einnahmequelle entdeckt hatten.

Der produktivste aller Pin-up-Künstler aus der Art-deco-Epoche, der sich auf Zeitschriftentitel spezialisierte, war Enoch Bolles. Seine amüsant überzogenen, verspielten und verführerischen Pin-ups zierten die Titel von Männermagazinen wie Film Fun oder Gay Book, während seine provozierenderen Bilder auf den Umschlagseiten „pikanter" Groschenhefte wie Bedtime Stories, Tattle Tales oder Pep Stories zu sehen waren. An Talent und Erfolg taten es ihm zwei weitere erfolgreiche Pin-up-Künstler gleich. Auch ihre Cover lagen in ganz Amerika an den Zeitungskiosken aus: Earle K. Bergey und George Quintana. Beide arbeiteten hauptsächlich für die „Pulps", aber auch für Männerzeitschriften wie Real Screen, Fun, Movie Humor und Reel Humor.

Unter den Kalenderillustratoren der 20er und 30er Jahre waren Edward M. Eggleston, Henry Clive und Gene Pressler sicherlich die begabtesten. Alle drei waren technisch überaus versiert, auch wenn Eggleston und Clive Öl auf Leinwand bevorzugten und Pressler mit Pastell auf Leinwand arbeitete. Peter Driben, der in den 40er und 50er Jahren einer der ganz Großen der Pin-up-Kunst werden sollte, begann in den 20er Jahren zu malen. Damals lebte er in Paris, belieferte aber bereits den amerikanischen Pin-up- und Groschenheftmarkt mit gewagten Zeichnungen und Gemälden. Es ist interessant, daß Driben nicht der einzige bedeutende Pin-up-Künstler war, dessen Karriere sich über die Jahrzehnte vor und nach dem Ersten Weltkrieg erstreckte. Zu den Künstlern, die in beiden Epochen bedeutende Werke schufen, gehören Rolf Armstrong, Bradshaw Crandell, Billy DeVorss, Gil Elvgren, Jules Erbit, Earl Moran, Zoë Mozert, George Petty und Alberto Vargas.

Drei weitere Pin-up-Künstler, deren Karriere sich ebenfalls bis ins Art deco zurückverfolgen läßt, sind Charles Sheldon, Billy DeVorss und Jules Erbit. In den 20er und 30er Jahren waren Sheldons Modezeichnungen Vorlagen für eine Reihe berühmter Werbeanzeigen für Damenschuhe, -strümpfe und -unterwäsche, die

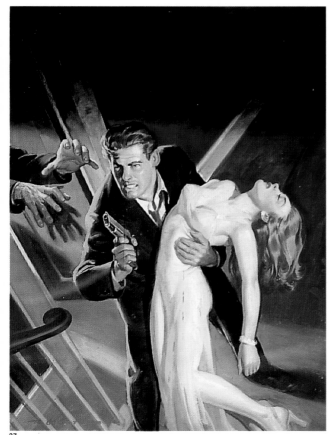

37

37–38. RAPHAEL DESOTO
ORIGINAL (OIL ON BOARD) AND REPRODUCTION AS FRONT
COVER OF "NEW DETECTIVE MAGAZINE", JANUARY 1948
ORIGINAL (ÖL AUF KARTON) UND REPRODUKTION AUF DER
TITELSEITE DES „NEW DETECTIVE MAGAZINE", JANUAR 1948
ORIGINAL (HUILE SUR CARTON) ET REPRODUCTION EN
COUVERTURE DE «NEW DETECTIVE MAGAZINE», JANVIER 1948

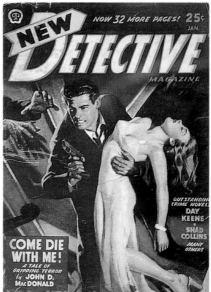

38

im Ladies' Home Journal und Woman's Home Companion erschienen. 1937 schuf er das legendäre „Breck Girl", das für Breck Shampoo warb. Die „Breck-Girl"-Werbekampagne sollte zu einer der erfolgreichsten in der Geschichte der amerikanischen Werbung werden. Viele halten Sheldons „Breck Girl" für das perfekte Beispiel des Typs „Glamour" innerhalb der Pin-up-Kunst.

DeVorss und Erbit arbeiteten hauptsächlich in Pastell und waren beide sehr produktiv. Ihre Bilder waren alle großformatig, ca. 100 x 76 cm. DeVorss' Glamour-Frauen schienen gerade von den Dreharbeiten eines opulenten Hollywood-films der 30er Jahre zu kommen. Erbits Frauen dagegen wirkten weniger mondän, sondern sahen meistens aus wie das perfekte Mädchen, das jeder junge Mann in den 30er Jahren gern seinen Eltern vorgestellt hätte.

Das Art deco brachte auch viele Künstlerinnen hervor, deren Pin-up- und Glamour-Girls mehr als zwei Jahrzehnte lang zur amerikanischen Szene gehörten: Mabel Rollins Harris, Laurette und Irene Patten sowie Pearl Frush. Harris hatte ein Faible für die Pastellmalerei, die sie perfekt beherrschte. Es gelang ihr, eine große Bandbreite von Stimmungen in ihren Bildern auszudrücken. Die Geschwister Patten waren gleichermaßen versierte Pastellmalerinnen und einander stilistisch so ähnlich, daß ihre Werke austauschbar schienen. Frushs Œuvre ist noch gar nicht richtig entdeckt worden. Ihre Arbeiten, Gouache auf Karton, wirken wie dicht und exakt ausgeführte Ölgemälde. Sie war technisch so brillant, daß ihre Arbeiten bei genauer Betrachtung von geradezu fotografischer Klarheit zu sein scheinen. Sammler, die ihre Gemälde genau kennen, halten Frush für ebenso bedeutend wie Alberto Vargas.

Ende der 30er und Anfang der 40er Jahre, als Amerika mit den Folgen der Depression zu kämpfen hatte, waren viele Amerikaner angesichts der politischen Entwicklung in Europa besorgt. Der Gedanke, daß ihr Land vielleicht bald in einen Krieg hineingezogen werden könnte, versetzte Männer und Frauen in Angst und Sorge, der sie sich nicht entziehen konnten. Und wie immer, versuchten sich die Menschen durch Unterhaltung von ihren Sorgen abzulenken: Sie hörten Radio, gingen ins Kino, lasen Zeitschriften, Romane und andere Bücher. Vom wachsen-den Bedürfnis nach Unterhaltung profitierten auch die Magazine und Kalender, die Pin-ups abbildeten.

Schon 1933, als die erste Nummer der Zeitschrift an den Kiosken auslag, hatte Esquire den Stellenwert der Pin-up-Kunst merklich erhöht. Im Herbst 1940 hatte sich Esquire zu einem der wichtigsten Magazine Amerikas entwickelt, für das bekannte Schriftsteller, Künstler und Fotografen und ein hervorragender Mitarbei-terstab unter der straffen Führung des Verlegers David Smart arbeiteten. Das hohe Qualitätsniveau von Esquire holte die Pin-ups aus den Umkleideräumen, Autowerkstätten, Studentenwohnheimen, Kasernen und Clubhäusern, wo sich Generationen amerikanischer Männer heimlich an ihnen ergötzt hatten.

Es war weniger der Verkauf an Kiosken als vielmehr die ungeheuer große Zahl von Abonnenten des Esquire, die das Pin-up salonfähig werden ließ. Monat für Monat flatterte das Magazin in die amerikanischen Wohnzimmer, wo sich die gan-ze Familie an den brillant geschriebenen Artikeln und Kurzgeschichten sowie an dem glänzenden Angebot an Fotos, Kunst und Humor erfreute. Wenn Esquire nicht darauf geachtet hätte, seinen Lesern in jeder Hinsicht das Beste zu bieten, hätten die Amerikaner die „Qualitäts-Pin-ups" vielleicht nicht so bereitwillig akzeptiert, wie sie das unmittelbar vor dem Krieg taten.

1940 brachte Esquire in seiner Oktobernummer Pin-up-Centerfolds von zwei Künstlern, deren Illustrationen nicht nur den Absatz des Magazins steigerten, son-dern auch den Stellenwert der Pin-up-Kunst in der amerikanischen Gesellschaft neu definierten. Der eine war George Petty, der berühmt geworden war als der „Vater" des Petty Girl, dem ersten modernen Pin-up-Bild. Kontinuierlich hatte Esquire Pettys Karriere gefördert und während der gesamten 30er Jahre jeden Monat mindestens eines seiner Bilder reproduziert. Der andere war Alberto Var-gas, der sich in den 20er Jahren auf Porträts und Werbebilder für die Ziegfeld Fol-lies und in den 30er Jahren auf Werbung für Hollywood spezialisiert hatte.

Das Erscheinen seines ersten Pin-up-Bildes in Esquire machte Vargas einer breiten Öffentlichkeit bekannt. Es vergingen nur zwei Monate, und Esquire brachte seine wie Traumgestalten wirkenden „Varga Girls" (das Magazin hatte das „s" am Ende seines Namens gestrichen) als Vargas-Kalender heraus und legte den Grundstein für Vargas Weltruhm. Dem Kalender von 1941 folgten noch sieben weitere, und alle gingen in die Verlagsgeschichte als Bestseller ein: Weltweit ver-kaufte sich kein Kalender, gleich welcher Art, besser. Das „Varga Girl" gehörte

nun zur amerikanischen Gesellschaft. Kaum ein Jahr war seit dem ersten Erscheinen des „Varga Girl" vergangen, als Amerika sich für den Kriegseintritt rüstete.

Als amerikanische Soldaten an Bord der Transportschiffe gingen, um in den Krieg zu ziehen, nahmen sie nicht nur die Fotos ihrer Lieben von daheim mit, sondern auch ihre Lieblings-Pin-ups. Außer den Pin-up-Bildern hatten die Soldaten Kartenspiele, Kalender und Notizblöcke mit Pin-up- und Glamour-Motiven im Gepäck. Die Bilder hoben die Stimmung. Während vieler Wochen im Krieg boten sie den Soldaten etwas, wovon sie träumen konnten. Sowohl General Eisenhower als auch General MacArthur wiesen in öffentlichen Ansprachen auf dieses Phänomen hin und betonten, welchen Nutzen solche Bilder für die Truppe hatten.

Vargas ist der bekannteste unter den Pin-up-Künstlern des Zweiten Weltkriegs; aber es gab noch viele andere, die sich in dieser Zeit auf das Genre spezialisiert hatten. So paradox es klingen mag, aber die Jahre 1942 bis 1945 waren die zweite Blütezeit der Pin-up- und Glamour-Kunst. Der wichtigste Künstler dieser Zeit war zweifellos Gil Elvgren. Seine Bilder wurden seit Ende der 30er Jahre von der Louis P. Dow Calendar Company in St. Paul verlegt. Als die Nachfrage nach seinen Bildern während der Kriegsjahre zunahm, gab Dow Hefte mit Elvgrens Bildern im Format 20 x 25,5 cm heraus. Das Format war gut für den Versand nach Übersee geeignet und ließ sich fast überall befestigen („pin up"!). Nach dem Krieg war Elvgren populärer als je zuvor. Seine Arbeiten für Brown und Bigelow vom Ende der 40er bis in die frühen 70er Jahre wurden unglaublich oft reproduziert. Man schätzt, daß weltweit über eine Milliarde der „Elvgren Girls" im Umlauf waren.

Elvgrens Pin-ups hatten dieses außerordentliche, schwer zu beschreibende „gewisse Etwas", auf das sich seine ungeheure Popularität gründete, und um das ihn sogar die „seriösen" Künstler unter seinen Zeitgenossen beneideten. Seine ungewöhnliche Begabung kam besonders in seinen „Situationsbildern" zur Geltung. Seine Erfindungsgabe schien unerschöpflich, wenn es darum ging, witzige Szenarien darzustellen. Ob seine „Girls" nun Opfer eines plötzlichen Windstoßes wurden oder ob ihnen vertrackte Äste „auflauerten": Ihre Eskapaden endeten immer mit interessanten Blößen. Ein weiteres wichtiges Moment in Elvgrens Kunst war seine virtuose Maltechnik. Seine weiche Pinselführung und die satten Farben, die an John Singer Sargent erinnerten, wurden von vielen anderen Künstlern imitiert, zum einen, weil sie seinen Stil bewunderten, zum anderen, weil die Leiter der Kunstabteilungen auf der Suche nach gut verkäuflichen Bildern genau das verlangten.

Ein weiterer bedeutender Pin-up- und Glamour-Künstler der 40er Jahre war Earl Moran. Er etablierte sich Mitte der 30er Jahre und konnte es bald an Berühmtheit mit Elvgren aufnehmen, obwohl sein Stil grundverschieden war. Moran malte seine Pin-ups in Pastell; und obwohl oft weniger strahlend als Elvgrens, erfreuten sie sich während des Krieges doch ungeheurer Beliebtheit. Ein Artikel über populäre Kalenderkunst in der Neujahrsausgabe des Magazins Life von 1940 zeigte hauptsächlich seine Bilder. Auf dem Begleitfoto sah man ihn mit seiner Tochter, die ihm oft Modell stand, bei der Arbeit im Atelier.

Rolf Armstrong war bei Kriegsbeginn bereits ein bekannter Pin-up-Künstler. Während der 20er und 30er Jahre sah man seine Pastellzeichnungen von Glamour-Frauen auf Magazintiteln, die nur den Kopf der Modelle zeigten, Notenblättern, in der Werbung und natürlich auf Kalendern. Seine frühen Bilder gehörten meistens in die Rubrik „Glamour-Kunst". In den Kriegsjahren malte Armstrong dann die traditionellen Ganzfiguren-Pin-ups. Die von Armstrong in den 40er und 50er Jahren gemalten Pin-ups erschienen ebenfalls bei Brown and Bigelow. Während des Zweiten Weltkriegs blieb Brown and Bigelow Amerikas bedeutendster Kalenderverlag und ist es auch heute noch.

In den 40er und 50er Jahren gesellten sich zwei Frauen zu den Superstars der Pin-up-Kunst: Zoë Mozert und Pearl Frush. Mozert stand sich selbst oft Modell für ihre in Pastell gemalten Pin-ups, indem sie vor dem Spiegel posierte. Auch ihre Pin-up- und Glamour-Bilder wurden von Brown and Bigelow herausgebracht. Sie waren äußerst begehrt, da sie gut waren, aber auch, weil sie von einer Frau stammten. Zusammen mit Mozert stand Pearl Frush im Rampenlicht. Ihre vorzüglichen Gouachen wurden von der Gerlach-Barklow Company herausgebracht. Beide Frauen arbeiteten regelmäßig für Kalenderverlage und Glamour-Magazine. Ihre Pin-ups lernten zahllose junge Amerikaner kennen und lieben.

1942 erschien das berühmte Werbefoto für den Film Pin-up-Girl von Betty Grable mit ihren „Millionen-Dollar-Beinen". Die Filmgesellschaft erhielt daraufhin wöchentlich über 20000 Briefe von amerikanischen Männern, Soldaten wie Zivi-

listen, die alle ein Foto haben wollten. Als der Film zwei Jahre später anlief, waren alle Vorstellungen restlos ausverkauft. Die Amerikaner waren offenbar genauso begeistert von lebendigen Pin-up-Girls wie von den Geschöpfen der besten Pin-up-Künstler!

Es gab noch andere Pin-up-„Ikonen", die zur Hebung der Moral der Truppe beitrugen: Lana Turner, die seit 1938 als „The Sweater Girl" bekannt war, und „The Oomph Girl" (Die Frau mit Sex-Appeal), Ann Sheridan. 1942 sollte das beliebteste amerikanische Pin-up-Girl in einem Wettbewerb ermittelt werden. Betty Grable landete erwartungsgemäß auf Platz eins – schließlich war sie schon vorher von dem Magazin Movie Stars Parade zur „Königin der Pin-up-Girls" gekürt worden. Rita Hayworth, die einen großen Wirbel verursacht hatte, als sie sich für die Titelseite von Life im schwarzen Unterrock fotografieren ließ, landete auf Platz zwei. Dritte wurde Ann Sheridan.

Während des Krieges flogen Tausende von amerikanischen und alliierten Flugzeugen mit Pin-ups als „Nasenschmuck" herum. Auf jedem US-Luftwaffenstützpunkt wurde der jeweils beste Maler der Truppe mit der ehrenvollen Aufgabe betraut, auf die Nase eines Flugzeugs provozierende Pin-up-Bilder zu malen, die als Glücksbringer bei gefährlichen Einsätzen galten. Aus demselben Grund schmückten viele Flieger auch ihre Lederjacken mit Pin-ups.

In den Kriegsjahren steigerten alle größeren Kalenderverlage ihren Absatz von Pin-up-Kalendern, und diese wurden immer patriotischer. Während die Andrew Sisters im Radio sangen, und die Pin-up-Stars vor Soldaten in der USO Hollywood Canteen auftraten, leisteten Künstler wie Elvgren, Moran, Armstrong und Mozert ebenfalls „Kriegsdienst". Die Verleger druckten Pin-up- und Glamour-Kunst in allen Variationen, um die Stimmung bei der Truppe und den Bürgern, die sie in der Heimat unterstützten, zu heben. Esquire brachte während des Krieges Varga-Girls auf der Titelseite, und durch das Magazin Yank (Abb. 41) gelangten Pin-up-Bilder an die Front. Etablierte populäre Magazine wie Life und Look schmückten ihre Titelseiten stolz mit Pin-ups (Abb. 42). Originale von Pin-up- und Glamour-Kunst wurden als Preise bei Tombolas für Kriegsanleihen gespendet. So stiftete die Curtis Publishing Company, der The Saturday Evening Post, Ladies' Home Journal und Country Gentleman gehörten, regelmäßig Kunstwerke, die vorher für Titelbilder verwendet worden waren. Von Betty Grable über Esquire bis Brown and Bigelow: Patriotische amerikanische Pin-up-Girls überschwemmten das ganze Land. Auch sie haben ihren Teil dazu beigetragen, daß der Krieg gewonnen wurde.

1950 standen Amerika und die Pin-up-Kunst an der Schwelle eines aufregenden Jahrzehnts. Rita Hayworth, ohnehin schon ein Kassenmagnet in den Kinos, wurde die neue Königin der Pin-ups. Als der Koreakrieg ausbrach, wurde sie „erneut einberufen". Pro Woche schrieben mehr als 2500 Soldaten an die Regierung und baten um ihr Foto. 1950 brachte Columbia Pictures den Film The Petty Girl mit Joan Caulfield in der Titelrolle heraus, der ein durchschlagender Erfolg wurde. Pin-up-Girls aller Schattierungen waren nicht nur salonfähig – sie gehörten einfach zum nationalen Kulturgut.

Obwohl die in den 40er und 50er Jahren entstandenen Pin-up- und Glamour-Girls ausgesprochen amerikanisch waren, fanden sie auch außerhalb Amerikas großen Anklang. Sie zeigten Sex-Appeal, nicht Sex. Der leicht kokette Gesichtsausdruck und die gewagt-provozierenden Situationen waren eine Quelle unschuldiger Heiterkeit: Die Menschen hatten einfach Spaß an dem Humor, der auch in diesen Werken steckte.

Vom Ende der 30er bis weit in die 50er Jahre hinein war das „Punch-Board" (ein Glücksspiel; Abb. 43) ein beliebtes Medium, mit dem man Pin-ups richtig zur Geltung bringen konnte. Die „Punch Boards" waren überall zu haben: in jedem Kramladen an der Ecke, bei jedem Herrenfriseur, in jeder Bar, jedem Clubhaus und an jeder Tankstelle. Auf manchen „Punch Boards" waren Pin-ups in Prägedruck angebracht. Bis 1951 hatten sich die „Punch Boards" zu einem Milliarden-Dollar-Geschäft entwickelt, und die häufigsten Illustrationsmotive waren Pin-up- und Glamour-Bilder.

Während des Krieges und in der Nachkriegszeit benutzten viele amerikanische Unternehmen Pin-up- und Glamour-Bilder in ihrer Werbung. Damit wollten sie nicht nur ihren Umsatz steigern, sondern auch zur Hebung der Stimmung in der Bevölkerung beitragen. Das größte unter diesen Unternehmen war Coca-Cola; eigentlich war es diesem Konzern zu verdanken, daß sich um den Künstler Haddon Sundblom eine Gruppe von Pin-up-Illustratoren zwanglos zusammengeschlossen hatte. Sundblom, der sich in den 20er Jahren in Chicago ein Atelier eingerichtet hatte, wurde im Laufe der Jahre zum Mentor vieler bedeutender Pin-up- und Glamour-

Illustratoren. Er selbst schuf den ungeheuer beliebten, klassischen Werbeträger: Santa Claus.

Zum „Sundblom Circle", wie die Gruppe um den Künstler genannt wurde, gehörten viele Größen der zeitgenössischen Pin-up-Kunst: Joyce Ballantyne, Al Buell, Bill Medcalf, Robert Skemp, Al Moore, Thornton Utz, Jack Whittrup, Al Kortner, Euclid Shook, Harry Ekman, Walt Otto, Vaughn Bass und der überragende Gil Elvgren. Die Arbeiten des Sundblom Circle zeichneten sich durch eine gekonnte Maltechnik aus. Ihr Farbauftrag war dick und pastos, so daß er ihnen den Beinamen „the mayonnaise school" eintrug. Sie waren einander im Stil derartig ähnlich, daß sie selbst kaum feststellen konnten, wer was gemalt hatte. Norman Rockwell sprach oft davon, daß er gerne hinter die Geheimnisse des Sundblom Circle kommen würde, wie beispielsweise das charakteristische „Sonnenleuchten". Die Gruppe war bekannt für den freizügigen Geist. Alle Künstler inspirierten einander, ohne sich bewußt darum zu bemühen – eine Folge der wohlwollenden, freundlichen Atmosphäre, die Sundblom um sich verbreitete.

Der Sundblom-Stil in der Werbekunst kommt sehr gut in Gil Elvgrens Reklamebild für Coca-Cola aus dem Jahre 1950 (Abb. 45) zum Ausdruck. William Dolwick, ein weiteres Mitglied des Sundblom Circle, bewies Einfallsreichtum bei dem für Coca-Cola gemalten Bild, auf dem zwei Cola trinkende Matrosen hinter einem Mädchen herpfeifen, das sich knapp außerhalb des Bildes befindet (Abb. 44). Die Anwesenheit des geheimnisvollen Mädchens wird augenzwinkernd durch den Zipfel des rosa Schals angedeutet, den man in der rechten unteren Ecke des Bildes sieht.

Ed Runci, Joyce Ballantyne und Al Buell hatten zwei Dinge gemeinsam: das Format ihrer Bilder und den künstlerischen Einfluß, der sie geprägt hatte. Alle drei arbeiteten in Öl auf Leinwand im Format 76 x 61 cm, und alle waren am Anfang ihrer Karriere Mitglieder des Sundblom Circle gewesen. Wie Elvgren, so schildert auch Runci in seinen Bildern oft Situationen, in denen sich seine Pin-up-Girls gerade befinden. Aber sein dünner Farbauftrag unterscheidet ihn sehr von den anderen Mitgliedern der Gruppe. Ballantyne wird am häufigsten mit Elvgren verglichen, was Stil, Farbe und „Situationsposen" betrifft; und tatsächlich arbeiteten die beiden in Chicago sehr eng zusammen. In Anlehnung an eine Skizze von Art Frahm schufen sie die bekannte Coppertone Reklametafel, auf der ein kleines Mädchen zu sehen ist, dessen Hund nach ihrem Badeanzug schnappt. Buells Farbauftrag ist dichter als der von Runci und Ballantyne, aber sonst gibt es viele Gemeinsamkeiten in ihren Arbeiten.

Zwei weitere Sundblom-Schüler, Harry Ekman und Vaughn Bass, wurden stark von der Zusammenarbeit mit Elvgren beeinflußt, gingen aber später mit Erfolg eigene Wege. Bass begann seine Karriere als Maler mit einer Auftragsarbeit, die darin bestand, daß er einige Werke von Elvgren übermalte. Ende der 30er Jahre beauftragte ihn die Louis F. Dow Company mit der „Überarbeitung" von vielen Pin-up-Bildern, die Elvgren früher für die Firma gemalt hatte, damit sie noch einmal verwertet werden könnten. Mit demselben pastosen Farbauftrag wie Elvgren bemühte sich Bass, Hintergrund und Kleidung der Figuren zu verändern, aber die Gesichter und Körper so zu belassen, wie Elvgren sie ursprünglich gemalt hatte. (Zum Glück wurden nicht alle Elvgren-Originale übermalt, so daß einige heute noch erhalten sind.)

1946, nach Kriegsende, hörte auch Alberto Vargas' „Regierungszeit" bei Esquire auf. Der Esquire-Kalender für 1947 enthielt zwar noch zwölf Bilder von Vargas, aber weder seinen Namen noch seine Signatur. Esquire fand schon bald einen Nachfolger für Vargas: Al Moore, einer der begabtesten Künstler um Sundblom. Moores Pin-up-College-Girls – so ganz anders als die Varga-Girls – erschienen fast zehn Jahre lang als doppelseitige Gatefolds in Esquire. Moores Pin-up-Girls fanden sich auch in den Esquire-Kalendern, die weiterhin Jahr für Jahr herauskamen (allerdings verkauften sie sich nicht so gut wie Vargas' Kalender). Moores Zusammenarbeit mit Esquire endete 1958, als Fotos die gemalten Illustrationen verdrängten.

Während der 50er Jahre war Esquire Marktführer im Bereich der Pin-up- und Glamour-Kunst. Außer Moore war bei dem Magazin noch eine weitere Gruppe begabter Künstler beschäftigt, darunter Fritz Willis, Joe DeMers, Ernest Chiriaka, Thornton Utz, Frederick Varady, Eddie Chan, Euclid Shook und Ben-Hur Baz. Interessanterweise arbeiteten alle diese Künstler außerdem noch für die „seriösen" überregionalen Magazine, von denen das bekannteste The Saturday Evening Post war. Allerdings gelang es nur diesen Künstlern, gleichzeitig beide lukrativen „Berufe" auszuüben; die meisten anderen, wie Elvgren, Moran und Mozert, beschränkten sich auf ein Genre.

Nach dem Krieg versuchte das Magazin True, in die Fußstapfen von Esquire zu treten. Es hatte sich mit Themen wie Abenteuer, Sport, Reisen und Natur an eine männliche Leserschaft gewandt; nun brachte es zusätzlich jeden Monat „Petty-Girl"-Centerfolds heraus. Dann kamen Arbeiten von Vargas hinzu; unter anderem Fotos, die Vargas bei der Arbeit im Atelier zeigten. 1947 und 1948 brachte Fawcett, die Dachgesellschaft von True, zwei „Petty-Girl"-Kalender heraus, die exakt dem Vargas-Kalender von Esquire entsprachen.

Auch in den 50er Jahren nahmen Brown and Bigelow in bezug auf Pin-up-Kunst eine Spitzenstellung ein. Wie andere aus der Branche, so war auch die Firma Brown and Bigelow von den Talenten des Sundblom Circle beeindruckt. Viele dieser Künstler – einschließlich Elvgren, Ballantyne und Buell – wurden die Stars unter den Vertragskünstlern der Firma.

Zur gleichen Zeit brachten Brown and Bigelow auch eine neue Kalenderreihe heraus, die sich als Bestseller erweisen sollte. Sie hieß „Artist's Sketch Pad" („Skizzenblock des Künstlers"), und Earl Mac Pherson hatte sie 1942 entwickelt. Obwohl später verschiedene Künstler für die Serie verantwortlich waren – K.O. Munson, Ted Withers, Joyce Ballantyne, Freeman Elliot und Fritz Willis – blieb die einheitliche Erscheinungsbild dank der zum Teil gleichen Grundidee des Designs erhalten. Das Hauptsujet in der Mitte des Kalenderblatts – gewöhnlich ein Pin-up-Girl – war immer von zwei oder drei kleinen Skizzen umgeben, die Vorstufen des größeren Bildes darstellten. Später entwickelte Mac Pherson für die Shaw-Barton Company eine neue, überaus erfolgreiche Version des Designs, die später von seinem Assistenten, T.N. Thompson, übernommen wurde.

Es besteht kein Zweifel daran, daß die Welt der Pin-ups in den 50er Jahren ebenso von dem Werk Gil Elvgrens beherrscht wurde wie in den 40er Jahren. Elvgren war der überragende Künstler in der Kalender- und Werbebranche, und seine „Girls" blieben bis Ende der 60er Jahre die beliebtesten Pin-ups. Der Künstler, der es zu dieser Zeit am ehesten an Popularität mit ihm aufnehmen konnte, war Art Frahm. Obwohl Frahm schon über ein Jahrzehnt vorher künstlerisch aktiv gewesen war, waren die 50er Jahre seine Glanzzeit. Damals hatte er die Idee zu einer Serie von Pin-ups, die alle ein Thema hatten: eine junge Frau in einer normalerweise harmlosen Alltagssituation, die in ihrem Fall aber dazu führt, daß ihr das Höschen bis auf die Füße herunterrutscht. Frahms „Girls" mit verrutschender Wäsche sorgten für den Absatz von Millionen von Kalendern und Werbeträgern. Die Kalenderfirma Joseph C. Huber and Sons behielt Frahms Bilder viele Jahre lang im Programm, und von allen auf ein Thema spezialisierten Pin-up-Serien erwies diese sich als die langlebigste und erfolgreichste des Jahrhunderts.

Billy DeVorss, der schon seit den späten 30er Jahren sehr bekannt war, schuf in den 50er Jahren viele wunderschöne Pin-up- und Glamour-Bilder. Er arbeitete primär in Pastell, gelegentlich in Öl, und seine „Kalender-Girls" wurden so oft reproduziert und in der ganzen Welt vertrieben, daß man ihre Gesamtzahl einmal auf 50 Millionen geschätzt hat. Der Pin-up-Künstler Edward D'Ancona war vor allem wegen seiner Kalenderbilder bekannt, die aber auch auf Briefbeschwerern, Schlüsselringen oder Herrenbrieftaschen reproduziert wurden. Bill Medcalf war ein weiterer Pin-up-Künstler, der in den 60er Jahren den Zenit seiner Karriere erreichte. Seine Arbeiten für Brown and Bigelow wirkten wunderbar „cremig", aber die Oberfläche seiner Bilder war glatt strukturiert. Da Medcalf durch Brown and Bigelow viele Sonderaufträge von der Autoindustrie erhielt, sieht man auf seinen Pin-up-Bildern oft Autos und Autoaccessoires.

Ein anderer Künstler, der den Stil des Sundblom Circle beherrschte, war Walt Otto. Seine erfolgreiche Karriere in der Werbebranche hatte er einem Sujet zu verdanken, das zu seinem Markenzeichen wurde: das knackig-gesunde Bauernmädchen. Ob beim Angeln im Bach oder bei der Heuernte – das „Otto Girl" genoß das Landleben. Es lächelte, trug Shorts und einen Strohhut, und ihr Hund war immer an ihrer Seite.

Der wahrscheinlich vielseitigste Pin-up-Künstler dieser Zeit war Arthur Sarnoff, der hauptberuflich als „seriöser" Illustrator tätig war. Von 1935 bis 1975 erschienen seine Arbeiten regelmäßig in den bekannten amerikanischen Magazinen, besonders in The Saturday Evening Post. Sarnoff arbeitete auch für die Pin-up-Branche und produzierte soviel Pin-up- und Glamour-Kunst, daß es ihm als Einzigem gelang, sich einen Namen sowohl in der Welt der Pin-ups als auch in der Welt der Werbung und Magazine zu machen. Er war so gefragt, daß viele Kalenderverlage zwei Jahre im voraus ihre Aufträge bei ihm anmeldeten.

Ein Geschäftszweig, der während des Krieges besonders schnell expandiert war, war die Taschenbuchbranche. Die Streitkräfte hatten ihre Soldaten mit diesen kleinfor-

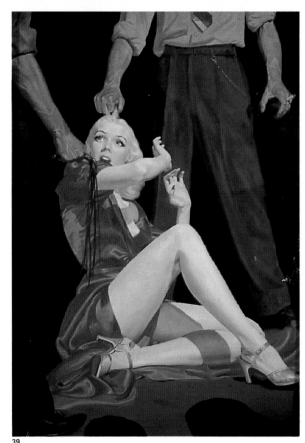

39

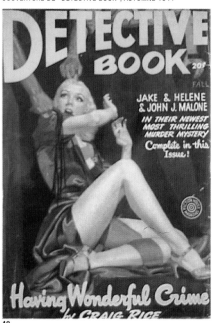

40

matigen Büchern versorgt, und bei Kriegsende hatten sie – wie viele andere Amerikaner – die Taschenbücher zu schätzen gelernt. Die Verleger wußten, daß die Qualität des Umschlagbildes oft darüber entschied, ob sich ein Titel verkaufte. Deshalb verpflichteten sie die besten Illustratoren der Zeit in der Hoffnung, daß deren Bilder zur Absatzsteigerung beitragen würden. In der Frühzeit der Taschenbücher waren Digests (etwas größer als normale Taschenbücher) äußerst beliebt (Abb. 46 und 47).

Der Roman Teacher's Pet erschien 1958 mit einem Umschlagbild des Pin-up-Künstlers Paul Radar auf dem Umschlag (Abb. 48 und 49). Manchmal war der Umschlagtext sogar Teil des Pin-up-Bildes, wie bei Just Like a Dame (Abb. 51).

Auf der Höhe ihrer Popularität konnte man Pin-ups sogar auf den Titelseiten altehrwürdiger, seriöser Magazine wie The Saturday Evening Post finden. Künstler wie Norman Rockwell und seine Zeitgenossen bestätigten die Popularität solcher Bilder, indem sie Pin-up-Elemente in ihre Arbeiten, die doch im Grunde ganz anderer Natur waren, aufnahmen. In den 50er und 60er Jahren liebäugelten sogar die sentimentalsten und traditionellsten Kalender mit der Pin-up-Kunst. So erinnern viele Bilder in einem von Edward D'Ancona illustrierten Kalender zum Thema Sicherheit an Rockwells verklärte Sicht des amerikanischen Alltags. D'Ancona konnte offenbar der Versuchung nicht widerstehen, in diese bodenständige Bilderwelt ein kleines Miss Me-Pin-up einzuschleusen (Abb. 51).

Mitte der 60er Jahre verschwanden die von Künstlern gestalteten Pin-up-Kalender allmählich vom Markt. Obwohl die meisten der führenden amerikanischen Kalenderverlage schon seit Ende der 40er Jahre bei anderen Themen Fotos benutzten, ließen sie für ihre Pin-up-Kalender Illustrationen anfertigen. Auf dem Weg zur endgültigen Umstellung auf Fototitel wurde im Januar 1964 in England ein wichtiger Schritt getan, als der Autoreifenhersteller Pirelli seinen ersten Pin-up-Kalender mit Fotos herausbrachte. Die Gestaltung oblag Robert Freeman (der als Fotograf mit den Beatles zusammengearbeitet hatte), dem Atelierleiter Derek Forsyth und dem Designer Derek Birdsall. Das Ergebnis dieser Zusammenarbeit war der Anlaß, daß das klassische Pin-up als Kalendermotiv dem Foto weichen mußte.

Ein Pin-up-Künstler blieb bis in die 70er Jahre hinein populär: Fritz Willis. Die Öffentlichkeit wurde in den 40er Jahren erstmals auf ihn aufmerksam, als er für Esquire arbeitete. Als das Magazin nach dem Krieg auf Vargas verzichten mußte,

war Willis einer der Künstler, welche die Lücke füllen sollten. 1946 erhielt er als erster Künstler den ehrenvollen Auftrag an der „Esquire Gallery Series" mitzuarbeiten; die produktive Zusammenarbeit mit Esquire endete erst in den 50er Jahren. Das Erscheinen seines ersten „Artist's Sketch Book and Memo"-Kalender bei Brown and Bigelow im Jahr 1962 machte Willis zum Superstar. Willis' Frauen sahen einfach „sexy" aus. Sie waren gewandt, raffiniert und äußerst provozierend. Willis stellte sie oft in Strümpfen, in Dessous oder Négligé dar. Auf vielen seiner Bilder stand eine in satten Farben gemalte Obstschale im Hintergrund, und manchmal malte Willis noch eine Flasche Wein oder eine Packung Zigaretten dazu. Willis' Pin-up-Geschöpfe waren etwas Besonderes: exklusive, elegante, erotische Frauen von Welt.

Als 1975 Willis' letzter „Artist's Sketch Book and Memo"-Kalender erschien, gab es nur noch einen anderen Pin-up- und Glamour-Künstler, dessen Illustrationen in Amerika reißenden Absatz fanden – und mit dem auch die Kunstsachverständigen bei Brown and Bigelow zufrieden waren: Mayo Olmstead, der schon seit über 25 Jahren bei dem Verlag unter Vertrag stand. Anfang und Mitte der 70er Jahre wurden Olmsteads weibliche Figuren moderner, ein Zugeständnis an den Zeitgeist. Damit ebnete er für Brown and Bigelow den Weg in die Ära des mit Fotos illustrierten Pin-up- und Glamour-Kalenders.

Mitte der 70er Jahre waren fast alle amerikanischen Kalenderverlage dazu übergegangen, ihre Pin-up- oder Glamour-Kalender statt von Malern von Mode- und anderen Berufsfotografen illustrieren zu lassen. Mit ihren Aufnahmen von Topmodellen und exotischen Schauplätzen wurden diese Kalender bald sehr populär, und sie sind es bis heute geblieben. Als die von Künstlern gemalten oder gezeichneten Pin-up- und Glamour-Girls aus den Kalendern verschwanden, verlegten sich die Künstler, die sich auf diese Gattung spezialisiert hatten, auf Porträt- oder andere Staffeleimalerei, oder sie hörten ganz auf zu malen. Die zunehmende Zahl von Fotoillustrationen bedeutete auch das berufliche Ende für viele „seriöse" Illustratoren aus der Werbebranche. Vielen dieser Künstler wird erst heute der ihnen gebührende Platz in der Geschichte der amerikanischen Kunst zuerkannt.

Fast 100 Jahre lang, von dem ersten Gibson Girl bis zum letzten Willis Girl, bezeugte die Pin-up- und Glamour-Kunst auf eindrucksvolle Weise Schönheit,

Vitalität und Anziehungskraft der amerikanischen Frau. Heiß geliebt von Generationen von Amerikanern beiderlei Geschlechts, gebührt ihr ein wichtiger Platz in der amerikanischen Kunst, Gesellschaft und Kultur des 20. Jahrhunderts.

Anmerkung: *Die folgenden Seiten sind in drei Abschnitte unterteilt. Der erste Abschnitt beschäftigt sich mit denjenigen Künstlern, deren Arbeiten in bezug zum Art deco standen. Der zweite Abschnitt mit den wichtigsten Werken der Pin-up- und Glamour-Kunst ist den Künstlern vorbehalten, die nahezu ihre gesamte künstlerische Laufbahn diesem Genre widmeten und dieses Gebiet der Kunst durch bedeutende Beiträge bereicherten. Im dritten Abschnitt setzen wir uns aus historischen Gründen mit den Künstlern auseinander, die in diesem Genre tätig waren, ihm aber keine nennenswerte Anzahl von Kunstwerken beisteuerten.*

Erst in den vergangenen Jahren gelangten Originale der Pin-up- und Glamour-Kunst in der Kunstbranche zum Verkauf, so daß diese Kunstform bis zu diesem Zeitpunkt weder sorgfältig dokumentiert noch beschrieben wurde. Die zur Veröffentlichung bestimmten Originale wechselten ursprünglich gegen ein Honorar in die Hand des Verlages; nur selten erbat oder erhielt ein Künstler sein Original zurück, und der Verlag entledigte sich der Werke auf unterschiedlichste, nicht dokumentierte Weise.

Darüber hinaus verliehen die Künstler ihren Werken auch keine Titel – dafür waren Verlagsjuristen, Werbetexter oder sogar der Vertrieb zuständig. Ein und dasselbe Bild konnte in verschiedenen Formaten, in verschiedenen Jahren und unter (manchmal bis zu drei oder vier) verschiedenen Titeln auftauchen. Die Originale wurden weder vermessen noch dokumentierte der Verlag Bildgrund und Malmedium. Auch das Datum fehlt den meisten dieser Arbeiten, die manchmal erst Jahre später veröffentlicht wurden. Daher läßt sich der Zeitpunkt der Fertigstellung oft nur auf einen Rahmen von mehreren Jahren festlegen.

Aufgrund der geschilderten Umstände wurde jedem abgedruckten Werk eine Nummer zugeordnet, um eine zukünftige Dokumentation zu ermöglichen. In den kurzen Essays zu den jeweiligen Künstlern haben wir uns nach Kräften bemüht, die wichtigsten Daten sowie das für den Künstler typische Malmedium und die Größe seiner bedeutendsten Reihen oder Bilder so genau wie möglich anzugeben.

L'Age d'or de
la pin up américaine

Charles G. Martignette

41

42

La plupart des Américains de la fin du dix-neuvième et de la première moitié du vingtième siècle n'avaient pas la possibilité de visiter des musées ou d'acheter des livres d'art. L'illustration était la seule forme d'expression artistique à laquelle ils avaient régulièrement accès. Une grande variété d'images infiltrait la vie des Américains sous toutes ses formes et s'imprimait sur le tissu même du quotidien. Dans ce sens, l'illustration apparaît comme le véritable art américain.

L'histoire de l'illustration américaine est étroitement liée à celle du développement et de la croissance des Etats-Unis. A partir de 1875, l'explosion démographique entraîna un besoin accru de nouveaux moyens de communication. Les progrès techniques de l'imprimerie favorisèrent la multiplication des journaux locaux et régionaux. Les magazines et les périodiques nationaux tels que *Scribner's, The Century, Puck, Harper's Weekly* et *The Saturday Evening Post* assuraient à cette masse de nouveaux lecteurs la libre circulation des informations, des idées et des services. En outre, tous publiaient des récits (histoires d'amour, récits d'aventures, enquêtes policières et autres) ainsi que des chroniques mondaines, politiques et sportives qui étaient extrêmement divertissantes.

Les éditeurs de magazines comprirent rapidement qu'un article attirait beaucoup plus de lecteurs quand il était accompagné d'une illustration. Ils s'aperçurent également qu'une belle couverture était un important facteur de vente dans les kiosques et pouvait considérablement faire augmenter le nombre de leurs abonnés. Dès 1920, les différents titres rivalisaient pour conquérir les lecteurs. C'est cette concurrence qui a ouvert la voie à l'âge d'or de l'illustration américaine qui allait perdurer jusqu'en 1970.

Lorsqu'on passe en revue l'histoire de la pin up américaine, il faut préciser que ces images ne s'adressaient pas à un public particulier. Pratiquement tous les magazines à grand tirage faisaient appel à une armée d'illustrateurs chargés d'orner leurs couvertures mensuelles ou hebdomadaires d'hommes, de femmes et d'enfants, très séduisants, isolés ou en groupe. Sur un marché aussi compétitif, le meilleur moyen d'attirer de nouveaux lecteurs était d'avoir des couvertures montrant des personnages fascinants ou des scènes évoquant des histoires sensationnelles. Et quoi de plus fascinant qu'une jolie femme? On distinguait alors trois types d'illustration de jolie femme: la «pin up», l'image «glamour» et la «pretty girl» (la jolie fille).

Il serait sans doute opportun de définir ces termes d'emblée. La «pin up» est un portrait en pied de jolie femme, présentant un élément thématique ou évoquant implicitement une histoire. La pin up porte généralement une tenue qui révèle ses formes avantageuses, soit un vêtement qui peut être porté en public, comme un maillot de bain, un short et un corsage bain de soleil, ou une robe légère, soit un vêtement plus provocant et intime, tel que de la lingerie fine. Il arrive que la pin up soit entièrement nue, mais cela reste l'exception qui confirme la règle.

L'image «glamour» est soit un portrait en pied soit un portrait présentant uniquement le buste du sujet. La beauté glamour porte généralement une robe du soir, une tenue de gala ou quelque autre vêtement moins provocant que celui de la pin up. La «pretty girl» est un portrait de femme de style glamour exécuté par un illustrateur de magazine à grand tirage *The Saturday Evening Post* ou *Cosmopolitan* ou destiné aux publicités. Ainsi, les termes de «pin up» et de «glamour» renvoient généralement au travail d'artistes spécialisés dans ces genres, alors que les «pretty girls» étaient presque toujours exécutées par des artistes touchant à tous les domaines de l'illustration et réalisant occasionnellement un sujet glamour. La plupart des illustrateurs ont à un moment ou un autre peint des «pretty girls». Certaines de ces images se rapprochaient des pin up mais la plupart se concentraient sur les aspects «glamour» de la beauté féminine.

De nombreux magazines populaires publiaient volontiers les sujets pin up et glamour que leurs illustrateurs leur soumettaient pour leur couverture. C'était le cas de *The Saturday Evening Post, Collier's, Liberty, Ladies' Home Journal, Cosmopolitan, Woman's Home Companion, Life, Judge, McCall's, Redbook, American Weekly, Vogue, Esquire* et *True*. Même *Time*, qui se définissait comme «l'hebdomadaire d'information de l'Amérique», ne résista pas à la tentation. La couverture de son numéro daté du 10 novembre 1941 présentait Rita Hayworth en pin up, peinte par George Petty, père de la pin up américaine du vingtième siècle et de l'art glamour.

Sur les centaines d'artistes et d'illustrateurs qui travaillèrent pour la presse entre 1920 et 1970, une cinquantaine peignaient presque exclusivement des pin up et des beautés glamour. (Certains acceptaient d'autres tâches éditoriales mais

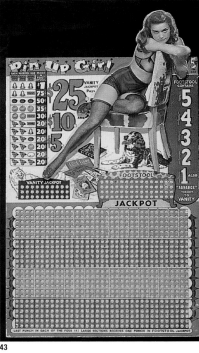

43

elles se limitaient principalement au domaine publicitaire, grand consommateur de ce type d'images.) En règle générale, ces artistes choisirent de peindre des pin up afin de saisir l'essence de la féminité de la femme américaine et de la célébrer. Les quelque cinq cents artistes employés dans les autres grands secteurs de l'illustration peignaient généralement des scènes narratives, sentimentales, romantiques et patriotiques de la vie américaine. Toutefois, au fil des années, ils se mirent eux aussi à introduire des thèmes glamour dans leurs images, afin de combler le vide laissé par les illustrateurs spécialisés, de plus en plus accaparés par les éditeurs de calendriers.

Devant le succès croissant des pin up et des beautés glamou, la presse grand public perdit son monopole: la publicité, les calendriers, les revues spécialisées de «pulp fiction» et de pin up, les cartes d'art et les gadgets publicitaires s'en emparèrent. Les grandes agences de publicité avaient fréquemment recours à l'art glamour et aux pin up pour vendre et promouvoir des produits et des idées. Des entreprises telles que Kodak, Coca-Cola et General Motors exploitèrent souvent ces images lors de campagnes de publicité nationales s'étalant parfois sur plusieurs dizaines d'années et influençant ainsi des générations d'Américains.

Mais de tous les supports de pin up et d'art glamour, les calendriers furent incontestablement les plus importants et les plus répandus. Les illustrations, mesurant entre 5,1 x 7,6 cm et 50,8 x 72,2 cm, étaient fixées ou collées sur une page unique de calendrier, puis renforcées par un support en carton et agrémentées de rubans permettant de suspendre le tout. Les plus grands de ces calendriers, appelés «cintres», étaient souvent placés dans les ateliers d'usines et les bureaux où des centaines d'employés pouvaient voir l'image et la date bien en vue dans leur espace de travail. Autre format très populaire, le calendrier-agenda à spirale, avec ses douze feuillets présentant chaque mois une nouvelle pin up ou beauté glamour. Avec le temps, ces calendriers, et leurs pin up, envahirent les foyers et les lieux de travail des Américains, jusqu'à devenir partie intégrante de leur vie quotidienne.

Le second grand vecteur de pin up était la couverture des magazines spécialisés. Les années 20 et 30 virent fleurir des titres tels que *Film Fun, Movie Humor,* *High Heel, Silk Stocking Stories* et *Gay Book*, autant de publications remplies de photographies de starlettes légèrement vêtues, de girls de revue comme les Ziegfeld Follies, de modèles new-yorkais et des célèbres baigneuses de Mack Sennett. Dans les années 40 et 50, la plupart des magazines avec des pin up en couverture sortaient du quartier général new-yorkais de l'éditeur Robert Harrison. Ses publications, *Beauty Parade, Whisper, Wink, Eyeful, Titter, Flirt, Giggles* et *Joker,* étaient présentes dans tous les kiosques à journaux. A l'intérieur, outre des clichés assez semblables à ceux des années 20 et 30, on trouvait des modèles totalement inconnus, des personnalités «culte» telles que Betty Page et Irish McCalla («Sheena, Reine de la Jungle»), et une pléthore d'autres jeunes beautés aspirant à la gloire.

Les posters centraux des magazines jouèrent un rôle déterminant dans la popularisation de l'art glamour et des pin up dans le monde entier. Ils firent leur apparition dès 1880, quand *Life* publia des dessins de la *Gibson Girl* sous ce format. Placées au centre du magazine, ces reproductions sur double page étaient fixées par des agrafes ou reliées dans le magazine par une bordure courant tout le long du côté gauche de l'image. Le lecteur pouvait ainsi les détacher pour les punaiser au mur, les encadrer, les coller dans un album, voire les découper comme des poupées en papier. Au fil des années, de nombreux magazines publièrent des posters centraux, mais ces derniers prirent une importance toute particulière dans plusieurs grands titres, notamment *Esquire, True* et *Playboy. Esquire* publia son premier poster central à la fin des années 30, utilisant un format plus grand que les autres (correspondant à trois pages du magazine). Quelques années plus tard, *Esquire* avait déjà publié plusieurs posters géants de la célèbre Petty Girl.

Un autre secteur de la presse eut largement recours aux pin up: les «pulps» (magazines de littérature de gare). D'un prix et d'une qualité inférieurs à ceux des publications grand public, les «pulps» se multiplièrent et connurent leur heure de gloire entre les années 20 et le début des années 50. Leurs sujets étaient variés: enquêtes policières, science-fiction, horreur, aventures, crimes, roman rose, westerns. Leurs couvertures arboraient souvent des pin up suggestives, provocantes et d'un érotisme fréquemment explicite. La communauté d'artistes exclusivement spécialisés dans le «pulp» se dispersa vers 1952, quand les éditeurs de digests

44

et de livres de poche commencèrent à solliciter leurs talents pour réaliser des images moins «osées» destinées à leurs lecteurs de plus en plus nombreux.

Les «cartes d'art» (ou «cartes mutoscopiques») contribuèrent elles aussi à populariser la pin up. Ces images, légèrement plus petites que les cartes postales classiques, étaient vendues dans les innombrables distributeurs automatiques des galeries marchandes. Adultes et adolescents collectionnaient ces pin up vivement coloriées, comme les enfants collectionnaient les photos des grands joueurs de base-ball. Il s'en vendit des millions d'exemplaires de par le monde entre le milieu des années 30 et le milieu des années 50.

Enfin, les gadgets publicitaires furent le dernier outil qui contribua à la gloire des pin up et des beautés glamour. Jeux de cartes, buvards, bloc-notes, miroirs de poche, verres, cendriers, porte-clefs, crayons, stylos, briquets, cravates, assiettes et, surtout, pochettes d'allumettes: tous les supports étaient bons. Les dizaines de millions de produits de ce type qui ont circulé dans le monde entier pendant plus de soixante-quinze ans ont donné aux pin up et aux beautés glamour une portée et un attrait vraiment universels.

L'avènement de la pin up américaine est étroitement lié à celui de l'industrie du calendrier. On raconte que c'est Benjamin Franklin qui a introduit le premier calendrier en Amérique avec son édition du *Poor Richard's Almanac* de 1752. Il y reprenait la version adoptée par tous les pays anglophones cette même année. Après avoir connu de nombreux changements au fil des siècles, le calendrier se stabilisa ainsi sous sa forme actuelle en supprimant onze jours de l'année.

Vers 1850, un nouvel outil commercial fit son apparition en Amérique: le calendrier d'une page utilisé comme moyen promotionnel. Ces feuillets rudimentaires, mais considérés à l'époque comme des inventions modernes, portaient le nom de la maison qui les imprimait ou celui des lithographes, des graveurs et des éditeurs qui y étaient associés.

Le premier calendrier proprement publicitaire parut en 1889. Deux éditeurs de journaux de Red Oak, dans l'Iowa, Edmund B. Osborne et Thomas D. Murphy, imprimèrent un calendrier mural sur lequel ils vendirent un espace publicitaire à une douzaine de commerçants locaux. Ils disposèrent les annonces autour d'une xylographie représentant le nouveau tribunal de la ville. A l'origine, les deux édi-

teurs avaient voulu commander cette xylographie pour la publier dans leur journal, mais elle s'avéra trop chère. En la plaçant au centre d'un calendrier publicitaire, ils purent non seulement l'acheter mais réalisèrent en outre un bénéfice de 300 dollars, somme considérable à l'époque! Le calendrier se vendit à plus d'un millier d'exemplaires. Un nouveau marché était né. Il allait générer des milliards de dollars de profit.

Le premier représentant qu'Osborne et Murphy engagèrent pour vendre leur calendrier s'appelait Herbert Huse Bigelow. Après avoir travaillé pour ses patrons pendant cinq ans, Bigelow s'installa dans le Minnesota, où il rencontra l'imprimeur Hiram D. Brown. Ils devinrent amis et décidèrent de s'associer. Bigelow avait 1500 dollars d'économies et Brown accepta d'apporter deux fois cette somme dans leur nouvelle entreprise: une maison d'édition spécialisée dans les calendriers. Sa seule condition était que son nom figurât en premier dans la raison sociale de leur société.

Brown and Bigelow vit officiellement le jour le 7 février 1896. Six mois plus tard, la société emménageait dans son premier «atelier» (composé d'une seule pièce!) et publiait son premier calendrier: une gravure monochrome de George Washington accompagnée d'une annonce publicitaire pour une entreprise de bois et charbons de Saint Paul. En 1899, soit trois ans plus tard, Brown and Bigelow était déjà une entreprise florissante et s'installait dans un immeuble de trois étages. En 1902, elle ouvrait ses premiers bureaux de vente à Boston. Un an plus tard seulement, elle occupait tout un immeuble de dix étages. Cette croissance n'a jamais vraiment cessé depuis. Dès le départ, Brown and Bigelow était voué à devenir un jour le plus grand, le plus important et le plus prospère des éditeurs de calendriers dans le monde. D'abord connue comme «La maison de la qualité», la compagnie enregistra en 1921 son célèbre slogan définitif: *Remembrance Advertising* («La publicité du souvenir»).

Au fil des ans, d'autres éditeurs publièrent avec succès des calendriers de pin up et de beautés glamour: Shaw-Barton dans l'Ohio, Joseph C. Hoover and Sons à Philadelphie, McCleery-Cummings dans l'Iowa, Kemper-Thomas à Cincinnati, Joseph Baumgarth à Chicago, Gerlach-Barklow dans l'Illinois, Louis F. Dow à Saint Paul, Skinner Kennedy à Saint Louis, Forbes à Boston, C. Moss à Philadel-

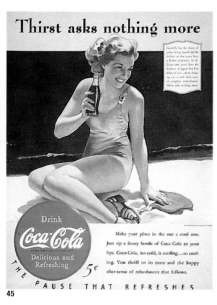

Thirst asks nothing more

Drink
Coca-Cola
Delicious and
Refreshing
5¢

THE PAUSE THAT REFRESHES

45

phie et Thomas D. Murphy à Red Oak, Iowa. Mais aucun n'atteignit jamais la suprématie de Brown and Bigelow. En tant que premier éditeur dans ce domaine, il fut la force la plus influente qui porta la pin up américaine à son apogée. La plupart des œuvres originales présentées dans ce livre furent créées pour lui. C'est Brown and Bigelow qui passa commande aux meilleurs artistes d'art glamour et de pin up du pays et leur permit de créer l'iconographie extrêmement riche et variée qui orna des milliards de calendriers. Ce faisant, cet éditeur contribua à porter la pin up et l'art glamour à leur plus haut niveau.

Au cours des dix dernières années du dix-neuvième siècle, la croissance de Brown and Bigelow établit les fondations du principal secteur d'activité dans lequel la pin up américaine allait s'épanouir. Vers la même époque, un jeune artiste de Boston, Charles Dana Gibson (1867–1944), entama une carrière qui allait donner naissance à la pin up la plus célèbre de tous les temps – la légendaire «Gibson Girl». Au printemps 1885, armé d'un portfolio contenant ses dessins au crayon et à l'encre de Chine, Gibson alla frapper à la porte des directeurs artistiques des magazines et des maisons d'édition new-yorkais. Le jeune artiste ne rencontra guère d'enthousiasme et dut attendre l'automne de 1886 avant de connaître son premier succès. Un tout nouveau magazine appelé *Life* lui acheta un dessin et lui en commanda d'autres pour ses numéros à venir.

1887 vit la première apparition publique de la Gibson Girl. Elle est incontestablement la première vraie pin up américaine et la première beauté glamour. Sa popularité dépassa celle de toutes ses rivales, contemporaines ou futures, y compris la Christy Girl, la Fisher Girl, la Grandell Girl et, plus tard, la Varga Girl et la Petty Girl. Quelques années après ses débuts, la Gibson Girl était devenue la chérie de l'Amérique, l'idéal de la féminité américaine. Sa renommée s'étendit également à l'étranger: des millions d'admirateurs de par le monde constituaient en quelque sorte son fan club international.

L'aspect sans doute le plus remarquable de la Gibson Girl était qu'elle était vénérée non seulement par tous les Américains, mais également, sinon plus, par toutes les Américaines. Sûre d'elle, indépendante et volontaire, elle était perçue comme l'incarnation de la femme moderne, socialement à son aise dans tous les types de situation. Bien que souvent représentée comme appartenant aux classes

supérieures, elle plaisait pareillement aux riches et aux pauvres, aux jeunes et aux vieux de tous bords.

Au sommet de sa gloire, la Gibson Girl influença la mode, les styles de vie, les comportements, et même la morale. Des chansons louaient ses charmes et, sur Broadway, des spectacles rendaient hommage à sa beauté. On la voyait partout: cartes postales, assiettes en porcelaine, boîtes à bonbons, petites cuillères, éventails, mouchoirs et, naturellement, calendriers et magazines.

L'un des dessins préférés de Gibson était un portrait glamour (illustration 12) auquel son nom devint étroitement associé. De fait, cette image était si célèbre qu'elle parut dans une série de livres d'art que le magazine *Collier's* publia à partir de 1894. Elle servit même de base pour un motif de papier peint.

Vers 1900, l'engouement des Américains pour la Gibson Girl était tel que *Collier's* offrit à l'artiste la somme inouïe de 100000 dollars contre cent dessins à livrer sur une période de quatre ans. Ces illustrations furent publiées (comme dans *Life* une décennie plus tôt) sous forme de poster central, ce qui fait de la Gibson Girl la première vraie pin up à paraître sous forme de poster. Outre *Life* et *Collier's,* Gibson collaborait à d'autres magazines et son travail paraissait fréquemment dans trois autres grands périodiques de l'époque: *Scribner's, The Century* et *Harper's Weekly.*

Gibson créa également le premier homme pin up américain. Comme la Gibson Girl, le Gibson Man séduisait autant les femmes que les hommes. Son charme viril, son élégance vestimentaire et la noblesse de son tempérament faisaient de lui l'idéal de tous. Il apparaissait parfois aux côtés de la Gibson Girl, dans une scène narrative éclairée par un titre ou une légende commentant un aspect de la vie américaine sur un ton humoristique ou satirique. C'est le cas du célèbre dessin de Gibson (crayon et encre de Chine), traitant de l'éternel triangle amoureux, avec cette maîtrise typique de l'artiste (illustration 13).

En tant que première grande pin up américaine, la Gibson Girl occupe une place sans précédent dans l'histoire de l'art américain. On ne peut sous-estimer son influence sur les pin up et beautés glamour. Elle représentait l'image même de la beauté, de la sophistication et de la liberté américaines, et allait inspirer des générations d'artistes.

Au début du siècle, tandis que la Gibson Girl se lançait à la conquête de l'Europe, les créations d'un artiste italien connaissaient un succès phénoménal en Amérique. Angelo Asti s'accapara une grande partie du marché naissant des calendriers après sa première publication en 1904 par Brown and Bigelow. Première «pretty girl» à être acceptée par l'éditeur, cette image d'une beauté aux cheveux longs dans le style Art nouveau fit vendre plus d'un million et demi de calendriers (en cinq ans, les «pretty girls» et les beautés glamour allaient constituer les deux branches principales du secteur des calendriers artistiques).

Vers 1910, une autre peinture d'Asti publiée par Shaw-Barton remporta un grand succès en Europe et aux Etats-Unis (illustration 14). Les belles d'Asti furent reproduites sous de nombreuses formes, notamment sur des cartes postales et des assiettes en porcelaine. La jeune beauté «artistique» du tableau de Hy Withroy, *Biruté* (illustration 15), fut publiée vers 1915 dans un calendrier de Joseph C. Hoover and Sons.

Les pin up fleurirent dès lors des deux côtés de l'Atlantique. Le marché européen de l'art érotique était alors dominé par le peintre Raphaël Kirchner. Les belles de Kirchner paraissaient régulièrement dans le magazine français le plus osé: *La Vie parisienne*. Elles traversèrent l'Atlantique sous forme de reproductions, de cartes postales et de calendriers. Une œuvre originale à l'aquarelle et à la gouache, publiée sous forme de calendrier et de carte postale, témoigne du style délicat et tendre de Kirchner (illustration 16). La cigarette était alors un accessoire tabou, impensable dans la représentation d'une femme dans son intimité. Les belles de Kirchner reflétaient le vent de libéralisation qui soufflait sur toutes les couches de la société de la Belle Epoque. Son art encouragea les artistes du monde entier à faire preuve de plus de spontanéité et d'audace.

Au début de sa carrière, Alberto Vargas, qui allait jouer un rôle central dans l'histoire de la pin up américaine, fut fortement influencé par le style européen. Jeune artiste péruvien, Vargas avait étudié l'art en Suisse avant de s'installer à New York en 1916. Les belles de Kirchner, qui l'avaient inspiré en Europe, continuèrent à influencer son travail dans les années 20 et 30.

L'extraordinaire capacité de Vargas à créer une atmosphère de sensualité rêveuse est frappante dans une ravissante aquarelle réalisée entre 1922 et 1924 (illustration 17). Vargas travaillait alors sur une commande des Ziegfeld Follies pour peindre les girls de la revue. De temps à autre, il demandait à l'une des vedettes de poser pour lui à titre privé. Les résultats étaient souvent merveilleux, sans doute parce que ces œuvres n'étaient pas soumises aux habituels délais de livraison et diktats commerciaux.

Dans un autre superbe portrait d'une vedette des Ziegfeld Follies (illustration 18), le modèle porte un extraordinaire costume Art déco taillé dans une étoffe imprimée de scènes de contes de fées. Le traitement délicat des motifs imbriqués, associé à une superbe technique d'aquarelliste, montre clairement une facette importante du génie de l'artiste.

Vargas expérimenta de nombreux styles avant de trouver sa «griffe» personnelle, faisant fréquemment appel à son extraordinaire talent de dessinateur de mode, souvent sous-estimé. La très stylisée *Robe d'après-midi* est l'une des importantes images publicitaires de Vargas. Illustration de mode inspirée des couvertures de *Vogue*, cette aquarelle ne mesure pas moins de 76,2 x 55,9 cm.

En 1927, Vargas créa une autre belle image publicitaire pour les studios Paramount (illustration 19). Il la signa «Albert Vargas», tout comme d'autres œuvres des années 20 dont il savait qu'elles seraient vues par le plus grand nombre. Des reproductions de cette aquarelle parurent sous forme d'affiches et de publicités pleine page pour *Glorifying the American Girl* («A la gloire de la jeune Américaine»), un film sur les Ziegfeld Follies, que les images de Vargas contribuèrent à promouvoir dans le monde entier tout au long des années 20. Le titre du film résume d'ailleurs assez bien l'objectif de Vargas dans toute son œuvre. Et c'en est un que peu d'artistes américains du vingtième siècle ont atteint aussi bien que lui.

L'industrie du calendrier connut sa première grande expansion immédiatement après la Grande Guerre. Les soldats qui avaient quitté les Etats-Unis adolescents et jeunes hommes avaient vu du pays. Outre le souvenir des belles Européennes, ils rapportaient avec eux un nombre considérable de cartes postales «légères». Produites à partir d'œuvres originales ou de photos, ces images montraient des Françaises et des Italiennes délurées, nues ou/et dans des poses suggestives. Les soldats importèrent également des portraits de Françaises «glamour».

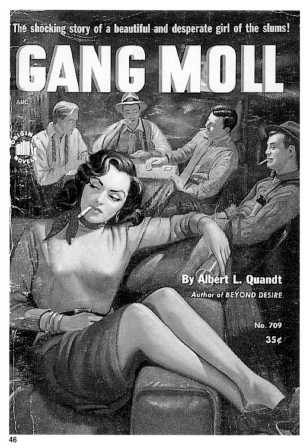

The shocking story of a beautiful-and desperate girl of the slums!

GANG MOLL

By Albert L. Quandt
Author of BEYOND DESIRE

No. 709
35¢

46. RUDY NAPPI
FRONT COVER FOR "GANG MOLL", 1953
TITELBLATT FÜR „GANG MOLL", 1953
COUVERTURE DE «GANG MOLL», 1953

46

Les éditeurs de calendriers se lancèrent rapidement dans une vaste production de pin up basée sur ces nouvelles images du Vieux Continent. Les versions américaines de l'Européenne émancipée, bientôt baptisées «flappers», se répandirent tout au long des années 20 au son du charleston. Jamais on n'avait vu de telles femmes sur les pages de calendrier: la Gibson Girl entrait dans l'ère du jazz.

Un grand nombre d'illustrateurs travaillant pour la publicité et les magazines populaires se mirent à peindre des «pretty girls» (avec une forte tonalité glamour). Parmi eux, Norman Rockwell, qui tout au long de sa carrière, recourut régulièrement aux images de jolies filles, de beautés glamour et de pin up, utilisant des mannequins, des starlettes et des vedettes de cinéma. Cette tendance de l'illustration américaine commença en fait au début du siècle et perdura jusque vers le milieu des années 70.

Joseph Christian Leyendecker (1874–1951) était un autre de ces illustrateurs très admirés du grand public. Il était le père d'un second homme pin up, l'homme des chemises Arrow, qui devait devenir aussi célèbre que le Gibson Man. Au début des années 20, le fringant héros de Leyendecker séduisait tant les Américaines qu'elles lui envoyaient chaque semaine des centaines de demandes en mariage par la poste. Le superbe coup de crayon et les compositions méticuleuses de l'artiste lui valurent de réaliser plusieurs campagnes de publicité qui connurent un succès triomphal, notamment celle des chemises Arrow, conçue par l'agence Cluett Peabody.

Lorsqu'on lui commandait une image de jolie fille, Leyendecker livrait une toile accomplie, comme celle utilisée pour la publicité des cigarettes Chesterfield, produite par l'agence Liggett and Meyers (illustration 20). On y retrouve la patte caractéristique de Leyendecker, qui intègre la toile brute dans ses compositions. La jolie personne qui y est représentée nous laisse deviner ce qu'aurait été la «Leyendecker Girl» si l'artiste avait réalisé des campagnes de publicité de mode féminine.

Howard Chandler Christy (1873–1952) connut une renommée similaire à celle de son contemporain Leyendecker. Travailleur acharné, excellent en tout, Christy aimait les gens et la vie. Dès son entrée en 1892 à l'Art Students League puis à la National Academy de New York, il impressionna ses professeurs par son talent.

L'un d'eux, l'artiste William Merritt Chase, accepta même de lui donner des leçons particulières, un grand honneur à l'époque.

Après trois années d'études seulement, Christy fit son entrée dans le monde de l'illustration: en 1895, il livra ses premiers dessins au magazine *Life,* comme Charles Dana Gibson avant lui. Egalement comme Gibson, Christy se spécialisa dans d'élégants portraits de femmes qui célébraient la beauté américaine et que l'on associa bientôt à son nom: les Christy Girls.

En vingt ans de carrière, Christy se fit connaître dans tous les foyers de l'Amérique. En 1900, soit cinq ans après leur première apparition dans *Life,* les Christy Girls firent l'objet d'un livre d'illustrations qui devint rapidement un best-seller et fut suivi de six autres volumes au cours des douze années suivantes. La signature de Christy était connue de tous et il accéda lui-même au statut de célébrité. Sa personnalité chaleureuse lui valait la sympathie de tous et notamment des journalistes, avec lesquels il entretenait des rapports joviaux et espiègles.

En 1921, au sommet de la gloire, Christy décida de prendre sa retraite pour se consacrer exclusivement à la peinture de chevalet, notamment aux nus et aux paysages. Il continua d'accepter des projets de temps à autre quand ils lui paraissaient suffisamment stimulants. Ce fut le cas quand on lui proposa, au début des années 20, de créer une série de fresques pour le célèbre Café des Artistes de New York.

De 1915 à sa mort en 1952, Christy vécut et travailla à l'hôtel des Artistes, où se trouvait le café du même nom. Son atelier dans l'hôtel était l'un des plus élégants du monde. Lorsque son travail fut achevé, tous les murs du café étaient splendidement ornés de nus grandeur nature s'ébattant dans une forêt luxuriante.

Plus tard, vers 1925, Christy reçut une autre commande de peinture murale, d'un particulier cette fois. L'œuvre réalisée à cette occasion (illustration 21) peut être considérée comme un cinquième mur du Café des Artistes. Elle représente trois nus dans un Eden onirique. Pour souligner la nature particulière du sujet, Christy utilisa de l'or à vingt-quatre carats pour peindre le ciel et le soleil couchant.

On peut encore admirer la fresque de Christy au Café des Artistes. Avec ses superbes représentations de beauté féminine, elle constitue un témoignage per-

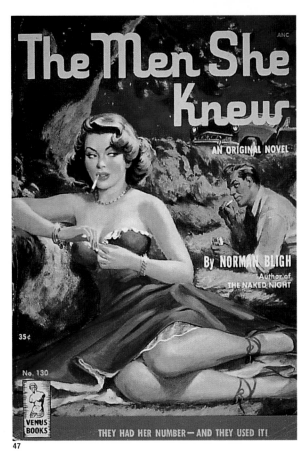

manent de son génie artistique, de la sensualité et de l'érotisme de ses compositions.

Harrison Fisher (1875–1934) était un autre talentueux artiste Art déco qui, comme Gibson et Christy, accéda à une telle célébrité que ses créations portaient son nom. Fils et petit-fils de peintres, Fisher naquit à New York mais grandit à San Francisco, où il fit ses études à la Mark Hopkins Institute of Art. Après avoir peaufiné son éducation en Angleterre et en France, puis travaillé pour les publications Hearst de San Francisco, il s'installa à New York en 1897. Engagé à plein temps par le magazine *Puck,* il se fit rapidement connaître pour ses dessins au crayon et à l'encre de Chine qui ornaient souvent la couverture (la couleur était ajoutée par la suite).

Pendant la plus grande partie de sa carrière, Fisher travailla principalement à la gouache et au pastel. Il exprima sa vision de la beauté américaine idéale à travers une série de portraits qui firent les couvertures de *Cosmopolitan* de 1912 à 1934, une collaboration d'une longévité extraordinaire. Cette même revue décrivit plus tard la Fisher Girl comme «débordante de santé, sûre d'elle, perspicace (…) ni paresseuse ni négligée, (…) qui sait obtenir ce qu'elle veut grâce à son charme, sa grâce, sa sincérité. Elle sait être tendre quand il le faut, énergique quand la situation l'exige, mais reste toujours féminine».

Fisher travailla également pour d'autres publications telles que *The Saturday Evening Post, McClure's, Ladies' Home Journal* et *Scribner's.* Une gouache intitulée *Dear Sweetheart* (illustration 22), publiée en 1914 en couverture de *American Sunday Monthly Magazine,* offre un exemple type de son travail. Fisher était également connu pour ses illustrations de romans sentimentaux.

Comme d'autres grands illustrateurs de son temps, Fisher devint riche et très courtisé par les modèles qui voulaient poser pour lui. Il vit, lui aussi, ses belles Américaines publiées dans des livres. Et enfin, dernier point commun avec Gibson et Christy, il se consacra aux portraits et à la peinture de chevalet vers la fin de sa vie.

Les exemples ci-dessus montrent clairement que les artistes Art déco incorporaient très souvent des images de pin up ou d'art glamour dans leur travail ou qu'ils les utilisaient comme point de départ pour de nombreux autres types

d'illustrations. Les exemples cités proviennent des plus célèbres illustrateurs «populaires» des premières décennies du siècle. Bien que l'une des œuvres mentionnées soit une image «glamour» utilisée dans une campagne de publicité nationale (illustration 20), il ne s'agit pas d'une pin up à proprement parler.

Pour voir une vraie pin up, il faut nous tourner vers une superbe aquarelle de Coles Phillips, publiée pour la première fois en 1922 dans une publicité pleine page pour Holeproof Hosiery (une marque de sous-vêtements féminins; illustrations 23 et 24). Elle parut dans pratiquement tous les grands magazines populaires, dont *The Saturday Evening Post, Cosmopolitan,* et même *Good Housekeeping.* De nombreux lecteurs écrivirent pour demander une reproduction de l'œuvre originale. De toute évidence, la pose tranquille du modèle, associée à la composition et au dessin sophistiqués de Phillips, permirent ici au thème de la pin up d'opérer avec grâce, élégance et sensualité.

Coles Phillips eut une carrière brillante mais brève (de 1908 à 1927). Comme Christy et Gibson avant lui, il fit ses premières armes à *Life.* Toutefois, contrairement à ses aînés, il réalisa sa première couverture quelques mois à peine après son recrutement et continua à dessiner des couvertures pour *Life* jusqu'à sa mort. Ses illustrations embellirent également la plupart des grands titres de presse – *Ladies' Home Journal, Collier's, McCall's, Liberty* et *Woman's Home Companion.* La plupart de ces œuvres avaient pour thème central une pin up ou une beauté glamour. Son travail fut également publié dans un livre à succès intitulé *A Gallery of Girls.*

Phillips attachait une importance particulière à la composition, qu'il considérait comme l'outil primordial pour construire une image. Il devint célèbre pour son utilisation inventive du «fondu», où un élément de l'image, un pardessus d'homme par exemple, se perdait progressivement dans le fond du tableau tandis que la silhouette et le visage du sujet étaient définis par un jeu adroit de traits de lumière.

Au cours de sa brève existence, Coles Phillips se montra très prolifique. Sa mort prématurée en 1927 consterna le monde de l'art comme le grand public. En prononçant son oraison funèbre lors de son enterrement, son ami J.C. Leyendecker le décrivit comme un artiste «unique en son genre, doté d'un sens profond

de l'ornement et de la couleur (…). Sa vision de la féminité américaine était en avance sur son temps».

De tous les grands illustrateurs de «pretty girls», James Montgomery Flagg (1877–1960) fut le plus truculent. Rebelle né, Flagg était de ces rares personnages qui savent se faire aimer du grand public tout en s'attirant le respect de leurs pairs. On comparait souvent sa façon de vivre à celle de Howard Chandler Christy. Tous deux aimaient parcourir le monde en compagnie de la «jet set». Flagg passait beaucoup de temps à Hollywood, où il fréquentait un cercle haut en couleurs d'écrivains, d'acteurs et de personnalités bohèmes, dont son grand ami John Barrymore.

Flagg grandit, travailla et mourut à New York. Comme d'autres grands illustrateurs de son temps, il commença par travailler pour *Life* et continua de le faire pendant de longues années. A mesure que sa renommée s'épanouit, ses peintures et ses dessins illustrèrent des couvertures de magazines, des calendriers, des publicités et des romans. Pratiquement toutes les publications d'importance durant la première moitié du siècle publièrent un jour ou l'autre une œuvre de Flagg. Dans une peinture reproduite vers 1930 en couverture d'un magazine, sans doute *Life* ou *Judge,* on peut admirer tout le talent de l'artiste dans sa représentation d'une beauté Art déco surprise dans une pose sensuelle et sophistiquée tandis qu'elle se met du rouge à lèvres (illustration 25).

Flagg était un artiste habile et touche-à-tout. Travaillant à une vitesse prodigieuse, il maîtrisait pratiquement toutes les techniques avec la même facilité: huiles, crayon et encre de Chine, aquarelles opaques et transparentes, fusain et graphite. C'était également un bon sculpteur. Les affiches qu'il réalisa pour les campagnes de mobilisation de l'armée américaine pendant la Deuxième Guerre mondiale le rendirent très célèbre, notamment celle où l'oncle Sam chapeauté du drapeau américain pointe un doigt péremptoire en déclarant: *I Want You in the U.S. Army.*

Flagg aimait surtout peindre les femmes, qui jouaient un grand rôle dans sa vie privée et publique. Comme d'autres célèbres illustrateurs des années 20 et 30, c'était un connaisseur des formes féminines. Il retrouvait souvent ses amis artistes dans des soirées et des clubs privés qu'ils avaient fondés eux-mêmes, comme le

Dutch Treat Club. Dans un dessin réalisé vers 1930 pour l'annuaire de ce club (illustration 26), Flagg montre une femme aux seins nus assise dans son lit et répondant au téléphone: «Non, Madame, vous vous êtes trompée de numéro. Vous êtes au Muséum d'Histoire Naturelle!» L'homme dans le fond représente un ami de l'artiste, l'illustrateur John LaGatta, que Flagg adorait taquiner.

Dean Cornwell (1892–1960) était un autre célèbre illustrateur qui utilisait des pin up et des beautés glamour dans la presse populaire. Dans un fusain réalisé en 1935 pour le même Dutch Treat Club, Cornwell traite le sujet de l'artiste et de son modèle (illustration 27). C'était un thème souvent traité par les artistes et prisé du grand public pour ses sous-entendus coquins. En hommage aux qualités artistiques de Cornwell, ses confrères le surnommèrent «le doyen des illustrateurs».

L'illustrateur William Reusswig (1902–1978) recourait souvent aux pin up dans ses images destinées aux magazines populaires et aux grands annonceurs. Comme ses amis Flagg et Cornwell, Reusswig contribuait régulièrement à l'annuaire du Dutch Treat Club. Une de ses illustrations montre un modèle nu assis à un bar qui pourrait être celui du Club 21, du Lotos Club ou de n'importe quel autre lieu nocturne de New York fréquenté assidûment par les artistes (illustration 28). Sa pose espiègle et sa nudité décontractée évoquent bien la complicité qui unissait à l'époque les artistes et leurs modèles.

Bradshaw Crandell (1896–1966) fut le dernier des grands artistes de «pretty girls» des années 20 et 30 à devenir si célèbre que son nom fut régulièrement associé à ses créations. Crandell travailla à plusieurs reprises pour des éditeurs de calendriers, mais il se fit surtout connaître pour ses pastels qui faisaient chaque mois la couverture de *Cosmopolitan*. Sa collaboration au célèbre magazine féminin commença vers le milieu des années 30 et dura douze ans (il prit la relève de Harrison Fisher). La couverture du numéro d'août 1940 (illustrations 29 et 30) est typique de ses pastels «glamour».

Crandell consacra la majeure partie de sa carrière à peindre des jolies femmes, une activité largement facilitée par son adhésion au Dutch Treat Club et à d'autres groupes d'artistes de Manhattan. En 1952, une astucieuse peinture de Crandell servit de page de garde à l'annuaire du Dutch Treat Club (illustration 31). Le noms et les numéros de téléphone sur le mur derrière le modèle sont ceux des

membres du club. Chaque nom est accompagné d'un commentaire humoristique émanant soi-disant du modèle lui-même. S'il y eut jamais une pin up «type» par excellence, c'est bien celle-ci!

Entre la période Art déco et la Deuxième Guerre mondiale, les «pulps» donnèrent naissance à une nouvelle branche de l'art de la pin up. Ces magazines bon marché, qui fleurirent entre les années 20 et les années 40, publiaient des nouvelles policières, de science-fiction, d'horreur ou d'aventure illustrées souvent de pin up sexy représentées dans des situations périlleuses à forte connotation érotique. Les pulps avaient leurs propres écuries d'artistes qui se spécialisaient soit dans les couvertures en couleurs soit dans les illustrations en noir et blanc qui accompagnaient les textes. Un grand nombre d'artistes de pin up et de beautés glamour des années 20 et 30 commencèrent par faire des couvertures pour les pulps. Parmi eux, Earle K. Bergey, Enoch Bolles, Peter Driben, George Quintana, Arthur Sarnoff et William Fulton Soare. Une image désormais classique de Bergey, par exemple, mêlant science-fiction et glamour, fit la couverture de *Thrilling Wonder Stories* (illustration 32).

Inversement, de nombreux artistes qui se consacrèrent exclusivement aux pulps incorporèrent des éléments glamour et des pin up dans leurs images, comme on peut le constater avec le dessin de Howard McCauley daté de 1940 (illustration 33). Même *Weird Tales* publia des pin up, tel que le nu spectaculaire de Virgil Finlay, le «grand-père» de l'art pulp (illustrations 34 et 35). Quelques artistes passaient régulièrement d'un genre à l'autre tout en faisant également quelques incursions dans d'autres domaines de l'illustration. Parmi ces derniers se trouvaient le génial touche-à-tout Bergey; George Rozen, créateur des célèbres couvertures du magazine *Shadow*; Jerome Rozen, son frère; John Newton Howitt et Harry T. Fisk.

Parmi ceux qui peignaient presque exclusivement des couvertures de pulps, on ne peut omettre Margaret Brundage, qui réalisait des pin up au pastel pour les couvertures de *Weird Tales,* ainsi que Hugh J. Ward et Harry Parkhurst qui travaillaient tous deux pour *Spicy Magazine* (bien que Ward ait réalisé quelques illustrations pour des magazines populaires comme *Liberty* et *Collier's*). Le recours intensif aux pin up par les pulps coquins est manifeste dans la magnifique couverture réalisée par Ward, qui mêle adroitement pin up et horreur (illustration 36). Quant aux illustrateurs des pulps «noirs», comme Raphael DeSoto et George Gross (illustrations 37 à 40), ils parvenaient régulièrement à placer une pin up aux côtés de leurs héros ou de leurs gangsters.

Comme nous l'avons vu, les calendriers et les pulps connurent leur apogée entre les deux guerres. Dans ces deux domaines, les pin up et les sujets glamour étaient ceux qui se vendaient le mieux, au point qu'un grand nombre d'illustrateurs traditionnels, de Gibson à Flagg, les incorporèrent dans leur travail. Toutefois, il existait un groupe d'artistes Art déco qui avaient fait de ces thèmes la base même de leur travail, trouvant dans les calendriers et les magazines pour hommes leur marché le plus lucratif.

Enoch Bolles fut sans doute le plus célèbre et le plus prolifique d'entre eux. Ses pin up cabotines et ravageuses apparaissaient sur les couvertures de *Film Fun* et *Gay Book,* mais il réservait ses dessins plus osés à des pulps coquins comme *Bedtime Stories, Tattle Tales* et *Pep Stories*. Aussi doués que Bolles, Earle K. Bergey et George Quintana réalisaient des couvertures que l'on voyait dans tous les kiosques de New York à Los Angeles. Tous deux travaillaient principalement pour des pulps de charme mais collaboraient également à d'autres magazines pour hommes tels que *Real Screen Fun, Movie Humor* et *Reel Humor.*

Pendant les années 20 et 30, Edward M. Eggleston, Henry Clive et Gene Pressler furent de loin les artistes les plus talentueux à réaliser des images glamour et des pin up pour les calendriers. Ils maîtrisaient tous de nombreuses techniques, mais Eggleston et Clive préféraient les huiles et Pressler les pastels. Chacun était un véritable peintre académique chez qui on peut déceler l'influence de John Singer Sargent.

Peter Driben, qui allait devenir l'un des géants des couvertures de pin up dans les années 40 et 50, commença sa carrière pendant les années Art déco. Il commença à fournir des peintures et des dessins coquins aux pulps américains dans les années 20, alors qu'il vivait à Paris. (A dire vrai, Driben n'est pas le seul à avoir fait une aussi longue carrière avant et après la Deuxième Guerre mondiale. D'autres artistes ont connu un parcours aussi fructueux, dont Rolf Armstrong, Bradshaw Crandell, Billy DeVorss, Gil Elvgren, Jules Erbit, Earl Moran, Zoë Mozert, George Petty et Alberto Vargas.)

Trois autres peintres de pin up commencèrent leur carrière à l'époque Art déco: Charles Sheldon, Billy DeVorss et Jules Erbit. Pendant les années 20 et 30, les dessins de mode de Sheldon inspirèrent une série de célèbres publicités pour des chaussures de femmes, des bas et de la lingerie qui parurent dans *Ladies' Home Journal* et *Woman's Home Companion.* En 1937, Sheldon créa la première de ses légendaires pin up pour les shampooings Breck, à l'occasion d'une des campagnes les plus réussies de l'histoire de la publicité américaine. Les Breck Girls sont souvent considérées comme le plus bel exemple de «pin up glamour».

DeVorss et Erbit, qui travaillaient principalement au pastel sur de grands formats de 101,6 x 76,2 cm en moyenne, étaient tous deux extrêmement prolifiques. Les beautés glamour de DeVorss semblaient tout droit sorties d'un luxueux plateau de cinéma des années 30. En revanche, les images d'Erbit étaient légèrement moins sophistiquées et, le plus souvent, montraient le genre de jeune fille que tout jeune homme des années 30 aurait aimé présenter à ses parents.

La période Art déco vit également fleurir le talent de quatre femmes artistes dont les pin up et les beautés glamour firent partie du paysage américain pendant plus de vingt ans: Mabel Rollins Harris, Laurette Patten, Irene Patten et Pearl Frush. Harris possédait une maîtrise exceptionnelle et un sens profond du pastel, avec lequel elle savait évoquer une extraordinaire gamme de situations et d'atmosphères. Les sœurs Patten, également aquarellistes accomplies, avaient des styles si semblables que leur travail semblait parfois interchangeable. Frush est véritablement un génie artistique méconnu. Ses œuvres originales, peintes à la gouache sur des cartons à dessin, avaient la qualité d'huiles denses. De fait, elle possédait une telle maîtrise technique que, vues de près, ses œuvres ont une clarté quasiment photographique. Les connaisseurs qui collectionnent son travail la jugent souvent comme l'égale d'Alberto Vargas en excellence artistique.

A la fin des années 30 et au début des années 40, alors que l'Amérique sortait enfin de la grande dépression, la situation périlleuse de l'Europe commença à inquiéter les esprits. Craignant que leur pays ne fût entraîné dans la guerre d'un moment à l'autre, les Américains, hommes et femmes, furent pris d'une angoisse qui n'épargna personne. Comme toujours, beaucoup cherchèrent à fuir leurs soucis en se réfugiant dans les divertissements: radio, cinéma, magazines, romans. Dans la foulée, l'engouement pour les pin up, ainsi que pour les revues et les calendriers dans lesquels elles figuraient, s'accentua encore.

En automne 1940, *Esquire* était devenu la première publication des Etats-Unis. Réunissant l'élite des écrivains, des artistes et des photographes, le magazine disposait également d'une équipe rédactionnelle de premier ordre, sous la poigne de fer du directeur David Smart. Grâce à l'aura d'excellence cultivée par *Esquire,* la pin up vit son statut s'élever. La sortant des vestiaires, des garages, des dortoirs, des baraques de chantiers et des clubs privés où elle avait été secrètement vénérée par des générations d'Américains, le magazine l'imposa au grand jour dès 1933, quand son premier numéro parut dans les kiosques.

Mais plus que les ventes en kiosque, c'est la multiplication des abonnements qui donna un nouveau statut à la pin up. Chaque mois, les foyers américains accueillaient le magazine dans leur salon, où tout le monde pouvait bénéficier de ses brillants articles d'information et de fiction, de son formidable sens de l'humour, de ses photographies et de ses illustrations superbes. Sans la volonté d'*Esquire* d'apporter à ses lecteurs les meilleurs talents du moment, les Américains n'auraient peut-être jamais digéré ses images de pin up avec autant de facilité, comme ce fut le cas juste avant la guerre.

Le numéro d'octobre 1940 contenait deux posters centraux de pin-up réalisés par des artistes qui allaient jouer un rôle crucial tant pour le magazine que pour l'histoire de la pin up. Le premier était George Petty, qui s'était rendu célèbre en tant que père de la Petty Girl, première pin up moderne à émerger des années de vaches maigres de la dépression. *Esquire* contribua fortement à lancer la carrière de Petty, s'engageant à publier une de ses créations au moins par mois tout au long des années 30. Le second était Alberto Vargas, qui s'était spécialisé dans les années 20 dans les portraits de vedettes et les affiches des Ziegfeld Follies, avant d'enchaîner dans les années 30 avec le même genre de travail pour les studios hollywoodiens.

La première pin up de Vargas parue dans *Esquire* marqua le début de sa renommée internationale. Les Varga Girls (le magazine prit la liberté d'ôter le «s» final de son patronyme) furent de nouveau promues par *Esquire* deux mois plus tard, quand le magazine édita le premier calendrier réalisé par l'artiste. Le calen-

drier de 1941 fut suivi de sept autres, et chacun battit des records de vente dans le monde entier. La Varga Girl devint partie intégrante de la vie américaine. Un an après son apparition, le pays s'apprêtait à entrer en guerre.

En s'embarquant sur les navires de guerre, les soldats américains n'emportaient pas seulement avec eux leurs fusils, leur paquetage et les photos de leurs petites amies, mais également leurs pin up favorites. Outre les reproductions photographiques, elles figuraient sur des jeux de cartes, des calendriers et des blocs-notes. Ces images remontaient le moral des troupes en donnant à chacun de quoi rêver pendant les heures, les jours et les semaines loin du pays. Les généraux Eisenhower et MacArthur en personne commentèrent publiquement ce phénomène, mentionnant son rôle positif auprès de leurs hommes.

Si Vargas est sans doute le peintre de pin up le plus connu de cette époque, il était loin d'être le seul à travailler dans ce genre, qui connut son deuxième âge d'or pendant la Deuxième Guerre mondiale. Son principal rival fut sans doute Gil Elvgren. Depuis la fin des années 30, le travail d'Elvgren était publié par l'éditeur de calendriers de Saint Paul Louis F. Dow. Devant le succès des pin up d'Elvgren, Dow les publia sous forme de petits livres de 20,3x25,4cm, un format facile à envoyer à l'étranger par la poste. En outre, on pouvait facilement détacher les pin up et les punaiser sur toutes sortes de supports. Après la guerre, la popularité d'Elvgren augmenta encore. Ses œuvres pour Brown and Bigelow de la fin des années 40 au début des années 70 ont été reproduites un tel nombre de fois qu'on estime à plus d'un milliard les Elvgren Girls ayant circulé dans le monde.

Les pin up d'Elvgren avaient cet extraordinaire et indéfinissable je ne sais quoi qui le rendit extrêmement populaire auprès du grand public mais lui valut également la jalousie de ses confrères. Une des particularités de son travail était son utilisation ingénieuse de «situations». Il semblait capable d'inventer une inépuisable variété de scénarios astucieux pour le plus grand plaisir de son public. Victimes d'une bourrasque inattendue ou d'une branche d'arbre polissonne, ses belles se retrouvaient invariablement prises au piège de circonstances où leurs charmes étaient dévoilés. Sa grande technique picturale était un autre élément important de son talent. Son style, avec d'épais coups de pinceau et des couleurs fortes à la John Singer Sargent, fut imité par de nombreux confrères, non seulement parce qu'ils l'admiraient mais également parce que les directeurs artistiques en quête d'images capables de faire vendre leurs magazines le leur demandaient.

Earl Moran était un autre grand peintre de pin up et d'art glamour de cette époque. Vers le milieu des années 30, Moran se forgea une réputation comparable à celle d'Elvgren, bien que leurs styles soient fort différents. Souvent plus mélancoliques que les belles d'Elvgren, les pin up au pastel de Moran devinrent très populaires pendant la guerre. Au point que dans son numéro de janvier 1940, Life illustra presque entièrement un article sur les calendriers artistiques avec des œuvres de Moran et une photo de lui dans son atelier en compagnie de sa fille, qui lui servait souvent de modèle.

Rolf Armstrong s'était déjà fait connaître avant la guerre. Pendant les années 20 et 30, ses pastels de beautés glamour avaient paru en couverture de magazines et de partitions musicales, dans des publicités et, naturellement, des calendriers. Toutefois, jusque-là la plupart de ses œuvres étaient de style glamour, ne montrant que le visage du modèle. Au début des années 40, Armstrong s'attaqua aux portraits de belles en pied. Ses pin up des années 40 et 50, comme celles d'Elvgren et de Moran, furent publiées par Brown and Bigelow. Pendant la guerre, cette maison continua d'être le plus grand éditeur américain de calendriers, ce qu'elle est encore aujourd'hui.

Deux femmes peintres de pin up devinrent des superstars dans les années 40 et 50: Zoë Mozert et Pearl Frush. Mozert posait souvent comme son propre modèle, travaillant devant un miroir. Ses pastels de pin up et de beautés glamour, également publiés par Brown and Bigelow, étaient extrêmement populaires en raison de leur qualité mais également du sexe de l'artiste. Pearl Frush partageait les feux de la rampe avec Zoë Mozert, ses ravissantes gouaches paraissant dans les calendriers de Gerlach-Barklow. Les deux artistes travaillèrent régulièrement pour des éditeurs de calendriers et des magazines glamour, où d'innombrables jeunes Américains découvrirent et aimèrent leurs créations.

En 1942 parut la célèbre photo de Betty Grable, The million-dollar legs, qui devait servir d'outil de promotion pour le film Pin up Girl. Les hommes envoyés au front et ceux restés au pays adressèrent plus de vingt mille lettres par semaine aux studios, réclamant à cor et à cri des photos à punaiser aux murs. Quand le

film sortit enfin deux ans plus tard, il fit salle comble dans tout le pays. Les Américains accueillaient les pin up en chair et en os avec autant d'enthousiasme que celles de papier créées par les artistes!

D'autres incarnations de la pin up contribuèrent à remonter le moral des troupes sur le front: Lana Turner, connue comme la «fille au pull-over» depuis 1938, et Ann Sheridan, baptisée la «Oomph Girl» (la fille bath). Dans un concours organisé en 1942 pour élire la plus belle pin up des Etats-Unis, Betty Grable remporta haut la main la première place. Après tout, n'avait-elle pas été couronnée «Reine des pin up» par Movie Stars Parade? En deuxième place arrivait Rita Hayworth dont la photo – en combinaison noire – pour la couverture de Life venait de faire sensation. Ann Sheridan était troisième.

Pendant la guerre, les nez de milliers de bombardiers américains et alliés arborèrent une pin up. Sur chaque base aérienne, les meilleurs artistes se virent confier la mission prestigieuse de peindre une fille sexy sur les fuselages. Les pilotes et leur équipage pensaient que la belle leur porterait chance. Pour les mêmes raisons, les pilotes portaient une pin up peinte sur leur blouson de cuir.

Au fil des années de guerre, les éditeurs de calendriers augmentèrent leur production de pin up, qui devenaient de plus en plus patriotiques. Pendant que les Andrews Sisters chantaient à la radio et que les pin up stars passaient les plats à la Hollywood Canteen, des artistes tels que Elvgren, Moran, Armstrong et Mozert contribuaient de leur mieux à l'effort de guerre. Les éditeurs exploitèrent les pin up et les beautés glamour sous toutes les formes imaginables afin de remonter le moral des troupes et des citoyens qui les soutenaient. Tout au long de la guerre, Esquire publia des Varga Girls en couverture, et Yank (illustration 41) distribuait les images de pin up jusqu'en première ligne. Des magazines populaires comme Life et Look présentaient eux aussi fièrement des pin up en couverture (illustration 42). Des œuvres originales de pin up et d'art glamour figuraient parmi les lots de tombolas organisées pour recueillir des fonds pour les soldats: à cette occasion, le groupe de presse Curtis, propriétaire de The Saturday Evening Post, Ladies' Home Journal et Country Gentlemen donnait régulièrement les originaux qui avaient fait ses couvertures. De Betty Grable à Esquire en passant par Brown and Bigelow, le pays tout entier fut envahi de pin up patriotiques. A leur manière, elles contribuèrent elles aussi à la victoire.

En 1950, l'Amérique et les pin up se trouvaient au seuil d'une nouvelle ère pleine de promesses. Rita Hayworth était devenue la nouvelle reine des pin up et ses films faisaient se déplacer des foules. Lorsqu'éclata la guerre de Corée, le gouvernement la «rappela au service» après avoir été submergé par plus de 2500 lettres par semaine de soldats réclamant sa photo. 1950 vit également la sortie du film The Petty Girl, des studios Columbia, avec Joan Caulfield en vedette. Ce fut un succès colossal. Non seulement les pin up étaient devenues socialement acceptables, mais elles étaient parfaitement intégrées dans la culture populaire de la nation.

En dépit de leur caractère et de leur aspect typiquement américains, les pin up et les beautés glamour trouvèrent également un public hors des frontières. Elles étaient pleines de sex-appeal, sans pour autant inciter à la débauche. Leurs moues séductrices et leurs poses suggestives suscitaient un amusement innocent: le public répondait spontanément à l'humour de ces images.

De la fin des années 30 aux années 50, les pin up constituèrent le motif favori des «punch board» (illustration 43). Disponibles dans toutes les quincailleries de quartier, salons de coiffure pour hommes, bars, salles de gym et stations-service, les punch boards étaient des jeux de hasard très prisés. Sur certains, la pin up était en relief. Vers 1951, les punch boards étaient devenus une industrie prospère rapportant un milliard de dollars de bénéfices par an. La plupart étaient illustrés avec des pin up ou des images glamour.

Pendant et après la Deuxième Guerre mondiale, les pin up et les beautés glamour furent également largement exploitées dans les multiples campagnes de publicité déployées par de grands annonceurs. C'était un excellent moyen de promouvoir leurs produits tout en présentant une image pleine de vie et d'espoir. Coca-Cola était la plus importante de ces firmes. Elle disposait de sa propre écurie d'illustrateurs, rassemblée autour d'Haddon Sundblom. Sundblom, qui avait établi son atelier à Chicago dans les années 20, s'était lui-même rendu très célèbre avec son portrait du père Noël, désormais un classique, qui réapparut dans de nombreuses publicités pour Coca-Cola au fil des ans.

Le «cercle de Sundblom», comme on appelait le groupe d'artistes gravitant autour d'Haddon Sundblom, incluait un grand nombre des meilleurs illustrateurs

de pin up et de beautés glamour de l'époque, dont Joyce Ballantyne, Al Buell, Bill Medcalf, Robert Skemp, Al Moore, Thorton Utz, Jack Whittrup, Al Kortner, Euclid Shook, Harry Ekman, Walt Otto, Vaughn Bass et, surtout, Gil Elvgren. Le travail des proches de Sundblom se distinguait par une technique picturale particulière. De fait, leur pâte picturale épaisse et dense leur valut le surnom officieux «d'école mayonnaise». Leurs œuvres se ressemblaient tellement que les artistes eux-mêmes avaient du mal à les différencier. Pourtant, ils avaient tant de talent que Norman Rockwell lui-même déclarait souvent qu'il aurait bien aimé connaître leur secret, ou ce qu'il appelait «leur éclat ensoleillé». Le groupe était également connu pour la grande générosité qui unissait ses membres, tous s'inspirant librement les uns des autres, dans cet esprit de bonne volonté que Sundblom savait susciter.

Le style Sundblom est particulièrement évident dans une publicité pour Coca-Cola réalisée en 1950 par Elvgren (illustration 44). William Dolwick, autre membre du groupe, peignit une affiche très originale pour la même firme, où deux marins buvant du soda sifflent une pin up qui sort du champ (illustration 45). Comme toutes les œuvres inspirées par Sundblom, la composition est excellente: seul un bout d'écharpe rose apparaissant en bas à droite suggère le passage de la pin up.

Ed Runci, Joyce Ballantyne et Al Buell, trois grands illustrateurs de pin up, partageaient le même format et la même influence artistique. Tous trois travaillaient à l'huile, sur des toiles de 76,2 x 61 cm, et tous firent partie du cercle de Sundblom tôt dans leur carrière. Comme Elvgren, Runci plaçait souvent ses pin up dans des situations narratives. Toutefois, ses fines applications de peinture le distinguaient des autres membres du groupe. On compare souvent Ballantyne à Elvgren en raison de leur style, de leurs couleurs et de leur recours aux images de situations. De fait, les deux artistes collaborèrent étroitement à Chicago. Travaillant à partir des esquisses préliminaires d'Art Frahm, Ballantyne créa la célèbre affiche publicitaire des produits solaires Coppertone, où un chien tire sur le maillot de bain d'une petite fille. Le style de Buell était plus dense que celui de ses deux confrères, même si son travail ressemble au leur à bien d'autres égards.

Harry Ekman et Vaughn Bass, deux autres élèves de Sundblom, furent considérablement influencés par leur travail avec Elvgren avant de voler de leurs propres ailes. Bass fut engagé par l'éditeur de calendriers Louis F. Dow à la fin des années 30 pour retoucher des originaux d'Elvgren. L'éditeur souhaitait en effet réutiliser un grand nombre des pin up réalisées pour lui par Elvgren. Reprenant la même technique crémeuse que son ancien mentor, Bass retravailla principalement les fonds et les costumes, laissant souvent les visages et les corps tels que l'artiste les avait peints. (Heureusement, quelques originaux d'Elvgren sont restés intacts.)

Peu de temps après la guerre, la collaboration entre Alberto Vargas et Esquire prit fin. Le calendrier que publia le magazine en 1947 contenait douze créations de l'artiste, mais ni son nom ni sa signature n'y figuraient. Esquire le remplaça bientôt par Al Moore, l'un des jeunes talents du cercle de Sundblom. Pendant près de dix ans, les étudiantes pin up de Moore, aux antipodes de celles de Vargas, firent l'objet du poster central du magazine. Elles figurèrent également sur les calendriers d'Esquire, qui continuèrent à bien se vendre chaque année (mais moins bien que ceux de Vargas) jusqu'en 1958, quand les photographies remplacèrent les peintures.

Tout au long des années 50, Esquire continua d'être le plus grand promoteur mondial de pin up. Outre Moore, le magazine publiait d'autres artistes doués dont Fritz Willis, Joe DeMers, Ernest Chiriaka, Thornton Utz, Frederick Varady, Eddie Chan, Euclid Shook et Ben-Hur Baz. Tous réalisaient également des couvertures et des illustrations pour de grands magazines nationaux, dont le plus important était The Saturday Evening Post. Cependant, les artistes d'Esquire furent les seuls peintres de pin up et d'art glamour qui réussirent à jongler avec deux carrières parallèles aussi lucratives. La plupart des autres illustrateurs, comme Elvgren, Moran et Mozert, ne travaillaient qu'un seul genre.

Dans l'après-guerre, le magazine True suivit les traces d'Esquire. Au départ, il publia des articles d'aventure, de sports, de voyage et de mode pour un public essentiellement masculin. Il commença par publier chaque mois un poster central avec une Petty Girl. Il y ajouta bientôt des œuvres de Vargas, souvent accompagnées de photos de l'artiste en train de peindre ou de photographier un modèle dans son atelier. En 1947 et 48, Fawcett, une filiale de True, édita deux calendriers de Petty Girls en reprenant exactement le format des calendriers d'Esquire réalisés par Vargas.

Tout au long des années 50, fidèle à sa tradition, Brown and Bigelow continua de commander, produire et distribuer plus de pin up que tout autre éditeur de calendriers. Impressionnée, comme beaucoup dans le monde de l'illustration, par le talent du cercle de Sundblom, la maison fit de ses membres, dont Elvgren, Ballantyne et Buell, les vedettes de son écurie.

Parallèlement, Brown and Bigelow lança une nouvelle collection de calendriers qui devait remporter un énorme succès. Appelée Artist's Sketch Pad (Le cahier d'esquisses de l'artiste), il s'agissait d'un concept déjà lancé par Earl Mac Pherson en 1942. Bien que différents artistes aient travaillé pour cette série (K.O. Munson, Ted Withers, Joyce Ballantyne, Freeman Elliot et Fritz Willis), la collection conservait un aspect homogène grâce à sa présentation qui était toujours la même: le sujet principal, généralement une pin up, occupait le centre de la page et était entouré par deux ou trois de ses esquisses préliminaires. Mac Pherson conçut plus tard une autre version très appréciée de ce format pour la maison d'édition Shaw-Barton, poursuivie ensuite par son assistant, T.N. Thompson.

Comme pendant les années 40, la pin up des années 50 fut dominée par le travail de Gil Elvgren, maître incontesté des illustrateurs de calendriers et d'affiches publicitaires, dont les «girls» continuèrent de faire rêver les Américains jusque dans les années 60. Art Frahm venait juste derrière. Frahm était déjà publié dans les années 40, mais ne devint célèbre que dans les années 60, quand il réalisa une série de pin up autour d'un thème central: une jolie fille surprise dans une situation apparemment banale où, pour une raison ou une autre, elle perd sa petite culotte. Les filles de Frahm et leurs sous-vêtements rebelles, variations sur les situations astucieuses d'Elvgren, firent vendre des millions de calendriers et de gadgets publicitaires. Son éditeur, Joseph C. Hoover and Sons, continua de le publier pendant des années et ses pin up spécialisées constituent un exemple unique de longévité et de succès.

Billy DeVorss, célèbre depuis la fin des années 30, réalisa pendant les années 50 des pin up et des beautés glamour magnifiques. Il travaillait surtout au pastel, parfois à l'huile, et ses pin up de calendrier furent publiées et reproduites tant de fois qu'on en a estimé plus de cinquante millions en circulation dans le monde. Edward D'Ancona était surtout connu pour ses calendriers, mais ses travaux

furent également reproduits sur toutes sortes de supports dont des presse-papiers, des porte-clefs et des portefeuilles.

Bill Medcalf était un autre artiste de pin up accompli qui atteignit son apogée dans les années 60. Ses œuvres, publiées par Brown and Bigelow, rappelaient le style «mayonnaise» du cercle de Sundblom, mais la surface de ses toiles était parfaitement lisse. Son travail pour Brown and Bigelow lui valut de nombreuses commandes de la part d'annonceurs du secteur automobile, d'où la fréquente présence de voitures et d'accessoires de voitures dans ses peintures de pin up.

Autre maître du style «crémeux» du cercle de Sundblom, Walt Otto fit une belle carrière dans la publicité grâce un thème qui devint sa spécialité: la belle paysanne. Qu'elle soit en train de pêcher la truite ou de glaner le foin, l'Otto Girl s'épanouissait au grand air. Souriante, elle portait généralement un short et un chapeau de paille et était accompagnée de son chien fidèle, son meilleur ami et protecteur.

Arthur Sarnoff fut probablement le peintre de pin up le plus pluridisciplinaire des années 50. De 1935 à 1975, il illustra principalement les magazines populaires, notamment *The Saturday Evening Post*. Toutefois, il réalisa également un grand nombre de pin up et beautés glamour de grande qualité, et il est un des rares à s'être fait un nom à la fois dans le secteur des pin up et celui de la publicité et des revues. Il était tellement demandé que les éditeurs de calendriers devaient lui commander des œuvres plusieurs années à l'avance.

Pendant la guerre, le secteur des livres de poche connut un essor sans précédent. Les petits livres, d'un format plus pratique, convenaient parfaitement aux soldats et étaient distribués par l'armée elle-même. Lorsque les hommes rentrèrent au bercail, ils s'y étaient attachés, comme de nombreux Américains. Conscients que la qualité de la couverture était déterminante pour le succès d'un titre, les éditeurs recrutèrent les meilleurs illustrateurs, espérant que leurs créations feraient augmenter les ventes dans les kiosques, les drugstores et les librairies. Les «digests», qui étaient légèrement plus gros que les «poche», étaient également très populaires (illustrations 46 et 47). En 1958, une pin up de Paul Radar parut en couverture d'un roman intitulé *Teacher's Pet* («Le chouchou du prof»; illustrations 48 et 49). Parfois, le texte de la couverture était intégré à l'image, comme dans le cas de *Just Like a Dame* (illustration 50).

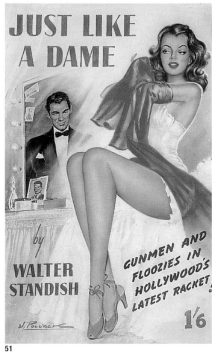

50

51

Au sommet de leur gloire d'après-guerre, les pin up apparurent même sur la couverture de magazines fort respectables, comme *The Saturday Evening Post*. Des artistes comme Norman Rockwell et d'autres, conscients de la puissance de telles images, les incorporaient dans des œuvres qui étaient pourtant d'une tout autre nature. Dans les années 50 et 60, même les calendriers les plus fleur bleue et traditionnels flirtaient avec la pin up. Edward D'Ancona, par exemple, réalisa des illustrations de calendrier sur le thème de la sécurité qui, à de nombreux égards, s'inspiraient de la vision idéalisée de la vie américaine de Rockwell. Mais il ne put s'empêcher d'incorporer une petite pin up *Miss Me* dans toute cette imagerie traditionnelle (illustration 51).

Le calendrier artistique de pin up entama son déclin vers le milieu des années 60. Bien qu'ayant introduit la photographie dans leurs autres lignes de calendriers dès la fin des années 40, les éditeurs étaient jusque-là restés fidèles aux peintures de pin up. Le premier coup fut donné en janvier 1964, en Angleterre, par le fabricant de pneus Pirelli, qui publia le premier calendrier photographique de pin up de la firme. Robert Freeman (ex-photographe des Beatles), associé au directeur artistique Derek Forsyth et au styliste Derek Birdsall, réalisa un calendrier qui acheva de faire basculer le goût du public vers les pin up photographiées.

Un artiste de pin up et d'art glamour resta toutefois populaire jusque dans les années 70. Fritz Willis s'était fait connaître dans les années 40 à travers *Esquire*. Lorsque la publication perdit Vargas après la guerre, elle employa très souvent Willis pour tenter de combler le vide. Elle le choisit également en 1946 comme premier artiste à collaborer à la prestigieuse série *Esquire Gallery*. Willis poursuivit sa brillante collaboration avec *Esquire* pendant les années 50 et devint une superstar en 1962 avec ses premiers Artist Sketch Book et Memo Calendar pour Brown and Bigelow.

Les femmes de Willis n'étaient pas que sexy. Elles créaient autour d'elles une atmosphère érotique et étaient extrêmement sophistiquées et provocantes, implicitement ou explicitement. Willis les représentait en déshabillés transparents ou en bas de soie et se caressant subrepticement les seins. Dans un grand nombre de ses toiles, il peignait une coupe remplie de fruits, une bouteille de vin ou un paquet de cigarettes, comme autant d'accessoires suggestifs. Ses pin up étaient

des femmes du monde élégantes et sensuelles qui avaient une manière bien à elles d'interpeller le spectateur. La réputation de Willis ira sans doute grandissante car il est de plus en plus reconnu comme un grand maître de la pin up.

En 1975, année de la parution des derniers Artist Sketch Book et Memo Calendar de Willis, il ne restait plus qu'un autre illustrateur de pin up et d'art glamour qui continuait à ravir le public américain et à satisfaire les directeurs artistiques de Brown and Bigelow. Mayo Olmstead avait travaillé pour le premier éditeur américain de calendriers pendant plus d'un quart de siècle. Dans les années 70, les femmes d'Olmstead devinrent plus modernes, répondant au goût du jour et préparant la transition de Brown and Bigelow vers les pin up et les beautés photographiées.

Vers le milieu des années 70, presque tous les éditeurs américains recouraient aux photographes de mode plutôt qu'aux illustrateurs pour orner leurs calendriers de pin up et de beautés glamour. Avec leurs top modèles photographiées dans des lieux exotiques, les calendriers évoluèrent vers une nouvelle forme d'art populaire qui perdure encore aujourd'hui. Leurs pin up ne faisant plus recette, les illustrateurs se tournèrent vers le portrait, d'autres formes de peintures de chevalet, ou rangèrent simplement leurs pinceaux. L'avènement de la photographie mit également fin à la carrière des illustrateurs traditionnels qui travaillaient pour la publicité et la presse populaire. Quelle que soit leur sphère d'activité, la plupart de ces artistes-illustrateurs commencent tout juste à être reconnus pour leur véritable contribution à l'histoire de l'art américain.

Dans les presque cent années qui se sont écoulées entre la première Gibson Girl et la dernière Willis Girl, les pin up et l'art glamour ont rendu un vibrant hommage à la beauté, à la vitalité et au charme de la femme américaine. Adulées par des générations d'Américains des deux sexes, les pin up ont constitué un chapitre riche et significatif de la culture, de la société et de l'art américains du vingtième siècle.

Note: les pages qui suivent sont divisées en trois parties. La première présente les artistes dont le travail est apparenté au style Art déco qui prévalait au début du siècle. La seconde, comptant le plus grand nombre de pin up et de beautés gla-

50. N. POLLACK
FRONT COVER FOR "JUST LIKE A DAME"
GOUACHE ON BOARD, 1948
UMSCHLAG VON „JUST LIKE A DAME"
GOUACHE AUF KARTON, 1948
COUVERTURE DE «JUST LIKE A DAME»
GOUACHE SUR CARTON, 1948

51. EDWARD D'ANCONA
MISS ME
OIL ON CANVAS, REPRODUCED IN A
CALENDAR ON SAFETY, 1960
ÖL AUF LEINWAND, REPRODUZIERT IN EINEM
KALENDER ZUM THEMA SICHERHEIT, 1960
HUILE SUR TOILE, REPRODUITE DANS UN
CALENDRIER SUR LA SÉCURITÉ, 1960

mour, présente les principaux artistes ayant presque entièrement consacré leur carrière à ce genre. Dans la troisième figurent, pour des raisons historiques, les artistes ayant réalisé quelques incursions dans ce domaine.

Jusqu'à récemment, les pin up et les beautés glamour n'avaient jamais été traitées ou distribuées par les réseaux habituels du monde de l'art. Les œuvres présentées ici n'ont donc jamais été méthodiquement répertoriées, mesurées ni décrites. Créées pour être reproduites et publiées, elles étaient livrées aux éditeurs contre des honoraires. Les artistes demandaient rarement et récupéraient encore moins souvent leurs originaux, dont les éditeurs disposaient à leur guise.

Les artistes ne donnaient pas non plus de titres à leurs œuvres, laissant ce soin aux rédacteurs et aux publicitaires. La même image pouvait réapparaître sous différents formats à des années d'intervalle et sous des titres différents (parfois jusqu'à trois ou quatre). Les originaux n'étaient jamais mesurés et les éditeurs ne notaient pas les techniques utilisées. Les artistes ne dataient pas leurs originaux, qui étaient publiés parfois plusieurs années après leur exécution. Par conséquent, les dates indiquées ont été déterminées à quelques années près.

Compte tenu de ces circonstances, nous nous sommes contentés d'attribuer un numéro à chaque œuvre, afin de faciliter les références à venir. Dans les brèves biographies d'artistes, nous avons essayé, dans la mesure du possible, d'indiquer la date approximative, la technique et les dimensions habituelles de chaque grande série ou type d'images.

American Pin-Up Artists
1920–1980

Vaughan Alden Bass

Alden's *Keep 'Em Flying* (figure 52) was one of the most famous pin-up images ever published. As a symbol of America's determination to win World War II, it was published in every conceivable calendar size, from tiny prints of 2 x 3 inches (5.1 x 7.6 cm) to giant wall hangers of 30 x 20 inches (76.2 x 50.8 cm). It also appeared on a popular mutoscope card.

Bass appears to have been strongly influenced by the circle of artists that grew up around Haddon Sundblom. He was a Chicago artist who began his pin-up career working for the Louis F. Dow Company in St. Paul during the mid- to late 1930s.

Bass created his own pin-ups for Dow, but he was also employed as a "paint-over" artist, commissioned to redo the work that Gil Elvgren had previously created for the company. Dow was motivated by economic interests, hoping to earn more money from such "redesigned" Elvgrens. Fortunately, Bass was a skilled and sensitive artist: he strove to leave the faces, hands, skin, and other key areas of the Elvgrens essentially untouched. However, he occasionally had to repaint an arm or hand because it had to be repositioned to accommodate a new overpainted image.

Bass's painting style was often compared to that of Elvgren, Buell, and Ballantyne. He worked in oil on canvas in almost the same sizes as the others, ranging from 30 x 24 inches (76.2 x 61 cm) to 28 x 22 inches (71.1 x 55.9 cm). In the 1950s, the versatile Bass did a series of spectacular oils depicting wrestling scenes that clearly demonstrated his ability to be comfortable with any subject matter.

Aldens Keep 'Em Flying *(Abb. 52) war eines der berühmtesten Pin-ups, die je veröffentlicht wurden. Es symbolisierte den Willen und die Entschlossenheit Amerikas, den Zweiten Weltkrieg zu gewinnen und wurde in jeder nur vorstellbaren Kalendergröße publiziert, vom Kleinformat (5 x 8 cm) bis hin zu übergroßen Wandkalendern (76 x 51 cm). Es war auch ein beliebtes Thema für Mutoskopkarten. Vaughn malte in den frühen 60er Jahren gelegentlich unter dem Namen Alden.*

In den 40er und 50er Jahren zählte Vaughn Bass zum Kreis der besten Pin-up-Künstler. Seine Arbeit war nachhaltig von der Künstlergruppe um Haddon Sundblom beeinflußt. Der Chicagoer Bass begann seine Karriere im Pin-up-Genre bei der Louis F. Dow Company in St. Paul, für die er von Mitte bis Ende der 30er Jahre tätig war.

Dort kreierte er eigene Pin-ups, war aber auch als „Recycling"-Künstler im Verlag angestellt: Er übermalte und retuschierte die von Gil Elvgren geschaffenen Arbeiten. Dow war an diesem Auftrag aus finanziellen Gründen interessiert und erhoffte sich von alten Elvgrens mit neuem Design höhere Einnahmen. Glücklicherweise war Bass ein sensibler und fähiger Künstler: Er suchte Hände, Gesichter, Hauttöne und andere typische Elvgren-Merkmale nicht zu verändern. Doch manchmal mußte er schon einen Arm oder eine Hand neu malen, damit sie in einem neuen Motiv noch einen Sinn ergaben.

Seine Malerei wurde oft mit der von Elvgren, Buell und Ballantyne verglichen. Er arbeitete in Öl auf Leinwand und verwendete dabei fast die gleiche Formatgröße wie sie (zwischen 76 x 61 cm und 71x60cm). In den 50er Jahren zeigte Bass mit einer Serie von Ringkampfszenen seine künstlerische Wandlungsfähigkeit; er schien mit jedem Thema umgehen zu können. Er schuf das „Wonder Bread Girl" in den fünfziger Jahren, wobei ihm seine Tochter Nancy Modell stand. Sein Porträt von Präsident Dwight D. Eisenhower hängt im Smithsonian Institution in Washington D. C.

La pin up d'Alden, *Keep 'Em Flying* (illustration 52), fut l'une des plus célèbres jamais publiées. Symbole de la détermination de l'Amérique à gagner la Deuxième Guerre mondiale, elle parut sur des calendriers de toutes les dimensions imaginables, de minuscules reproductions de 5,1 x 7,6 cm à de grands cintres de 76,2 x 50,8 cm. Elle fit également l'objet de cartes d'art très prisées.

Un des meilleurs artistes de pin up des années 40 et 50, Bass semble avoir été considérablement influencé par le cercle d'artistes rassemblés autour d'Haddon Sundblom. Originaire de Chicago, il commença sa carrière de peintre de pin up entre 1935 et 1940 auprès de l'éditeur de calendriers de Saint Paul, Louis F. Dow.

Bass créait ses propres pin up pour Brown and Bigelow, mais il fut également engagé par la compagnie Louis F. Down pour retoucher les œuvres originales que Gil Elvgren avait réalisées pour elle des années plus tôt. Pour Bass, il s'agissait d'un travail purement alimentaire. Heureusement, cet artiste doué et sensible s'arrangea pour laisser les visages, les mains, la peau et les autres parties importantes des créations d'Elvgren pratiquement intactes. Toutefois, il lui fallait parfois repeindre une main ou un bras pour adapter le sujet à une nouvelle situation.

On a souvent comparé le style de Bass à celui d'Elvgren, de Buell et de Ballantyne. Il travaillait à l'huile sur des toiles aux dimensions similaires aux leurs, entre 76,2 x 61 cm et 71,1 x 55,9 cm. Dans les années50, cet artiste pluridisciplinaire peignit une magnifique série de scènes de lutte gréco-romaine, démontrant ainsi son aisance à traiter toutes sortes de sujets. Vers la même époque, il créa également la «Wonder Bra Girl», en se servant de sa fille Nancy comme modèle. Son portrait du président Dwight D. Eisenhower est aujourd'hui à la Smithsonian Institution de Washington.

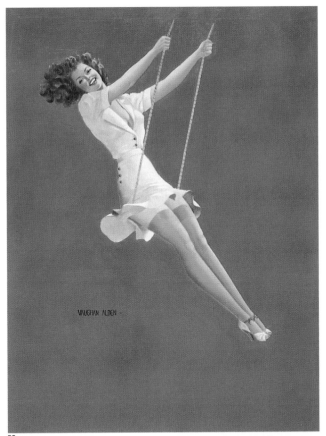

52

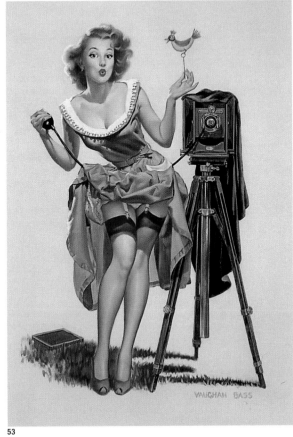

53

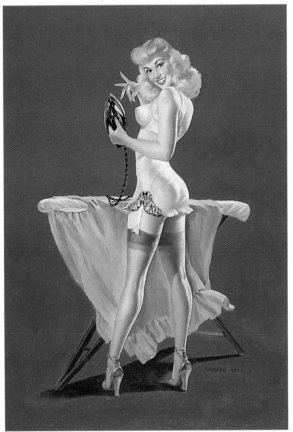

54

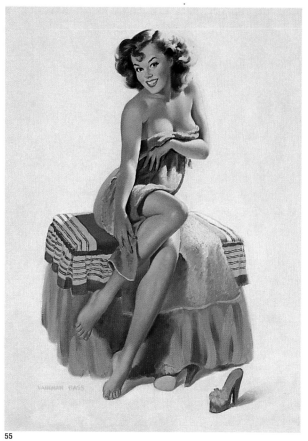

55

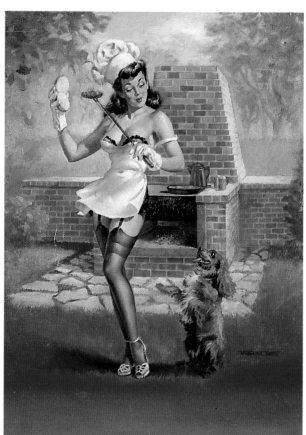

56

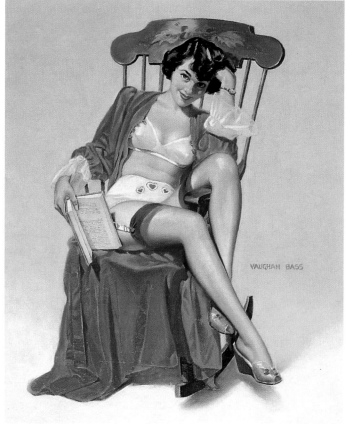

57

Arnold Armitage

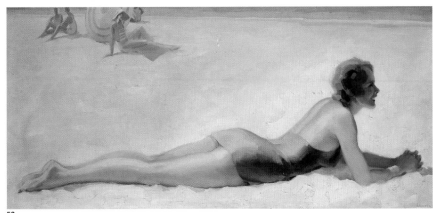

58

The British-born artist and illustrator Arnold Armitage was known to both English and American audiences simply by his last name. Upon moving to the United States about 1925, Armitage settled in Hollywood and went to work for the Foster and Kleiser Company, which produced advertising billboards. During the 1930s, he developed a reputation as an innovative modern designer specializing in roadside and highway billboards, and he went on to design many of these for American corporations.

Also in the 1930s, Armitage created a series of paintings for an American beer company that depicted young couples sharing romantic moments such as fishing from a small boat that glowed under a sunny, golden afternoon light. Armitage's

colors in those works were influenced by the Sundblom/Chicago Art Institute/ Academy of Art school.

About 1940, Armitage began a series of paintings of "pretty girl" subjects for the calendar market. Although not strictly pin-ups, Armitage's calendar girls were very reminiscent of the work of Gil Elvgren. Continuing to paint in the rich, lush style of the Sundblom school, he employed vivid colors and worked mostly in a large-size, oil-on-canvas format. Armitage's pretty girls were well received both in the United States and in England. In fact, all of Armitage's work commanded respect; he was equally adept and successful in calendar, advertising, and commercial art.

Der Maler und Illustrator Arnold Armitage war gebürtiger Engländer. Als er 1925 in die Vereinigten Staaten übersiedelte, wählte Armitage Hollywood als Heimat und arbeitete dort für die Foster and Kleiser Company. Während der 30er Jahre spezialisierte er sich auf Werbetafeln für Autobahnen und Überlandstraßen und machte sich auf diesem Gebiet als innovativer Designer einen Namen. Für viele amerikanische Großunternehmen entwarf er in der Folgezeit solche überdimensionalen Billboards.

Ebenfalls in den 30er Jahren entstand seine Bilderserie für eine amerikanische Bierbrauerei. Junge Pärchen zelebrierten ihr romantisches Tête-à-Tête in der freien Natur, zum Beispiel beim Fischen auf einem kleinen Boot, das von der Nachmittagssonne golden beschienen wurde. Armitages Farbpalette war in die-

sen Bildern von der Sundblom-Schule, dem Art Institute of Chicago und der Academy of Art beeinflußt.

Um 1940 begann Armitage die Arbeit an einer Bilderserie mit dem Thema „hübsche Mädchen", die für den Kalendermarkt gedacht war. Obwohl sie nicht im engsten Sinne des Wortes „Pin-ups" sind, erinnern seine Kalender-Girls doch sehr an die Arbeiten von Gil Elvgren. Armitage arbeitete weiterhin in dem satten Stil der Sundblom-Schule, setzte kräftige Farben ein und malte meist in Öl auf großformatigen Leinwänden. Seine hübschen Mädchen kamen nicht nur in den Staaten gut an, sondern auch jenseits des Atlantiks in England. Auf allen Ebenen seines beruflichen Schaffens war Armitage anerkannt: als Werbegrafiker, bei der Konzeption und Ausführung von Anzeigen und bei seiner Arbeit für Kalenderverlage.

D'origine anglaise, Arnold Armitage était connu du public britannique et américain simplement comme «Armitage». Il émigra aux Etats-Unis vers 1925. Etabli à Hollywood, il commença par travailler pour l'agence Foster and Kleiser, spécialisée dans les grands panneaux publicitaires. Pendant les années 30, il se forgea une solide réputation d'innovateur dans le secteur des affiches géantes destinées à border les routes et les autoroutes et reçut de nombreuses commandes de grands annonceurs.

Vers la même époque, il créa une série d'affiches pour une brasserie montrant de jeunes amoureux dans diverses occupations romantiques, comme pêchant depuis une barque dans une lumière dorée de fin d'après-midi. Les couleurs utili-

sées dans ces œuvres témoignent de l'influence du cercle de Sundblom, de l'Art Institute de Chicago et de l'Academy of Art School.

Vers 1940, Armitage réalisa une série de «pretty girls» pour calendriers. Bien qu'il ne s'agisse pas de pin up à proprement parler, les belles d'Armitage rappelaient indubitablement le travail de Gil Elvgren. Utilisant la palette riche et les traits épais du cercle de Sundblom, il travaillait principalement à l'huile sur des toiles de grand format. Les jolies filles d'Armitage furent bien accueillies tant aux Etats-Unis qu'en Grande-Bretagne. De fait, l'ensemble de son œuvre est remarquable. Tout au long de sa carrière, il navigua avec la même aisance et le même succès entre l'industrie des calendriers, la publicité et les illustrations de magazines.

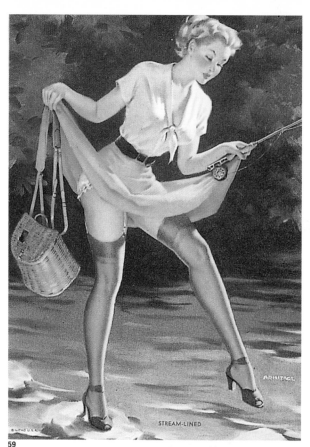

59

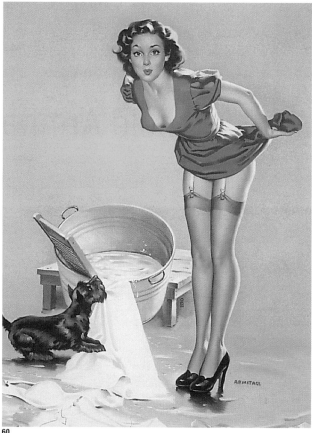

60

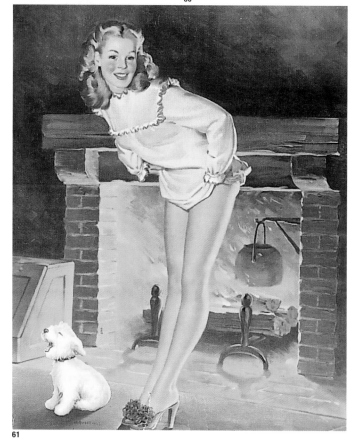

61

Rolf Armstrong

Born in Seattle in 1899, Armstrong grew up in the rugged environment of the Pacific Northwest. He moved to Chicago in 1908 and later enrolled at the Art Institute, where he studied for three years under the master draftsman John Vanderpoel. He then went on to New York, where he became a student of Robert Henri. Athletic as well as artistic, Armstrong both boxed and sketched at the New York Athletic Club; his early pictures regularly featured sailors, boxers, and cowboys.

After a trip in 1919 to study art at the Académie Julian in Paris, Armstrong established a studio in Greenwich Village and started to paint Ziegfeld Follies girls. In 1921, he went to Minneapolis-St. Paul to study calendar production at Brown and Bigelow. A perfectionist all his life, Armstrong mastered the technical aspects of modern publishing because he wanted his work to have the same "freshness and beaming color" on paper as on canvas. Not surprisingly, he refused to work from photographs, and his search for the perfect model was unending.

During the 1920s and 30s, Armstrong's work appeared on numberless pieces of sheet music as well as on the front covers of many mainstream and theater and film magazines. All the great stars posed for his glamorous portraits – Mary Pickford, Greta Garbo, Marlene Dietrich, Katherine Hepburn; he even persuaded Boris Karloff to pose for him on the set of *Frankenstein*.

Armstrong's covers for *Pictorial Review* were largely responsible for the magazine's achieving, by 1926, a circulation of more than two million copies per issue. A year later, Armstrong emerged as the best-selling calendar artist at Brown and Bigelow. RCA hired Armstrong in 1930 to paint pin-ups to advertise their products, and by 1933 his popularity was so great that the Thomas D. Murphy Company signed him to produce a series of ten paintings for their line – an honor shared only by Billy DeVorss.

Armstrong maintained a "fantasy mansion" on Little Neck Bay in Bayside, Long Island, complete with a lagoon and sailboats for his friends to enjoy. Because light was so crucial to his work, he often painted his models outdoors in the glow of the setting sun. Employing an extraordinary selection of pastel colors for most of his work, Armstrong also at times utilized charcoal, pencil, and oils. In the mid-1930s, the artist realized his quest for the "perfect, dream-come-true model" when he met Jewel Flowers, whom he later adopted. He lived in Hollywood, from 1935 to 1938, then returned to New York.

In 1943, Armstrong joined Earl Moran, Zoë Mozert, and Norman Rockwell as the guest artists at a War Advertising Conference in Minneapolis-St. Paul. With Jewel Flowers by his side, the articulate and elegant Armstrong generated a lot of press. When asked why he insisted on a live model, Armstrong said, "When I paint, I want the living person in front of me. As I look at her again and again and again while I work, I get a thousand fresh, vivid impressions. ... all the glow, exuberance, and spontaneous joy that leaps from a young and happy heart." (The last Armstrong model to have these qualities was Patty Jenkins.)

Armstrong was inspired by the glitter of society, and he appreciated beauty in people, cars, furniture, fabrics, and, of course, in art. A collector of swords and antique lances, he built one of the greatest private collections of ancient weapons in America. He died on February 22, 1960, on the island of Oahu in Hawaii, surrounded by his beloved blue ocean and tropical winds.

Armstrong's artistry was an amalgam of brilliant lighting techniques, magnificent vivid colors, superior craftsmanship, and beautiful subjects – his vivacious, spirited ideals of American femininity.

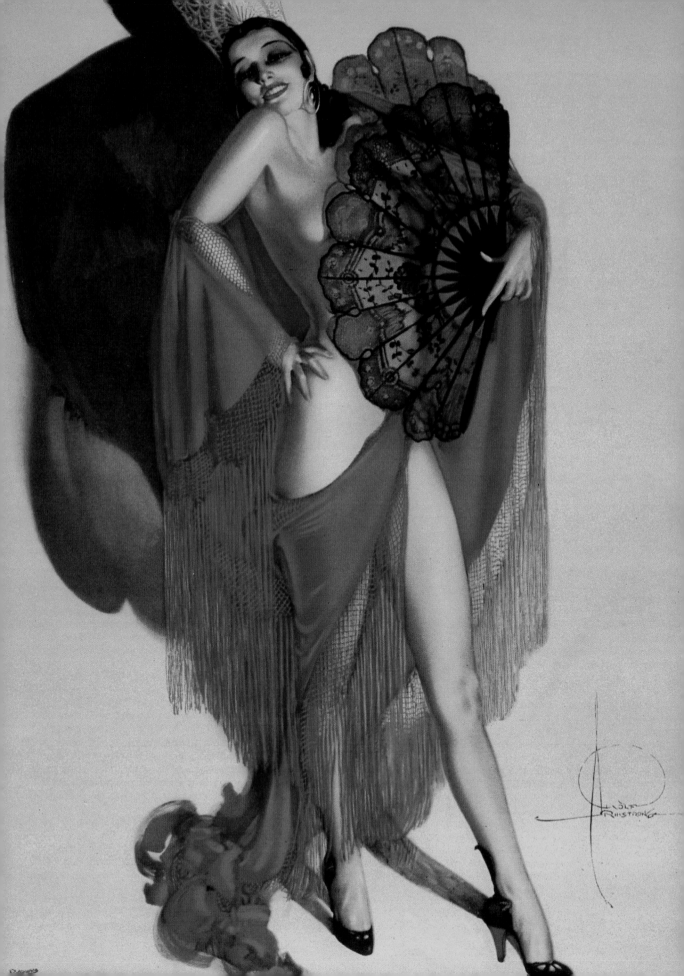

Armstrong wurde 1899 in Seattle geboren und wuchs im harten Klima des pazifischen Nordwestens auf. 1908 zog er nach Chicago; später schrieb er sich am dortigen Art Institute ein und studierte drei Jahre unter dem Zeichner John Vanderpoel, bevor er in New York bei Robert Henri sein Studium fortsetzte. Armstrong war nicht nur ein Künstler, sondern auch Sportler: Er boxte im New York Athletic Club, wo er gleichzeitig auch Skizzen anfertigte. In seinen frühen Arbeiten tauchten regelmäßig Matrosen, Boxer und Cowboys auf.

1919 reiste er nach Paris, um dort an der Académie Julian zu studieren. Nach seiner Rückkehr nach New York richtete er sich in Greenwich Village ein Studio ein und begann, die Mädchen der Ziegfeld Follies zu zeichnen. 1921 ging er nach Minneapolis-St. Paul, um dort bei Brown and Bigelow die Produktion von Kalendern zu lernen. Er war Perfektionist. Armstrong wollte die technische Seite des modernen Verlagswesens beherrschen, denn er hatte den Ehrgeiz, daß seine Arbeiten als Druck die gleiche „Frische und strahlende Farbe" besaßen wie das Leinwandoriginal. Deshalb überrascht weder, daß er sich weigerte, nach Fotografien zu arbeiten, noch, daß seine Suche nach dem perfekten Modell eine nie endende war.

Während der 20er und 30er Jahre veröffentlichte Armstrong seine Arbeiten als Lose-Blatt-Sammlungen und auf den Titelblättern vieler Zeitschriften und Film- und Theatermagazine. Die großen Stars posierten alle für ihn: Mary Pickford, Greta Garbo, Marlene Dietrich und Katharine Hepburn. 1935 gelang es ihm sogar, Boris Karloff am Drehort von Frankenstein zu einer Sitzung zu überreden.

Armstrongs Titelillustrationen verdankt die Zeitschrift Pictorial Review zu einem großen Teil ihre Auflage von über zwei Millionen ab 1926. Ein Jahr später wurde Armstrong mit seinen Kalendern der bestverkaufte Maler bei Brown and Bigelow. Die Plattenfirma RCA beauftragte ihn 1930 mit Pin-ups, die für ihre Produkte werben sollten. 1933 war seine Popularität so groß, daß ihn die Thomas D. Murphy Company mit einer Serie von zehn Arbeiten für ihr Programm beauftragte – eine Ehre, die neben ihm nur Billy DeVorss zuteil wurde.

In Little Neck Bay bei Bayside auf Long Island hatte sich Armstrong ein „Haus der Phantasie" mit Lagune und Segelbooten gebaut, die auch seinen Freunden zur Verfügung standen. Da das Licht in seinen Arbeiten eine so große Rolle spielte, arbeitete er mit seinen Modellen oft im Freien im Glanz der untergehenden Sonne. Armstrong verwendete in den meisten seiner Arbeiten eine ungewöhnliche Pastell-palette, manchmal aber auch Kohle, Bleistift oder Ölfarben. Mitte der 30er Jahre fand er endlich sein Modell: „ein perfekter, Fleisch gewordener Traum". Es war Jewel Flowers, die er später adoptierte. Zwischen 1935 und 1938 lebte er in Hollywood, ging dann aber nach New York zurück.

1943 war Armstrong zusammen mit Earl Moran, Zoë Mozert und Norman Rockwell einer der geladenen Künstler bei einer in Minneapolis-St. Paul stattfindenden War Advertising Conference. Mit Jewel Flowers an seiner Seite erregte der eloquente und elegante Armstrong reichlich Aufsehen. Gefragt, warum er auf einem lebenden Modell bestehe, antwortete Armstrong: „Wenn ich male, möchte ich die lebende Person vor mir sehen. Und während ich sie beim Malen wieder und wieder anschaue, bekomme ich Tausende neuer, lebhafter Eindrücke (…) ein Leuchten, Überschwenglichkeit und spontane Freude, wie sie aus einem jungen und glücklichen Herzen stammen." Das letzte Modell von Armstrong, das diese Qualitäten besaß, war Patty Jenkins.

Gesellschaftlicher Glanz inspirierte Armstrong, und er wußte Schönheit zu schätzen – bei Menschen, Autos, Möbeln, Stoffen und natürlich in der Kunst. Er sammelte Schwerter und alte Lanzen und baute eine der größten Privatsammlungen des Landes für alte Waffen auf. Am 22. Februar 1960 starb Armstrong auf der hawaiianischen Insel Oahu, umgeben von tropischen Winden und seinem geliebten Pazifik.

Seine Kunst war eine Mischung aus brillanter Lichttechnik, wunderbar lebendigen Farben und ausgezeichnetem handwerklichem Können, in deren Mittelpunkt das Thema Schönheit stand: sein Idealbild amerikanischer Weiblichkeit, temperamentvoll, mutig, feurig.

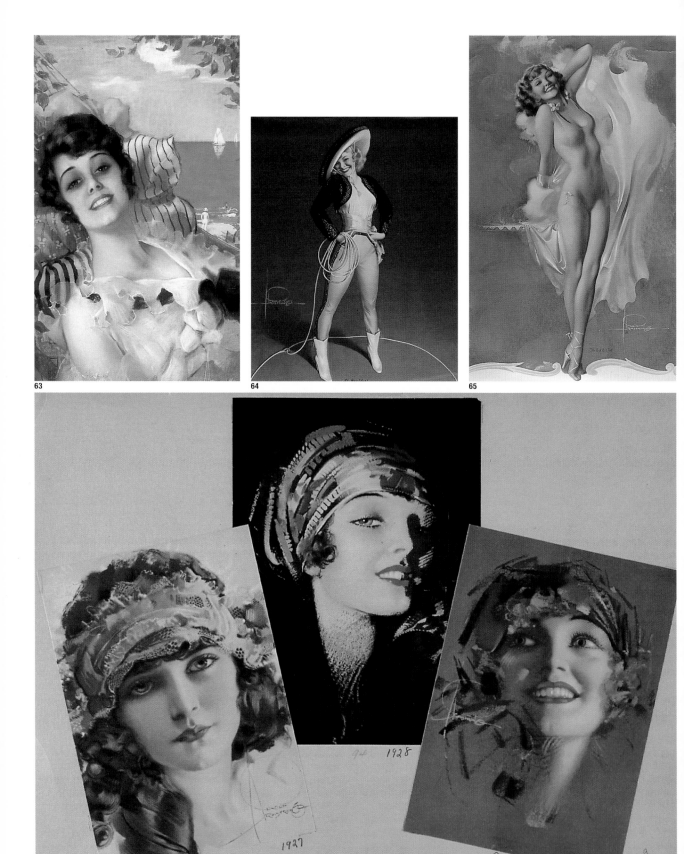

63

64

65

66

Né à Seattle en 1899, Armstrong grandit dans les paysages sauvages du nord-ouest américain. Sa famille emménagea à Chicago en 1908, où il s'inscrivit plus tard à l'Art Institute. Il étudia trois ans avec le grand maître du dessin John Vanderpoel. Il alla ensuite à New York où il devint l'élève de Robert Henri. Sportif et artiste de talent, il fréquentait le New York Athletic Club, tantôt boxant tantôt faisant des esquisses des athlètes. Ses premières peintures représentaient régulièrement des marins, des boxeurs et des cow-boys.

Après un séjour à Paris en 1919 pour suivre des cours à l'Académie Julian, Armstrong ouvrit un atelier dans le Greenwich Village de Manhattan et commença par peindre des girls des Ziegfeld Follies. En 1921, il se rendit au siège de Brown and Bigelow à Minneapolis-Saint Paul pour y étudier la production de calendriers. Perfectionniste, il apprit à maîtriser les techniques modernes d'imprimerie afin que ses œuvres reproduites conservent toute leur «fraîcheur et vivacité de couleurs». Il refusait de travailler d'après des photographies et était perpétuellement en quête du modèle parfait.

Pendant les années 20 et 30, son travail parut sur d'innombrables partitions musicales ainsi qu'en couverture de magazines grand public, de revues de théâtre et de cinéma. Toutes les grandes stars posèrent pour lui : Mary Pickford, Greta Garbo, Marlene Dietrich, Katherine Hepburn, etc. Il persuada même Boris Karloff de poser pour un portrait sur le plateau de *Frankenstein*.

C'est en grande partie grâce à ses couvertures qu'en 1926, *Pictorial Review* atteignit un tirage de plus de deux millions d'exemplaires par numéro. Un an plus tard, Armstrong était l'artiste qui faisait vendre le plus de calendriers à Brown and Bigelow. En 1930, la R.C.A. lui commanda une série de pin up publicitaires pour vanter ses produits. Vers 1933, il avait acquis une telle notoriété que l'éditeur de calendriers Thomas D. Murphy lui passa commande de dix œuvres, un honneur que seul DeVorss partagea.

Armstrong possédait un «manoir de rêve» à Bayside, Long Island, avec son lagon privé et plusieurs voiliers pour le plus grand plaisir de ses amis. La lumière étant essentielle dans sa peinture, il peignait ses modèles en extérieur, à la lueur du soleil couchant. Dans la plupart de ses toiles, il utilisait une extraordinaire palette de pastels mais savait aussi bien manier le fusain, le crayon et les huiles. Vers le milieu des années 30, l'artiste découvrit enfin le modèle idéal, «une créature de rêve», en la personne de Jewel Flowers, qu'il adopta plus tard. Il vécut à Hollywood entre 1935 et 1938, avant de revenir à New York.

En 1943, Armstrong fut invité, avec Earl Moran, Zoë Mozert et Norman Rockwell, à participer à la «War Advertising Conference» de Minneapolis-Saint Paul (Conférence sur la campagne de mobilisation). Accompagné de Jewel Flowers, l'élégant et éloquent Armstrong fit couler beaucoup d'encre. Quand on l'interrogea sur son besoin de peindre les modèles d'après nature, il répondit: «Quand je peins, il me faut le sujet en chair et en os en face de moi. A force de l'observer sous toutes les facettes tout en travaillant, il me vient sans cesse une multitude d'impressions nouvelles et palpitantes. Je perçois toute la lumière, l'exubérance et la joie qui jaillissent spontanément d'un cœur jeune et heureux» (le dernier modèle d'Armstrong à avoir toutes ces qualités fut Patty Jenkins).

Armstrong puisait son inspiration dans l'éclat de la société dans laquelle il vivait. Il aimait la beauté sous toutes ses formes: hommes et femmes, automobiles, meubles, étoffes et, naturellement, œuvres d'art. Collectionneur d'épées et de lances, il rassembla l'une des plus belles collections d'armurerie ancienne des Etats-Unis. Il s'éteignit le 22 février 1960, sur l'île de Oahu à Hawaï, bercé par cet océan bleu et ces vents tropicaux qu'il aimait tant.

L'art d'Armstrong était un amalgame d'éclairages savants, de somptueuses couleurs vives, de grande maîtrise technique et de superbes femmes – sa vision débordante d'énergie de l'idéal féminin.

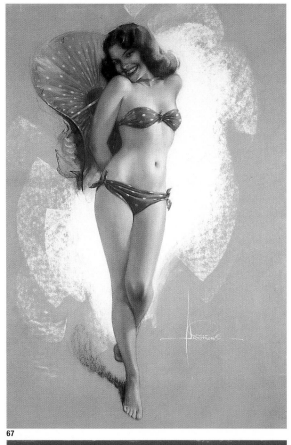

67

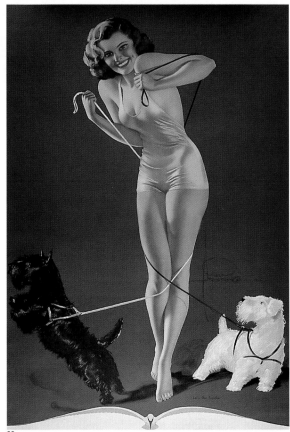

68

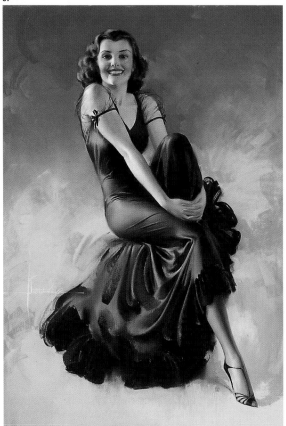

69

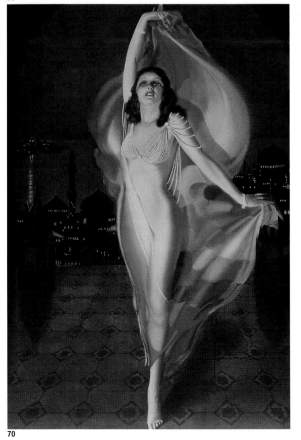

70

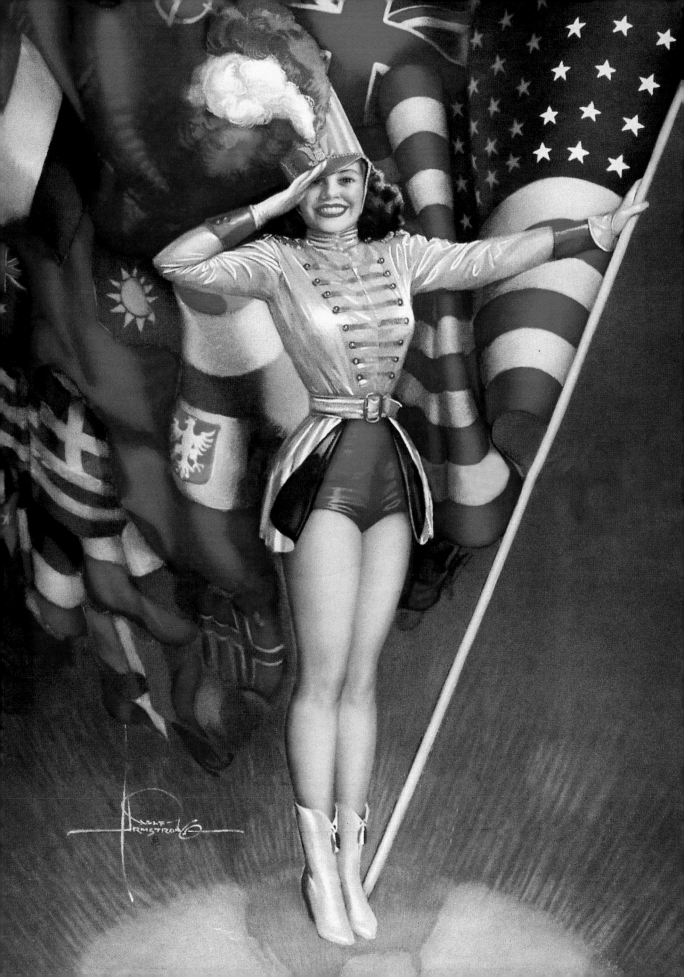

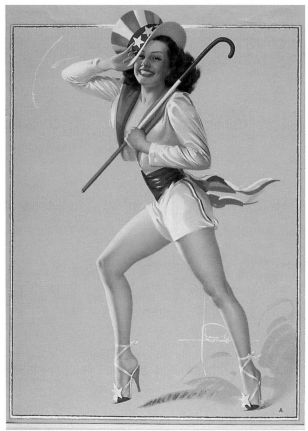

72

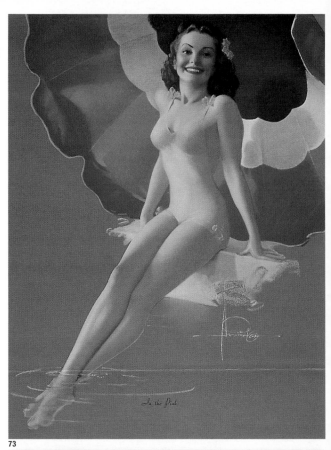

73

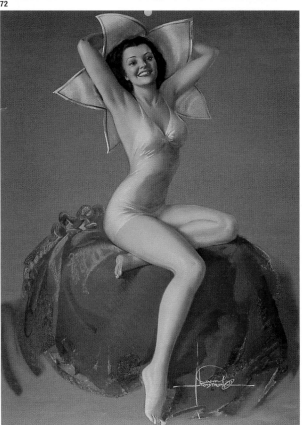

74

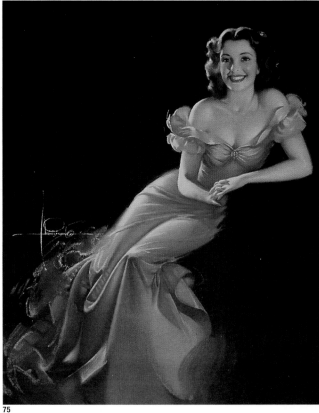

75

90 | ROLF ARMSTRONG

76 ▷

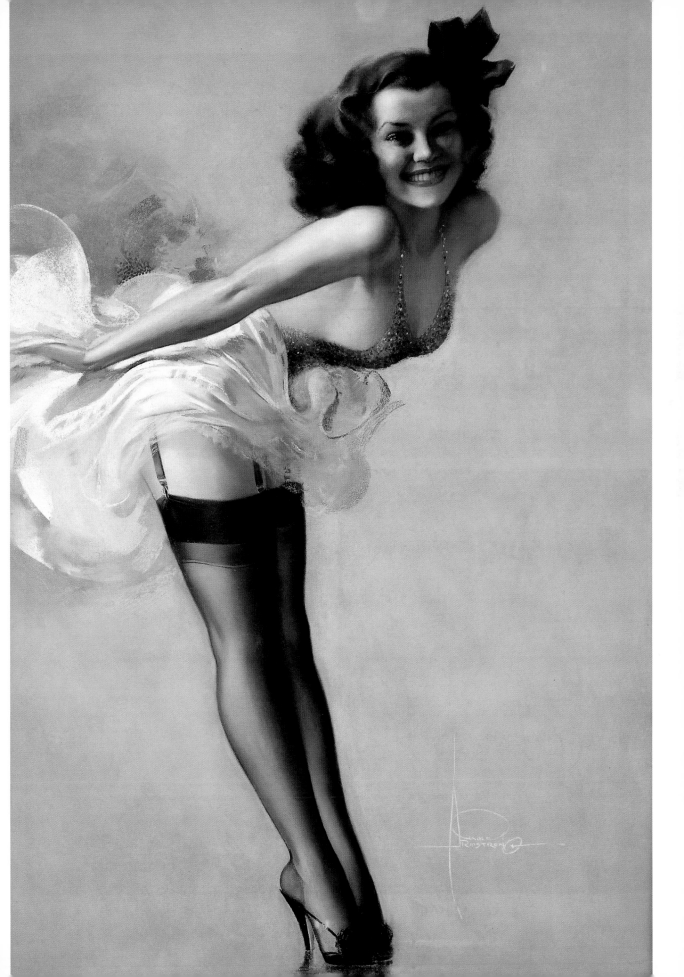

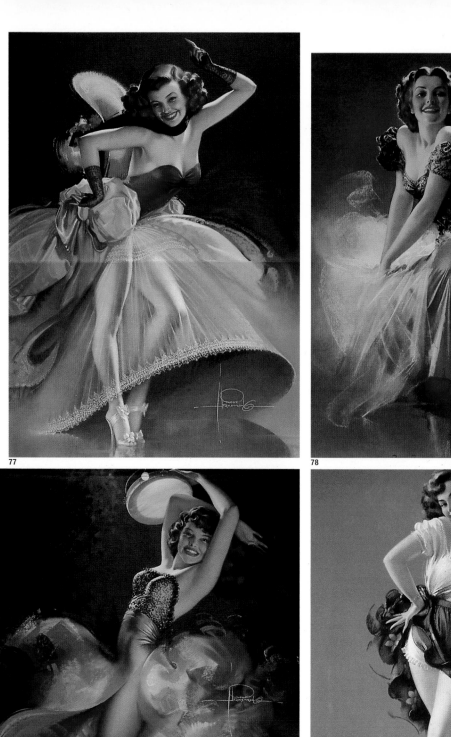

77

78

79

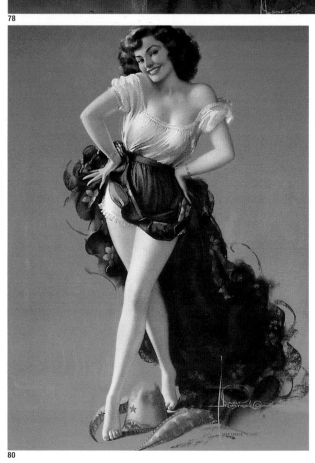

80

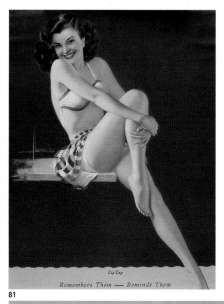

Remembers Them — Reminds Them

81

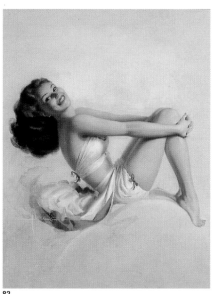

82

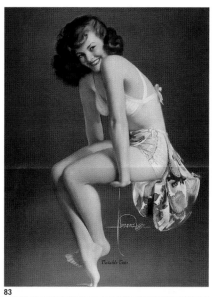

83

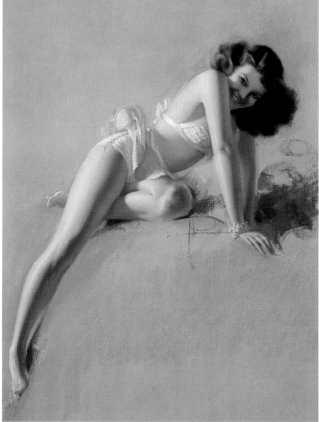

84

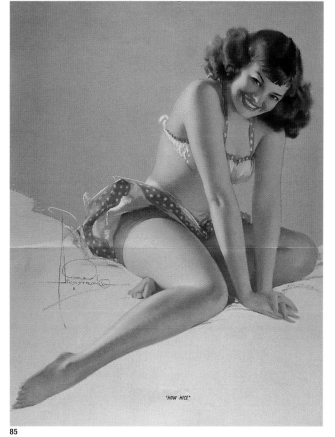

"HOW NICE"

85

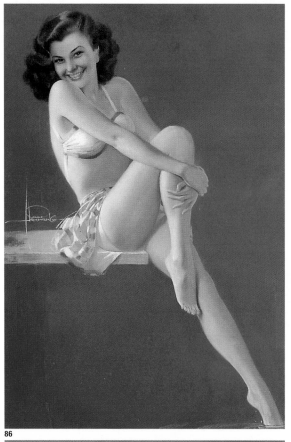

86

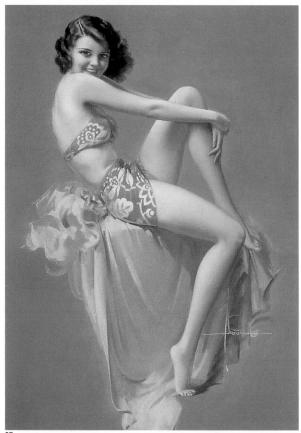

87

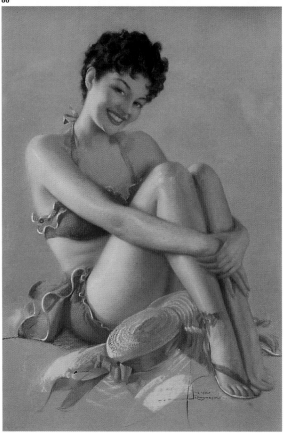

88

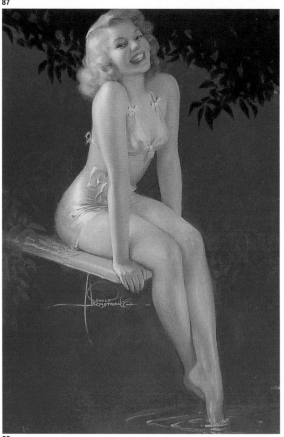

89

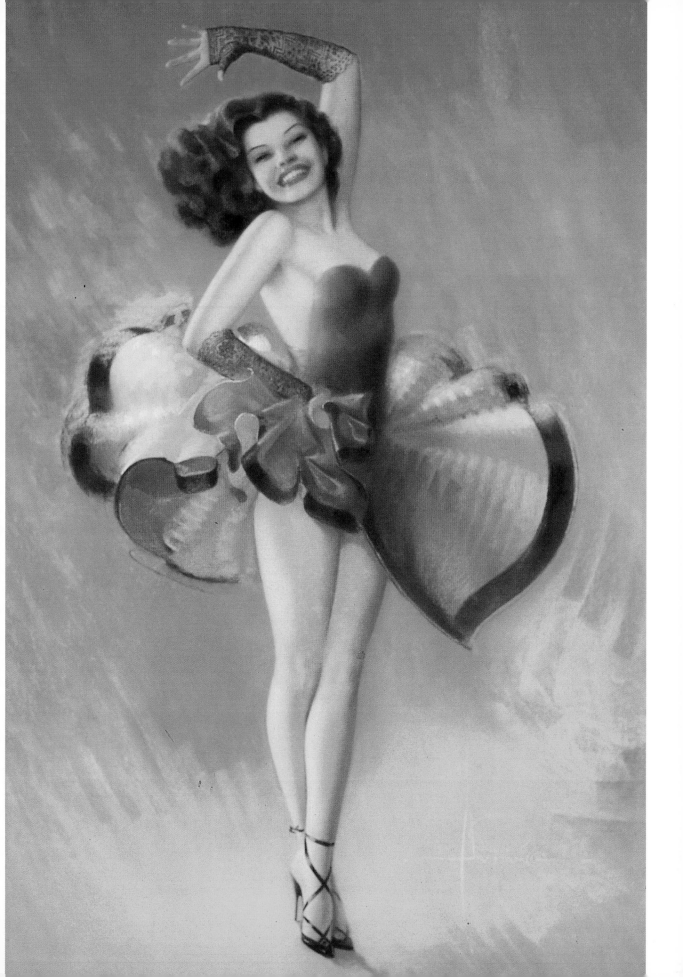

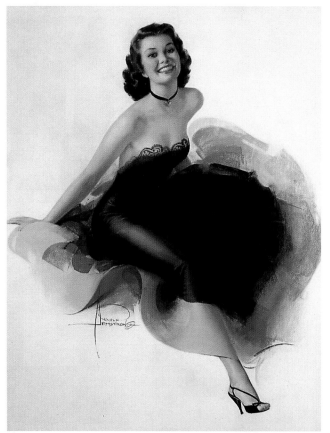

91

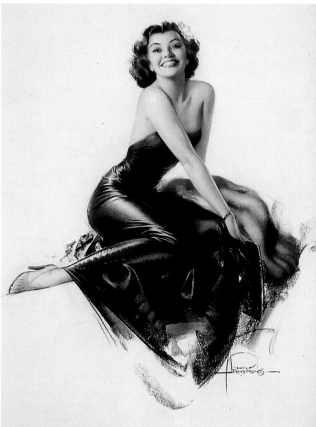

92

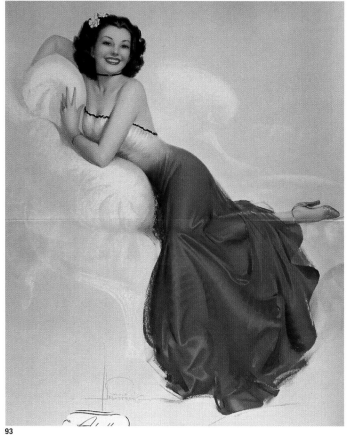

93

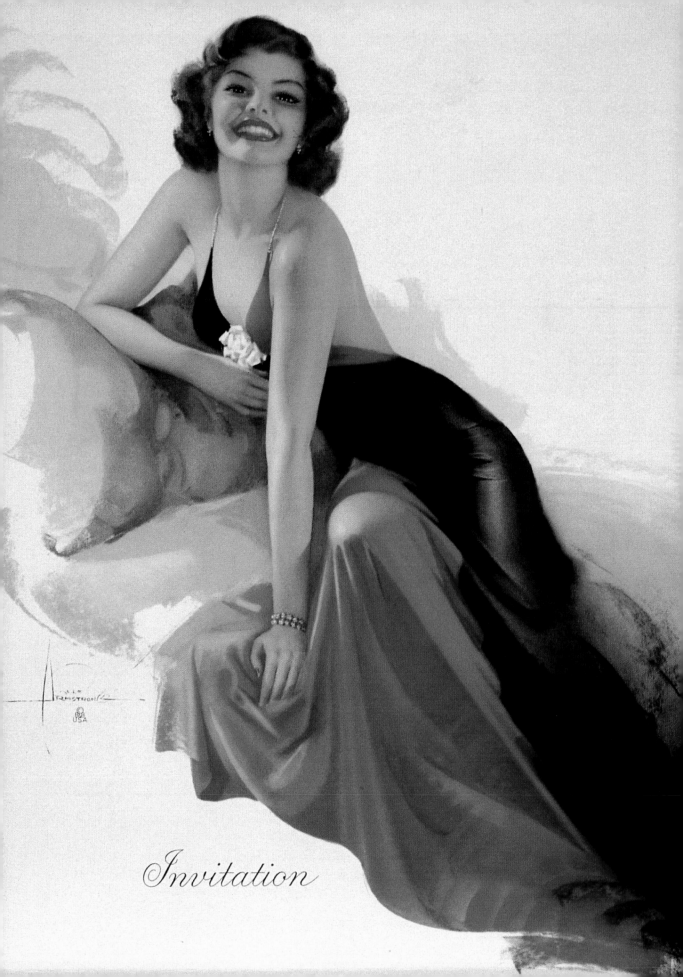

Invitation

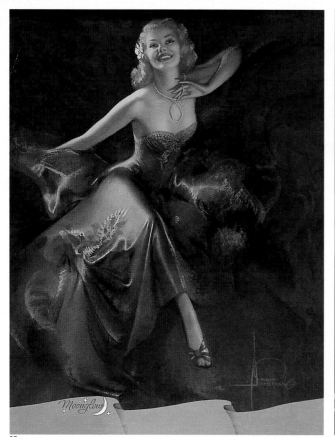

95

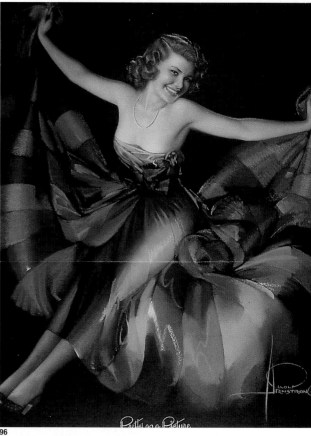

96

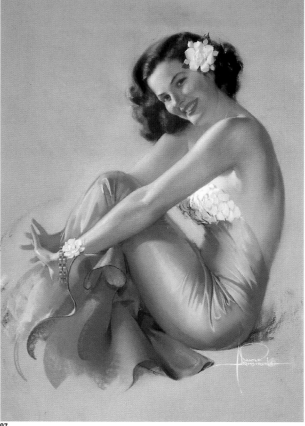

97

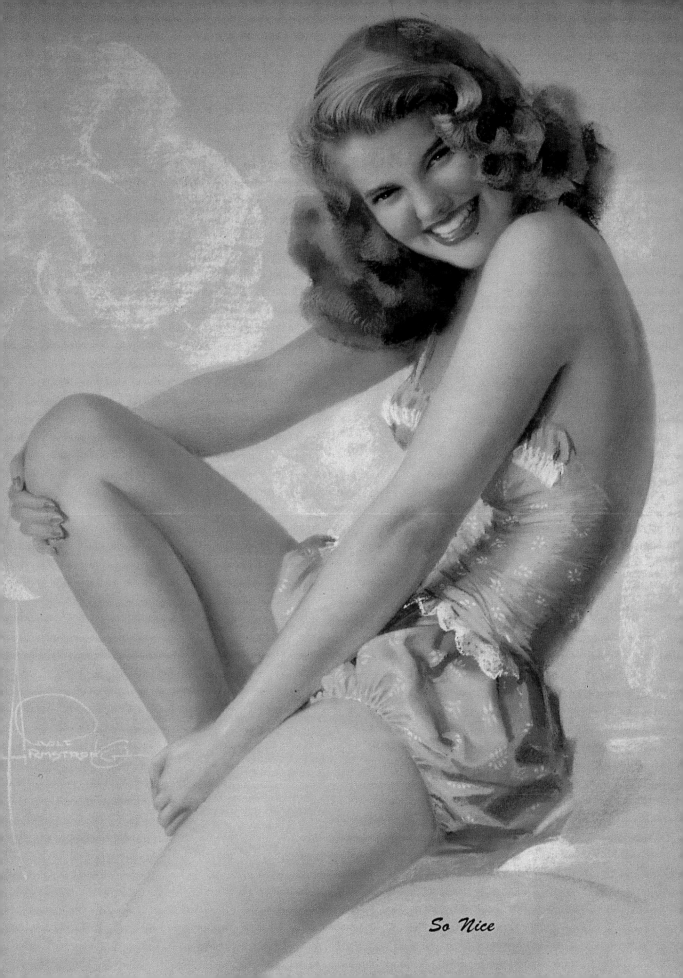

So Nice

Joyce Ballantyne

Ballantyne was born in Norfolk, Nebraska, just after World War I. She attended Nebraska University for two years, painting murals in her spare time for department stores and movie theaters before leaving to study commercial art. After studying at the Academy of Art in Chicago for two years, she joined Kling Studios, where she painted Rand McNally road maps and illustrated a dictionary for the Cameo Press.

Ballantyne then moved on to the Stevens/Gross studio, where she stayed for more than ten years. Influenced, as much of the studio was, by Haddon Sundblom, she became part of a group of artists who were extremely close, both professionally and personally, including Gil Elvgren, Earl Gross, Al Moore, Coby Whitmore, Thornton Utz, and Al Buell. She had first met Elvgren when he was teaching at the Academy of Art and she was a student. After years of working closely together, however, they often shared assignments if one of them became ill or if a schedule was tight.

In 1945, Ballantyne began painting pin-ups for Brown and Bigelow, having been recommended by Elvgren. The firm introduced her to their national sales and marketing staff as "the brightest young star on the horizon of illustrative art." Ballantyne designed a "novelty-fold" direct mail pin-up brochure for the company and eventually was given the honor of creating an Artist's Sketch Pad twelve-page calendar.

Ballantyne's most important pin-ups were the twelve she painted in 1954 for a calendar published by Shaw-Barton (figures 100–107, 111, 113, 114 and 116). When it was released nationally in 1955, the demand from new advertisers was so great that the company reprinted it many times. Ballantyne then went on to paint one of the most famous advertising images ever. Coppertone suntan lotion asked several illustrators to submit preliminary ideas for a special twenty-four-sheet billboard for their American and international markets. Ballantyne won the commission, and her final painting (based somewhat on an idea of Art Frahm's) became a national icon: its little pig-tailed girl whose playful dog pulls at her bathing suit charmed the entire nation.

Ballantyne also did much advertising work for other national clients, including Sylvania TV, Dow Chemical, Coca-Cola, and Schlitz Beer. She painted pin-ups for the calendar companies Louis P. Dow and Goes and illustrations for such magazines as Esquire and Penthouse.

The strikingly attractive Ballantyne often posed as her own model, as Zoë Mozert did. Like her friend Gil Elvgren, she preferred to work in oil on canvas that measured 30 x 24 inches (76.2 x 61 cm).

Ballantyne and her husband, Jack Brand, moved in 1974 to Florida, where she began painting fine-art portraits. She lives there today and still keeps in touch with her friends, and fellow Floridians, Al Buell and Thornton Utz.

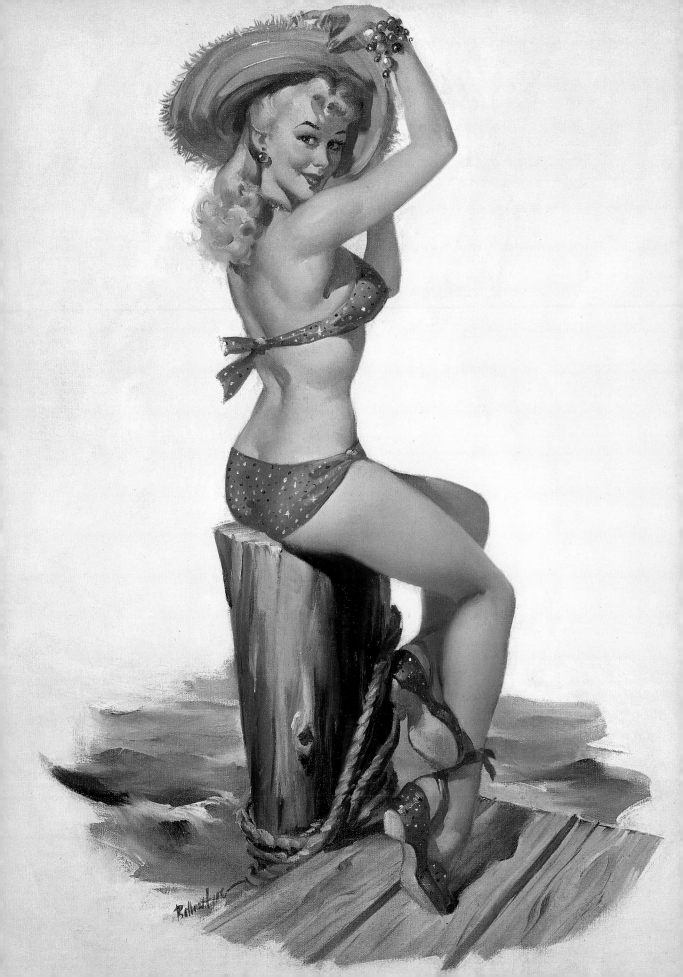

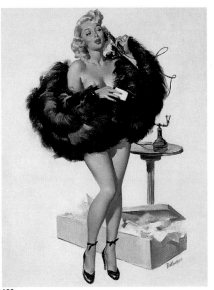

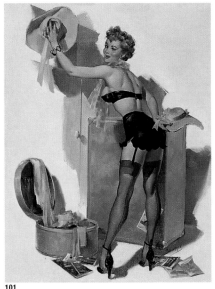

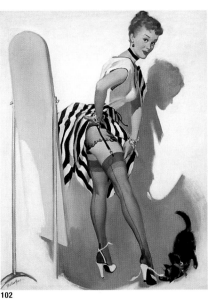

100

101

102

Joyce Ballantyne wurde kurz nach dem Ersten Weltkrieg in Norfolk, Nebraska, gebo-ren. Zwei Jahre studierte sie an der University of Nebraska; in ihrer Freizeit bemalte sie Fassaden von Kaufhäusern und Kinos. Dann verließ sie ihren Heimatstaat, um Werbegrafik zu studieren. Nach zwei Jahren des Studiums an der Art Academy of Chicago arbeitete sie für die Kling Studios. Hier zeichnete und illustrierte sie Stra-ßenkarten von Rand McNally und ein Wörterbuch für den Verlag Cameo Press.

Danach wechselte Ballantyne zum Stevens/Gross Studio über, wo sie über zehn Jahre bleiben sollte. Sie nahm den Sundblom-Einfluß, der im Studio überall zu spü-ren war, in ihre Arbeiten auf und stieß zu einer Clique von Künstlern, die auf privater und beruflicher Ebene sehr eng verbunden waren. Zu ihnen gehörten Gil Elvgren, Earl Gross, Al Moore, Coby Whitmore, Thornton Utz und Al Buell. Elvgren kannte Ballantyne schon von der Art Academy; wo er sie als Professor betreut hatte. Nach-dem sie jahrelang eng zusammengearbeitet hatten, teilten sie sich oft Aufträge, falls einer von beiden durch Krankheit oder andere Aufträge verhindert war.

Aufgrund einer Empfehlung von Elvgren begann Ballantyne 1945, Pin-ups für Brown and Bigelow zu malen. Diese Firma stellte sie ihrem auf nationaler Ebene operierenden Verkaufs- und Marketingteam als „den strahlendsten Nachwuchsstar am Horizont der illustrativen Kunst" vor. Ballantyne entwarf etwas ganz Neues für die Firma, eine gefaltete Direct Mail Pin-up-Broschüre. Später wurde ihr dann die Ehre zuteil, einen zwölfseitigen Kalender für „Artists Sketch Pads" zu entwerfen.

Ihre wichtigsten Pin-ups waren die zwölf, die sie 1954 für einen Kalender der Fir-

ma Shaw-Barton malte (Abb. 100 bis 107, 111, 113, 114 und 116). Als man ihn im darauffolgenden Jahr im ganzen Land erwerben konnte, war die Nachfrage seitens neuer Anzeigenkunden so groß, daß die Firma ihn viele Male auflegte. Ein weiterer Auftrag wurde zu einem der bekanntesten Anzeigenmotive, das es je gab. Die Firma Coppertone bat mehrere Illustratoren um Ideen für eine riesige Reklametafel. Sie sollte national und international für ihr gleichnamiges Sonnenöl werben. Ballantynes Idee erhielt den Zuschlag und ihre endgültige Fassung (in Anlehnung an eine Idee von Art Frahm) wurde eine amerikanische Ikone, die jeden in ihren Bann zog: Ballan-tynes Tochter Cheri mit Rattenschwänzen, deren verspielter Hund an ihrem Badean-zug zupfte.

Ballantyne arbeitete auch für viele andere Anzeigenkunden, die auf nationaler Ebene operierten. Dazu gehörte Sylvania TV, Dow Chemical, Coca-Cola und die Bier-brauerei Schlitz. Für die Kalenderverleger Louis P. Dow und Goes lieferte sie Pin-ups, für Zeitschriften wie Esquire und Penthouse Illustrationen.

Die außergewöhnlich attraktive Ballantyne stand sich oft selbst Modell – wie auch Zoë Mozert. Und wie ihr Freund Gil Elvgren arbeitete sie am liebsten in Öl auf Leinwand im Format von 72 x 61 cm.

1974 zogen Ballantyne und ihr Ehemann Jack Brand nach Florida, wo sie noch heute lebt und den Kontakt zu zwei weiteren nach Florida ausgewanderten ehemali-gen Mitgliedern ihrer Clique, Al Buell und Thornton Utz, pflegt.

In Florida begann sie, sich der klassischen Porträtmalerei zuzuwenden.

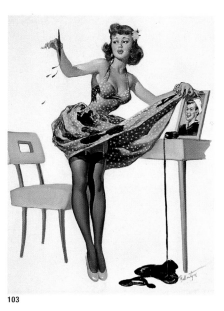

103

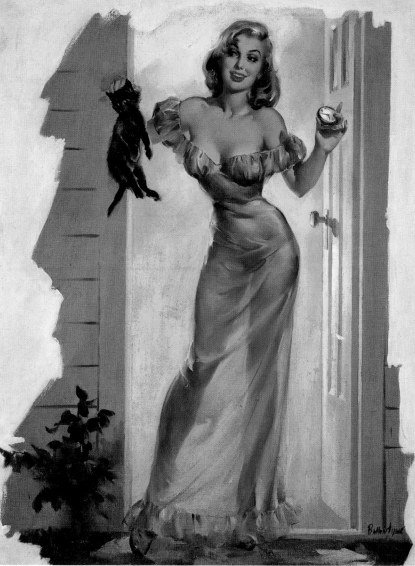

104

Née à Norfolk, dans le Nebraska, juste après la Première Guerre mondiale, Ballantyne étudia pendant deux ans à l'Université du Nebraska. Pendant son temps libre, elle peignait des fresques dans des grands magasins et des salles de cinéma. Après avoir passé deux autres années à étudier les arts appliqués à l'Art Institute de Chicago, elle fut engagée par Kling Studios, où on l'employa à dessiner des cartes routières pour Rand McNally et des illustrations pour un dictionnaire de Cameo Press.

Ballantyne entra ensuite aux studios Stevens-Gross, où elle resta plus de dix ans. Absorbant en grande partie l'influence du cercle de Sundblom qui régnait dans cet atelier d'illustrateurs, elle fit partie d'un groupe d'artistes très unis tant sur le plan professionnel que personnel et qui incluait Gil Elvgren, Earl Gross, Al Moore, Coby Whitmore, Thornton Utz et Al Buell. Elle avait précédemment rencontré Elvgren à l'Academy of Art où il enseignait et elle suivait des cours. Après des années d'étroite collaboration, ils se partageaient souvent des commandes lorsque l'un des deux était indisponible ou que les délais étaient trop courts.

En 1945, Ballantyne commença à travailler pour Brown and Bigelow, après avoir été recommandée par Elvgren. La maison la présenta à l'équipe de marketing et de ventes nationales comme «la jeune étoile la plus brillante au firmament de l'illustration». Ballantyne conçut pour eux une pin up publicitaire destinée à promouvoir les ventes par correspondance et eut même plus tard l'honneur de créer un calendrier de douze pages pour la ligne Artist's Sketch Pad.

En 1954, Ballantyne réalisa ses douze pin up les plus importantes pour un

calendrier de Shaw-Barton (illustrations 100–107, 111, 113, 114 et 116). Lorsqu'il parut en 1955, les annonceurs se bousculèrent pour obtenir les services de l'artiste, au point que la compagnie le rééédita de nombreuses fois. Ballantyne peignit ensuite une des affiches les plus célèbres de l'histoire publicitaire. Le fabricant de produits solaires Coppertone demanda à plusieurs illustrateurs de proposer un projet d'affiche géante pour le marché américain et international. Ballantyne l'emporta et son image finale (inspirée d'une idée d'Art Frahm) devint une icône nationale: sa fille Cheri (qui lui servit de modèle) séduisit tout le pays avec ses couettes et son petit chien joueur qui la retient par son maillot de bain.

Ballantyne travailla également pour de nombreux autres grands annonceurs américains, dont Sylvania TV, Dow Chemical, Coca-Cola et Schlitz Beer. Elle peignit d'autres pin up pour les calendriers de Louis P. Dow et de Goes, ainsi que des illustrations pour des magazines tels que *Esquire* et *Penthouse*.

A l'instar de Zoë Mozert, Joyce Ballantyne posait souvent comme son propre modèle. Il faut dire qu'elle était très belle. Comme son ami Gil Elvgren, elle préférait travailler à l'huile sur des toiles de 76,2x61 cm.

En 1974, Ballantyne et son mari, Jack Brand, s'installèrent en Floride où elle se consacra à l'art du portrait. Elle y vit toujours et reste en contact avec ses vieux amis et voisins, Al Buell et Thornton Utz.

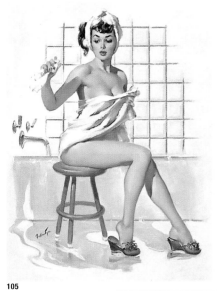

105

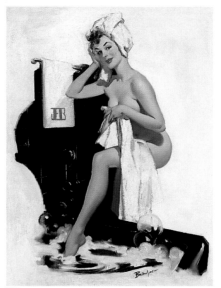

106

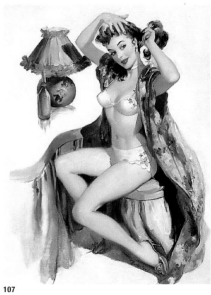

107

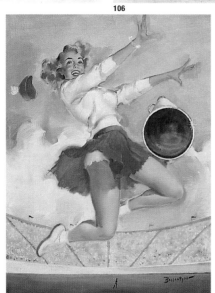

108

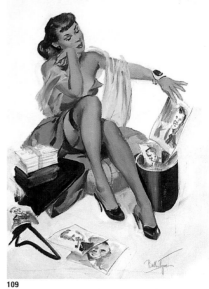

109

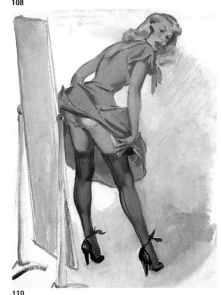

110

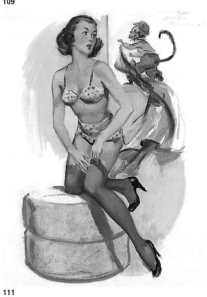

111

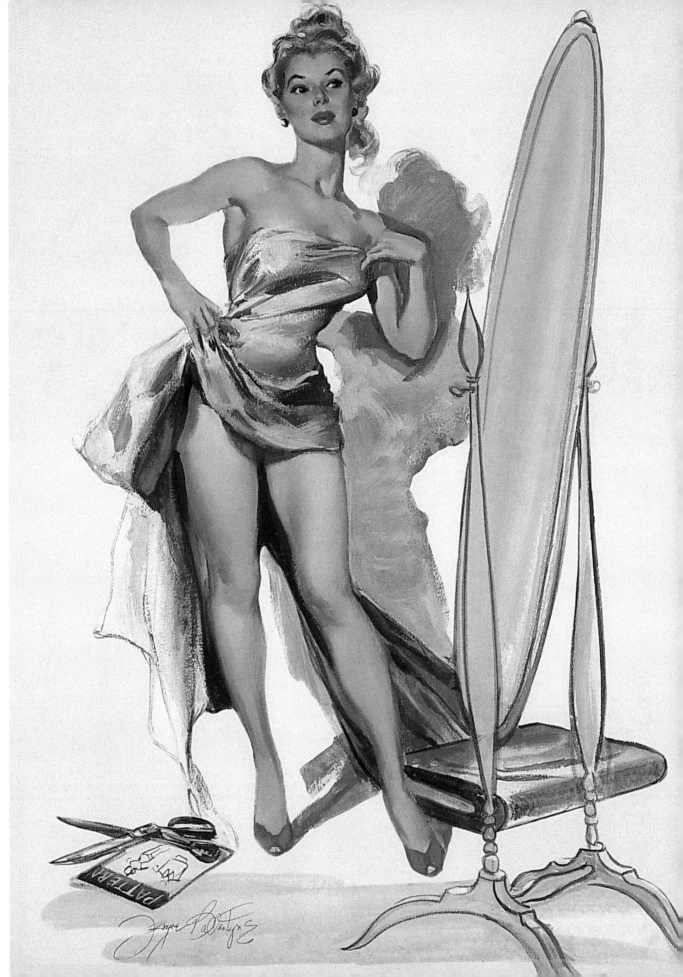

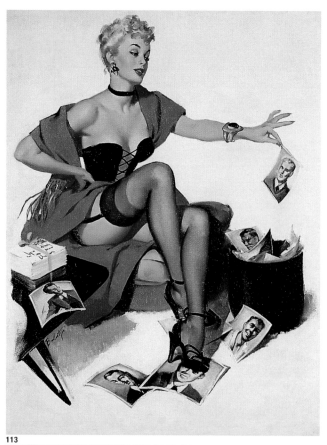

113

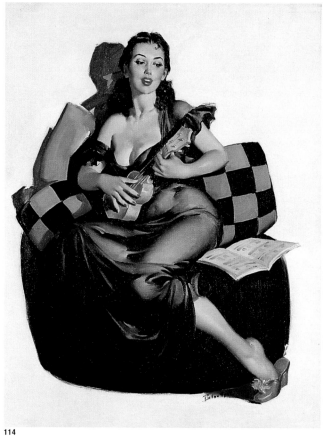

114

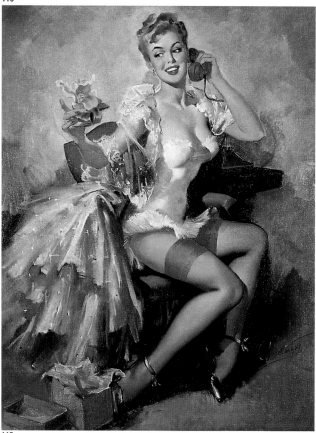

115

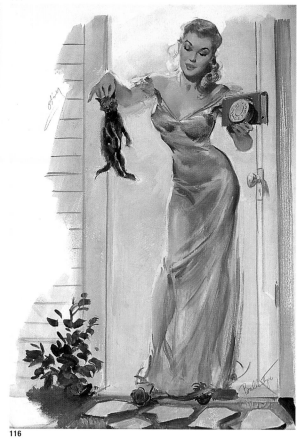

116

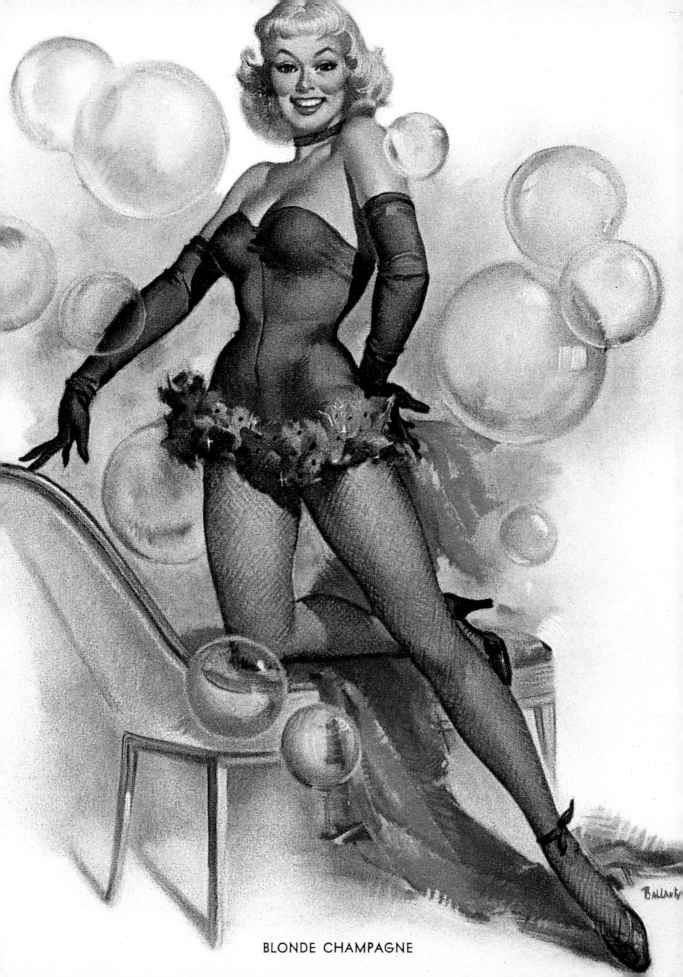

BLONDE CHAMPAGNE

McClelland Barclay

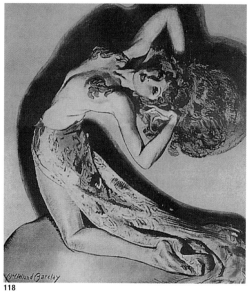

118

One of the most famous national campaigns in the history of American advertising art was the one General Motors devised for its Fisher Body automobiles. During the 1920s and 1930s, McClelland Barclay immortalized the slogan "Body by Fisher" with his stunning images of women also made Barclay one of the top pin-up and glamour artists in the calendar marketplace. From about 1935 until the beginning of World War II, he executed full-length pin-up paintings for several calendar-publishing houses. Among his many other commercial illustrations was the popular series of advertisements he painted for the A&P grocery stores in the late 1920s and the 1930s.

Born in St. Louis in 1891, Barclay was the son of a surgeon of Scottish descent. He studied at the Art Institute of Chicago and later moved on to the Art Students League in New York, where he was instructed by George Bridgman and Thomas Fogarty. By the age of twenty-one, Barclay had achieved professional status as an illustrator, and his work had appeared in *The Saturday Evening Post*, *Ladies' Home Journal*, and *Cosmopolitan*. By 1925 he was painting front covers and story illustrations for many national "slick" magazines.

Barclay also created front-cover portraits of movie stars for film magazines in the 1920s and 1930s. Hollywood actively sought him out to furnish movie poster art during the 1930s: beginning in 1933 with Paramount Pictures' *From Hell to Heaven* and ending in 1939 with Twentieth Century Fox's *Hotel for Women*, Barclay was a superstar in the film industry. He was also one of the first pin-up artists to paint Betty Grable, World War II's most famous pin-up girl.

Within two weeks of the Japanese attack on Pearl Harbor, Barclay completed the first of his many recruiting posters for the Navy. Appointed a lieutenant commander, Barclay worked on camouflage assignments until 1942, when he was reported missing in action in the Solomon Islands.

In 1940, Barclay had been chosen to paint the official portrait and publicity poster for the Ziegfeld Follies Girl for 1941 (figure 119). For this, his most important glamour commission, he had worked on a larger scale than normal to make the image suitable for a Times Square billboard. The Follies later issued a lithograph of the image as a commemoration of this talented artist.

Eine der berühmtesten Anzeigenkampagnen Amerikas war die für die Fisher-Body-Automobile von General Motors. Während der 20er und 30er Jahre machte McClelland Barclay mit atemberaubenden Illustrationen von selbstbewußten, modischen und raffinierten Frauen den Slogan „Body by Fisher" (ein nicht zu übersetzendes Wortspiel: ‚body' heißt im Englischen sowohl Körper als auch Karosserie) unsterblich. Barclay konnte die amerikanische Frau auf eindrucksvolle Art porträtieren, und diese Fähigkeit katapultierte ihn an die Spitze der im Kalenderbereich tätigen Pin-up- und Glamourillustratoren. Von 1935 bis zum Ausbruch des Zweiten Weltkriegs malte er für mehrere Verlage lebensgroße Pin-ups. Zu sei-

nen kommerziellen Illustrationen gehört auch die beliebte Anzeigenserie für die Lebensmittelkette A & P, die er in den späten 20er und frühen 30er Jahren schuf.

Barclay wurde 1891 in St. Louis als Sohn eines aus Schottland stammenden Chirurgen geboren. Er studierte am Art Institute of Chicago und später unter George Bridgman und Thomas Fogarty an der Art Students League in New York. Im Alter von 21 Jahren arbeitete er als professioneller Illustrator; seine Arbeiten erschienen in The Saturday Evening Post, Ladies' Home Journal *und* Cosmopolitan. *1925 schuf er Zeitschriftencover und illustrierte Geschichten für viele überregionale, „schlüpfrigen" Magazine.*

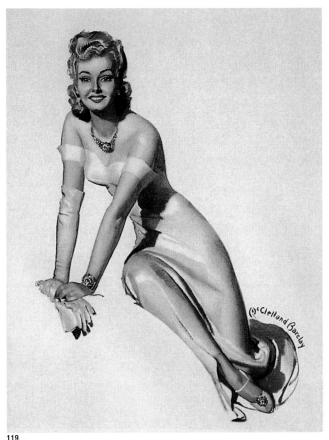

119

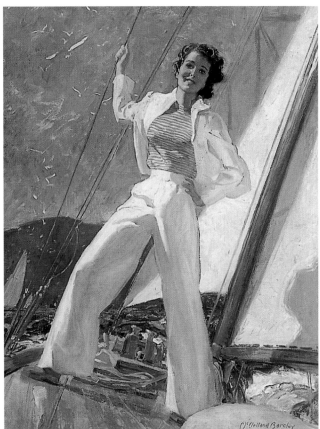

120

In den 20er und 30er Jahren zeichnete Barclay auch Coverporträts von Filmstars für Filmzeitschriften, und in den 30er Jahren beauftragte ihn Hollywood mit Filmpostern. Die Zusammenarbeit begann 1933 mit dem Paramount-Film From Hell to Heaven und endete 1939 mit Hotel for Women für die 20th Century Fox. Barclay wurde zu einem Superstar in der Filmindustrie. Ihm ist auch das berühmteste Pin-up des Zweiten Weltkriegs zu verdanken: Betty Grable.

Den Höhepunkt seiner Karriere markierte 1940 der Auftrag, ein Poster für das Ziegfeld Follies Girl des Jahres 1941 (Abb. 119) zu malen. Um den Ausmaßen für eine Anzeigenwand am New Yorker Times Square gerecht zu werden, mußte er mit einem größeren Maßstab als üblicherweise arbeiten. Die Ziegfeld Follies veröffentlichten später eine Lithographie der Arbeit.

Zwei Wochen nach dem japanischen Angriff auf Pearl Harbor hatte Barclay das erste einer Serie von Rekrutierungspostern für die Marine fertiggestellt. Er wurde zum Fregattenkapitän ernannt und mit geheimen Missionen beauftragt. 1942 wurde er bei Kämpfen auf den Salomoninseln als vermißt gemeldet.

Dans les années 20 et 30, General Motors lança une campagne qui devait faire date dans l'histoire de la publicité américaine. Il s'agissait de présenter au public les automobiles Fisher Body. Avec ses superbes images de femmes élégantes, sophistiquées et sûres d'elles, McClelland Barclay immortalisa le slogan «Body by Fisher». Son extraordinaire capacité à représenter les belles Américaines fit de lui l'un des principaux peintres de pin up et d'art glamour sur le marché des calendriers. Entre 1935 et le début de la Deuxième Guerre mondiale, il travailla pour différents éditeurs de calendriers. Il réalisa également de nombreuses affiches publicitaires dont une célèbre série d'illustrations pour la chaîne d'épiceries A & P entre la fin des années 20 et les années 30.

Né en 1891 à Saint Louis, Barclay était le fils d'un chirurgien d'origine écossaise. Il étudia à l'Art Institute de Chicago puis à l'Art Students League de New York, où il eut comme professeurs George Bridgman et Thomas Fogarty. A vingt et un an, Barclay s'était déjà fait un nom comme illustrateur et son travail paraissait dans The Saturday Evening Post, Ladies' Home Journal et Cosmopolitan. Dès 1925, il peignait des couvertures et des illustrations pour de nombreuses revues de luxe.

Dans les années 20 et 30, Barclay peignit aussi des portraits de stars pour des couvertures de magazines de cinéma. Hollywood ne tarda pas à lui commander des affiches de films: entre 1933, où il réalisa celle de From Hell to Heaven pour les studios Paramount, et 1939, quand il fit celle de Hotel for Women pour la Twentieth Century Fox, Barclay devint un superstar du genre. Il fut également l'un des premiers à peindre Betty Grable, la plus célèbre des pin up de la Deuxième Guerre mondiale.

Deux semaines après l'attaque des Japonais sur Pearl Harbour, Barclay acheva la première d'une longue série d'affiches destinées à inciter les jeunes à s'enrôler dans la Marine. Promu au grade de capitaine de corvette, il se vit confier des missions de camouflage jusqu'en 1942, quand il fut porté disparu alors qu'il était en mission dans les îles Salomon.

En 1940, Barclay avait été choisi pour peindre le portrait et l'affiche officielle de la Ziegfeld Follies Girl de 1941 (illustration 119). Pour cette prestigieuse commande d'art glamour, il travailla sur un format plus grand que d'habitude afin que l'image puisse être reproduite sur une affiche géante de Times Square. Plus tard, les Follies publièrent une lithographie de cette œuvre en hommage à cet artiste de talent.

Ben-Hur Baz

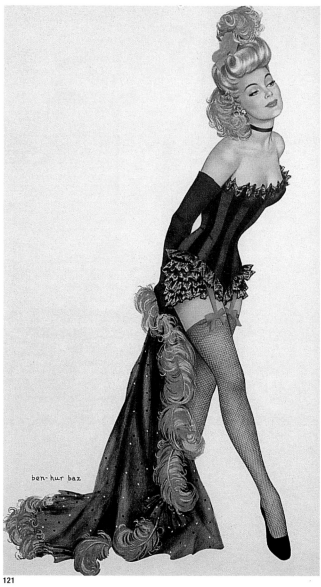

121

Baz was a pin-up and glamour artist who became well known in the late 1940s and early 1950s for his association with *Esquire* magazine. Beginning in 1946, he painted pin-ups for that publication's Gallery of Glamour and later contributed to their calendars and monthly centerfolds as well.

Baz war ein Pin-up- und Glamour-Künstler, der in den späten 40er und frühen 50er Jahren durch seine Arbeiten für die Zeitschrift Esquire *bekannt wurde. Seit 1946 lieferte er für deren ständige Serie* Gallery of Glamour Pin-ups; *später dann wurden seine Motive auch in den Kalendern der Zeitschrift und im monatlichen „Centerfold", dem ausklappbaren Mittelteil des Heftes, abgedruckt.*

Baz se fit connaître à la fin des années 40 et au début des années 50 par ses pin up et ses beautés glamour qui paraissaient dans le magazine *Esquire*. A partir de 1946, il réalisa des pin up pour la série d'*Esquire* Gallery of Glamour, puis contribua aux calendriers et aux posters centraux du magazine.

Born in Mexico in 1906, Baz was extremely prolific. Aside from pin-up and glamour art, he provided story illustrations to mainstream magazines, worked on various national advertising campaigns, and was a successful paperback novel cover artist.

Baz wurde 1906 in Mexiko geboren. Er war ein sehr produktiver Künstler und engagierte sich nicht nur im Glamour und im Pin-up, sondern illustrierte auch Geschichten für die großen Magazine des Landes, arbeitete an vielen Anzeigenkampagnen mit und war auch mit seinen Taschenbuch-Covern erfolgreich.

Né en 1906 au Mexique, Baz était très prolifique. Outre ses pin up et ses beautés glamour, il réalisa de nombreuses illustrations d'articles pour des magazines grand public, travailla pour de grandes campagnes nationales de publicité et fit une belle carrière d'illustrateur de couvertures de livres de poche.

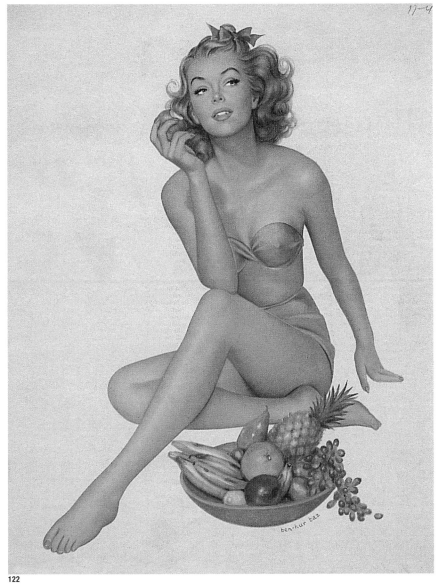

17-4

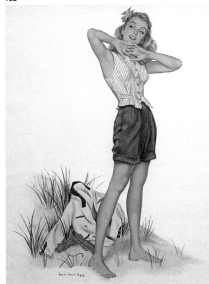

122

123

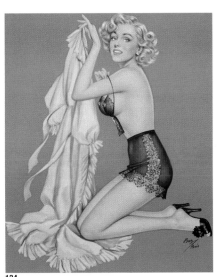

124

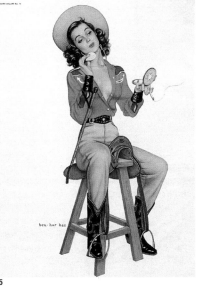

125

Earle K. Bergey

Earle Kulp Bergey was born in Philadelphia on August 26, 1901, and attended the Academy of Fine Art there from 1921 to 1926. His first job was working in the art department at the *Philadelphia Ledger*, but he later switched to the pulp-magazine publisher Fiction House. In 1935, Bergey married and, while still continuing to paint for the pulps, also went to work for *The Saturday Evening Post*. He moved his family to Bucks County, Pennsylvania, and opened a studio in New York.

Work for other mainstream magazines like *Liberty* followed, as did dozens of front covers showing scantily clad dancers, actresses, and starlets for large, full-size men's magazines like *Real Screen Fun* (1935–38; figure 136), *Gay Broadway* (1935–37), and *Snappy* (1931–38).

From 1939 until about 1950, Bergey's pin-up and glamour girls clad in bras and breastplates appeared on the covers of the science-fiction pulps – initially for Standard Publishers, whose roster included *Strange Stories*, *Startling Stories*, *Thrilling Wonder Stories*, and *Captain Future*, and later for *Fantastic Story Quarterly*, *Future Science-Fiction*, *Planet Stories*, and *Popular Love*. Among the other pulp magazines that he supplied pin-ups to were *La Paree* (1934–36), *Bedtime Stories* (1935), *Tattle Tales* (1934–38), *The Stocking Parade* (June 1938), and *Pep* (1934–36; figures 134 and 135).

In 1948, Bergey made the transition to the new, rapidly expanding paperback book industry, working first for Popular Library and then for Pocket Books. His cover art, depicting sexy pin-up girls posed in perilous situations, helped to sell millions of paperback novels.

Bergey died in 1952, while visiting a doctor's office.

Earle Kulp Bergey wurde am 26. August 1901 in Philadelphia geboren und besuchte von 1921 bis 1926 die dortige Academy of Fine Arts. Sein erster Job war beim Philadelphia Ledger *im Art Department. Später wechselte er zum Verlag Fiction House über, der Groschenromane publizierte. Nach seiner Heirat im Jahr 1935 arbeitete er weiterhin für Groschenromane, doch nahm er auch Aufträge der* Saturday Evening Post *an. Die Familie siedelte nach Bucks County in Pennsylvania über, und Bergey eröffnete ein Studio in New York.*

Es folgten Aufträge für andere bekannte Magazine wie Liberty *und Dutzende von Titelseiten von Männermagazinen wie* Real Screen Fun *(1935–38; Abb. 136),* Gay Broadway *(1935–37) und* Snappy *(1931–38), die leicht bekleidete Tänzerinnen, Schauspielerinnen und Starlets zeigten.*

Von 1939 bis ungefähr 1950 erschienen die Pin-up- und Glamour-Girls, von Bergey in Bustiers und knappen Korsetts gemalt, auf den Covern von Science-Fiction-Groschenromanen; ursprünglich für Standard Publishers, die unter anderem Strange Stories, Startling Stories, Thrilling Wonder Stories *und* Captain Future *herausgaben. Später arbeitete er für* Fantastic Story Quarterly, Future Science-Fiction, Planet Stories, Popular Love. *Darüber hinaus übernahm Bergey ähnliche Aufträge wie* La Paree *(1934–36),* Bedtime Stories *(1935),* Tattle Tales *(1934–38),* The Stocking Parade *(Juni 1938) und* Pep *(1934–36, Abb. 134 und 135).*

1948 wechselte Bergey von diesem Metier in eine andere, sich in rasantem Tempo entwickelnde neue Sparte: das Taschenbuch. Anfangs arbeitete er für Popular Library und später für Pocket Books. Seine Cover mit Pin-up-Girls, die selbst in gefährlichen Situationen noch sexy aussahen, wurden millionenfach verkauft.

Bergey starb 1952 im Wartezimmer eines Arztes.

Né à Philadelphie le 26 août 1901, Earle Kulp Bergey étudia à la Philadelphia Academy of Fine Arts entre 1921 et 1926. Il travailla d'abord dans le département artistique du *Philadelphia Ledger,* avant d'être engagé par Fiction House, éditeur d'une revue de «pulp». Bergey se maria en 1935 et, tout en continuant à travailler pour des pulps, collabora à *The Saturday Evening Post*. Il s'installa avec sa famille à Bucks County, en Pennsylvanie, et ouvrit un atelier à New York.

Il travailla ensuite pour des magazines populaires comme *Liberty* et réalisa des dizaines de couvertures montrant des danseuses légèrement vêtues, des actrices et des starlettes pour les magazines pour hommes tels que *Real Screen Fun* (1935–38; illustration 136), *Gay Broadway* (1935–37), et *Snappy* (1931–38).

De 1939 à 1950, les pin up guerrières et cuirassées de Bergey ornèrent les couvertures de pulps de science-fiction, d'abord pour Standard Publishers, qui possédait entre autres *Strange Stories, Startling Stories, Thrilling Wonder Stories, Captain Future*, puis plus tard pour *Fantastic Story Quarterly, Future Science Fiction, Planet Stories* et *Popular Love*. Parmi les autres pulps auxquels Bergey collabora, on compte *La Paree* (1934–36), *Bedtime Stories* (1935), *Tattle Tales* (1934–38), *The Stocking Parade* (juin 1938) et *Pep* (1934–36; illustrations 134 et 135).

En 1948, Bergey passa dans le secteur en rapide expansion du livre de poche, travaillant d'abord pour Popular Library puis pour Pocket Books. Ses couvertures, montrant des pin up sexy dans des situations périlleuses, firent vendre des millions de titres.

Bergey est mort en 1952, lors d'une visite chez un médecin.

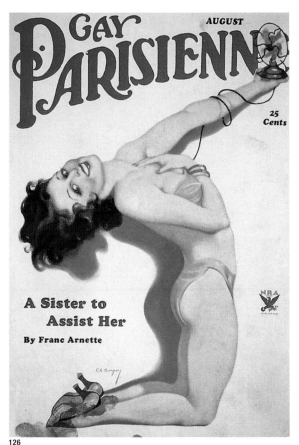

126

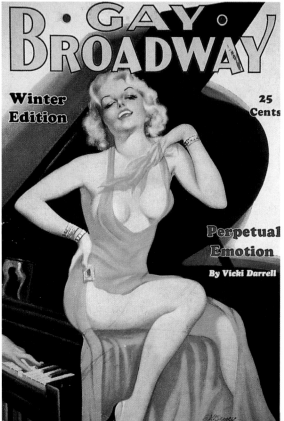

127

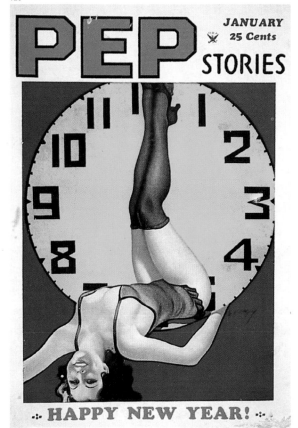

128

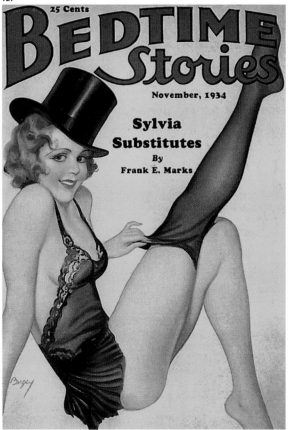

129

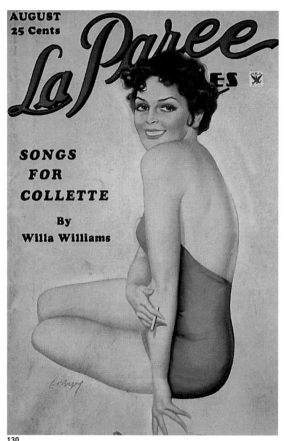

130

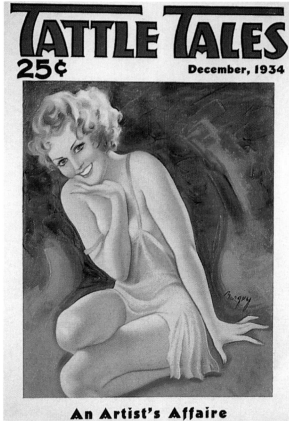

An Artist's Affaire

131

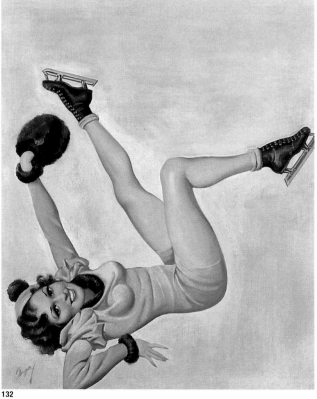

132

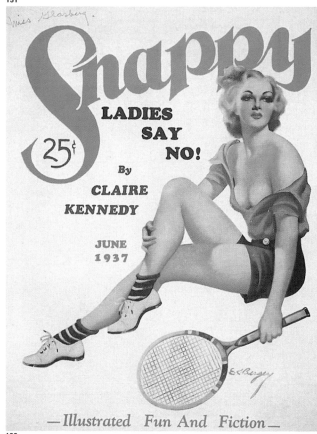

133

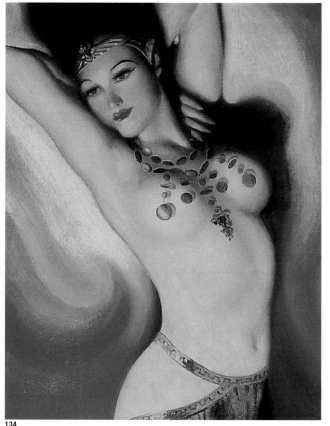

134

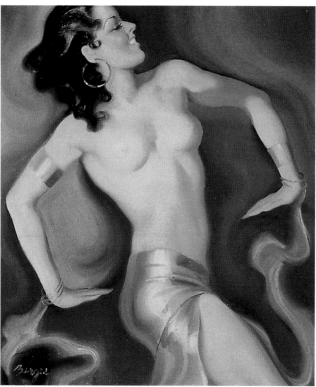

135

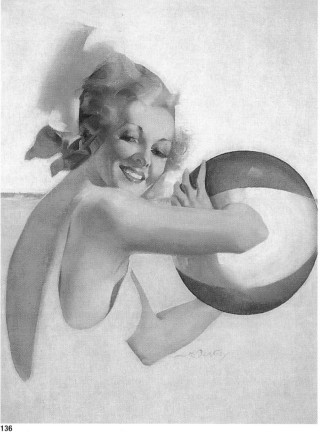

136

Roy Best

From the 1930s to the mid-1940s, Roy Best became known for creating strong, crisp pictures of all-American girls with pastels that reproduced beautifully when printed as calendars.

Best was born in Waverly, Ohio, and worked on railroad construction crews to support his studies at the Art Academy of Cincinnati. He subsequently moved to Chicago and enrolled in the Art Institute there. Later, in New York, he was represented by American Artists, Sidney and Celia Mendelsohn's well-known agency on West Forty-fourth Street which handled almost a hundred top-flight illustrators, including Norman Rockwell. In the 1930s, he painted several front covers for *The Saturday Evening Post.*

Roy Best wurde in den 30er Jahren bis Mitte der 40er Jahre durch seine kraftvollen Bilder von ganz normalen amerikanischen Mädchen bekannt. Er arbeitete mit Pastellfarben, die sich für die Reproduktionen von Kalenderblättern hervorragend eigneten.

Best wurde in Waverly, Ohio, geboren und verdiente sich beim Eisenbahnbau sein Studium an der Art Academy of Cincinnati. Später zog er nach Chicago und studierte dort am Art Institute. In New York wurde er von der bekannten Agentur American Artists vertreten, die Sidney und Celia Mendelsohn auf der 44. Straße West betrieben. Zu ihrer Klientel gehörten fast 100 der besten Illustratoren, unter ihnen Norman Rockwell. Für The Saturday Evening Post *schuf Best in den 30er Jahren einige Cover.*

Des années 30 jusqu'au milieu des années 40, Roy Best se fit connaître pour ses pastels puissants et précis de belles Américaines, qui étaient du plus bel effet une fois reproduits sur des calendriers.

Né à Waverly dans l'Ohio, Best finança ses études à l'Art Academy de Cincinnati en travaillant dans la construction de chemins de fer. Il étudia ensuite à l'Art Institute de Chicago. Plus tard à New York, il devint l'un des poulains d'American Artists, la célèbre agence tenue par Sidney et Celia Mendelsohn et située sur la Quarante-quatrième rue. Elle gérait près de cent illustrateurs de haut niveau, dont Norman Rockwell. Dans les années 30, Best réalisa plusieurs couvertures pour *The Saturday Evening Post.*

By 1931, Best was executing fabulous pastels of sensuous Art Deco pin-ups and nudes for the Joseph C. Hoover and Sons calendar company (figure 137). That year, he received a phone call from the Whitman Publishing Company in Racine, Wisconsin, asking him to consider an assignment for a series of twenty-one full-color, full-page illustrations for a children's book. Best accepted and went on to create a masterpiece – *The Peter Pan Picture Book*, based on the J.M. Barrie play.

In 1942, Best came to the attention of Brown and Bigelow, which offered him the opportunity to paint pin-ups and glamour art for the calendar market. Accepting the company's generous financial offer, Best went on to a highly successful calendar career.

Berühmt sind seine wundervollen Pastellzeichnungen von Art-deco-Pin-ups und seine Bilder für den Kalenderverlag Joseph C. Hoover and Sons, die aus dem Jahr 1931 stammen (Abb. 137). Im selben Jahr beauftragte ihn die Whitman Publishing Company in Racine, Wisconsin, mit einer Serie von 21 ganzseitigen Farbillustrationen für ein Kinderbuch, das auf einem Bühnenstück von J.M. Barrie basierte. Mit diesem Auftrag gelang Best sein Meisterwerk: das Peter Pan Picture Book.

1942 wurden Brown and Bigelow auf seine Arbeiten aufmerksam und boten ihm die Möglichkeit, für den Kalendermarkt Pin-ups und Glamourkunst zu malen. Best nahm das großzügige finanzielle Angebot an und machte als Kalenderillustrator Karriere.

A partir de 1931, Best commença à peindre de superbes pastels de voluptueuses pin up Art déco pour les calendriers de Joseph C. Hoover (illustration 137). Cette même année, il reçut un appel de la maison d'édition Whitman Publishing Company de Racine, dans le Wisconsin, lui commandant une série de vingt et une illustrations en couleurs, pleine page, pour un livre d'enfants. Best créa un chef-d'œuvre: *The Peter Pan Picture Book*, d'après la pièce de J.M. Barrie.

En 1942, Best fut remarqué par Brown and Bigelow qui lui proposa de réaliser des pin up et des images glamour pour ses publications. Acceptant l'offre particulièrement lucrative de l'éditeur, Best entama alors une très belle carrière dans le domaine des calendriers.

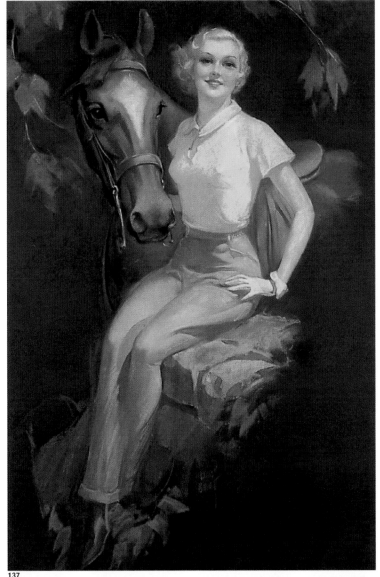

137

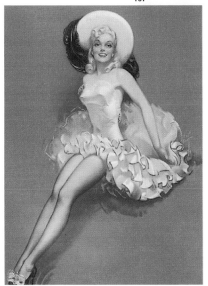

138

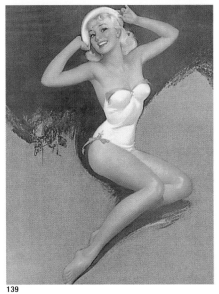

139

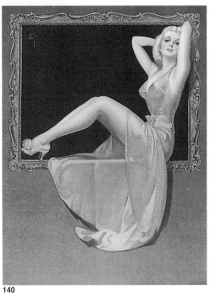

140

Enoch Bolles

After Alberto Vargas and George Petty, Enoch Bolles was the best known of the Deco-era pin-up artists, mostly because of the massive exposure his images received on newsstands from coast to coast. Bolles's art – both in terms of technique and subject matter, the playful, yet somewhat racy flapper girl – clearly exerted a strong influence on many artists of his time.

Bolles began his career in 1915, when he was hired by the Dell Publishing Company to paint front covers for its line of spicy pulp magazines (figures 141, 145, 146, and 148). He, like many other pin-up artists of the early Deco era, found a ready-made audience among the mostly male readership of the pulps. *Film Fun* was the pin-up magazine that immortalized the Bolles name. From 1921 to 1948, it carried his cover-art pin-ups (figures 142, 143, 149, 150, 153–157), which the American public came to recognize almost as much as the Petty Girl from *Esquire*. Bolles worked for many other pulps, including *Gay Book* and *Cupid's Capers*, which invited him to design their inaugural covers, and *Spicy Stories*, which had the biggest circulation among such magazines.

Bolles's pin-up girls were fun-loving and sexy, often provocative in their poses but occasionally caught in embarrassed or slightly self-conscious moods. Usually full of energy and brimming with health and a sense of adventure, they had almost childlike faces that contrasted with their sensual bodies. Bolles often incorporated Art Deco backgrounds, spotlights and other props, and clothing such as flimsy negligées and wet bathing suits into his work.

Bolles painted in oil on canvas in a variety of sizes ranging from 10 x 8 inches (25.4 x 20.3 cm) to 14 x 11 inches (35.6 x 27.9 cm) for his pulp magazine pin-ups all the way up to 30 x 24 inches (76.2 x 61 cm) for the *Film Fun* assignments. The wide variety of primary colors he employed was notable at a time when many of his contemporaries were using much more subdued tonal schemes. Although Bolles was a prolific artist, only a handful of his original paintings exist today.

Very little is known about Bolles's life. Probably born in the Chicago area, he worked in New York City, where he could be near the many publishing houses specializing in pulps and racy men's magazines in the 1920s and 1930s. It is rumored that Bolles had emotional problems near the end of his life that led him to overpaint some of his *Film Fun* covers, creating horrific expressions on his formerly fun-loving pin-up girls.

Neben Alberto Vargas und George Petty gehörte Enoch Bolles zu den bekanntesten Pin-up-Künstlern des Art deco; an Zeitungskiosken im ganzen Land waren seine Illustrationen zu sehen. Bolles' modernes „Flapper Girl" der 20er Jahre, das er als eine Mischung aus verspielt und gewagt darstellte, wurde als Motiv häufig kopiert; ebenso übte seine Technik großen Einfluß auf viele Künstler seiner Zeit aus.

Die Karriere von Enoch Bolles begann 1915, als er bei der Dell Publishing Company Titelmotive für eine Reihe pikanter Groschenromane lieferte (Abb. 141, 145, 146 und 148). Wie viele andere Pin-up-Künstler des frühen Art deco, so mußte sich auch Bolles sein Publikum in dieser vorwiegend männlichen Leserschaft von „Pulp"-Romanen nicht mehr erobern. Film Fun *wurde das Pin-up-Magazin, mit dem er seinen Namen verewigte. Zwischen 1921 und 1948 verwendete das Magazin seine Pin-up-Coverillustrationen (Abb. 142, 143, 149, 150, 153–157), die in Amerika bald so bekannt wurden wie das Petty Girl der Zeitschrift* Esquire. Bolles arbeitete auch für viele andere Groschenromane, wie Gay Book, Spicy Stories *und* Cupid's Caper. *Letztere gaben ihm den Auftrag für ihr Erstlings-Cover.*

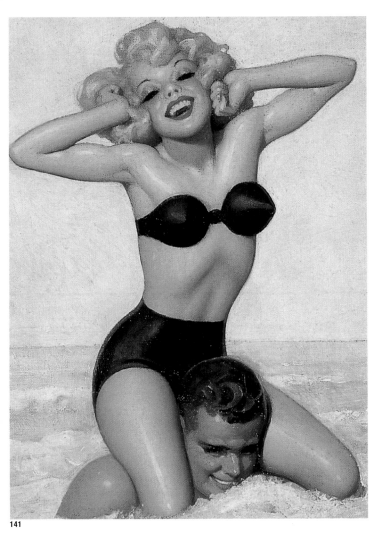

141

Die Pin-up-Mädchen von Bolles waren lebenslustig und sexy, oft provokant in ihren Posen, doch manchmal zeigte er sie auch in Stimmungen, in denen sie zurückhaltend wirkten. Meistens aber waren sie energiegeladen und abenteuerlustig. Ihre fast kindlichen Gesichter kontrastierte Bolles mit sinnlichen Körperformen. Oft bezog er Art-deco-Hintergründe, Spotlights und andere Requisiten in seine Arbeiten ein und kleidete seine Figuren in hauchdünne Négligés oder nasse, sich eng anschmiegende Badeanzüge.

Bolles arbeitete in Öl, die Bandbreite seiner Leinwandformate erstreckte sich von 25 x 20 cm bis zu 35 x 28 für Pin-ups, die für Groschenromane bestimmt waren, großformatige Bilder (76 x 61 cm) für Aufträge von Film Fun. Er arbeitete viel mit Primärfarben – bemerkenswert zu einer Zeit, in der die meisten seiner Zeitgenossen eine gedämpftere Farbgebung vorzogen. Obwohl Bolles ein sehr produktiver Maler war, existiert heute nur noch eine Handvoll seiner Gemälde.

Über sein Leben ist nur wenig bekannt. Wahrscheinlich wurde er in der Gegend um Chicago geboren und arbeitete in New York City. Gerüchten zufolge hatte er in seinem späteren Leben mit psychischen Problemen zu kämpfen, die ihn dazu brachten, einige seiner Film Fun-Cover zu übermalen. Den lebenslustigen Pin-ups von einst verpaßte er erschreckende Gesichtszüge.

Enoch Bolles était le peintre de pin up Art déco le plus célèbre après Alberto Vargas et George Petty, notamment parce que ses images étaient présentes partout de New York à Los Angeles. L'art de Bolles, tant sur le plan de la technique que des sujets – les jeunes délurées, joyeuses et moqueuses – exerça une grande influence sur de nombreux autres artistes de son temps.

Bolles commença sa carrière en 1915 comme illustrateur de pulps coquins pour les éditions Dell (illustrations 141, 145, 146 et 148), et il trouva un public sur mesure parmi les lecteurs principalement masculins des pulps. Film Fun immortalisa le nom de Bolles. L'artiste réalisa les couvertures de cette publication de 1921 à 1948 (illustrations 142, 143, 149, 150, 153–157) et son style fut bientôt reconnu par tous les Américains au même titre que la «Petty Girl» qui, elle, paraissait dans Esquire. Bolles travailla pour de nombreux autres pulps, dont Gay Book et Cupid's Capers, qui l'invitèrent à réaliser la couverture de leurs premiers numéros, et Spicy Stories, qui avait le plus gros tirage de tous.

Les pin up de Bolles étaient sexy et joyeuses. Elles avaient souvent des poses provocantes et étaient parfois surprises arborant une moue gênée ou confuse. Pleines d'énergie et d'audace, débordantes de santé, leurs visages enfantins contrastaient avec leur corps de femme épanouie. Bolles intégrait souvent dans ses images des décors Art déco, des spots et autres accessoires de plateau, et revêtait fréquemment ses beautés de nuisettes transparentes ou de maillots de bain mouillés.

Bolles peignait à l'huile sur des toiles dont le format variait entre 25,4 x 20,3 cm et 35,6 x 27,9 cm pour les pin up de pulps, allant jusqu'à 76,2 x 61 cm pour ses illustrations destinées à Film Fun. Contrairement à la plupart de ses contemporains qui avaient une palette plutôt douce, il utilisait une vaste gamme de couleurs primaires. Il ne reste aujourd'hui que quelques œuvres de cet artiste pourtant très prolifique.

On sait fort peu de choses sur la vie de Bolles. Sans doute né dans la région de Chicago, il travaillait à New York, où il était proche des nombreuses maisons d'édition spécialisées dans les pulps et les magazines de charme dans les années 20 et 30. On raconte qu'à la fin de sa vie, atteint de troubles psychiques, il se mit à peindre sur ses couvertures de Film Fun, défigurant le visage autrefois souriant de ses pin up avec des expressions d'horreur.

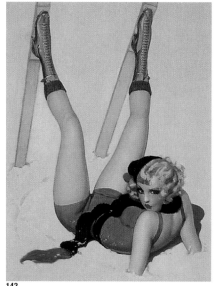

142

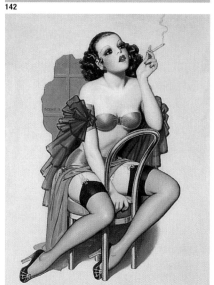

143

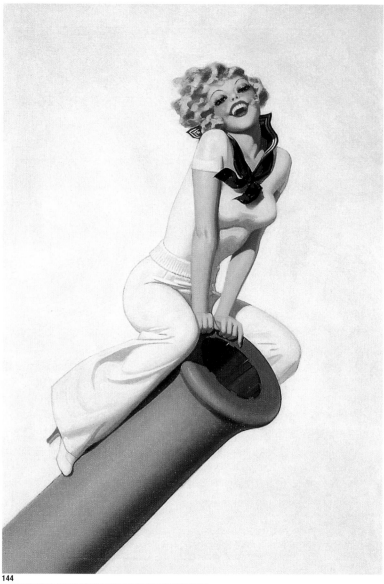

144

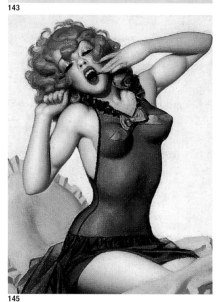

145

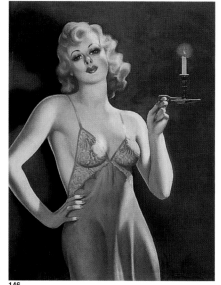

146

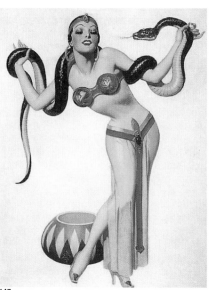

147

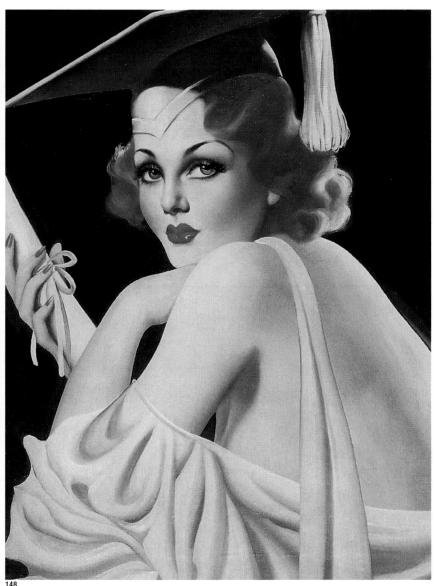

148

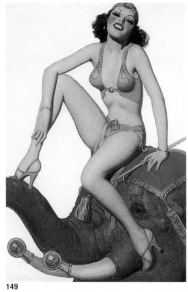

149

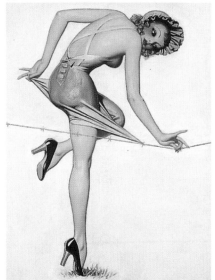

150

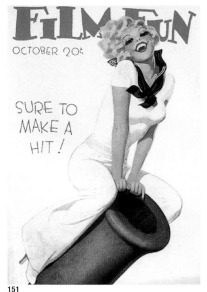

151

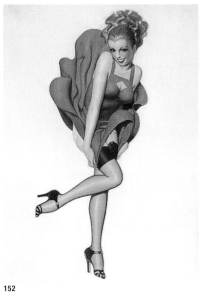

152

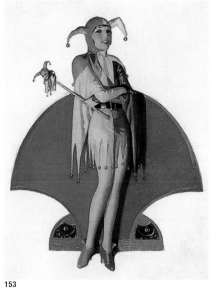

153

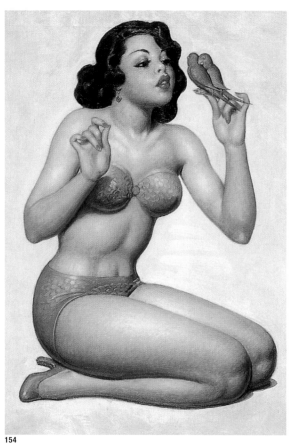

154

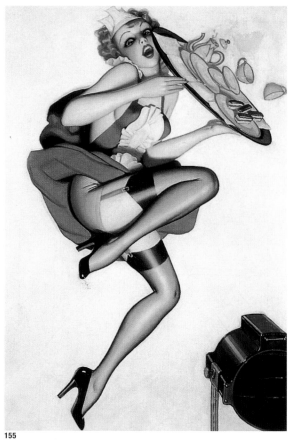

155

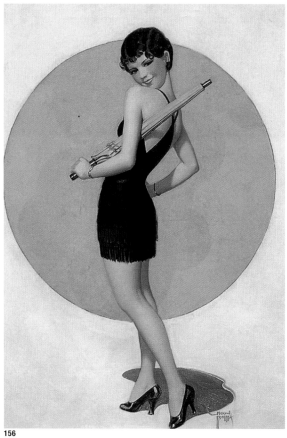

156

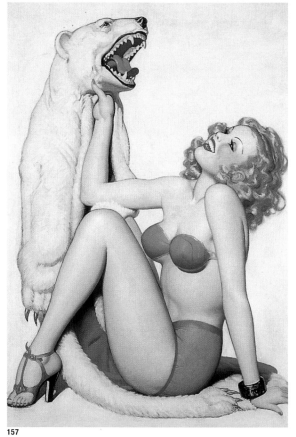

157

Harry C. Bradley

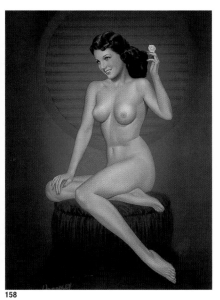

158

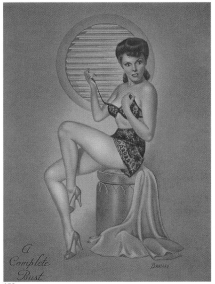

159

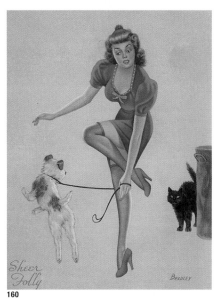

160

Bradley painted one of the most famous and successful pin-up images of all time: *Sitting Pretty* (figure 158), published in 1943 by Joseph C. Hoover and Sons of Philadelphia. This Art Deco-inspired depiction of a beautiful nude seated in front of a rich burgundy background was one of the most well known pin-ups during and after World War II. Reproduced on a man's wallet and on key chains, it was also manufactured in various sizes of calendar prints, ranging from 2 x 3 inches (5.1 x 7.6 cm) to 20 x 30 inches (50.8 x 76.2 cm). Bradley's original airbrush work was executed on Whatman board measuring 28 x 22 inches (71.1 x 55.9 cm).

Not much is known about Bradley, except that he was a Philadelphia artist and illustrator whose studio was located at 5800 Walnut Street in downtown Philadelphia. Other than several published pin-ups, including a February 1955 front cover for *Clifton's Motor Age* magazine, there is little documentation of his career.

Bradley gelang eines der erfolgreichsten und berühmtesten Pin-ups aller Zeiten: Sitting Pretty *(Abb. 158), 1943 vom Verlag Joseph C. Hoover and Sons in Philadelphia auf den Markt gebracht: ein vor einem satten burgunderroten Hintergrund positionierter wunderschöner Frauenakt im Art-deco-Stil; während und nach dem Zweiten Weltkrieg war er einer der bekanntesten Pin-ups. Das Motiv fand sich nicht nur auf Herrenportemonnaies und Schlüsselanhängern, sondern wurde auch als Kalendermotiv in diversen Größen – von 5 x 8 cm bis hin zu 51 x 76 cm – viele Male aufgelegt. Bradley arbeitete in der Airbrush-Technik auf Whatman-Karton im Format 71 x 56 cm.*

Über Bradley selbst ist nicht viel bekannt. Man weiß, daß er in Philadelphia als Künstler und Illustrator arbeitete und dort auch ein Studio in der Innenstadt an der Walnut Street Nr. 5800 hatte. Außer einigen Pin-up-Veröffentlichungen, unter anderem das Februarcover des Jahres 1955 für die Zeitschrift Clifton's Motor Age, *existieren nicht viele Nachweise seiner Arbeit.*

Bradley est l'auteur de l'une des pin up les plus célèbres de tous les temps: *Sitting Pretty* (illustration 158), publiée en 1943 par Joseph C. Hoover and Sons de Philadelphie. Ce beau nu d'inspiration Art déco se détachant sur un fond bordeaux fit fureur pendant et après la Deuxième Guerre mondiale. Il fut reproduit sur des portefeuilles d'homme, des porte-clefs et des calendriers de différents formats (allant de 5,1 x 7,6 cm à 50,8 x 76,2 cm). Les originaux de Bradley, peints à l'aérographe, étaient réalisés sur des cartons Whatman de 71,1 x 55,9 cm. On ne sait pas grand-chose sur Bradley, si ce n'est que cet artiste et illustrateur avait un atelier situé au 5800 Walnut Street, dans le centre de Philadelphie. Mis à part quelques reproductions de pin up, dont la couverture du numéro de février 1955 du magazine *Clifton's Motor Age,* on dispose de très peu de documentation à son sujet.

Al Brule

One of the few artists who worked with Art Frahm on his "panties-falling-down" works, Brulé contributed a spectacular image of an airline stewardess (figure 162) to the series.

Brulé was a Chicago illustrator whose style, with its painterly technique and strong primary colors, closely resembled that of the Sundblom Circle. During the 1940s and 1950s, he created many advertisements for major national corporations, most of them appearing as full pages in leading magazines like *The Saturday Evening Post*. Brulé also painted a number of advertising images that were repro-duced as twenty-four-sheet billboards, which lined America's highways or were hung on the sides of buildings or on specially erected platforms.

Like so many commercial illustrators, Brulé eventually took up fine-art painting, specializing in Western subjects. He resided in the West and thus was able to live the life he depicted on his easel. Yet even in his Western paintings, Brulé still expressed his appreciation of beautiful women. In fact, he began his fine-art career with an Indian pin-up girl, *Buffalo Woman*, an oil on canvas measuring 24 x 36 inches (61 x 91.4 cm), which was painted on a Sioux Indian Reservation in South Dakota.

Al Brulé gehörte zu den wenigen Künstlern, die an Art Frahms Serie Panties Falling Down *mitarbeiteten. Für diese Reihe kreierte er eine sensationelle Stewardeß (Abb. 162).*

Brulé lebte und arbeitete in Chicago. Sein Illustrationsstil ähnelte in seiner Maltechnik und dem Einsatz von satten Primärfarben sehr dem der Sundblom-Clique. In den 40er und 50er Jahren entwarf er viele Anzeigen für amerikanische Groß-unternehmen. Die meisten von ihnen wurden auch als ganzseitige Anzeigen in führenden Zeitschriften wie der Saturday Evening Post *geschaltet. Eine Reihe seiner Anzeigenvorlagen konzipierte Brulé auch für eine Wiedergabe auf großformatigen Billboards entlang der Überlandstraßen und Highways des Landes oder als* überdimensionale Werbetafeln, die an Gebäudefronten oder eigens dafür errichtete Gerüste gehängt wurden.

Wie viele andere Werbegrafiker wandte sich auch Brulé später der klassischen Malerei zu und spezialisierte sich in seinen Gemälden auf Western-Motive. Brulé selbst lebte im amerikanischen Westen; sein Lebensstil und die Themen, mit denen er sich in der Malerei befaßte, ähnelten sich daher sehr. Seine neue Karriere in der klassischen Malerei begann er denn auch mit Buffalo Woman, *dem Bild eines Indianermädchens. Es war in Öl auf Leinwand im Format 61 x 91 cm ausgeführt und entstand in einem Reservat der Sioux-Indianer in Süddakota.*

Brulé est l'un des rares artistes à avoir travaillé avec Art Frahm sur sa série de pin up «sans culotte» (il est entre autres l'auteur d'une superbe hôtesse de l'air victime d'une méchante bourrasque, illustration 162).

Brulé était un illustrateur de Chicago dont le style, avec ses épais coups de pinceau et ses couleurs vives, était proche de celui du cercle de Sundblom. Pendant les années 40 et 50, il réalisa de nombreuses affiches pour de grands annonceurs nationaux, la plupart publiées pleine page dans de prestigieux magazines tels que *The Saturday Evening Post*. Brulé créa également des images qui furent reproduites sur des panneaux publicitaires géants postés le long des auto-routes, accrochés au flanc de buildings ou présentés sur de hautes plates-formes conçues à cet effet.

Comme de nombreux autres illustrateurs, Brulé prit sa retraite pour se consacrer à la peinture de chevalet, se spécialisant dans des thèmes liés à la conquête de l'Ouest. Habitant la côte ouest, il pouvait mener la vie qu'il décrivait dans ses tableaux. Toutefois, même dans ces scènes, il continua d'exprimer son amour des belles femmes. Il commença sa seconde carrière dans les beaux-arts avec le portrait d'une pin up squaw, *Buffalo Woman*, une huile sur toile de 61 x 91,4 cm, réalisée dans une réserve sioux du Dakota du Sud.

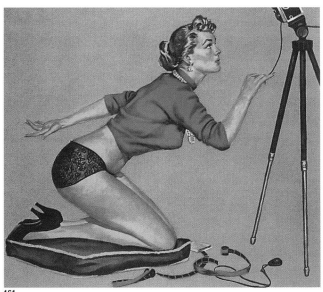

161

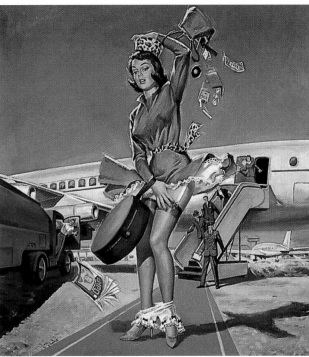

162

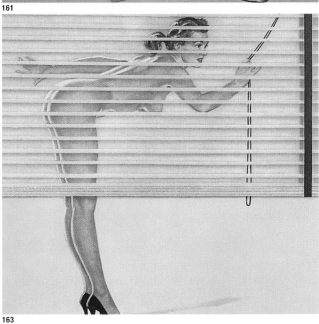

163

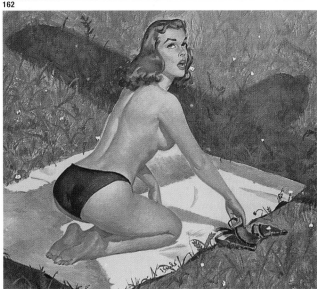

164

Al Buell

Alfred Leslie Buell was born in 1910 in Hiawatha, Kansas, and grew up in Cushing, Oklahoma. He briefly considered an engineering career before classes at the Chicago Art Institute and a trip to New York City decided him on art. About 1930, he began to concentrate seriously on teaching himself to be an artist, and five years later, he and his new wife, Ruth, moved to Chicago where Alfred could better pursue his dream of being a commercial artist.

Buell joined the Stevens/Hall/Biondi art studio in Chicago in 1935, and his association there with Haddon Sundblom was to prove crucial to his artistic development. By 1940, Buell had opened his own studio, but he kept in touch with the Sundblom group for another five years, cherishing his friendships with artists like Gil Elvgren, Thornton Utz, and Joyce Ballantyne.

Buell painted pin-ups for the Gerlach-Barklow calendar company for five years starting about 1937 (figures 166, 170, 173–175). His original paintings for the company were painted in oil on illustration board, averaged 20 x 16 inches (50.8 x 40.6 cm), and were signed with the block signature "Buell." Among the several other calendar companies he worked for in the early 1940s was Kemper-Thomas, for which he painted brightly colored canvases averaging 32 x 28 inches (81.3 x 71.1 cm), which he signed with his full name (figures 165 and 167).

Rejected by the draft in World War II, Buell spent the war years painting such popular pin-ups as WAVE, WAC, Nurse (1944) and They're All Tops (1945), which were terrific successes on Brown and Bigelow posters, calendars, and specialty products. About this time, the artist decided to adopt Al Buell as his official professional name.

Buell was among the important glamour artists who contributed to Esquire's Gallery of Glamour, beginning in September 1946. He provided illustrations to many of America's mainstream magazines and was also active in the advertising field, most notably for Coca-Cola in the 1940s and 1950s. The only self-taught artist of the Sundblom Circle, Buell was featured in a June 1956 article on the group in American Artist magazine. After he and his family moved to Sarasota, Florida, in 1951, he began painting paperback-novel covers.

Buell returned to the Brown and Bigelow fold in the late 1950s, creating such fabulous images as Summer Sweetheart (1959; figure 169). In the early 1960s, he did his own twelve-page calendar for the firm, Al Buell's DELECTaBELLES (1960), followed by an Artist's Sketch Pad assignment (Al Buell's Beauties, 1961; figures 180–183) and the stunning glamour art image Top Date (1962; figure 1).

Buell ended his commercial career about 1965 and went on to paint fine-art subjects, including landscapes and portrait commissions. He remained active until 1993, when he was injured in an accident. He now resides in a nursing home.

Alfred Leslie Buell wurde 1910 in Hiawatha, Kansas, geboren. In Chushing, Oklahoma, wuchs er auf. Kurzzeitig wollte er Ingenieur werden, doch entschied sich, nach Seminaren am Art Institute of Chicago und einem Trip nach New York, für die Kunst. 1935 zog er mit seiner Frau Ruth nach Chicago, da er dort seinen Traum von einer kommerziellen Karriere besser verwirklichen konnte.

Zu dieser Zeit stieß Buell zu dem Chicagoer Studio Stevens/Hall/Biondi. Seine dortige Verbindung zu Haddon Sundblom sollte sich als entscheidend für seine künstlerische Entwicklung erweisen. 1940 eröffnete Buell sein eigenes Studio, blieb jedoch noch fünf Jahre in Kontakt mit der Sundblom-Truppe und pflegte seine Freundschaften mit Künstlern wie Gil Elvgren, Thornton Utz und Joyce Ballantyne.

Um 1937 begann Buell, für den Kalenderverlag Gerlach-Barklow Pin-ups zu malen. Diese Zusammenarbeit dauerte fünf Jahre. Seine Originale malte er in Öl auf Karton, normalerweise im Format 50x40cm und in Großbuchstaben mit „Buell" signiert (Abb. 166, 170, 173 bis 175). Auch für mehrere andere Kalenderverlage war er in den frühen 40er Jahren tätig, unter anderem für Kemper-Thomas. Für diesen Verlag schuf er leuchtend-kolorierte Leinwände (83 x 71cm), die er mit seinem vollen Namen signierte (Abb. 165 und 167).

Da er im Zweiten Weltkrieg nicht eingezogen wurde, schuf er in diesen Kriegsjahren solch bekannte Pin-ups wie WAVE, WAC, Nurse (1944) und They're All Tops (1945), die als Kalender, Poster und in der Sparte Spezialprodukte bei

Brown and Bigelow große Erfolge verbuchen konnten. Zu dieser Zeit entschied sich der Künstler auch, Al Buell als seinen offiziellen, professionellen Namen anzunehmen.

Buell gehörte zu den wichtigsten Glamour-Künstlern, die ab September 1946 Beiträge für Esquire's „Gallery of Glamour" lieferten. Er versorgte viele führende Zeitschriften des Landes mit Illustrationen und arbeitete in der Werbung, vor allem in den 40er und 50er Jahren für Coca-Cola. Er war der einzige Künstler der Sundblom-Clique, der sich das Malen selbst beigebracht hatte. Im Juni 1956 erschien in der Zeitschrift American Artist ein Artikel über diese Künstlerclique. Nachdem er mit seiner Familie im Jahr 1951 nach Sarasota in Florida gezogen war, begann Buell mit der Arbeit an Taschenbuch-Covern.

In den späten 50er Jahren kehrte Buell in den Schoß von Brown and Bigelow zurück und schuf so wunderbare Bilder wie Summer Sweetheart (1959; Abb. 169). In den frühen 60er Jahren erschien bei Brown and Bigelow ein eigener Kalender, genannt Al Buell's DELECTaBELLES (1960), gefolgt von einem Auftrag von „Artist's Sketch Pad" (Al Buell's Beauties, 1961; Abb. 180 bis 183) und dem atemberaubenden Glamourbild Top Date (1962, Abb. 1).

Buell beendete seine Karriere auf dem kommerziellen Sektor Mitte der 60er Jahre und malte fortan Landschaften und Porträts. 1993 zwang ihn eine Unfallverletzung, diese Arbeit aufzugeben. Heute lebt Al Buell in einem Pflegeheim.

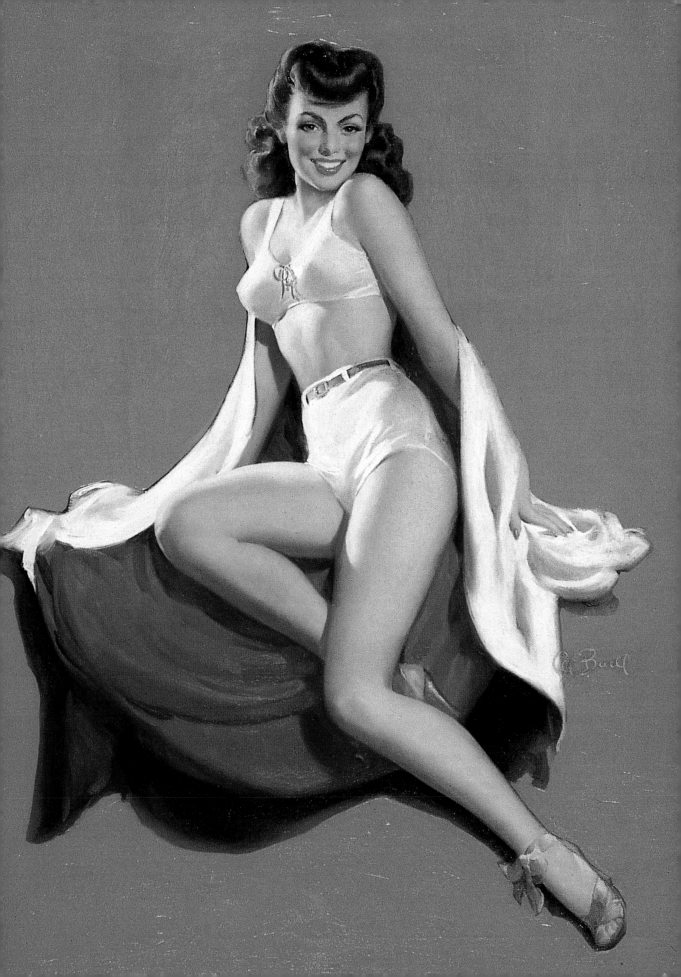

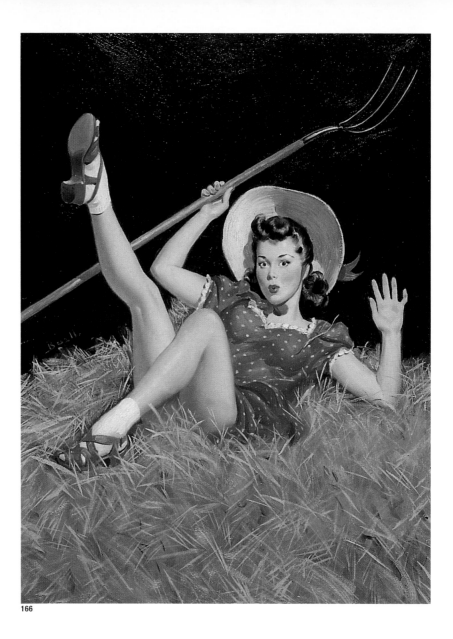

166

Né en 1910 à Hiawatha, au Kansas, Alfred Leslie Buell grandit à Cushing, dans l'O-klahoma. Il envisagea brièvement une carrière d'ingénieur avant que des cours à l'Art Institute de Chicago et un séjour à New York ne le décident à se lancer dans la peinture. Il commença à se consacrer sérieusement à l'apprentissage du métier d'artiste vers 1930 et, avec sa femme Ruth, emménagea cinq ans plus tard à Chi-cago, où il était plus à même de poursuivre son rêve de devenir illustrateur.

Buell rejoignit l'atelier Stevens-Hall-Biondi à Chicago en 1935. Il y rencontra Haddon Sundblom, qui allait jouer un rôle crucial dans son évolution artistique. Il ouvrit son propre atelier vers 1940 mais resta en contact avec le groupe de Sund-blom pendant cinq autres années, et surtout avec ses grands amis Gil Elvgren, Thornton Utz et Joyce Ballantyne.

Buell peignit des pin up pour les calendriers de Gerlach-Barklow dès 1937 (illustrations 166, 170, 173–175). Ses œuvres originales étaient peintes à l'huile sur des cartons à dessin d'environ 50,8 x 40,6cm, et étaient signées «Buell» en lettres d'imprimerie. Parmi les autres éditeurs de calendriers pour lesquels il travailla au début des années 40 se trouvait Kemper-Thomas, pour qui il réalisa des toiles vivement colorées de 81,3 x 71,1 cm, signées de son nom intégral (illustrations 165 et 167).

Pendant la Deuxième Guerre mondiale, jugé inapte à servir sous les drapeaux, Buell peignit des pin up très populaires telles que *WAVE, WAC, Nurse* («Auxiliaires féminines de l'infanterie, de la marine et infirmières», 1944) et *They're All Tops* (1945), qui remportèrent un immense succès sous forme de posters, de calen-

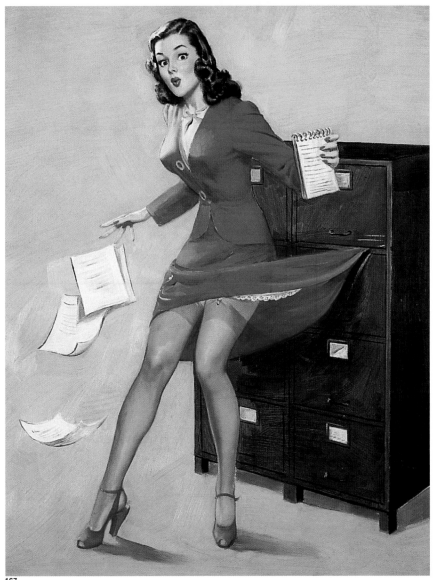

167

driers et de produits divers édités par Brown and Bigelow. Vers la même époque, l'artiste adopta définitivement le nom de «Al Buell».

Buell fut parmi les artistes glamour importants de la série Gallery of Glamour d'*Esquire,* qui parut à partir de septembre 1946. Il fournit des illustrations à un grand nombre de magazines populaires et reçut de nombreuses commandes publicitaires, notamment de la part de Coca-Cola dans les années 40 et 50. Seul artiste autodidacte du cercle de Sundblom, Buell figura dans un article sur ce groupe de juin 1956 de la revue *American Artist.* En 1956, il s'installa avec sa famille à Sarasota en Floride, et se mit à peindre des couvertures pour livres de poche.

A la fin des années 50, Buell travailla de nouveau pour Brown and Bigelow, créant de superbes images telles que *Summer Sweetheart* (1959 ; illustration

169). Au début des années 60, il réalisa son propre calendrier de douze pages pour la même maison, *Al Buell's DELECTaBELLES* (1960), suivi d'un Artist's Sketch Pad (Al Buell's Beauties, 1961 ; illustrations 180–183) et de la magnifique image glamour *Top Date* (1962, illustration 1).

Buell mit un terme à sa carrière d'illustrateur vers 1965 pour se consacrer à la peinture de paysages et aux portraits. Il continua de travailler jusqu'en 1993, date où il fut blessé dans un accident. Il vit aujourd'hui dans une maison de repos.

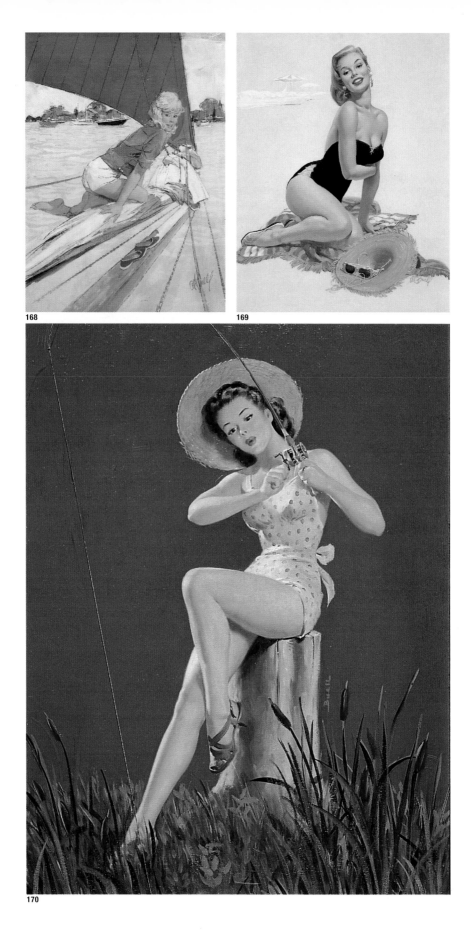

168

169

170

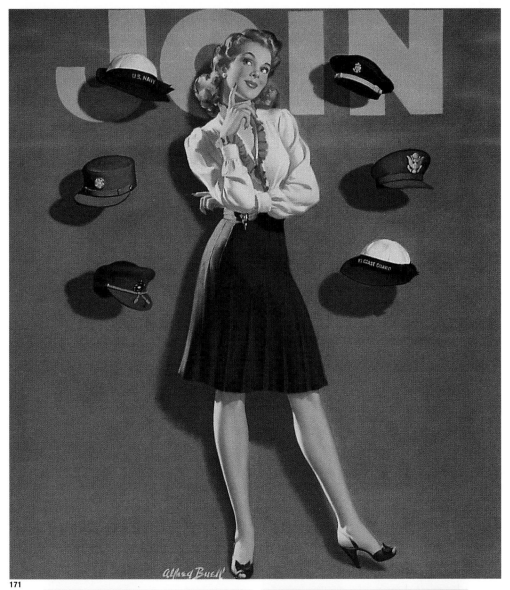

171

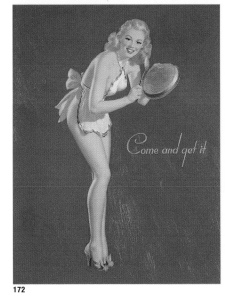

172

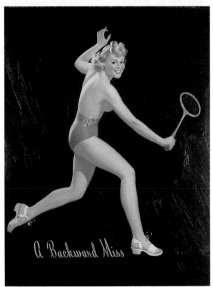

173

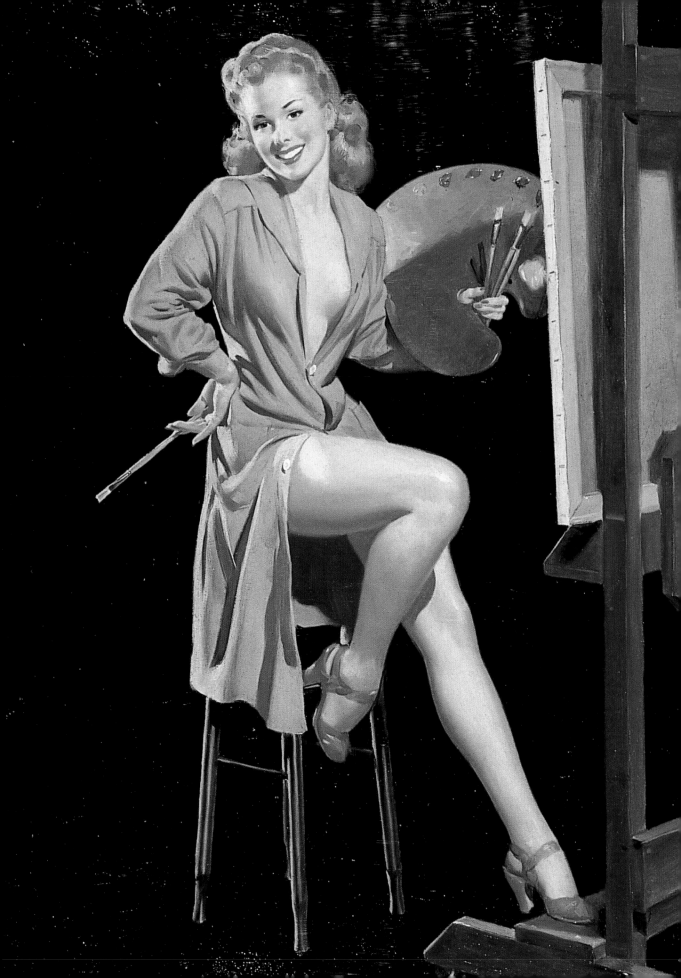

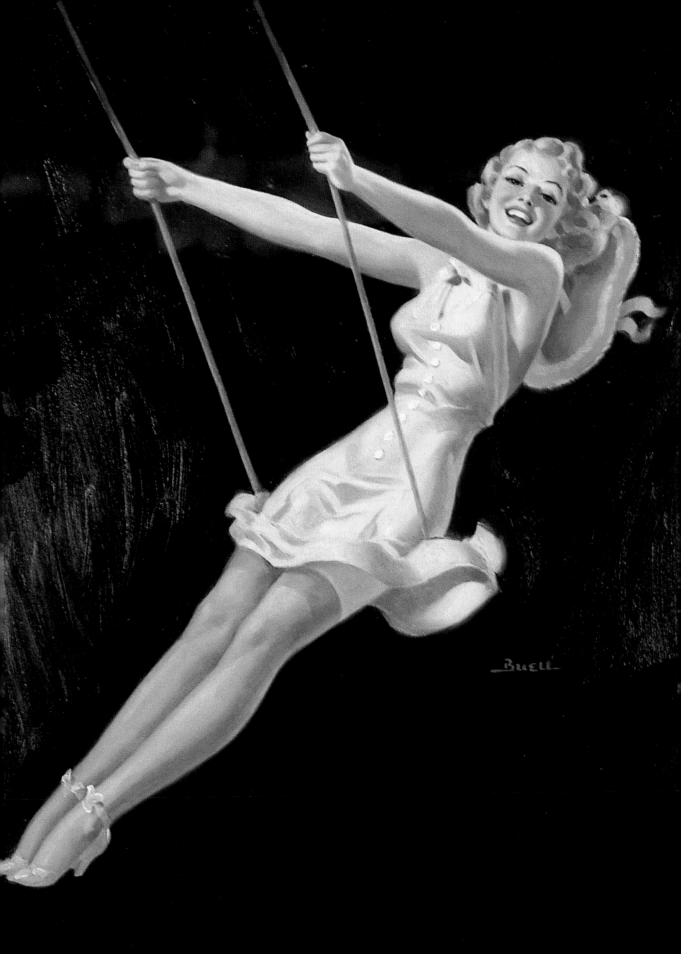

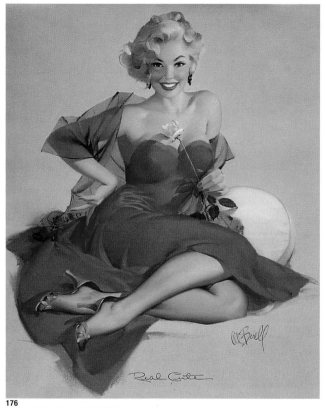

176

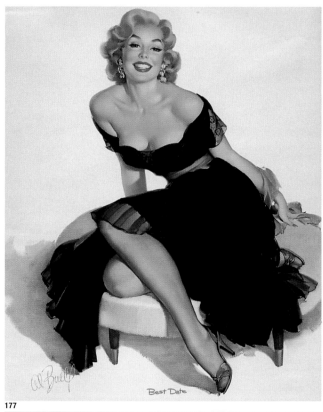

177

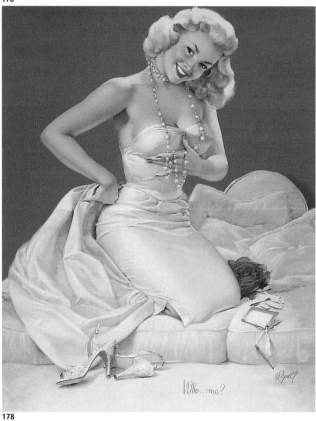

178

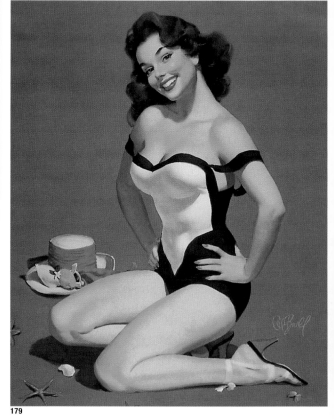

179

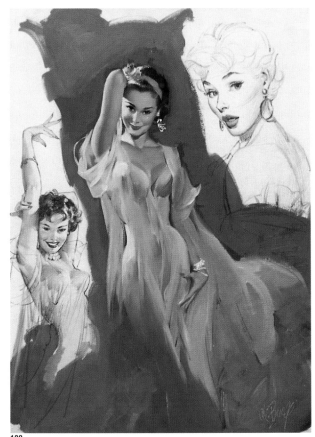

180

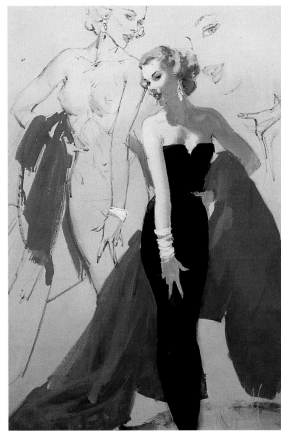

181

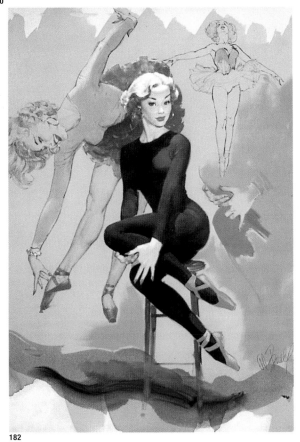

182

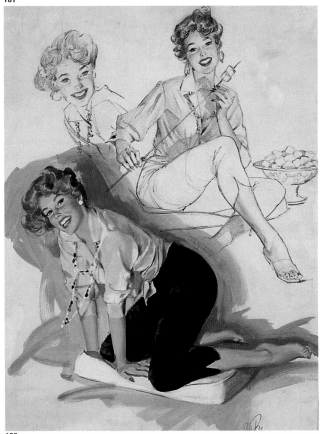

183

Eddie Chan

184

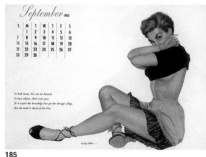

185

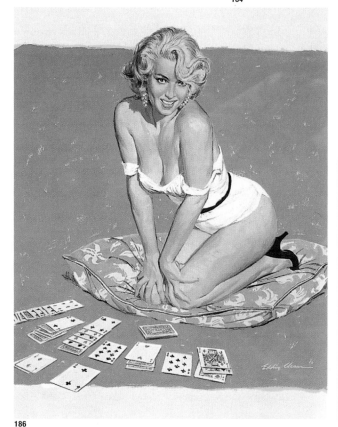

186

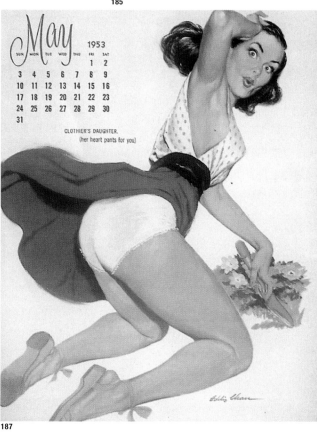

187

Chan painted sexy pin-ups for both *Esquire* magazine and Brown and Bigelow. His work was seen in *Esquire* as two-page gatefolds, beginning in 1952, and also as part of the magazine's 1952 pin-up calendar. Chan was one of a handful of artists selected for Brown and Bigelow's famous 1953 Ballyhoo Calendar (among the others on the project were Al Moore, J. Frederick Smith, and Ward Brackett; figure 187).

Chans Pin-ups für die Zeitschrift Esquire *und den Kalenderverlag Brown and Bigelow waren einfach sexy. Seit 1952 sah man seine Arbeiten auf aufklappbaren Doppelseiten im* Esquire*; im gleichen Jahr war er auch einer der Gestalter des Pin-up-Kalenders der Zeitschrift. Er gehörte zu den wenigen Künstlern, die für eine Mitarbeit am berühmten* Ballyhoo-Kalender (Trara und Tamtam), *den Brown and Bigelow 1953 herausgaben, ausgewählt wurden; neben ihm arbeiteten Al Moore, J. Frederick Smith und Ward Brackett an dem Kalender mit (Abb. 187).*

Chan peignait des pin up sexy pour *Esquire* et Brown and Bigelow. A partir de 1952, ses créatures parurent dans le calendrier du magazine et sur ses posters centraux. Il fut également l'un de ceux choisis par Brown and Bigelow pour illustrer le célèbre calendrier Ballyhoo de 1953, aux côtés de Al Moore, J.Frederick Smith et Ward Brackett (illustration 187).

In addition to pin-up and glamour art, Chan painted a series of front covers for *American Weekly*, the Hearst newspaper's Sunday magazine supplement. During his commercial art career, he did a great deal of advertising work for national accounts. From the late 1940s through the 1960s, he also painted front covers and story illustrations for most of the major mainstream magazines.

Doch Chan schuf nicht nur Pin-ups oder Glamourkunst, sondern gestaltete auch eine Serie von Titelblättern der im Hearst-Imperium erscheinenden Sonntagszeitungsbeilage American Weekly*; als Werbegrafiker arbeitete er für viele national tätige Großunternehmen. Seit Ende der 40er bis zum Ende der 60er Jahre war er außerdem für mehrere der führenden Zeitschriften des Landes im Bereich Covergestaltung und Illustration von Geschichten tätig.*

Outre ses pin up et ses beautés glamour, Chan peignit des couvertures pour *American Weekly,* le supplément dominical du quotidien de Hearst. Au cours de sa carrière, il créa un grand nombre d'images publicitaires pour des annonceurs nationaux. De la fin des années 40 aux années 60, il peignit également des couvertures et des illustrations pour la plupart des magazines à grand tirage.

Ernest Chiriaka

Although Esquire initially hired Al Moore to replace Vargas in the late 1940s, it was Ernest Chiriaka who took over the magazine's twelve-page calendar from 1953 to 1957 – a great responsibility since the calendar had continued to be the largest-selling and most popular in the world.

Born in 1910, Chiriaka got a job painting movie and theater posters for the Associated Display Company in New York City in the early 1930s, even though he had had no formal art training. Realizing he had much to learn, he enrolled in the Art Students League and then moved on to study at the Grand Central School of Art under Harvey Dunn, his greatest influence. In the late 1930s, he worked for the pulps, doing front-cover paintings mainly of Western subjects. Among the "slicks" that employed him were The Saturday Evening Post and Cosmopolitan. During the 1940s and early 1950s, he created front-cover paintings for American Weekly, the Sunday-magazine supplement of the Hearst newspapers.

Chiriaka's first pin-ups were for Esquire in 1952. Working in gouache, he produced works that had very distinctive skin tones, especially in their printed form. Chiriaka contributed pin-ups to the 1953 Brown and Bigelow Ballyhoo Calendar and later did three additional pin-ups (figures 188 and 193) that the firm published as separate calendars. He also traveled often to Hollywood to paint film stars.

In the late 1930s, Chiriaka had devised wonderful front covers for Western pulp magazines. He later went on to create front-cover Western subjects for the paperback book market, working mostly for Pocket Books and Cardinal Editions. When his career in commercial illustration ended, Chiriaka brought his love of the Old West to the field of fine art. His distinctive style, influenced by Impressionism, established him as one of the greats in the field of contemporary Western painting.

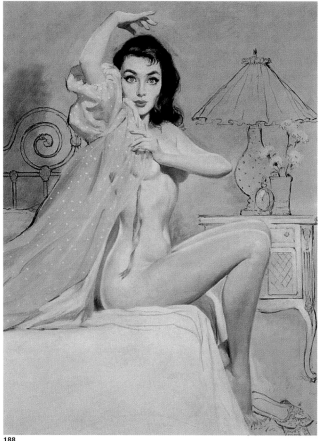

188

Obwohl Esquire *Ende der 40er Jahre eigentlich Al Moore als Ersatz für Alberto Vargas eingestellt hatte, war es doch Ernest Chiriaka, der den zwölfseitigen Kalender der Zeitschrift zwischen 1953 und 1957 betreute. Damit oblag ihm eine große Verantwortung, denn dieser Kalender war weiterhin der bekannteste und meistgekaufte seiner Art, und das auch im internationalen Maßstab.*

Chiriaka wurde 1910 geboren. In den frühen 30er Jahren malte er in New York Kino- und Theaterplakate für die Associated Display Company. Ihm war bewußt, daß er noch viel dazulernen mußte und schrieb sich daher in der Art Students League und später an der Grand Central School of Art ein. Dort wurde Harvey Dunn sein Lehrer, dessen Einfluß in seinem Werk deutlich spürbar ist. In den späten 30er Jahren arbeitete Chiriaka für Groschenromane und konzentrierte sich vorrangig auf Coverillustrationen mit Westernmotiven. Zu den Hochglanzmagazinen, die ihn mit Aufträgen versorgten, gehörten auch die Saturday Evening Post *und* Cosmopolitan.

Während der 40er und frühen 50er Jahre malte Chiriaka Cover für die Zeitschrift American Weekly.

Seine ersten Pin-ups schuf Chiriaka 1952 für den Esquire. *Er arbeitete in Gouache, und seine Arbeiten besaßen einen besonderen Hautton. Pin-ups von Chiriaka wurden 1953 in den Ballyhoo-Kalender aufgenommen; drei spätere Pin-up-Serien Chiriakas (Abb. 188 und 193) brachte der Verlag als Einzelkalender heraus. Chiriaka reiste oft nach Hollywood, um Filmstars zu porträtieren.*

In den späten 30er Jahren waren ihm wunderbare Groschenromancover mit Westernmotiven geglückt. Später entwickelte er solche Cover für den Taschenbuchmarkt und arbeitete vorrangig für die Verlage Pocket Books und Cardinal Editions. Nach dem Ende seiner Laufbahn als Werbegrafiker wandte sich Chiriaca der klassischen Malerei zu und arbeitete mit Westernmotiven im Stil des Impressionismus. Er wurde einer der ganz Großen im Genre der modernen Westernmalerei.

*Bien qu'*Esquire *ait initialement engagé Al Moore pour remplacer Vargas à la fin des années 40, c'est Ernest Chiriaka qui prit en charge le calendrier de douze pages du magazine entre 1953 et 1957: une grande responsabilité puisque ce calendrier continua d'être le plus vendu et le plus populaire au monde.*

Né en 1910, Chiriaka commença par peindre des affiches de théâtre et de cinéma pour l'American Display Company à New York au début des années 30, sans avoir jamais fait d'études d'art. Se rendant compte qu'il avait beaucoup à apprendre, il s'inscrivit à l'Art Students League, puis paracheva sa formation à la Grand Central School of Art sous la direction d'Harvey Dunn, qui l'a le plus influencé. A la fin des années 30, il réalisa des couvertures pour les pulps, le plus souvent sur le thème de l'Ouest américain. The Saturday Evening Post *et* Cosmopolitan *furent parmi les magazines de luxe qui le publièrent. Pendant les années*

40 et le début des années 50, Chiriaka réalisa des couvertures pour American Weekly, *le supplément dominical des publications Hearst.*

Les premières pin up de Chiriaka pour Esquire *parurent en 1952. Il travaillait à la gouache, avec des tons chair très particuliers, notamment sur les reproductions. Chiriaka peignit des pin up pour le calendrier Ballyhoo de Brown and Bigelow en 1953, puis trois autres (illustrations 188 et 193) que l'éditeur publia dans d'autres calendriers. Il se rendit également à Hollywood pour faire des portraits de stars.*

A la fin des années 30, Chiriaka conçut de superbes couvertures pour différents pulps de westerns. Il en réalisa d'autres plus tard pour les livres de poche, principalement pour Pocket Books et Cardinal Editions. Lorsque sa carrière d'illustrateur prit fin, Chiriaka revint à ses premières amours et se mit à peindre des scènes du grand Ouest américain. Son style très personnel, influencé par les impressionnistes, a fait de lui un des grands maîtres contemporains de ce genre de peinture.

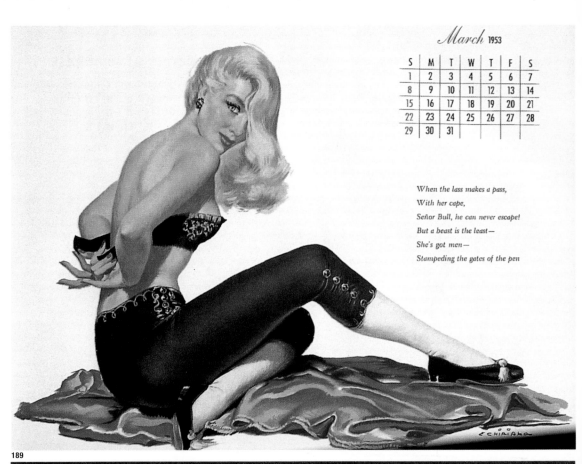

S	M	T	W	T	F	S
1	2	3	4	5	6	7
8	9	10	11	12	13	14
15	16	17	18	19	20	21
22	23	24	25	26	27	28
29	30	31				

When the lass makes a pass,

With her cape,

Señor Bull, he can never escape!

But a beast is the least—

She's got men—

Stampeding the gates of the pen

189

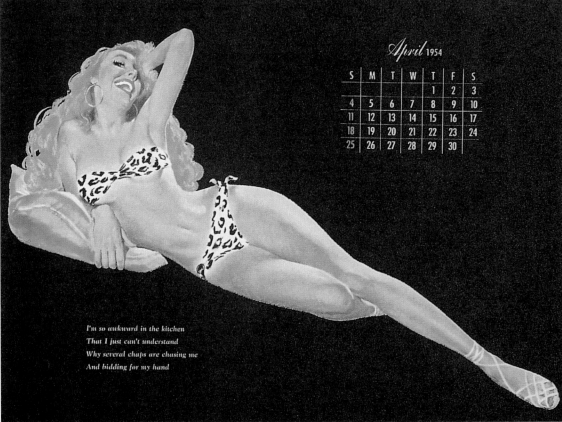

April 1954

S	M	T	W	T	F	S
				1	2	3
4	5	6	7	8	9	10
11	12	13	14	15	16	17
18	19	20	21	22	23	24
25	26	27	28	29	30	

I'm so awkward in the kitchen
That I just can't understand
Why several chaps are chasing me
And bidding for my hand

190

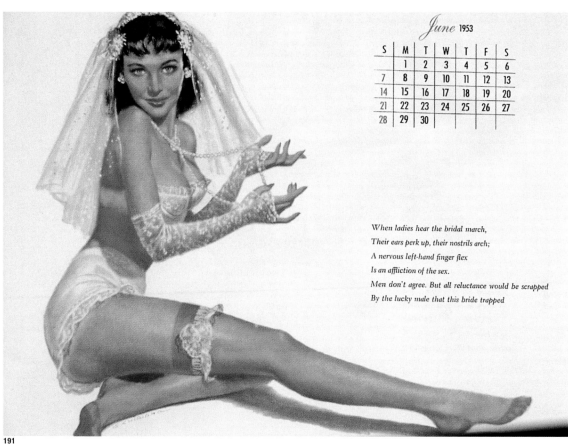

June 1953

S	M	T	W	T	F	S
	1	2	3	4	5	6
7	8	9	10	11	12	13
14	15	16	17	18	19	20
21	22	23	24	25	26	27
28	29	30				

When ladies hear the bridal march,
Their ears perk up, their nostrils arch;
A nervous left-hand finger flex
Is an affliction of the sex.
Men don't agree. But all reluctance would be scrapped
By the lucky male that this bride trapped

191

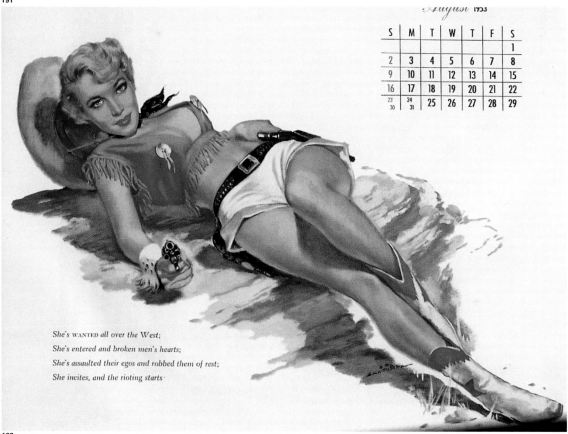

August 1953

S	M	T	W	T	F	S
						1
2	3	4	5	6	7	8
9	10	11	12	13	14	15
16	17	18	19	20	21	22
23 / 30	24 / 31	25	26	27	28	29

She's WANTED all over the West;
She's entered and broken men's hearts;
She's assaulted their egos and robbed them of rest;
She incites, and the rioting starts·

192

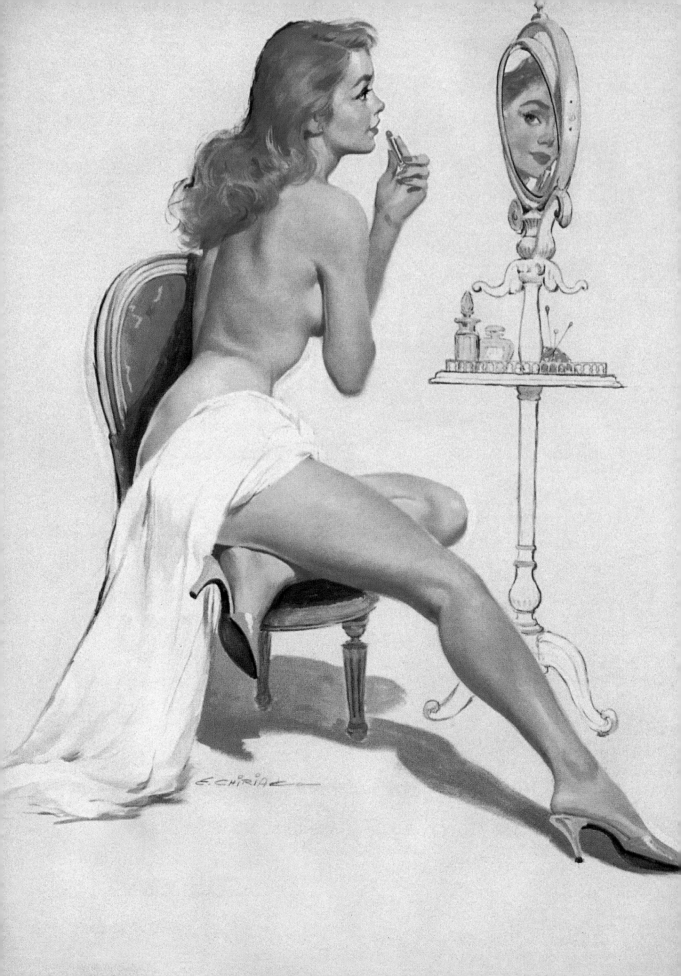

Henry Clive

Clive was born Henry O'Hara in 1882 and spent his childhood on a sheep ranch in Melbourne, Australia, before leaving home to become a magician. A strikingly handsome young man, he arrived in Hollywood in 1917 and soon found success in silent films. By 1920, he had transformed himself yet again, this time into an accomplished artist.

Clive's assignments in the early 1920s included paintings of the Ziegfeld Follies Girls (figure 194), a poster for Richard Barthelmess's film *Experience*, and portraits of Pola Negri and Gloria Swanson that were reproduced on lunch boxes distributed free to moviegoers. By 1925, after designing dozens of covers for *Theatre* magazine, he began to create pin-ups for a number of major publishing houses and calendar companies, most notably, Joseph C. Hoover and Sons in Philadelphia (figure 195).

Most of Clive's work was executed in oil on board in a fairly large format, generally about 30 x 24 inches (76.2 x 61 cm). His elaborately sensuous, painterly images showed a skillful use of color and almost always had beautifully painted backgrounds (figure 196).

Among the highlights of Clive's later career were his artwork for Billy Rose's extravaganza *Jumbo* and his weekly portraits of movie stars in exotic settings for the series entitled Enchantresses of the Ages, published in Hearst's *American Weekly Magazine*.

Embraced by both Hollywood and New York City, Clive lived a rich life. He maintained a studio in the renowned Beaux Arts Building in Manhattan until his death in 1960. In a tribute to his artistic brilliance, the hard-cover magazine *Audience* selected one of Clive's vintage pin-ups for its October 1971 front cover. Today, collectors value his calendar prints highly; no more than six of his original paintings are known to exist.

Clive wurde 1882 als Henry O'Hara geboren. Seine Kindheit verbrachte er auf einer Schafranch in Melbourne, Australien. Er verließ sein Elternhaus mit dem Wunsch, Zauberer zu werden. 1917 landete der ausgesprochen gutaussehende junge Mann in Hollywood und hatte dort bald Erfolg in Stummfilmen. Drei Jahre später interessierte ihn bereits etwas anderes. Er war ein mehr als passabler Künstler geworden.

Zu seinen Aufträgen in den frühen 20er Jahren gehörten Gemälde für die Ziegfeld Follies Girls (Abb. 194) ein Poster für Richard Barthelmess' Film Experience *sowie Porträts von Pola Negri und Gloria Swanson, die, auf Frühstücksboxen reproduziert, Kinogänger als Geschenk erhielten. Nachdem er Dutzende von Covern für das Magazin* Theatre *entworfen hatte, begann er 1925 für mehrere große Verlagshäuser und Firmen – Joseph C. Hoover and Sons in Philadelphia war die wichtigste von ihnen – Pin-ups zu malen (Abb. 195).*

Die meisten seiner Arbeiten wurden in Öl auf Karton in einem verhältnismäßig großen Format, normalerweise 76 x 61 cm, ausgeführt. Seine detaillierten, sinnlichen Bilder bezeugen eine kunstvolle Verwendung der Farbe; in den meisten Fällen stattete er sie mit wunderschön gemalten Hintergründen aus (Abb. 196).

Zu den Highlights seiner späteren Karriere gehören die Werbung zu dem Billy-Rose-Spektakel Jumbo *und seine wöchentlich erscheinenden Porträts von Filmstars vor exotischer Kulisse. „Enchantresses of the Ages" (Bezaubernde Frauen der Geschichte) hieß diese Serie, die in Hearst's* American Weekly Magazine *veröffentlicht wurde.*

Er hatte Erfolg an beiden Küsten des Landes – in Hollywood und in New York – und konnte sich ein luxuriöses Leben leisten. Bis zu seinem Tod 1960 hatte er in dem bekannten Beaux Arts Building in Manhattan ein Studio. Das Hardcover-Magazin Audience *wählte für die Oktoberausgabe 1971 eines von Clives herausragendsten Pin-ups als Cover: ein Tribut an seine künstlerische Leistung. Heute werden seine Kalender von Sammlern hoch geschätzt; nur von sechs seiner Originalgemälde weiß man mit Sicherheit, daß sie existieren.*

Clive, né Henry O'Hara en 1882, passa son enfance dans un élevage de moutons à Melbourne, en Australie, avant de quitter la maison familiale pour devenir magicien. Très beau garçon, il arriva à Hollywood en 1917, où il commença rapidement une carrière prometteuse dans le cinéma muet. Vers 1920, il subit une nouvelle métamorphose, devenant cette fois un brillant artiste.

Au début des années 20, Clive peignit des girls pour Ziegfeld Follies (illustration 194), une affiche pour le film de Richard Barthelmess Experience, *et des portraits de Pola Negri et de Gloria Swanson qui furent reproduits sur des paniers repas distribués gratuitement dans les salles de cinéma. En 1925, après avoir réalisé des dizaines de couvertures pour le magazine* Theatre, *il commença à peindre des pin up pour plusieurs grandes maisons d'édition et des éditeurs de calendriers, notamment Joseph C. Hoover and Sons de Philadelphie (illustration 195).*

Clive réalisa la plupart de ses œuvres à l'huile sur carton dans un format assez grand, généralement 76,2 x 61 cm. Ses images sensuelles, à la composition élaborée, avec de superbes fonds travaillés, démontrent un grand sens de la couleur (illustration 196).

Parmi les moments forts de sa carrière, on compte ses affiches pour le somptueux spectacle de Billy Rose «Jumbo» et ses portraits hebdomadaires de stars dans des paysages exotiques réalisés pour la série Enchantresses of the Ages, parue dans une publication de Hearst, American Weekly Magazine.

Enfant chéri d'Hollywood et de New York, Clive eut une vie haute en couleurs. Il conserva son atelier dans le célèbre Beaux Arts Building à Manhattan jusqu'à sa mort en 1960. En hommage à son talent, la prestigieuse revue Audience *choisit l'une de ses pin up pour sa couverture d'octobre 1971. Aujourd'hui, les collectionneurs s'arrachent les reproductions de ses œuvres pour calendriers. On ne connaît que six de ses originaux.*

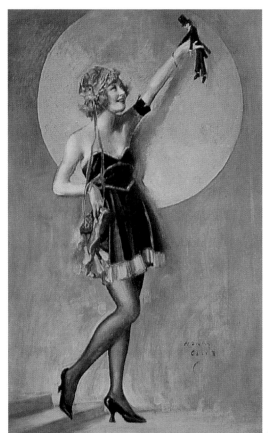

194

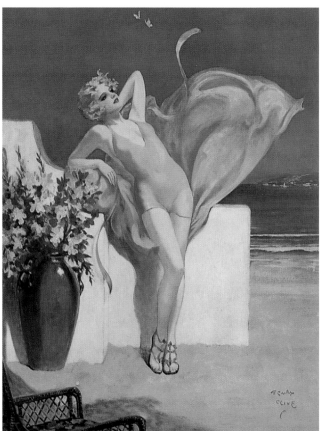

195

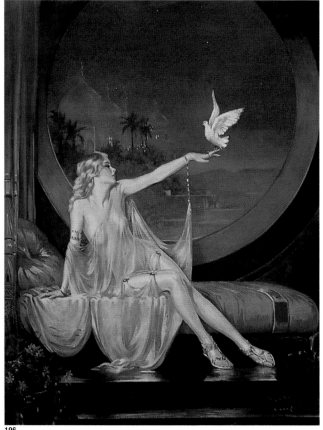

196

Forest Clough

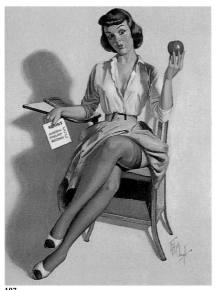

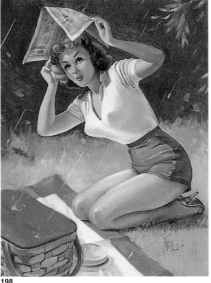

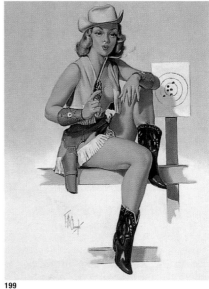

197

198

199

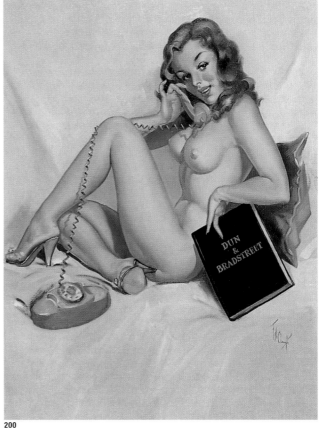

Clough was born in 1910 and grew up in Houston, Texas. He studied at the Ameri-
can Academy of Art in Chicago as well as at the New Orleans Art School. Although
his greatest influence was Gil Elvgren (with whom he corresponded at length),
Clough also traveled to California to meet Earl Moran, whom he admired, and to
Taos, New Mexico, to see Zoë Mozert after she retired.

Clough's commercial art was published by the McCleery-Cummings Company
in Washington, Iowa, and the Skinner-Kennedy Company in St. Louis. His business
clients included the KLM Corporation and the Keherlinus Lithography Company,
both in Chicago. In 1958, Clough moved to Hollywood, California. He later
returned to Texas, where he died in 1985.

*Clough, 1910 geboren, wuchs in Houston, Texas, auf. Er studierte an der Ameri-
can Academy of Art in Chicago und an der New Orleans Art School. Obwohl Gil
Elvgren ihn mehr als jeder andere beeinflußte, inspirierte ihn auch das Werk Earl
Morans und Zoë Mozerts.*

*Cloughs Arbeit als Werbegrafiker wurde von der McCleery-Cummings Compa-
ny veröffentlicht, die in Washington, Iowa, ansässig war, sowie von der Skinner-
Kennedy Company aus St. Louis. Zu seinen Werbekunden gehörten die beiden
Chicagoer Unternehmen KLM Corporation und Keherlinus Lithography Company.
1958 zog Clough nach Hollywood, kehrte dann aber wieder nach Texas zurück,
wo er 1985 starb.*

Originaire de Houston, au Texas où il naquit en 1910, Clough étudia à l'American
Academy of Arts de Chicago, puis à la New Orleans Art School. Si Gil Elvgren eut
la plus grande influence sur lui (ils entretinrent une longue correspondance),
Clough avait une grande admiration pour Earl Moran, auquel il rendit visite en
Californie, et Zoë Mozert, qu'il alla voir à Taos, au Nouveau-Mexique.

Les images de Clough furent publiées par la McCleery-Cummings Company,
basée à Washington dans l'Iowa, et la Skinner-Kennedy Company de Saint Louis.
Il travailla pour de nombreux grands annonceurs, dont K.L.M. et la Keherlinus
Lithography Company, tous deux à Chicago. En 1958, Clough s'établit à Holly-
wood. Il revint plus tard au Texas, où il mourut en 1985.

200

Howard Connolly

Connolly was born in 1903 in New Bedford, Massachusetts. During the 1920s, he attended the Swin School of Design there, the Massachusetts School of Art in Boston, and the Art Students League in New York. He also studied in Europe under the great English watercolorist Sir Russell Flint, and later at the John Pike School of Watercolor in New York.

From the beginning of his career, Connolly's first love was capturing the beauty of women in his art. His earliest commercial work was for Montgomery-Ward in 1930 (later corporate clients included Campbell's Soup, Beefeater Gin, Armstrong Tires, and Newport cigarettes). He also worked as a painter of movie signs and billboards, most notably for the Tremont Theatre in Boston. In 1938, *Collier's* published his first glamour art magazine cover, and his pin-ups soon began to appear on magazine covers as well. During the 1940s and 1950s, he created full-length pin-ups for various calendar companies. In 1946, Connolly was commissioned to paint a portrait of Miss America, for both the United States and Canadian markets, and the magazines *Romance* and *Love* also carried his work. Among his 1950s paintings were covers for Car Life (1954) and reprints of his Miss America pin-up in *Toronto's Star Weekly* (1952, 1954). Highlights of his 1960s work include covers for *Ford Times* (1966, 1969) as well as illustrations for *Collier's*.

Connolly taught at the Academy of Art in Newark, New Jersey, as well as at schools in Westerly, Rhode Island. He is a member of the American Watercolor Society and the Society of Illustrators. He has consistently credited Rolf Armstrong as his greatest artistic inspiration.

Howard Connolly wurde 1903 in New Bedford im Bundesstaat Massachusetts geboren. Während der 20er Jahre besuchte er die dortige Swin School of Design und wechselte später an die Bostoner Massachusetts School of Art und die in New York ansässige Art Students League. Er nahm außerdem Unterricht bei dem herausragenden englischen Aquarell-Maler Sir Russell Flint; danach studierte Connolly an der auf Aquarelle spezialisierten John Pike School of Watercolor in New York.

Schon zu Beginn seiner Laufbahn galt Connollys Interesse immer der Darstellung weiblicher Schönheit. Aus dem Jahr 1930 stammt seine erste Auftragsarbeit für den Werbekunden Montgomery-Ward (später wurden Großunternehmen wie Campbell's Soup, Beefeater Gin, Armstrong Tires und die Zigarettenmarke Newport seine Auftraggeber). Vorrangig für das Tremont Theatre in Boston malte er Schilder und Billboards, auf denen für Filme geworben wurde. 1938 gelang ihm der Sprung auf die Titelseite: Die Zeitschrift Collier's verwendete ein Glamourbild von Connolly als Cover. Bald wurden auch seine Pin-ups bei Zeitschriften titelfähig. Während der 40er und 50er Jahre schuf er für diverse Kalenderverlage Ganzkörper-Pin-ups.

1946 erhielt Connolly den Auftrag, für den amerikanischen und den kanadischen Markt Miss America zu porträtieren. Zum gleichen Zeitpunkt begannen die Zeitschriften Romance und Love, seine Arbeiten zu übernehmen. Zu seinen Bildern der 50er Jahre gehören Cover für Car Life (1954). Nachdrucke seines Miss America Pin-ups wurden im kanadischen Star Weekly aus Toronto veröffentlicht (1952, 1954). Highlights seiner Karriere in den 60er Jahren waren Cover für die Ford Times (1966, 1969) und Illustrationen für die Zeitschrift Collier's.

Connolly lehrte an der Academy of Art in Newark, New Jersey, und unterrichtete auch an Schulen im Umkreis von Westerly im Bundesstaat Rhode Island. Er gehört der American Watercolor Society und der Society of Illustrators an. Den größten künstlerischen Einfluß, so Connolly, habe Rolf Armstrong auf ihn gehabt.

Né en 1902 à New Bedford, dans le Massachusetts, Connolly fit ses études à la Swin School of Design de sa ville natale, à la Massachusetts School of Art de Boston puis à l'Art Students League de New York. Il étudia également en Europe avec le grand aquarelliste anglais Sir Russell Flint, avant de revenir à New York pour s'inscrire à la John Pike School of Watercolor.

Dès le début de sa carrière, Connolly s'attacha à restituer l'essence de la beauté féminine. Il peignit ses premières images publicitaires en 1930 pour Montgomery-Ward (ses autres grands clients étaient Campbell's Soup, Beefeater Gin, Armstrong Tires et les cigarettes Newport). Il réalisa également des affiches et des panneaux publicitaires de cinéma, notamment pour la salle du Tremont Theatre à Boston. En 1938, *Collier's* publia sa première couverture glamour et ses pin up ne tardèrent pas à fleurir sur des couvertures de magazine. Pendant les années 40 et 50, il créa des pin up pour différents éditeurs de calendriers. En 1946, Connolly fut chargé du portrait officiel de Miss Amérique, destiné aux marchés américain et canadien. Cette même année, ses images parurent dans les magazines *Romance* et *Love*. Dans les années 50, il réalisa entre autres des couvertures pour *Car Life* (1954) et sa pin up de Miss Amérique fut republiée plusieurs fois dans un journal de Toronto, *Star Weekly* (1952, 1954). Les moments forts de sa carrière dans les années 60 furent entre autres des couvertures pour *Ford Times* (1966, 1969) ainsi que des illustrations pour *Collier's.*

Connolly a enseigné à l'Academy of Art de Newark, dans le New Jersey, ainsi que dans plusieurs écoles de Westerly, à Rhode Island. Il est membre de l'American Watercolor Society et de la Society of Illustrators. Selon ses propres dires, Rolf Armstrong est l'illustrateur qui l'a le plus influencé.

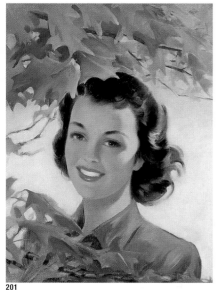

201

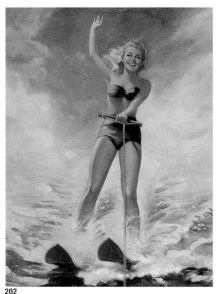

202

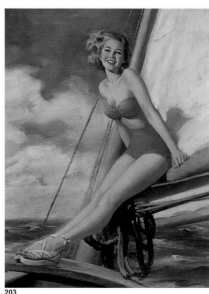

203

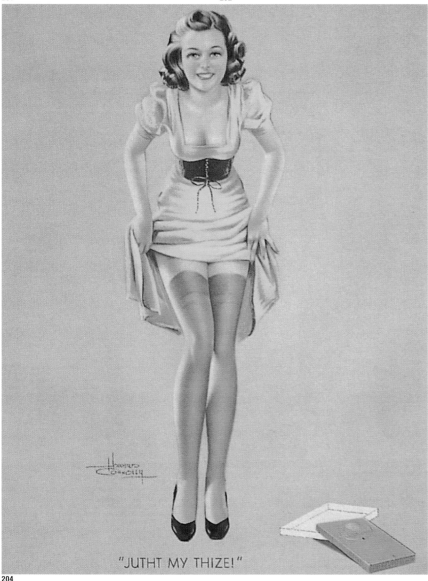

"JUTHT MY THIZE!"

204

Bradshaw Crandell

In 1935, Bradshaw Crandell signed a ten-year contract with the Gerlach-Barklow Company of Joliet, Illinois, for the delivery every year on or about Thanksgiving of one pin-up girl pastel for the sum of $10,000 per painting. This arrangement not only made Crandell the highest paid pin-up artist of the time, but also underscored his tremendous importance in the field of commercial art, and specifically in the glamour industry.

Born in Glens Falls, New York, in 1896, Crandell attended Wesleyan University and then studied commercial illustration and fine art at the Chicago Art Institute. At the age of twenty-five, he sold a design to *Judge*, the first of his many prestigious front-cover assignments featuring glamorous women. In the mid-1930s, Crandell replaced Harrison Fisher as the illustrator of *Cosmopolitan*'s monthly front covers. Working exclusively in pastel on illustration board, he designed more than twelve years of covers for the magazine, often using movie actresses as his models to capture the latest trends.

The versatile Crandell enjoyed working in many fields of illustration, including calendars, advertising-specialty products, and film posters. He painted the two most famous pin-up girls as the subjects for movie posters: Rita Hayworth, in *The Loves of Carmen*, and Betty Grable, in *Footlight Serenade*. In 1939, both he and McClelland Barclay designed posters for the film *Hotel for Women*.

Crandell was an active member of the Dutch Treat Club, the Artists and Writers Association, and the Society of Illustrators. He particularly enjoyed portraiture, and his work in that genre included likenesses of several state governors and many prominent society figures. Although he worked mostly in pastels, Crandell sometimes employed charcoal on canvas when the assignment required it.

During a career that spanned twenty-five years, Crandell created many images that combined sex appeal, sophistication, and glamour in his own distictive way.

1935 unterzeichnete Bradshaw Crandell einen Zehnjahresvertrag mit der Gerlach-Barklow Company aus Joliet, Illinois. Jedes Jahr an amerikanischen Traditionsfest Thanksgiving sollte der Künstler ein Pin-up-Girl in Pastell malen. – für 10000 Dollar pro Gemälde. Diese Vereinbarung machte Crandell nicht nur zum bestverdienenden Pin-up-Künstler der damaligen Zeit, sondern war gleichzeitig ein Indiz für den hohen Stellenwert, den Crandell im Bereich der Werbegrafik und ganz besonders in der Glamourkunst besaß.

Bradshaw Crandell wurde 1886 in Glen Falls im Bundesstaat New York geboren. Er studierte an der Wesleyan University und belegte dann Kurse in Werbeillustration und -grafik sowie klassischer Malerei am Art Institute of Chicago. Als er als 25jähriger eine Arbeit an Judge *verkaufen konnte, war es der Beginn einer lukrativen Zusammenarbeit mit renommierten Zeitschriften. Mitte der 30er Jahre löste Crandell Harrison Fisher als Illustrator der Titel von* Cosmopolitan *ab. Mehr als zwölf Jahre lang war Crandell nun für die Titelbilder des Magazins verantwortlich; er arbeitete ausschließlich in Pastell auf Karton und wählte, auf der Suche nach den neuesten Trends, oft Filmschauspielerinnen als Modelle aus.*

Der talentierte und überaus vielseitige Crandell arbeitete für Kalenderverlage und als Werbegrafiker für Spezialprodukte. Berühmt wurde er durch seine Filmplakate: Zwei der berühmtesten Pin-ups in der Geschichte der Filmposter stammen von ihm: Rita Hayworth als männermordende Zigeunerin für The Loves of Carmen *(Liebesnacht in Sevilla) und Betty Grable in dem Musical* Footlight Serenade. *Gemeinsam mit McClelland Barclay entwarf er 1939 Filmposter zu* Hotel for Women, *dem Debütfilm der Schauspielerin Linda Darnell.*

Crandell war aktives Mitglied des Dutch Treat Clubs, der Artists and Writers Association und der Society of Illustrators. Sein Lieblingssujet waren Porträts; er erhielt offizielle Aufträge von Politikern, porträtierte aber auch viele Mitglieder der feinen Gesellschaft. Obwohl er vorrangig in Pastell arbeitete, verwendete Crandell, je nach Auftrag, auch manchmal Kohle auf Leinwand.

Während seiner 25jährigen beruflichen Laufbahn schuf Crandell viele Bilder und Motive, die auf ihre eigene und unverwechselbare Weise Sex-Appeal, Glamour und elegante weibliche Raffinesse miteinander verbinden.

En 1935, Bradshaw Crandell signa un contrat de dix ans avec l'éditeur de calendriers Gerlach-Barklow de Joliet, dans l'Illinois: il s'y engageait à livrer chaque année, vers l'époque du Thanksgiving, un pastel de pin up pour la somme de 10000 dollars pièce. A l'époque, cet accord faisait de Crandell l'artiste de pin up le mieux payé des Etats-Unis et témoignait de son importance dans le monde de l'illustration, notamment de l'illustration glamour.

Né en 1896, à Glens Falls dans l'Etat de New York, Crandell étudia à la Wesleyan University, puis dans le département d'arts appliqués et des beaux-arts du Chicago Art Institute. A vingt-cinq ans, il vendit un dessin à *Judge*. Ce devait être la première d'une longue série de couvertures prestigieuses montrant de belles élégantes. Vers le milieu des années 30, Crandell remplaça Harrison Fisher qui illustrait chaque mois la couverture de *Cosmopolitan*. Travaillant exclusivement au pastel sur des cartons à dessin, il réalisa des couvertures pour cette publication pendant plus de douze ans, prenant souvent des actrices de cinéma comme

modèles afin de transmettre l'esprit du temps. La sphère d'activité de Crandell englobait de nombreux secteurs de l'illustration: calendriers, publicités, gadgets publicitaires et affiches de cinéma. Pour ces dernières, il peignit les deux pin up vivantes les plus célèbres de l'histoire: Rita Hayworth, dans *The Loves of Carmen*, et Betty Grable, dans *Footlight Serenade*. En 1939, il conçut avec McClelland Barclay les affiches du film *Hotel for Women*.

Crandell était un membre actif du Dutch Treat Club, de l'Artist and Writers Association et de la Society of Illustrators. Il aimait particulièrement peindre des portraits et réalisa celui de plusieurs gouverneurs d'Etat ainsi que d'autres personnalités importantes de son temps. Si le pastel était son outil de prédilection, il lui arrivait de travailler au fusain sur toile lorsque la commande l'exigeait.

Au cours d'une carrière qui dura vingt-cinq ans, Crandell créa de nombreuses images où il sut mêler sex-appeal, raffinement et glamour avec une touche toujours très personnelle.

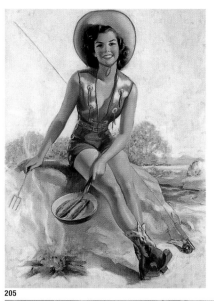

205

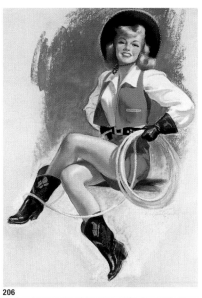

206

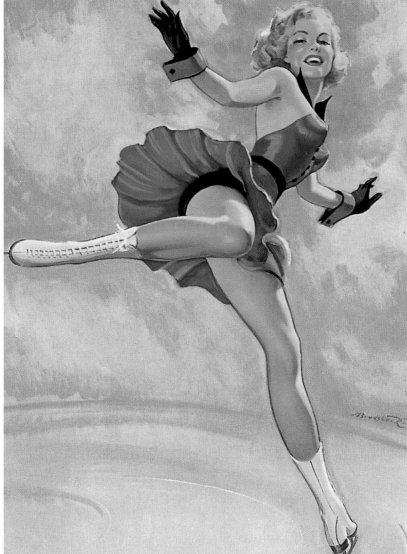

207

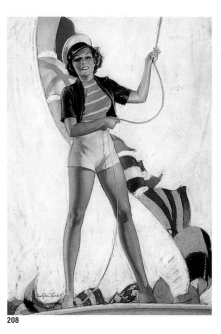

208

Edward
D'Ancona

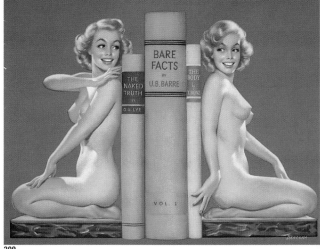

209

Although D'Ancona was a prolific pin-up artist who produced hundreds of enjoyable images, almost nothing is known about his background. He sometimes signed his paintings with the name "D'Amarie," but his real name appears on numerous calendar prints published from the mid-1930s through the mid-1950s, and perhaps as late as 1960.

The first company to publish D'Ancona pin-ups, about 1935 to 1937, was Louis F. Dow in St. Paul (figures 210, 211, 218, 222 and 224). D'Ancona worked in oil on canvas and his originals from that time usually measured about 30 x 22 inches (76.2 x 55.9 cm). His early work is comparable in quality to that of the young Gil Elvgren, who had begun to work for Dow in 1937. Because D'Ancona produced so much work for Dow, one might assume that he was born in Minnesota and lived and worked in the St. Paul-Minneapolis area. It is known that he supplied illustrations to the Goes Company in Cincinnati and to several soft-drink firms, which capitalized on his work's similarity to the Sundblom/Elvgren style, which was so identified with Coca-Cola.

During the 1940s and 1950s, D'Ancona's superb use of primary colors, masterful brushstrokes, and painterly style elevated him to the ranks of the very best artists in pin-up and glamour art. His subject matter at this time resembled Elvgren's: both enjoyed painting nudes and both employed situation poses a great deal. D'Ancona also painted a fair amount of evening-gown scenes, as did Elvgren, Frahm, and Erbit. By 1960, D'Ancona had moved into the calendar art field. Instead of doing pin-ups and glamour images, however, he specialized in pictures on the theme of safety in which wholesome policemen helped children across the street in suburban settings that came straight out of Norman Rockwell.

Obwohl D'Ancona ein sehr produktiver Pin-up-Maler war, der Hunderte von schönen Bildern schuf, ist über sein Leben so gut wie gar nichts bekannt. Manchmal signierte er seine Arbeiten mit „D'Amarie", doch sein richtiger Name taucht auf vielen Kalenderdrucken auf, die von Mitte der 30er Jahre bis Mitte der 50er Jahre erschienen, möglicherweise sogar noch 1960.

Die Louis F. Dow Company in St. Paul war der erste Verlag, der von 1935 bis 1937 Pin-ups von D'Ancona herausbrachte (Abb. 210, 211, 218, 222 und 224). Er arbeitete in Öl auf Leinwand; seine Originale aus dieser Zeit waren normalerweise im Format 76 x 55 cm gehalten. Seine frühen Arbeiten lassen sich in der Qualität mit denen des jungen Gil Elvgren vergleichen, der seit 1937 für Dow arbeitete. Da D'Ancona soviel für Dow tätig war, ist anzunehmen, daß er in Minnesota geboren wurde und in der Gegend um Minneapolis-St. Paul lebte und arbeitete. Es ist bekannt, daß er für die Goes Company in Cincinnati Illustrationen lieferte und auch für mehrere Hersteller von Erfrischungsgetränken arbeitete, die

Kapital aus der Ähnlichkeit seiner Arbeiten mit dem Stil von Sundblom/Elvgren schlugen, der für Coca-Cola charakteristisch war.

In den 40er und 50er Jahren verschafften ihm seine meisterliche Verwendung von Primärfarben, sein gekonnter Strich und sein künstlerischer Stil Zugang zu den Reihen der besten Pin-up- und Glamourkünstler. Seine Themenpalette ähnelte der Elvgrens: Beide malten gerne Akte und ließen ihre Modelle häufig in Situationen agieren. D'Ancona zeichnete auch mehrere festliche Abendszenen, so wie Elvgren, Frahm und Erbit.

Im Jahr 1960 begann D'Ancona für Kalenderverlage tätig zu werden. Doch anstelle von Pin-ups und Glamourbildern spezialisierte er sich auf Sicherheitsthemen und schuf Bilder von gesunden, properen Polizisten, die in idyllischen amerikanischen Kleinstädten, die auch von Norman Rockwell hätten stammen können, Kindern über die Straße helfen.

Bien que D'Ancona ait été un peintre de pin up prolifique, auteur de centaines de belles images, on ne sait presque rien sur ses origines. Il signait parfois «D'Amarie», mais son véritable nom figure sur de nombreuses reproductions de calendriers du milieu des années 30 au milieu des années 50, et peut-être même jusqu'en 1960.

La première maison à publier les pin up de D'Ancona de 1935 à 1937 fut Louis F. Dow de Saint Paul (illustrations 210, 211, 218, 222 et 224). D'Ancona travaillait à l'huile sur toile et les originaux de cette époque mesuraient généralement 76,2 x 55,9 cm. Ses premières œuvres rappellent celles du jeune Gil Elvgren, qui commença à travailler pour Dow en 1937. D'Ancona ayant travaillé si souvent pour Dow, on peut supposer qu'il était originaire du Minnesota et qu'il vivait dans la région de Saint Paul-Minneapolis. Il fournissait également des illustrations à l'éditeur Goes de Cincinnati ainsi qu'à plusieurs entreprises de boissons non

alcoolisées. Celles-ci misaient sur la ressemblance entre son travail et celui de Sundblom et d'Elvgren, associé au grand rival Coca-Cola.

Pendant les années 40 et 50, son utilisation virtuose des couleurs primaires, la maestria de sa touche et de son style pictural le haussèrent au niveau des plus grands artistes de pin up et d'art glamour. Ses sujets de cette époque ressemblaient à ceux d'Elvgren: tous deux aimaient peindre des nus et avaient souvent recours aux scènes de «situation». D'Ancona peignit également un grand nombre de scènes en robe du soir, tout comme Elvgren, Frahm et Erbit.

Vers 1960, D'Ancona entra sur le marché des calendriers. Toutefois, au lieu de pin up et d'images glamour, il se spécialisa dans le thème de la sécurité, peignant de gentils agents de police joufflus aidant des enfants à traverser la rue dans un environnement urbain semblant tout droit sorti des compositions de Norman Rockwell.

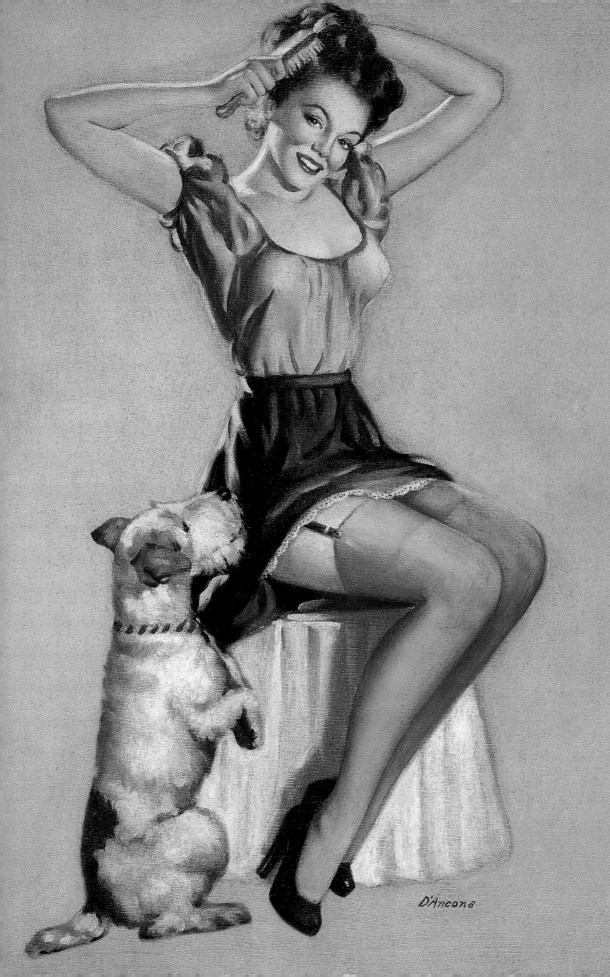

D'Ancona

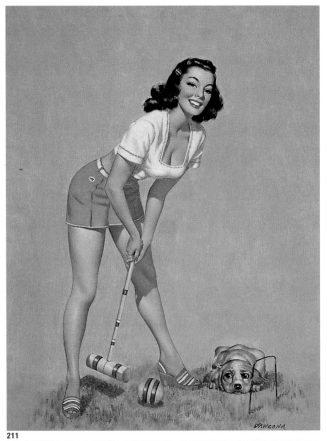

211

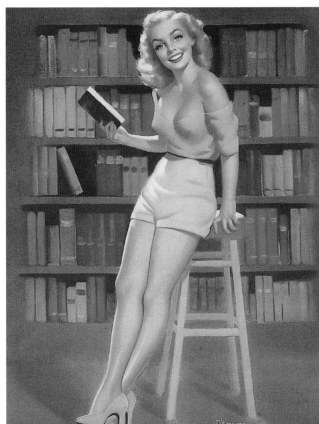

212

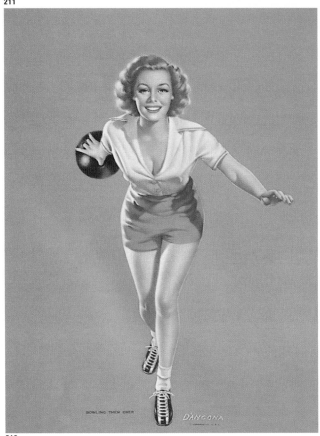

213

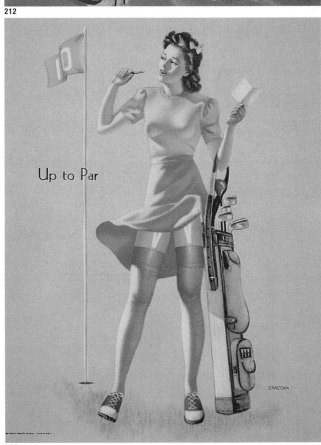

Up to Par

214

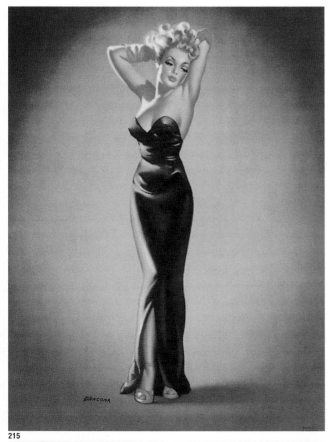

215

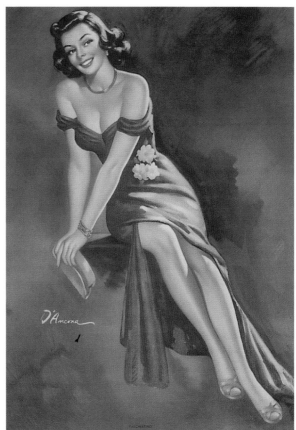

216

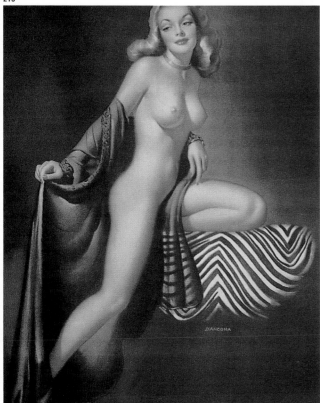

217

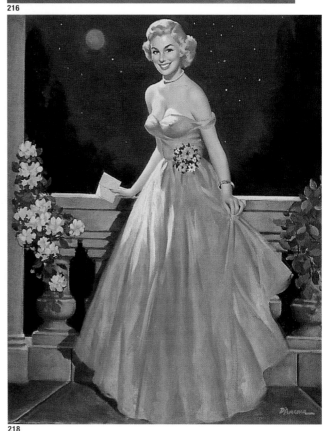

218

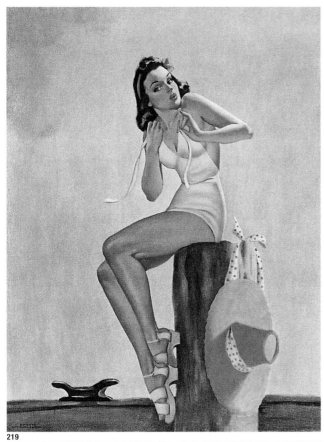

219

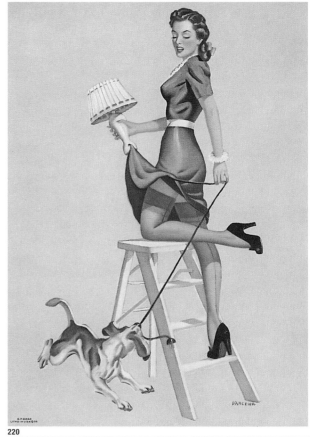

220

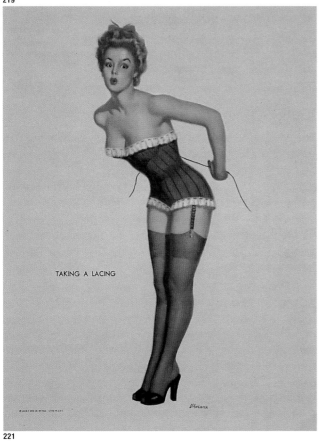

TAKING A LACING

221

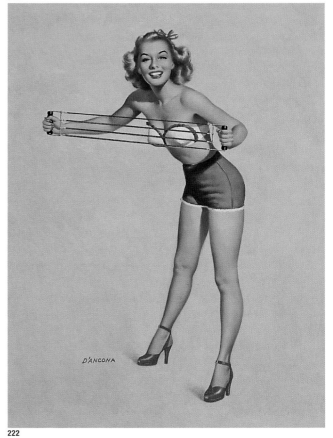

222

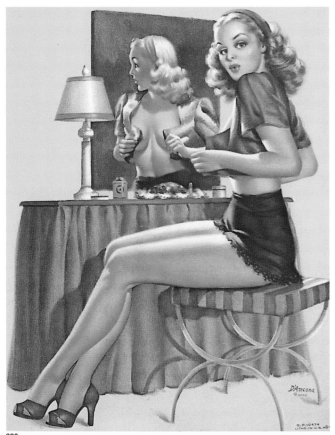

223

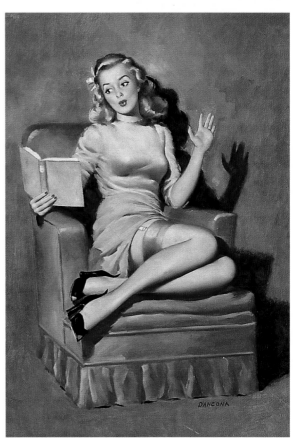

224

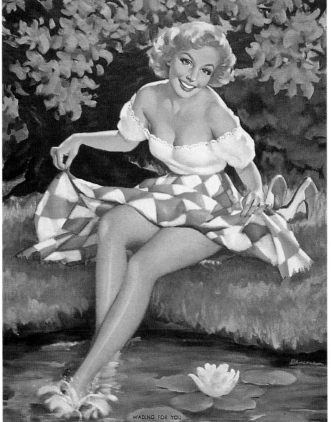

WADING FOR YOU

225

Ruth Deckard

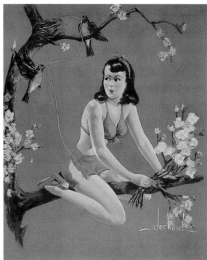

226

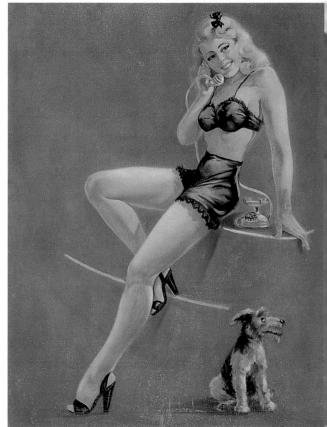

227

According to pin-up authority and renowned collector Max Allen Collins, Deckard was a Chicago-based artist who had many of her pin-up paintings published by the Louis F. Dow Company in St. Paul. She began working in the mid-1930s and created pin-ups until about 1950. One of her most famous images was *What Lines!* (figure 227), which showed a classically posed girl wearing a black bra and panties talking on the telephone while her dog sits next to her listening.

Deckard worked in oil on both canvas and illustration board; her originals measured, on average, from 30 x 24 inches (76.2 x 61 cm) to 36 x 24 inches (91.4 x 61 cm).

Ruth Deckard war nach Informationen der Pin-up-„Koryphäe" Max Allen Collins, einem der bekanntesten Sammler des Genres, eine in Chicago lebende Künstlerin, deren Pin-ups in der Mehrzahl von der Louis F. Dow Company in St. Paul veröffentlicht wurden. Sie arbeitete von Mitte der 30er Jahre bis ungefähr 1950 im Bereich Pin-up. Zu ihren berühmtesten Bildern zählt What Lines! *(Abb. 227): Ein Mädchen in klassischer Pose, mit schwarzem Büstenhalter und schwarzem Höschen bekleidet, telefoniert angeregt, während ihr Hund neben ihr sitzt und aufmerksam mithört.*

Deckard arbeitete in Öl auf Leinwand oder Karton; das Format ihrer Originale reicht von 76 x 61 cm bis zu 91 x 61 cm.

Selon Max Allen Collins, collectionneur de renom et autorité en matière de pin up, Deckard était une artiste travaillant à Chicago qui réalisa un grand nombre de pin up pour les calendriers de Louis F. Dow, l'éditeur de Saint Paul. Elle commença à travailler vers le milieu des années 30 et peignit des pin up jusque dans les années 50. L'une de ses images les plus célèbres était *What Lines!* («Quelle ligne!»; illustration 227), montrant une jeune femme dans une pose classique, portant un soutien-gorge et une culotte noirs, parlant au téléphone et accompagnée d'un petit chien qui écoute à ses pieds.

Deckard travaillait à l'huile sur des toiles et des cartons à dessin. Ses originaux mesuraient en moyenne entre 76,2 x 61 cm et 91,4 x 61 cm.

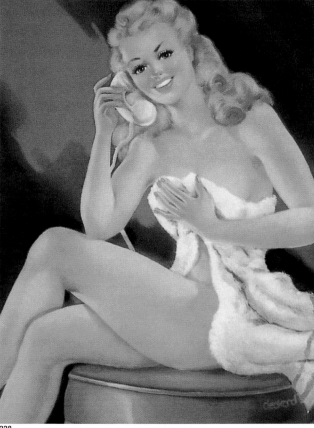

228

Joe DeMers

One of America's top glamour artists, DeMers was first known in the mid-1940s for his sexy pin-ups, but he later attained fame as a illustrator of romance fiction for magazines like *The Saturday Evening Post, McCall's, Ladies' Home Journal*, and *Reader's Digest*.

Born in 1910 in San Diego, DeMers attended Los Angeles's Chouinard Art School and studied there with Pruett Carter. He later enrolled at the Brooklyn Museum Art School, where one of his teachers was Reuben Tam. Between 1927 and 1937, DeMers worked in the art department at Warner Brothers in Hollywood. He met Fritz Willis there, and the two became close friends. During his last three years at the studio, DeMers taught at Chouinard. He began his freelance career in 1937 with an assignment from *Fortune* magazine.

DeMers began painting pin-ups in the late 1930s. After working for several calendar companies, he was approached in the mid-1940s by the giant Shaw-Barton Calendar Company. The firm's top-flight national sales force soon had the entire nation

familiar with the artist's work. In 1946, DeMers received the biggest break of his career. His pal Fritz Willis had been asked to paint the first image in the *Esquire* Gallery of Glamour; the magazine next turned to DeMers and commissioned him to do the second, as well as to become a regular contributor to the series. The joint pin-up that DeMers and Willis contributed to the magazine's October 1946 issue was a significant development in the history of American illustration. The two artists went on to create other works together for the magazine, while continuing to paint individual pin-ups as well.

During the 1950s, DeMers taught at the Parsons School of Design in New York City. In 1953, his pin-ups gained a new family audience when they appeared on the cover of the Ice Capades program. DeMers's fine-art paintings were exhibited at the Museum of Modern Art in New York and at the Los Angeles County Museum. He died in 1984 on Hilton Head Island, South Carolina.

Joe DeMers gehört zur ersten Liga der amerikanischen Glamourkünstler. Mitte der 40er Jahre wurde er durch Pin-ups bekannt; später erlangte er dann als Illustrator von Liebesromanen Berühmtheit, die in Zeitschriften wie The Saturday Evening Post, McCall's, Ladies' Home Journal *und* Reader's Digest *erschienen.*

Joe DeMers wurde 1910 in San Diego geboren und studierte unter Pruett Carter an der Chouinard Art School in Los Angeles und unter Reuben Tam an der Brooklyn Museum Art School. Zwischen 1927 und 1937 arbeitete DeMers in Hollywood in der künstlerischen Abteilung des Filmgiganten Warner Brothers, wo er Fritz Willis kennenlernte. Während seiner letzten drei Arbeitsjahre im Filmstudio unterrichtete DeMers selbst an der Chouinard School. 1937 machte er sich mit einem Auftrag der Zeitschrift Fortune *selbständig.*

DeMers kam Ende der 30er Jahre zur Pin-up-Malerei, und Mitte der 40er Jahre warb ihn der Branchengigant Shaw-Barton Calendar Company an. 1946 kam für DeMers der Durchbruch. Fritz Willis hatte gerade von der Zeitschrift

Esquire *den Auftrag erhalten, für eine neue Folge der „Gallery of Glamour" den ersten Pin-up zu gestalten; nun wandte sich das Blatt an DeMers und bat ihn nicht nur um den Nachfolge-Pin-up, sondern auch um eine regelmäßige Mitarbeit an dieser Serie. In der Oktoberausgabe des Jahres 1946 erschien ein Pin-up, den DeMers und Willis gemeinsam geschaffen hatten. Dieses Bild symbolisiert eine bedeutende Entwicklung in der Geschichte der amerikanischen Illustration. Die beiden Künstler schufen später noch weitere gemeinsame Pin-ups für* Esquire.

In den 50er Jahren unterrichtete DeMers an der Parsons School of Design in New York. Im Jahr 1953 erreichte er mit seinen Pin-ups die Familie als neues Publikum. Er gestaltete Cover der Programmhefte der Revue Ice Capades. *Seine Werke in der Tradition der klassischen Malerei wurden im Museum of Modern Art in New York und im Los Angeles County Museum ausgestellt. DeMers starb 1984 auf Milton Head Island in South Carolina.*

Un des maîtres américains de l'art glamour, DeMers se fit d'abord connaître vers le milieu des années 40 avec ses pin up sexy. Mais il dut surtout sa notoriété à ses illustrations de nouvelles sentimentales publiées dans *The Saturday Evening Post, McCall's, Ladies' Home Journal* et *Reader's Digest*.

Né en 1910 à San Diego, DeMers étudia à la Chouinard Art School de Los Angeles sous la direction de Pruett Carter. Il s'inscrivit ensuite à la Brooklyn Museum Art School, où il eut Reuben Tam comme professeur. Entre 1927 et 1937, il travailla dans le département artistique de Warners Brothers à Hollywood. Il y rencontra Fritz Willis avec lequel il noua une solide amitié. Pendant ses trois dernières années aux studios, il enseigna également à la Chouinard School. Il devint illustrateur free-lance en 1937, avec une commande pour le magazine *Fortune*.

DeMers commença à peindre des pin up à la fin des années 30. Après avoir travaillé pour plusieurs éditeurs de calendriers, il fut contacté vers le milieu des années 40 par l'un des plus prestigieux d'entre eux, Shaw-Barton. Les publications de ce

dernier propulsèrent le nom de DeMers dans tous les foyers d'Amérique. En 1946, DeMers connut la plus belle occasion de sa carrière. *Esquire* avait demandé à son ami Fritz Willis de réaliser la première image de la série Gallery of Glamour; la revue se tourna ensuite vers DeMers et lui commanda la seconde et il devint bientôt un collaborateur régulier du magazine. La pin up que DeMers et Willis réalisèrent ensemble pour le numéro d'octobre 1946 marqua une étape importante dans l'histoire de l'illustration américaine. Les deux artistes continuèrent à travailler ensemble pour le magazine, tout en poursuivant leur production personnelle de pin up.

Pendant les années 50, DeMers enseigna à la Parsons School of Design de New York. En 1953, ses pin up trouvèrent un nouveau public familial en apparaissant sur les programmes des spectacles sur glace Ice Capades. DeMers peignait aussi des tableaux «sérieux», qui furent exposés au Museum of Modern Art de New York et au Los Angeles County Museum. Il est mort en 1984 à Hilton Head Island, en Caroline du Sud.

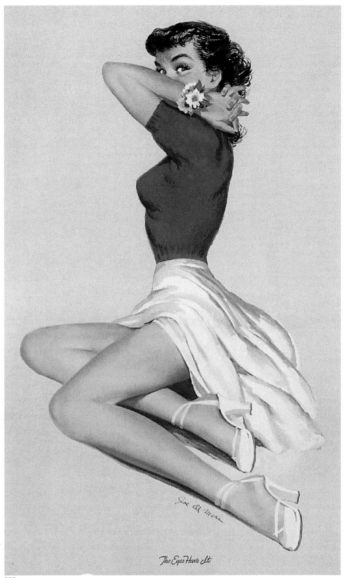

229

The Eyes Have It

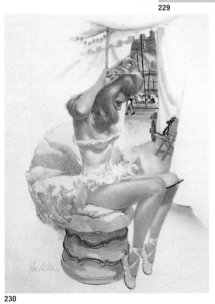

230

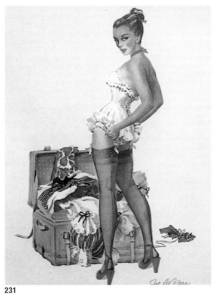

231

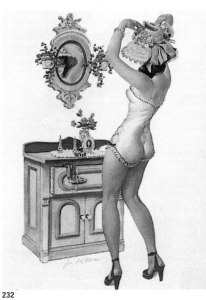

232

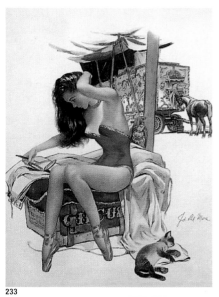

233

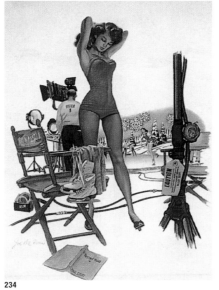

234

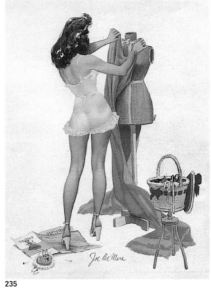

235

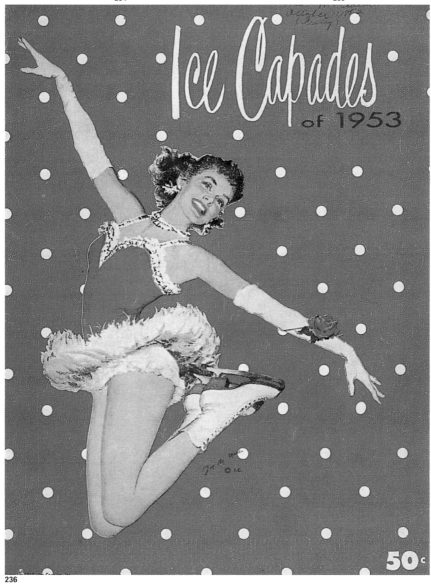

236

Billy DeVorss

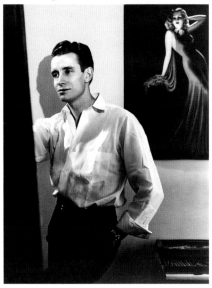

Alone among the pin-up artists in being entirely self-taught, Billy DeVorss sold his first three published pin-ups to the Louis F. Dow Calendar Company in St. Paul about 1933. Until that time, he had been working as a teller in a bank in St. Joseph, Missouri; there he had met the stunning woman, Glenna, who became his wife and first official model. Encouraged to develop his talent by Gene Sayles, the manager of Brown and Bigelow's Kansas City branch office, DeVorss soon received his first commission from the company.

To celebrate, DeVorss and his wife moved to New York and set up a penthouse studio in the Beaux Arts Building, at Eighteen East Tenth Street. Signing up with the prestigious American Artists group, DeVorss spent the next several years working for calendar-publishing houses such as Brown and Bigelow, Joseph C. Hoover, and Louis F. Dow. Most of his pastel originals were large (40 x 30 inches; 101.6 x 76.2 cm) and bore his highly distinctive Art Deco– inspired signature.

Covers for *Beauty Parade* (figure 247) and the King Features Syndicate as well as

calendar commissions from the Osborne and Goes companies followed in the early 1940s. *Help Wanted* (1944; figure 237), DeVorss's most famous pin-up image, was kept in the Shaw-Barton line for more than five years. In 1949, the artist illustrated a highly successful campaign for Botany Woolen's robes with depictions of handsome men lounging at home with their own DeVorss pin-up girls.

DeVorss used an incredible variety of pastel colors for his work, and he applied them directly onto the board, blending them dry with his fingers. His occasional oil paintings bear the rich, painterly brushstrokes of the Sundblom School. Like Rolf Armstrong, DeVorss always worked from live models for the final painting; he did, however, employ photographs for preliminary stages. His vibrant pin-ups, inspired by New York's theaters and nightclubs, display a fine sense of composition, a flowing, graceful line, and a daring blend of colors.

In 1951, Billy and Glenna DeVorss returned to St. Joseph, their first home. After some time there, they settled in Scottsdale, Arizona, where DeVorss died in 1985.

Billy DeVorss ist der einzige Pin-up-Künstler, der sich das Malen völlig eigenständig und selbst beigebracht hat. Seine ersten drei veröffentlichten Pin-ups verkaufte er um 1933 an die Louis F. Dow Calendar Company in St. Paul. Bis dahin hatte er als Schalterbeamte bei einer Bank in St. Joseph, Missouri, gearbeitet. Dort hatte er auch Glenna kennengelernt, die phantastisch gut aussehende Frau, die seine Ehefrau und erstes offizielles Modell werden sollte. Gene Sayles, der Niederlassungsleiter von Brown and Bigelow in Kansas, ermutigte ihn, sein Talent auszubilden. Bald darauf erhielt DeVorss auch den ersten Auftrag von Brown and Bigelow.

Um diesen Auftrag gebührend zu würdigen, zogen die DeVorss nach New York und richteten sich im Beaux Art Gebäude auf der Eighteen East Tenth Street ein Penthouse-Studio ein. DeVorss unterschrieb bei der berühmten American Artists Gruppe und arbeitete in den nächsten Jahren für Kalenderverlage wie Brown and Bigelow, Joseph C. Hoover und Louis F. Dow. Die meisten seiner Originale waren großformatige Pastelle (101 x 76 cm) und trugen seine sehr außergewöhnliche, vom Art deco inspirierte Handschrift.

Titelblätter für Beauty Parade *(Abb. 247) und für Objekte von King Features Syndicate folgten in den frühen 40er Jahren, zusammen mit Kalenderaufträgen*

der Firmen Osborne und Goes. Help Wanted *(1944; Abb. 237) war DeVorss' bekanntestes Pin-up-Bild und blieb über fünf Jahre lang im Sortiment von Shaw-Barton. 1949 illustrierte der Künstler eine außerordentlich erfolgreiche Kampagne für Botany Woolen's Kleider: Gutaussehende Männer machten es sich zu Hause mit ihren eigenen DeVorss Pin-up-Girls gemütlich.*

Bei seiner Arbeit verwendete DeVorss eine beeindruckende Bandbreite an Pastelltönen und applizierte sie direkt auf den Karton, um sie dann mit den Fingern zu verwischen. Seine seltenen Ölbilder tragen den sattmalenden Pinselstrich der Sundblom-Schule. Wie Rolf Armstrong arbeitete auch DeVorss für die endgültige Fassung eines Bildes immer mit dem lebenden Modell; doch er verwendete im Anfangsstadium eines Bildes Fotografien. Seine dynamischen Pin-ups, die von den New Yorker Theatern und Nachtclubs inspiriert waren, zeigen ein feines Gespür für Bildkomposition, eine fließende, elegante Linie und eine kühne, gewagte Farbzusammenstellung.

1951 zogen Billy und Glenna DeVorss nach St. Joseph, ihrem ersten gemeinsamen Zuhause, zurück. Später siedelten sie nach Scottsdale in Arizona über. Dort starb DeVorss 1985.

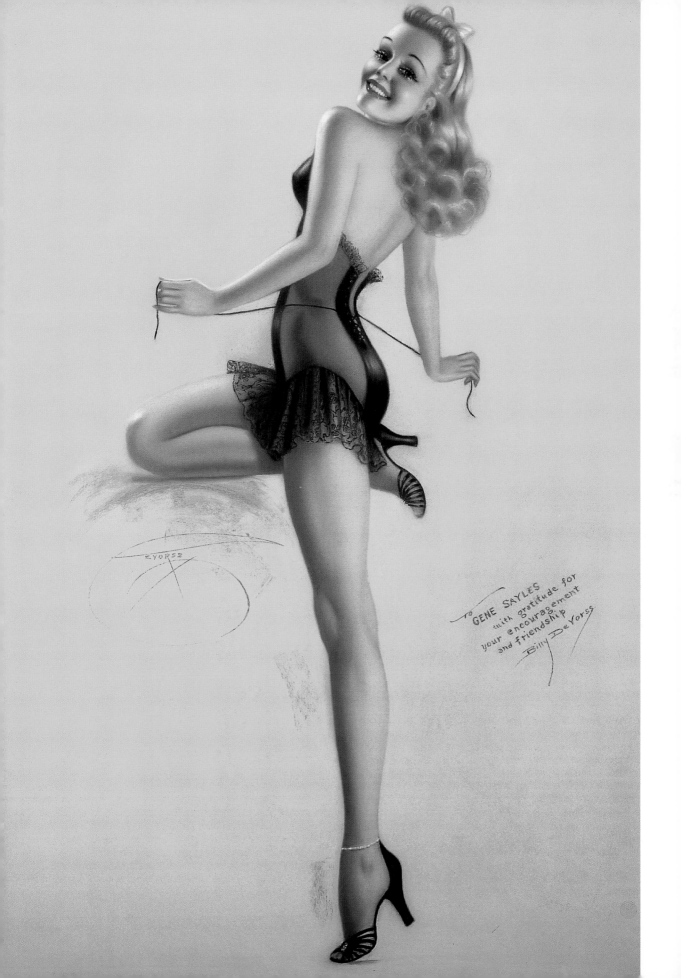

To GENE SAYLES
with gratitude for
your encouragement
and friendship
Billy DeVorss

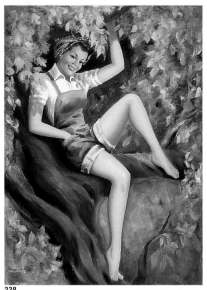

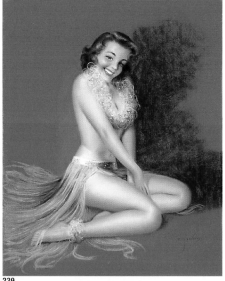

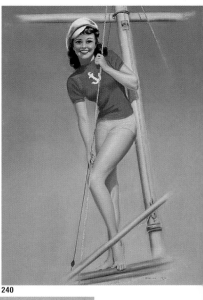

238

239

240

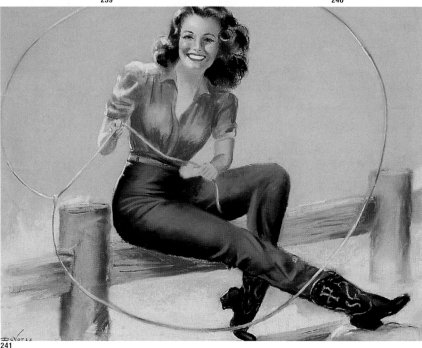

241

Seul artiste de pin up entièrement autodidacte, Billy DeVorss vendit ses premières créatures de rêve à l'éditeur de calendriers Louis F. Dow de Saint Paul vers 1933. Jusque-là, il avait été guichetier dans une banque de Saint Joseph, dans le Missouri, où il avait rencontré une femme superbe, Glenna, qui devint son épouse et son premier modèle. Encouragé à développer son talent par Genne Sayles, directeur des bureaux de Brown and Bigelow à Kansas City, DeVorss reçut bientôt sa première commande de cette même compagnie.

Pour fêter l'occasion, les DeVorss déménagèrent à New York dans un luxueux appartement du Beaux Arts Building, au dix-huit de la Dixième rue. Représenté par la prestigieuse agence American Artists, DeVorss passa les années suivantes à travailler pour les calendriers de Brown and Bigelow, de Joseph C. Hoover et de Louis F. Dow. La plupart de ses pastels étaient réalisés sur de grandes toiles (101,6 x 76,2 cm) et portaient sa belle signature de style Art déco.

Au début des années 40, il réalisa des couvertures pour *Beauty Parade* (illustration 247) et The King Feature Syndicate ainsi que plusieurs illustrations de calendriers pour les éditeurs Osborne et Goes. *Help Wanted* (1944 ; illustration

237), la plus célèbre pin up de DeVorss, fut republiée dans les calendriers de Shaw-Barton pendant plus de cinq ans. En 1949, l'artiste illustra une campagne publicitaire pour les robes de chambre Botany Woolen qui remporta un grand succès. Elle présentait de séduisants messieurs se prélassant dans leurs intérieurs en compagnie de leur propre DeVorss Girl.

DeVorss utilisait une incroyable variété de couleurs pastel qu'il appliquait directement sur le papier en les mélangeant avec les doigts. Ses rares peintures à l'huile portent l'empreinte de l'école de Sundblom, caractérisée par une touche épaisse. Comme Rolf Armstrong, DeVorss n'achevait une œuvre qu'en présence du modèle. Toutefois, il se servait de photographies pour les esquisses préliminaires. Ses œuvres pleines de vie, inspirées des théâtres et des night-clubs new-yorkais, témoignent d'un sens aigu de la composition, d'un coup de crayon naturel et gracieux et d'une audacieuse combinaison de couleurs.

En 1951, Billy et Glenna DeVorss retournèrent à Saint Joseph, leur ville natale, avant de s'installer quelque temps plus tard à Scottsdale, en Arizona, où DeVorss mourut en 1985.

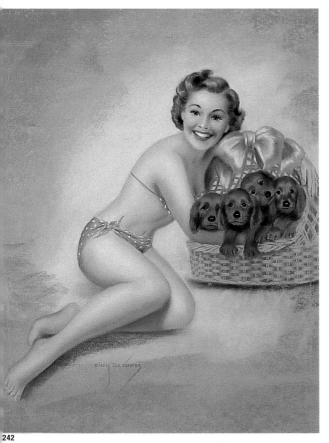

242

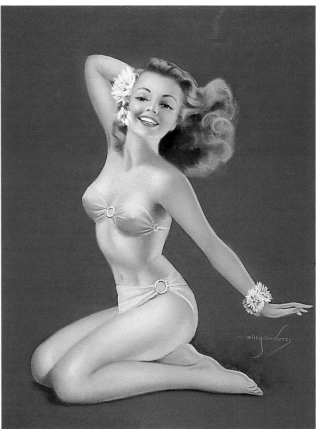

243

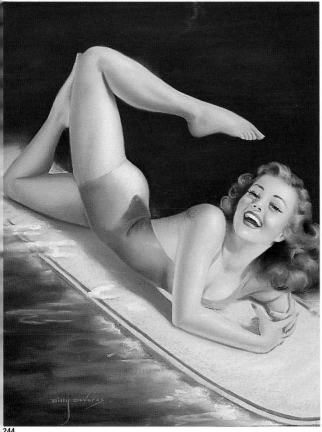

244

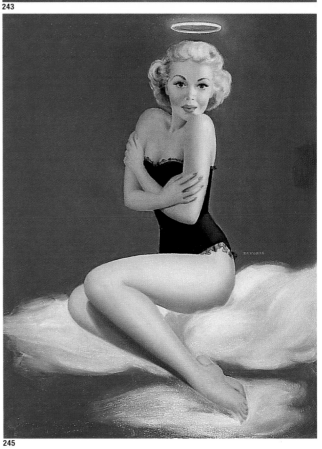

245

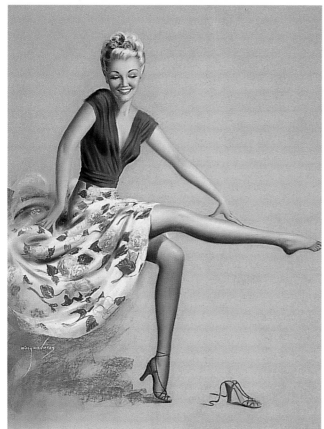

246

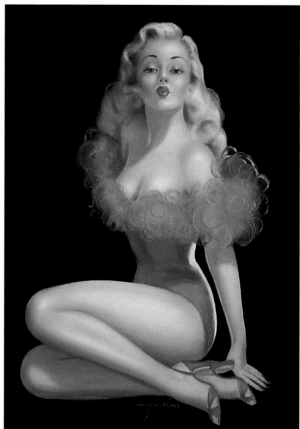

247

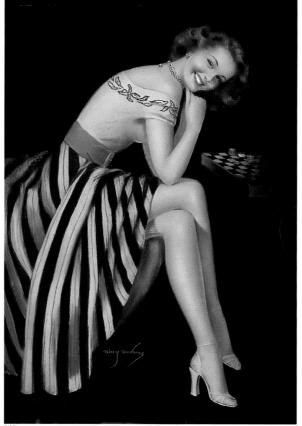

248

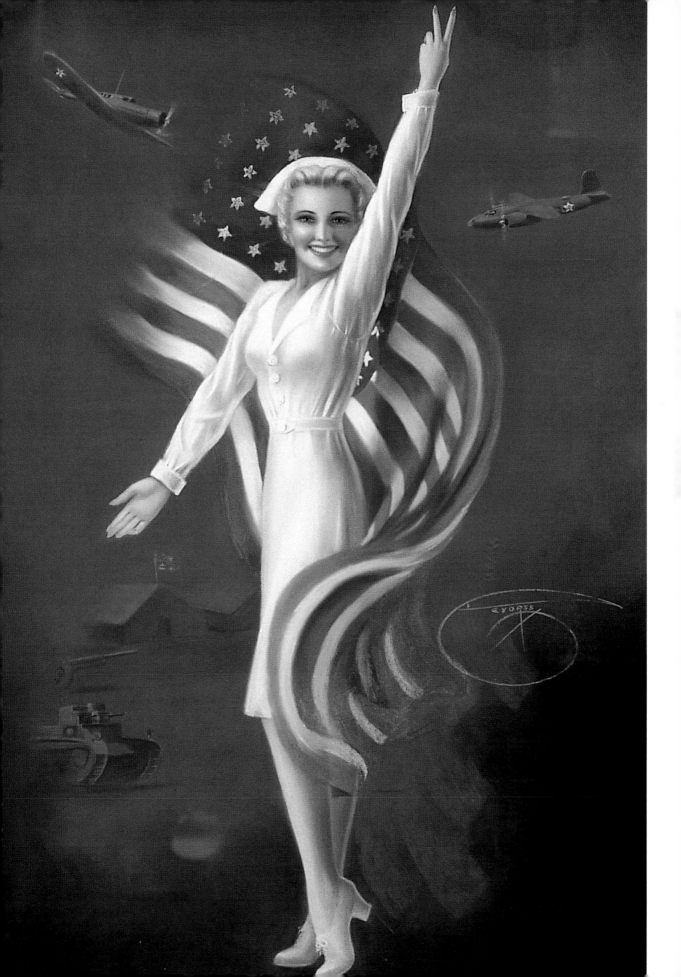

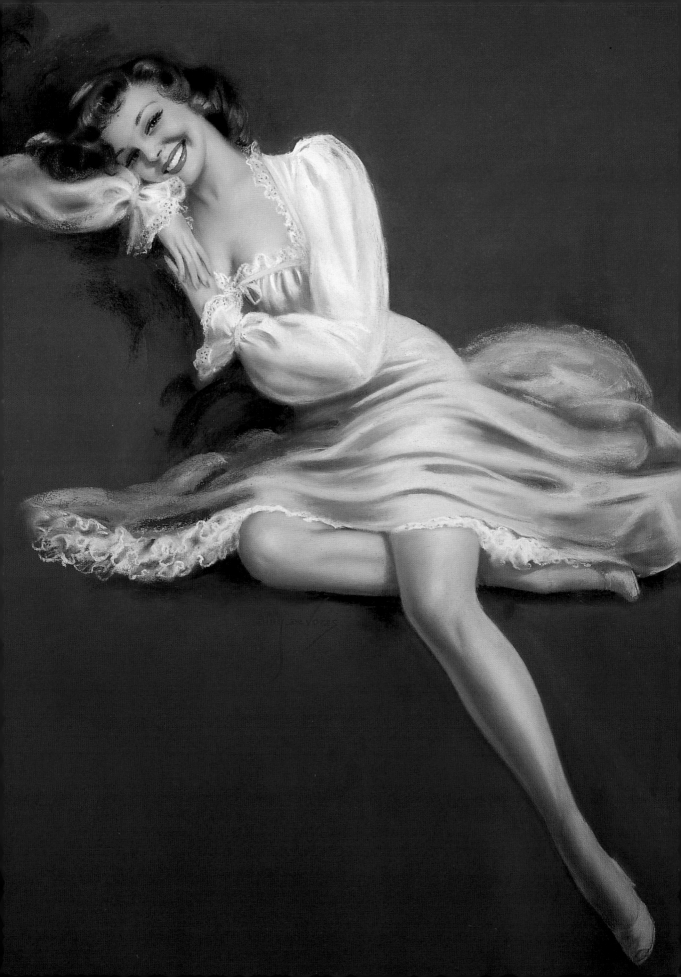

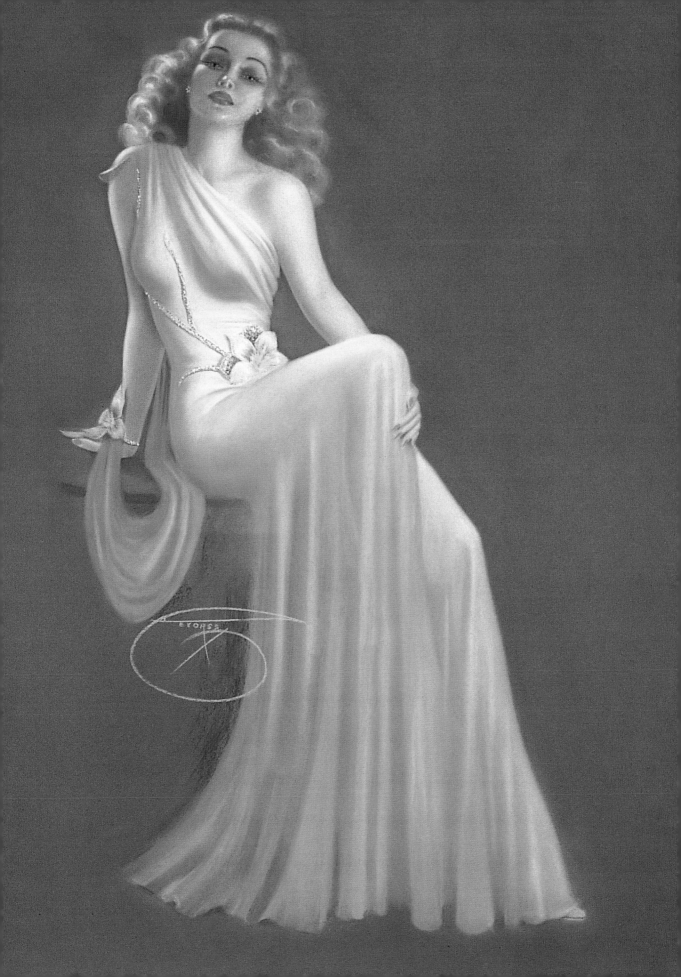

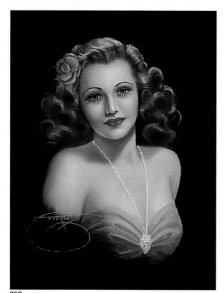

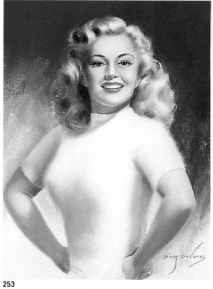

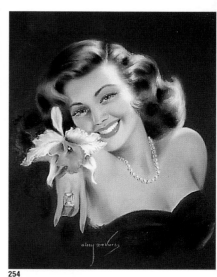

252

◁ ◁ 250 | 251

253

254

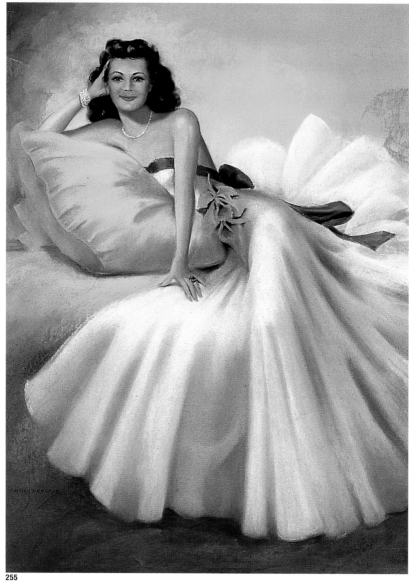

255

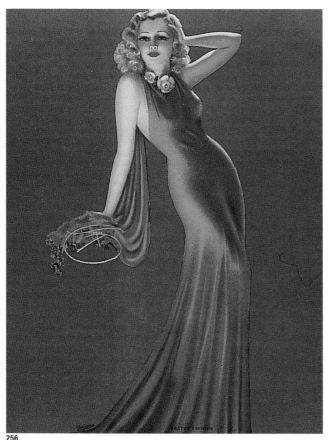

256

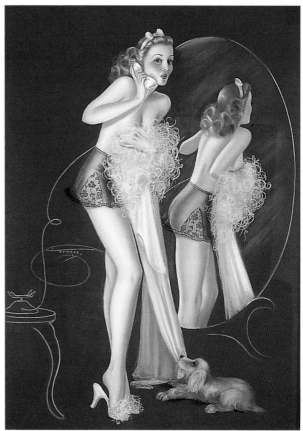

257

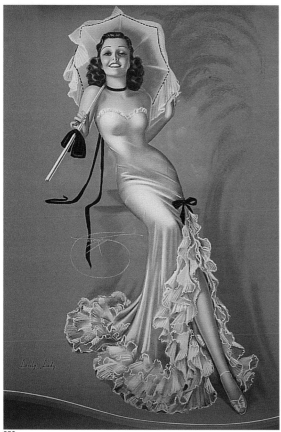

258

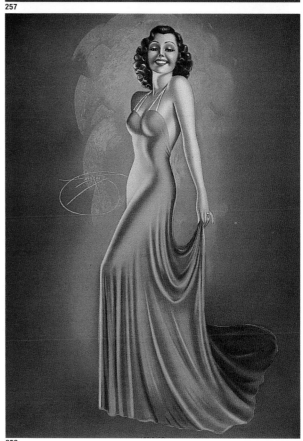

259

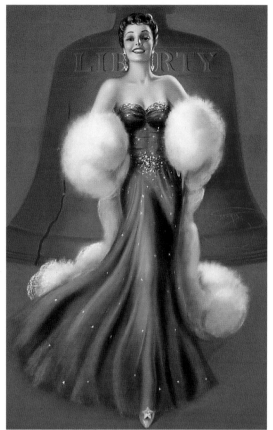

260

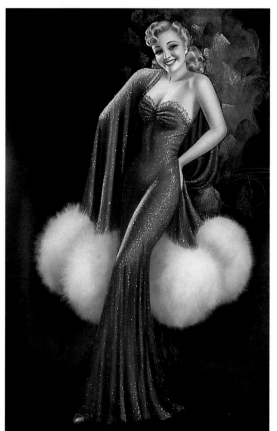

261

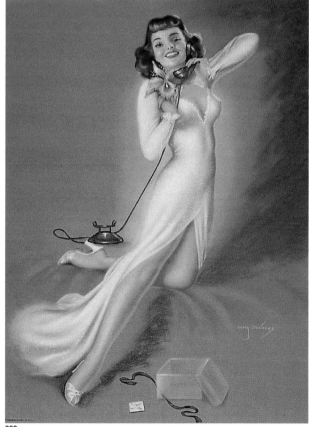

262

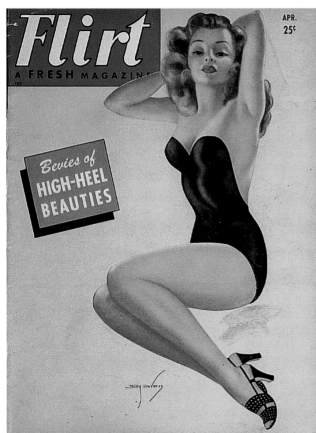

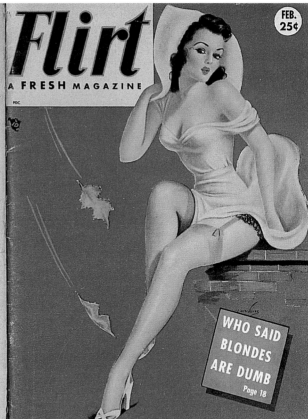

263

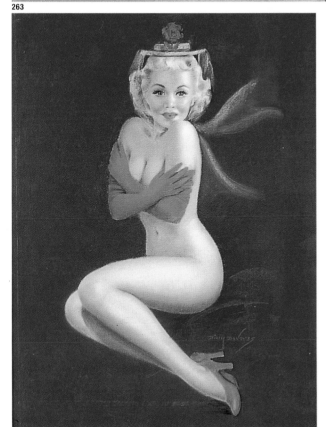

264

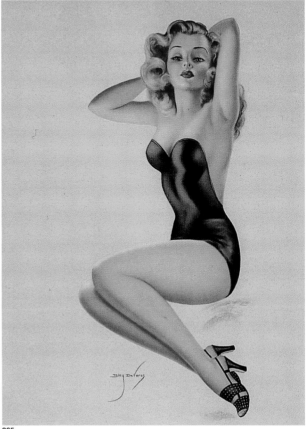

265

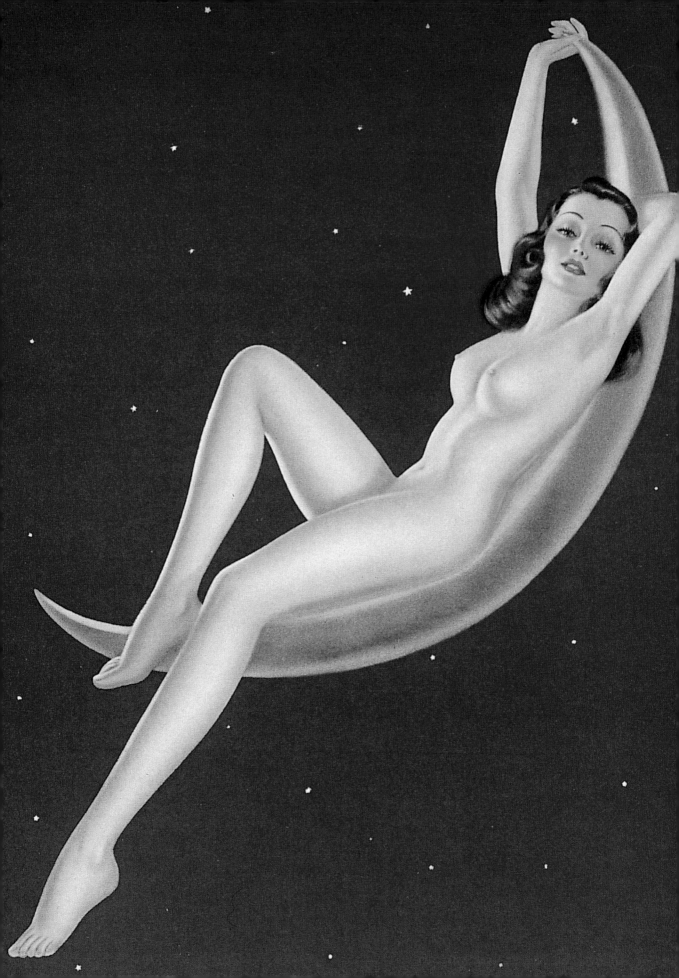

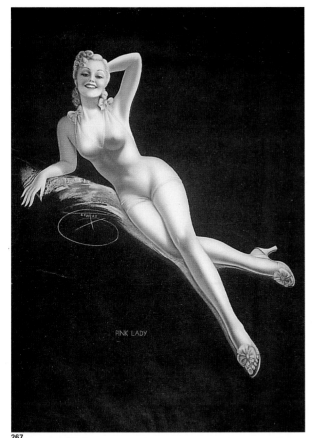

267

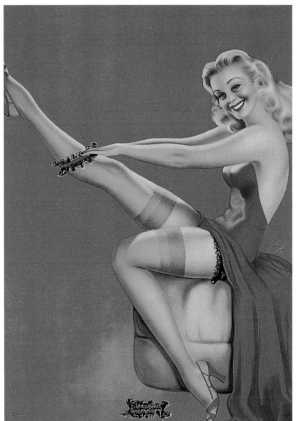

268

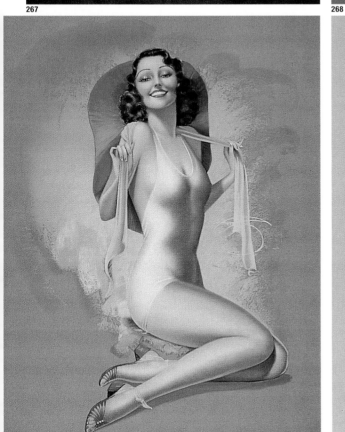

269

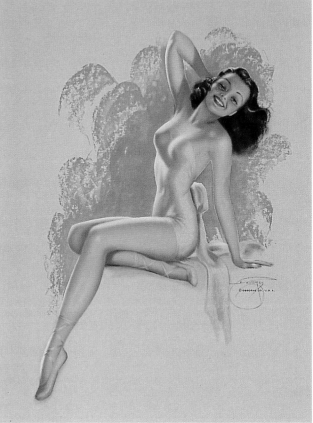

270

Peter Driben

PETER & LOUISE DRIBEN

Driben's parade of sexy, fun-loving showgirls delighted the American public from the beginning of World War II until the great baby boom of the 1950s. Appearing on the front covers of five or six magazines a month, Driben's leggy dream girls were strikingly portrayed in as many bold colors as possible, especially red, yellow, blue, and green.

Born in Boston, Driben studied at Vaesper George Art School before moving to Paris about 1925. While taking classes at the Sorbonne, he began a series of highly popular pen-and-ink drawings of the city's showgirls. But American pulp magazines soon beckoned: the October 1934 *Tattle Tales* carried his first known pin-up front cover; in 1935, he contributed covers to *Snappy*, *Pep*, *New York Nights*, *French Night Life*, and *Caprice*, among others; and he later did pin-ups for *Bedtime Stories* and sixteen covers for *La Paree*. Driben also became known in the 1930s for his front covers for full-size pin-up magazines, including *Silk Stocking Stories*, *Gay Book*, *Movie Merry-Go-Round*, and his personal favorite, *Real Screen Fun*.

Driben's career expanded into advertising after he moved to New York late in 1936. He created original three-dimensional die-cut window displays for Philco Radios, Cannon Bath Towels, and the Weber Baking Company. Hollywood also came calling: he did the poster and publicity artwork for *The Maltese Falcon*, Warner Brothers hired him for *Bought*, and his work for *Big Business Girl* led to a

close friendship with its star, Loretta Young. In the early 1940s, his beautiful, sexy – and generally terrified – glamour girls adorned covers of magazines like *Inside Detective* and *Exclusive Detective* (figures 313–16). Also adding to his full workload were several assignments for book jackets.

In 1941, his friend Bob Harrison asked him to contribute to a new men's magazine, *Beauty Parade*. After some negotiation, Driben signed on; he painted hundreds of spectacular pin-ups for that publication and for the other seven titles Harrison was to launch, *Flirt*, *Whisper*, *Titter*, *Wink*, *Eyeful*, *Giggles*, and *Joker*. Driben's work for Harrison established him as one of America's most recognized and successful pin-up and glamour artists.

Driben married the artist, actress, and poet Louise Kirby just before he began to work for Harrison. In 1944, he was offered the unusual opportunity, for a pin-up artist, of becoming the art director of the newspaper the *New York Sun*, a post he retained until 1946. During the war, his popular painting of American soldiers raising the flag at Iwo Jima sparked a considerable amount of media attention.

In 1956, Driben and Louise moved to Miami Beach. He spent his retirement years painting portraits (including one of Dwight Eisenhower) and other fine-art works, which were organized into successful exhibitions by his wife. Driben died in 1975, Louise in 1984.

Dribens Parade von Showgirls, die lebenslustig und sexy waren, unterhielt die amerikanische Öffentlichkeit von Beginn des Zweiten Weltkriegs an bis zu den Jahren des Baby Booms in den 50er Jahren. Auf fünf bis sechs Zeitschriftencovern pro Monat waren seine langbeinigen Traumgirls vertreten; Driben malte sie in auffallender Pose in so vielen gewagten Farben wie möglich, besonders in Rot, Gelb, Blau und Grün.

Der gebürtige Bostoner Driben studierte an der Vaesper George Art School, bevor er 1925 nach Paris ging. Er hörte Vorlesungen an der Sorbonne und begann mit der Arbeit an einer Serie sehr populärer Federzeichnungen von Showgirls der Stadt. Doch die heimischen „Pulp"-Magazine klopften bald an seine Tür: Die Oktoberausgabe des Jahres 1934 von Tattle Tales *war sein erstes bekanntes Pin-up-Cover; 1935 lieferte er dann unter anderem Titelbilder für* Snappy, Pep, New

York Nights, French Night Life *und* Caprice. *Später folgten Pin-ups für* Bedtime Stories *und insgesamt 16 Titelbilder für* La Paree.

In den 30er Jahren wurde Driben durch seine Cover für großformatige Magazine berühmt. Er arbeitete unter anderem für Silk Stocking Stories, Gay Book, Movie Merry-Go-Round *und* Real Screen Fun, *seine Lieblingszeitschrift.*

Ende 1936 siedelte Driben nach New York über und übernahm nun Anzeigenaufträge. Für Philco Radios, Cannon Bath Towels und die Weber Baking Company entwarf er die Originale zu dreidimensionalen, ausgestanzten Schaufensterdekorationen. Auch Hollywood verlangte nach ihm: Driben kreierte das Poster und die Anzeigenvorlagen für The Maltese Falcon *(Die Spur des Falken) mit Humphrey Bogart. Die Filmfirma Warner Brothers beauftragte ihn mit dem Film* Bought, *und bei der Arbeit an* Big Business Girl *entwickelte sich zwischen ihm und der Haupt-*

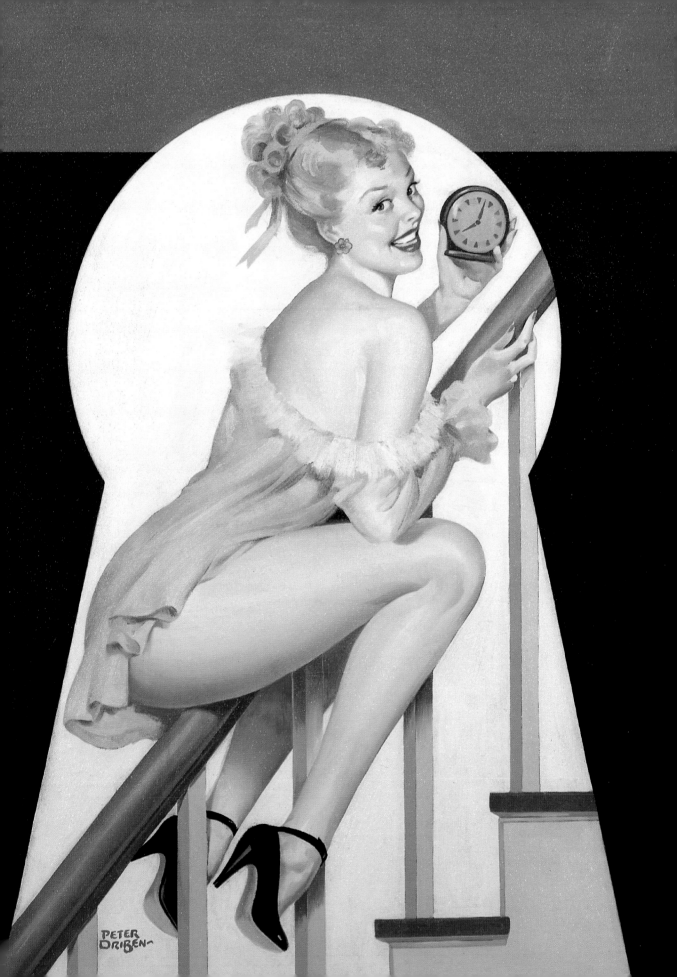

darstellerin Loretta Young eine enge Freundschaft. In den frühen 40er Jahren schmückten seine Glamour-Girls – wunderschön, sexy und zumeist gerade zu Tode erschrocken – Zeitschriftencover von Inside Detective oder Exklusive Detective (Abb. 313 bis 316). Aufträge für Buchumschläge füllten seinen ohnehin prallen Terminkalender noch mehr.

1941 bat ihn Bob Harrison, mit dem er befreundet war, um seine Mitarbeit an einem neuen Männermagazin namens Beauty Parade. Nach einigen Verhandlungen stimmte Driben zu, eine Vielzahl spektakulärer Pin-ups für diese Zeitschrift zu malen, wie auch für andere Titel, die Harrison noch gründen würde, wie Flirt, Whisper, Titter, Wink, Eyeful, Giggles und Joker. Dribens Arbeiten für Harrison machten ihn zu einem der anerkanntesten und erfolgreichsten Pin-up- und Glamourkünstler Amerikas.

Kurz vor Beginn dieser Zusammenarbeit mit Harrison heiratete Driben die Künstlerin, Schauspielerin und Dichterin Louise Kirby. 1944 bot man ihm den für einen Pin-up-Künstler ungewöhnlichen Job des Art Directors bei einer Tageszeitung an, der New York Sun. Diesen Posten behielt er bis 1946. Sein berühmtes Bild von amerikanischen Soldaten bei Iwo Jima wurde in der Medienwelt mit großer Aufmerksamkeit bedacht.

1956 zogen Peter Driben und seine Frau Louise nach Miami Beach. Während seines Ruhestandes malte er klassische Porträts (darunter eines von Dwight Eisenhower) und anderes aus der Gattung „Schöne Künste", das von seiner Frau zu erfolgreichen Ausstellungen zusammengestellt wurde. Driben starb 1975, Louise 1984.

Le joyeux défilé des girls de revue de Driben ravit les Américains du début de la Deuxième Guerre mondiale au grand baby boom des années 50. Paraissant tous les mois sur les couvertures de cinq ou six magazines à la fois, les belles créatures aux longues jambes jaillissaient dans une explosion de couleurs vives, où dominaient le rouge, le jaune, le bleu et le vert.

Né à Boston, Driben étudia à la Vaesper George Art School avant de partir pour Paris vers 1925. Tout en suivant des cours à la Sorbonne, il commença une série de dessins de danseuses de revue parisiennes au crayon et à l'encre de Chine qui remporta un grand succès. Les pulps américains ne tardèrent pas à le repérer: il réalisa la couverture du numéro d'octobre 1934 de Tattle Tales. En 1935, il fit des couvertures pour, entre autres, Snappy, Pep, New York Nights, French Night Life et Caprice. Il réalisa plus tard des pin up pour Bedtime Stories et seize couvertures pour La Paree. Driben devint également célèbre dans les années 30 pour ses couvertures de magazines de pin up grand format, dont Silk Stocking Stories, Gay Book, Movie Merry-Go-round, et son préféré, Real Screen Fun.

Lorsqu'il s'installa à New York à la fin de 1936, sa sphère d'activité s'étendit à la publicité. Il réalisa des silhouettes en trois dimensions pour les vitrines de Philco Radios, Cannon Bath Towels et Weber Bank. Hollywood s'intéressa bientôt à lui: il créa l'affiche et les images promotionnelles du Faucon Maltais; Warner Brothers lui confia celles de Bought, et à l'occasion de son travail sur Big Business Girl, il noua une longue amitié avec sa star, Loretta Young. Au début des années 40, ses irrésistibles beautés glamour ornèrent – le plus souvent avec des expressions de pure terreur – les couvertures de magazines comme Inside Detective et Exclusive Detective (illustrations 313–316). Il trouva également le temps de réaliser plusieurs couvertures pour des livres de poche.

En 1941, son ami Bob Harrison lui proposa de collaborer à un nouveau magazine pour hommes, Beauty Parade. Driben signa un contrat avec lui, non sans l'avoir dûment négocié. Il donna naissance à plusieurs centaines de pin up spectaculaires pour cette publication et les sept autres titres qu'Harrison lança plus tard: Flirt, Whisper, Titter, Wink, Eyeful, Giggles et Joker. Le travail de Driben pour Harrison en fit l'un des peintres de pin up et d'art glamour les plus célèbres et prospères des Etats-Unis.

Driben épousa l'artiste, actrice et poétesse Louise Kirby peu avant de commencer à travailler pour Harrison. En 1944, on lui offrit l'occasion, rare pour un artiste de pin up, de devenir le directeur artistique du quotidien New York Sun, poste qu'il occupa jusqu'en 1946. Sa célèbre peinture de soldats américains brandissant le drapeau à Iwo Jima lui valut les éloges de la presse.

En 1956, Driben et Louise s'installèrent à Miami Beach, en Floride. Là, Driben consacra ses vieux jours à peindre des portraits (dont celui de Dwight Eisenhower) et des paysages, que sa femme présentait lors d'expositions. Driben mourut en 1975, Louise en 1984.

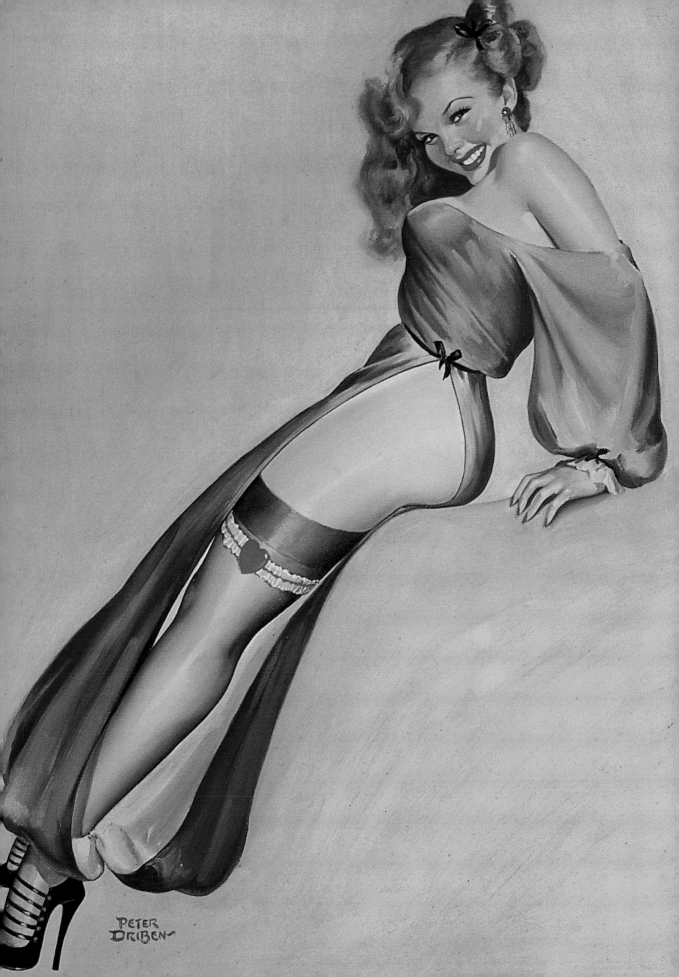

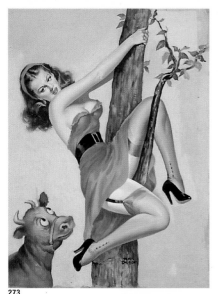

273

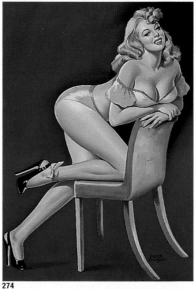

274

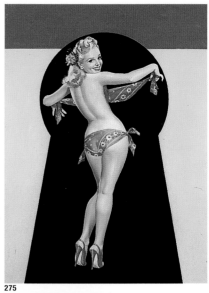

275

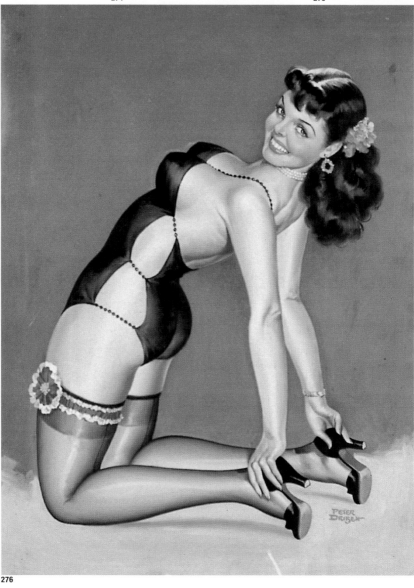

276

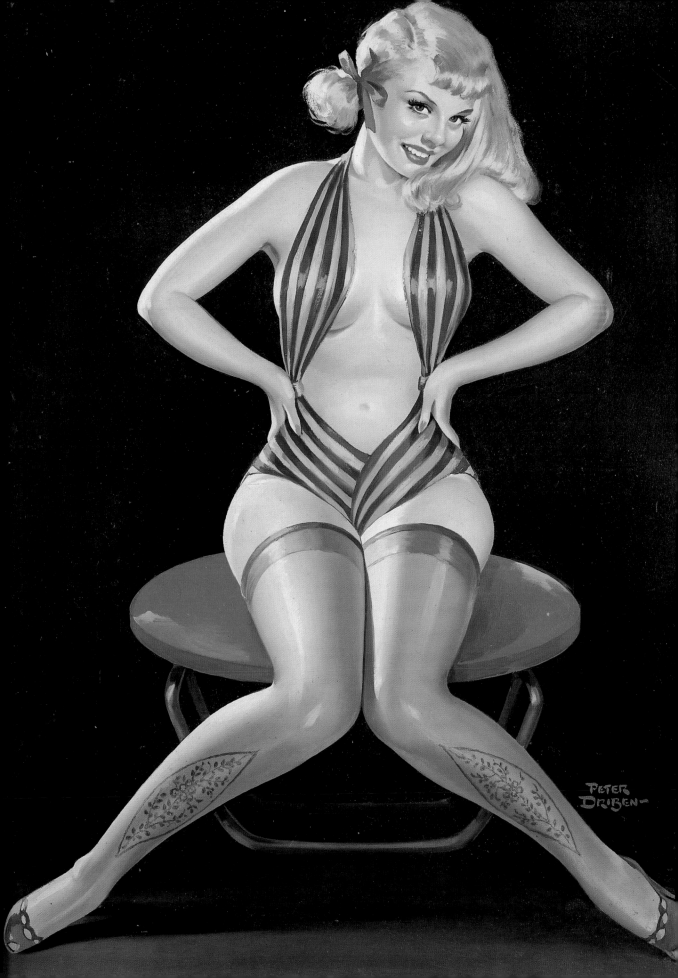

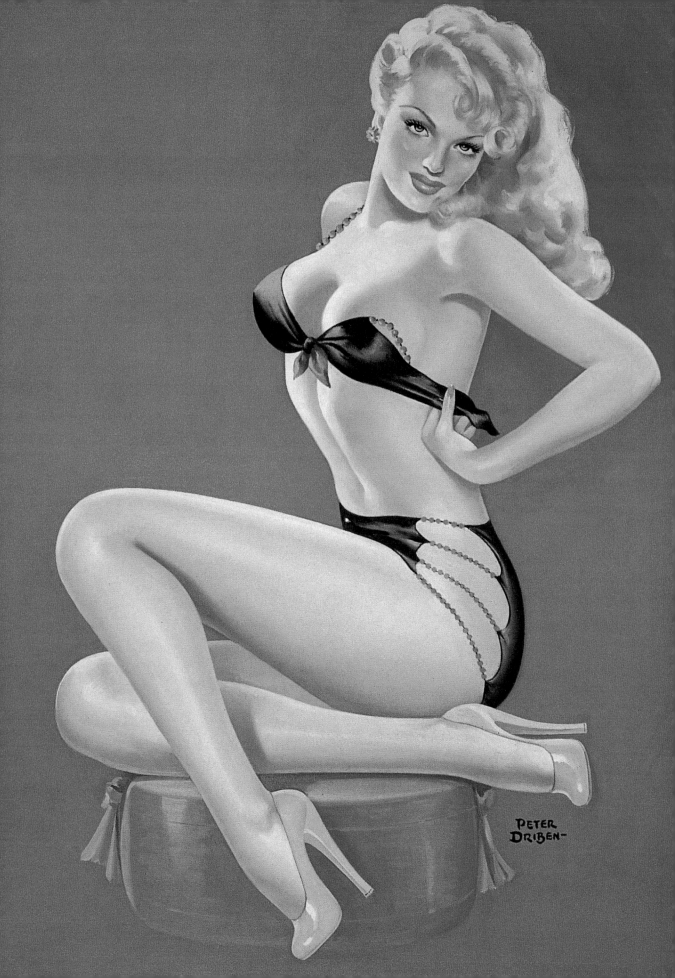

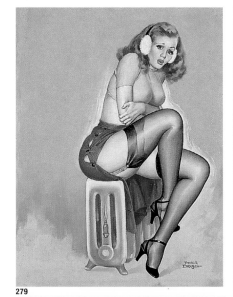

279

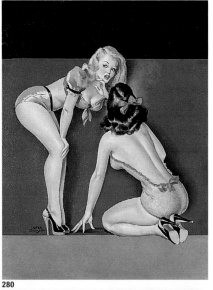

280

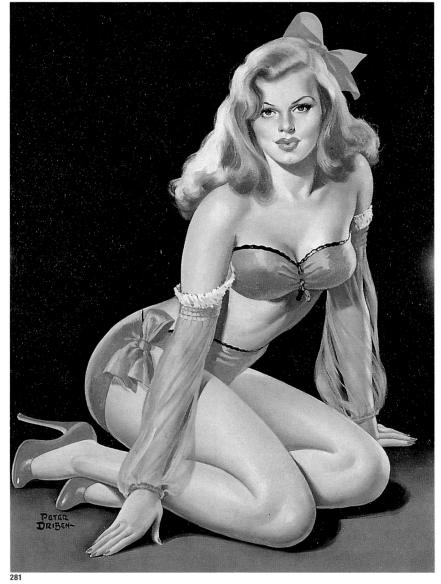

281

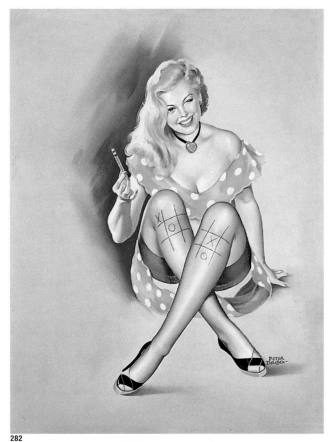

282

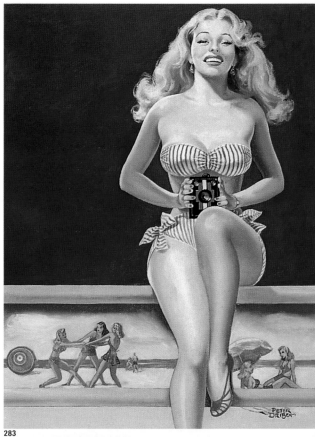

283

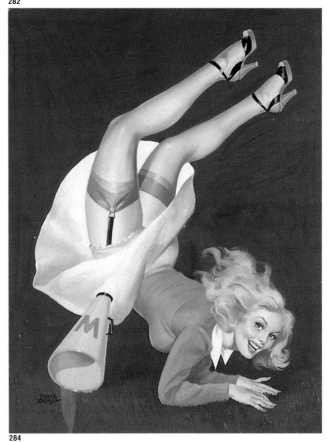

284

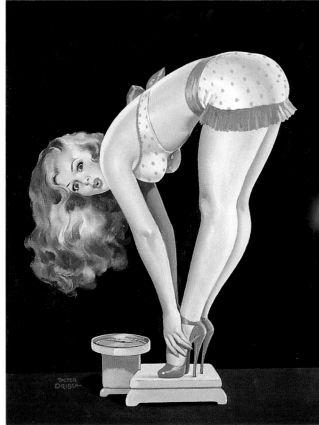

285

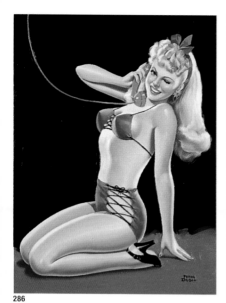

286

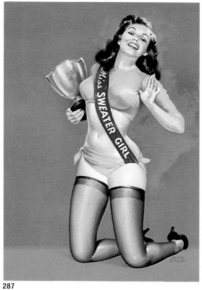

287

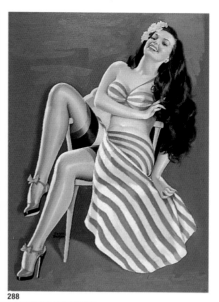

288

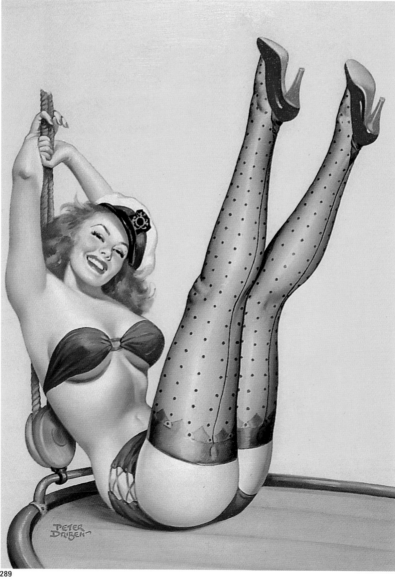

289

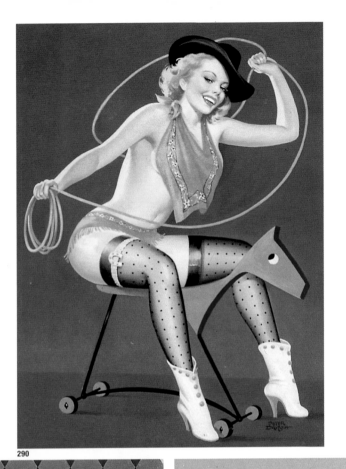

290

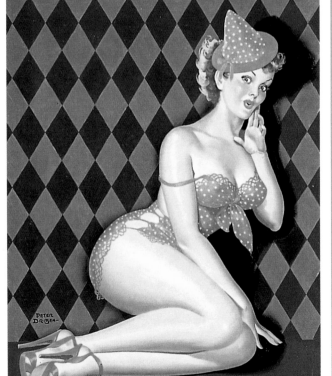

291

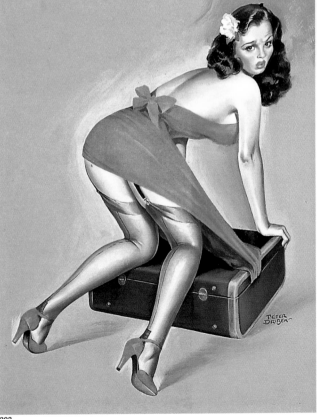

292

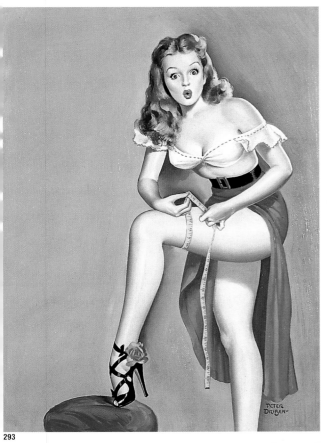

293

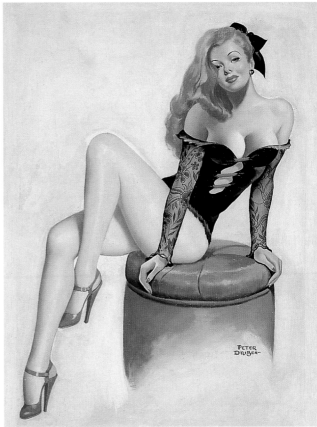

294

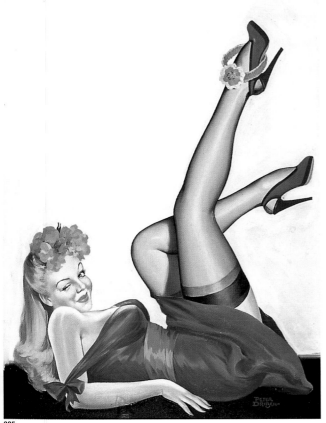

295

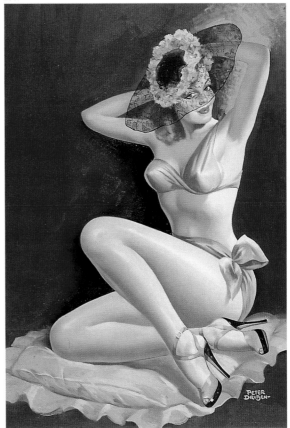

296

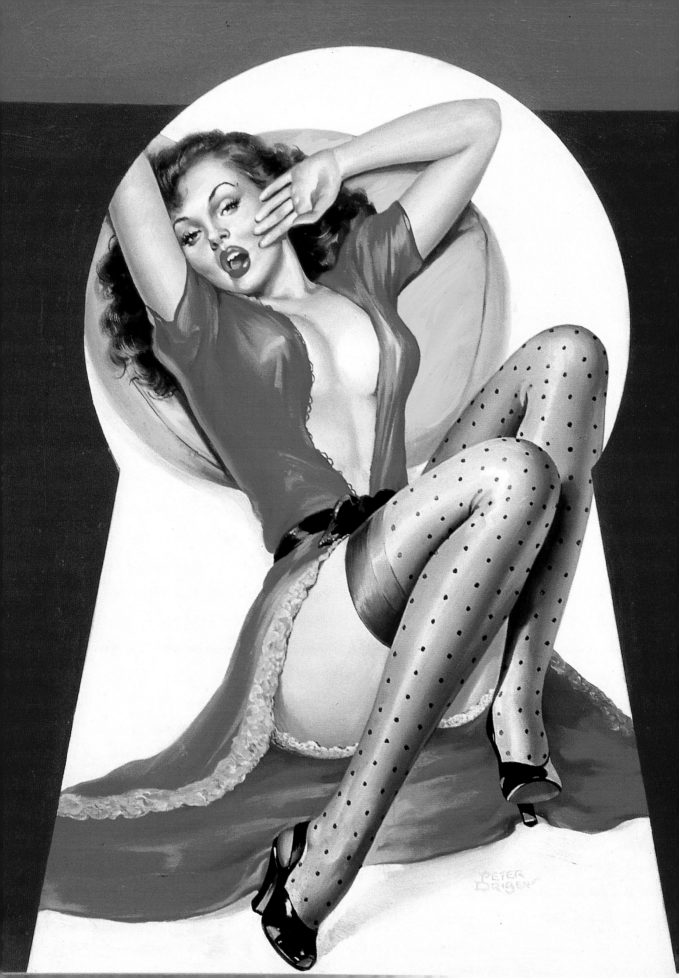

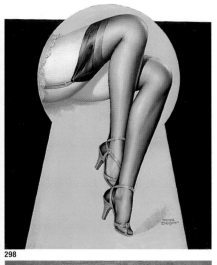

298

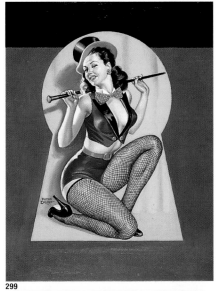

299

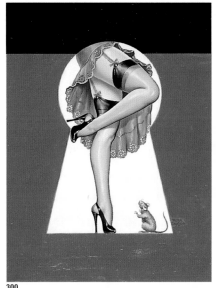

300

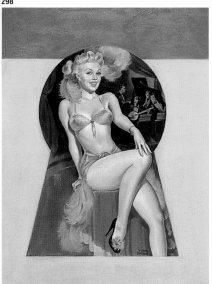

301

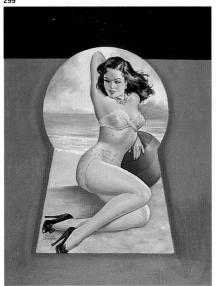

302

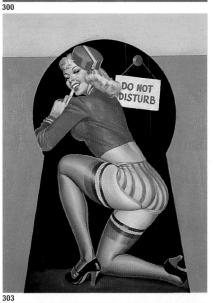

303

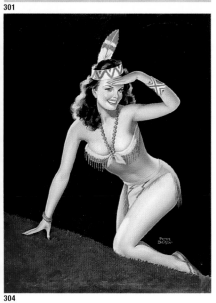

304

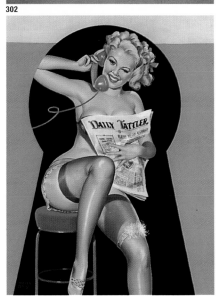

305

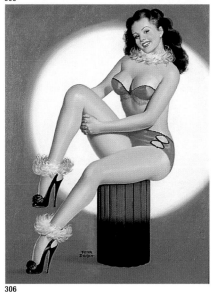

306

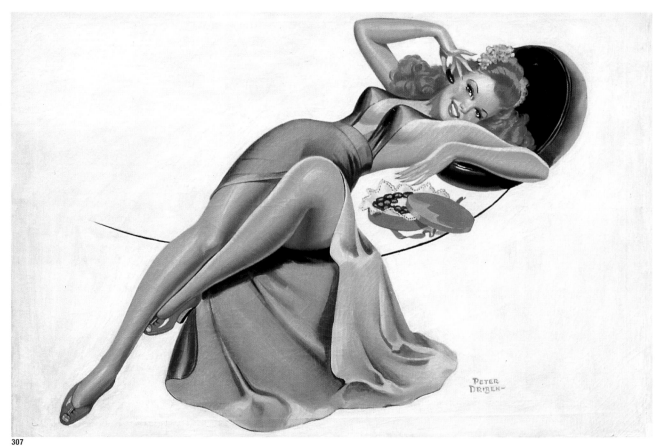

307

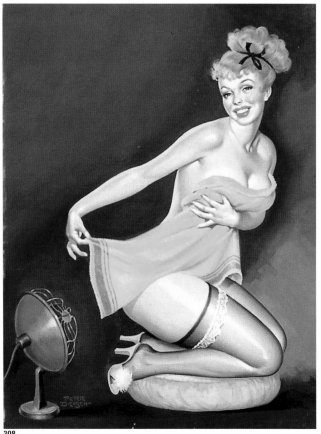

308

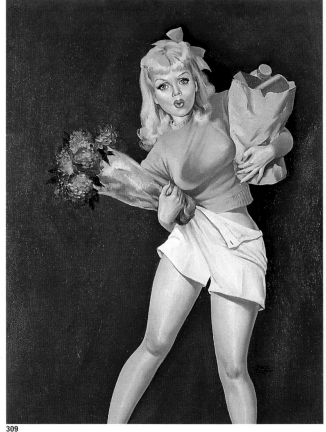

309

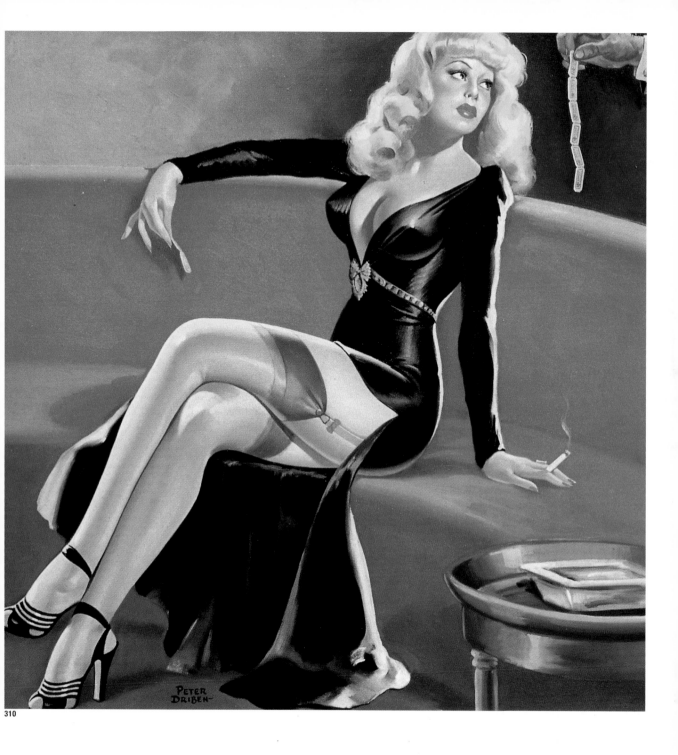

310

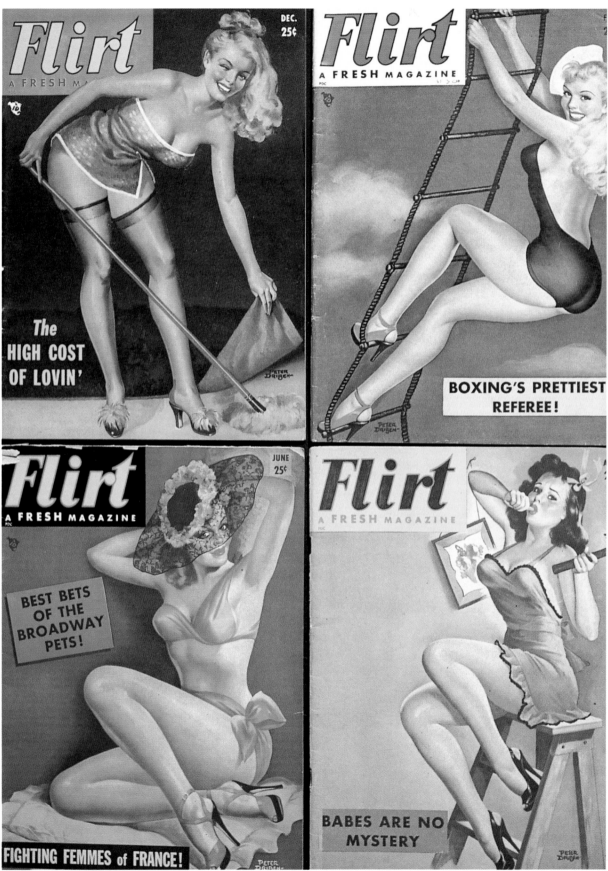

311

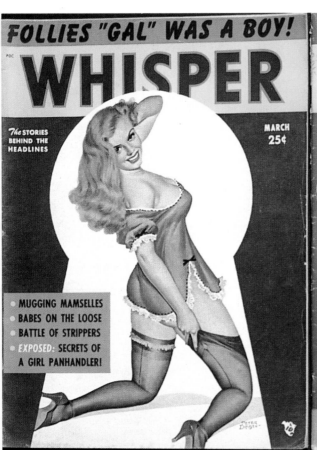

FOLLIES "GAL" WAS A BOY!

WHISPER

The STORIES BEHIND THE HEADLINES

MARCH 25¢

- MUGGING MAMSELLES
- BABES ON THE LOOSE
- BATTLE OF STRIPPERS
- EXPOSED: SECRETS OF A GIRL PANHANDLER!

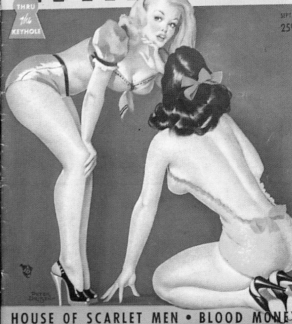

VILLAGE OF FREE LOVE Page 22

WHISPER

THRU this KEYHOLE

SEPT. 25¢

HOUSE OF SCARLET MEN • BLOOD MONEY
I was a DOPE SLAVE • IS SUICIDE A THRILL?

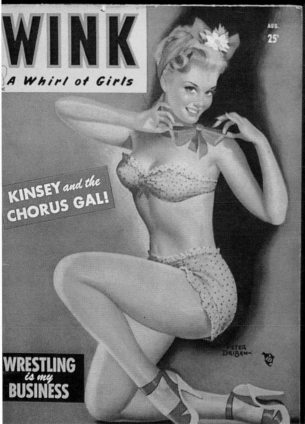

WINK

A Whirl of Girls

AUG. 25¢

KINSEY and the CHORUS GAL!

WRESTLING is my BUSINESS

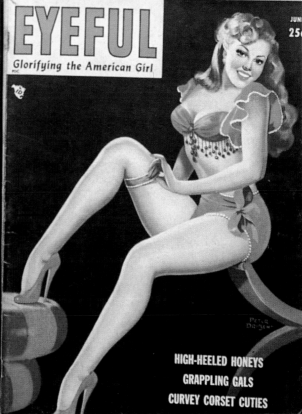

EYEFUL

Glorifying the American Girl

JUNE 25¢

HIGH-HEELED HONEYS
GRAPPLING GALS
CURVEY CORSET CUTIES

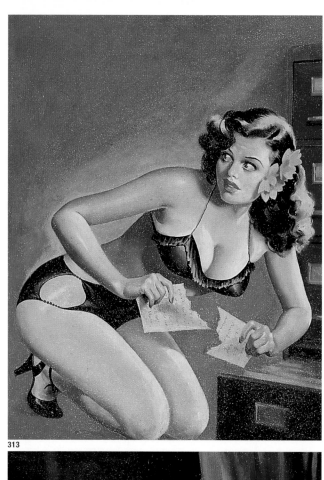

313

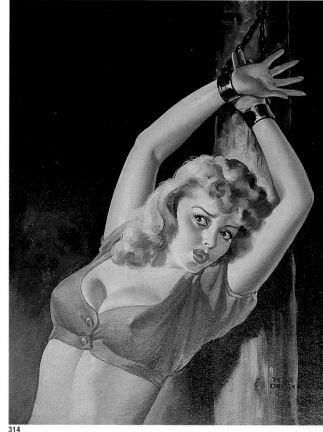

314

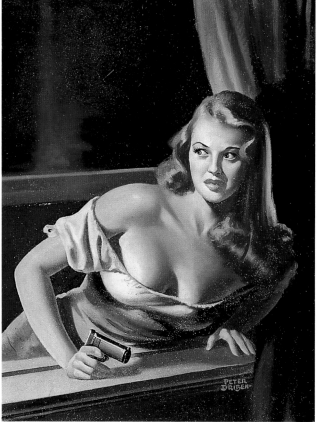

315

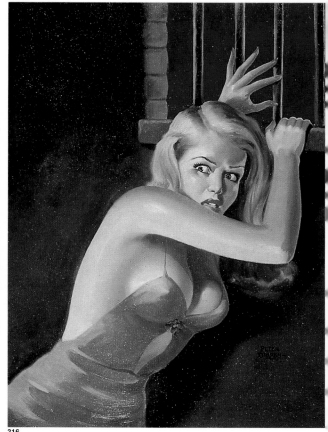

316

Edward M. Eggleston

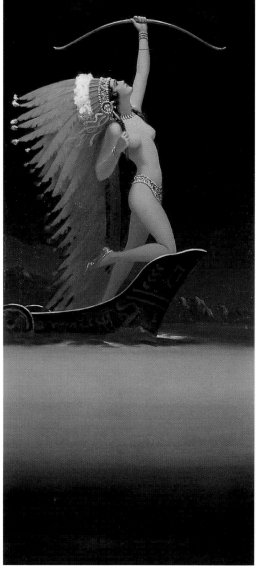

317

Like his fellow illustrator Gene Pressler, Eggleston specialized in painting exotic, romantic subjects – Indian maidens, Hawaiian dancers, and "moonlight girls" with a fantastic Arabian Nights mood to them (figure 320).

In the early 1920s, Eggleston painted movie stars for the covers of film magazines; his 1922 portrait of Betty Compton for *Motion Picture Classic* was the talk of Hollywood when it hit the newsstands. He also did a series of hosiery ads during this time, as well as numerous magazine front covers, many of which were for mainstream publications.

In 1925, Eggleston opened a studio in New York and began painting pin-up and glamour images for the calendar market, most notably at first for the Thomas D. Murphy Company. His first assignment for Brown and Bigelow, *The Treasure Princess* (1928), was done to the company's exact specifications. After Eggleston insisted on being given free rein in choosing subjects, he began to design some of the most striking Art Deco pin-ups ever.

In 1932, Eggleston delivered to Brown and Bigelow the biggest-selling image of his career. According to the artist, he created *Let's Go America* (figure 318) in a time of economic depression "to symbolize renewed hope and confidence" in the nation's future. The work showed a beautiful lady riding a "magic carpet" through a midnight-blue Maxfield Parrish sky and surrounded by modern airplanes and a zeppelin.

In 1936, Eggleston began a productive relationship with the Joseph C. Hoover and Sons calendar company in Philadelphia; his first oil painting for Hoover, *Flaming Arrow* (1936; figure 317), was an extremely popular portrayal of an Indian girl. He followed this image up with *Cleopatra* (1938; figure 319), a classic Eggleston work and another smashing success.

Eggleston was still working out of his studio in Manhattan as late as 1940. His last recorded commercial work, from that year, was a front cover to the program guide for Billy Rose's Aquacade, which had been playing to record-breaking audiences at the New York World's Fair of 1939.

A distinguished, businesslike man, Eggleston created paintings that had a wealth of detail, careful drawing, superb composition, and a finished technique. He had a thorough knowledge of color values and was highly accomplished in oil, pastel, watercolor, and gouache. Most of his calendar assignments were executed in oil on canvas, in a large format averaging 30 x 24 inches (76.2 x 61 cm) to 40 x 30 inches (101.6 x 76.2 cm).

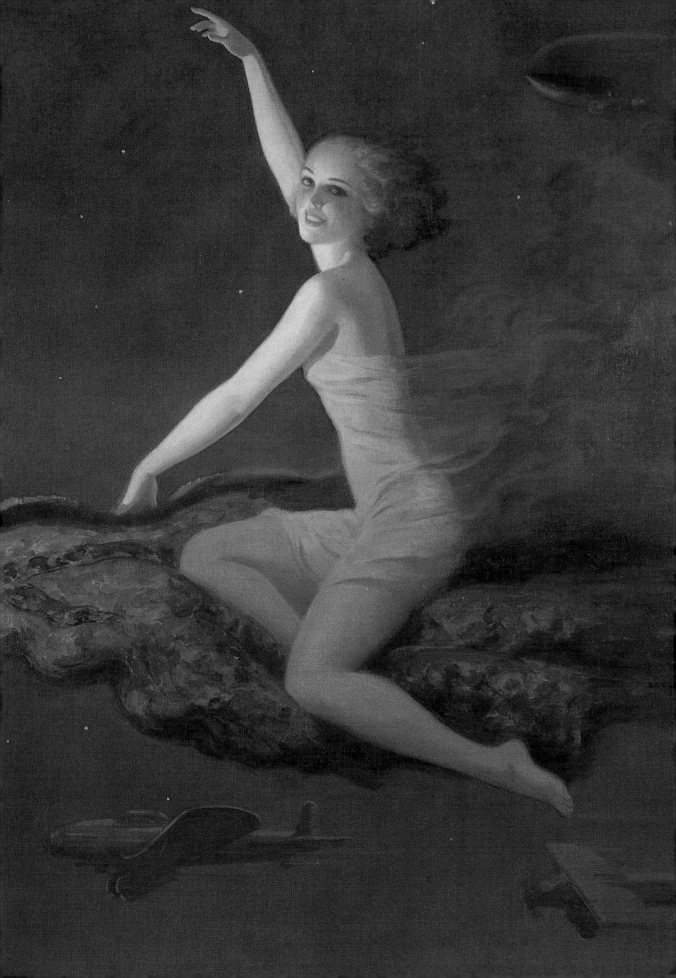

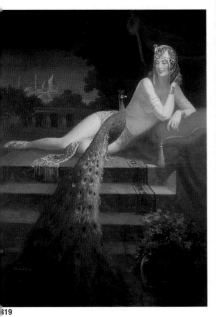

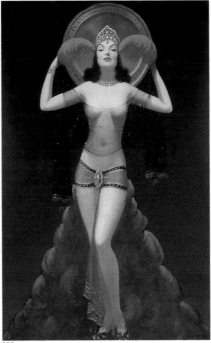

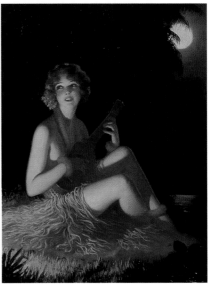

319

320

321

Wie sein Illustratorkollege Gene Pressler spezialisierte sich auch Eggleston auf exotische, romantische Themen: Indianermädchen, hawaiianische Tänzerinnen und Nachtschwärmerinnen, die Tausendundeiner Nacht zu entstammen scheinen (Abb. 320).

In den frühen 20er Jahren malte Eggleston Filmstars für Magazin-Cover: Sein Porträt von Betty Compton für Motion Picture Classic war die Sensation in Hollywood. In diese Zeit fielen auch eine Anzeigenserie für Strümpfe, zahlreiche Magazin-Cover, davon etliche für die großen Zeitschriften des Landes.

1925 eröffnete Eggleston in New York ein Studio und malte nun Pin-up- und Glamourbilder für den Kalendermarkt, anfänglich vor allem für die Thomas D. Murphy Company. Sein erster Auftrag für Brown and Bigelow, The Treasure Princess, wurde nach genauen Vorgaben der Firma ausgeführt. Doch Eggleston bestand auf freier Motivwahl und entwarf von da an Pin-ups, die zu den bemerkenswertesten des Art deco gehören.

1932 lieferte Eggleston bei Brown and Bigelow ein Bild ab, das zum bestverkauften seiner Karriere werden sollte. Let's Go America (Abb. 318) schuf er, so Eggleston, um in einer Zeit wirtschaftlicher Depression „eine wiedererstarkende Hoffnung und Zuversicht in die Zukunft der Nation zu symbolisieren". Let's go

America zeigt eine wunderschöne Frau, die auf einem fliegenden Teppich durch einen mitternächtlich-dunklen Himmel reitet, wie ihn Maxfield Parrish gemalt haben könnte, umgeben von modernen Flugzeugen und einem Zeppelin.

1935 begann eine produktive Zusammenarbeit zwischen Eggleston und dem Kalenderverlag John C. Hoover and Sons in Philadelphia; sein erstes Ölbild für Hoover, Flaming Arrow (1936; Abb. 317), war ein ungemein populäres Indianermädchen. Darauf folgte Cleopatra (1938; Abb. 319), ein klassischer Eggleston und wieder ein großer Erfolg.

Bis 1940 arbeitete Eggleston in seinem Studio in Manhattan..Sein letzter bekannter Werbeauftrag datiert aus dieser Zeit: das Cover des Programmheftes von Billy Roses „Aquacade", das während der New Yorker Weltausstellung von 1939 Zuschauerrekorde aufstellte.

Der distinguierte und geschäftstüchtige Eggleston schuf detailreiche, sorgfältig gezeichnete Bilder mit meisterlichem Bildaufbau und in einer vollendeten Technik. Er beherrschte die Arbeit in Öl, Pastell, Aquarell und Gouache. Die meisten seiner Kalenderaufträge führte er jedoch in Öl auf Leinwand aus und verwendete dabei große Formate zwischen 76 x 61 cm und 100 x 76 cm.

Comme son confrère Gene Pressler, Eggleston se spécialisa dans les sujets exotiques et romantiques: belles squaws, danseuses hawaïennes et «jeunes filles au clair de lune» surprises dans un décor des Mille et Une nuits (illustration 320).

Au début des années 20, Eggleston peignait des stars pour les couvertures de magazines de cinéma. Son portrait de Betty Compton de 1922, réalisé pour Motion Pictures Classic, fit parler tout Hollywood lorsqu'il parut dans les kiosques. Il réalisa également une série de publicités pour la lingerie fine ainsi que de nombreuses couvertures de magazines, dont la plupart étaient destinées au grand public.

En 1925, Eggleston ouvrit un atelier à New York et commença à peindre des pin up et des images glamour pour les éditeurs de calendriers, d'abord principalement pour Thomas D. Murphy. Pour sa première commande pour Brown and Bigelow, The Treasure Princess (1928), il dut suivre des consignes très précises. Par la suite, il insista pour qu'on lui laisse carte blanche et réalisa ainsi certaines des pin up Art déco les plus admirables du genre.

En 1932, Eggleston livra à Brown and Bigelow une image qui allait battre tous les records de ventes. D'après l'artiste, Let's Go America («En avant, l'Amérique!»; illustration 318) fut réalisé pendant la crise économique pour «symboliser la

renaissance de l'espoir et de la confiance» en l'avenir de la nation. L'œuvre montrait une belle dame sur un tapis volant traversant un ciel bleu nuit à la Maxfield Parrish et escortée par des avions et un dirigeable.

En 1936, Eggleston entama une collaboration féconde avec l'éditeur de calendriers Joseph C. Hoover de Philadelphie. Sa première peinture pour cette maison, Flaming Arrow (1936; illustration 317) était un portrait de squaw qui devint extrêmement populaire. Suivit Cleopatra (1938; illustration 319), un classique d'Eggleston et un autre grand succès.

Eggleston travailla dans son atelier jusqu'en 1940. Sa dernière œuvre connue, datée de cette même année, était la couverture d'un programme pour le spectacle de Billy Rose, Aquacade, qui avait battu tous les records d'affluence à l'Exposition universelle de New York en 1939.

Distingué, très professionnel, Eggleston peignait des œuvres au dessin soigné et riches en détails, avec une superbe composition et une grande maîtrise technique. Il avait un profond sens de la couleur et maîtrisait à la fois l'huile, le pastel, l'aquarelle et la gouache. La plupart de ses œuvres pour calendriers étaient réalisées à l'huile sur des toiles allant de 76,2 x 61 cm à 101,6 x 76,2 cm.

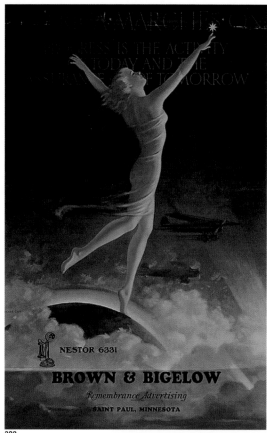

322

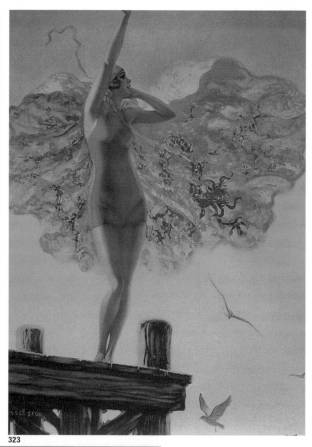

323

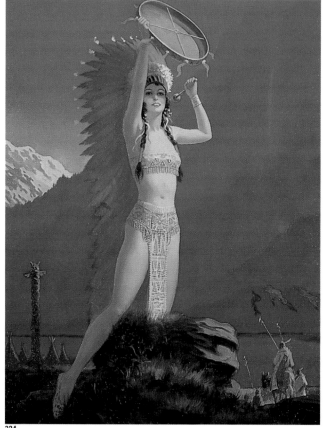

324

Harry Ekman

Harry Ekman's pin-ups are often compared in style and format to Gil Elvgren's (figures 325, 326, 328, 329, and 336). Born in Chicago, the home of the Sundblom "gang," Ekman actually worked as an apprentice to Elvgren. He not only absorbed as much as he could from his mentor but also helped Elvgren to develop ideas and themes.

Ekman's years with Elvgren paid off handsomely, for he immediately met with success when he went out on his own: he sold a number of his pin-up paintings to Shaw-Barton, the prestigious Ohio-based calendar-publishing house. Although Ekman mostly limited his calendar work to straightforward or situation pin-ups, he did create an exquisite glamour-oriented calendar showing girls with parrots for the Rustcraft Greeting Card Company's short-lived calendar division.

With their smiling faces, jaunty attitudes, and frequent canine companions, Ekman's pin-up girls always had a fresh, wholesome Sundblom-like glow. Like Elvgren, he always photographed his models before beginning to paint. By the winter of 1957, Ekman was the subject of an article published in *Art & Camera* magazine, testimony to how well established he had become as an artist and photographer in his own right.

Ekman worked almost identically to Elvgren in every way. His primary medium was oil on canvas, and his paintings were exactly the same size as Elvgren's, 30 by 24 inches (76.2 by 61 cm). Although Elvgren did not make many preliminary studies in pencil, Ekman rendered fully finished drawings of his images before beginning his canvases (figures 338, 339, and 342).

It is thought that Ekman moved from the Chicago area upon retirement and settled near Salt Lake City, Utah.

Die Pin-ups von Harry Ekman werden in Stil und Format oft mit denen von Gil Elvgren verglichen (Abb. 325, 326, 328, 329 und 336). Ekman stammte aus Chicago, der Heimat der Sundblom-Clique und war ein Schüler von Elvgren. Dabei übernahm er nicht nur soviel wie möglich von seinem Mentor, sondern war Elvgren auch bei der Entwicklung von Themen und Ideen behilflich.

Ekmans Lehrjahre bei Elvgren waren eine gute Investition: Als er sich selbständig machte, konnte er sich sofort durchsetzen und verkaufte eine Reihe seiner Pin-ups an den angesehenen Kalenderverlag Shaw-Barton, der in Ohio ansässig war. Obwohl Ekman sich bei seinen Kalenderaufträgen fast ausschließlich auf reine Pin-ups oder Pin-ups konzentrierte, die seine Girls in bestimmten Situationen zeigten, schuf er für den nur kurzlebigen Kalenderbereich der auf Grußkarten spezialisierten Firma Rustcraft auch einen exquisiten Glamourkalender, der Mädchen mit Papageien zeigte.

Ekmans Pin-up-Girls lächelten, hatten eine sorglos-unbekümmerte Attitüde und häufig einen Hund als Begleiter an ihrer Seite. Sie besaßen den Sundblom-Touch, wirkten unverbraucht und gesund. Wie Elvgren fotografierte auch Ekman seine Modelle, bevor er sie zeichnete. Im Winter des Jahres 1957 widmete man Ekman dann einen Artikel in der Zeitschrift Art & Camera, ein Beleg seiner Anerkennung als Künstler und Fotograf, der aus dem Schatten von Elvgren getreten war.

Die Arbeitsweise Ekmans war fast in jeder Beziehung identisch mit der von Elvgren. Sein hauptsächliches Medium war Öl auf Leinwand; die Bilder waren im gleichen Format wie die Elvgrens (76 x 61 cm). Doch Elvgren fertigte zu seinen Bildern selten vorbereitende Bleistiftstudien an, während Ekman ein Bild als Zeichnung anfertigte, bevor er mit der Arbeit an der Leinwand begann (Abb. 338, 339 und 342).

Man nimmt an, daß Ekman nach seinem Rückzug aus dem Berufsleben aus Chicago wegging und in die Nähe von Salt Lake City in Utah zog.

On compare souvent le style et le format des pin up d'Harry Ekman à ceux de Gil Elvgren (illustrations 325, 326, 328, 329 et 336). De fait, originaire de Chicago, patrie du «gang» de Sundblom, Ekman fut un temps l'apprenti d'Elvgren. Si Elvgren lui apprit beaucoup, Ekman aida également son mentor à développer des nouvelles idées et des thèmes inédits.

Les années passées auprès d'Elvgren furent très profitables: dès qu'il se mit à voler de ses propres ailes, Ekman rencontra le succès. Il vendit un grand nombre de pin up à Shaw-Barton, le prestigieux éditeur de calendriers de l'Ohio. Bien que son œuvre pour calendriers soit principalement centrée sur les pin up, simples ou en situation, il réalisa également une superbe série de beautés glamour «avec perroquets» pour l'éphémère ligne de calendriers lancée par la maison Rustcraft, spécialisée dans les cartes de vœux.

Les pin up souriantes et guillerettes d'Ekman, souvent accompagnées de leur toutou, dégageaient une aura de fraîcheur et de bonne santé qui rappelle le travail du cercle de Sundblom. Comme Elvgren, Ekman photographiait toujours ses modèles avant de les peindre. En hiver 1957, il fit l'objet d'un article de la revue *Art & Camera*, preuve que sa réputation était déjà fermement établie en tant qu'artiste et photographe.

La technique et le format d'Ekman étaient les mêmes que ceux d'Elvgren. Il travaillait principalement à l'huile sur des toiles de 76,2 x 61 cm. Elvgren ne faisait que très peu d'esquisses préliminaires, mais Ekman réalisait d'abord un dessin complet du sujet avant d'attaquer la toile (illustrations 338, 339 et 342).

Après avoir pris sa retraite, Ekman semble avoir quitté la région de Chicago pour s'établir près de Salt Lake City, dans l'Utah.

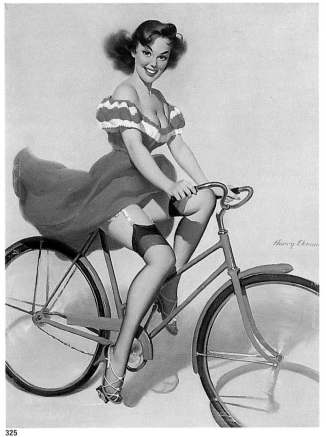

325

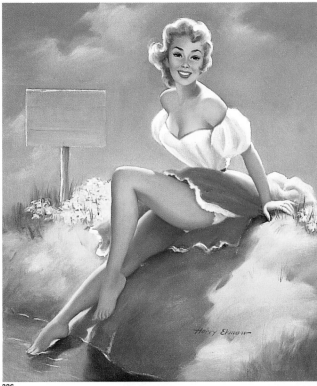

326

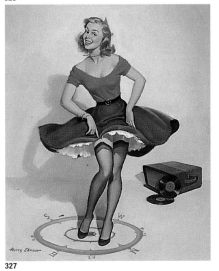

327

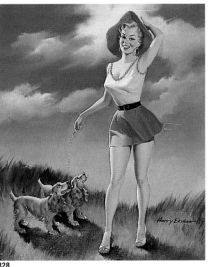

328

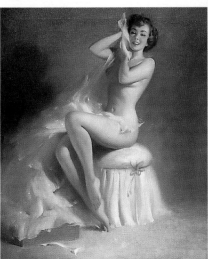

329

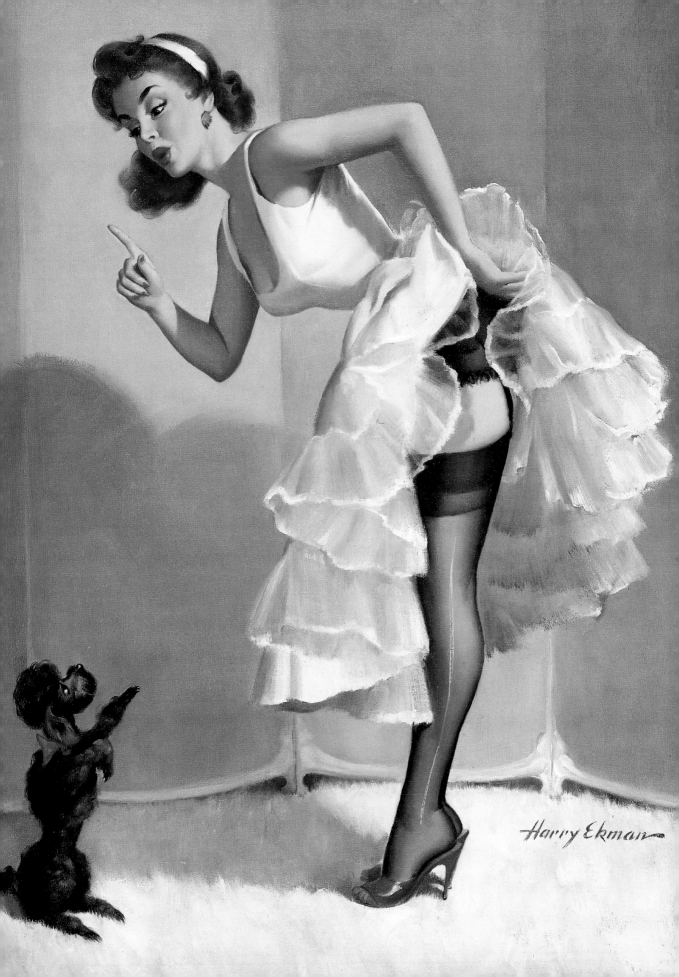

Harry Ekman

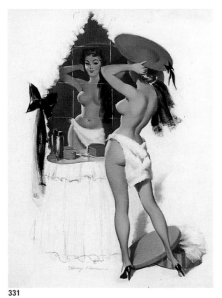

331

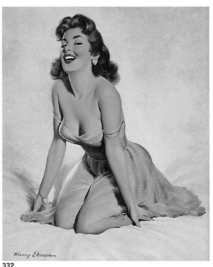

332

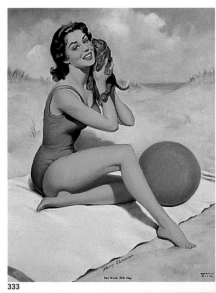

333

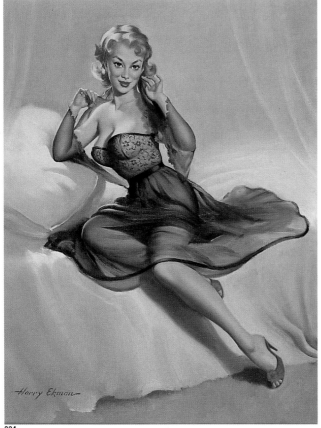

334

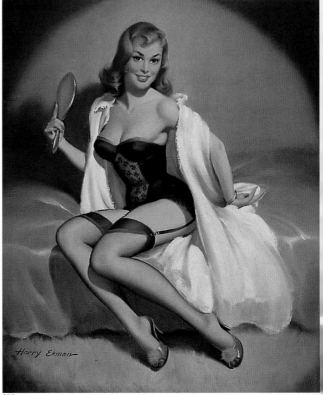

335

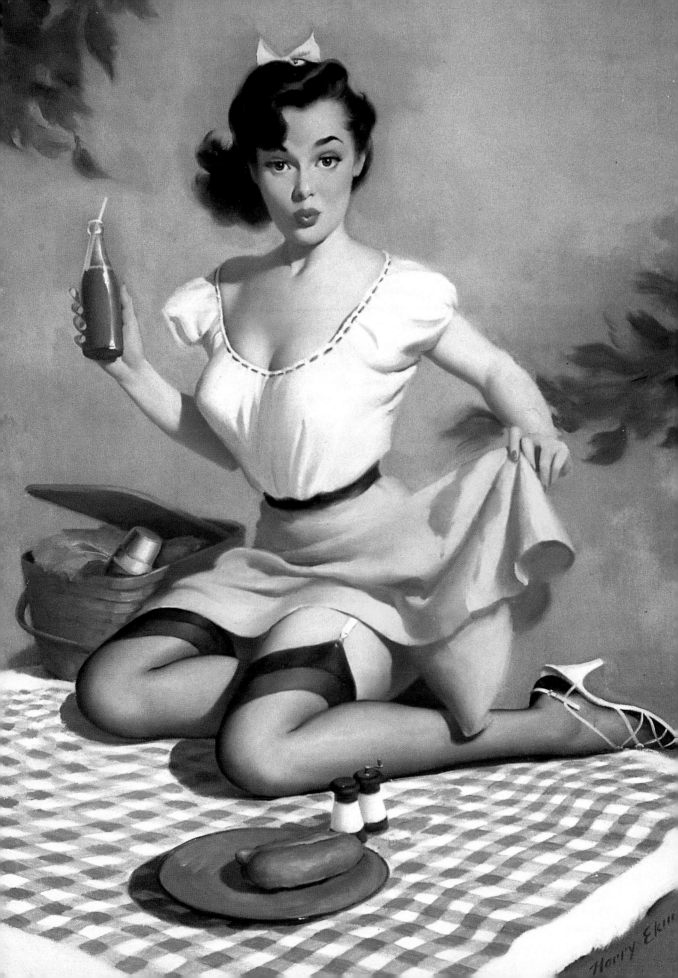

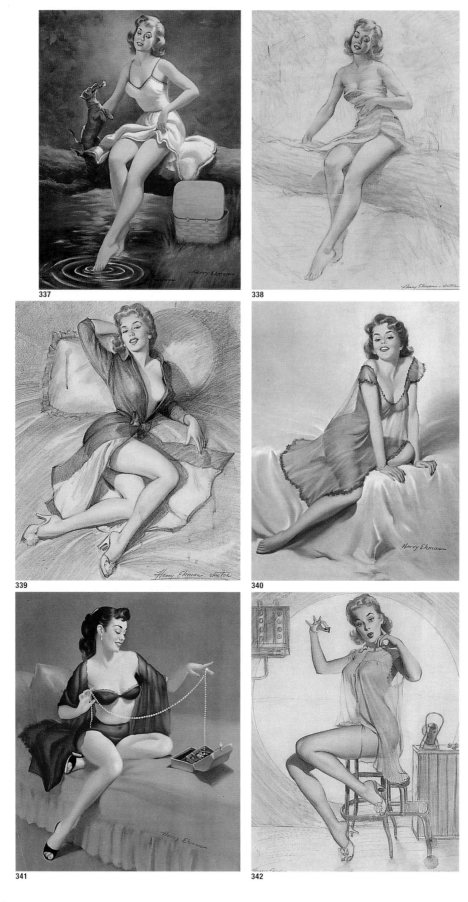

337

338

339

340

341

342

Freeman Elliot

Elliot is best known for the three Artist's Sketch Pads he illustrated for Brown and Bigelow from 1949 to 1951. Each page of these twelve-page calendars had a primary pin-up figure surrounded by several razor-crisp side sketches commenting in some way on the main picture. The large pin-up was painted in gouache, Elliot's favorite medium, the smaller sketches done in pencil (figure 339).

Born in 1922 in a suburb of Chicago, Elliot apprenticed at the Stevens/Gross studio, where he had the opportunity to learn from Gil Elvgren, Joyce Ballantyne, Al Buell, and Haddon Sundblom. Shortly after serving in the Navy in World War II, he was commissioned by Brown and Bigelow to create two sets of double card decks: *Winning Aces* (figure 350) and *Hit the Deck* (figure 351) became runaway

best-sellers. In 1953, Elliot's work appeared on Brown and Bigelow's successful Ballyhoo Calendar, along with that of *Esquire* artists Al Moore, Ernest Chiriaka, Eddie Chan, and Ward Brackett. Millions of Americans saw his pin-ups on the covers of Hearst's *Pictorial Weekly* during the 1950s.

Elliot worked in gouache, watercolor, pencil, and oil on illustration board that ranged from 18 x 24 inches (45.7 x 61 cm) to 20 x 30 inches (50.8 x 76.2 cm). Though often amusing, his pin-ups could also be sexy and sensual. Elliot, who was represented by Stevens/Gross, had a cross-over career that encompassed front covers for national magazines, story illustrations, and advertising art.

Die drei „Artist's Sketch Pads", die Elliot zwischen 1949 und 1951 für Brown and Bigelow illustrierte, machten ihn bekannt. Auf jeder Seite dieser zwölfseitigen Kalender war in der Mitte eine Pin-up Figur abgebildet, umgeben von mehreren gestochen scharfen und präzisen Skizzen, die die Hauptfigur kommentierten. Die großformatigen Pin-ups malte Elliot in seiner favorisierten Technik, der Gouache, die kleinen Skizzen fertigte er als Bleistiftzeichnungen an (Abb. 339).

Elliot wurde 1922 in einem Vorort von Chicago geboren. Im Studio von Stevens/Gross arbeitete er als Lehrling und hatte dort die Möglichkeit, von Gil Elvgren, Joyce Ballantyne, Al Buell und Haddon Sundblom zu lernen. Im Zweiten Weltkrieg diente er bei der Navy und erhielt kurz danach den Auftrag von Brown and Bigelow, zwei Spielkartensets zu entwerfen. Winning Aces *(Abb. 350) und* Hit

the Deck *(Abb. 351) wurden auf Anhieb Bestseller. 1953 veröffentlichte Brown and Bigelow seine Arbeiten zusammen mit Beiträgen von Ernest Chiriaka, Eddie Chan, Ward Brackett und dem für* Esquire *tätigen Al Moore in ihrem erfolgreichen Ballyhoo-Kalender. In den 50er Jahren sahen Millionen von Amerikanern seine Pin-ups auf dem Cover von Hearsts* Pictorial Weekly.

Elliot arbeitete in Gouache, Aquarell, Bleistift und Öl auf Karton, dessen Größe zwischen 45 x 61 cm und 50 x 76 cm variierte. Obwohl sie oft amüsant waren, konnten seine Pin-ups auch sehr sinnlich und erotisch sein. Elliot, der von der Agentur Stevens and Gross vertreten wurde, gelang es, in verschiedenen Bereichen erfolgreich zu sein – von Coverillustrationen für große landesweite Zeitschriften, der Illustrierung von Zeitschriftengeschichten bis hin zu Anzeigenaufträgen.

On connaît surtout Elliot à travers ses trois Artist's Sketch Pads réalisés pour Brown and Bigelow de 1949 à 1951. Le principe de ces calendriers était de présenter chaque mois une image centrale en couleurs entourée de plusieurs petites esquisses préliminaires qui étaient autant de variations sur le sujet principal. La pin up centrale était réalisée à la gouache, le technique préférée d'Elliot, les esquisses au crayon (illustration 339).

Né en 1922 dans une banlieue de Chicago, Elliot fit ses premières armes dans l'atelier Stevens-Gross, où il apprit le métier aux côtés de Gil Elvgren, Joyce Ballantyne, Al Buell et Haddon Sundblom. A son retour de la guerre, où il avait servi dans la marine, Brown and Bigelow lui demanda d'illustrer deux doubles jeux de cartes. *Winning Aces* (illustration 350) et *Hit the Deck* (illustration 351), qui se

vendirent comme des petits pains. En 1953, il collabora au fameux calendrier Ballyhoo de Brown and Bigelow (un autre best-seller) aux côtés des artistes d'*Esquire* Al Moore, Ernest Chiriaka, Eddie Chan et Ward Brackett. Pendant les années 50, des millions d'Américains admirèrent également ses pin up sur les couvertures de *Pictorial Weekly,* une publication Hearst.

Elliot travaillait la gouache, l'aquarelle, le crayon et l'huile sur des cartons à dessin mesurant entre 45,7 x 61 cm et 50,8 x 76,2 cm. Souvent drôles, ses pin up étaient aussi sexy et langoureuses. Elliot, qui était représenté par l'agence Stevens-Gross, eut une carrière en zigzag, réalisant également des couvertures pour des magazines à grand tirage, des illustrations de romans et des affiches publicitaires.

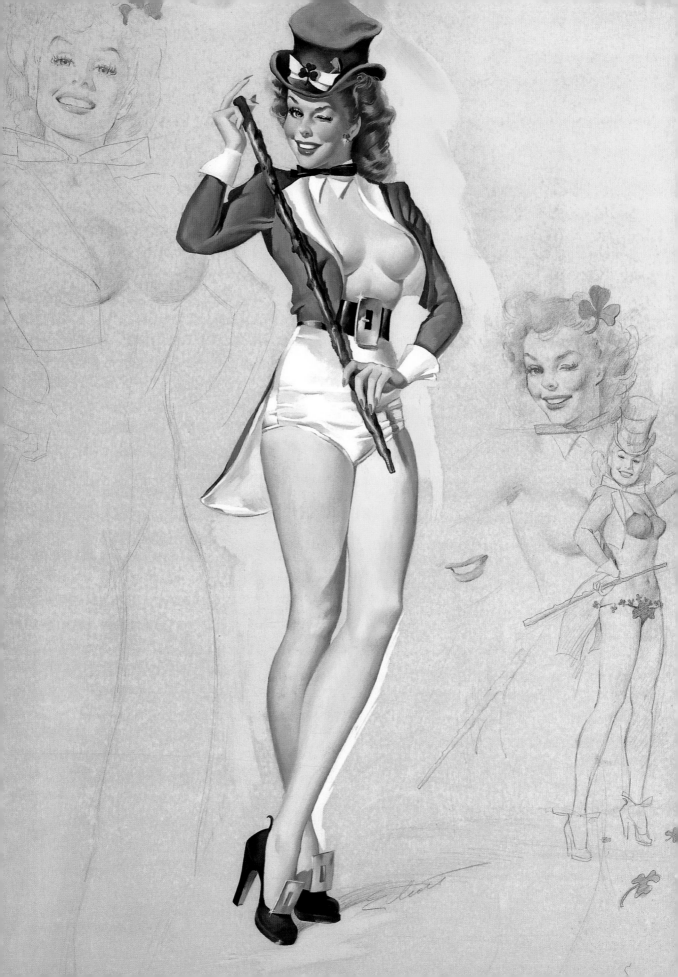

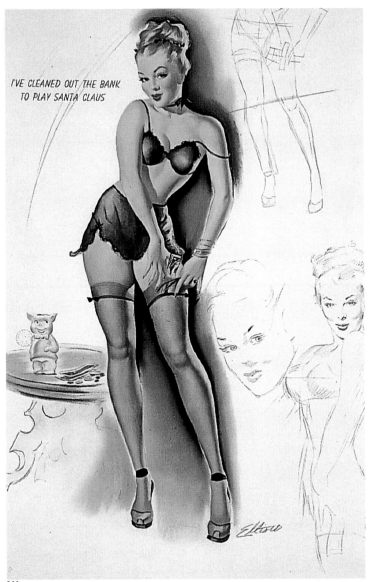

I'VE CLEANED OUT THE BANK
TO PLAY SANTA CLAUS

344

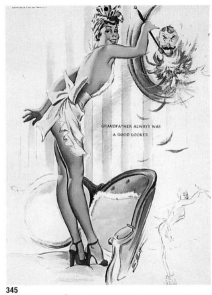

GRANDFATHER ALWAYS WAS
A GOOD LOOKER

345

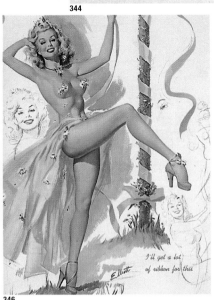

I'll get a lot
of ribbon for this

346

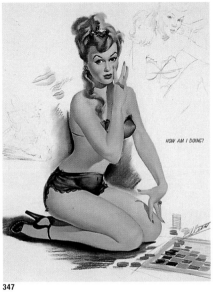

HOW AM I DOING?

347

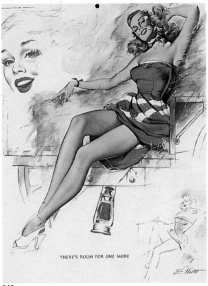

THERE'S ROOM FOR ONE MORE

348

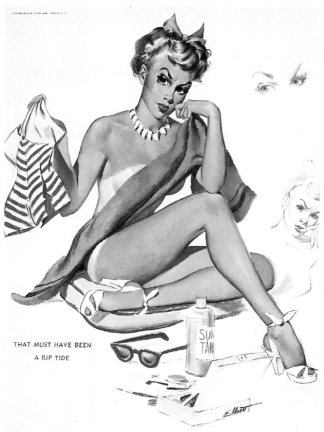

THAT MUST HAVE BEEN
A RIP TIDE

349

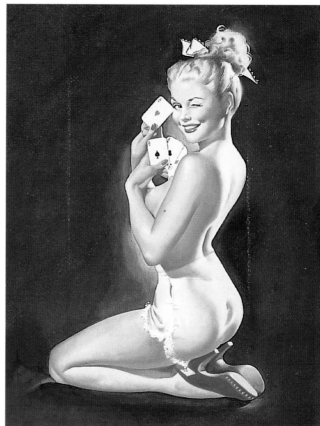

350

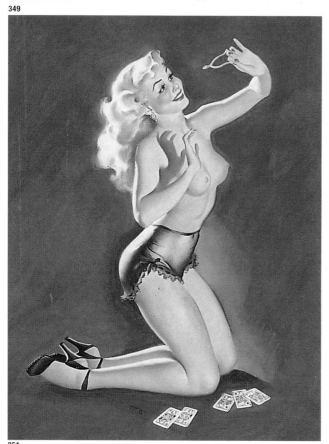

351

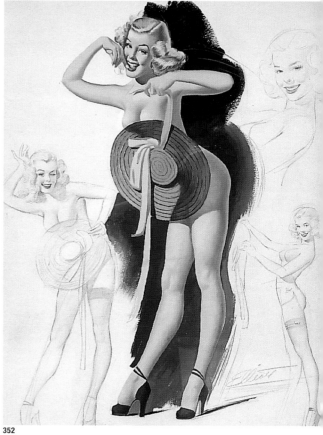

352

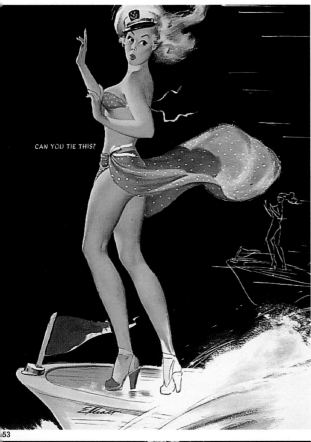

CAN YOU TIE THIS?

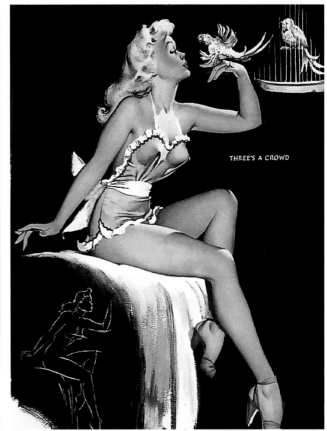

THREE'S A CROWD

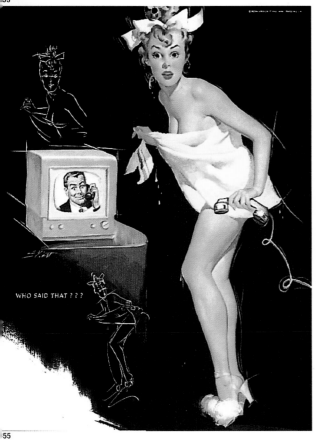

WHO SAID THAT ? ? ?

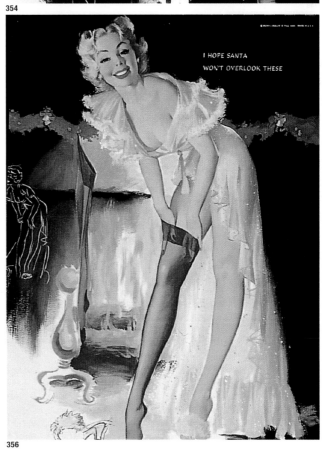

I HOPE SANTA
WON'T OVERLOOK THESE

Gil Elvgren

Although George Petty and Alberto Vargas have achieved more fame and public recognition, Gil Elvgren has emerged in recent years as the artist most loved and respected by pin-up collectors and fans worldwide. A genius who set the standard for pin-up and glamour painting, Elvgren is in a class by himself because of his brilliant painting technique and his ability to make every pin-up entertaining and lifelike. Clearly influenced by John Singer Sargent and Haddon Sundblom, Elvgren combined creative compositional schemes and an exceptional use of color with magically rich, passionate brushstrokes. The Elvgren Girl had a fresh and whole-some personality, a slender, shapely form, and a sparkling quality that made her cuter, sexier, and more alive than any other pin-up in the world.

Born March 15, 1914, in St. Paul, Minnesota, Gillette A. Elvgren was the son of Alex and Goldie Elvgren. At nineteen years of age, he eloped with his high school sweetheart, Janet Cummins; the two would spend thirty-three happy years together. Elvgren enrolled at the University of Minnesota as an architecture major, but decided to become an artist after taking summer classes at the Minneapolis Art Institute.

In 1934, Elvgren moved with his wife to Chicago and immediately enrolled in both day and night courses at the American Academy of Art. There, he studied under Bill Mosby and met other students who would eventually become friends and artistic colleagues: Thornton Utz, Coby Whitmore, Andrew Loomis, Bob Skemp, Al Buell, Edwin Henry, and Harry Anderson. He graduated in 1936, moved back to St. Paul, and opened his first studio.

Elvgren was almost iimmediately hired to paint two pictures of the Dionne Quintuplets for Brown and Bigelow which, when published in 1937 and 1938 became smashing successes, generating hundreds of thousands of dollars in rev-enue. His second big break was a commission from the Louis F. Dow Company for a series of calendar and mutoscope pin-ups, an assignment that lasted until the beginning of World War II.

In 1938, as the Elvgrens became the proud parents of their first child, Karen, the artist agreed to paint a pin-up for Royal Crown Soda that would be reproduced on 6,500 life-size die-cut advertising displays. By 1940, the Elvgrens decided to return to Chicago, where Gil soon joined the Stevens/Gross studio. With Sund-blom's guidance, he began a series of advertising paintings for Coca-Cola that were to become hugely significant, to the company, to the artist, and to the history of American advertising art. Appearing as full-page ads in mainstream magazines, twenty-four-sheet roadside billboards, posters, and special displays, these fresh, sentimental images captured the heart of the American public.

Just before the war started, Elvgren began to teach a few classes at the Ameri-can Academy of Art. There he met a student, Joyce Ballantyne, who would become his protégé, friend, and new colleague at Stevens/Gross. When war broke out, the Dow company reissued many of his 1937–38 pin-up images as twelve-page 8-x-10-inch (20.3-x-25.4-cm) booklets to be mailed to soldiers stationed overseas. Elvgren and Janet had their second child, Gillette, Jr., in 1942.

Elvgren's calendar continued to be booked solid. In 1944, his third child, Drake was born, and Brown and Bigelow offered him $1,000 per painting if he would work exclusively for them. While considering this offer, he accepted a commission from Joseph C. Hoover and Sons calendar company for a glamour painting for their 1945 line, but insisted he would not sign the work since he did not want to jeopardize his negotiations with the other firm. His painting for Hoover, *Dream Girl*, was the finest full-length glamour subject he had ever executed and was so popu-lar that *Hoover* kept it in their line for almost ten years.

Elvgren's decision to accept Brown and Bigelow's invitation marked the begin-ning of an almost thirty-year relationship that made calendar-art history. Launched with a major publicity campaign, Elvgren produced his first pin-up for the firm in 1945. One year later, his first nude image, *Sea Nymph*, became the best-selling nude in the company's history. More record-breaking images were to follow: *Aiming to Please* (1947), a cowgirl subject; *Too Good to be True*, published as a hanger calendar in 1948 and in 1952 as a page in the Ballyhoo Calendar; and *Vision of Beauty* (1948), another nude subject.

The March 1948 issue of See magazine ran a five-page article about Elvgren and his Brown and Bigelow pin-up girls, the first of dozens of such articles. In 1950, the Schmidt Lithography Company of Chicago and San Francisco asked Elvgren to paint a series of glamour heads for their "universal" billboards. In addi-tion to regularly delivering pin-ups to Brown and Bigelow (about twenty-four a year for an average fee of $2,500 each), he accepted a great many advertising assignments during the 1950s for such clients as Schlitz Beer, Ovaltine, General Tire, General Electric, Serta Perfect Sleep, and Red Top Beer.

Elvgren and his family moved in 1956 to Siesta Key in Sarasota, Florida. As the decade came to a close, he had become the most important artist at Brown and Bigelow, which reproduced his pin-ups in every feasible form. Clair Fry, art direc-tor at the firm, said this about Elvgren: "Gil's work is sincere and very honest. The reaction to Gil's paintings is that here is a real girl. The carefully thought out ges-ture and expression are done with such mastery that they convey the exact mean ing Gil intended without the phony quality that exists in such a vast percentage of commercial pin-ups."

The prolific Elvgren also spent hundreds of hours executing magazine-story illustrations, usually of boy/girl "love and romance" subjects, for such mainstream magazines as *Cosmopolitan, Redbook, McCall's, Woman's Home Companion,* and *The Saturday Evening Post*. The 1960s were the time of Elvgren's greatest suc-cess, for a number of reasons: the artist himself reached the peak of his skill, Brown and Bigelow marketed his images superbly, and the American public responded to them enthusiastically.

Elvgren once described his ideal model as having a fifteen-year-old face on a twenty-year-old body. He also cited the following features: high forehead, long neck, eyes that were set wide apart, small ears, pert nose, great hair, full but not overblown breasts, nice legs and hands, a pinched-in waist, and natural grace and

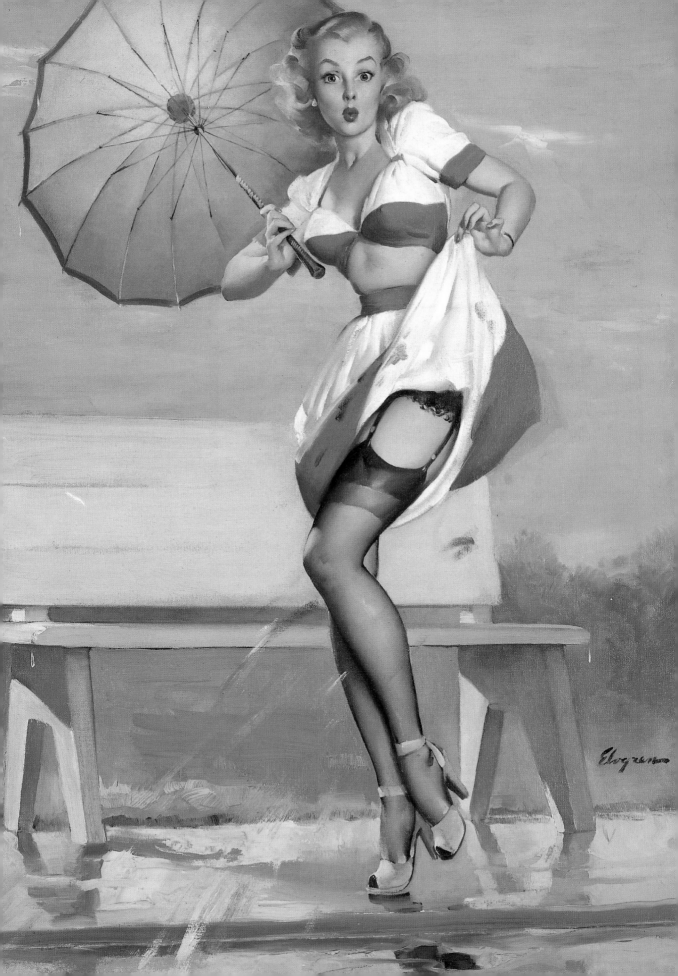

poise. He explained that he made subtle alterations in the model's physique, accentuating areas like the legs, nose, and lips, and added that he tried to create the feeling that, underneath all the surface beauty, behind the model's eyes, there was a delicious, mischievous warmth. For him, the model "with highly mobile facial features capable of a wide range of expression is the real jewel. The face is the personality." Many of Elvgren's models, including Myrna Loy, Donna Reed, Arlene Dahl, Barbara Hale, and Kim Novak, went on to successful careers of their own.

Elvgren's pin-up paintings were always studiously planned out. Beginning with careful selection of the model, he would next choose the wardrobe, hair-style, background, props, and lighting. He then photographed the scene himself, shooting with a 2¼-inch (5.7-cm) format Rollei camera. With thirty-two colors on his palette, Elvgren set his canvas on a large wooden easel. He usually sat in a chair with wheels, thus allowing him to view the subject from different angles. For an overall view, he would look behind him at a mirror on the wall.

Almost all of Elvgren's Brown and Bigelow pin-up subjects were executed in oil on canvas measuring 30 x 24 inches (76.2 x 61 cm). Occasionally, while working

for the firm in the late 1940s and the 1950s, Elvgren would do a pencil study of a pin-up subject, but few of these works survive. The only large preliminary studies of his career are the oil-on-board renderings that were part of a Brown and Bigelow project for the NAPA Corporation. These full-color works of the 1960s are almost as beautiful as finished paintings.

Elvgren's Dow pin-ups, which dated from 1937 to about 1942, were always painted in oil on canvas (28 x 22 inches; 71.1 x 55.9 cm) and were never signed. Many of these works were overpainted by Vaughn Bass at Dow's request; by thus changing the image, the company hoped to get a second use out of the paintings. A few of Elvgren's Dow originals have survived as they were painted, and a few of Bass's overpainted works are only minimally altered. When the Dow Elvgrens were published – both originally and after the overpainting – they bore a mechanical "slug" signature that depicted the artist's name in block, printed lettering.

Elvgren's wife passed away in 1966 after a bout with cancer, and he later remarried one of his former models, Marjorie Shuttleworth. He died of cancer in 1980.

Obwohl George Petty und Alberto Vargas größere öffentliche Anerkennung und Ruhm zuteil wurde, hat sich Gil Elvgren jedoch in den letzten Jahren als der Favorit bei Pin-up-Sammlern und -Fans auf der ganzen Welt herauskristallisiert. Er war ein Genie, das für Pin-ups und Glamourkunst Maßstäbe setzte, ein Künstler, der durch seine brillante Technik und die Fähigkeit, jedes Pin-up lebensecht, amüsant und unterhaltsam zu gestalten, hervorstach. Unverkennbar von John Singer Sargent und Haddon Sundblom beeinflußt, kombinierte Elvgren kreative Kompositionsschemata mit einer außergewöhnlichen Farbpalette und einer wunderbar satten und leidenschaftlichen Pinselführung. Das „Elvgren Girl" war appetitlich und unverbraucht, mit schlanker, guter Figur und einer von Leben und Geist sprühenden Persönlichkeit. Sie war niedlicher, hatte mehr Sex-Appeal und wirkte lebendiger als jedes andere Pin-up-Girl der Welt.

Gillette A. Elvgren wurde am 15. März 1914 als Sohn von Alex und Goldie Elvgren in St. Paul, Minnesota, geboren. Als Neunzehnjähriger brannte er mit seiner Highschool-Liebe Janet Cummins durch; die beiden sollten 33 glückliche Jahre miteinander verbringen. Elvgren schrieb sich an der Universität von Minnesota im Fachbereich Architektur ein, doch entschloß er sich nach dem Besuch von Sommer-Ferienkursen am Minneapolis Art Institute dazu, Künstler zu werden.

1934 zog Elvgren mit seiner Frau nach Chicago und schrieb sich dort für den regulären und den zusätzlichen Abendstudiengang an der American Academy of Art ein. Dort studierte er bei Bill Mosby und lernte andere Studenten kennen, die später Freunde und Künstlerkollegen werden sollten: Thornton Utz, Coby Whitmore, Andrew Loomis, Bob Skemp, Al Buell, Edwin Henry und Harry Anderson. 1936 machte er seinen Abschluß, zog zurück nach St. Paul und eröffnete sein erstes eigenes Studio.

Fast sofort erhielt Elvgren den Auftrag, für Brown and Bigelow zwei Bilder der Dionne-Vierlinge zu malen. Sie wurden 1937 veröffentlicht und ein Riesenerfolg, der Hunderttausende von Dollars an Einkünften erbrachte. Mit einem Auftrag der Louis F. Dow Company über eine Serie von Kalender-Pin-ups und Mutoskop-Pin-ups hatte er zum zweiten Mal Glück: Bis zum Beginn des Zweiten Weltkriegs lief dieser Auftrag weiter.

1938 wurden die Elvgrens stolze Eltern ihrer ersten Tochter Karen, und Elvgren willigte ein, für das Unternehmen Royal Crown Soda ein Pin-up zu malen, das auf 6500 ausgestanzten Displays in Lebensgröße reproduziert werden sollte. 1940 entschloß sich die Familie, nach Chicago zurückzugehen. Dort arbeitete Gil im Studio von Stevens/Gross. Unter der Führung von Sundblom begann Elvgren mit der Arbeit an einer Reihe von Anzeigenvorlagen für Coca-Cola, die für den Künstler, seinen Auftraggeber und die Geschichte der amerikanischen Werbegrafik bedeutend werden sollte. Sie wurden als ganzseitige Anzeigen in führenden Zeitschriften, auf riesigen Reklametafeln entlang der Straßen, als Poster und andere Werbemittel gedruckt. Mit diesen unverbrauchten und neu wirkenden, etwas kitschigen Bildern traf Elvgren mitten ins Herz der Amerikaner.

Kurz vor Ausbruch des Krieges begann Elvgren, an der American Academy of Art einige Kurse zu geben. Dort traf er die Studentin Joyce Ballantyne, die sein Protégé, seine enge Freundin und seine neue Kollegin im Studio von Stevens/Gross wurde. Als der Krieg ausbrach, legte die Dow Company viele sei-

ner Pin-ups aus den Jahren 1937/38 als zwölfseitige kleine Bücher im Format 20 x 25 cm neu auf, um sie an in Übersee stationierte amerikanische Soldaten zu schicken. 1942 wurde das zweite Kind der Elvgrens, Gillette jun., geboren. Elvgren war weiterhin fest ausgebucht. 1944 wurde ihr drittes Kind Drake geboren. Zu diesem Zeitpunkt boten ihm Brown and Bigelow 1000 Dollar pro Bild unter der Voraussetzung, daß er exklusiv für sie arbeiten würde. Während Elvgren noch über dieses Angebot nachdachte, nahm er einen Auftrag von dem Kalenderverleger Joseph C. Hoover and Sons an, ein Glamourbild für ihr 1945er Programm. Allerdings bestand Elvgren darauf, diese Arbeit nicht zu signieren, um Verhandlungen mit anderen Firmen nicht zu gefährden. Sein Bild für Hoover, Dream Girl, war das beste großformatige Glamourmotiv, das ihm je gelungen war und überdies so populär, daß es Hoover fast zehn Jahre lang im Programm behielt.

Elvgrens Entschluß, das Angebot von Brown and Bigelow anzunehmen, stand am Beginn einer fast 30 Jahre währenden Zusammenarbeit, die Kalendergeschichte schrieb. Begleitet von einer großen Publicitykampagne schuf Elvgren im Jahre 1945 sein erstes Pin-up für Brown and Bigelow. Ein Jahr später wurde sein erster Akt, Sea Nymph, der bestverkaufte Akt in der Geschichte des Unternehmens. Und noch weitere seiner Bilder erreichten Rekorde: Das Cowgirl-Motiv Aiming to Please (1947); Too Good to be True kam 1948 als Wandkalender auf den Markt und wurde 1952 im Ballyhoo-Kalender nachgedruckt; dann kam Vision of Beauty (1948), ein weiterer Akt.

In ihrer Märzausgabe des Jahres 1948 widmete die Zeitschrift See Elvgren und seinen Pin-up-Girls für Brown and Bigelow einen fünfseitigen Artikel, der erste von Dutzenden, die noch folgen sollten. 1950 bat die Schmidt Lithography Company of Chicago and San Francisco ihn um eine Reihe von Glamourköpfen für ihre Anzeigentafeln. Zusätzlich zu seiner regulären Arbeit für Brown and Bigelow, denen er ungefähr 24 Pin-ups pro Jahr (zu einem durchschnittlichen Preis von je 2500 Dollar) lieferte, nahm er während der 50er Jahre viele Anzeigenaufträge für Klienten wie Schlitz Beer, Ovaltine, General Tire, General Electric, Serta Perfect Sleep und Red Top Beer an.

1956 zog Elvgren mit seiner Familie nach Siesta Key in Sarasota, Florida. Als sich das Jahrzehnt seinem Ende näherte, war er der bedeutendste Künstler unter Vertrag bei Brown and Bigelow geworden, die seine Pin-ups in jeder nur möglichen Form reproduzierten. Clair Fry, Art Director bei Brown and Bigelow, sagte über Elvgren: „Gils Arbeiten haben etwas Ehrliches und Echtes. Man hat das Gefühl, als seien die Mädchen in seinen Pin-ups real. Ihre sorgfältig bedachten Gesten und ihr Gesichtsausdruck werden mit solcher Kunstfertigkeit dargestellt, daß sie das wiedergeben, was Gil vorschwebt. Ihnen fehlt völlig das Künstliche, das so vielen kommerziellen Pin-ups eigen ist".

Der sehr produktive Elvgren verbrachte viel Zeit mit der Illustration von Geschichten für Zeitschriften, die sich meist um Liebe und amouröse Abenteuer drehten und in so großen Zeitschriften wie Cosmopolitan, Redbook, McCall's, Woman's Home Companion und The Saturday Evening Post gedruckt wurden. Die 60er Jahre waren das Jahrzehnt seines größten Erfolgs, und das aus einer Reihe von Gründen: Er selbst erreichte den Höhepunkt seines künstlerischen Schaffens, Brown and Bigelow verstanden es, seine Bilder ausgezeichnet zu vermarkten, und die amerikanische Öffentlichkeit reagierte enthusiastisch.

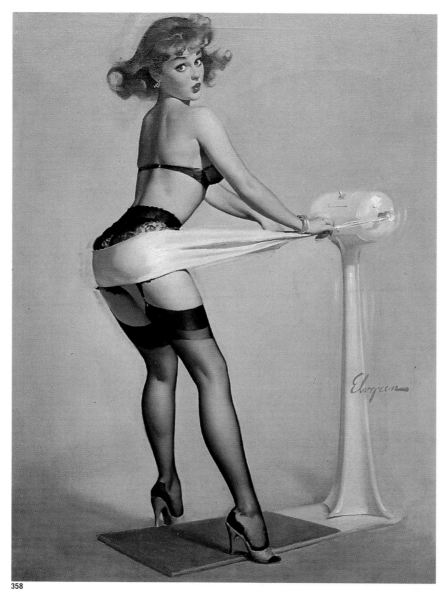

358

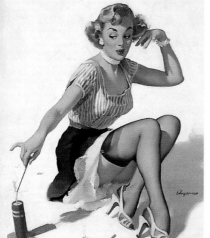

59

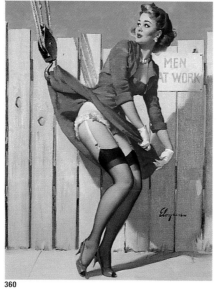

360

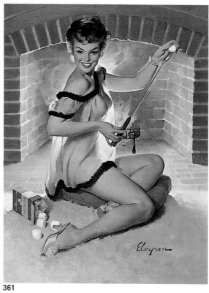

361

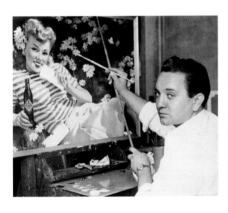
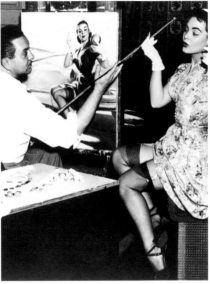

Sein Idealmodell beschrieb Elvgren einmal folgendermaßen: das Gesicht einer Fünfzehnjährigen mit dem Körper einer Zwanzigjährigen. Und mit folgenden Merkmalen: hohe Stirn, schmaler Hals, weit auseinanderstehende Augen, kleine Ohren, keckes Näschen, schöne Haare, volle, doch nicht zu große Brüste, lange Beine und Hände, schmale Taille und mit natürlicher Anmut und Grazie. Er nehme kleine Veränderungen am Körperbau eines Modells vor, erklärte Elvgren, und akzentuiere Beine, Nase oder Lippen. Und er versuche, eine hinter dieser äußeren Schönheit in den Augen des Modells liegende verschmitzte Wärme zu zeigen. Für Elvgren war ein Modell mit „sehr beweglichen und ausdrucksstarken Gesichtszügen, das eine ganze Bandbreite von Ausdrücken zeigen kann, ein wahres Juwel. Das Gesicht drückt die Persönlichkeit aus". Viele seiner Modelle, zu denen Myrna Loy, Donna Reed, Arlene Dahl, Barbara Hale und Kim Novak gehörten, machten später Karriere.

Elvgrens Pin-up-Gemälde war immer sehr sorgfältig konzipiert. Zuerst suchte er ausführlich nach einem Modell, wählte dann Kleidung und Frisur aus sowie den passenden Hintergrund, die Requisiten und die Beleuchtung. Dann fotografierte er die so entstandene Szene mit einer Rolleikamera. Mit 32 Farben auf seiner Palette setzte Elvgren dann seine Leinwand auf eine große, hölzerne Staffelei. Meist saß er auf einem mit Rollen versehenen Sessel, der es ihm ermöglichte, sein Modell aus verschiedenen Winkeln zu betrachten. Um einen

Gesamteindruck von seinem Aufbau zu erlangen, blickte er hinter sich in einen an der Wand angebrachten Spiegel.

Fast ausnahmslos waren die Pin-ups für Brown and Bigelow in Öl auf 76 x 61 cm großen Leinwänden ausgeführt. In den späten 40er und den 50er Jahren begann er diese Auftragsarbeiten bisweilen mit einer Bleistiftstudie eines Pin-ups, doch nur wenige dieser Arbeiten sind erhalten geblieben. Die einzigen großen Vorabstudien seiner Karriere waren in Öl auf Karton und Teil eines Projektes von Brown and Bigelow für die NAPA Corporation. Diese Arbeiten aus den 60er Jahren stehen den endgültigen Bildern in nichts nach.

Elvgrens Pin-ups für Dow aus den Jahren 1937 bis 1942 entstanden immer in Öl auf Leinwand (71 x 56 cm) und wurden nie signiert. Viele dieser Pin-ups wurden auf Geheiß von Dow von Vaughn Bass übermalt; durch diese Veränderung der Bilder erhoffte sich die Firma eine Zweitverwertung. Einige seiner Gemälde blieben im Originalzustand; verschiedene der von Bass übermalten Bilder wurden nur geringfügig verändert. Die veröffentlichten Pin-ups von Elvgren – sowohl seine Originale als auch die übermalten – trugen eine mechanisch angefertigte Setzmaschinensignatur, die den Namen des Künstlers in groß geschriebenen Druckbuchstaben trug.

1966 erlag Elvgrens Frau einem Krebsleiden. Später heiratete Gil Elvgren eines sehr früheren Modelle, Marjorie Shuttleworth. Er starb 1980, ebenfalls an Krebs.

Même si, de leur vivant, George Petty et Antonio Vargas ont accédé à une notoriété et une reconnaissance publiques supérieures à la sienne, Gil Elvgren est apparu ces dernières années comme l'artiste le plus recherché et respecté des collectionneurs et des fans de pin up dans le monde entier. Véritable génie qui sut rehausser les critères de l'art glamour et des pin up, Elvgren constitue une catégorie à lui seul du fait de sa superbe technique et de sa capacité à rendre ses créations plus fun, amusantes et plus vraies que nature. Nettement influencé par John Singer Sargent et Haddon Sundblom, Elvgren conjuguait des compositions créatives et un sens magistral des couleurs avec un coup de pinceau d'une densité et d'une énergie hors pair. La «Elvgren Girl» était charmante et pleine de fraîcheur, pourvue d'une silhouette svelte toute en courbes et d'un éclat qui la rendait plus adorable, sexy et vivante que toute autre pin up au monde.

Né le 15 mars 1914 à Saint Paul, dans le Minnesota, Gillette A. Elvgren était le fils d'Alex et de Goldie Elvgren. A dix-neuf ans, il prit la clef des champs avec sa petite amie et ex-camarade de classe, Janet Cummins, avec laquelle il devait passer trente-trois ans de vie commune et heureuse. Il s'inscrivit d'abord en architecture à l'Université d'Etat du Minnesota mais décida finalement de devenir artiste après avoir suivi des cours d'été à l'Art Institute de Minneapolis.

En 1934, Elvgren s'installa avec son épouse à Chicago et s'inscrivit aussitôt aux cours du jour et du soir à l'American Academy of Art. Là, il étudia avec Bill Mosby et rencontra d'autres étudiants qui allaient devenir ses amis et confrères:

Thornton Utz, Coby Whitmore, Andrew Loomis, Bob Skemp, Al Buell, Edwin Henry et Harry Anderson. Il décrocha son diplôme en 1936, revint vivre à Saint Paul et y ouvrit son premier atelier.

Elvgren fut presque immédiatement engagé par Brown and Bigelow pour peindre deux portraits des quintuplées Dionne qui, lorsqu'ils furent publiés en 1937 et 1938, firent un tabac, générant des centaines de milliers de dollars de bénéfices. La deuxième grande occasion de sa carrière lui fut fournie par Louis F. Dow, qui lui demanda une série de pin up pour calendriers et cartes d'art, commande régulièrement renouvelée jusqu'au début de la Deuxième Guerre mondiale.

En 1938, la famille s'enrichit d'un premier enfant, Karen, et Elvgren accepta une commande pour les sodas Royal Crown. Sa pin up fut reproduite grandeur nature 6500 fois sous forme de mannequin en carton. En 1940, les Elvgren décidèrent de revenir à Chicago, où Gil rejoignit bientôt l'atelier Stevens-Gross. Sur les conseils de Sundblom, il réalisa une série de publicités pour Coca-Cola qui allaient jouer un rôle déterminant pour l'annonceur, l'artiste et l'histoire de l'art publicitaire américain. Apparaissant sous forme de publicités pleine page dans les magazines, de panneaux géants sur le bord des routes, d'affiches et de présentoirs, les images fraîches et sentimentales d'Elvgren allèrent droit au cœur des consommateurs américains.

Juste avant la guerre, Elvgren donna quelques cours à l'American Academy of Art. Il y rencontra une étudiante, Joyce Ballantyne, qui allait devenir sa protégée,

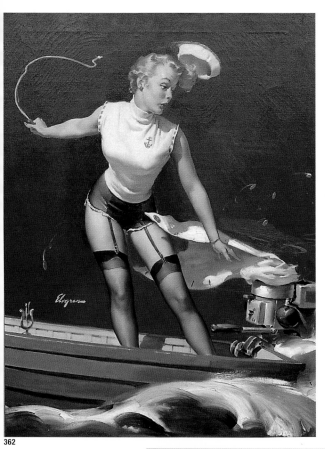

362

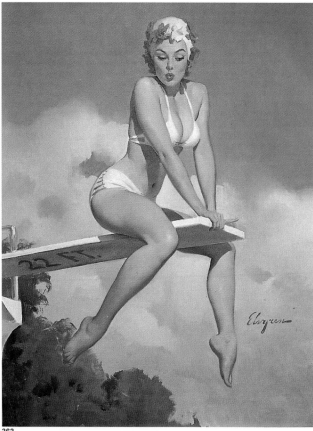

363

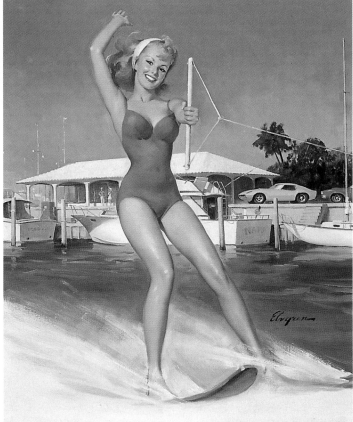

364

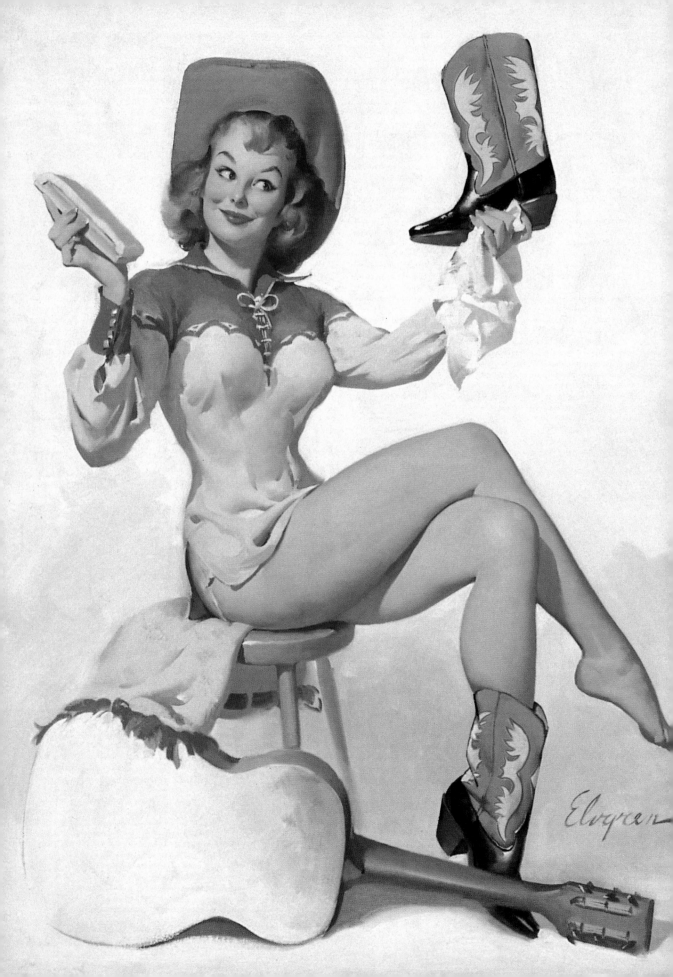

son amie et sa collègue chez Stevens-Gross. Lorsque la guerre éclata, l'éditeur Dow réédita un grand nombre des pin up d'Elvgren de 1937 et 38 sous forme de petits livres de 20,3 x 25,4 cm pour les envoyer aux soldats basés outre-mer. En 1942, les Elvgren eurent un deuxième enfant, Gillette Junior.

Les commandes continuèrent de pleuvoir. En 1944, un troisième petit Elvgren vint au monde, Drake. La même année, l'éditeur Brown and Bigelow proposa à l'artiste 1000 dollars par peinture à condition d'avoir l'exclusivité sur son travail. Tandis qu'il réfléchissait à cette offre, Elvgren accepta une commande pour un des calendriers de 1945 de Joseph C. Hoover and Sons. Il ne la signa pas afin de ne pas compromettre ses négociations avec l'autre éditeur. Sa peinture pour Hoover, *Dream Girl,* était l'un des plus beaux sujets glamour qu'il eut jamais réalisés jusque-là et rencontra un tel succès qu'Hoover continua de la rééditer pendant près de dix ans.

Elvgren accepta l'offre de Brown and Bigelow et entama ainsi une collaboration de près de trente ans qui fit date dans l'histoire de l'édition de calendriers. Sa première pin up pour l'éditeur, annoncée à grand renfort de publicité, parut en 1945. Un an plus tard, son premier nu, *Sea Nymph,* devint un best-seller. D'autres images suivirent et battirent à leur tour des records de ventes: une pin up cow girl intitulée *Aiming to Please* (1947); *Too Good to be True,* publié sous forme de calendrier-cintre en 1948, puis dans le Ballyhoo Calendar de 1952; et enfin un autre nu, *Vision of Beauty* (1948).

Dans son numéro de mars 1948, la revue *See* publia un article de cinq pages consacré à Elvgren et ses pin up pour Brown and Bigelow, le premier d'une dizaine d'autres. En 1950, l'agence Schmidt Lithography Company, basée à Chicago et à San Francisco, demanda à Elvgren une série de portraits glamour pour ses panneaux publicitaires «Universal». Pendant les années 50, outre ses livraisons régulières de pin up à Brown and Bigelow (environ vingt-quatre par an au prix moyen de 2500 dollars pièce), il accepta un grand nombre de commandes publicitaires pour des annonceurs tels que Schlitz Beer, Ovaltine, General Tire, General Electric, Serta Perfect Sleep et Red Top Beer.

En 1956, les Elvgren emménagèrent à Siesta Key, près de Sarasota, en Floride. Elvgren était désormais le plus important des artistes de Brown and Bigelow, qui reproduisait ses pin up sous toutes les formes imaginables. Clair Fry, directrice artistique de la maison d'édition, déclara à son sujet: «Le travail de Gil reflète une grande sincérité et une profonde honnêteté. Ses pin up ressemblent à de vraies jeunes femmes. Leur attitude et leur expression sont soigneusement étudiées et elles sont exécutées avec une telle maîtrise qu'elles évoquent exactement ce que Gil souhaitait, sans reproduire tous les clichés habituels de beaucoup d'images commerciales de pin up.»

Prolifique, Elvgren réalisa d'innombrables illustrations de nouvelles, généralement des histoires d'amour publiées dans des magazines à grand tirage – *Cosmopolitan, Redbook, McCall's, Woman's Home Companion* et *The Saturday Evening Post.* Les années 60 marquèrent l'apogée d'Elvgren, et ce pour plu-

sieurs raisons: ses images n'avaient jamais atteint une telle qualité artistique, Brown and Bigelow les commercialisait magnifiquement et le public américain en raffolait.

Elvgren décrivit un jour son modèle idéal comme ayant le visage d'une adolescente de quinze ans et le corps d'une femme de vingt ans. Il mentionna également les traits suivants: un front haut, un cou de cygne, des yeux bien écartés, de petites oreilles, un nez espiègle, une chevelure luxuriante, des seins généreux mais pas trop, de jolies jambes, de belles mains, une taille de guêpe et enfin, une grâce et un port naturels. Il expliqua qu'il modifiait légèrement le corps de son modèle, accentuant certains détails comme les jambes, le nez et les lèvres, et ajouta qu'il essayait de créer l'impression que, derrière la beauté physique du sujet, dans son regard, se cachait une personnalité chaleureuse, délicieuse et mutine. Pour lui, la vraie perle était «un modèle au visage très mobile, capable d'une vaste gamme d'expressions. Le visage, c'est la personnalité!» De fait, un grand nombre des modèles d'Elvgren, dont Myrna Loy, Donna Reed, Arlene Dahl, Barbara Hale et Kim Novak, firent ensuite de brillantes carrières.

Elvgren préparait méticuleusement ses images. Il commençait par sélectionner soigneusement un modèle, puis choisissait sa tenue, sa coiffure, le fond, les accessoires et la lumière. Il photographiait ensuite la scène avec un Rollei muni d'un objectif de 5,7 cm. Il plaçait sa toile sur un grand chevalet en bois et préparait trente-deux couleurs sur sa palette. Il travaillait assis sur une chaise à roulettes, ce qui lui permettait de voir son modèle sous des angles différents. Pour avoir une vue d'ensemble, il se tournait vers un grand miroir accroché au mur derrière lui.

Presque toutes ses pin up pour Brown and Bigelow furent peintes à l'huile sur des toiles de 76,2x61cm. Dans les années 40 et 50, travaillant toujours pour cet éditeur, il lui arrivait de faire préalablement des esquisses au crayon, mais peu d'entre elles ont survécu. Les seules grandes études préliminaires qu'il ait réalisées sont des huiles sur bois exécutées à l'occasion d'un projet de Brown and Bigelow pour la corporation NAPA. Ces œuvres aux couleurs vives qui datent des années 60 sont presque aussi belles que des toiles achevées.

Les pin up d'Elvgren pour l'éditeur Dow entre 1937 et 1942 furent peintes à l'huile sur des toiles de 71,1 x 55,9 cm et n'étaient jamais signées. Bon nombre de ces œuvres furent retouchées plus tard par Vaughn Bass à la demande de Dow. En modifiant ces images, l'éditeur espérait les remettre sur le marché. Peu de ces originaux d'Elvgren ont donc survécu, et la plupart de ceux repeints par Bass sont considérablement altérés. Lorsque ces œuvres furent publiées par Dow, avant et après retouches, elles portaient un cartouche indiquant le nom de l'artiste en lettres capitales en guise de signature.

La femme d'Elvgren mourut d'un cancer en 1966. L'artiste se remaria plus tard avec l'un de ses modèles, Marjorie Shuttleworth, avant de mourir à son tour d'un cancer en 1980.

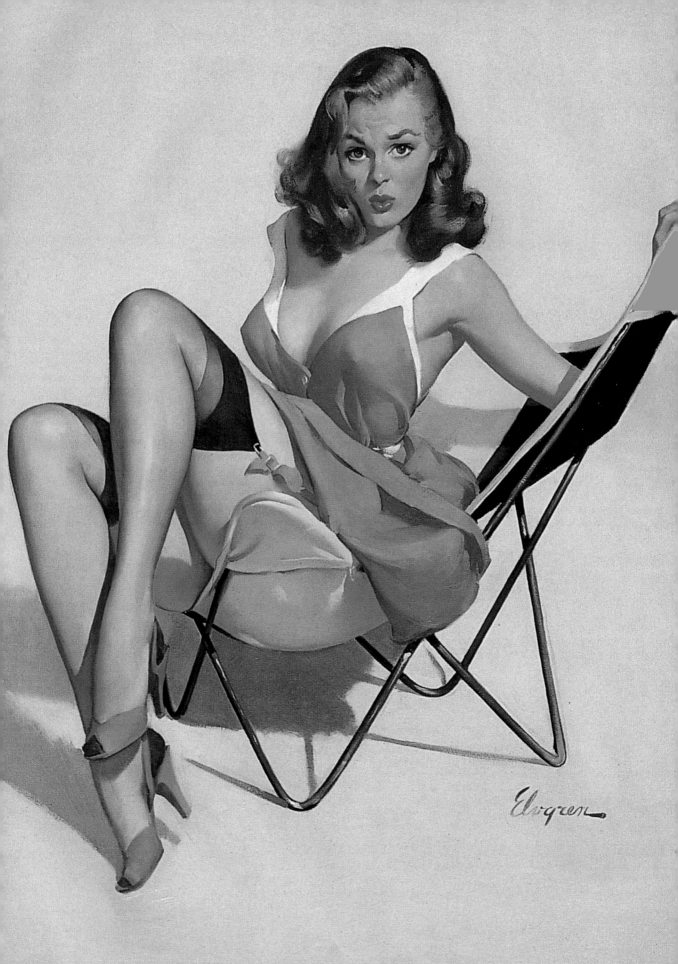

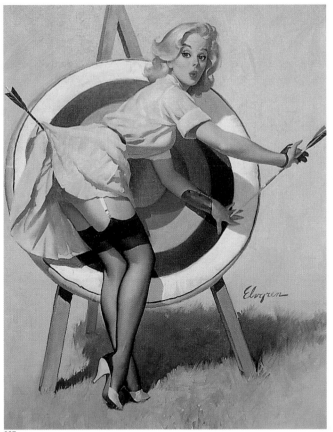

367

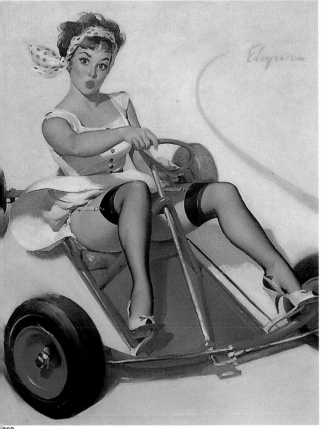

368

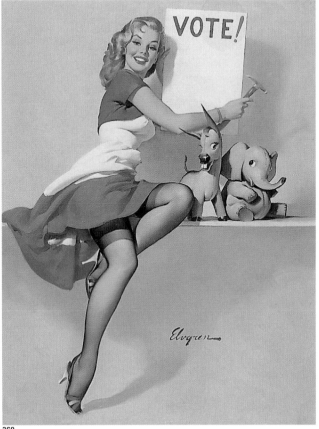

369

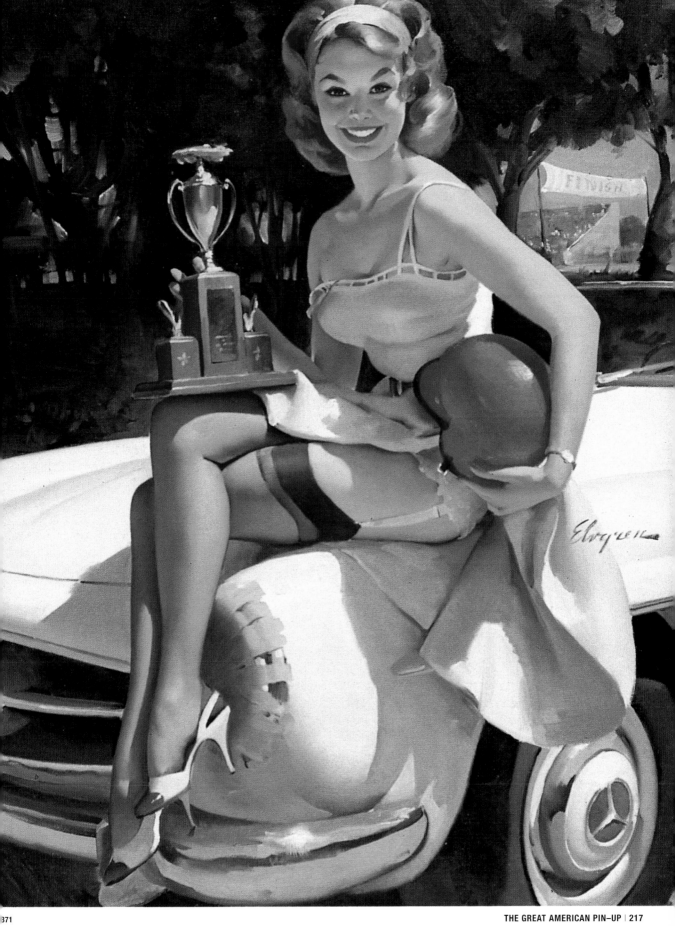

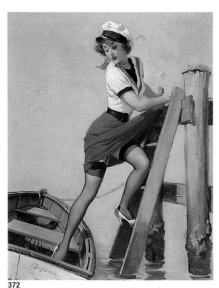

372

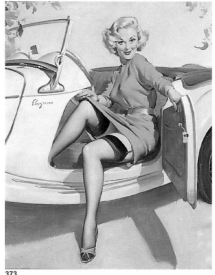

373

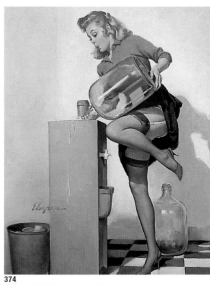

374

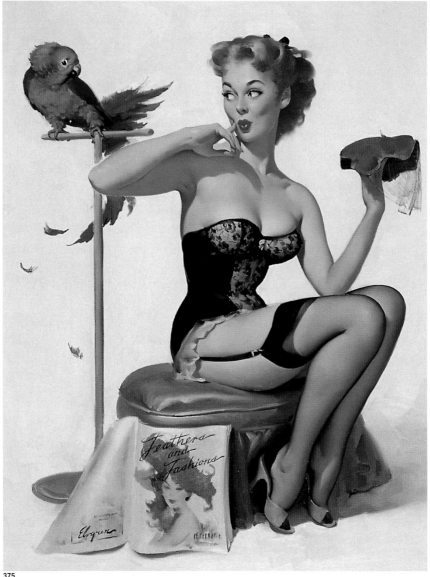

375

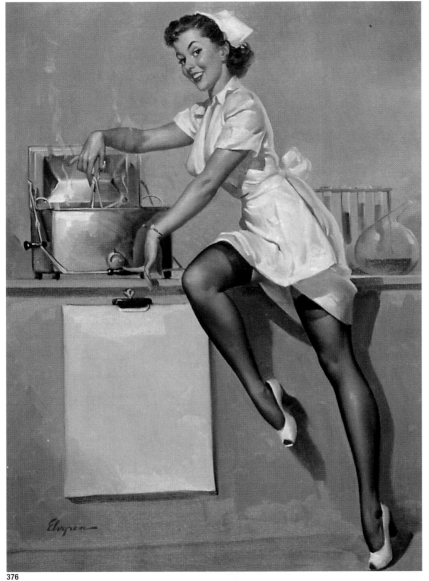

376

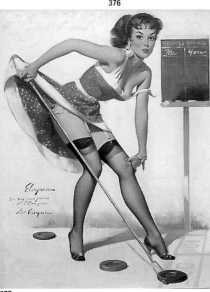

377

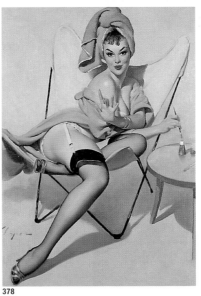

378

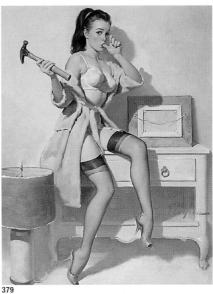

379

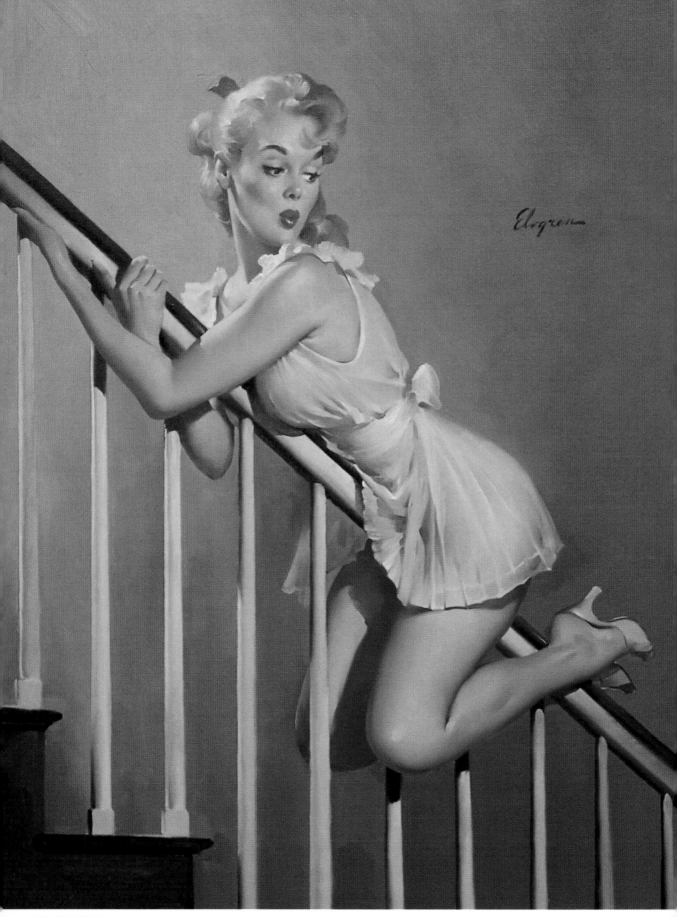

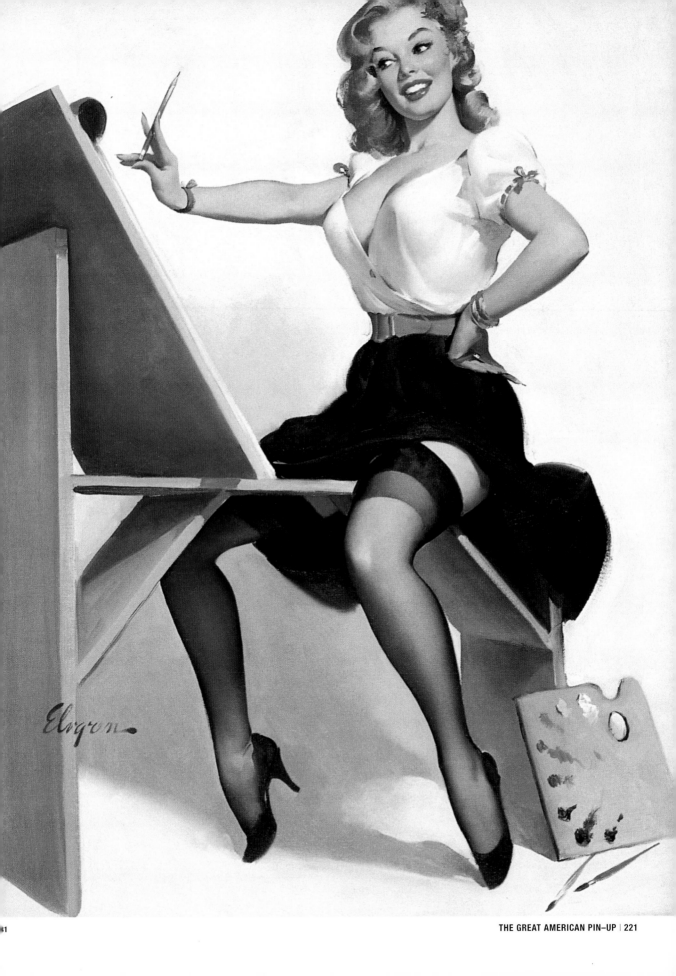

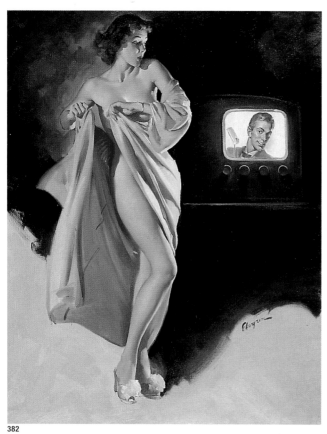

382

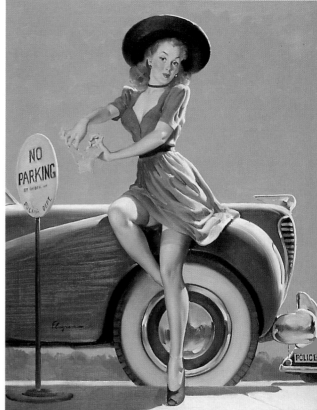

383

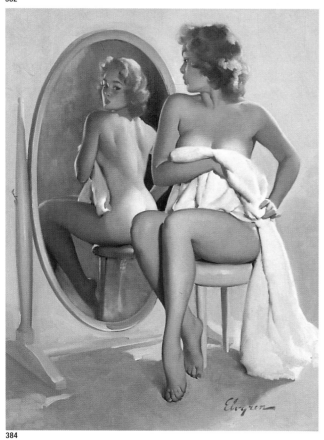

384

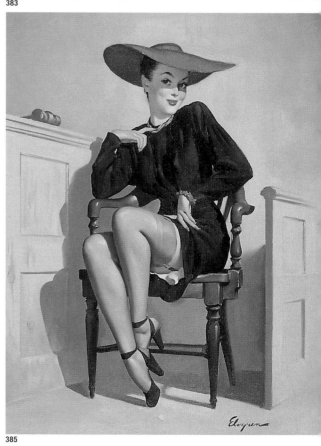

385

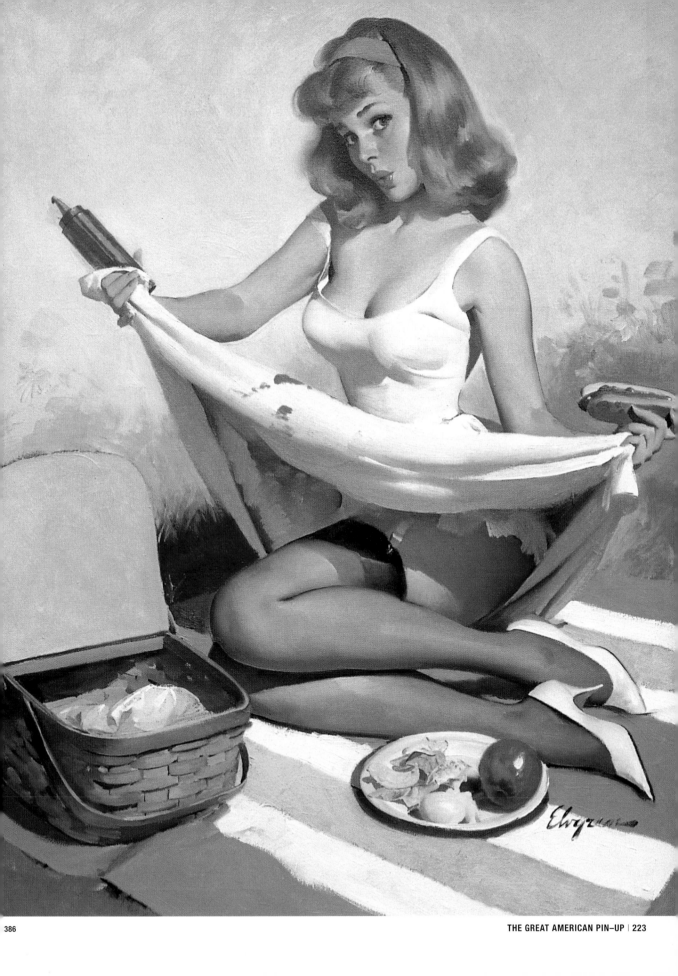

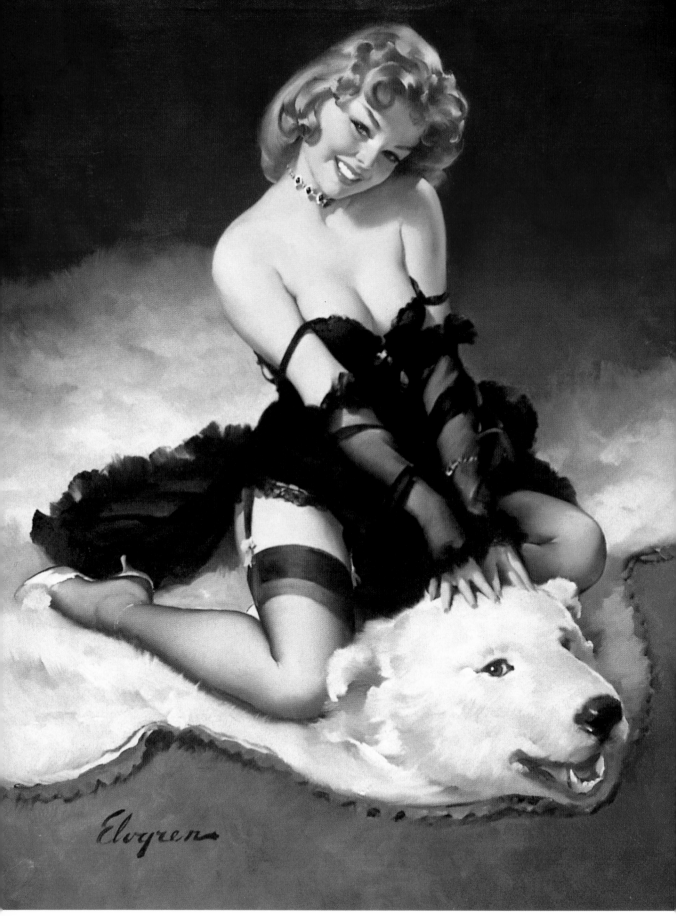

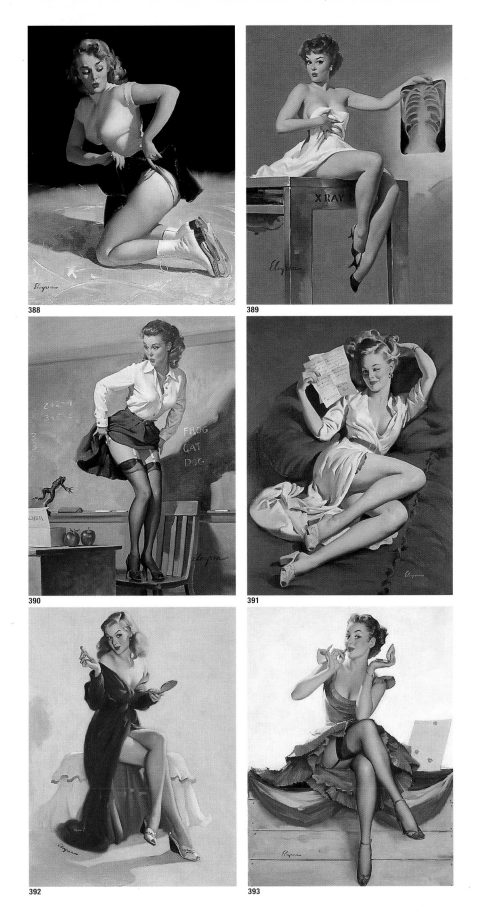

388

389

390

391

392

393

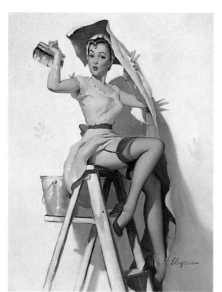

394

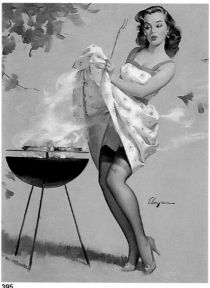

395

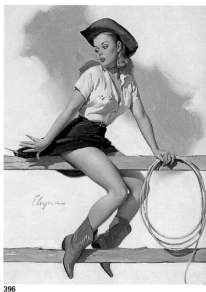

396

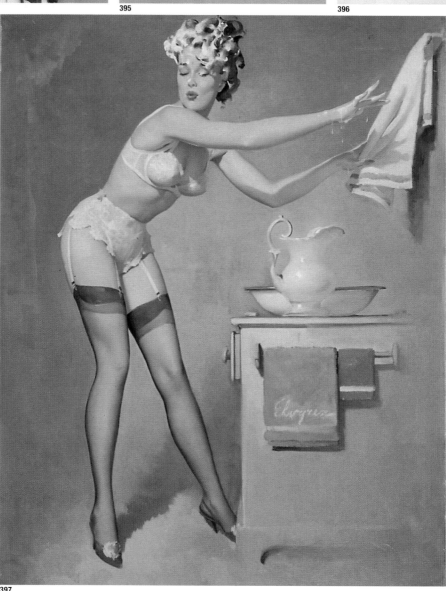

397

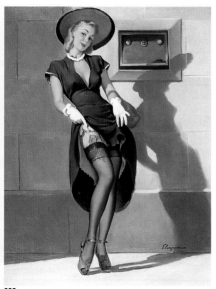

398

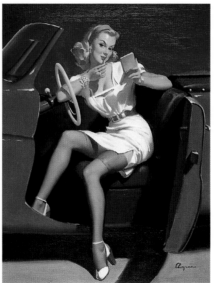

399

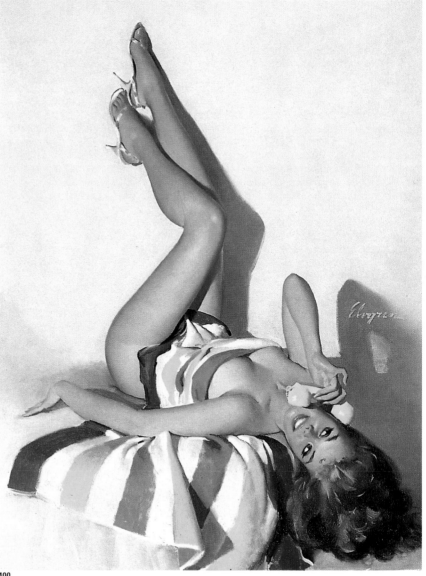

400

Merlin
Enabnit

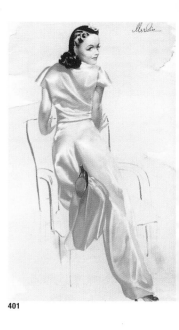

401

Enabnit was born in 1903 in a small town outside Des Moines, Iowa. He began his career as a window dresser at a Chicago department store, while taking courses at the Cummings School of Art. He first painted pin-ups in 1936 for the calendars of Louis F. Dow Company. About this time, he also worked for two years in England, finding much success there.

The Shaw-Barton Calendar Company became Enabnit's major publisher, using his pin-ups on advertising-specialty products as well as on calendars. Signing his work with his first name only, Enabnit produced a series of successful ads for Formfit, Jantzen Bathing Suits, and the White Owl Cigar Company. In the mid-1940s, he worked in Hollywood painting portraits of movie stars like Harold Lloyd and Virginia Mayo for publicity and promotional uses.

Known as the "Wizard of Color," Enabnit devised his own system of produc-

ing and using colors by drawing upon natural sources. He published *Nature's Basic Color Concept* in 1975 and spread the message expressed in that book through workshops, magazine and newspaper interviews, and television appearances.

Enabnit worked primarily in oils, in a large format (40 x 30 inches; 101.6 x 76.2 cm) and with a rich palette reminiscent of the Sundblom school's. He worked from photographs of his models, combining the best features of each to reach an ideal figure. A gregarious, warm personality and a devoted family man, Enabnit received an honorary doctorate from the Royal Society of the Arts in London in recognition of his talent. In 1969, he and his wife moved to Phoenix, Arizona, where he spent his time painting the colors of the Southwestern desert. Enabnit died in November 1979.

Merlin Enabnit wurde 1903 in einer Kleinstadt in der Nähe von Des Moines, Iowa, geboren. Er begann als Schaufensterdekorateur für ein Warenhaus in Chicago und nahm nebenbei Unterricht an der Cummings School of Art. Für die Kalender des Verlags Louis F. Dow Company malte er 1936 seine ersten Pin-ups. Ungefähr in diese Zeit fiel auch ein zweijähriger Arbeitsaufenthalt in England, der für Enabnit sehr fruchtbar war.

Der Verlag Shaw-Barton Calendar Company wurde Enabnits Hauptauftragge-ber. Seine Pin-ups, die er nur mit seinem Vornamen signierte, wurden im regulä-ren Kalenderbereich und bei der Werbung für Spezialprodukte eingesetzt. Enabnit schuf eine ganze Reihe erfolgreicher Anzeigen für Formfit, den Bademodenher-steller Jantzen Bathing Suits und die White Owl Cigar Company. Mitte der 40er Jahre arbeitete er in Hollywood und malte dort Porträts von Hollywoodgrößen wie Harold Lloyd und Virginia Mayo.

Merlin Enabnit war auch als „Wizard of Color" bekannt: Sein berühmter

Namensvetter Merlin war ein Zauberer (Wizard) aus der Artussage. Als „Hexen-meister der Farben" hatte er ein eigenes System zur Herstellung und Verwendung von Farben entwickelt, das auf natürlichen Stoffen basierte. Sein Buch Nature's Basic Color Concept *erschien 1975 und wurde im Fernsehen, in Zeitungen und Zeitschriften diskutiert.*

Enabnit arbeitete vorrangig in Öl auf großer Leinwand (102 x 76 cm) und mit einer kräftigen Farbpalette, die an die der Sundblom-Schule erinnerte. Arbeitsvorla-ge waren Fotografien seiner Modelle, und Enabnit verband dabei die Vorzüge der einzelnen Mädchen zu Idealfiguren. Er war ein geselliger, warmherziger Mensch, der seine Familie über alles liebte. Die Londoner Royal Society of the Arts verlieh ihm in Anerkennung seiner Leistungen einen Ehrendoktorhut. 1969 zog Enabnit mit seiner Frau nach Phoenix, Arizona, und die Wüstenlandschaften des Südwesten mit ihren ungewöhnlichen Farben wurden nun sein bevorzugtes Thema. Enabnit starb im November 1979.

Enabnit est né en 1903 dans une petite ville près de Des Moines, dans l'Iowa. Il commença sa carrière comme étalagiste dans un grand magasin de Chicago, tout en suivant des cours à la Cummings School of Art. Il réalisa ses premières peintures de pin up pour l'éditeur de calendriers Louis F. Dow en 1936. Il partit ensuite travailler pendant deux ans en Angleterre, où il rencontra un succès considérable.

L'éditeur Shaw-Barton devint bientôt son plus gros client, reproduisant ses pin up sur des calendriers et des gadgets publicitaires. Signant uniquement de son patronyme, Enabnit créa également une série d'images publicitaires pour Formfit, Jantzen Bathing Suits et la White Owl Cigar Company. Vers le milieu des années 40, il travailla à Hollywood, peignant des portraits de vedettes de cinéma telles que Harold Lloyd et Virginia Mayo.

Connu comme le «magicien de la couleur», Enabnit créait lui-même ses huiles à partir de produits naturels. En 1975, il publia *Nature's Basic Color Concept* («Les couleurs de base de la nature») et divulgua ses techniques à travers une série de conférences, d'articles et d'entretiens avec la presse écrite et télévisée.

Enabnit travaillait principalement à l'huile sur de grands formats (101,6 x 76,2 cm), avec une palette vivement colorée qui rappelle celle du cercle de Sundblom. Il peignait à partir de photos de ses modèles, conjuguant les meilleures qualités de chacune pour créer une image idéale. Aimant la compagnie et chaleureux, chef de famille dévoué, il fut nommé docteur honoris causa de la Royal Society of the Arts de Londres. En 1969, sa femme et lui s'installèrent à Phoenix, dans l'Arizona, où il se consacra à la peinture des paysages colorés du sud-ouest améri-cain. Il mourut en novembre 1979.

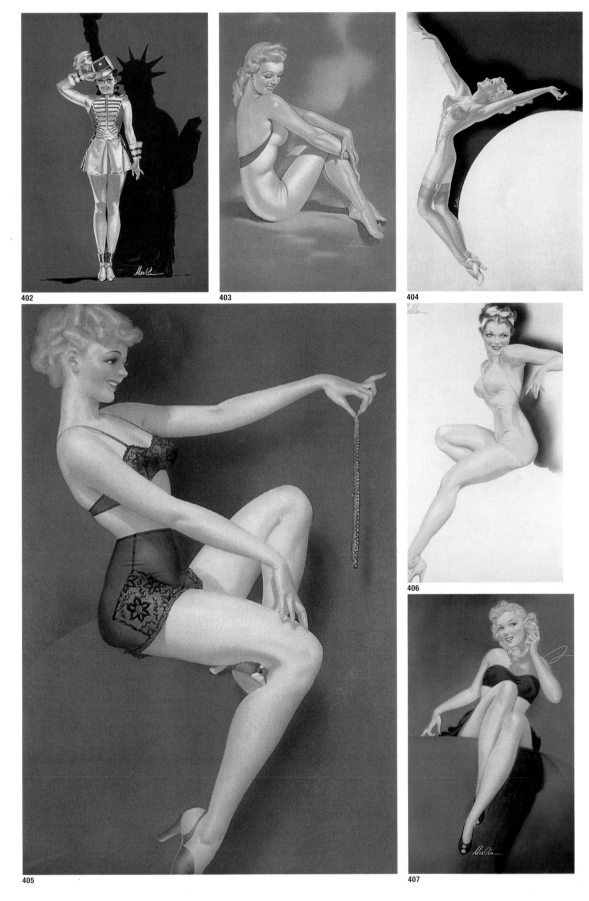

402

403

404

405

406

407

Jules Erbit

During the 1930s and 1940s, Erbit's pastel pin-up and glamour calendar subjects featured wholesome, all-American girls attired in conservative clothing. True examples of the girl-next-door, these sedate beauties lacked the strong sex appeal that marked the creations of so many of his contemporaries.

Erbit was born in Budapest and as a teenager illustrated for a magazine there before winning a state scholarship for study in Munich. He came to the United States in 1930, settling in New York and opening his first studio in Carnegie Hall. At the time, Erbit had five daughters, who often provided the inspiration for his glamour-girl calendar paintings.

In 1933, Erbit secured his first assignment from Brown and Bigelow, and he went on to work for them until 1945. Yet, wanting the widest possible exposure to the American public, he contracted with American Artists to represent him to other publishers as well. As a result, he worked for most of the top calendar houses in the United States, including Joseph C. Hoover and Sons, which hired him to paint more than a dozen glamour images for their Superior line. One of these, *Waiting For You* (figure 412) from 1939, became the best-selling of Erbit's "glamour girls." His most popular pin-up, *All-American Swinger* (figure 416), was published by another of Erbit's new clients, Oval and Koster. This girl in a one-piece bathing suit riding on a swing sold more than one million calendars.

Erbit also received many advertising commissions, the most well known being his outstanding magazine ads for Palmolive Soap in 1933. Erbit worked exclusively in pastel on heavy board measuring 40 x 30 inches (101.6 x 76.2 cm). He retired from the pin-up and glamour art business about 1950 to focus instead on portraiture and his now-grown family.

Während der 30er und 40er Jahre malte Jules Erbit Pin-ups und Glamourgirls für den Kalendermarkt. In Pastell ausgeführt, zeigten sie das amerikanische Mädel von nebenan. Seine Modelle waren typisch amerikanisch und zuweilen etwas hausbacken; ihnen fehlte der ordentliche Schuß Sex-Appeal.

Erbit wurde in Budapest geboren und zeichnete bereits als Teenager für ein dortiges Magazin. Mit einem staatlichen Stipendium ging er zum Studium nach München. 1930 siedelte er in die USA über und ließ sich in New York nieder. Zum damaligen Zeitpunkt war Erbit bereits Vater von fünf Töchtern, die ihn oft zu seinen Kalendermotiven inspirierten. 1933 erhielt Erbit seinen ersten Auftrag von Brown and Bigelow, für die er bis 1945 arbeitete. Er beauftragte die Agentur American Artists, ihn bei anderen Verlegern zu vertreten. Bald arbeitete er für die meisten der führenden Kalenderverlage des Landes, unter ihnen auch Joseph C. Hoover, die bei ihm mehr als ein Dutzend Glamourbilder in Auftrag gaben. Darunter war das bestverkaufte Glamour-Girl Erbits: Waiting For You (Abb. 412) von 1939. Sein bekanntestes Pin-up war American Swinger (Abb. 413), das von Oval and Koster veröffentlicht wurde. Mehr als eine Million Kalender mit diesem Bild wurden verkauft.

Erbit erhielt viele Anzeigenaufträge. Der bekannteste war seine Zeitschriftenanzeige für Palmolive-Seife aus dem Jahr 1933. Er arbeitete ausschließlich in Pastell auf festem Karton im Format 102 x 76 cm. Um 1950 herum zog sich Erbit aus dem Pin-up- und Glamourgeschäft zurück, um sich Porträtarbeiten und seiner Familie zu widmen.

Pendant les années 30 et 40, les pastels d'Erbit pour les calendriers de pin up étaient de jeunes Américaines bon chic bon genre, l'incarnation même de «la fille d'à côté», débordantes de santé mais dépourvues du puissant sex-appeal qui émanait des créations de ses confrères.

Né à Budapest, Erbit commença dès son adolescence à fournir des illustrations à un magazine hongrois avant de décrocher une bourse d'Etat pour aller étudier à Munich. Il arriva à New York en 1930 et ouvrit un atelier à Carnegie Hall. A l'époque, il était déjà père de cinq filles, qui lui servaient souvent d'inspiration pour ses beautés glamour.

En 1933, Erbit reçut sa première commande de Brown and Bigelow, avec lequel il travailla jusqu'à 1945. Parallèlement, il demanda à l'agence American Artists de le représenter auprès d'autres éditeurs. Il travailla ensuite pour la plupart des grands éditeurs de calendriers, dont Joseph C. Hoover qui lui commanda une douzaine de beautés glamour pour sa Superior Line. L'une d'elles, *Waiting for You* (illustration 412), fut un best-seller. Sa pin up la plus populaire, *All-American Swinger* (illustration 413), fut publiée par Oval and Koster, un autre de ses nouveaux clients. Cette jolie fille sur une balançoire fit vendre plus d'un million de calendriers.

Erbit réalisa également de nombreuses affiches publicitaires, la plus célèbre étant celle de Palmolive, qui parut dans les magazines en 1933. Erbit travaillait exclusivement au pastel sur d'épais cartons mesurant 101,6x76,2cm. Il cessa de peindre des pin up et des beautés glamour vers 1950 pour se consacrer au portrait et à sa nombreuse famille.

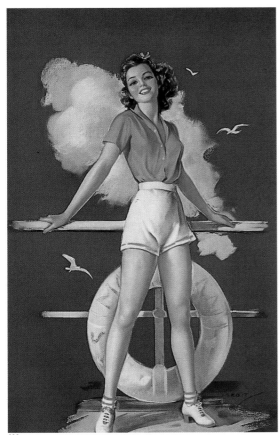

408

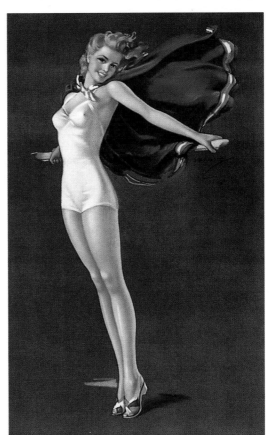

409

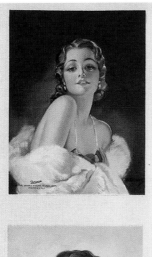

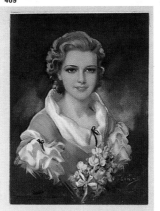

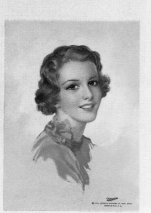

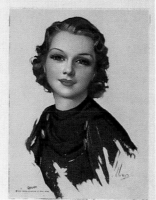

410

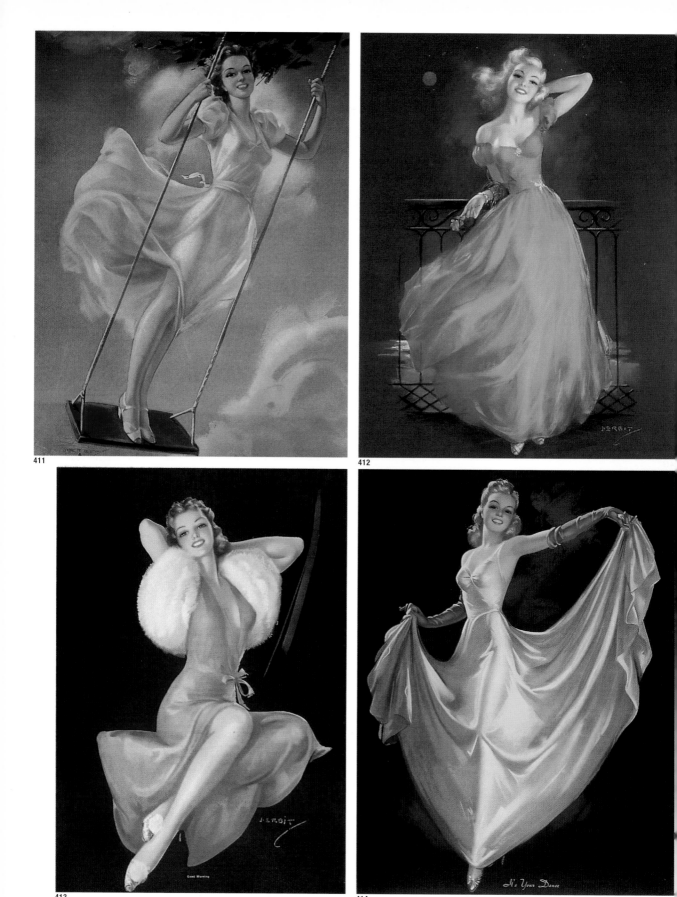

411

412

413

414

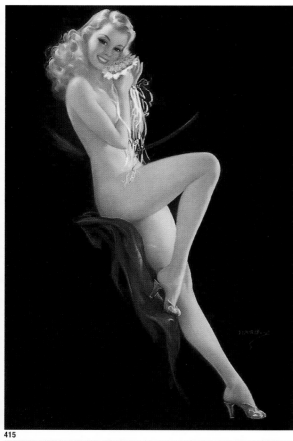

415

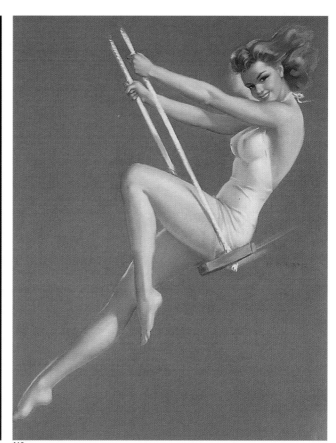

416

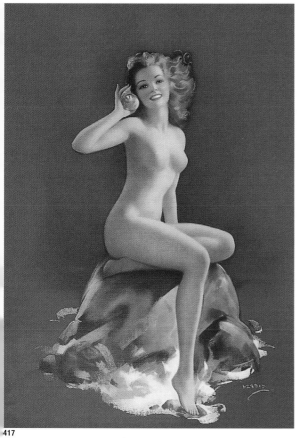

417

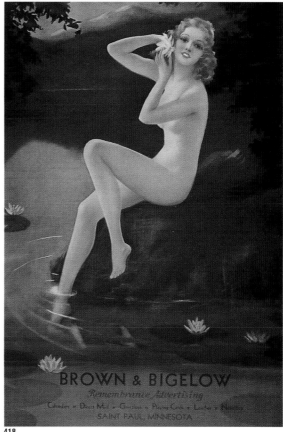

BROWN & BIGELOW
Remembrance Advertising
Calendars • Direct Mail • Greetings • Playing Cards • Leather • Novelties
SAINT PAUL, MINNESOTA

418

Art Frahm

Frahm devised this century's most famous series of pin-up images in his ten "panties falling down" works, created for the Joseph C. Hoover and Sons calendar company from 1950 to 1960 (figures 9, 430–438).

Born in 1907 in Chicago, Frahm studied with three great American illustrators, Andrew Loomis, Frederic Mitzen, and Ben Stahl, at the Art Institute there. His first jobs after art school were at a printing and engraving company, where he learned much about graphic art and printing techniques, and at Zipprodt, Inc., where he soon became the firm's number one "idea" man in the billboard advertising division. In 1935, Frahm opened his own studio in Chicago and went on to sell pin-ups to several prominent calendar companies. Four years later, he and his wife Ruth had a daughter, Diana, who subsequently became the model for his classic Coppertone billboards.

Frahm also provided pin-ups to the Kemper-Thomas Calendar Company (1939) and Hoover's Superior line (1941). After spending the war years stationed in Italy with the army, he and his family moved in 1954 to Asheville, North Carolina, where he painted many of his finest pin-ups. About 1955, he began a series of full-length glamour paintings of evening-gowned women posed in the moonlight next to elaborate fountains or wrought-iron gates.

Frahm contributed a number of fabulous Sundblom-like paintings to Coca-Cola's national advertising campaign under the slogan "Work Refreshed." Especially notable was his blacksmith being handed a bottle of Coke, which was made in 1950 into a life-size display for grocery stores throughout the United States. Frahm also created the classic smiling Quaker on the Quaker Oats package, along with other memorable images for Crane Plumbing, Schlitz Beer, and Libby foods. Two of his calendar series from the early 1960s were extremely successful: one depicting the adventures of a group of fun-loving hoboes traveling across America; the other, showing policemen instructing children on various aspects of safety.

Frahm generally worked in oil on canvas sized from approximately 30 x 24 inches (76.2 x 61 cm) to 36 x 24 inches (91.4 x 61 cm). He occasionally used heavy illustration board instead of canvas, and he varied his full-length pin-ups with head-and-shoulder glamour art. He died at Fountain Inn, North Carolina, in 1981.

Es war Art Frahm, der sich mit seinen zehn Bildern „Panties falling down" („Wenn die Höschen fallen") die berühmteste Pin-up-Serie dieses Jahrhunderts ausdachte. Sie entstand zwischen 1950 und 1960 für den Kalenderverlag Joseph C. Hoover and Sons (Abb. 9, 430 bis 438).

Frahm wurde 1907 in Chicago geboren und studierte an dem dortigen Art Institute bei drei der berühmtesten amerikanischen Illustratoren: Andrew Loomis, Frederic Mitzen und Ben Stahl. Seine ersten Jobs nach der Kunsthochschule waren bei einer Druck- und Gravuranstalt, wo er viel über Grafik und Drucktechniken lernte und bei Zipprodt, wo er binnen kurzem zum Ideenlieferanten Nummer 1

für die großflächigen Billboards der Anzeigenabteilung wurde. 1935 eröffnete Frahm in Chicago ein eigenes Studio und verkaufte Pin-ups an führende Kalenderverlage. Vier Jahre später bekamen Art und seine Frau Ruth eine Tochter, Diana. Sie stand ihm später bei seinen zu Klassikern gewordenen großformatigen Anzeigen für die Firma Coppertone Modell.

Für den Kalenderverlag Kemper-Thomas lieferte Frahm 1939 die Pin-ups; für Hoover's Superior Line im darauffolgenden Jahr. Während des Krieges war Art Frahm in Italien stationiert. 1954 zog er mit seiner Familie nach Asheville in North Carolina und malte dort viele seiner besten Pin-ups. Um 1955 begann er mit einer

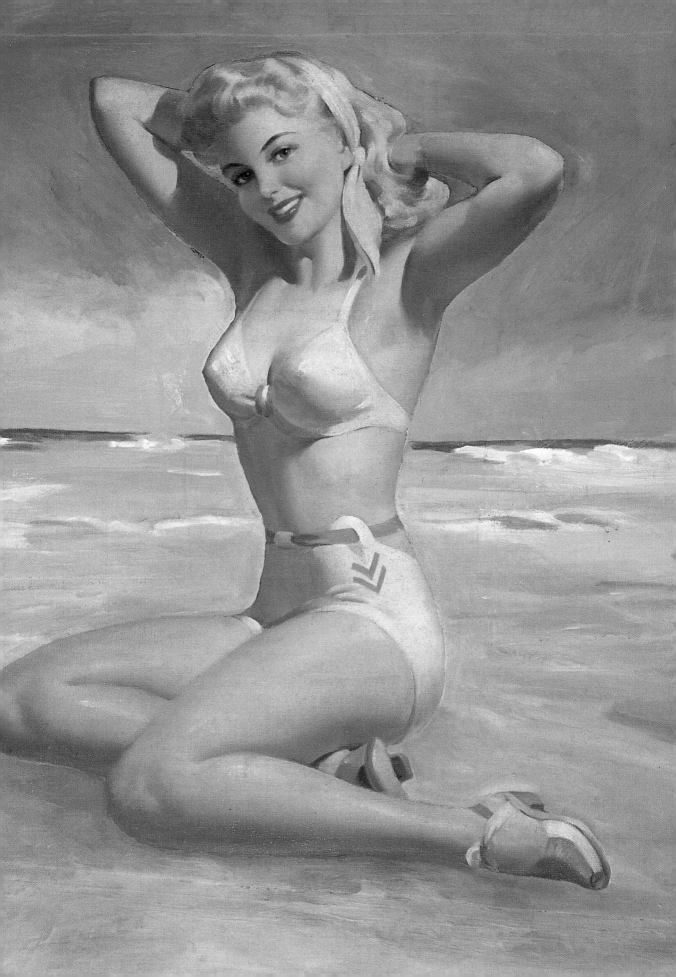

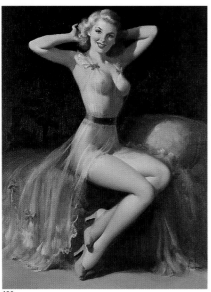

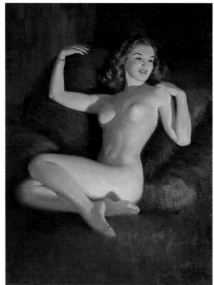

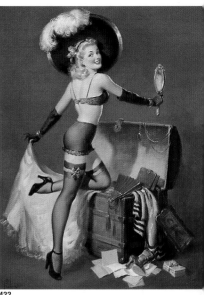

420

421

422

Serie von lebensgroßen Glamourgemälden: Frauen in Abendroben, die im Mond-licht vor kunstvoll gefertigten Brunnen oder schmiedeeisernen Gittern posierten.

Für die im ganzen Land laufende Anzeigenkampagne von Coca-Cola lieferte Frahm unter dem Slogan „Work Refreshed" („Erfrischt zurück an die Arbeit") eine Reihe von Bildern im Sundblom-Stil. Besonders bemerkenswert war das Motiv eines Schmieds, dem eine Flasche Coca-Cola gereicht wird. 1950 wurde es als Display in Lebensgröße für Lebensmittelläden in den Vereinigten Staaten produ-ziert. Weiterhin entwarf Frahm für die Verpackung eines Frühstücksmüslis namens „Quaker Oats" den lächelnden Quäker, einen weiteren Klassiker; unver-

gessen sind auch die Motive, die er für Crane Plumbing, Schlitz Beer und Libby Foods schuf. Zwei seiner Kalenderserien aus den frühen 60er Jahren waren äußerst erfolgreich: Eine schildert die Abenteuer einer Truppe von lebenslustigen Landstreichern, die quer durch die Staaten ziehen, die andere die Arbeit von Poli-zisten, die Kinder auf verschiedene Sicherheitsprobleme aufmerksam machen.

Frahm arbeitete meist in Öl auf Leinwand (meist zwischen 76 x 61 cm und 91 x 61 cm). Ab und zu verwendete er auch festen Karton anstelle der Leinwand und variierte lebensgroße Pin-ups mit Brustbildern. Er starb 1981 bei Fountain Inn in North Carolina.

Frahm conçut la série de pin up la plus célèbre du siècle avec ses dix images de femmes perdant leur culotte réalisées pour les calendriers de Joseph C. Hoover entre 1950 et 1960 (illustrations 9, 430–438).

Né en 1907 à Chicago, Frahm étudia à l'Art Institute de sa ville natale où il eut pour professeurs trois grands illustrateurs: Andrew Loomis, Frederic Mitzen et Ben Stahl. Après ses études, il travailla un temps pour une imprimerie, où il apprit beaucoup sur l'art graphique et les techniques d'impression, puis pour la firme Zipprodt, où il devint bientôt le premier «créatif» du bureau chargé de la concep-tion des panneaux publicitaires. En 1935, Frahm ouvrit son propre atelier à Chica-go et commença à fournir des pin up à plusieurs grands éditeurs de calendriers. Quatre ans plus tard, sa femme Ruth mit au monde une fille, Diana, qui devint le modèle de ses affiches publicitaires pour les produits solaires Coppertone.

Frahm réalisa également des pin up pour les calendriers de Kemper-Thomas (1939) et ceux de la collection «Superior» de Hoover (1941). Après avoir servi en Italie pendant la guerre, il s'installa en 1954 à Asheville, en Caroline du Nord, où il peignit certaines de ses plus belles pin up. Vers 1955, il commença une série de

beautés glamour en robe du soir, posant au clair de lune près d'élégantes fontai-nes et grilles en fer forgé.

Frahm créa un certain nombre de superbes images «à la Sundblom» pour la campagne de Coca-Cola intitulée «Travaillez au frais». Parmi elles, un remarqua-ble portrait de forgeron à qui on tend une bouteille de Coca-Cola, qui fut reprodui grandeur nature en 1950 dans toutes les épiceries des Etats-Unis. Frahm créa également le célèbre quaker jovial des boîtes de céréales Quaker Oats, ainsi que d'autres images mémorables pour Crane Plumbing, Schlitz Beer et Libby Foods. Au début des années 60, deux de ses séries pour calendriers remportèrent un grand succès: l'une montrait les aventures de joyeux vagabonds traversant les Etats-Unis, l'autre des agents de police enseignant à des enfants diverses règles de sécurité.

Frahm travaillait généralement à l'huile sur des toiles mesurant entre 76,2 x 61 cm et 91,4 x 61 cm. Il remplaçait parfois la toile par un épais carton à dessin et peignait en alternance des pin up en pied et des portraits de beautés glamour. Il est mort à Fountain Inn, en Caroline du Nord, en 1981.

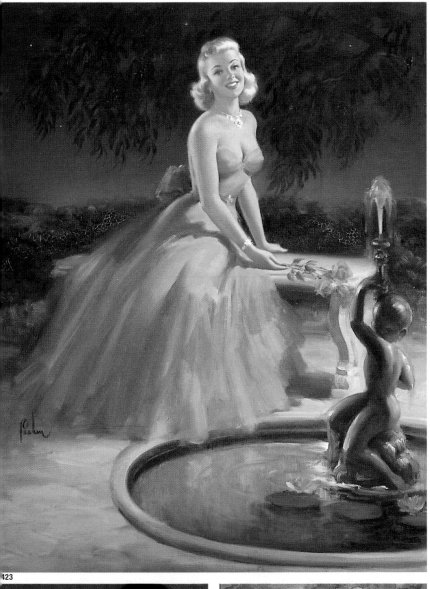

423

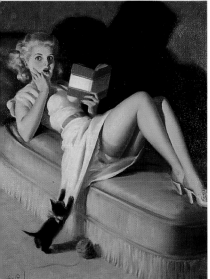

424

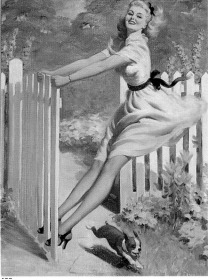

425

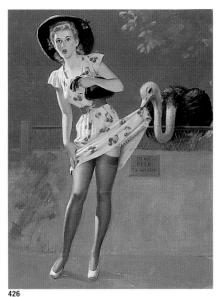

426

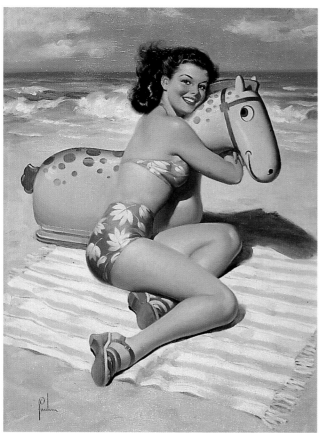

427

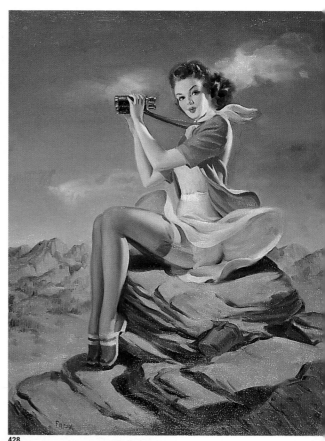

428

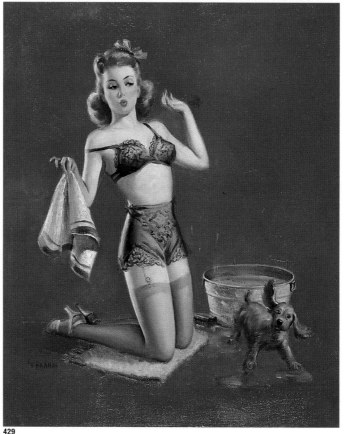

429

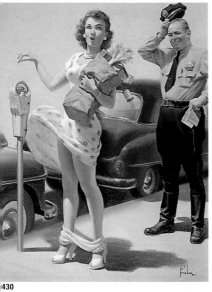

430

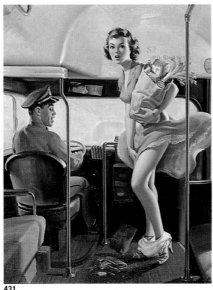

431

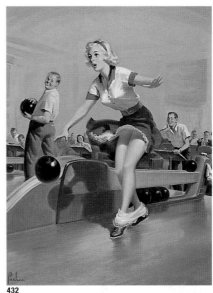

432

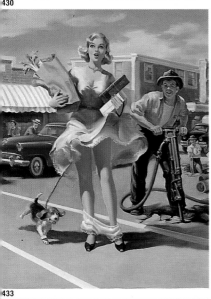

433

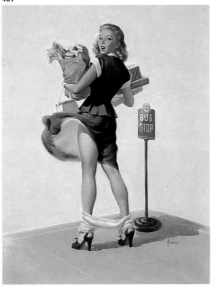

434

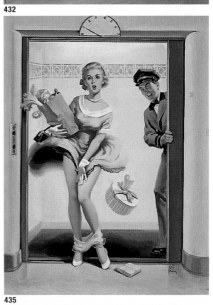

435

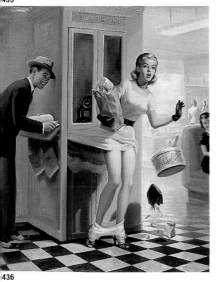

436

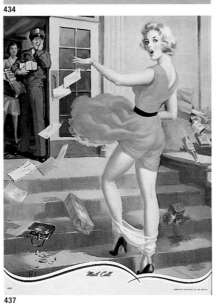

437

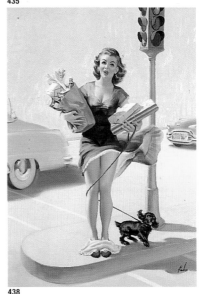

438

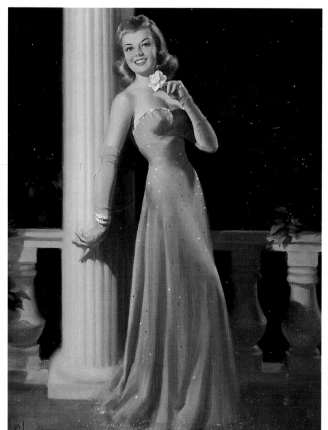

439

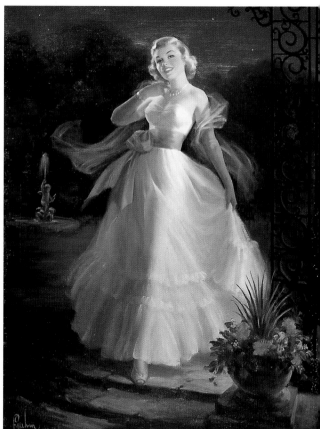

440

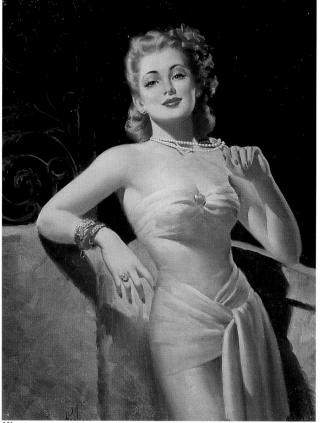

441

442 ▷

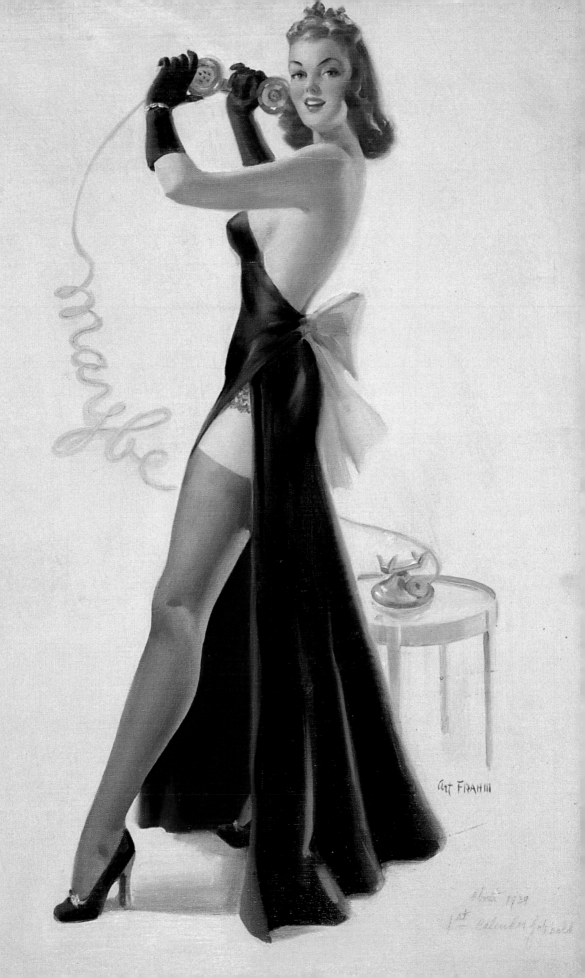

Pearl Frush

As one of the top three women pin-up and glamour artists in the calendar art market at mid-century, Pearl Frush readily commanded the respect of the art directors, publishers, sales managers, and printers with whom she worked. Yet because she worked primarily in watercolor and gouache, her originals could rarely be reproduced in large enough quantities for her to achieve widespread popular acclaim. A close examination of her work, however, reveals a talent for meticulously realistic images comparable to those of the far better known Alberto Vargas.

Frush was born in Iowa and moved to the Gulf Coast of Mississippi as a child. She began drawing as soon as she could hold a crayon in her hand; when she was ready for formal studies, she enrolled in art instruction courses in New Orleans. After additional training in Philadelphia and New York, Frush joined her family in Chicago, where she studied at the Chicago Art Institute under Charles Schroeder.

Frush opened her first studio in Chicago in the early 1940s. While she accepted freelance jobs, she also worked at the studio of Sundblom, Johnson, and White. By 1943, she had become one of the Gerlach-Barklow Calendar Company's most important artists, creating a string of popular series: Liberty

Belles, Sweethearts of Sports, Girls of Glamour, and Glamour round the Clock. 1947, her Aquatour series, a dozen pin-ups all located in aquatic settings, broke all sales records. By 1955, Frush had become a "hot property" in the calendar-publishing business, so it was only natural that Brown and Bigelow should seek her out. A year later, the firm published its first Frush pin-up, a horizontal picture especially done for "hangers" (large wall calendars with one print attached).

A vigorous and attractive woman, Frush enjoyed sailing, canoeing, swimming, and playing tennis, and she would often incorporate sport themes into her work. Portrayed in a crisp, straightforward style, her pin-ups and glamour paintings effectively captured the spirit of young womanhood. Her girls were wholesome and fresh, shapely but never overtly sexual. Somehow they were able to look both like movie stars and like the girls-next-door.

Frush's original paintings were executed on illustration board that usually measured about 20 x 15 inches (50.8 x 38.1 cm). She sometimes used her married name, "Mann," in signing her paintings. Her renderings were always done with great precision, capturing every nuance of a subject in an almost Photo-Realist technique.

Pearl Frush gehörte in den 50er Jahren zu den drei erfolgreichsten weiblichen Pin-up- und Glamourkünstlerinnen für den Kunstkalendermarkt. Bei den Art Directors, Verlegern, Verkaufsleitern und Druckern, mit denen sie zusammenarbeitete, genoß sie Respekt. Da sie vorwiegend Aquarelle und Gouachen malte, konnten ihre Originalvorlagen allerdings nur selten in den Auflagen reproduziert werden, die für einen durchschlagenden Erfolg beim Publikum notwendig waren. Bei genauerer Betrachtung zeigen ihre Arbeiten jedoch eine Begabung für peinlich genaue, realistische Bilder, die sogar den Vergleich mit denen des weitaus bekannteren Alberto Vargas durchaus standhalten.

Frush wurde in Iowa geboren und zog als Kind an die Golfküste von Mississippi. Sie begann zu zeichnen, sobald sie einen Stift in der Hand halten konnte. Als sie alt genug für eine offizielle Ausbildung war, belegte Frush in New Orleans Zeichenkurse. Sie setzte ihre Ausbildung in Philadelphia und New York fort und zog dann zu ihrer Familie nach Chicago. Am Chicagoer Art Institute studierte sie unter Charles Schroeder.

In den frühen 40er Jahren eröffnete sie in Chicago ihr erstes Studio. Sie arbeitete freiberuflich, aber auch im Studio von Sundblom, Johnson und White. 1943 war Frush zu einer der wichtigsten Künstlerinnen der Gerlach-Barklow Calendar

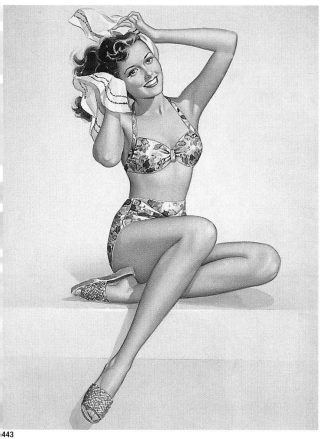

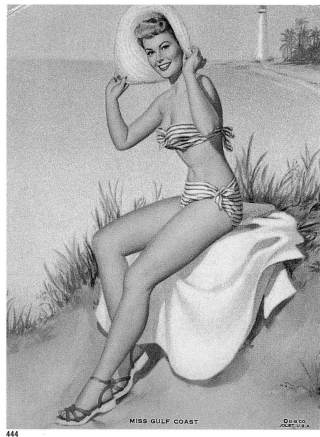

443

444

MISS GULF COAST

© G-B CO.
JOLIET, U.S.A.

Company geworden, für die sie eine ganze Reihe erfolgreicher Serien schuf: Liberty Belles, Sweethearts of Sports, Girls of Glamour *und* Glamour round the Clock. *1947 brach ihre Aquatour-Serie, ein Dutzend Pin-ups, die sich im Wasser tummelten, sämtliche Verkaufsrekorde. 1955 war Frush ein „hot property" geworden, ein Verkaufsschlager im Kalenderbereich. So war es nur logisch, daß sie von Brown and Bigelow angesprochen wurde. Ein Jahr später veröffentlichte die Firma ihren ersten Pin-up, ein Querformat (speziell zum Aufhängen), wie es für große Wandkalender mit einem Motiv verwendet wurde.*

Frush war eine dynamische und attraktive Frau, die gerne segelte, Kanu fuhr, schwamm und Tennis spielte. Sportliche Themen flossen oft in ihre Arbeiten ein. Ihre Pin-ups und Glamourbilder fingen den Stil der jungen Frauen wirkungsvoll ein. Frush gab ihren Pin-up- Girls ein unverbrauchtes, frisches Äußeres, eine gute Figur, doch nicht zuviel Sex. Sie waren eine gelungene Mischung aus Filmstar und Mädchen von nebenan.

Frushs Originale wurden auf Karton ausgeführt, meistens in Aquarell oder Gouachen im Format 58 x 38 cm. Manchmal signierte sie ihre Arbeiten mit ihrem Ehenamen „Mann". Sie zeichnete stets mit großer Präzision und konnte Nuancen eines Themas fast so einfangen, als arbeite sie fotorealistisch.

L'une des trois plus grandes femmes peintres de pin up et d'art glamour travaillant pour les calendriers au milieu du siècle, Pearl Frush s'attira rapidement le respect des directeurs artistiques, des éditeurs, des directeurs de ventes et des imprimeurs. Malheureusement, parce qu'elle travaillait principalement à la gouache et à l'aquarelle, ses originaux pouvaient rarement être reproduits en nombre suffisant pour lui permettre d'accéder à une grande notoriété publique. Cependant, lorsqu'on examine ses œuvres de près, on est frappé par la qualité de ces images méticuleusement réalistes, comparables à celles de son confrère beaucoup plus célèbre, Alberto Vargas.

Née dans l'Iowa, Frush grandit en grande partie dans le golfe du Mississippi. Elle commença à dessiner dès qu'elle fut en âge de tenir un crayon. Plus tard, elle suivit des cours de dessin à La Nouvelle-Orléans. Après d'autres études à Philadelphie et à New York, elle rejoignit sa famille à Chicago, où elle suivit des cours à l'Art Institute sous la direction de Charles Schroeder.

Frush ouvrit son premier atelier à Chicago au début des années 40. Tout en acceptant des commandes en free-lance, elle travaillait régulièrement pour l'atelier de Sundblom, Johnson et White. En 1943, elle était devenue l'une des artistes les plus importantes de Gerlach-Barklow, réalisant une succession de séries à

grand succès: Liberty Belles, Sweethearts of Sports, Girls of Glamour et Glamour around the Clock. En 1947, sa série Aquatour, une douzaine de pin up «aquatiques», battit tous les records de ventes. En1955, Frush était devenue un nom très rentable pour ses employeurs. Il était donc tout naturel que Brown and Bigelow tente de la débaucher: un an plus tard, cet éditeur publiait sa première pin up de Frush, une image horizontale conçue spécialement pour un calendrier-cintre (grand calendrier mural d'une seule page).

Belle et débordante d'énergie, Frush aimait la voile, le canoë, la natation, le tennis, et incorporait souvent un thème sportif dans ses œuvres. Ses pin up et ses beautés glamour avaient un côté franc et volontaire qui saisissait bien l'esprit énergique de la jeune Américaine d'alors. Ses filles étaient fraîches et pleines de santé, avec des formes généreuses sans être ouvertement érotiques. Elles parvenaient à ressembler à des vedettes de cinéma tout en restant des Mademoiselle Tout-le-monde.

Les œuvres originales de Frush étaient réalisées sur des cartons à dessin mesurant généralement 50,8 x 38,1 cm. L'artiste travaillait principalement à l'aquarelle et à la gouache. Elle signait parfois de son nom de femme mariée «Mann». Son style était toujours d'une grande précision, restituant les moindres nuances du sujet avec une netteté quasi photographique.

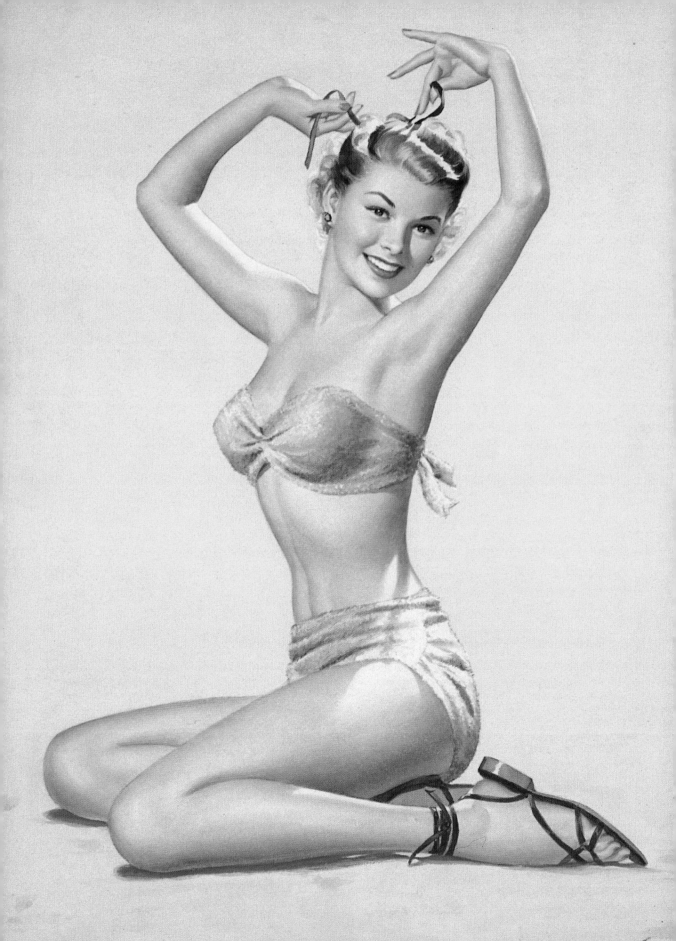

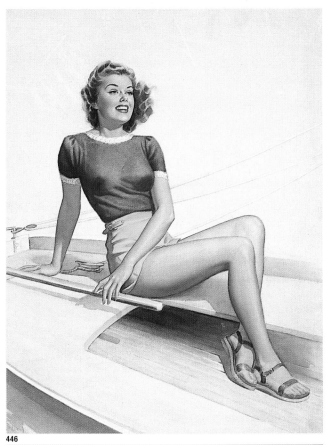

446

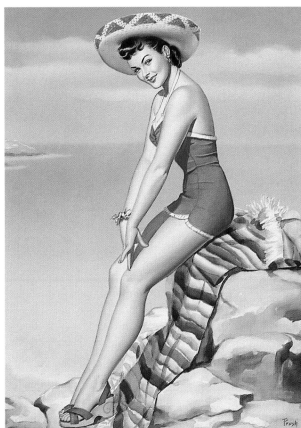

447

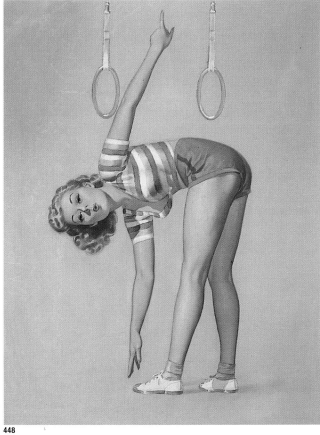

448

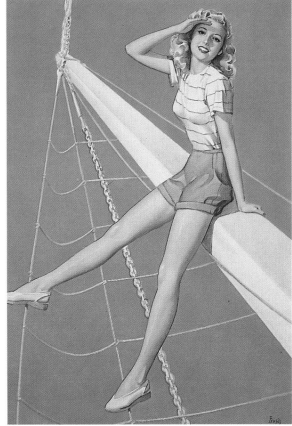

449

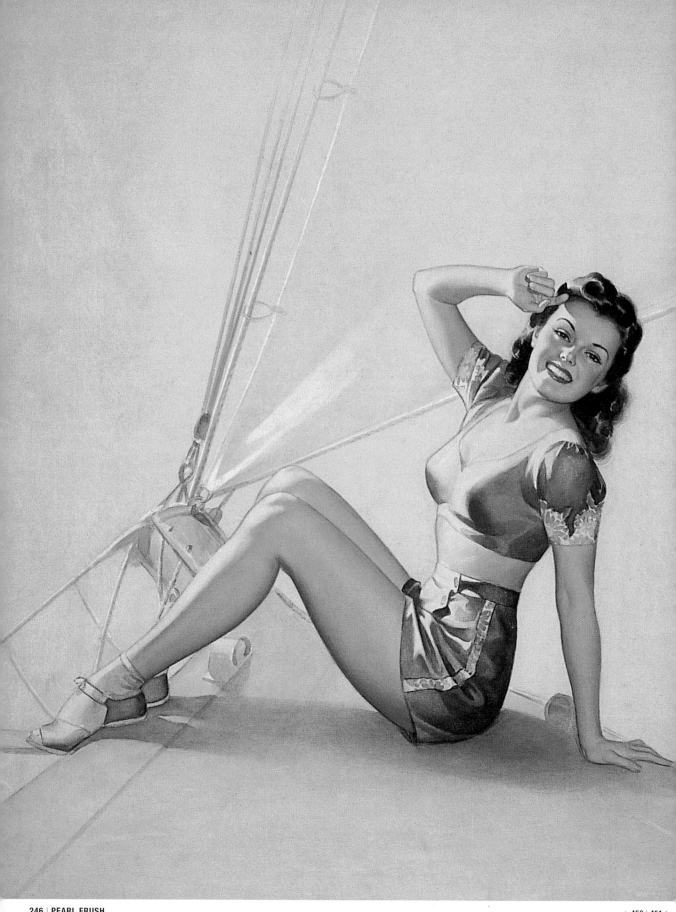

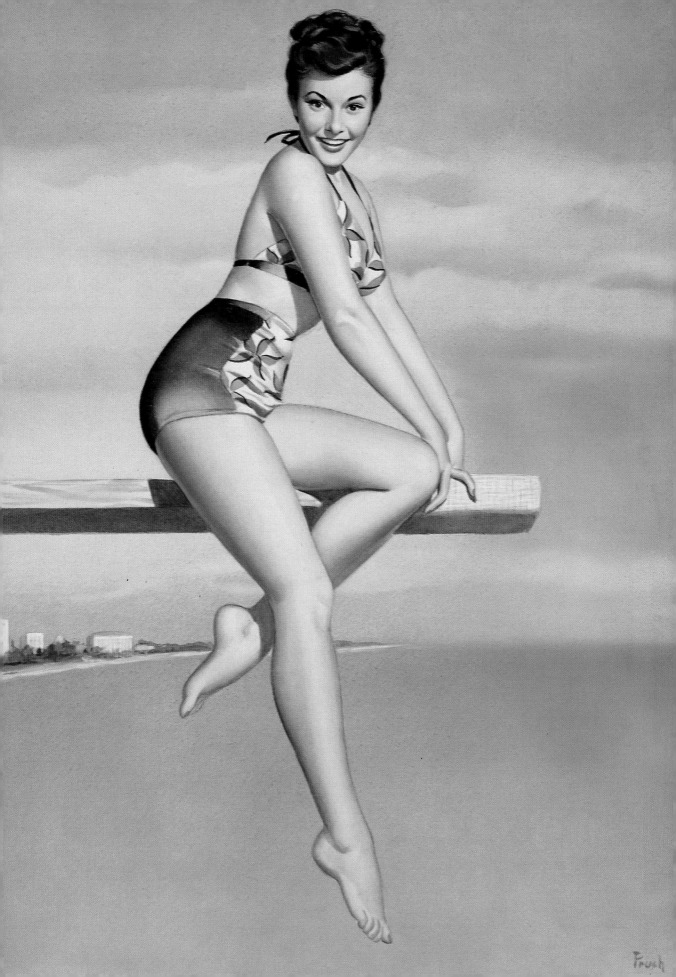

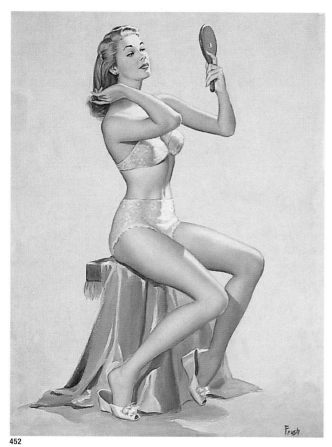

452

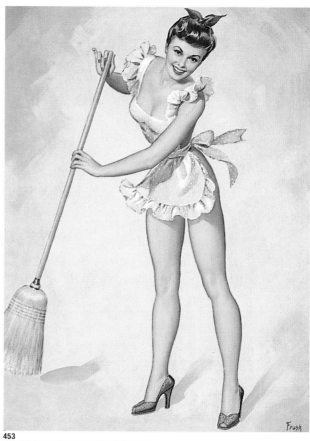

453

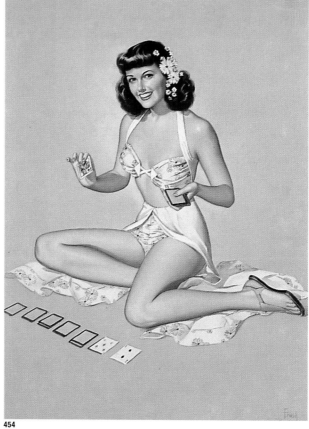

454

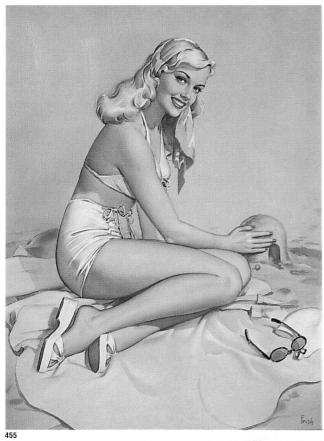

455

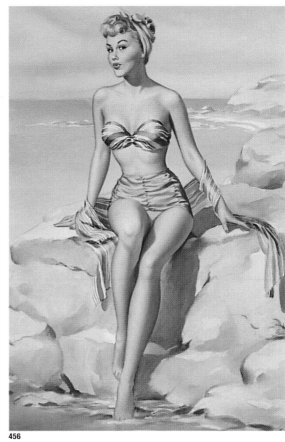

456

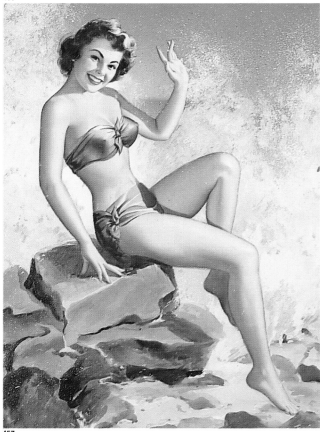

457

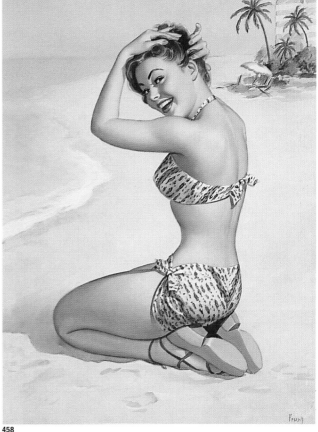

458

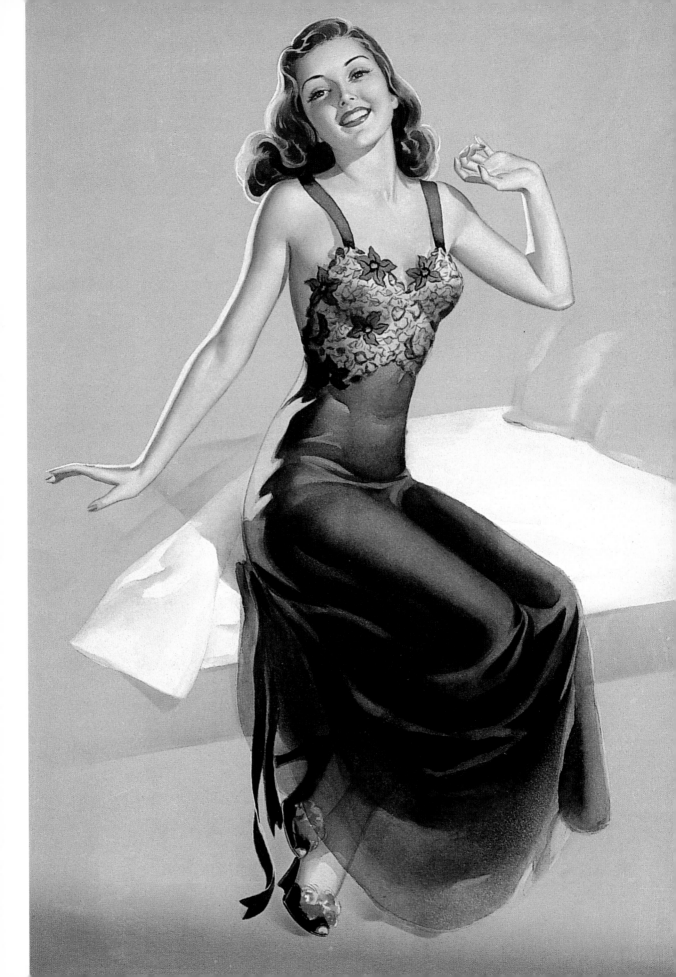

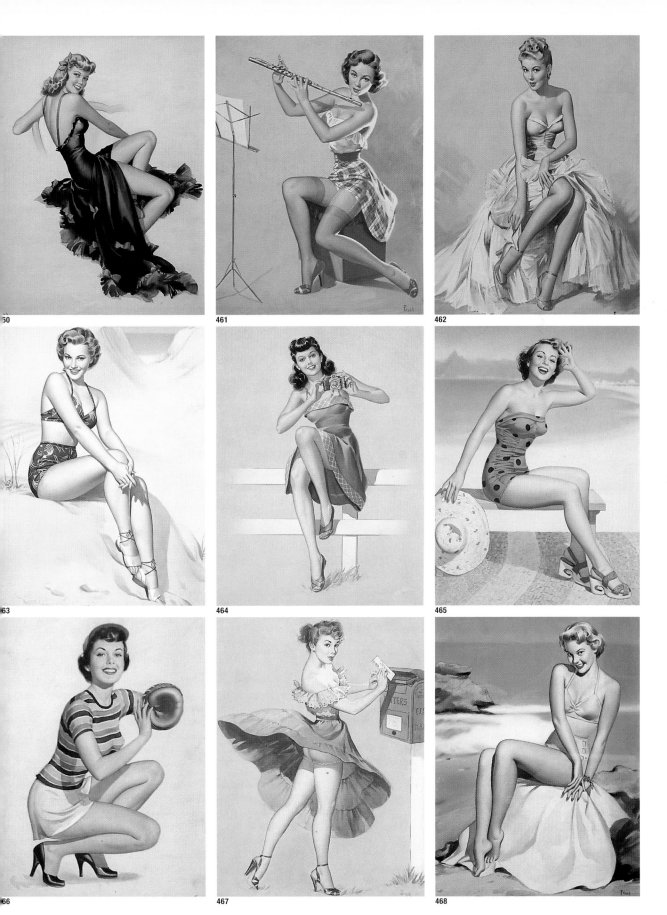

460

461

462

463

464

465

466

467

468

Q. Wilson Hammell

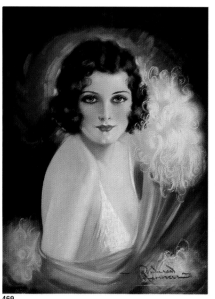

469

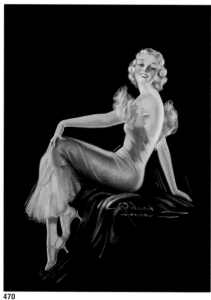

470

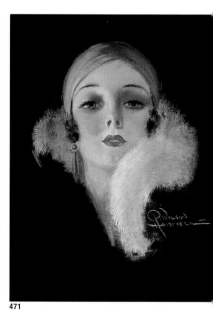

471

Hammell was one of the finest pastel pin-up and glamour artists working from the late 1920s through the 1930s. He has often been compared to Rolf Armstrong and Billy DeVorss, because the three utilized colors in the same way. Hammell worked in a large format and exclusively in pastels; his subjects ranged from full-length pin-ups to head-and-shoulder glamour subjects.

Hammell lived in Red Bank, New Jersey, but maintained a studio in New York City at Twenty-five West Forty-fifth Street. Known to his friends and fellow illustrators as Will, he was elected as an artist member to the Society of Illus-

trators on July 27, 1922. During the late 1920s, he painted a half dozen pin-up and glamour subjects for the prestigious Thomas D. Murphy Calendar Company.

During the 1930s, Hammell's name appeared on several million pin-up and glamour prints published by the Joseph C. Hoover and Sons calendar company in Philadelphia. Besides such sexy subjects, he also painted a series of sentimental themes for the calendar-art market; a number of these paintings were reproduced in the 1930s on picture puzzles for adults and children.

Hammell galt als einer der besten Pin-up- und Glamourkünstler vom Ende der 20er bis Ende der 30er Jahre. Er wurde oft mit Rolf Armstrong und Billy DeVorss verglichen, denn alle drei Maler setzten Farbe auf die gleiche Weise ein. Hammell arbeitete großformatig und ausschließlich in Pastell; seine Motive erstreckten sich vom Ganzkörper-Pin-up bis zum Glamourporträt und -brustbild.

Hammell lebte in Red Bank in New Jersey, und hatte in der Nr. 25 auf der 45. Straße West in New York sein Studio. Am 27. Juli 1922 wurde der von seinen Freunden und Kollegen Will genannte Hammell zum künstlerischen Mitglied der

Society of Illustrators gewählt. Während der späten 20er Jahre malte er ein halbe Dutzend Pin-ups und Glamourporträts für den Prestigeverlag Thomas D. Murphy.

In den 30er Jahren tauchte der Name Hammell auf mehreren Millionen von Pin-up- und Glamourdrucken des in Philadelphia ansässigen Kalenderverlags Joseph C. Hoover and Sons auf. Seine Motive konnten sexy sein oder auch romantisch-verkitscht. Eine Reihe seiner Bilder für den Kalendermarkt wurden in den 30er Jahren als Bildpuzzles für Erwachsene und Kinder reproduziert.

Entre la fin des années 20 et les années 30, Hammell fut l'un des meilleurs pastellistes de pin up. On le compare souvent à Rolf Armstrong et à Billy DeVorss, tous trois appliquant les couleurs de la même façon. Hammell travaillait sur grands formats et exclusivement au pastel. Ses sujets allaient de la pin up en pied aux portraits glamour.

Hammell vivait à Red Bank, dans le New Jersey, mais il avait un atelier à New York au vingt-cinq de la Quarante-cinquième rue. Baptisé Will par ses amis et ses confrères, il fut élu membre de la Society of Illustrators le 27 juillet 1922. Vers la

fin des années 20, il peignit une demi-douzaine de pin up et de beautés glamour pour le prestigieux éditeur de calendriers Thomas D. Murphy.

Pendant les années 30, la signature de Hammell parut sur plusieurs millions de reproductions de pin up et d'art glamour publiées dans les calendriers de Joseph C. Hoover and Sons de Philadelphie. Outre ces sujets sexy, il peignit une série d'images romantiques pour le marché des calendriers artistiques. Un grand nombre de ses œuvres furent reproduites dans les années 30 sur des puzzles pour adultes et pour enfants.

Mabel Rollins Harris

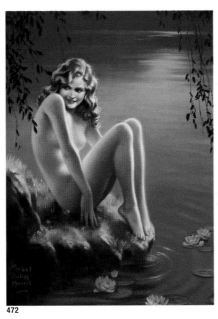

472

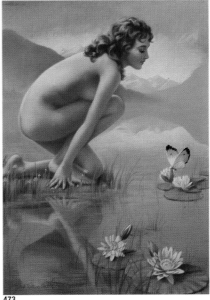

473

From the late 1920s until the end of the 1930s, Harris's exquisite pastels were among the most admired in the calendar-art business. Many of her great Art Deco pin-ups effectively expressed the magic and mystery inherent in the romantic themes that were so popular during the era. She was particularly known for spectacular nudes like *Golden Dawn* (1935; figure 473) and *Storm Queen* (1938; figure 474), which were kept in the catalogue of the Joseph C. Hoover and Sons calendar company for seven consecutive years.

Rollins's three pin-ups for the Thomas D. Murphy Company during the late 1920s aroused the admiration of Rolf Armstrong, who told the firm's art director that he envied the brilliant glow and softness of her finished pastels. Of her pin-ups during the 1930s for the Gerlach-Barklow Calendar Company, the most successful was another nude, seated in the moonlight on a rock surrounded by deep blue water (1930).

Harris also did calendar work for Brown and Bigelow, starting in 1933 with a commission for a sentimental subject entitled *Blue Heaven*. She continued to work on such non-pin-up themes, especially for Hoover, where her series depicting young girls in idyllic gardens was a great success. Her original paintings for such images were also executed in pastels, on stretched canvas; regardless of the subject matter, her paintings averaged 28 x 22 inches (71.1 x 55.9 cm).

Because of the special softness of Harris's pastels, her work was extremely popular in the mainstream illustration and publishing community. Major magazines like *The Saturday Evening Post* commissioned her to paint pastel images for their covers. For many years, she did freelance work for the Rustcraft and Norcross greeting card companies, specializing in religious and Christmas subjects.

Undoubtedly the finest female illustrator of the Art Deco era, Harris had her pin-up nudes and glamour art reproduced and published on millions of calendars. Her sentimental non-pin-up subjects enjoyed an equally long life span, being published in many forms, including puzzles, fans, and decorations on candy boxes.

Von den späten 20er Jahren bis zum Ende der 30er Jahre zählten die exquisiten Pastelle von Mabel Rollins Harris zu den Kalenderpublikationen, die sich großer Bewunderung erfreuten. Viele ihrer bedeutenden Art deco Pin-ups verkörperten höchst wirkungsvoll die Magie und das Mysteriöse der in dieser Zeit so beliebten romantischen Themen. Sie war besonders für atemberaubende Akte wie Golden Dawn *(Abb. 473) und* Storm Queen *(Abb. 474) bekannt, die im Katalog der Joseph C. Hoover and Sons Calendar Company sieben Jahre hintereinander aufgelistet waren.*

*Rolf Armstrong erzählte dem Art Director der Thomas D. Murphy Company, wie sehr er Rollins um das strahlende Leuchten und die Weichheit ihrer Pastellarbeiten beneidete. In den 30er Jahren malte sie Pin-ups für den Gerlach-Barklow Kalen-*derverlag. *Ihr erfolgreichstes Bild war dort ein weiterer Akt, ein auf einem Felsen hingestreckter Körper, vom Mondlicht beschienen und von tiefen dunklen Wassern umspült (1930).*

Harris illustrierte ebenfalls Kalenderblätter für Brown and Bigelow. Ihr erster Auftrag aus dem Jahr 1933 war ein etwas kitschiges Motiv namens Blue Heaven. *Sie arbeitete auch außerhalb des Pin-up-Bereichs, besonders für den Hoover Verlag. Dort wurde ihre Serie mit kleinen Mädchen in beschaulichen Gärten ein großer Erfolg. Die Originalvorlagen für solche Bilder wurden in Pastell auf Leinwand ausgeführt. Normalerweise arbeitete Harris themenunabhängig im Format 71 x 55 cm.*

Dank ihrer so besonders weichen Pastelle waren die Bilder von Harris sehr beliebt. Bedeutende Magazine wie The Saturday Evening Post *beauftragten sie mit*

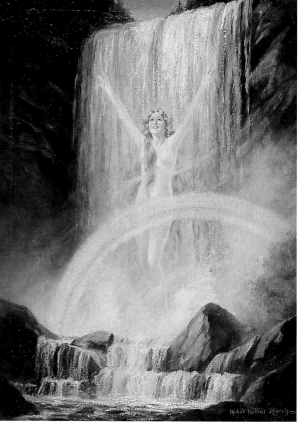

der Gestaltung der Titelseiten. Über viele Jahre hinweg lieferte sie als freiberufliche Mitarbeiterin Rustcraft und Norcross, beide Verleger von Grußkarten, religiöse und weihnachtliche Motive.

Sie war unbestritten die beste Illustratorin des Art deco. Ihre Pin-up-Akte und ihre Glamourmotive wurden millionenfach in Kalendern reproduziert. Ihr anderes Sujet, das Romantisch-verkitschte, erfreute sich gleichfalls dauernder Beliebtheit und wurde auf verschiedenste Weise veröffentlicht, beispielsweise als Aufdruck von Fächern oder Bonbonnieren und in Form von Puzzles.

De la fin des années 20 à la fin des années 30, les charmants pastels de Harris furent parmi les plus prisés du marché des calendriers. Un grand nombre de ses pin up Art déco dégageaient une aura magique et mystérieuse typique de l'imagerie romantique de l'époque. Harris était particulièrement connue pour ses nus spectaculaires comme *Golden Dawn* (1935; illustration 473) et *Storm Queen* (1938; illustration 474), qui restèrent dans le catalogue des calendriers de Joseph C. Hoover and Sons sept années de suite.

Les trois pin up réalisées par Harris pour Thomas D. Murphy à la fin des années 20 suscitèrent l'admiration de Rolf Armstrong, qui adorait le lustre brillant et la douceur des pastels de Harris. De toutes les pin up dessinées par Harris pendant les années 30 pour les calendriers de Gerlach-Barklow, la plus vendue fut un autre nu, assis sur un rocher au bord de l'eau au clair de lune (1930).

Harris travailla également pour Brown and Bigelow, commençant en 1933 avec une commande pour un sujet romantique intitulé *Blue Heaven*. Elle continua à travailler dans cette même veine, notamment pour Hoover, pour qui elle réalisa une série de pastels de jeunes filles dans des jardins idylliques qui connut un grand succès. Quel que soit le sujet, elle travaillait toujours sur des toiles tendues de 71,1 x 55,9 cm.

La douceur des pastels de Harris convenait bien à la presse populaire. De grands magazines comme *The Saturday Evening Post* commandèrent des couvertures. Pendant de longues années, l'artiste travailla également en free-lance pour les cartes de vœux de Rustcraft et Norcross, peignant des images de Noël et des thèmes religieux.

Sans doute la plus grande illustratrice de la période Art déco, Harris vit ses pin up et ses beautés glamour publiées dans des millions de calendriers. Ses images romantiques connurent une longévité tout aussi remarquable et furent reproduites sur de nombreux supports, dont des puzzles, des éventails et des boîtes de confiseries.

474

475

Cardwell S. Higgins

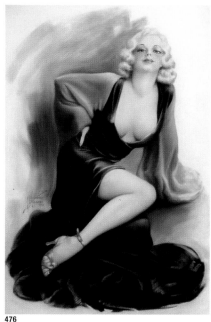

476

In 1927, two young artists joined the art department of Paramount Pictures in New York City: Alberto Vargas and Cardwell Higgins, who were to become good friends and artistic colleagues. Higgins had previously studied at the National Academy of Design, under George Bridgman and Ivan Olinsky, and at the Art Students League, under Harvey Dunn and Dean Cornwell. These four mentors greatly influenced the development of his career.

From 1932 to 1942, Higgins created highly stylized Art Deco pin-ups for the front covers of magazines like *Esquire, Film Fun, Screen Humor* (figure 482), *Silk Stocking Stories* (figures 476, 483, and 485), *Gayety* (figure 477), and *Sweetheart Stories*. A highlight of his advertising work came in 1937, when his painting for Palisades Park was made into a special billboard for Times Square (figures 480 and 481). This full-length portrayal of a long-legged pin-up girl in a bikini was such a success that the Park commissioned another Higgins work the next year (figures 478 and 479).

About the same time, Captain Eddie Rickenbacker hired Higgins to create a logo for Eastern Airlines that would "stand the test of time"; the artist responded with a design that would identify Eastern for the next forty years. In 1939, the New York World's Fair commissioned Higgins to design and paint the front cover for their *Railroads on Parade* brochure. Between 1937 and 1942, he also taught art at the Bloomfield Art League and the Fawcett School of Fine and Industrial Art in New Jersey. Besides all this work, he still found the time to create many illustrations with romantic themes for mainstream magazines.

The early years of World War II were the busiest of Higgins's career. He did a series of pin-up covers for leading detective magazines; he designed and painted two books of cutout dolls featuring Lana Turner and Carmen Miranda; and he painted his first front covers for Time-Life's *Omnibook* magazine, starting with a portrait of Winston Churchill and his cabinet. Higgins's single most famous work was his World War II poster for the USO depicting a WAC walking arm in arm with a soldier and a sailor, more than a million copies of which were distributed in the United States and overseas during the war.

Higgins was born in 1902, lived most of his life in West Nyack, New York, and died in 1983 in Hollywood, Florida. During World War II, he was an instructor in aviation camouflage in the Air Force's Corps of Engineers. He worked for ten years after the war as the art director of the Sears Roebuck catalogue and then retired.

1927 verzeichnete die künstlerische Abteilung von Paramount Pictures in New York zwei Neuzugänge: die jungen Künstler Alberto Vargas und Cardwell Higgins. Die beiden Kollegen sollten enge Freunde werden. Higgins hatte vorher an der National Academy of Design unter George Bridgman und Ivan Olinsky sowie an der Art Students League unter Harvey Dunn und Dean Cornwell studiert.

Zwischen 1932 und 1942 schuf er hochstilisierte Art deco Pin-ups für Cover von Esquire, Film Fun, Screen Humor *(Abb. 482),* Silk Stocking Stories *(Abb. 476, 483 und 485),* Gayety *(Abb. 477) und* Sweetheart Stories. *Ein Höhepunkt seiner Arbeit im Anzeigenbereich war sein Bild für den Palisades Park, das 1937 als Motiv für eine große Anzeigenwand am Times Square verwendet wurde (Abb. 480 und 481). Sein Motiv – ein lebensgroßes Porträt eines langbeinigen Pin-up-Girls im Bikini – war so erfolgreich, daß der Park im nächsten Jahr um einen neuen Higgins nachsuchte (Abb. 478 und 479).*

Ungefähr zur gleichen Zeit beauftragte ihn Eddie Rickenbacker mit dem Entwurf eines Logos für die Fluglinie Eastern Airlines, das „sich ändernden Moden und Zeiten standhalten sollte". Das Ergebnis war ein Design, welches Eastern Airlines für die nächsten 40 Jahre repräsentieren sollte. 1939 vergab die New Yorker Weltausstellung die Covergestaltung ihrer Broschüre Railroads on Parade *an Higgins, der sie vom Entwurf bis zur Realisierung betreute. Zwischen 1937 und 1942 unterrichtete*

er nebenbei Kunst an der Bloomfield Art League und der Fawcett School of Fine and Industrial Art in New Jersey. Trotz dieses Arbeitspensums fand er noch Zeit, für die populären Zeitschriften viele „romantische" Illustrationen zu malen.

Die ersten Jahre des Zweiten Weltkriegs waren für Higgins die geschäftigsten. Für Detektivmagazine entwarf er Pin-up-Cover; er zeichnete zwei Bücher mit Puppen zum Ausschneiden – in diesem Falle waren die „Puppen" Lana Turner und Carmen Miranda; und er schuf erste Cover für das Magazin Omnibook *aus dem Time-Life Verlag, beginnend mit einem Porträt von Winston Churchill und seinem Kabinett. Sein bekanntestes Bild ist ein Poster aus dem Zweiten Weltkrieg für die United Service Organisation, die unter anderem für die Truppenbetreuung zuständig war. Es zeigte ein Mitglied des Women's Army Corps, untergehakt bei einem Matrosen und einem Infanteristen. Über eine Million dieser Poster wurden während des Krieges in den Vereinigten Staaten und Europa in Umlauf gebracht.*

1902 geboren, verbrachte Higgins die meiste Zeit seines Lebens in West Nyack im Bundesstaat New York. 1983 starb er in Hollywood, Florida. Während des Zweiten Weltkriegs war er Ausbilder in der Luftwaffentarnung beim Ingenieurskorps der Air Force. Nach Kriegsende leitete Higgins zehn Jahre lang die Art Direction des vom Versandhaus Sears Roebuck herausgegebenen Katalogs, bevor er sich aus dem Berufsleben zurückzog.

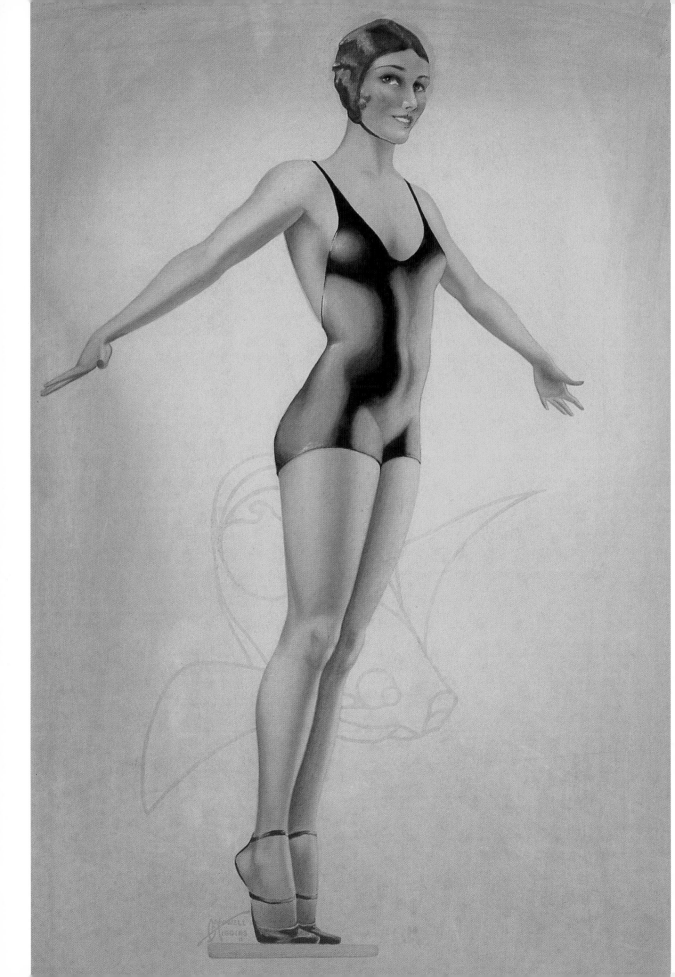

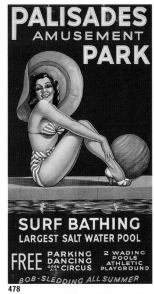

478

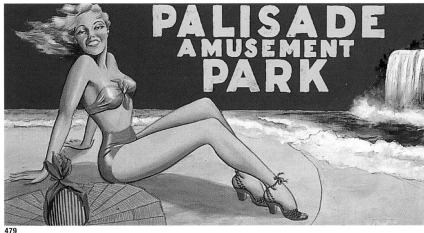

479

480

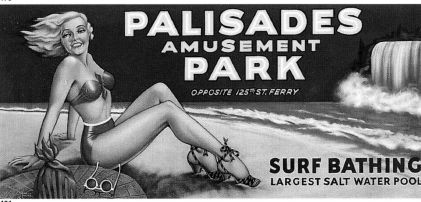

481

1927, deux jeunes artistes entrèrent au département artistique des studios Paramount de New York: Alberto Vargas et Cardwell Higgins, qui allaient devenir collègues et amis. Auparavant, Higgins avait étudié à la National Academy of Design, sous la direction de George Bridgman et d'Ivan Olinsky, puis à l'Art Students League, où il eut Harvey Dunn et Dean Cornwell comme professeurs. Ces quatre mentors influencèrent considérablement l'évolution de sa carrière.

De 1932 à 1942, Higgins dessina des pin up Art déco très stylisées pour des couvertures de magazine: *Esquire, Film Fun, Screen Humor* (illustration 482), *Silk Stocking Stories* (illustrations 476, 483 et 485), *Gayety* (illustration 477) et *Sweetheart Stories*. En 1937, il connut l'un des moments forts de sa carrière quand il réalisa une affiche géante pour le parc d'attractions Palisade destinée à Times Square (illustrations 480 et 481). Sa pin up aux longues jambes et en bikini eut un tel succès que le parc lui en commanda une autre l'année suivante (illustrations 478 et 479).

Vers la même époque, le capitaine Eddie Rickenbacker commanda à Higgins un logo pour Eastern Airlines capable de «résister à l'épreuve du temps». L'artiste répondit avec une image qui allait symboliser la compagnie aérienne pendant quarante ans. En 1939, les organisateurs de l'Exposition universelle de New York lui demandèrent une illustration pour la couverture de la brochure de *Railroads on Parade*. Entre 1937 et 1942, il enseigna également à la Blooms-field Art League et à la Fawcett School of Fine and Industrial Art dans le New Jersey. En dépit de cette énorme charge de travail, il trouva encore le temps de créer de nombreuses illustrations romantiques pour de nombreux magazines populaires.

Les premières années de la Deuxième Guerre mondiale furent particulièrement chargées pour Higgins. Il réalisa une série de pin up pour les couvertures de magazines d'enquêtes policières; il conçut et peignit deux livres de découpages avec les poupées de Lana Turner et de Carmen Miranda; il fit ses premières couvertures pour le magazine *Omnibook* de Time-Life, en commençant par les portraits de Winston Churchill et des membres de son cabinet. Mais son œuvre la plus célèbre de cette période est l'affiche de l'USO (Centre d'accueil pour les militaires américains) montrant une femme soldat marchant bras dessus, bras dessous avec un soldat et un marin. Pendant la guerre, il en fut distribué plus d'un million d'exemplaires aux Etats-Unis et à l'étranger.

Né en 1902, Higgins passa la majeure partie de sa vie à West Nyack, dans l'Etat de New York. Il est mort en 1983 à Hollywood, en Floride. Pendant la Deuxième Guerre mondiale, il servit comme instructeur en camouflage d'avions dans le corps des ingénieurs de l'armée de l'air. Après la guerre, il travailla dix ans comme directeur artistique du catalogue de vente par correspondance de Sears Roebuck, puis prit sa retraite.

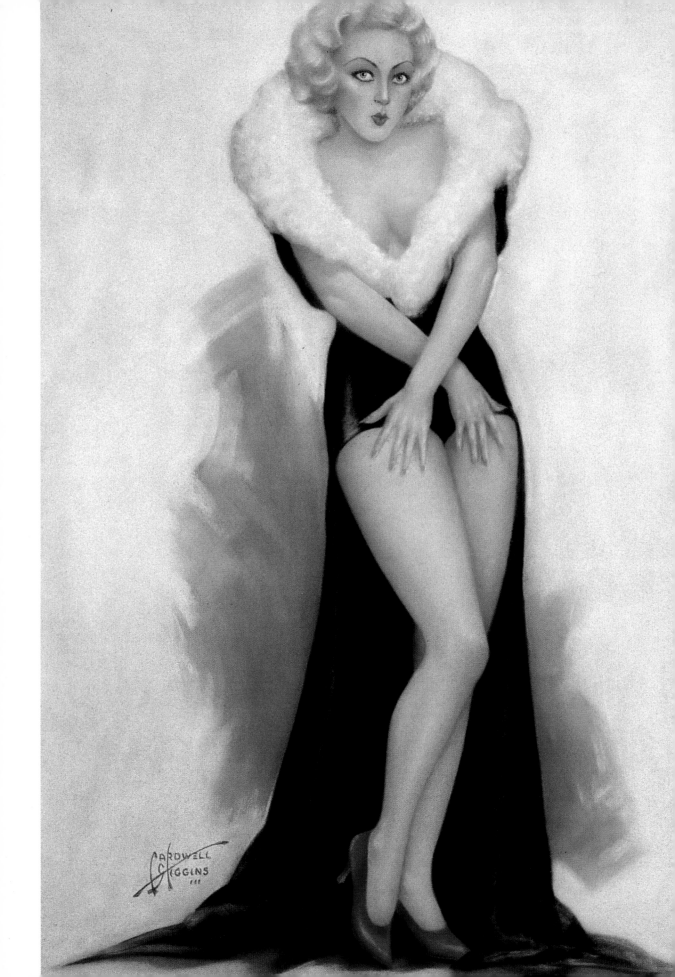

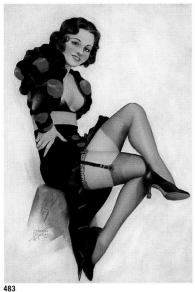

483

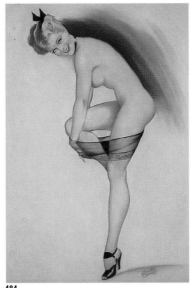

484

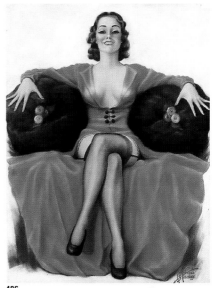

486

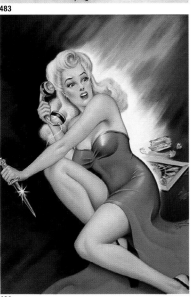

486

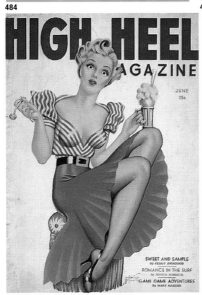

487

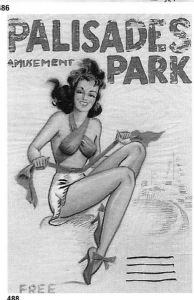

488

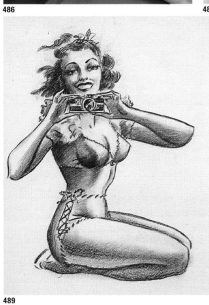

489

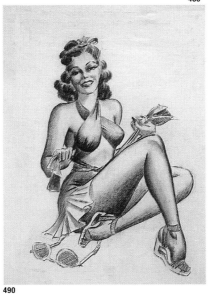

490

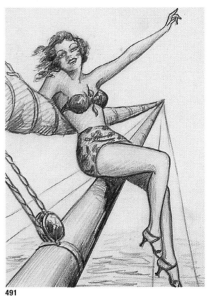

491

Hy Hintermeister

Henry (Hy) Hintermeister occupied a place in the calendar-art field comparable to Norman Rockwell's in American illustration as a whole. Like Rockwell, Hintermeister was a great painter. He was also a compulsive worker, unmatched in volume of work by any other artist working on calendars; his clients included almost every major calendar company of the twentieth century.

Although Hintermeister's subject matter was generally sentimental and nostalgic, he painted practically every kind of picture, including a few true pin-up and glamour images (figure 492). Published by Brown and Bigelow in the 1930s as calendar prints and mutoscope cards, these images are distinctive both in color and mood.

Hintermeister was born in 1897 and later lived in Brooklyn while maintaining a studio in New York. His teachers included Weston Taylor, O.W. Beck, and Anton Otto Fisher. In the 1920s and 1930s, he painted hundreds of fabulous images for the Thomas D. Murphy, Shaw-Barton, and Brown and Bigelow calendar companies. His notable 1940s series of calendar paintings for Joseph C. Hoover and Sons featured an elderly grandmother playing with a group of youngsters while a priest watches from a distance. Hintermeister often portrayed the grandmother doing daring things like walking on a pogo stick, riding a merry-go-round, or speeding down a snow-covered mountain on a toboggan.

Hintermeister was recognized by his peers as not only a talented illustrator but also a highly accomplished fine-art painter. His son, who also became an artist, adopted his father's style and signature in a series of calendar-art paintings for Hoover in the early 1960s. However, these works could not compare to his father's – the elder Hintermeister's creations were the products of an exceptional talent and ability.

Henry (Hy) Hintermeister nahm in der Kalenderkunst einen Platz ein, der mit dem Norman Rockwells vergleichbar ist, was die amerikanische Illustration im allgemeinen anbelangt. Wie Rockwell war auch Hintermeister ein sehr guter Maler. Und er war ein Workaholic. Er produzierte mehr als jeder andere der für Kalenderverlage tätigen Künstler. Zu seinen Auftraggebern gehörte fast jeder, der in dieser Branche Rang und Namen hatte.

Obwohl seine Themen durchweg gefühlvoll-sentimental und nostalgisch angehaucht waren, malte er quasi jede Art von Bild – darunter auch einige ech-te Pin-ups und Glamourmotive (Abb. 492). Von Brown and Bigelow wurden die-se in Farbe und Stimmung unverwechselbaren Arbeiten in den 30er Jahren auf den Markt gebracht – als Kalenderdrucke und Karten für den Mutoskopapparat, bei dem durch das Drehen an einer Kurbel die Bilder zum Laufen gebracht wer-den konnten.

Hintermeister wurde 1897 geboren und lebte später in Brooklyn, hatte sein Studio aber in New York. Zu seinen Lehrern gehörten Weston Taylor, O.W. Beck und Anton Otto Fisher. In den 20er und 30er Jahren kreierte er Hunderte wun-

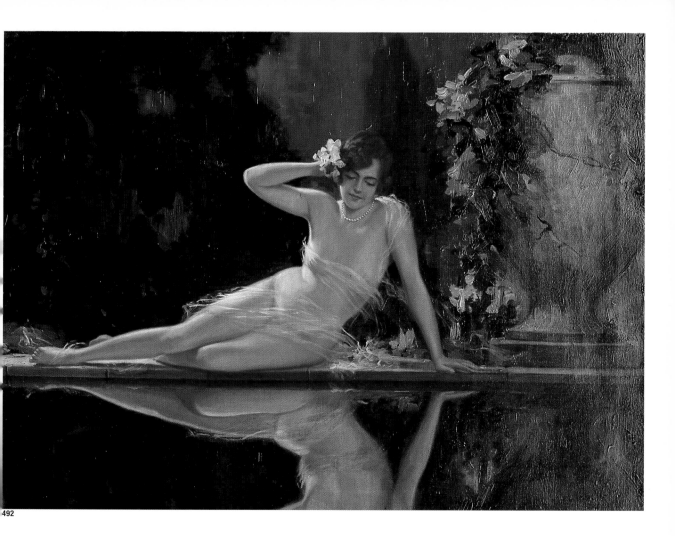

492

derbarer Bilder für die Kalenderverlage Thomas D. Murphy, Shaw-Barton und Brown and Bigelow. Seine bemerkenswerte Serie von Kalenderillustrationen für Joseph C. Hoover and Sons aus den 40er Jahren zeigte u. a. eine ältere Großmutter, die mit einigen Jungen spielt, während ein Priester das Geschehen aus der Ferne beobachtet. Diese Großmutter vollbrachte kühne Taten, ob mit einem Springseil, auf einem Karussell sitzend oder auf einem Schlitten schneebedeckte Hänge hinuntersausend.

Henry (Hy) Hintermeister occupe une place à part dans l'histoire des calendriers, comparable à celle de Norman Rockwell dans l'illustration américaine en général. Comme Rockwell, Hintermeister était un grand peintre. C'était également un travailleur acharné, dont la production atteignit un volume jamais égalé par d'autres illustrateurs. Pratiquement tous les éditeurs de calendriers du pays étaient ses clients.

Bien qu'il se soit principalement concentré sur des thèmes romantiques et nostalgiques, Hintermeister a abordé pratiquement tous les sujets, y compris les pin up et beautés glamour (illustration 492). Publiées par Brown and Bigelow dans les années 30 sous forme de calendriers et de cartes d'art, ses œuvres se distinguaient par leurs couleurs et leur atmosphère.

Né en 1897, Hintermeister vivait à Brooklyn mais avait un atelier à Manhattan. Il eut pour maîtres Weston Taylor, O. W. Beck et Anton Otto Fisher, entre autres. Dans

Seine Berufskollegen zollten ihm nicht nur als talentiertem Illustrator Anerkennung, sondern auch als einem sehr guten Maler. Sein Sohn, der auch eine künstlerische Laufbahn einschlug, übernahm den Stil und die Signatur seines Vaters, als er in den frühen 60er Jahren eine Serie von Kalenderblättern für Hoover fertigte. Doch seine Arbeiten hielten dem Vergleich mit denen seines Vaters nicht stand, die das Ergebnis eines außergewöhnlichen Talents waren.

les années 20 et 30, il peint des centaines d'images fabuleuses pour les calendriers de Thomas D. Murphy, de Shaw-Barton et de Brown and Bigelow. Sa célèbre série de peintures pour Joseph C. Hoover and Sons, réalisée dans les années 40, comprenait une image de grand-mère jouant avec un groupe d'enfants tandis qu'un prêtre les observait de loin. Hintermeister représentait souvent cette grand-mère dans les situations les plus inattendues: marchant sur des échasses à ressort, chevauchant un cheval de bois ou dévalant une pente enneigée sur une luge.

Hintermeister était reconnu par ses pairs comme un illustrateur talentueux mais également comme un peintre accompli. Son fils devint lui aussi artiste et adopta le style et la signature paternels dans une série d'images de calendriers pour Hoover au début des années 60. Toutefois, ses œuvres n'étaient pas à la hauteur de celles de son père. Les créations de Hintermeister père étaient le fruit d'un talent et d'une habileté exceptionnels.

Arnold Kohn

493

Kohn is best remembered for helping Hugh Hefner make *Playboy* magazine a success in the early years of its publication. A regular contributor to the magazine from its first issue in 1953, Kohn was an accomplished painter who enjoyed working in gouache for his pin-up subjects. Since his living in Chicago gave him access to various calendar-publishing houses as well as to *Playboy*, he began about 1955 to paint pin-ups and glamour subjects for such companies.

Der Name Kohn steht für den Playboy, *dem er zusammen mit seinem Herausgeber Hugh Hefner in den Anfangsjahren zum Erfolg verhalf. Seit ihrer ersten Ausgabe im Jahr 1953 war Kohn ständiger Mitarbeiter der Zeitschrift. Kohn war ein arrivierter Maler, der seine Pin-ups vorzugsweise in Gouache ausführte. Da er in seiner Heimatstadt Chicago sowohl zum* Playboy *als auch zu verschiedenen Kalenderverlagen Kontakte aufbauen konnte, begann er um 1955 herum mit der Arbeit an Pin-ups und Glamourbildern für die entsprechenden Verlage.*

Kohn est surtout connu pour avoir contribué au succès de *Playboy* lors de ses premières années de parution. Collaborateur régulier du magazine dès son premier numéro en 1953, Kohn était un peintre accompli qui aimait réaliser ses pin up à la gouache. Habitant Chicago, il avait également accès à de nombreuses maisons d'édition de calendriers, auxquelles il commença à fournir des pin up et des beautés glamour dès 1955.

During the 1940s, Kohn had produced many front-cover paintings for the pulp-magazine market. His last commission was a cover for *Amazing Stories* in 1948, just as the pulp era came to a close. From the 1950s to the mid-1960s, he painted front-cover subjects for the paperback market. Whatever the assignment, Kohn's work always focused effectively on beautiful, sexy girls.

Während der 40er Jahre hatte Kohn viele Groschenromane illustriert und Titelumschläge geliefert. Sein letzter derartiger Auftrag war das Cover aus dem Jahr 1948 für Amazing Stories, *das mit dem Ende dieses Genres zusammenfiel. Bis Mitte der 60er gestaltete er vor allem Taschenbuchcover. Wie immer der Auftrag auch lauten mochte, Kohn konzentrierte sich dabei immer auf wunderschöne Mädchen mit einer geballten Ladung Sex.*

Pendant les années 40, Kohn réalisa de nombreuses couvertures pour les magazines de pulp. Sa dernière commande fut une couverture pour *Amazing Stories,* en 1948, juste au moment où l'ère du pulp s'achevait. Des années 50 au milieu des années 60, il peignit des couvertures pour les livres de poche. Quelle que soit la nature de la commande, Kohn n'oubliait jamais d'introduire une jolie fille dans ses images.

494

495

496

Mike Ludlow

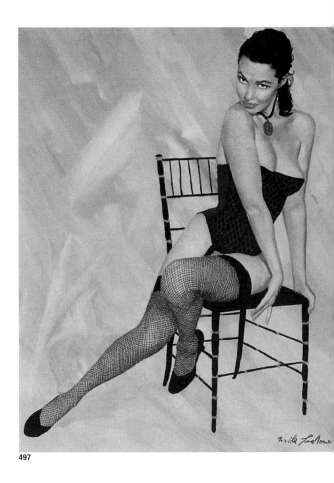

497

Ludlow was a glamour illustrator who did much pin-up work in the late 1950s for Esquire. He painted the entire twelve-page yearly calendar for 1957 – the last published by the magazine. His pin-ups also appeared in the series of three-page centerfolds known as *Esquire*'s Lady Fair. For these works, Ludlow often called on actresses like Virginia Mayo and popular personalities like Betsy Von Furstenberg in addition to professional models.

Besides painting his *Esquire* pin-ups, Ludlow had another entire career as an illustrator of romance articles, providing pictures of beautiful women to mainstream magazines such as *The Saturday Evening Post, Good Housekeeping, Col-*

lier's, and *Family Circle*. From 1950 to 1960, he also painted many front covers for paperback novels, including among his clients Pocket Books, Dell Books, and Bantam Books. All his paperback covers had a strong air of sensuality and featured sexy pin-up girls as the main figures.

Ludlow was born in 1921 and grew up in Buffalo, New York. He attended the Art Students League, where he studied with William McNulty. His first commercial art assignment, for the Sunday supplement of the Journal American, came in 1948. From the beginning, Ludlow has specialized in glamorous subjects and made beautiful women his trademark.

Ludlow arbeitete als Illustrator im Bereich Glamour und kreierte Ende der 50er Jahre viele Pin-ups für den Esquire. *1957 malte er den letzten der jährlich erscheinenden zwölfseitigen Kalender des Blattes. Seine Pin-ups erschienen auch in der Heftserie* Esquire's Lady Fair, *das auf drei Seiten ausklappbare Sahnestückchen" im Heftinnern. Bei diesen Arbeiten bat Ludlow neben professionellen Modellen gerne Schauspielerinnen wie Virginia Mayo oder bekannte Persönlichkeiten wie Betsy von Fürstenberg um ihre Mitarbeit.*

Neben seinen Pin-ups für Esquire *arbeitete Ludlow ebenso erfolgreich als Illustrator von Romanzen und Schmonzetten, wie sie in den Unterhaltungsblättern* The Saturday Evening Post, Good Housekeeping, Collier's *und* Family Circle *abge-*

druckt wurden. Ludlow lieferte die dazugehörigen schönen Frauen. Zwischen 1950 und 1960 entwarf er viele Taschenbuchcover; zu seinen Auftraggebern gehörten die Verlage Pocket Books, Dell Books und Bantam Books. Auf den von Ludlow gestalteten Covern standen fast immer sinnliche und aufregende Pin-up-Girls im Vordergrund.

Ludlow wurde 1921 geboren und wuchs in Buffalo im Bundesstaat New York auf. Er besuchte die Art Students League und belegte dort Kurse von William McNulty. Seine erste Auftragsarbeit war 1948 für die Sonntagsbeilage des Journal American. *Vom Beginn seiner Laufbahn an spezialisierte sich Ludlow auf Glamourthemen. Schöne Frauen waren sein Markenzeichen.*

Ludlow était un illustrateur glamour qui réalisa un grand nombre de pin up pour *Esquire* dans les années 50. En 1957, il peignit la totalité des douze illustrations du dernier calendrier publié par le magazine. Ses pin up parurent également dans une série de posters centraux géants (trois feuillets) baptisée Lady Fair. Pour ces œuvres, outre des modèles professionnels, Ludlow faisait souvent appel à des actrices comme Virginia Mayo ou des célébrités telles que Betsy Von Furstenberg.

Parallèlement à ses pin up pour *Esquire*, Ludlow se fit connaître comme illustrateur d'histoires sentimentales qui paraissaient dans des magazines à grand tirage comme *The Saturday Evening Post, Good Housekeeping, Collier's* et *Family*

Circle. De 1950 à 1960, il réalisa de nombreuses couvertures de livres de poche notamment pour les maisons d'édition Pocket Books, Dell et Bantam. La plupart de ces couvertures montraient des pin up sexy et avaient de fortes connotations érotiques.

Né en 1921, Ludlow grandit à Buffalo, dans l'Etat de New York. Il étudia à l'Art Students League, où il eut William McNulty comme professeur. Il reçut sa première commande en 1948, pour le supplément dominical de *Journal American*. Dès le début de sa carrière, il se spécialisa dans les sujets glamour et les images de jolies femmes.

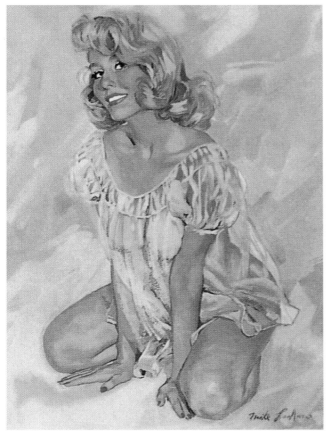

498

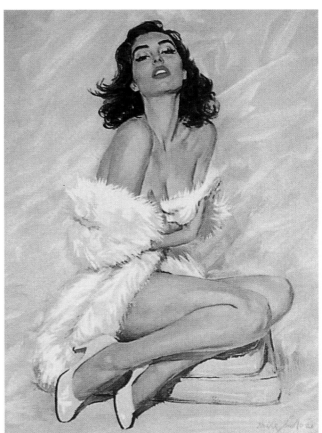

499

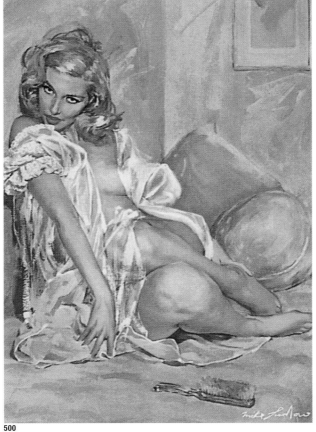

500

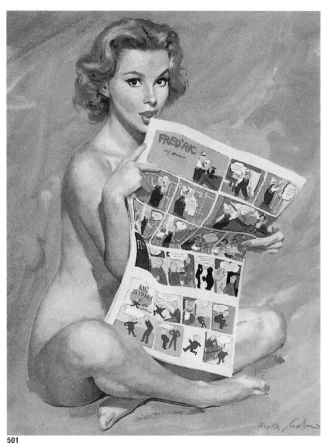

501

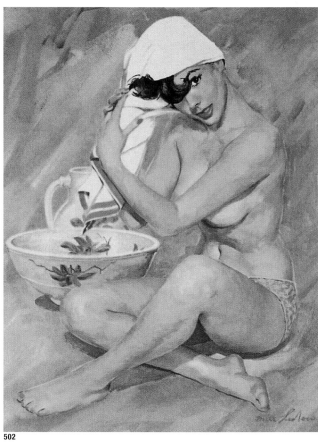

502

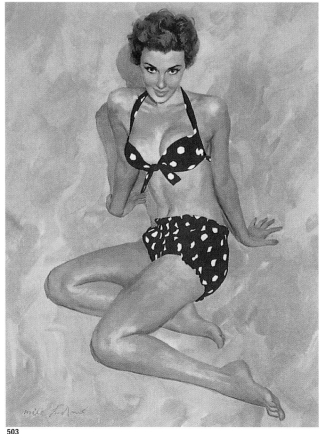

503

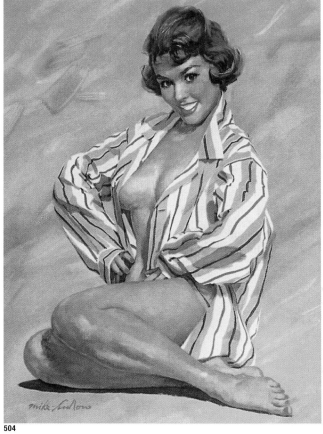

504

Earl Mac Pherson

1939, Mac Pherson was an aspiring glamour artist with a studio on Sunset Boulevard in Hollywood. One night, his phone rang with an invitation from Charlie Ward, the president of Brown and Bigelow, to meet him at the Beverly Hills Hotel. Impressed with the artist's work, Ward invited him to visit the firm's St. Paul headquarters. After some time spent "hanging around," observing and learning, Mac Pherson officially joined the staff in 1942.

Mac Pherson married his first model at Brown and Bigelow, then went on to create a unique pin-up calendar that would become a standard in the industry. First published in 1943, his Artist's Sketch Pad became a million-dollar seller. Each page of the twelve-page calendar, bound at the top with a spiral binder, featured a primary pin-up figure surrounded by pencil sketches showing the same model in various poses relating to the central image.

Before going to Brown and Bigelow, Mac Pherson had painted a very famous pin-up image for the Shaw-Barton Calendar Company. The best-selling image in the company's 1941 line, Going Places (figure 505) was so popular that Lucky Strike cigarettes asked to reproduce it on their 1942 calendar with the caption "Lucky Strike Green Goes to War."

Edgar Earl Mac Pherson was born on August 3, 1910, in Oklahoma. He moved to Los Angeles after high school, got a job painting movie posters for a downtown theater, and took evening art classes at the Chouinard School of Art. In 1929, he set up shop at the Royal Hawaiian Hotel in Honolulu, painting portraits of wealthy guests. Mac Pherson's smashing success with the Artist's Sketch Pad was followed by another triumph: his two-deck set of playing cards for Brown and Bigelow, called Win, Lose, or Draw, received a total of 168,000 orders in four months. His diary-style calendar, Something to Remember, was his last success before he went off to war in 1944.

Discharged in 1946, after teaching plane decoy recognition to Navy pilots, he settled on a four-acre ranch in Del Mar, California. He also hooked up once again with Shaw-Barton and began the first of nine consecutive years of Mac Pherson Sketch Book calendars for them (figures 506, 507, and 512). In 1954, Shaw-Barton published a book called Hunting With Mac Pherson, a parody with pin-up girls dressed as various hunting birds; the same year, the artist wrote and designed a best-selling how-to book entitled Pin-Up Art for the Walter Foster Company.

In 1951, Mac Pherson was stricken with polio, and his assistant, Jerry Thompson, took over the Sketch Book calendar series under the name T.N. Thompson. In the early 1950s, Mac Pherson had his own television show in Arizona; about 1960, he moved to Tahiti and then traveled widely in the South Pacific. He died in December 1993.

939 war Mac Pherson ein aufstrebender Glamour-Künstler mit einem Studio auf dem Sunset Boulevard in Hollywood. Eines Abends klingelte sein Telefon. Charlie Ward, der Boß von Brown and Bigelow, vereinbarte mit ihm ein Treffen im Beverly Hills Hotel. Ward war von den Arbeiten des jungen Mannes beeindruckt und lud ihn zu einem Besuch des Hauptsitzes der Firma in St. Paul ein. Nachdem er dort eine Weile „rumgehangen", beobachtet und gelernt hatte, fing Mac Pherson 1942 offiziell bei Brown and Bigelow an.

Mac Pherson heiratete das erste Mädchen, das ihm bei Brown and Bigelow Modell gestanden hatte. Er kreierte einen einzigartigen Pin-up-Kalender, der neue Maßstäbe setzte. Sein „Artist's Sketch Pad", ein Künstlerskizzenblock, kam 1943 erstmals auf den Markt und setzte Millionen um. Jede der zwölf Seiten des Kalenders, die am oberen Ende mit einer Spirale gebunden waren, zeigte ein Pin-up-Girl im Vordergrund, umgeben von Bleistiftskizzen des gleichen Modells in verschiedenen Posen, die mit dem Hauptmotiv thematisch verwandt waren.

Bevor er zu Brown and Bigelow ging, hatte Mac Pherson ein sehr berühmtes Pin-up für den Kalenderverlag Shaw-Barton geschaffen. Going Places (Abb. 505), der Verkaufsrenner im Verlagsangebot des Jahres 1941, wurde so erfolgreich, daß die Zigarettenmarke Lucky Strike darum bat, dieses Bild auf ihrem Jahreskalender 1942 mit der Unterschrift „Lucky Strike Green Goes to War" reproduzieren zu dürfen.

Edgar Earl Mac Pherson wurde am 3. August 1910 in Oklahoma geboren. Nach Abschluß der High School zog er nach Los Angeles. Dort malte er Filmposter für ein Kino in der Downtown von Los Angeles. Gleichzeitig besuchte er Abendkurse an der Chouinard School of Art. 1929 richtete er sich im Royal Hawaiian Hotel auf Honolulu ein Studio ein und porträtierte dort wohlhabende Gäste. Mac Pherson konnte seinen Riesenerfolg mit dem „Artist's Sketch Pad" mit einem anderen Auftrag von Brown and Bigelow wiederholen: Seine Spielkartenserie namens Win, Lose, or Draw wurde in vier Monaten 168000mal geordert. Sein im Stil eines Tagebuchs abgefaßter Kalender Something to Remember war sein letzter Erfolg, bevor er 1944 eingezogen wurde.

1946, nach seiner Entlassung aus der Armee, in der er Piloten der Navy in der Seeaufklärung unterwies, ließ er sich auf einer zwei Hektar großen Ranch im kalifornischen Del Mar nieder. Er schloß sich wieder Shaw-Barton an. In den kommenden neun Jahren veröffentlichte er bei Shaw-Barton seine MacPherson-Sketch-Book-Kalender (Abb. 506, 507 und 512). 1954 kam bei Shaw-Barton eine Parodie heraus: Hunting With Mac Pherson, die als Vögel verkleidete Pin-ups zeigte; im gleichen Jahr schrieb und entwarf er einen Bestseller im „Do It Yourself"-Bereich, der unter dem Titel Pin-up Art bei der Walter Foster Company erschien.

1951 erkrankte Mac Pherson an Kinderlähmung. Sein Assistent Jerry Thompson übernahm die Sketch Book-Kalenderserie unter dem Namen T.N. Thompson. In den frühen 50er Jahren hatte Mac Pherson in Arizona seine eigene Fernsehshow. Um 1960 zog er nach Tahiti und reiste viel durch den südpazifischen Raum. Er starb im Dezember 1993.

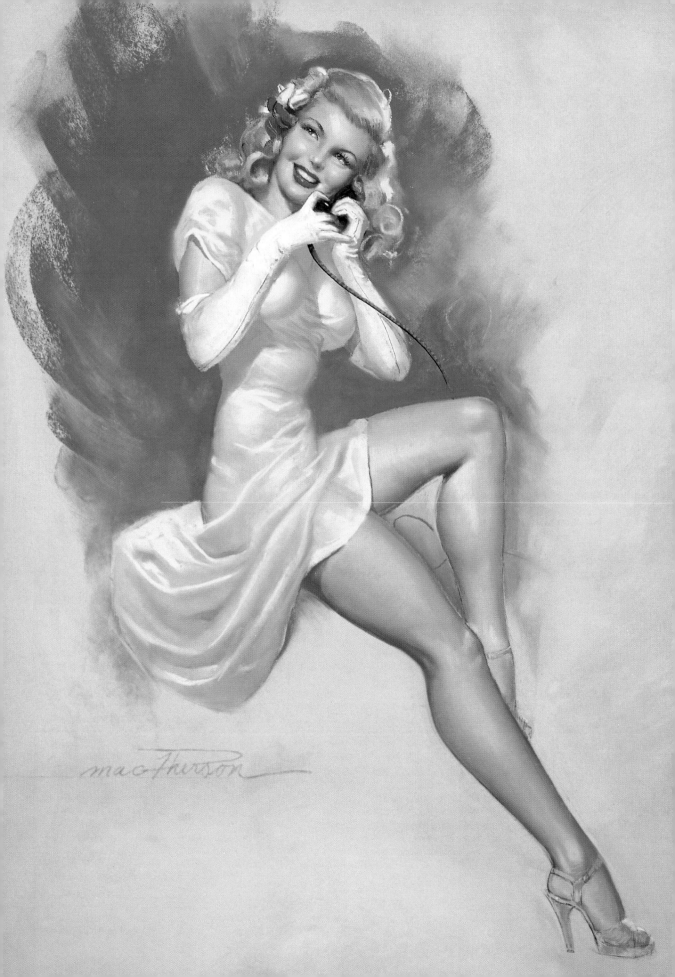

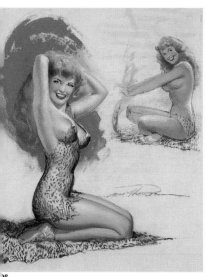

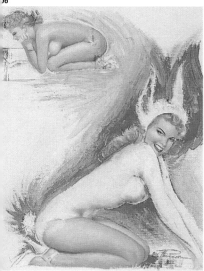

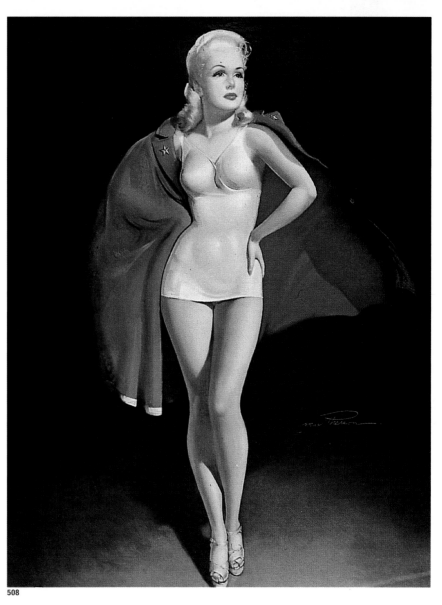

506

507 508

En 1939, le jeune Mac Pherson était un aspirant artiste glamour avec un atelier sur Sunset Boulevard, à Hollywood. Un soir, il reçut un appel de Charlie Ward, président de Brown and Bigelow, l'invitant à venir le rencontrer au Beverly Hills Hotel. Impressionné par le travail du jeune homme, Ward lui proposa de venir visiter le siège social de la firme à Saint Paul. Après avoir passé un certain temps à «traîner dans les parages», à observer et à apprendre, Mac Pherson fut officiellement engagé en 1942.

Mac Pherson épousa le premier modèle qui posa pour lui chez Brown and Bigelow, puis créa dans la foulée un nouveau type de calendrier de pin up qui allait devenir un modèle du genre. Publié pour la première fois en 1943, l'Artist's Sketch Pad rapporta un million de dollars à l'éditeur. Chacune des douze pages de ce calendrier, portant une reliure à spirale, arborait une pin up centrale entourée d'esquisses montrant le même modèle dans différentes poses.

Avant d'être engagé par Brown and Bigelow, Mac Pherson avait réalisé une très célèbre pin up pour Shaw-Barton. Cette image publiée dans un calendrier de 1941 et intitulée Going Places (illustration 505), devint si populaire que Luky Strike demanda l'autorisation de la reproduire dans son calendrier de 1942 avec la légende: «La petite bleue de Luky Strike part au front».

Né le 3 août 1910 dans l'Oklahoma, Edgar Earl Mac Pherson s'installa à Los Angeles peu après le lycée et commença par peindre des affiches pour un cinéma

du centre-ville. Parallèlement, il suivit des cours du soir à la Chouinard School of Art. En 1929, il ouvrit boutique à Honolulu dans l'hôtel Royal Hawaiian, peignant le portrait des riches clients. Le succès colossal de son Artist's Sketch Pad fut suivi d'un autre triomphe: son double jeu de cartes pour Brown and Bigelow, intitulé Win, Lose or Draw, dont 168000 exemplaires furent commandés en quatre mois. En 1944, Mac Pherson connut encore un succès avec son autre calendrier en forme de journal intime, Something to Remember, avant d'être mobilisé.

Libéré en 1946 après avoir enseigné aux pilotes de la marine à reconnaître les avions camouflés, il s'installa dans un ranch de deux hectares à Del Mar, en Californie. Il recommença à travailler pour Shaw-Barton, pour qui il réalisa pendant neuf années consécutives un Mac Pherson Sketch Book Calendar (illustrations 506, 507 et 512). En 1954, Shaw-Barton publia Hunting with Mac Pherson («A la chasse avec Mac Pherson»), un livre humoristique avec des pin up déguisées en divers oiseaux chasseurs. La même année, il écrivit et illustra un manuel de dessin intitulé Pin Up Art, publié par Walter Foster. Encore un grand succès.

En 1951, Mac Pherson fut atteint de la polio et son assistant, Jerry Thompson, reprit la direction de la collection des Artist's Sketch Pad sous le nom de T.N. Thompson. Au début des années 50, Mac Pherson eut même sa propre émission de télévision en Arizona. Vers 1960, il s'établit à Tahiti puis sillonna la région du sud Pacifique. Il est mort en 1993.

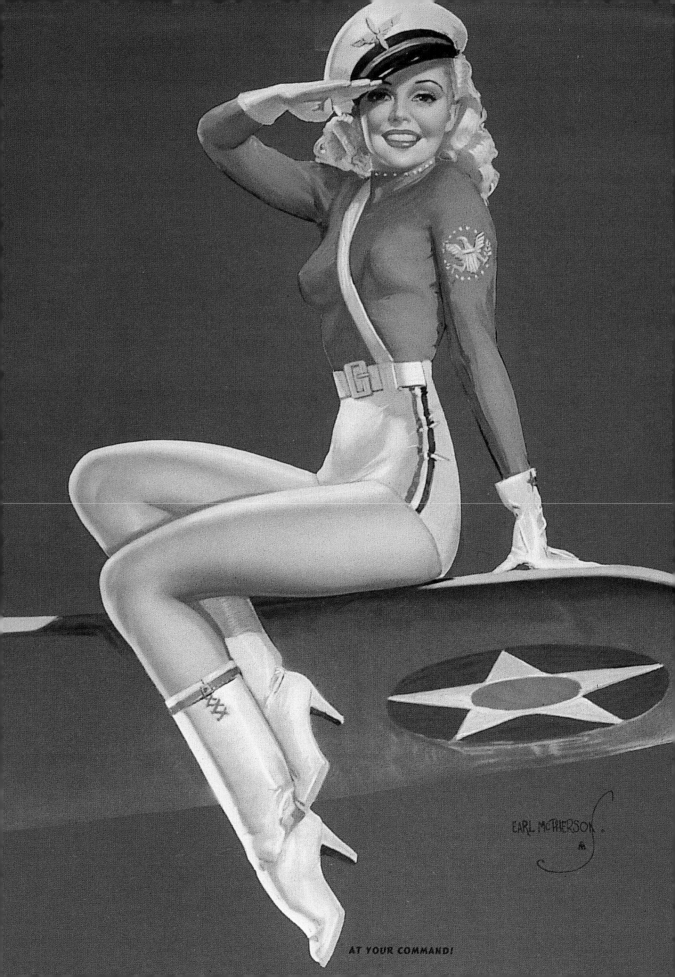

AT YOUR COMMAND!

510

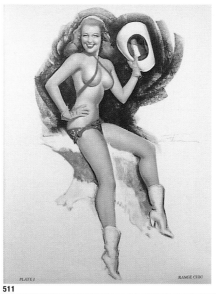

511

PLATE I RANGE CHIC

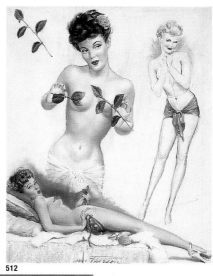

512

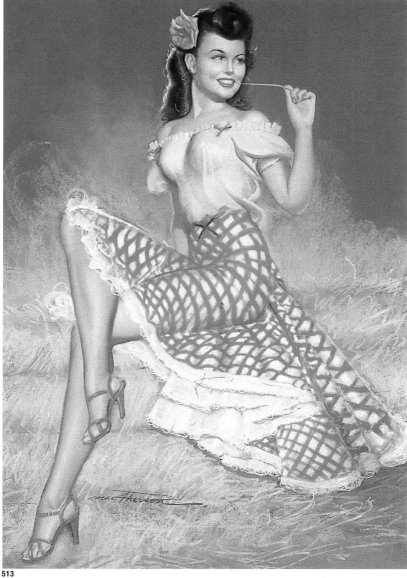

513

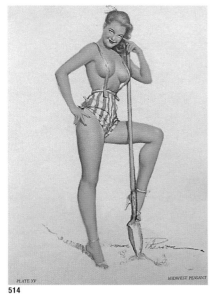

PLATE XV MIDWEST PEASANT

514

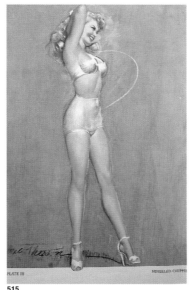

PLATE III NINEHEELED CHIPPIE

515

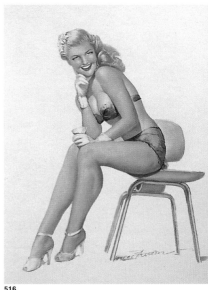

516

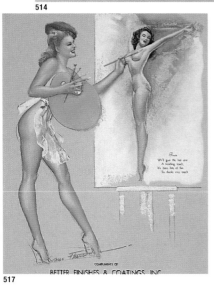

COMPLIMENTS OF
BETTER FINISHES & COATINGS, INC.

517

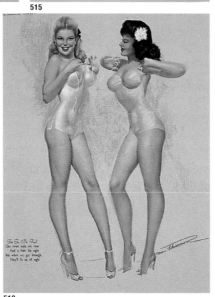

518

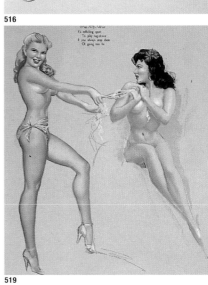

519

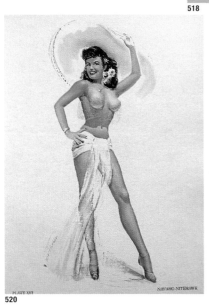

PLATE XVI NAVAHO NITEHAWK

520

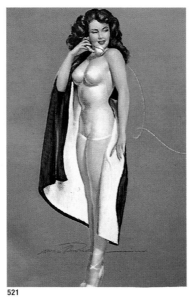

521

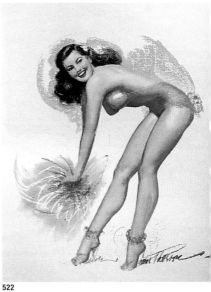

522

Bill Medcalf

Medcalf's pin-up work, like Elvgren's, set standards for artistry and imagery for his contemporaries. When Medcalf joined the staff of resident artists at Brown and Bigelow on March 18, 1946, he hoped to get some pointers from his two idols, Elvgren and Norman Rockwell, who were both contributors to the firm. When he met both men at a Christmas party that year, he was therefore stunned and flattered that they asked him how he imparted such a finished glow to his work.

Medcalf painted more than twenty years of beautiful pin-ups for Brown and Bigelow, handling all the special-project calendar commissions for their most important customers. For his first assignment in 1947, for Kelly-Springfield's Celebrity Tires, Medcalf painted a beautiful girl walking her dog on an estate, with a sports car in the background (figure 536). Then, for Dorman Products (auto parts manufacturers), he created a breathtaking picture of a girl and her dog having a picnic in front of an automobile (figure 531). While still handling these special pin-up projects, Medcalf also went on to deliver one winner after another to a new, more traditional Brown and Bigelow series, The Baseball Hall of Fame.

In 1949, Medcalf did his first pin-up "novelty fold" specialty item for the firm: a booklet that unfolded four times, each time revealing a larger pin-up image, the last being an oversized picture with an advertising message. Named one of

the company's top five pin-up artists in their 1951 *Business Builder*, Medcalf released his first pin-up hanger the next year. Entitled *Beautiful Morning* (figure 528), this depiction of a young girl just waking up proved to be a best-seller. The versatile Medcalf took on the responsibility for the company's American Boy calendar series in 1953, and he also created many best-selling evening-gown subjects for their glamour line (figures 533–535).

William Medcalf was a Midwestern boy, born in Minneapolis. All of his art education came from schools near his hometown, under teachers like Cameron Booth and Stan Fenelle. In 1940 and 1941, he worked in the art department of the United States Treasury's Bureau of Engraving; in 1942, he joined the Navy as a gunner's mate.

During his tenure at Brown and Bigelow, Medcalf worked first at the company's headquarters, then out of his home studio in a suburb of St. Paul, often using his family and neighbors as models. In a September 1950 article for a local art school magazine, he said this about his work: "I look for the things that make a girl appear feminine, outside of her face and figure, that is, her pose, expression, the way she fixes her hair, the way she handles her eyes, her buttons and bows" and "I play up the face and expression, making her look pleasant and sweet, with sex appeal but without sophistication, like someone's sweet sister."

Wie Elvgren setzte auch Medcalf für seine Zeitgenossen neue Maßstäbe in der künstlerischen Ausgestaltung und Metaphorik von Pin-ups. Als er am 18. März 1946 zum Stab der fest bei Brown and Bigelow angestellten Künstler stieß, erhoffte er sich einige Tips von seinen zwei Idolen, Elvgren und Norman Rockwell, die ebenfalls für Brown and Bigelow tätig waren. Als er beide im gleichen Jahr auf einer Weihnachtsfeier kennenlernte, war er verblüfft und geschmeichelt darüber, daß ausgerechnet die beiden ihn fragten, wie ihm dieser leuchtende Glanz in seinen Arbeiten gelang.

Mehr als 20 Jahre lang schuf Medcalf wunderschöne Pin-ups für Brown and Bigelow und war mit allen Spezialaufträgen der wichtigsten Kunden des Unternehmens betraut. 1947 malte er für Kelly-Springfield Celebrity Tires seinen ersten Auftrag, eine Schönheit, die ihren Hund auf einem Anwesen spazierenführt, während im Hintergrund ein Sportwagen zu sehen ist (Abb. 536). Für den Autozubehörhersteller Dorman Products entwarf er ein atemberaubendes junges Mädchen, das vor seinem Wagen mit seinem Hund ein Picknick macht (Abb. 531). Während Medcalf diese Sonderprojekte weiter betreute, gelang ihm in einer eher traditionellen Serie von Brown and Bigelow ein „Erfolgswurf" nach dem anderen.

1949 entwarf Medcalf für Brown and Bigelow seinen ersten „Novelty-fold", ein kleines Buch, das sich viermal aufklappen ließ und bei jedem Mal ein größeres Pin-up enthüllte. Das letzte Pin-up war ein überformatiges Motiv und trug die Werbebotschaft des Kunden. 1951 wurde Medcalf von der Publikation Business

Builder zu einem der fünf besten Pin-up-Künstler des Jahres gekürt. Im Folgejahr kam Medcalfs erster Pin-up-Wandkalender auf den Markt: Beautiful Morning *(Abb. 528) zeigt ein junges Mädchen beim Aufwachen und wurde zum Bestseller. Der vielseitige Medcalf zeichnete 1953 auch für die American Boy-Kalenderserie. Kassenschlager wurden ebenfalls viele seiner Motive für die Glamourlinie des Unternehmens, die elegante Abendszenen zum Thema hatten (Abb. 533 bis 535).*

William Medcalf stammte aus dem Mittleren Westen und wurde in Minneapolis geboren. Seine gesamte Kunsterziehung und Kunstausbildung erhielt Medcalf von den Künstlern aus der Umgebung seiner Heimatstadt; darunter waren Lehrer wie Cameron Booth und Stan Fenelle. 1940 und 1941 arbeitete er in der Abteilung Künstlerische Gestaltung der Gravuranstalt des Schatzamtes der Vereinigten Staaten. 1942 ging er als Schützenmaat zur Navy.

Während seiner Zeit bei Brown and Bigelow arbeitete Medcalf anfangs im Firmensitz des Unternehmens und später in seinem Studio. Oft standen ihm Familienmitglieder und Nachbarn Modell. In einem im September 1950 erschienenen Artikel für eine Kunstzeitschrift sagte er über seine Arbeit: „Ich suche nach den Dingen, die ein Mädchen neben ihrer Figur und ihrem Gesicht weiblich erscheinen lassen, ihre Haltung, ihr Ausdruck; die Art, wie sie ihr Haar richtet; was sie mit ihren Augen oder ihren Knöpfen und Schleifen tut". Und: „Ich verstärke das Gesicht und seinen Ausdruck, so daß das Modell niedlich und nett aussieht und Sex-Appeal ausstrahlt, ohne raffiniert zu sein, etwa so wie die süße Schwester von jedermann".

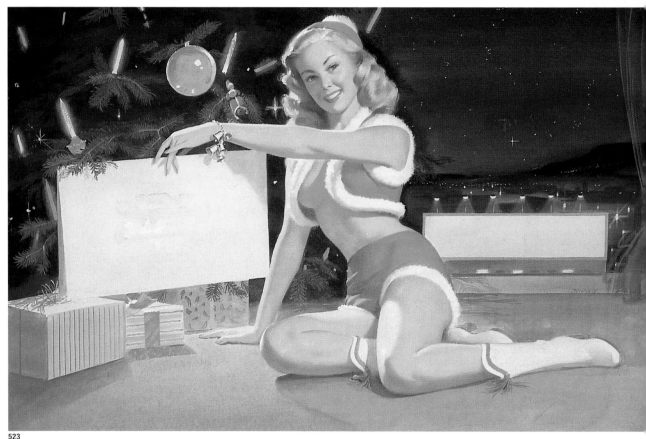

523

Les pin up de Medcalf, comme celles d'Elvgren, établirent de nouveaux critères de qualité dans la profession. Lorsque Medcalf rejoignit l'écurie des artistes-maison de Brown and Bigelow le 18 mars 1946, il espérait obtenir quelques tuyaux de la part de ses deux idoles, Gil Elvgren et Norman Rockwell, qui travaillaient tous deux pour l'éditeur. Lorsqu'il les rencontra enfin lors d'une soirée donnée à l'occasion de Noël cette même année, il fut donc stupéfait et flatté quand ils lui demandèrent son secret pour obtenir une aussi belle lumière dans ses œuvres.

Medcalf réalisa de superbes pin up pour Brown and Bigelow pendant plus de vingt ans, prenant en charge les commandes spéciales des grands annonceurs. En 1947, pour sa première affiche publicitaire pour Kelly-Springfield's Celebrity Tires (fabricant de pneus), il peignit une jolie femme promenant son chien devant sa propriété avec, en arrière-plan, une voiture de sport (illustration 536). Puis, pour Dorman Products (fabricant de pièces détachées pour automobiles), il réalisa une superbe pin up pique-niquant avec son chien devant sa voiture (illustration 531). Sans cesser de travailler sur ces projets spéciaux, Medcalf continua à produire des images toujours plus réussies pour la nouvelle collection de Brown and Bigelow, plus traditionnelle: une série de portraits des gloires du base-ball.

En 1949, Medcalf réalisa son premier «Novelty Fold» pour l'éditeur: il s'agissait d'un feuillet qui se dépliait quatre fois, chaque pan révélant une pin up un peu plus grande, jusqu'au poster central qui contenait un message publicitaire.

En 1951, Medcalf était placé en cinquième place (par ordre d'importance) dans la liste des artistes-maison de Brown and Bigelow. Il réalisa son premier calendrier-cintre l'année suivante. Intitulé *Beautiful Morning* (illustration 528), ce fut un nouveau best-seller même si le sujet n'était qu'une jeune fille faisant une promenade. En 1953, Medcalf, qui était décidément touche-à-tout, prit en charge la gamme de calendriers intitulée American Boy et créa un grand nombre de beautés en robe du soir pour la collection glamour de la maison (illustrations 533–535).

Né à Minneapolis, William Medcalf était originaire du Midwest. Il fit son éducation artistique dans différentes écoles de sa région, avec des professeurs tels que Cameron Booth et Stan Fenelle. En 1940 et 1941, il travailla dans le service des gravures du département artistique du ministère des Finances. En 1942, il s'enrôla dans la marine comme aide-canonnier.

Lors de son long séjour chez Brown and Bigelow, Medcalf travailla d'abord dans les locaux de l'éditeur, puis dans son propre atelier de la banlieue de Saint Paul, utilisant ses proches et ses voisins comme modèles. En septembre 1950, dans un article publié par la gazette d'une école d'art locale, il déclara: «Je cherche les détails qui rendent une fille féminine, en dehors de son visage et de sa silhouette, à savoir son allure, son expression, sa manière d'arranger ses cheveux, son regard, ses atours et ses rubans. (…) Je travaille son visage et son expression, les rendant agréables et doux, avec du sex-appeal mais sans sophistication, comme si j'avais devant moi la petite sœur d'un ami.»

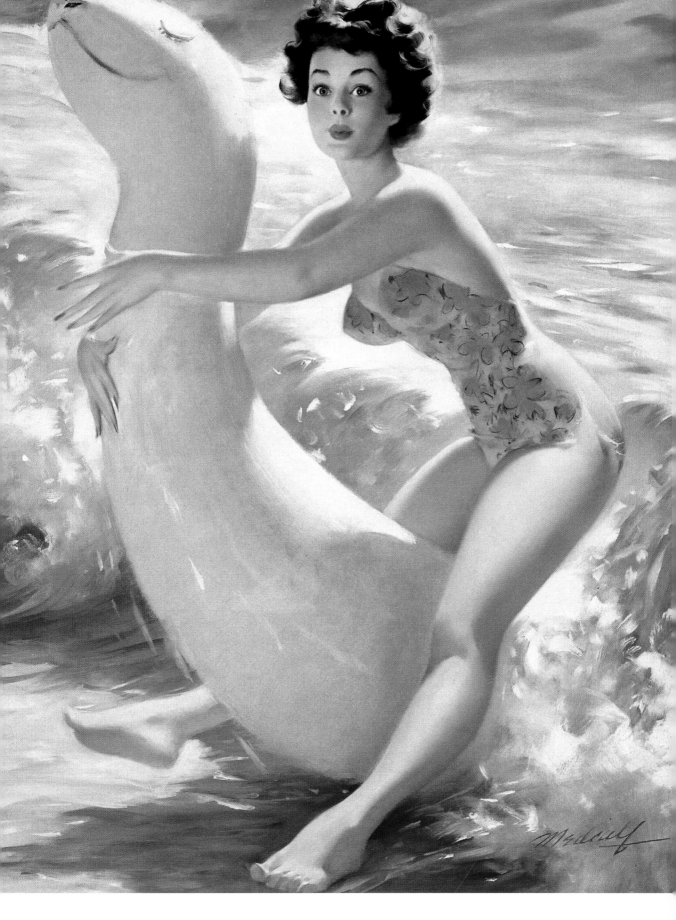

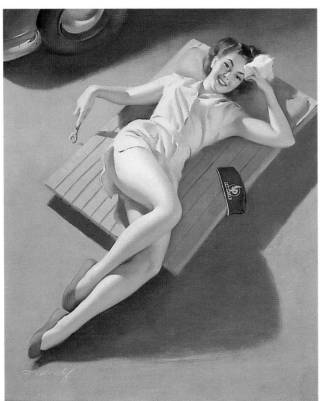

525

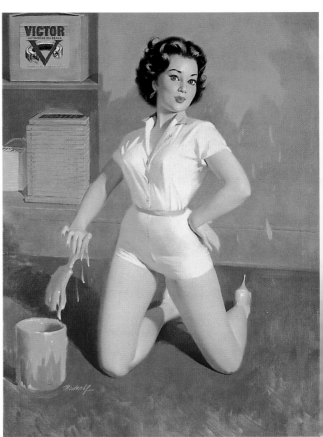

526

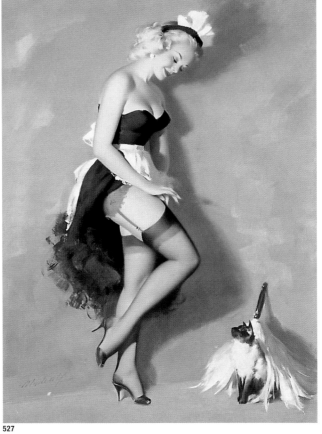

527

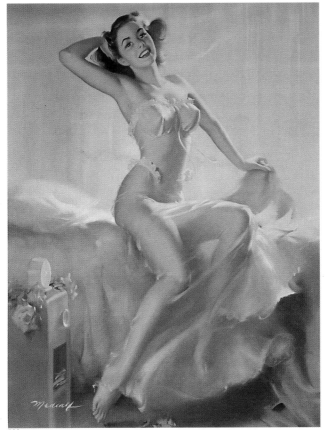

528

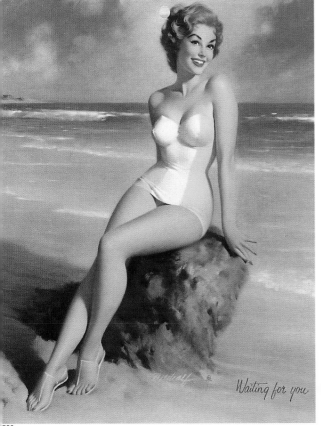

Waiting for you

529

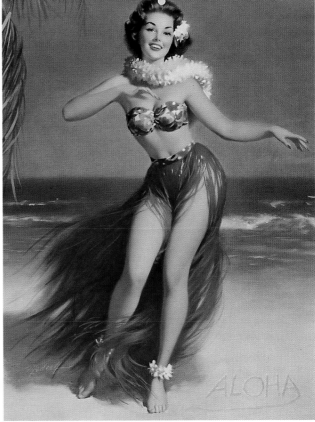

ALOHA

530

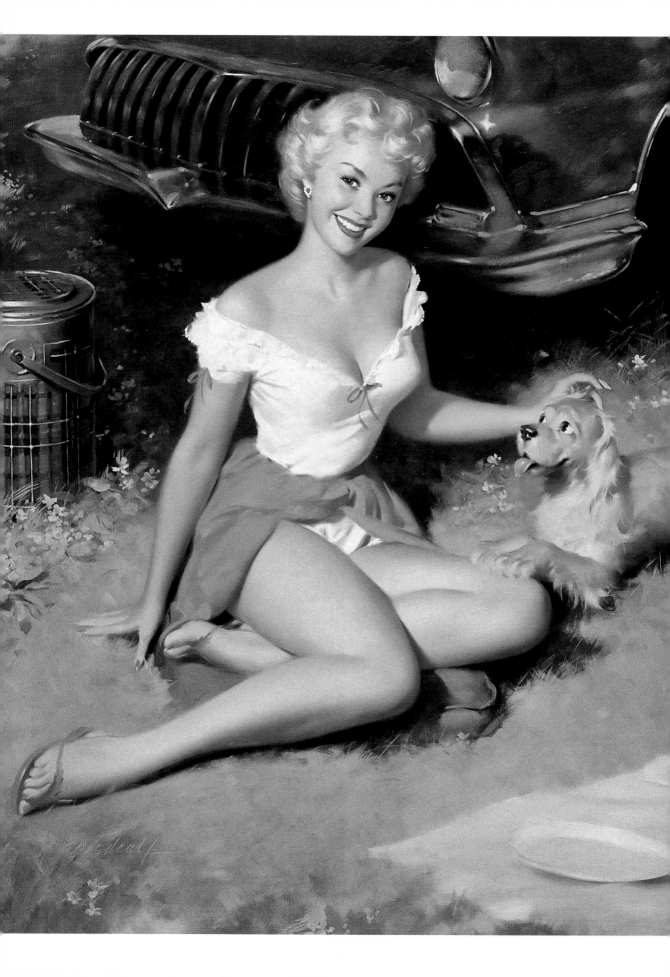

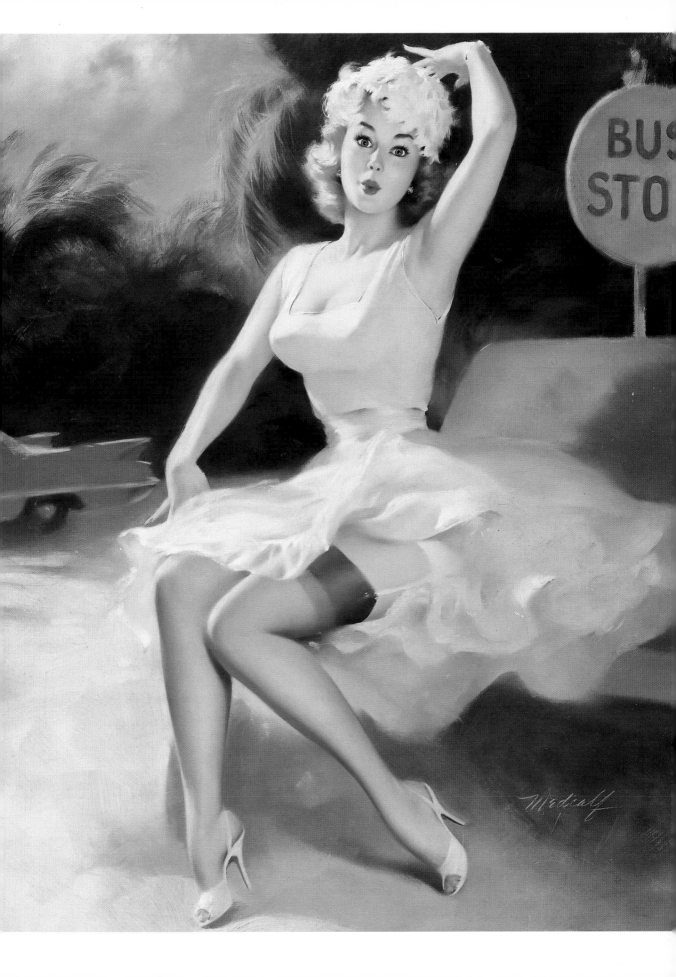

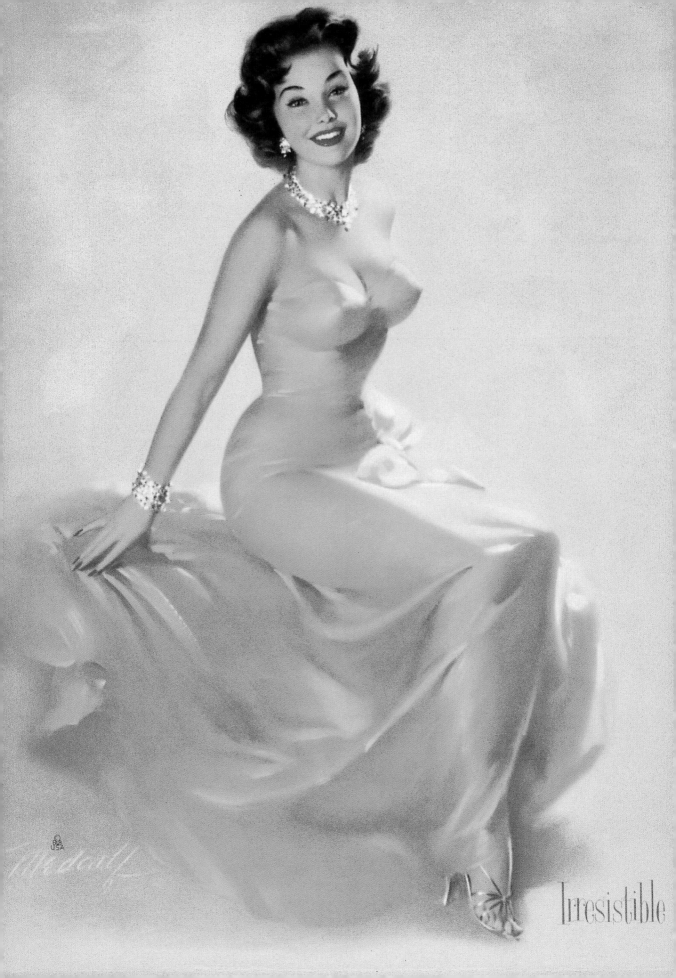

Irresistible

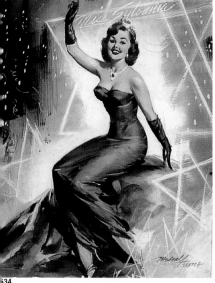

534

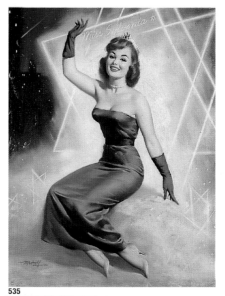

535

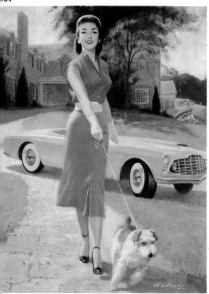

536

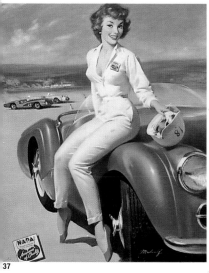

537

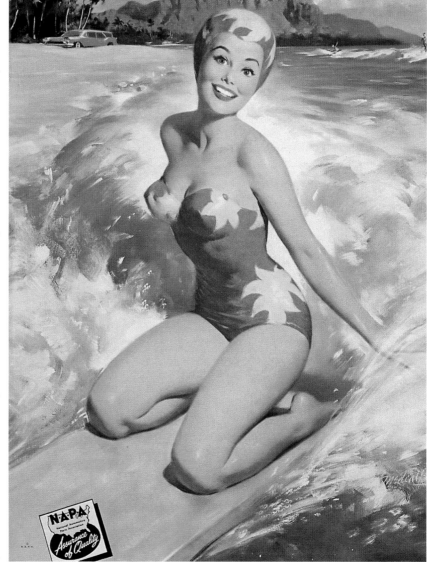

538

M. Miller

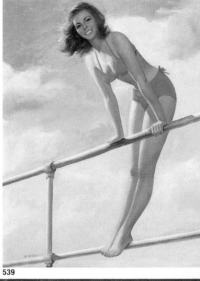

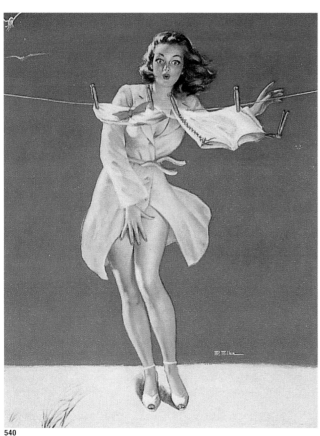
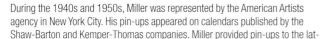

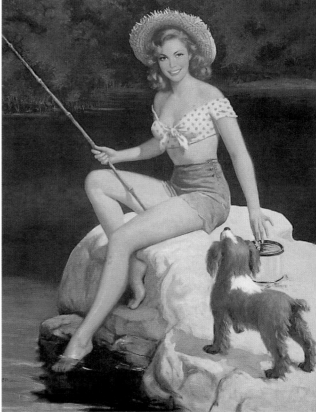

During the 1940s and 1950s, Miller was represented by the American Artists agency in New York City. His pin-ups appeared on calendars published by the Shaw-Barton and Kemper-Thomas companies. Miller provided pin-ups to the lat-ter firm for a 1949 twelve-page calendar that featured his work along with that of Erbit, Sarnoff, and F. Sands Brunner. He worked in oil on canvas in a format measuring 28 x 22 inches (71.1 x 55.9 cm).

Während der 40er und 50er Jahre wurde Miller von der in New York ansässigen Agentur American Artists vertreten. Er lieferte Pin-ups für Kalender aus den Verlagen Shaw-Barton und Kemper-Thomas. Zusammen mit Erbit, Sarnoff und F. *Sands Brunner malte Miller Pin-ups für einen zwölfseitigen Kalender für das Jahr 1949 von Kemper-Thomas. Miller arbeitete im Format 71x56cm in Öl auf Leinwand.*

Pendant les années 40 et 50, Miller fut représenté par l'agence new-yorkaise American Artists. Ses pin up furent publiées dans les calendriers des éditeurs Shaw-Barton et Kemper-Thomas. En 1949, Miller réalisa pour ce dernier des pin up qui parurent dans un calendrier de douze pages aux côtés de celles d'Erbit, de Sarnoff et de F. Sands Brunner. Il travaillait à l'huile sur des toiles de 71,1 x 55,9 cm.

Frederic Mitzen

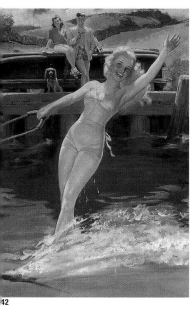

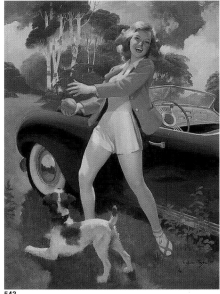

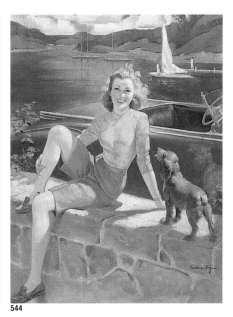

42 543 544

efore Haddon Sundblom ever painted an advertisement for the Coca-Cola Com-any, Frederic Mitzen had contributed many exquisite oils to the company's ational ad campaigns. Most of Mitzen's pin-ups depicted wholesome, all-Ameri-an girls involved in sports or other enjoyable pastimes.

Born in 1888 in Chicago, Mitzen studied at Smith's Art Academy from 1904 to 906 under John Vanderpoel, DeForrest Shook, and Walter Marshall Clute. He so attended night classes at the Chicago Art Institute. His first job was with Gun-ng Systems, the predecessor to General Outdoor Advertising Company, the giant national ad agency that specialized in billboard campaigns. Mitzen became one of the country's leading billboard illustrators, executing pin-up-like advertisements that sold everything from beer to sunglasses. Johnson and Johnson and General Motors were among the dozens of major corporations that sought his services.

Mitzen's earliest calendar pin-ups were created for the Louis F. Dow Company about 1938. During the 1930s and 1940s, he was also active in the mainstream illustration field, creating front covers for *The Saturday Evening Post*, *Cosmopolitan*, and many other important publications. Mitzen died in 1965.

evor Haddon Sundblom die erste Anzeige für die Coca-Cola Company malte, atte Frederic Mizen viele wunderbare Ölarbeiten für die in ganz Amerika laufen-en Werbekampagnen des Getränkemultis geliefert. Die meisten seiner Pin-ups aren „all-American Girls", typische Amerikanerinnen, die jung und frisch wirkten nd sich entweder sportlich betätigten oder einem anderen jugendfreien Hobby achgingen.

Mizen wurde 1888 in Chicago geboren. Zwischen 1904 und 1906 studierte er nter John Vanderpoel, DeForrest Shook und Walter Marshall Clute an der Smith's rt Academy und belegte am Chicago Art Institute zusätzlich Abendkurse. Sein rster Auftraggeber war Gunning Systems, ein Vorläufer der General Outdoor Advertising Agency, einer national arbeitenden bedeutenden Anzeigenagentur, die sich auf die „Billboards", großformatige Außenreklame, spezialisiert hatte. Mizen wurde einer der führenden Billboard-Maler. Mit seinen Pin-ups wurde für alles nur Denkbare geworben, von Bier bis zu Sonnenbrillen. Firmen wie Johnson and Johnson und General Motors gehörten zu den Dutzenden von Großunternehmen, die ihn mit Anzeigenkampagnen beauftragten.

Ungefähr in das Jahr 1938 fallen erste Kalender-Pin-ups, die Mizen für die Louis F. Dow Company malte. Von 1930 bis 1950 illustrierte er auch viel für Publi-kumszeitschriften und lieferte Cover für The Saturday Evening Post, Cosmopolitan *und viele andere wichtige Blätter. Mizen starb 1965.*

vant qu'Haddon Sundblom ne réalise sa première affiche pour Coca-Cola, Fre-erick Mizen avait peint de nombreuses superbes huiles pour les campagnes ationales de la compagnie. La plupart des pin up de Mizen étaient de jolies filles ypiquement américaines, faisant du sport ou occupées à d'autres agréables asse-temps.

Né en 1888 à Chicago, Mizen étudia à la Smith Art Academy entre 1904 et 906 sous la direction de John Vanderpoel, DeForrest Shook et Walter Marshall lute. Il suivit également des cours du soir au Chicago Art Institute. Il reçut sa pre-ière commande de Gunning Systems, prédécesseur de General Outdoor Adver-tising, la grande agence de publicité spécialisée dans les panneaux géants. Mizen devint l'un des principaux artistes spécialisés dans ce genre, ses pin up publicitai-res vantant les mérites de toutes sortes de produits, des bières aux lunettes de soleil. Johnson and Johnson et General Motors furent quelques-unes des grandes firmes qui eurent recours à ses services.

Mizen conçut ses premières pin up de calendriers pour Louis F. Dow vers 1938. Pendant les années 30 et 40, il travailla également pour la presse popu-laire, réalisant des couvertures pour *The Saturday Evening Post, Cosmopolitan*, et bien d'autres publications importantes. Il mourut en 1965.

Al Moore

545

Born in Illinois, Al Moore played college football at Northwestern University and professional football with the Chicago Bears. After attending classes at Chicago's Art Institute and Academy of Art, he opened a commercial art studio in New York in the late 1930s. By the mid-1940s, his clients included major companies like Galey and Lord, Beauty Counselors, the Viscole Corporation, and Champion Spark Flags.

During the war years, Moore painted posters for the government and also took on assignments from Old Gold cigarettes, *Cosmopolitan*, *The Saturday Evening Post*, and *Collier's*.

Advertising work for U.S. Rubber, Nash automobiles, and Coca-Cola led, in 1946, to Moore's breakthrough assignment – he was chosen by *Esquire* to replace Alberto Vargas, the most popular pin-up artist of the day. Among Moore's triumphs at the magazine were his creation of the *Esquire* Girl, his answer to the Varga Girl (figures 548–552); the 1948 *Esquire* calendar (with Ben-Hur Baz and others); front covers in 1948 and 1949; and the rare honor of painting the entire 1949 calendar himself. By 1950, his two-page gatefolds in *Esquire* were collected by millions of Americans.

Moore contributed four pin-ups (figures 545 and 546) and a centerfold print (figure 547) to Brown and Bigelow's Ballyhoo Calendar for 1953, which was as huge a success as Elvgren's work for the previous year's calendar. In the 1950s,

his corporate clients included Modern Munsingwear, Hertz Rent-a-Car, and the McGregor Corporation. During the same years, his illustrations appeared in *American Magazine*, *Woman's Home Companion*, *McCall's*, and *Woman's Day*, and he painted several front covers for *The Saturday Evening Post*. As an active member of the Society of Illustrators, Moore was asked to paint the poster for the society's 1959 exhibition; it was such a success that both Pan American Airlines and Germaine Monteil Perfume also commissioned posters for their national marketing campaigns.

When photographs began to replace artwork in magazines and advertising, Moore decided to retire and pursue fine-art painting, including portrait commissions. Shortly after he moved to Crawford, Colorado, he accepted a commission from the United States Olympic Committee for three paintings for their world headquarters that would call attention to the problem of illegal steroid use by athletes. Moore died in April 1991.

Moore's pin-ups for *Esquire* and Brown and Bigelow were executed primarily in gouache on illustration board averaging 26 x 20 inches (66 x 50.8 cm). His pin-up girls could sometimes have a dreamy, young look, yet at others be sophisticated and sensual; they had an earthy quality very different from Petty's and Vargas's. His granulated skin tones produced the almost iridescent quality that immediately identifies a Moore original.

Gebürtig aus Illinois, spielte Al Moore am Northwestern University College Football und wurde dann bei dem Team der Chicago Bears Football-Profi. Nach dem Besuch von Seminaren am dortigen Art Institute und an der Academy of Art, eröffnete er in den späten 30er Jahren in New York ein eigenes Studio für Werbegrafik. Mitte der 40er Jahre zählten Großunternehmen wie Galey and Lord, Beauty Counselors, die Viscole Corporation und Champion Spark Flags zu seinen Kunden.

Während des Krieges entwarf Moore Poster für die Regierung und arbeitete für die Zigarettenmarke Old Gold und die Zeitschriften Cosmopolitan, The Saturday Evening Post *und* Collier's.

Anzeigenaufträge für U.S. Rubber, Nash Automobiles und Coca-Cola führten 1946 zu seinem künstlerischen Durchbruch: Esquire *machte ihn zum Nachfolger von Alberto Vargas, dem seinerzeit berühmtesten Pin-up-Künstler. Zu Moores Erfolgen bei* Esquire *gehören die Erfindung des Esquire-Girl, seine Antwort auf das* Varga Girl *(Abb. 548 bis 552); der 1948er* Esquire*-Kalender (mit Ben-Hur Baz und anderen); Titelblätter aus den Jahren 1948 und 1949. Hinzu kam die seltene Ehre, den gesamten Kalender für 1949 allein gestalten zu dürfen. 1950 wurden Moores auf zwei Seiten in der Heftmitte gedruckte Zeichnungen schon von Millionen von Amerikanern gesammelt.*

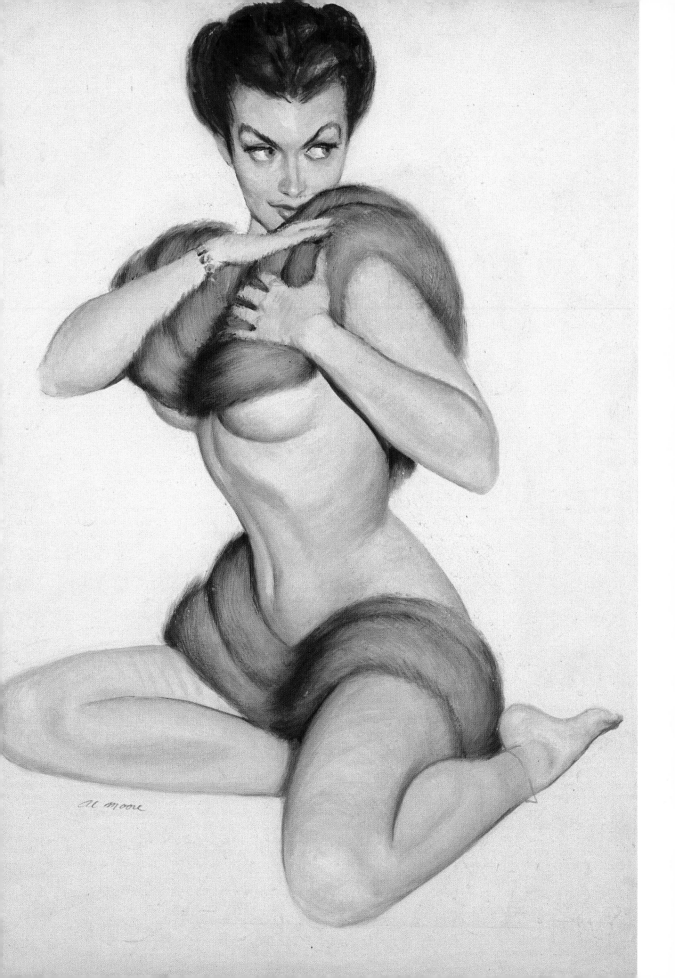

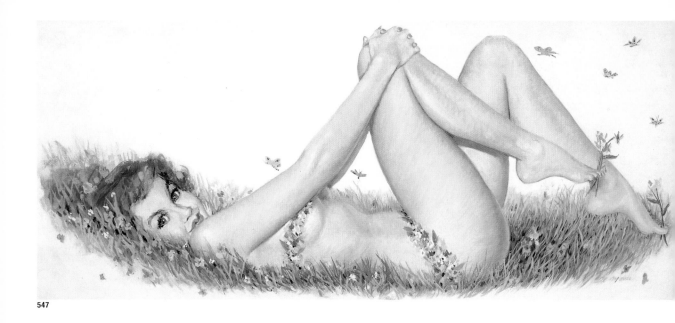

547

Zum Ballyhoo-Kalender 1953 von Brown and Bigelow steuerte Moore vier Pinups (Abb. 545 und 546) und die Doppelseite in der Mitte des Kalenders (Abb. 547) bei. Damit hatte er ähnlichen Erfolg wie Elvgren im vorangegangenen Jahr. In den 50er Jahren war er für Großunternehmen wie Modern Munsingwear, Hertz Rent-a-Car und die McGregor Corporation tätig. Während dieser Jahre erschienen seine Illustrationen auch in American Magazine, Woman's Home Companion, McCall's *und* Woman's Day. Für die Saturday Evening Post *zeichnete Moore mehrere Titelblätter. Als aktives Mitglied der Gesellschaft der Illustratoren wurde Moore gebeten, für die Ausstellung des Verbands im Jahr 1959 das Poster zu malen – mit so großem Erfolg, daß er von Pan American Airlines und dem Markenartikler Germaine Monteil Perfume Plakataufträge für national ausgeschriebene Marketingkampagnen erhielt.*

Als die Fotografie die Malerei in Zeitschriften und auf dem Anzeigenmarkt zu verdrängen begann, zog sich Moore aus dem Geschäftsleben zurück und konzentrierte sich auf klassische Malerei und Porträtaufträge. Er siedelte nach Crawford, Colorado, über und nahm kurz darauf einen Auftrag vom Olympischen Komitee der Vereinigten Staaten an. Für dessen Hauptniederlassung malte er drei Bilder zum Thema Anabolikamißbrauch bei Sportlern. Moore starb im April 1991.

Seine Pin-ups für Esquire *und Brown and Bigelow waren primär in Gouache auf Karton in einer Größe von 66 x 51 cm ausgeführt. Manchmal besaßen seine Pin-up-Girls einen verträumten, mädchenhaften Ausdruck; manchmal waren sie sinnlich und raffiniert. Sie waren etwas derb und unterschieden sich damit sehr von denen Pettys und Vargas'. Seine körnigen Hauttöne verliehen den Bildern einen fast irisierenden Charakter und machten sie unverwechselbar.*

Né dans l'Illinois, Al Moore joua dans l'équipe universitaire de football américain de Northwestern puis dans l'équipe professionnelle des Chicago Bears. Après avoir suivi des cours à l'Art Institute de Chicago puis à l'Academy of Art, il ouvrit un atelier de graphisme à New York à la fin des années 30. Vers le milieu des années 40, il comptait parmi ses clients de grandes compagnies comme Galey and Lord, Beauty Counselors, Viscole Corporation et Champion Spark Flags.

Durant la guerre, il peignit des affiches pour le gouvernement et accepta des commandes pour les cigarettes Old Gold, *Cosmopolitan, The Saturday Evening Post* et *Collier's*.

Ses œuvres publicitaires pour U.S. Rubber, Nash Automobiles et Coca-Cola lui valurent en 1946 une offre exceptionnelle: il fut choisi par *Esquire* pour remplacer Alberto Vargas, alors le plus célèbre des artistes de pin up. Parmi ses triomphes lors de sa collaboration à ce magazine, citons la *Esquire Girl,* sa réponse à la Varga Girl (illustrations 548–552); les images pour le calendrier d'*Esquire* de 1948 (avec Ben-Hur Baz et d'autres); les couvertures de 1948 et 1949; et l'honneur rare de réaliser la totalité des pin up du calendrier de 1949. En 1950, ses posters centraux dans *Esquire* étaient collectionnés par des millions d'Américains.

Moore réalisa quatre pin up (illustrations 545 et 546) et un poster central (illustration 547) pour le Ballyhoo Calendar de 1953 de Brown and Bigelow. Ces travaux remportèrent un succès identique à ceux qu'avait exécutés Elvgren un an

plus tôt. Dans les années 50, il travailla pour plusieurs grandes compagnies dont Modern Munsingwear, Hertz Rent-a-Car et McGregor Corporation. A la même époque, ses illustrations parurent dans *American Magazine, Woman's Home Companion, McCall's* et *Woman's Day*. Il peignit également plusieurs couvertures pour *The Saturday Evening Post*. Membre actif de l'American Society of Illustrators, il réalisa l'affiche de l'exposition organisée par cette association en 1959. Elle fut tellement appréciée que la Pan Am et les parfums Germaine Monteil firent appel à lui pour leurs campagnes nationales de publicité.

Lorsque la photographie commença à prendre le pas sur le dessin et la peinture, Moore prit sa retraite pour se consacrer à la peinture de chevalet, notamment aux portraits. Peu après s'être établi à Crawford, dans le Colorado, il accepta une commande du comité olympique américain. Il s'agissait de concevoir trois affiches pour le siège international du comité, attirant l'attention sur le problème de la consommation de stéroïdes anabolisants par les athlètes. Moore mourut en 1991.

Les pin up de Moore pour *Esquire* étaient réalisées à la gouache sur des cartons à dessin faisant en moyenne 66 x 50,8 cm. Ses pin up étaient tantôt des jeunes filles rêveuses tantôt des femmes du monde sensuelles. Elles avaient toutes une qualité réaliste très différente de celles de Petty ou de Vargas. La texture granuleuse de ses couleurs chair produisait un effet irisé à la surface de ses originaux, ce qui les rend très faciles à reconnaître.

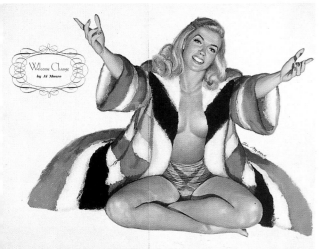

Welcome Change
by Al Moore

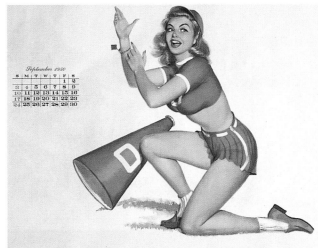

September 1950

S	M	T	W	T	F	S
					1	2
3	4	5	6	7	8	9
10	11	12	13	14	15	16
17	18	19	20	21	22	23
24	25	26	27	28	29	30

548

549

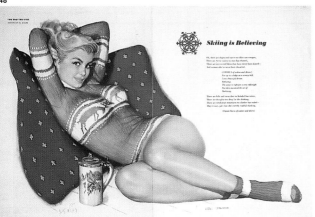

Skiing is Believing

550

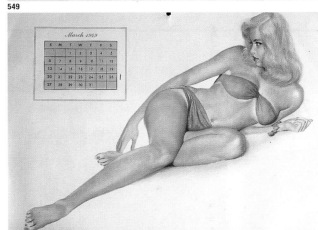

March 1949

S	M	T	W	T	F	S
		1	2	3	4	5
6	7	8	9	10	11	12
13	14	15	16	17	18	19
20	21	22	23	24	25	26
27	28	29	30	31		

551

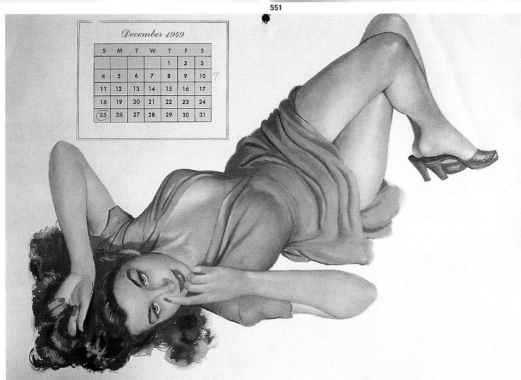

December 1949

S	M	T	W	T	F	S
				1	2	3
4	5	6	7	8	9	10
11	12	13	14	15	16	17
18	19	20	21	22	23	24
25	26	27	28	29	30	31

552

Earl Moran

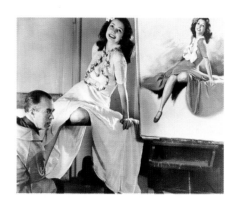

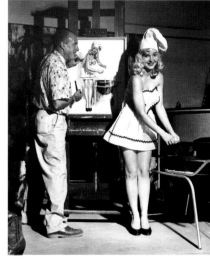

One of the century's most important pin-up and glamour artists, Earl Steffa Moran was born December 8, 1893, in Belle Plaine, Iowa. As a farm boy from the Midwest, he grew up to crave the lights and excitement of big cities. His first instruction in art came under the direction of John Stich, an elderly German artist who had taught the great illustrator W.H.D. Koerner. Moran also studied with Walter Biggs at the Chicago Art Institute, while working for a large engraving house that specialized in men's fashion illustrations.

After two years at the Institute, Moran headed for Manhattan and enrolled at the famed Art Students League, where he took instruction from the muralist Vincent Dumond, Robert Henri, Thomas Fogarty (Norman Rockwell's teacher), and the legendary anatomist George Bridgman. In 1931, he moved back to Chicago and opened a small studio, where he specialized in photography as well as illustration. Moran later sent some paintings of girls in bathing suits to two calendar companies as a way of introducing himself; when both Brown and Bigelow and Thomas D. Murphy Company bought the work, his career was officially launched.

In 1932, Moran signed an exclusive contract with Brown and Bigelow. His first pin-up for the company, *Golden Hours*, depicted a sensuous Art Deco girl in a baby blue bathing suit set against a brilliant orange background (figure 573). So successful was this image that it was licensed out for many uses, even as decoration for a huge five-pound box of chocolates.

Between 1933, when *Golden Hours* was first published, and 1937, when he burst upon the New York scene, Moran's pin-ups sold millions of calendars for Brown and Bigelow. In 1940, *Life* ran a feature article entitled "Speaking of Pictures," which focused largely on Moran's work and made him something of a national celebrity (figures 553, 579, and 580). In October 1941, he helped the brilliant magazine publisher Bob Harrison launch a new men's magazine called *Beauty Parade*, and he later contributed pin-ups to other Harrison magazines such as *Flirt*, *Wink*, and *Giggles*. By 1942, Moran had moved into a new studio on Fifth Avenue that became a meeting place for artists and café society celebrities. Two years later, his estranged wife, Mura, filed for divorce, bitterly accusing Moran of

adultery with Chili Williams, a model and starlet known as the Polka Dot Girl. The press had a field day.

In 1946, having survived his scandalous divorce proceedings and having become Brown and Bigelow's best-selling pin-up artist, Moran packed his bags and headed for a sunnier life in Hollywood. He had already painted many movie stars, including Betty Grable, for publicity posters. Soon after his arrival, he interviewed a young starlet named Norma Jean Dougherty who wanted to model for him. For the next four years, Marilyn Monroe posed for Moran (figures 557, 569, 571, and 572), and the two became friends. She always credited him with making her legs (which she felt were too thin) look better than they were, and he once remarked that "her body was as expressive as her face, which made all the poses good."

Moran lived in the San Fernando Valley from 1951 to 1955, hosting fabulous parties, directing and starring in a short television film, painting portraits of Earl Carroll's Vanities Girls, and maintaining his position as a star of the pin-up world. After a move to Las Vegas about 1955 and several years of living in the fast lane, he returned to Los Angeles and worked two more years for Brown and Bigelow. Moran then decided to call it quits and to devote his time to painting fine-art subjects, with nudes as his favorite theme. Signing with Aaron Brothers Galleries, he painted for collectors until 1982, when his eyesight failed. He died in Santa Monica on January 17, 1984.

An expert on lighting his models and sets, Moran used photography especially skillfully to capture the candid, natural expressions he sought in his work. He worked in various mediums and sizes throughout his career, and his originals for the pin-up and glamour market varied widely in size. Generally, though, he was most comfortable with pastels and liked to work large – usually 40 x 30 inches (101.6 x 76.2 cm), on toothed paper mounted to heavy illustration board. He did paint in oil on canvas in the 1940s ((figure 570) and in oil on canvasboard in the 1950s; occasionally he used gouache on illustration board. Some of his magazine work for Harrison is signed "Steffa" or "Black Smith."

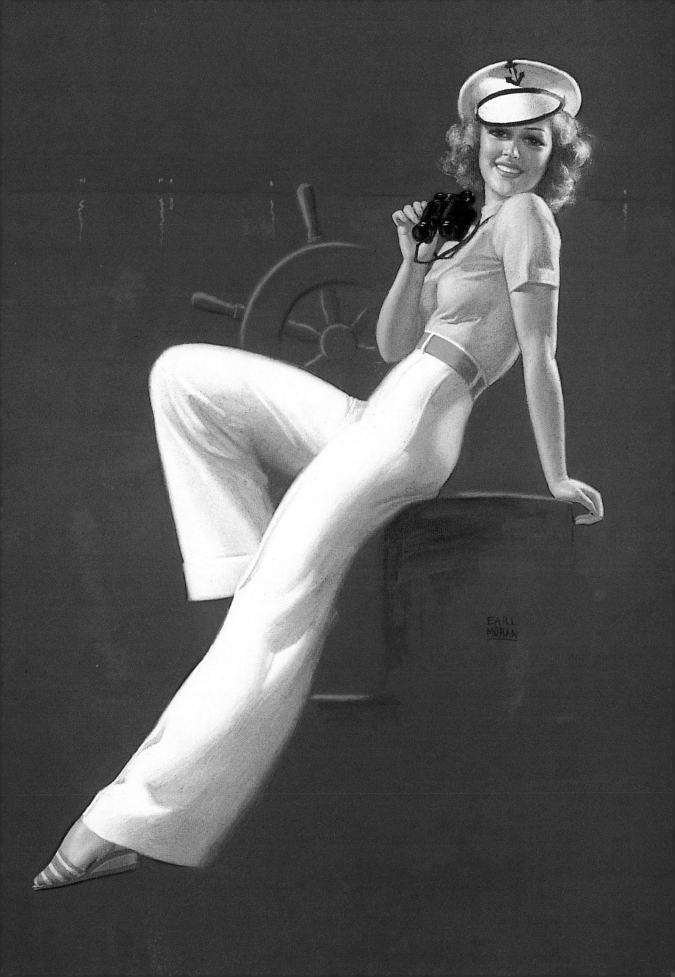

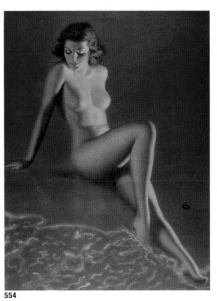

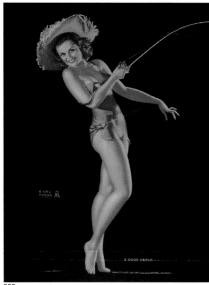

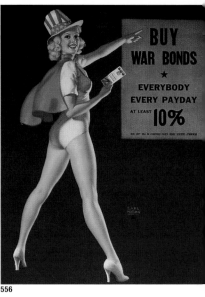

554 555 556

Earl Steffa Moran war einer der wichtigsten Pin-up- und Glamour-Künstler dieses Jahrhunderts. Er wurde am 8. Dezember 1893 in Belle Plaine, Iowa, geboren. Auf einer Farm im Mittleren Westen aufgewachsen, sehnte er sich nach dem aufregenden Leben und den Neonlichtern der Großstadt. Seinen ersten Kunstunterricht erteilte ihm John Stich, ein älterer deutscher Künstler, der auch den hervorragenden Illustrator W.H.D. Koerner unterwiesen hatte. Am Art Institute of Chicago studierte Moran bei Walter Biggs und arbeitete gleichzeitig für eine große Gravuranstalt, die sich auf Illustrationen im Bereich Männermode spezialisiert hatte.

Nach zwei Jahren Unterricht am Art Institute ging Moran nach Manhattan und schrieb sich dort an der berühmten Art Students League ein. Er nahm Unterricht bei dem für seine Wandgemälde bekannten Vincent Dumond, bei Robert Henri, Thomas Fogarty (dem Lehrer Norman Rockwells) und dem schon legendären Anatom George Bridgman. 1931 kehrte Moran nach Chicago zurück, wo er ein kleines Studio eröffnete und sich auf Fotografie und Illustrationen spezialisierte. Einige Zeit später schickte er mehrere Bilder von Mädchen in Badeanzügen als Visitenkarten an zwei Kalenderverlage; beide – Brown and Bigelow und die Thomas D. Murphy Company – kauften die Arbeiten an und gaben so den Startschuß zu Morans Karriere.

1932 unterzeichnete Moran einen Vertrag, der ihn exklusiv an Brown and Bigelow band. Sein erstes Pin-up für das Unternehmen, genannt Golden Hours, war ein sinnliches Art-deco-Girl in einem pastellblauen Badeanzug, das vor einem strahlend orangefarbenen Hintergrund posierte (Abb. 573). Dieses Bild war so erfolgreich, daß es für eine Vielzahl von Produkten lizenziert wurde, sogar als Dekoration einer riesigen zweieinhalb Kilo schweren Pralinenschachtel.

Zwischen 1933, als Golden Hours erstmals veröffentlicht wurde, und 1937, als er in die New Yorker Szene wechselte, verhalfen Morans Pin-ups den Kalendern von Brown and Bigelow zu einer Auflage in Millionenhöhe. 1940 druckte die Zeitschrift Life unter dem Titel „Speaking of Pictures" ein Feature, das sich hauptsächlich auf die Arbeiten Morans konzentrierte und ihm fast nationale Berühmtheit bescherte (Abb. 553, 579 und 580). Im Oktober 1941 half er dem brillanten Zeitschriftenverleger Bob Harrison, ein neues Männermagazin namens Beauty Parade auf den Markt zu bringen und arbeitete später auch für andere Zeitschriften dieses Verlegers wie Flirt, Wink und Giggles. 1942 zog Moran in ein neues Studio auf der Fifth Avenue, das zum Treffpunkt von Künstlern und der in den Trend-Cafés verkehrenden Szene wurde. Zwei Jahre später reichte seine von ihm

getrennt lebende Frau Mura unter bitteren Anschuldigungen die Scheidung ein – Moran habe sie mit dem Starlet und Modell Chili Williams, besser bekannt als das „Polka Dot Girl" (das Tupfen-Mädel) betrogen. Die Presse hatte einen großen Tag.

Nachdem er 1946 seine von Skandalen umwitterte Scheidung hinter sich gebracht hatte und zum bestverkauften Pin-up-Künstler bei Brown and Bigelow avanciert war, zog es Moran in sonnigere Gestade: nach Hollywood. Er hatte bereits viele Filmstars für Poster gemalt, darunter auch Betty Grable. Kurz nach seiner Ankunft interviewte er ein junges Starlet namens Norma Jean Dougherty (Marilyn Monroe), die sich als Modell beworben hatte. Vier Jahre lang saß sie ihm Modell (Abb. 557, 569, 571 und 572), und die beiden wurden Freunde. Es sei sein Verdienst gewesen, sagte die Monroe immer, daß ihre Beine, die sie für zu dünn hielt, besser aussahen. Und Moran sagte einmal: „Ihr Körper war so ausdrucksstark wie ihr Gesicht, und deshalb sah jede Pose gut aus".

Zwischen 1951 und 1955 lebte Moran im San Fernando Valley, gab wunderbare Parties, führte Regie in einem kurzen Fernsehfilm, in dem er auch die Hauptrolle spielte, malte Porträts von Earl Carrolls sogenannten Vanities Girls und behauptete seine Stellung als Star der Pin-up-Welt. Um 1955 zog er nach Las Vegas und lebte einige Jahre ein reichlich schnelles und intensives Leben. Dann kehrte er nach Los Angeles zurück, arbeitete noch zwei Jahre für Brown and Bigelow und zog dann einen Schlußstrich. Moran wandte sich der klassischen Kunst zu und spezialisierte sich auf Akte. Er wurde von der Galerie Aaron Brothers vertreten und malte bis 1982. Dann ließ sein Augenlicht nach. Er starb in Santa Monica am 17. Januar 1984.

Moran beherrschte die Kunst des Ausleuchtens seiner Modelle und des Bildaufbaus perfekt und setzte die Fotografie besonders kunstfertig da ein, wo er einen offenen und natürlichen Ausdruck für seine Arbeiten einzufangen suchte. Er arbeitete während seiner Karriere mit verschiedenen Techniken und Bildformaten; die Größe seiner Originale für den Pin-up- und Glamourmarkt variieren beträchtlich. Normalerweise fühlte er sich jedoch am wohlsten in der Arbeit mit Pastell und großen Formaten – meist 101 x 76 cm, auf gezahntem Skizzenpapier, das auf festen Karton aufgezogen wurde. In den 40er Jahren malte er zeitweise in Öl auf Leinwand; in den 50er Jahren in Öl auf aufgezogener Leinwand; manchmal arbeitete er auch in Gouache. Einige seiner Zeitschriften-Beiträge für Harrison sind mit „Steffa" oder „Black Smith" signiert.

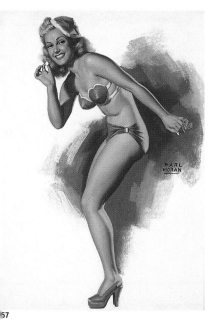

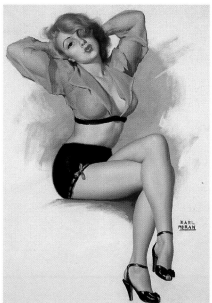

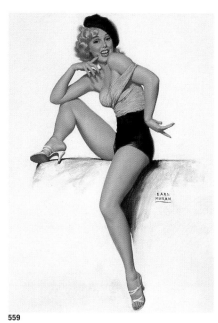

57 558 559

é le 8 décembre 1893, à Belle Plaine, dans l'Iowa, Earl Steffa Moran fut l'un es plus importants peintres de pin up et d'art glamour. Enfant de la campa- ne, il grandit en rêvant des lumières de la grande ville. Il prit ses premiers burs de dessin avec John Stich, un vieil artiste allemand qui avait également té le professeur du grand illustrateur W.H.D. Koerner. Moran étudia ensuite vec Walter Biggs à l'Art Institute de Chicago, tout en travaillant pour un gros nprimeur spécialisé dans les illustrations de mode masculine.

Après deux ans à l'Art Institute, Moran partit pour Manhattan où il s'inscrivit la célèbre Art Students League. Là, il eut pour professeurs le fresquiste Vin- ent Dumond, Robert Henri, Thomas Fogarty (professeur de Norman Rockwell) le légendaire anatomiste George Bridgman. En 1931, il revint à Chicago et uvrit un petit atelier spécialisé dans la photographie et l'illustration. Moran nvoya plus tard quelques peintures de jeunes filles en maillots de bain à deux diteurs de calendriers en guise de carte de visite. Lorsque Brown and Bigelow t Thomas D. Murphy répondirent qu'ils les lui achetaient, sa carrière était offi- ellement lancée.

En 1932, Moran signa un contrat d'exclusivité avec Brown and Bigelow. Sa remière pin up pour l'éditeur, *Golden Hours,* était une langoureuse beauté Art éco en maillot de bain bleu ciel, se détachant sur un fond orange vif (illustra- on 573). Cette image eut un tel succès qu'elle fut revendue de nombreuses is, notamment pour décorer une énorme boîte de chocolats de deux kilos et emi.

Entre 1933, date de la première publication de *Golden Hours* et 1937, rsque Moran fit irruption sur la scène new-yorkaise, ses pin up firent vendre es millions de calendriers à Brown and Bigelow. En 1940, *Life* publia un eportage intitulé «Et si on parlait d'images?» qui était centré principalement ur le travail de Moran et fit de lui une sorte de célébrité nationale (illustrations 53, 579 et 580). En octobre 1941, il aida le brillant éditeur de presse Bob arrison à lancer un nouveau magazine pour hommes: *Beauty Parade.* Plus rd, il réalisa des pin up pour les autres publications d'Harrison telles que *lirt, Wink* et *Giggles.* En 1942, Moran emménagea dans un atelier de la Cin- uième avenue qui devint bientôt un lieu de rendez-vous de tout ce que New ork comptait d'artistes et de célébrités. Deux ans plus tard, sa femme, dont il tait séparé, demanda le divorce en l'accusant d'adultère avec Chili Williams,

modèle et starlette connue sous le nom de «La fille aux petits pois». La presse se régala.

En 1946, après son divorce très médiatisé et sa collaboration remarquée avec Brown and Bigelow, Moran plia armes et bagages et s'en alla vers des contrées plus ensoleillées, à savoir Hollywood. Il avait déjà peint de nombreu- ses stars de cinéma, dont Betty Grable, pour des affiches promotionnelles. Peu après son arrivée, il eut un entretien avec une jeune starlette souhaitant poser pour lui. Elle s'appelait Norma Jean Dougherty. Au cours des quatre années qui suivirent, Marilyn Monroe – car c'était elle – posa régulièrement pour Moran (illustrations 557, 569, 571 et 572) et devint une amie. Elle déclara souvent par la suite qu'il avait rendu ses jambes (qu'elle trouvait maigrichonnes) plus belles qu'elles ne l'étaient. De son côté, il confia qu'elle «avait un corps aussi expressif que son visage, ce qui rendait toutes ses poses intéressantes».

Moran vécut dans la vallée de San Fernando de 1951 à 1955, organisant de fabuleuses soirées, dirigeant et jouant dans un court-métrage de télévision, peignant le portrait des Vanities Girls de Earl Caroll et conservant son titre de roi de la pin up. Après un long séjour à Las Vegas vers 1955 et plusieurs années de vie frénétique, il revint à Los Angeles où il reprit du service chez Brown and Bigelow pendant deux ans. Puis il décida de prendre sa retraite pour se consacrer à la «grande peinture» et à son thème de prédilection: le nu. Il signa un contrat avec Aaron Brothers Galleries et peignit pour des collec- tionneurs jusqu'en 1982, quand sa vue ne lui permit plus de continuer. Il mou- rut à Santa Monica le 17 janvier 1984.

Moran n'avait pas son pareil pour éclairer ses modèles et ses plateaux. Il savait parfaitement manier l'appareil-photo pour saisir les expressions candi- des et naturelles qu'il recherchait pour son travail. Il travailla divers formats et techniques, et ses originaux de pin up et de beautés glamour variaient consi- dérablement en taille. Toutefois, il semblait plus à l'aise avec les pastels et aimait travailler sur de grandes feuilles de papier grenu (généralement 101,6 x 76,2 cm) montées sur d'épais cartons à dessin. Dans les années 40, il peignit à l'huile sur toile (illustration 570), puis dans les années 50 sur des cartons entoilés. De temps à autre, il utilisait de la gouache sur des cartons à dessin. Certaines de ses œuvres pour les publications d'Harrison étaient signées «Stefa» ou «Black Smith».

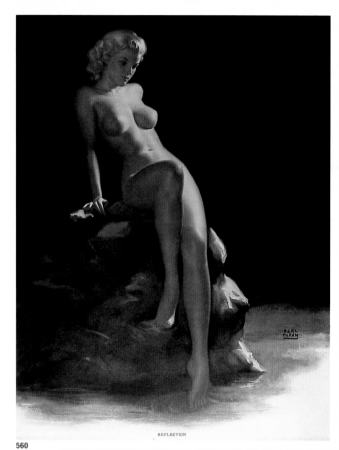

REFLECTION

560

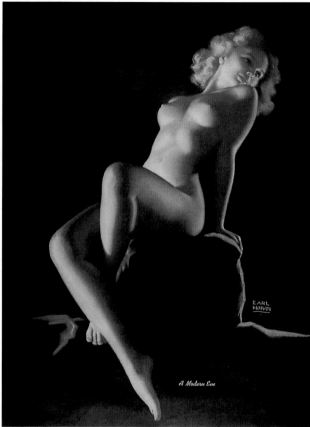

A Modern Eve

561

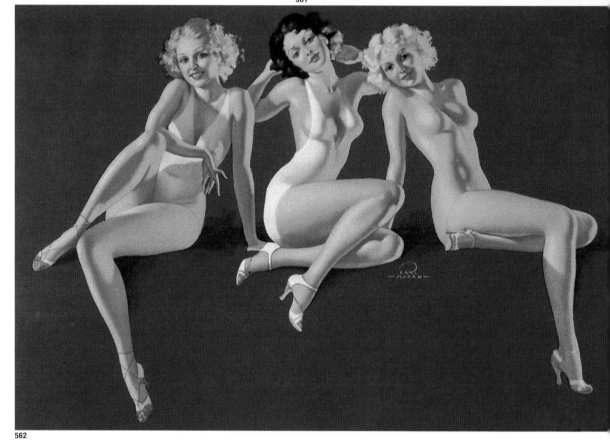

562

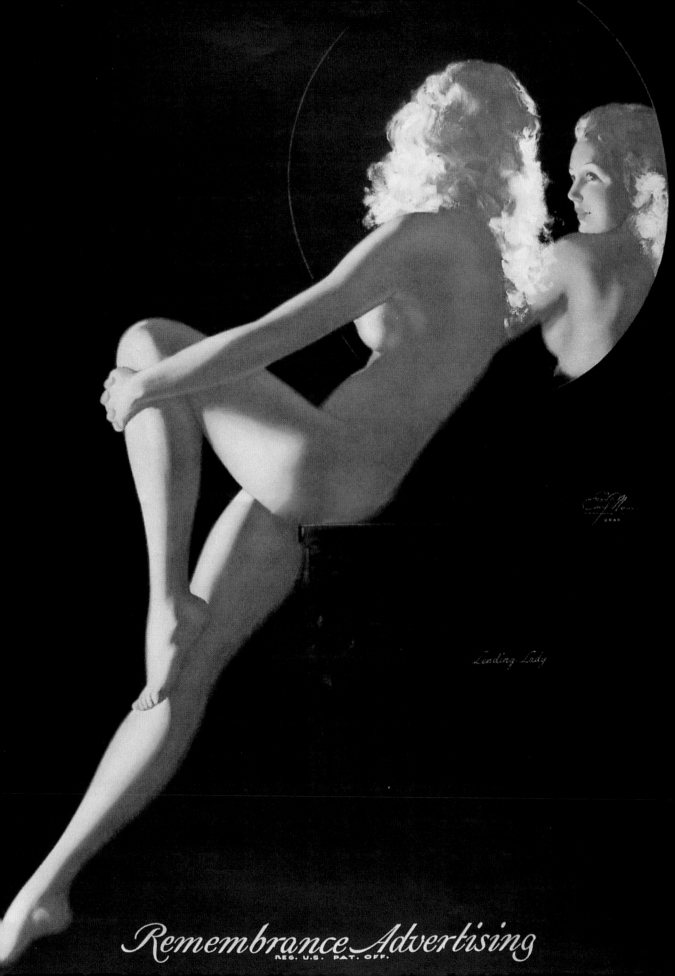

Leading Lady

Remembrance Advertising
REG. U.S. PAT. OFF.

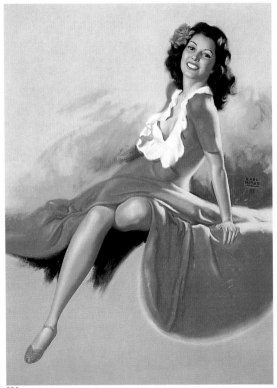

564

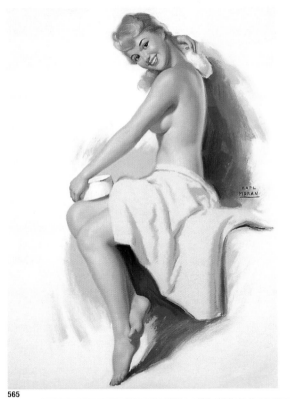

565

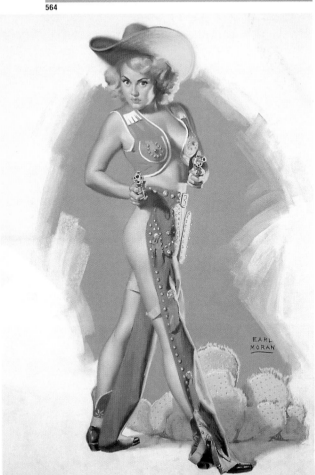

566

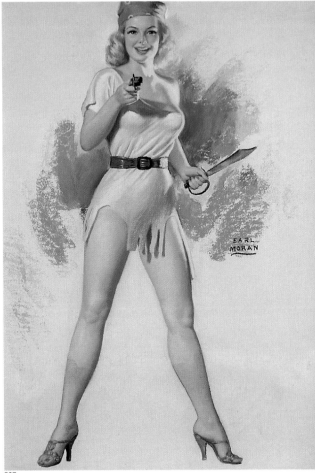

567

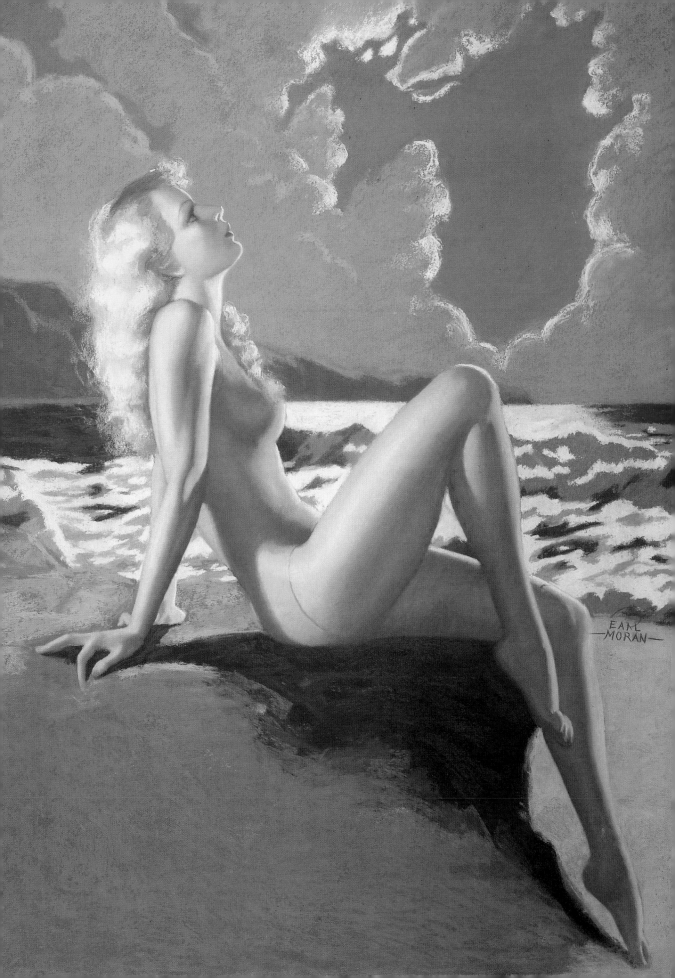

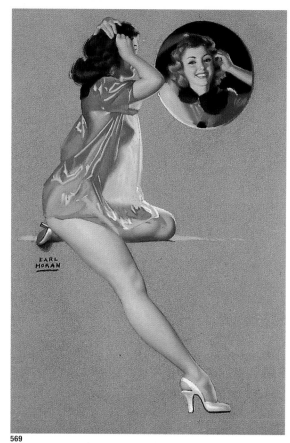

569

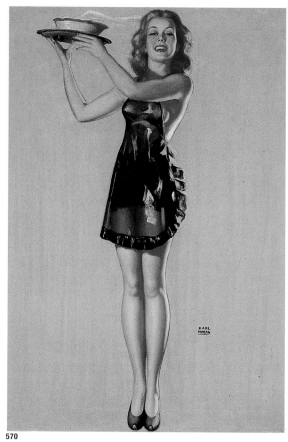

570

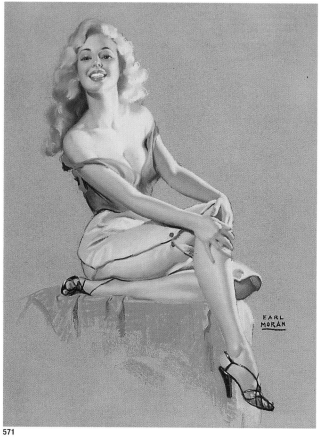

571

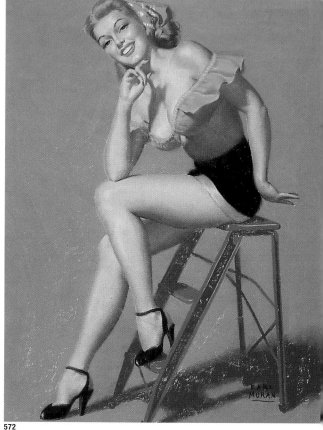

572

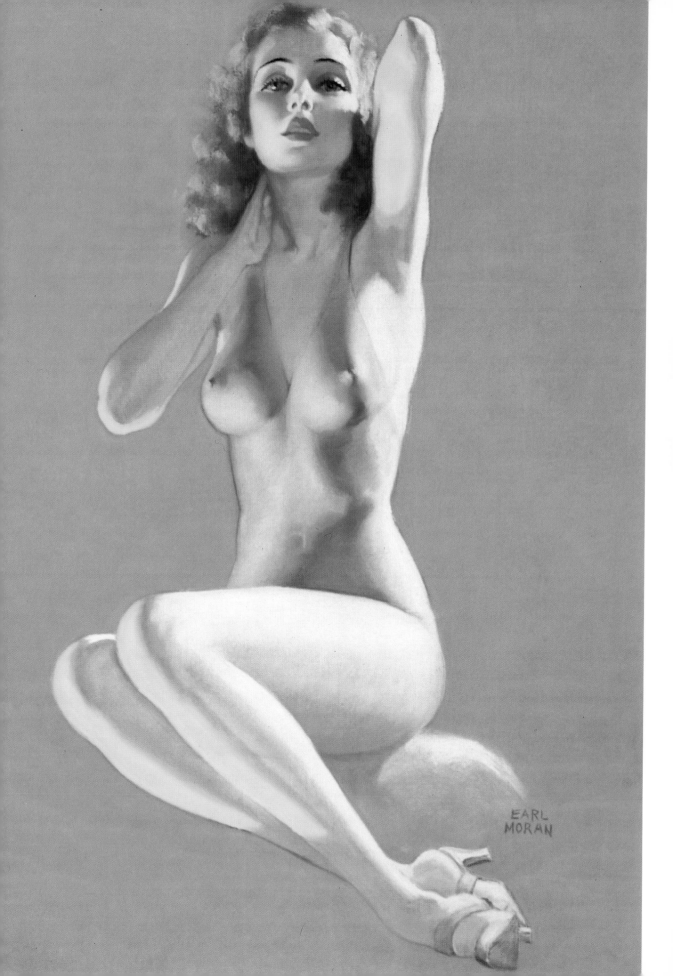

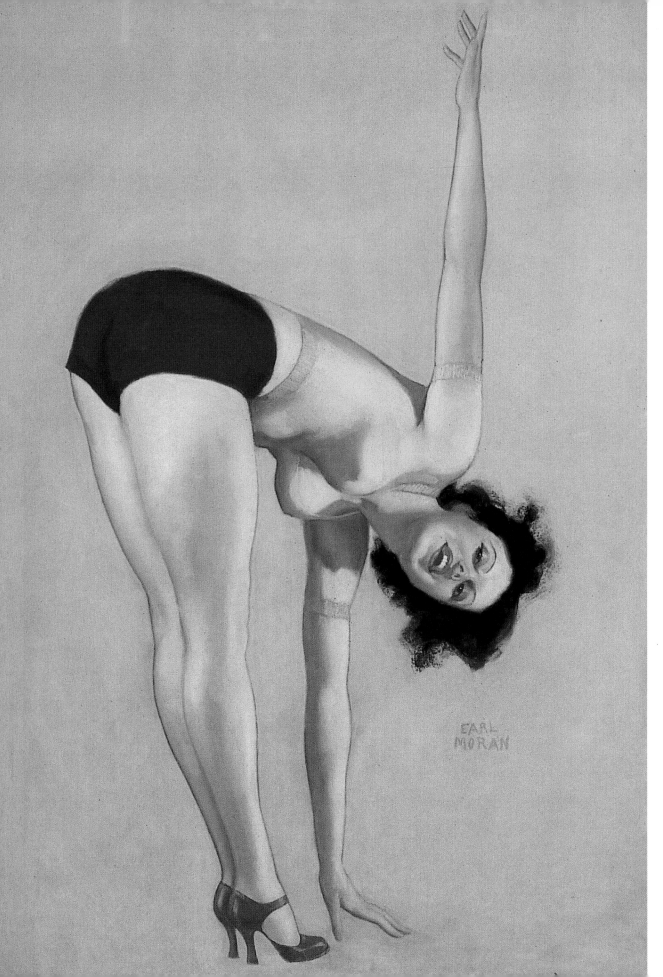

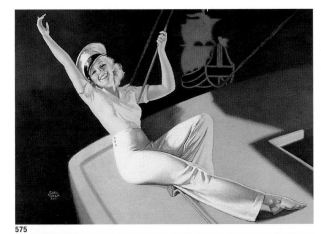

575

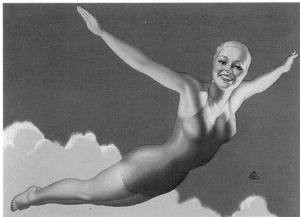

576

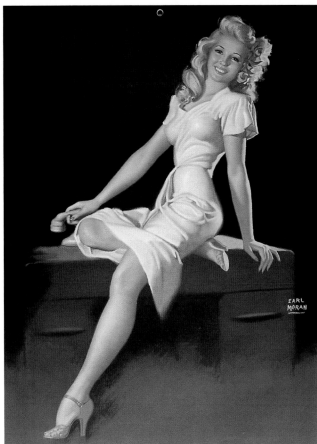

577

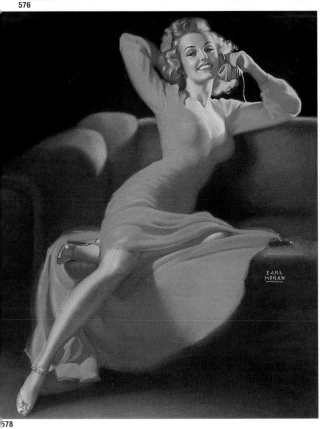

578

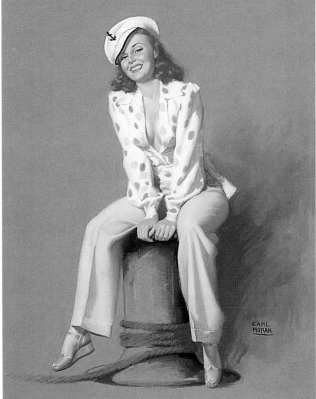

579

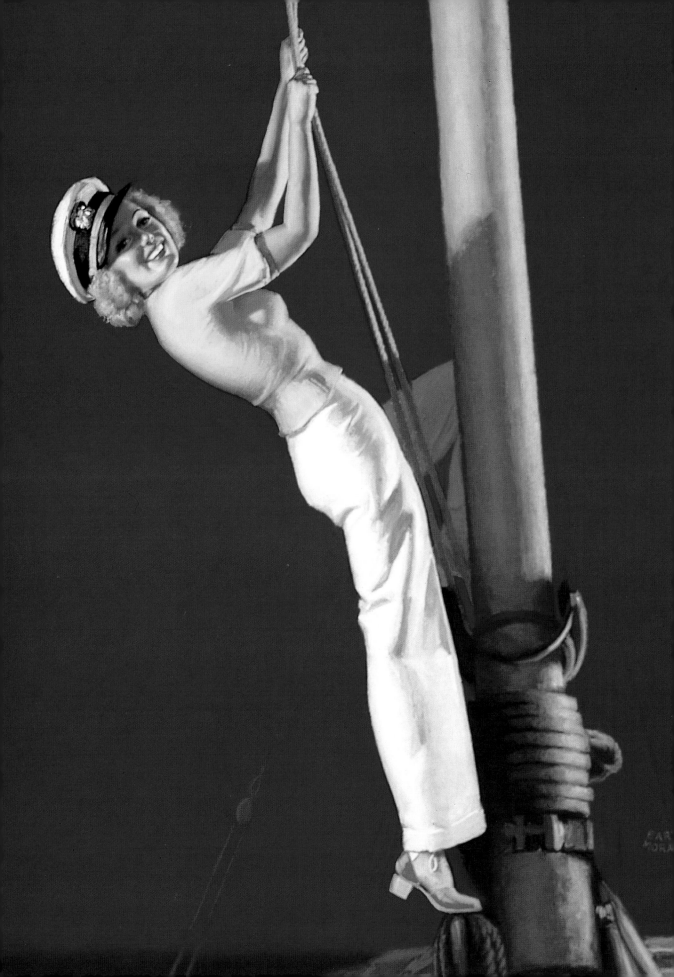

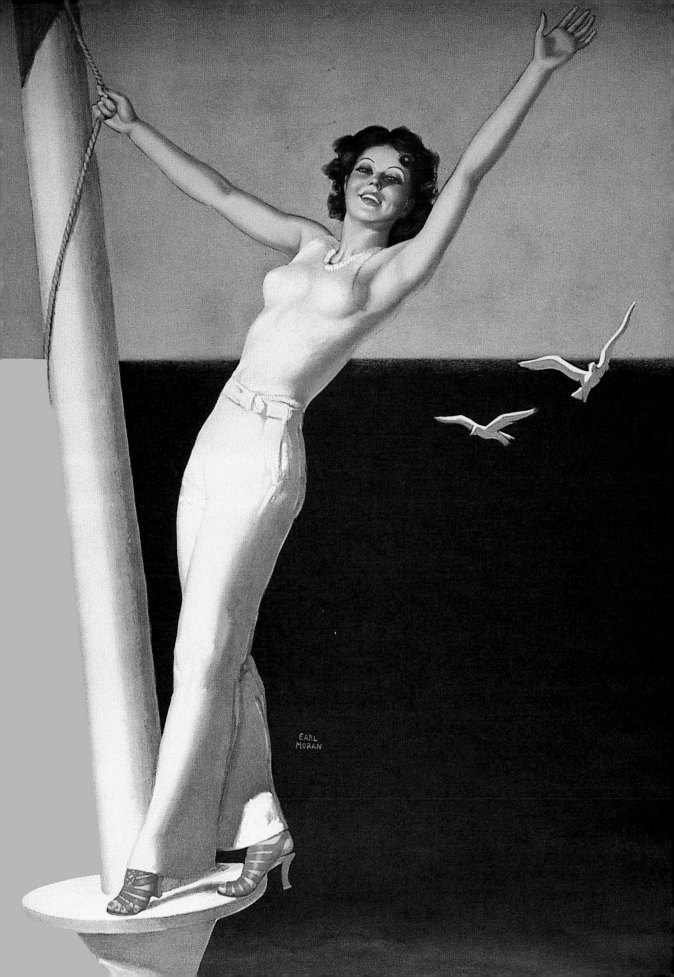

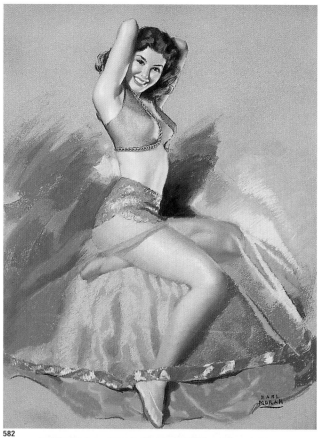

582

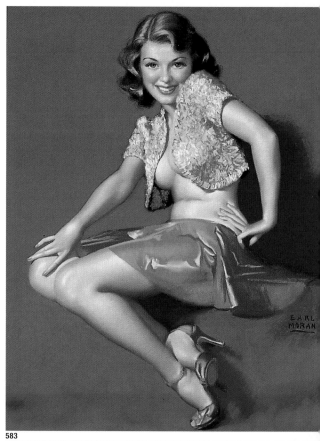

583

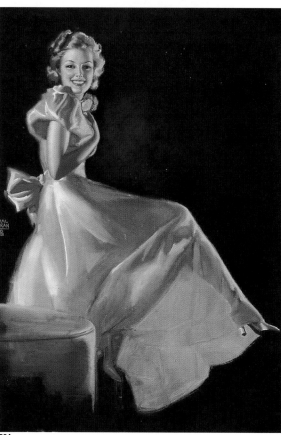

584

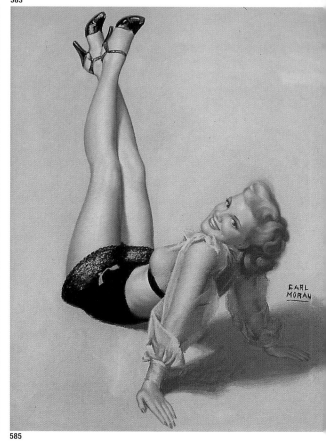

585

586

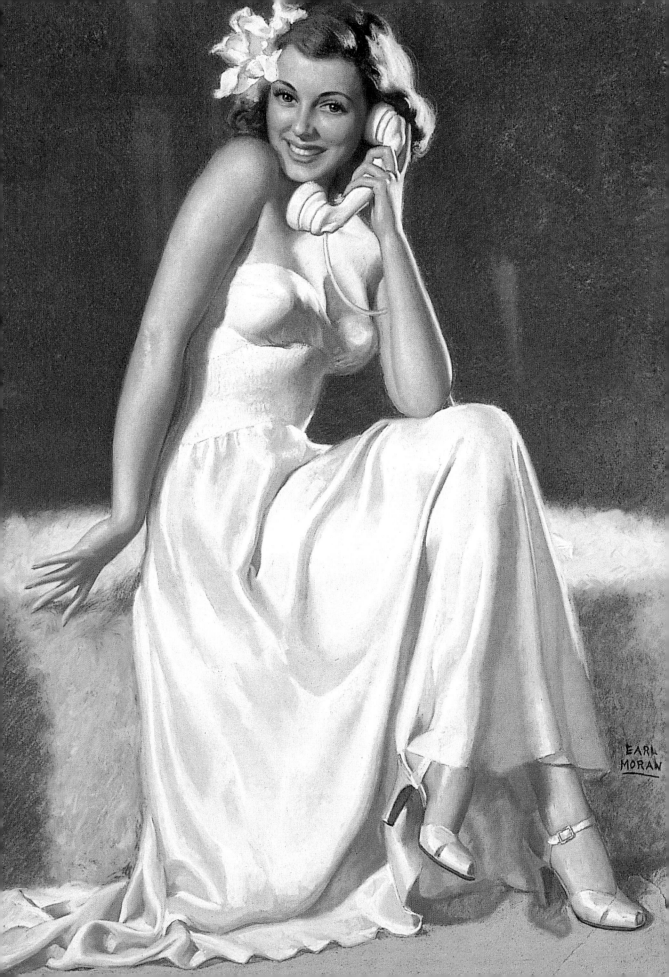

Zoë Mozert

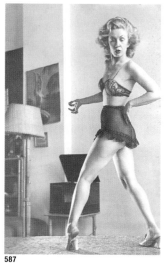
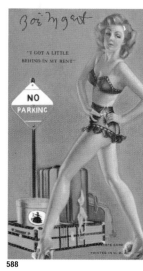

587

588

Zoë Mozert, the most successful and publicly well known of the three female calendar artists, was born in 1907 in Colorado Springs, Colorado. As soon as she was old enough, she changed her real name, Alice Adelaide Moser, because she said she could never become famous with a name like that. In 1925, she entered the Philadelphia School of Industrial Art where she studied under Thornton Oakley, a former student of Howard Pyle. To pay her tuition, she modeled in art classes at the nearby Women's School of Design.

Mozert moved to New York in 1932. In the next four years, she painted more than four hundred front covers for movie magazines like *Screen Book* and *True Romance* and for pulp magazines like *Paris Nights*. In 1937, Paramount Pictures asked her to create advertising art for their film *True Confessions*, starring Carole Lombard.

Covers for Hearst's *American Weekly* followed, as did advertisements for Wing cigarettes featuring Greta Garbo and Clark Gable. Mozert was a judge at the 1938 Miss America Beauty Pageant, along with James Montgomery Flagg and George Petty. Interviewed in Atlantic City by Pathé newsreel, she was increasingly recognized as a top glamour artist, receiving assignments from Dell, Fawcett, Street and Smith, and King Features.

In 1941, Brown and Bigelow bought Mozert's first nude and signed her to an exclusive calendar contract. A poster for Howard Hughes's film *The Outlaw* added to

her fame, and she was asked to appear in a 1945 Paramount Pictures film entitled *Unusual Occupations*. During the war, her pin-up series for Brown and Bigelow called Victory Girls was published both in calendar and mutoscope-card form. Pic magazine published an October 1946 cover story on Mozert entitled "Pin-Up Girl Who Paints 'Em Too!" – a reference to the fact that she was her own best model; she often posed herself before a mirror after she had skillfully manipulated the lights in her studio. She also worked as a consultant to the film *Never Say Good-by*, about a calendar artist trying to paint the perfect pin-up.

After moving to Hollywood in 1946, Mozert created the publicity poster for Republic Pictures' *Calendar Girl*, a movie about the Gibson Girl. By 1950, she had become one of the "big four" at Brown and Bigelow, along with Armstrong, Moran, and Elvgren. Her nudes had become so popular that many of the firm's biggest accounts had standing orders for a specified number of calendars every time a new one was released. Her most popular image, *Song of the Desert* (1950), depicted an exquisite blonde nude and her Arabian horse. She and Armstrong had introduced horizontal pin-ups to Brown and Bigelow's hanger line, and their cowgirl pin-ups were highly successful in that format.

Mozert left Hollywood for Arizona in 1956. Her 1958 marriage to the artist Herb Rhodes ended two years later in divorce. She died in Arizona on February 1, 1993.

Zoë Mozert, die erfolgreichste und bekannteste der drei für Kalenderverlage tätigen Frauen, wurde 1907 in Colorado Springs, Colorado, geboren. Sobald sie alt genug dazu war, änderte sie ihren richtigen Namen Alice Adelaide Moser in Zoë Mozert; denn mit so einem Namen, fand sie, könne man nicht berühmt werden. 1925 schrieb sie sich an der Philadelphia School of Industrial Art ein. Dort gehörte Thornton Oakley, ein früherer Student von Howard Pyle, zu ihren Dozenten. Um die Studiengebühren bezahlen zu können, stand sie in der nahegelegenen Women's School of Design den Kunststudentinnen Modell.

1932 zog Mozert nach New York. In den kommenden vier Jahren zeichnete sie mehr als 400 Titelbilder für Filmzeitschriften wie Screen Book *und* True Romance *und auch für Billigtitel wie* Paris Nights. *1937 beauftragte sie die Filmfirma Paramount Pictures mit der Anzeigenvorlage zu ihrem Film* True Confessions *mit Carole Lombard in der Hauptrolle.*

Cover für Hearsts American Weekly *folgten, ebenso Anzeigenvorlagen mit Greta Garbo und Clark Gable für die Zigarettenmarke Wing. Bei der Wahl zur Miss America 1938 war Mozert neben James Montgomery Flagg und George Petty eine der Juroren. Sie wurde von der Pathé-Wochenschau in Atlantic City interviewt und festigte ihren Ruf als eine der besten Glamour-Künstlerinnen. Aufträge von Verlagshäusern wie Dell und Fawcett, Street and Smith und King Features folgten.*

1941 kauften Brown and Bigelow Mozerts ersten Akt und boten ihr an, exklusiv für ihre Firma zu arbeiten. Ein Poster für den Film The Outlaw *(Geächtet) von Howard Hughes vergrößerte ihren Ruhm, und 1945 bot ihr Paramount eine Rolle in dem Film* Unusual Occupations *an. Während des Krieges wurde ihre Pin-up-Serie „Victory Girls" für Brown and Bigelow sowohl als Kalender als auch als Mutoskopkarten veröffentlicht. Unter der Überschrift „Pin Up Girl Who Paints 'Em Too!" („Sie*

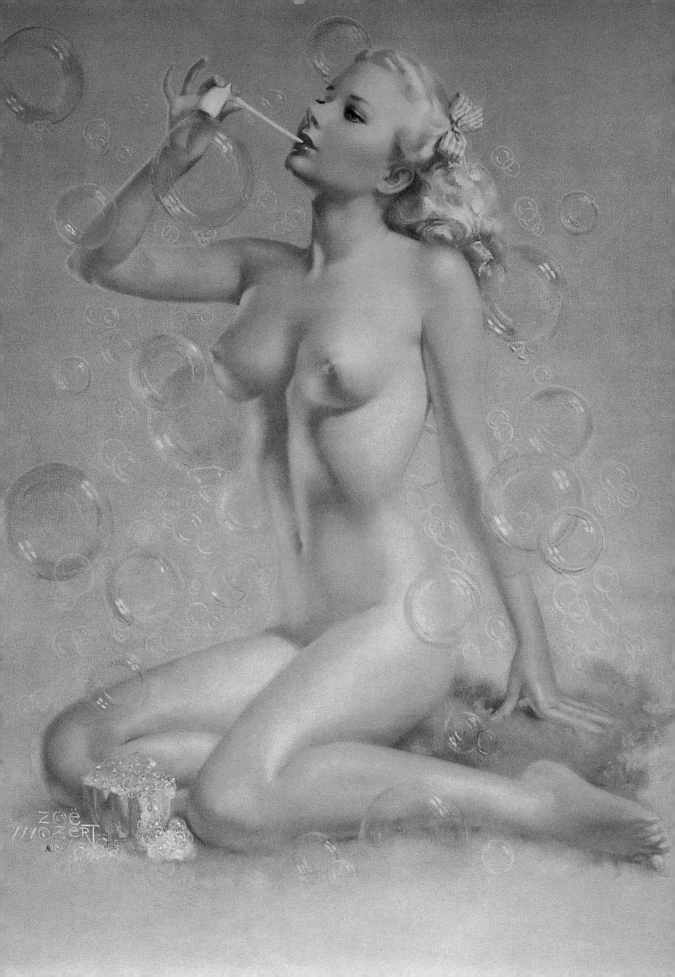

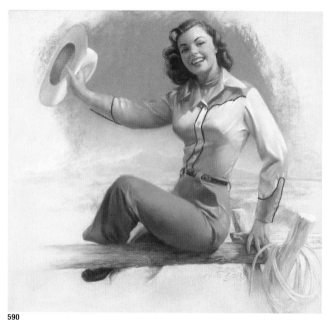

590

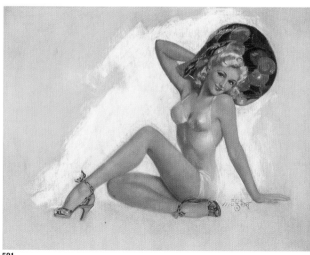

591

ist nicht nur selbst ein Pin-up-Girl, sondern malt sie auch") schrieb die Zeitschrift Pic im Oktober 1946 eine Titelgeschichte über Mozert und bezog sich darin auf die Tatsache, daß Mozert selbst ihr bestes Modell war. Oft setzte sie sich, nachdem sie den Arbeitsbereich im Studio sorgfältig ausgeleuchtet hatte, vor einen Spiegel und posierte für ihre Leinwand. Bei dem Film Never Say Good-bye, einer Geschichte über einen für Kalenderverlage arbeitenden Künstler, der das perfekte Pin-up zu malen versuchte, fungierte sie als Beraterin.

Nach ihrem Umzug nach Hollywood im Jahr 1946 entwarf Mozert das Filmposter zu Calendar Girl des Verleihers Republic Pictures, einer Geschichte über das Phänomen des Gibson Girl. 1950 war sie zu einer der „Großen Vier" bei Brown and

Bigelow geworden und teilte diese Ehre mit Armstrong, Moran und Elvgren. Ihre Akte waren nun so populär, daß viele der größten Kunden des Unternehmens Dau eraufträge für eine bestimmte Anzahl neuer Kalender erteilten. Ihr berühmtestes Bild, Song of the Desert (1950), zeigt einen exquisiten weiblichen Akt, eine Blond ne und ihr Araberpferd. Zusammen mit Armstrong hatte sie bei Brown and Bigelo Wandkalender im Querformat eingeführt, und ihre Cowgirl-Pin-ups in diesem For mat waren sehr erfolgreich.

1956 zog Mozert von Hollywood nach Arizona und heiratete 1958 den Künstle Herb Rhodes. Doch die Ehe wurde zwei Jahre später geschieden. Sie starb am 1. Februar 1993 in Arizona.

Née en 1907 à Colorado Springs, dans le Colorado, Zoë Mozert était la plus célèbre des trois femmes artistes qui travaillaient pour le secteur des calendriers. Dès qu'elle fut en âge de le faire, elle changea son nom de baptême, Alice Adelaïde Moser, estimant qu'elle ne pourrait jamais devenir célèbre avec un nom pareil. En 1925, elle entra à la Philadelphia School of Industrial Art, où elle suivit les cours de Thornton Oakley, lui-même ancien élève de Howard Pyle. Pour financer ses études, elle posait pour les cours de dessins de la Women's School of Design, située à deux pas.

Mozert s'installa à New York en 1932. Pendant les quatre années qui suivirent, elle peignit plus de quatre cents couvertures pour des magazines de cinéma dont Screen Book et True Romance, ainsi que pour des pulps comme Paris Nights. En 1937, les studios Paramount lui commandèrent les affiches du film True Confessions, dont la vedette était Carole Lombard.

Suivirent des couvertures pour la publication de Hearst American Weekly ainsi que des publicités pour les cigarettes Wing, où figuraient Greta Garbo et Clark Gable. En 1938, Mozert fit partie du jury de Miss Amérique, aux côtés de James Montgomery Flagg et de George Petty. A cette occasion, elle fut interviewée à Atlantic City pour les actualités Pathé. Elle était déjà reconnue comme une grande artiste glamour, recevant des commandes de maisons d'édition telles que Dell, Fawcett, Street and Smith et King Features.

En 1941, Brown and Bigelow lui acheta son premier nu et lui fit signer un contrat d'exclusivité pour ses peintures de calendriers. Une affiche pour le film

d'Howard Hughes, The Outlaw, et son apparition dans un film de la Paramount d 1945, Unusual Occupations, ajoutèrent encore à sa notoriété. Pendant la guerre elle réalisa une série de pin up patriotiques pour Brown and Bigelow baptisée «Victory Girls», publiée sous forme de calendrier et de cartes d'art. En octobre 1946, elle fit l'objet de la couverture de Pic. A l'intérieur, un grand article lui était consacré, intitulé «Une pin up qui peint des pin up», allusion au fait que Mozert était souvent son propre modèle. Après avoir minutieusement arrangé les lumières dans son atelier, elle peignait devant un miroir. Elle travailla également comm conseillère sur le film Never Say Good-bye, qui traitait d'un illustrateur de calendriers en quête de la pin up idéale.

Après s'être établie à Hollywood en 1946, Mozert créa l'affiche de Calendar Girl, un film de Republic Pictures sur la Gibson Girl. Vers 1950, elle était déjà l'ur des quatre «vedettes» de Brown and Bigelow, aux côtés d'Armstrong, de Moran d'Elvgren. Ses nus étaient devenus si populaires qu'un grand nombre de ses calendriers étaient commandés à l'avance avant même leur parution. Son nu le plus vendu, Song of the Desert (1950), montrait une ravissante blonde et un cheval arabe. Avec Armstrong, elle introduisit les pin up horizontales dans la collection des calendriers-cintres de Brown and Bigelow. Les pin up cow-girls réalisées par les deux artistes sous ce format firent un tabac.

Mozert quitta Hollywood en 1956 pour s'installer en Arizona. Son mariage ave l'artiste Herb Rhodes en 1958 se solda par un divorce deux ans plus tard. Elle mourut en Arizona le 1er février 1993.

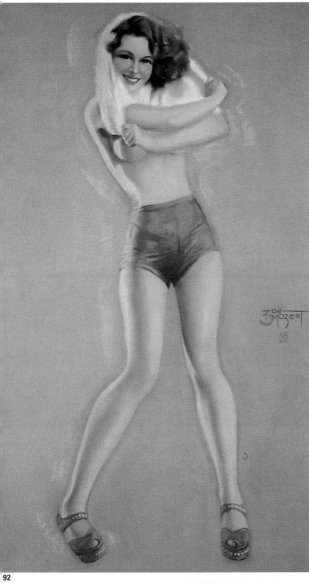

92

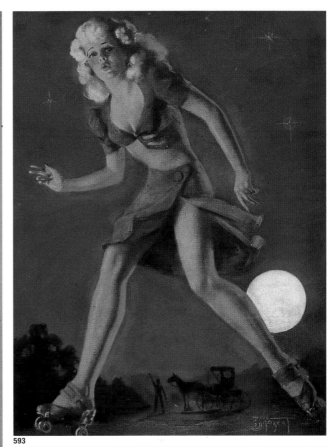

593

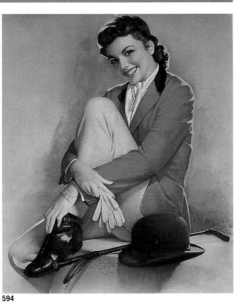

594

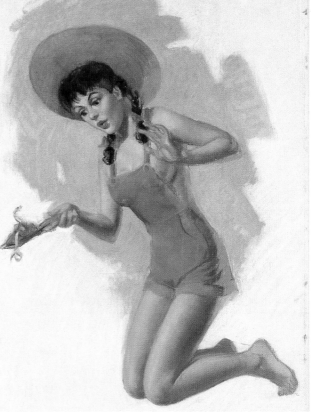

595

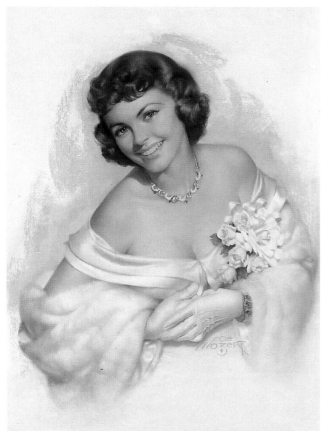

596

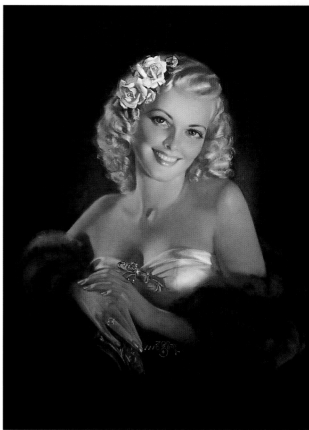

597

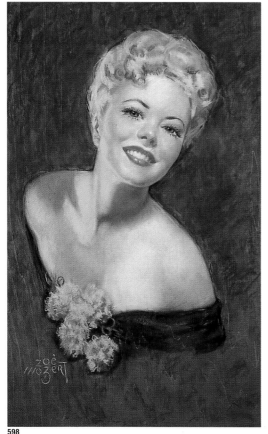

598

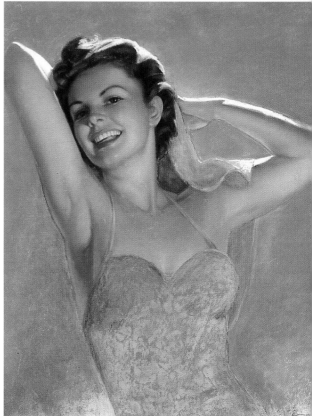

599

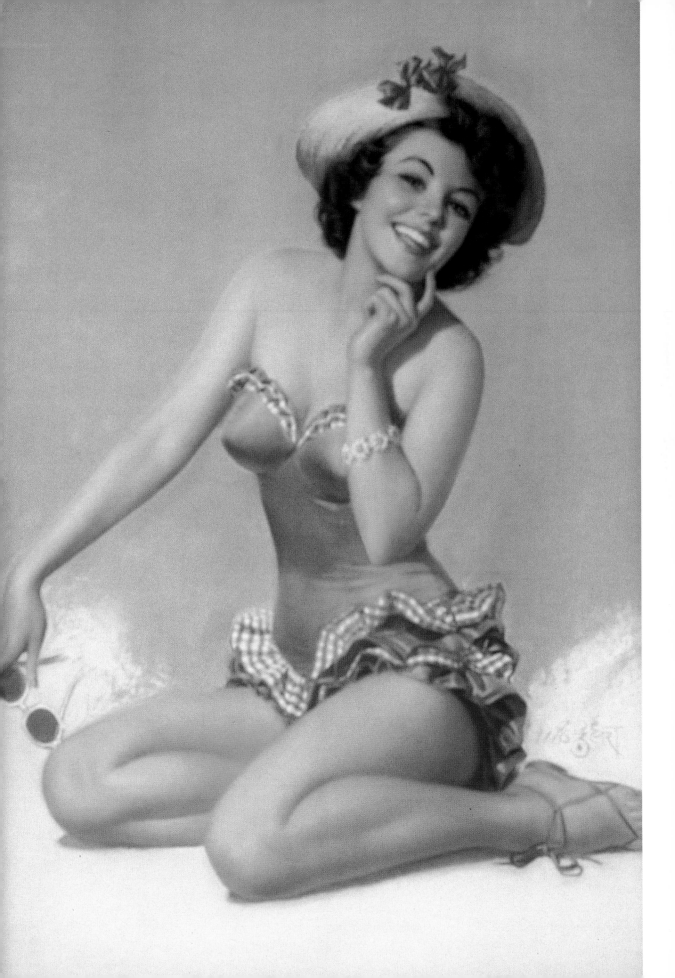

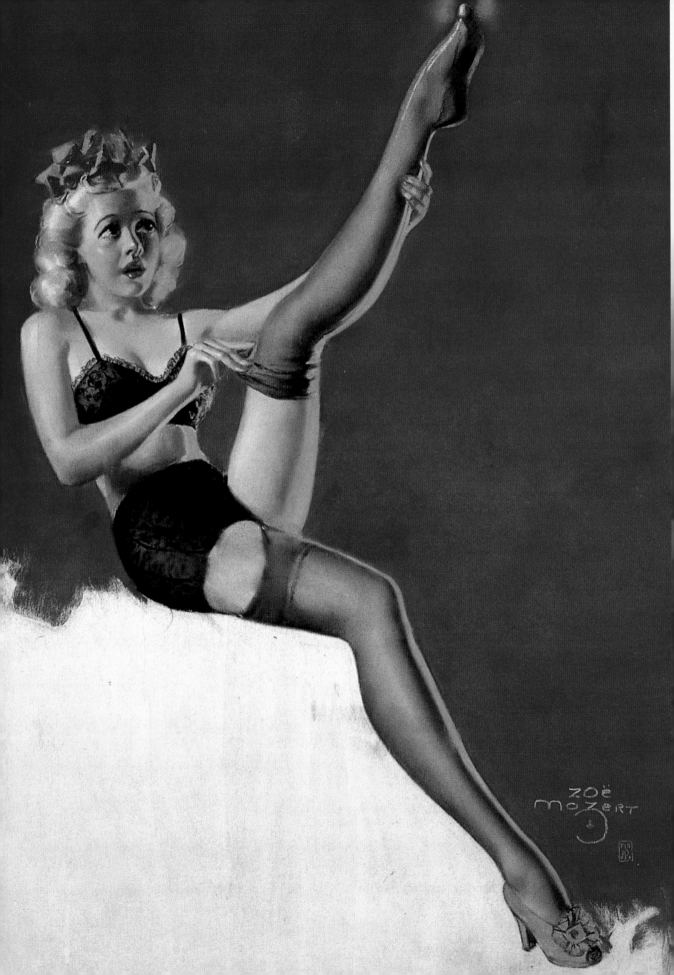

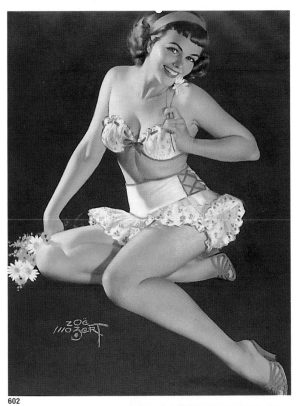

602

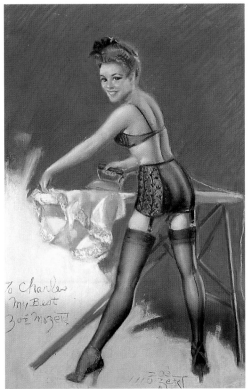

603

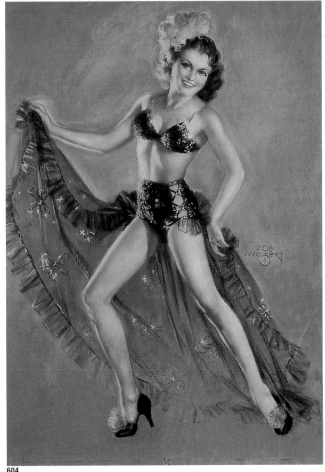

604

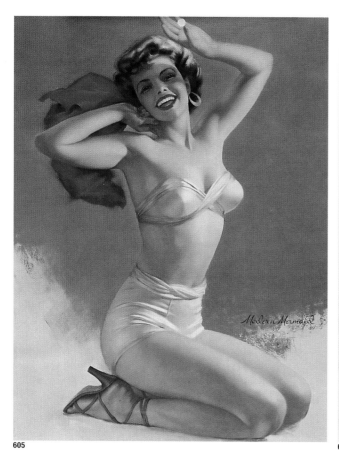

605

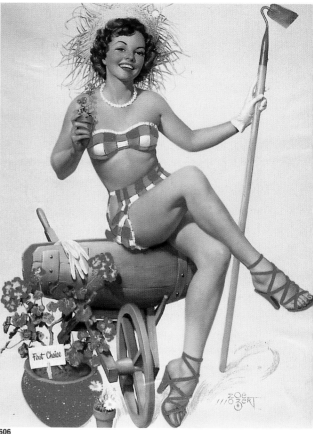

606

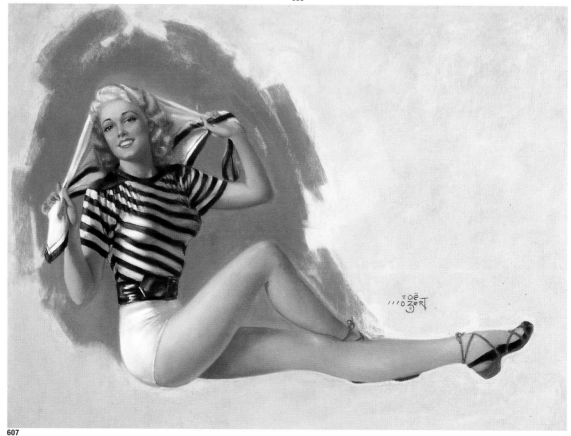

607

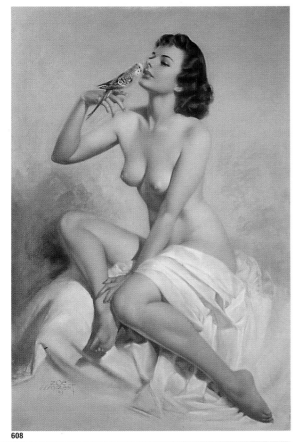

608

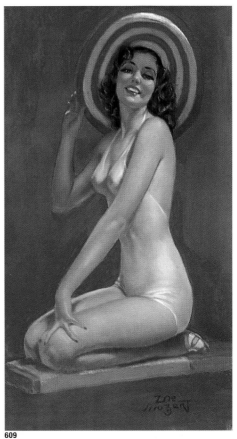

609

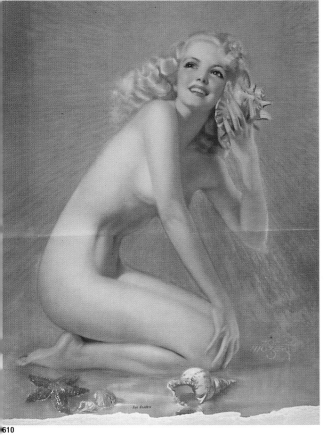

610

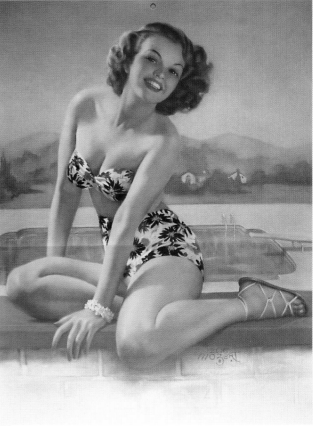

611

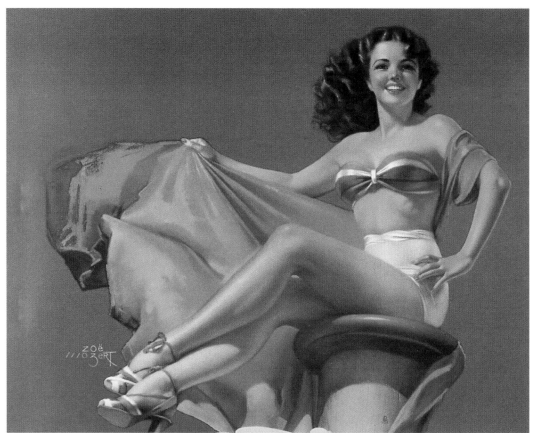

612

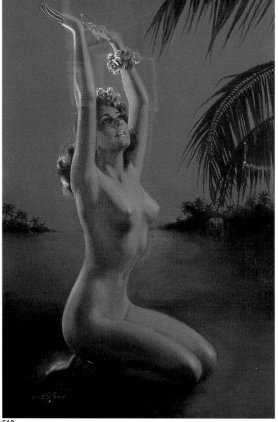

613

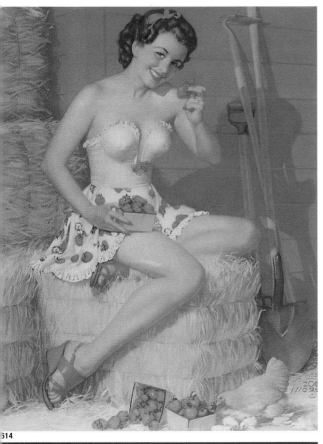

614

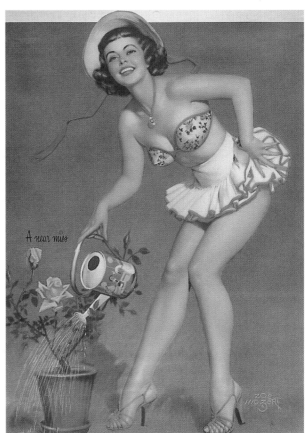

A near miss

615

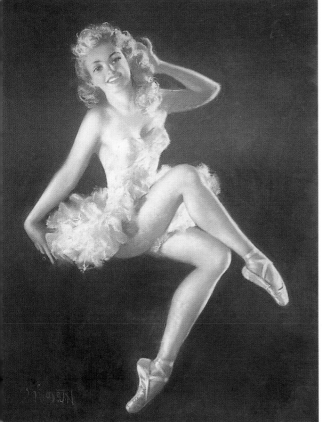

616

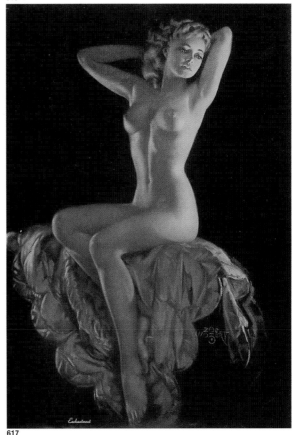

617

K. O. Munson

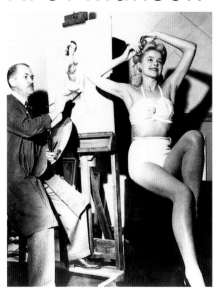

Knute (K.O.) Munson was born in Oslo, Norway, and grew up in Sweden. His family moved to the United States when he was a teenager and settled in Michigan. Munson received his first commission before he ever studied art, when a local doctor hired him to draw medical illustrations for his lectures on surgery. Munson went to Chicago when he was twenty-three to study at the Academy of Fine Art and the American Academy of Art, where his teachers included Andrew Loomis. He later studied with Harvey Dunn at the Grand Central School of Art in New York City.

Returning to Chicago, Munson got a job illustrating catalogues for men's clothing and accessories and became friends with Earl Moran on the job. Loomis later advised Munson to consider advertising art as a career and referred him to Outdoor Advertising Incorporated, where he painted advertisements for Milky Way candy bars. In 1936, Munson received a call from Moran, who was then a staff artist at Brown and Bigelow. Moran told him the firm had liked the samples he sent and that he should "grab [his] paint brushes and get here right away."

Seven years later, Munson inherited the firm's popular Artist's Sketch Pad calendar when Earl Mac Pherson entered the service. He revised the calendar a bit, applying a vignette technique inspired by Dean Cornwell's work that produced the overall effect of an intimate studio work. Munson's pastels for the calendar featured healthy, vital women, full of warmth and softness.

In 1945, Brown and Bigelow used Munson's pin-ups for their Direct Mail Calendar line. He continued to produce dozens of pin-up paintings and drawings for the firm until 1949, when he decided to return to Chicago. There he kept busy as a freelancer. Earl Carroll's Theatre Restaurant in Los Angeles, billed as "the Glamour Spot of Hollywood," commissioned him to do a painting for an over-size souvenir postcard. Among his many advertising jobs were assignments from Lucky Strike cigarettes, Kelly-Springfield Tires, U.S. Rubber Corporation, and Goodrich Tires.

During his years at Brown and Bigelow, Munson had become an accomplished color photographer, and in his new studio on Chicago's North Side, he added photographic work to his commercial art jobs. In 1958, *Artist and Photographer* magazine ran a cover story entitled "K.O. Munson and His Glamour Queens." Munson, described as "unpretentious, congenial, frank," reflected as follows on the interplay between painting and photography, "The camera becomes one of the painter's most useful and important tools. Painting, on the other hand, with its centuries of tradition and its massive accumulation of knowledge has been invaluable to the photographer. … Each has much to offer the other."

Knute (K.O.) Munson wurde im norwegischen Oslo geboren und wuchs in Schweden auf. Als er ein Teenager war, emigrierte seine Familie in die Vereinigten Staaten und ließ sich in Michigan nieder. Munson erhielt seinen ersten Auftrag, bevor er Kunst studiert hatte: Ein Arzt am Ort benötigte für seine Vorträge über Chirurgie medizinische Illustrationen. Im Alter von 23 Jahren ging Munson nach Chicago, um dort an der Academy of Fine Art und der American Academy of Art zu studieren, an letzterer auch unter Andrew Loomis. An der Grand Central School of Art in New York war dann Harvey Dunn sein Lehrer.

Nach Chicago zurückgekehrt, nahm Munson einen Job als Illustrator von Katalogen für Männermode und Accessoires an. Dort lernte er Earl Moran kennen, und die beiden wurden Freunde. Später empfahl Loomis Munson, sich auf Werbegrafik zu verlegen und verwies ihn an die Outdoor Advertising Incorporated, für die er Anzeigen für den Schokoriegel Milky Way malte. 1936 erhielt Munson einen Anruf von Moran, der damals zum Künstlerstab von Brown and Bigelow gehörte. Moran sagte, dem Unternehmen hätten seine Arbeitsproben gefallen, und er solle „schleunigst seine Pinsel zusammensuchen und sich hierher begeben".

Sieben Jahre später, als Earl Mac Pherson bei Brown and Bigelow arbeitete, „erbte" Munson den populären Artist's Sketch Pad-Kalender der Firma. Er veränderte ihn ein wenig und setzte – inspiriert von den Arbeiten Dean Cornwells – Vignetten ein, die den Motiven den Charakter einer intimen und vertrauten Stu-

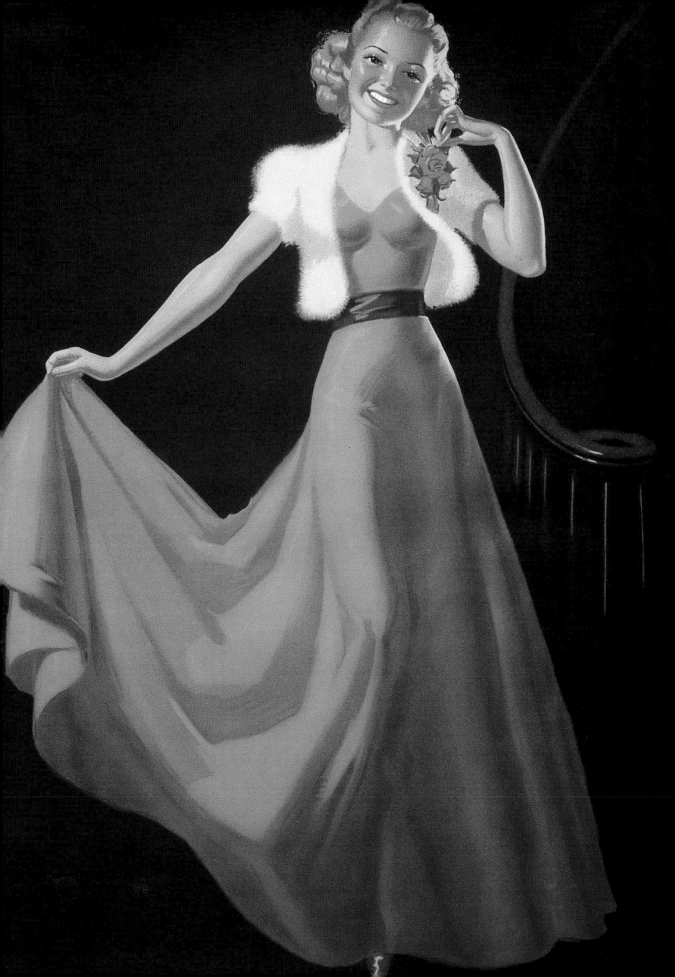

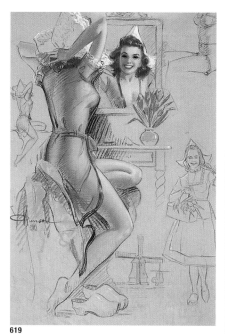

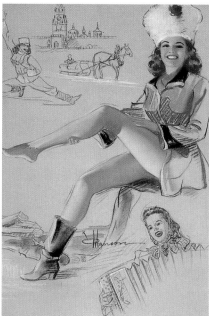

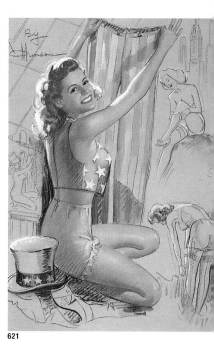

619

620

621

dioarbeit verliehen. Munsons Pastelle für diesen Kalender zeigten frisch und vital wirkende Mädchen voller Wärme und Weichheit.

1945 verwendeten Brown and Bigelow Munsons Pin-ups für ihr Kalendersortiment im Versandhandel. Bis 1949 arbeitete Munson noch weiter für Brown and Bigelow und schuf in diesem Zeitraum Dutzende von Pin-up-Zeichnungen und -Bildern. Dann entschloß er sich, nach Chicago zurückzukehren und baute sich dort eine Karriere als freier Mitarbeiter auf. Das Theaterrestaurant von Earl Carroll in Los Angeles, das sich als „der Glamourtreffpunkt von Hollywood" verkaufte, beauftragte ihn mit dem Entwurf einer großformatigen Souvenirpostkarte. Zu seinen Anzeigenkunden zählten Lucky Strike, Kelly Springfield Tires, U.S. Rubber Corporation und Goodrich Tires.

Während seiner Jahre bei Brown and Bigelow hatte Munson die Farbfotografie erlernt und bot in seinem Chicagoer Studio neben Werbegrafik auch kommerzielle Fotografie an. 1958 druckte die Zeitschrift Artist and Photographer eine Titelgeschichte über Munson mit dem Thema „K.O. Munson and His Glamour Queens". Munson, der als „unprätentiös, freundlich und offen" beschrieben wurde, äußerte sich über das Zusammenspiel von Malerei und Fotografie so: „Die Kamera wird für einen Maler zu einem der wichtigsten und nützlichsten Arbeitsmittel. Und die Malerei mit ihrer jahrhundertelangen Tradition und ihrem so großen Wissensschatz wiederum ist für den Fotografen von unschätzbarem Wert. (…) Jede Disziplin hat der anderen viel zu bieten."

Né à Oslo, Knute (K.O.) Munson grandit en Suède. Sa famille émigra aux Etats-Unis quand il était encore adolescent et s'installa dans le Michigan. Munson reçut sa première commande avant même d'entreprendre des études d'art, quand un médecin lui demanda des illustrations pour ses conférences sur la chirurgie. A vingt-trois ans, Munson se rendit à Chicago pour étudier à l'Academy of Fine Art et à l'American Academy of Art, où il eut Andrew Loomis comme professeur. Il étudia ensuite avec Harvey Dunn à la Grand Central School of Art de New York.

De retour à Chicago, il trouva un emploi d'illustrateur de catalogues de mode masculine et se lia d'amitié avec un collègue, Earl Moran. Loomis lui conseilla de chercher du travail dans la publicité et le recommanda auprès de l'agence Outdoor Advertising Incorporated, qui lui fit peindre des affiches pour les tablettes de chocolat Milky Way. En 1936, Munson reçut un appel de Moran, devenu artiste-maison chez Brown and Bigelow. Moran lui annonça que la maison avait aimé ses esquisses et lui conseilla de «ramasser ses pinceaux et de se ramener vite fait».

Sept ans plus tard, quand Earl Mac Pherson prit la direction de la collection, Munson hérita des célèbres calendriers Artist's Sketch Pad. Inspiré par le travail de Dean Cornwell, il modifia légèrement le concept original du calendrier, accentuant l'importance des esquisses en marge de l'image principale, ce qui donnait

à l'ensemble un caractère plus spontané. Les pastels qu'il réalisa pour cette ligne montraient de belles filles pleines de vie, de charme et de douceur.

En 1945, les pin up de Munson parurent dans la collection Direct Mail Calender de Brown and Bigelow. Il continua à réaliser des peintures et des dessins de pin up pour cet éditeur jusqu'en 1949, quand il décida de retourner à Chicago et d'y travailler en illustrateur free-lance. Earl Caroll, propriétaire du Theatre Restaurant de Los Angeles, baptisé «la boîte glamour d'Hollywood», lui commanda une peinture à reproduire sur une carte de visite géante. Il exécuta également des affiches publicitaires pour Lucky Strike et plusieurs fabricants de pneus dont Kelly-Springfield, U.S. Rubber Corporation et Goodrich.

Au cours de ses années chez Brown and Bigelow, Munson était également devenu un photographe accompli et, dans son nouveau studio du North Side à Chicago, il associait photos en couleurs et illustrations peintes. En 1958, Artist and Photographer publia un grand article intitulé «K.O. Munson et ses reines du glamour». Munson, décrit comme «humble, chaleureux et direct» y parlait de ses allers-et-retours entre la photo et la peinture: «L'appareil est un outil très utile et important pour le peintre. Inversement, la peinture, avec ses siècles de tradition et son accumulation massive de connaissances, est très précieuse au photographe.(…) Tous deux se complètent parfaitement.»

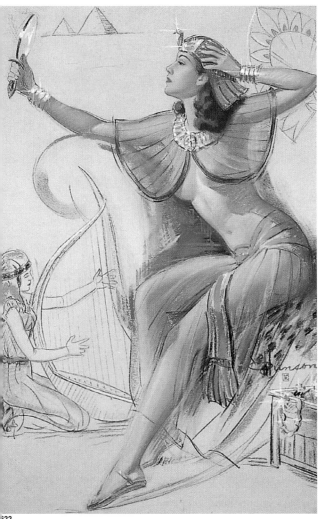

622

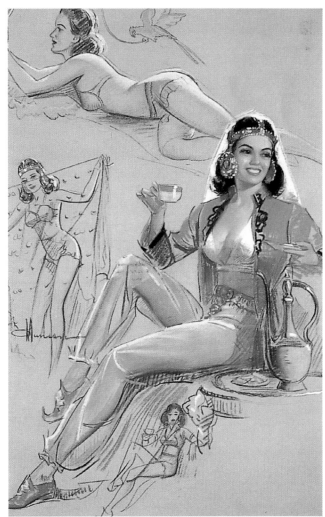

623

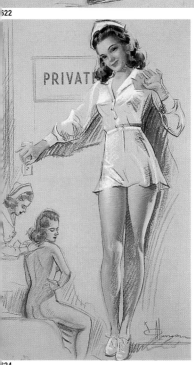

624

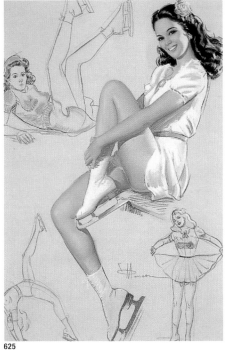

625

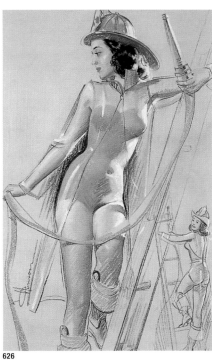

626

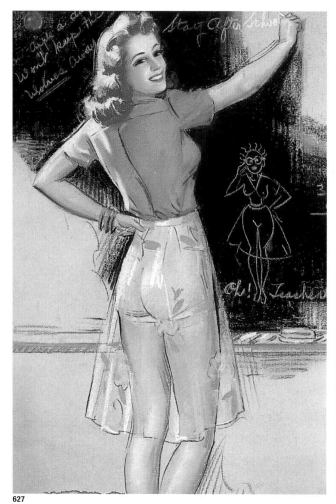

627

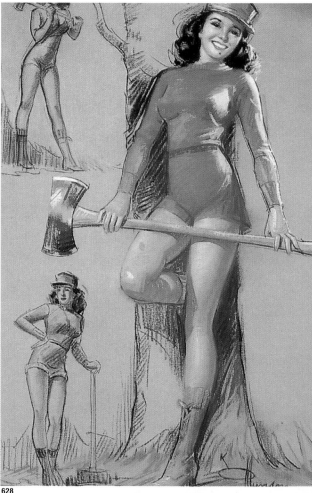

628

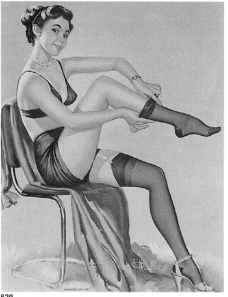

629

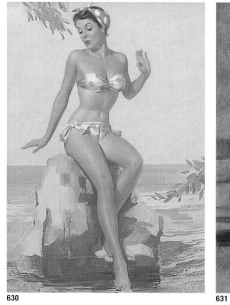

630

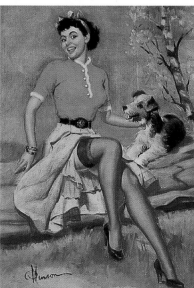

631

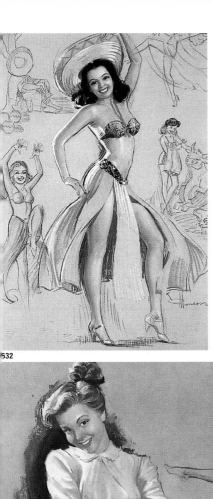

632

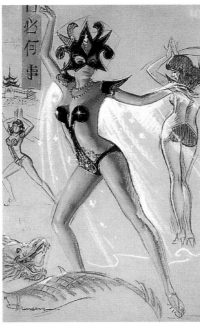

633

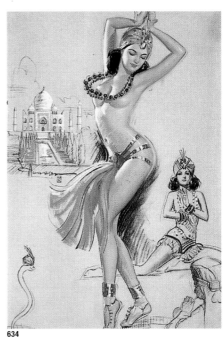

634

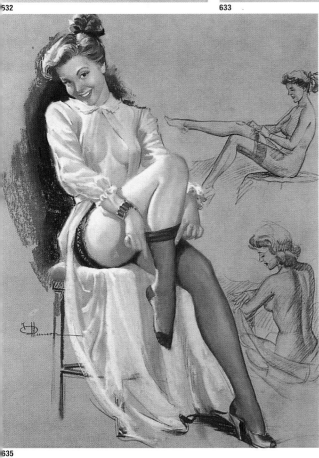

635

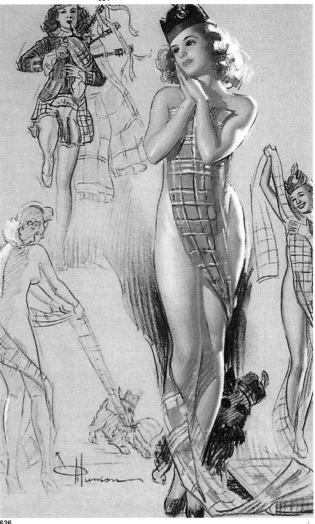

636

Mayo Olmstead

637

When Mayo Olmstead enlisted in the United States Navy in 1943, he never suspected that the course of his life would be changed forever. After basic training, he found himself in the Philippines, where he enrolled in commercial art courses. By the time he was discharged in 1946, he had decided to pursue a career in illustration.

Olmstead was born in Glendale, California, in 1925. At Hoover High School there, he was admired for his ability to copy extremely detailed illustrations from his physiology textbooks. He married Doris Larson on June 19, 1947, after returning from the war. Between 1947 and 1950, Olmstead attended Glendale's School of Allied Arts. Referred to Gil Elvgren by one of his teachers, he was hired by the Stevens/Gross studio in Chicago on the same day he was interviewed.

Olmstead worked for Stevens/Gross for three years, sharing assignments for *Sports Afield* magazine with Joyce Ballantyne. In 1953, he became a staff artist at Brown and Bigelow, again with the help of Elvgren. The firm immediately assigned him to paint pin-ups for the special calendar line they had created for major accounts. He shared this job with another staff artist, Bill Medcalf.

One of Olmstead's most significant achievements during his four years at Brown and Bigelow was a best-selling double set of playing card decks illustrated with two exquisite nudes entitled *Sincerely Yours* (1955), which Brown and Bigelow saw as their follow-up to Elvgren's card deck set *Hats Off*. Olmstead also created a series of large "hangers" that featured pin-up girls and automobiles. He painted all of his pin-ups in oil on canvas, generally measuring about 24 x 30 inches (61 x 76.2 cm), and he always signed his Brown and Bigelow pinups "Mayo." (Later, in the 1960s, he painted many works in gouache on illustration board.)

Olmstead left Brown and Bigelow in 1957 to freelance, but he continued to work for the company on that basis well into the late 1970s. He also accepted many assignments for glamour head-and-shoulder subjects as well as commissions for non-pin-up works from such clients as the 4-H Club and the Ford Motor Company. Between 1968 and 1978, Olmstead created the art for the Wheaties cereal boxes, including the famous image of Bruce Jenner, the 1976 Olympic Decathlon gold medalist.

Olmstead once told an interviewer, "To experience my subject tak[ing] on realism and form before my eyes has been a constant source of joy and amazement." He credits his wife and Gil Elvgren as the two most influential people in his life and career. Olmstead's pin-ups were the last original art Brown and Bigelow used before they turned to photography for their calendar-girl subjects.

Als Mayo Olmstead 1943 bei der U.S. Kriegsmarine anheuerte, ahnte er nicht, daß diese Entscheidung sein Leben für immer verändern sollte. Nach der Grundausbildung wurde er auf den Philippinen stationiert, wo er sich in Kurse für Werbegrafik einschrieb. Als er 1946 aus der Armee entlassen wurde, hatte er bereits beschlossen, als Illustrator zu arbeiten.

Olmstead wurde 1925 im kalifornischen Glendale geboren. Auf der Hoover High School kopierte er detailreiche Illustrationen aus Physiologie-Lehrbüchern und entwickelte dabei ein Talent, das bereits damals Anerkennung fand. Nach seiner Entlassung aus der Armee heiratete er am 19. Juni 1947 Doris Larson. Zwischen 1947 und 1950 besuchte Olmstead im heimischen Glendale die School of

Allied Arts. Einer seiner Lehrer empfahl ihn an Gil Elvgren, und das Stevens/Gross Studio in Chicago stellte ihn im Anschluß an ein Vorstellungsgespräch sofort ein.

Die nächsten drei Jahre arbeitete Olmstead für Stevens/Gross und teilte sich dort mit Joyce Ballantyne Aufträge für die Zeitschrift Sports Afield. *1953 erhielt er bei Brown and Bigelow eine Festanstellung als Künstler, wieder mit Hilfe von Gil Elvgren. Die Firma beauftragte ihn umgehend, gemeinsam mit dem Maler Bill Medcalf Kalender-Pin-ups zu kreieren.*

Zu seinen größten Erfolgen in den vier Jahren, die er bei Brown and Bigelow beschäftigt war, gehörte ein Kartenspiel namens Sincerely Yours *(1955). Zwei exquisite Akte schmückten die Karten, und das Spiel wurde ein Verkaufsschlager.*

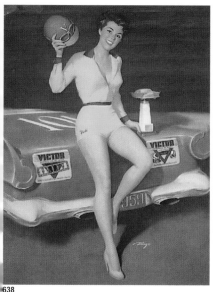

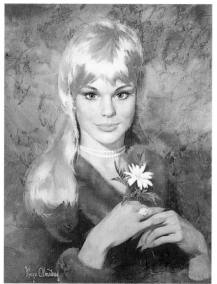

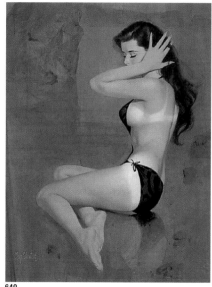

638

639

640

Brown and Bigelow sahen Olmsteads Entwurf als Nachfolger zu dem von Elvgren entworfenen Kartenspiel Hats Off. Olmstead entwarf auch eine Reihe von Wandkalendern mit Pin-up-Girls und Autos. Seine Pin-ups führte er in Öl auf Leinwand aus und verwendete dafür gewöhnlich das Format 61 x 76 cm. Seine Pin-ups für Brown and Bigelow signierte er mit „Mayo". Später, in den 60er Jahren, arbeitete er auch in Gouache auf Karton.

1957 verließ Olmstead Brown and Bigelow mit dem Ziel, sich selbständig zu machen, doch blieb er dem Unternehmen bis in die späten 70er Jahre als freier Mitarbeiter verbunden. Er nahm viele Aufträge für Brustbilder an und arbeitete auch in Bereichen außerhalb des Pin-up-Genres, unter anderem für Auftraggeber wie den 4-H-Club und die Ford Motor Company. Zwischen 1968 und 1978 entwarf er die Verpackung des Frühstücksmüslis Wheaties. Auch das berühmte Konterfei von Bruce Jenner, dem Goldmedaillengewinner im Zehnkampf von 1976, stammt von Olmstead.

In einem Interview sagte Olmstead einmal: „Ich fand es immer wundervoll und aufregend zu erleben, wie ein Objekt oder Thema langsam Gestalt und Form annimmt und vor meinen Augen wirklich und real wird." Seine Frau und Gil Elvgren nennt er als wichtigste Inspirationsquellen in seinem Leben und seiner beruflichen Laufbahn. Olmsteads Pin-ups gehörten zu den letzten Originalgemälden, mit denen Brown and Bigelow Kalender illustrierten, bevor sie Fotos veröffentlichten.

Lorsque Mayo Olmstead s'enrôla dans la marine américaine en 1943, il ne se doutait pas que sa vie allait changer radicalement. Après ses classes, il se retrouva basé aux Philippines, où il suivit des cours d'arts appliqués. Lorsqu'il fut démobilisé en 1946, il avait décidé de faire carrière dans l'illustration.

Né en 1925 à Glendale en Californie, Olmstead épatait déjà ses camarades et ses professeurs de lycée par la perfection avec laquelle il copiait les illustrations extrêmement détaillées de son manuel de physiologie. Le 19 juin 1947, il épousa Doris Larson. Entre 1947 et 1950, il étudia à la Glendale School of Applied Arts. Recommandé auprès de Gil Elvgren par un de ses professeurs, il fut engagé par le studio Stevens-Gross à Chicago le jour même de son premier entretien.

Olmstead travailla pour Stevens-Gross pendant trois ans, partageant des commandes pour Sports Afield avec Joyce Ballantyne. En 1953, il devint un des artistes-maison de Brown and Bigelow, cette fois avec l'appui d'Elvgren. L'éditeur lui confia immédiatement, en collaboration avec l'autre artiste-maison Bill Medcalf, les calendriers publicitaires de pin up pour de grands annonceurs.

L'une des plus grandes réalisations d'Olmstead au cours de ses quatre ans au service de Brown and Bigelow fut un double jeu de cartes illustré avec deux superbes nus, considéré comme la suite logique du jeu illustré par Elvgren, Hats Off. Intitulé Sincerely Yours (1955), il battit des records de vente. Olmstead créa également une série de grands calendriers-cintres avec des pin up et des automobiles. Il peignait toutes ses pin up à l'huile sur des toiles mesurant généralement 61 x 76,2 cm. Celles réalisées pour Brown and Bigelow étaient signées «Mayo».(Plus tard, dans les années 60, il peignit souvent à la gouache sur des cartons à dessin.)

Olmstead quitta Brown and Bigelow en 1957 pour travailler en free-lance mais continua à fournir des œuvres à l'éditeur jusqu'à la fin des années 70. Il accepta également de nombreuses commandes de portraits glamour et d'autres œuvres sans rapport avec des pin up pour des clients tels que 4-H Club et Ford. Entre 1968 et 1978, il fit les illustrations des boîtes de céréales Wheaties, dont le célèbre portrait de Brice Jenner, le décathlonien ayant remporté la médaille d'Or aux Jeux olympiques de 1976.

Olmstead déclara un jour à un journaliste: «J'ai toujours éprouvé une joie et une stupéfaction sans bornes à voir mes sujets prendre vie progressivement sous mes yeux.» Il estimait que sa femme et Gil Elvgren avaient été les deux personnes ayant le plus influencé sa vie et sa carrière. Les pin up d'Olmstead furent les dernières illustrations publiées par Brown and Bigelow avant que l'éditeur ne se tourne définitivement vers les photographies.

Walt Otto

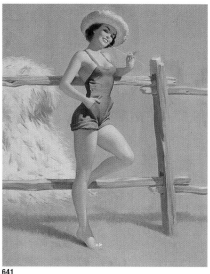

641

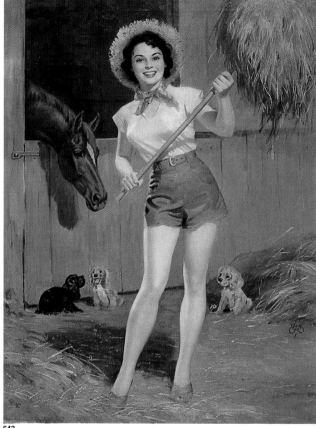

642

Walt Otto was born in Horicon, Wisconsin, in 1895. His family moved to Oshkosh when Otto was seventeen. Showing an early talent for drawing and a sensitivity to color, he opened his own photo studio in 1915. After service in World War I, Otto moved to Chicago to study art, and his first job, at the Edwards and Deutsch lithography company, gave him the chance to observe four of the leading artists of the day: Haddon Sundblom, Andrew Loomis, Frederic Mitzen, and James Montgomery Flagg.

In the 1920s, Otto's work appeared on the front covers of national magazines like *Woman's Weekly* and *The Saturday Evening Post*. He studied advanced painting at the Art Institute of Chicago during 1931–32, while also maintaining a busy career as a freelance illustrator. Between 1935 and 1945, Otto's artwork was seen on billboards, posters, and point-of-purchase display materials for a host of major United States corporations, including Alka Seltzer, Shell Oil, Schlitz Beer, Kellogg's, and H.J. Heinz. More often than not, Otto would incorporate pin-up themes into such mainstream advertising creations.

Walt Otto wurde 1895 in Horicon in Wisconsin geboren. Als Otto 17 Jahre alt war, zog die Familie nach Oshkosh. Er zeigte schon früh zeichnerische Begabung und hatte ein feines Gespür für den Einsatz von Farben. 1915 eröffnete er ein eigenes Fotostudio. Er nahm am Ersten Weltkrieg teil und zog danach nach Chicago, um Kunst zu studieren. Seine erste Stelle bei der Lithoanstalt Edwards und Deutsch verschaffte ihm die Möglichkeit, vier der führenden Künstler der damaligen Zeit bei der Arbeit zu beobachten: Haddon Sundblom, Andrew Loomis, Frederic Mitzen und James Montgomery Flagg.

Während der 20er Jahre erschienen Ottos Arbeiten auf den Covern von landes-

After teaching aerial photography and mapworks during World War II, Otto returned to a thriving pin-up and glamour career. His most classic images are the country girls that appeared on millions of calendars during the 1940s and 1950s. Attired in shorts and halters and accompanied by their trusty canine companions, Otto's girls had strong roots in America's countryside. His oil-on-canvas paintings of these images were usually quite large, measuring 40 x 30 inches (101.6 x 76.2 cm), and always carried Otto's distinctive logo signature. Not to be limited to one theme, Otto also became well known for a series of sophisticated, glamourous evening-gown pictures.

Otto returned to Oshkosh when his wife died in 1952. A few years later, he was asked, for the third time, to paint a cover for *The Saturday Evening Post*; Otto thus began and ended his career with an honor rarely bestowed on pin-up artists. In 1961, the New York Graphic Society published one of the fine-art works that Otto painted during the last ten years of his life. Appropriately titled *Summer Idyll* (figure 643), this Otto girl with her toe dangling in a stream clearly sums up many themes of the artist's career. Otto died in Oshkosh in 1963.

weit erscheinenden Zeitschriften wie Woman's Weekly *und* The Saturday Evening Post. *Zwischen 1931 und 1932 belegte er Fortgeschrittenenkurse im Fachbereich Malerei am Art Institute of Chicago. Zwischen 1935 und 1945 sah man seine Arbeiten auf großformatigen Billboards, auf Postern und Displays, auf denen für Produkte von Unternehmen wie Alka Seltzer, Shell Oil, Schlitz Beer, Kellogg's und H.J. Heinz geworben wurde. Oft setzte Otto Pin-up-Motive in der Werbung für solche familienorientierten Markenartikel ein.*

Während des Zweiten Weltkriegs war er als Ausbilder im Bereich Luftaufnahmen und Kartographie tätig. Nach dem Krieg nahm er seine erfolgreiche Karriere

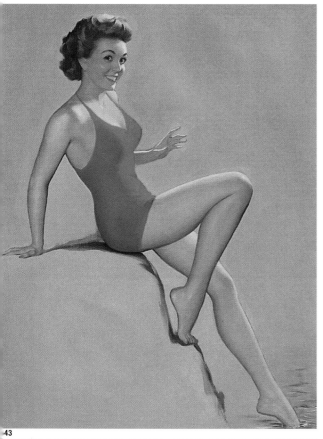

643

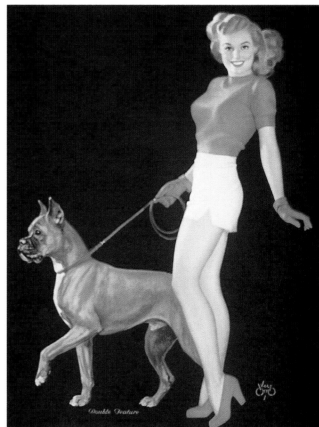

644

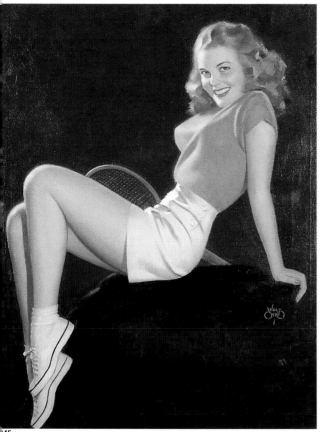

645

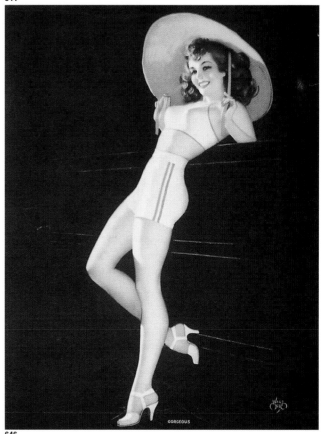

646

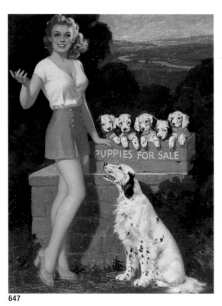

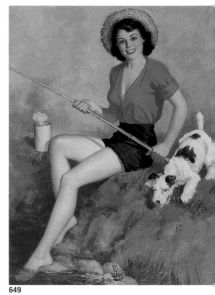

647 648 649

als Pin-up- und Glamourillustrator wieder auf. Zu seinen Klassikern gehören die „Mädchen vom Lande", die in den 40er und 50er Jahren millionenfach auf Kalendern reproduziert wurden. Otto bekleidete sie mit knappen Shorts und engem Top, stellte ihnen einen treuen Vierbeiner als Begleiter an die Seite und gab ihnen ländliche Schönheit, ohne sie zu Landpomeranzen zu machen. Diese Motive führte er in Öl auf Leinwand aus, meist im Format 102 x 76 cm. Daneben erreichte er auch mit seinen raffinierten Abendszenen einen großen Bekanntheitsgrad.

Nach dem Tod seiner Frau ging Otto 1952 nach Oshkosh zurück. Einige Jahre

später bat ihn The Saturday Evening Post *das dritte Mal um eine Coverillustration so begann und beendete Otto seine Karriere mit einem Auftrag, der schon dadurch ehrenvoll war, daß ihn Pin-up-Künstler selten erhielten. 1961 veröffentlichte die New York Graphic Society eine der Arbeiten in der Schule der klassischen Malerei, die Otto während seiner letzten zehn Lebensjahre gemalt hatte. In* Summer Idyll *(Abb. 643) läßt ein „Otto Girl" seinen Zeh in einem Bach spielen. Es ist ein passender Titel für ein Motiv, das viele Themen in Ottos Karriere vereint. 1963 starb Otto in Oshkosh.*

Né en 1895 à Horicon, dans le Wisconsin, Walt Otto vint vivre avec sa famille à Oshkosh à l'âge de dix-sept ans. Montrant très tôt des dons pour le dessin et un grand sens de la couleur, il ouvrit son propre studio de photographie en 1915. Après avoir servi dans l'armée pendant la Première Guerre mondiale, il s'installa à Chicago pour y étudier l'art et y trouva son premier emploi auprès de la Edwards and Deutsch Lithography Company. Là, il eut l'occasion de regarder travailler quatre des plus grands artistes de l'époque: Haddon Sundblom, Andrew Loomis, Frederic Mitzen et James Montgomery Flagg.

Dans les années 20, lesœuvres d'Otto parurent en couverture de magazines à grande diffusion tels que *The Saturday Evening Post* et *Woman's Weekly*. En 1931–1932, il poursuivit sa formation de haut niveau à l'Art Institute de Chicago tout en travaillant comme illustrateur free-lance. Entre 1935 et 1945, ses créacions figurèrent sur les grands panneaux publicitaires, les affiches et les présentoirs d'un grand nombre d'importantes firmes américaines, dont Alka Seltzer, Shell Oil, Schlitz Beer, Kellog's et H.J. Heinz. Le plus souvent, il incorporait des pin up dans ses réalisations publicitaires destinées au grand public.

Pendant la Deuxième Guerre mondiale, il enseigna la photographie aérienne et

la cartographie aux soldats, puis reprit sa carrière prospère de peintre de pin up e de beautés glamour. Ses images les plus connues sont les belles fermières qui ornèrent des millions de calendriers des années 40 et 50. Vêtues de shorts et de corsages bain de soleil, ces belles plantes profondément enracinées dans la tradi tion rurale américaine étaient toujours accompagnées de leur fidèle compagnon canin. Elles étaient peintes à l'huile sur des toiles faisant généralement 101,6 x 76,2 cm et arborant le logo Otto. Otto se fit également connaître pour ses images plus sophistiquées de beautés glamour en robe du soir.

À la mort de sa femme en 1952, Otto revint vivre à Oshkosh. Quelques années plus tard, on lui demanda pour la troisième fois de peindre une couverture pour *The Saturday Evening Post*. Otto commença et acheva ainsi sa carrière avec un honneur rarement accordé à un artiste de pin up. En 1961, la New York Geographic Society publia une des toiles qu'il peignit au cours des dix dernières années de sa vie. Intitulée *Summer Idyll* (Idylle d'été; illustration 643), cette peinture d'une Otto Girl trempant un orteil dans un ruisseau pourrait être un condensé des nombreux thèmes traités par l'artiste au cours de sa carrière. Otto mourut à Oshkosh en 1963.

Laurette & Irene Patten

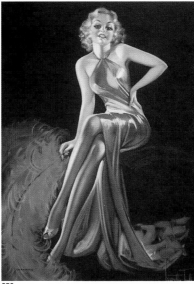

650

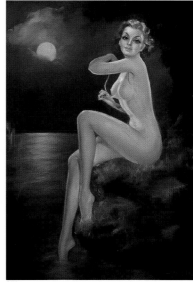

651

The Patten sisters worked together from 1920 to 1940, painting pastel pin-ups and glamour art subjects of high quality. Little is known about their backgrounds, except that they shared a studio at 7115 South May Street in Chicago. During their heyday, however, their names were well known among the country's leading publishers and calendar art industries.

The Pattens produced several hundred superb pin-up originals, which were published by many of the major American calendar companies, chief among them being Joseph C. Hoover and Sons in Philadelphia. Hoover published their work under the division name C. Moss, which included the firm's Superior Gift Line. The Pattens'

illustrations were generally in the style of Rolf Armstrong, and their subjects ranged from the quite wholesome to images that were daring and provocative for the time.

The primary medium of the Pattens' originals was pastel on stretched canvas. They generally worked in a large format, with most pieces averaging between 30 x 24 inches (76.2 x 61 cm) to 40 x 30 inches (101.6 x 76.2 cm). Some originals were very large – 48 x 24 inches (121.9 x 61 cm) – and a few have surfaced that are quite small, 20 x 16 inches (50.8 x 40.6 cm). The Patten sisters usually shipped their original pastels to their publishers or printers in specially made wooden crates designed to protect the artwork.

Die Geschwister Patten arbeiteten zwischen 1920 und 1940 zusammen. Ihre Pastelle für Pin-ups und Glamour-Kunst sind von hoher Qualität. Über ihren Hintergrund ist nur wenig bekannt, doch man weiß, daß sie sich in der 7115 South May Street in Chicago ein Studio teilten. Zur Zeit ihrer größten Erfolge waren ihre Namen führenden Verlegern und Kalenderverlagen ein Begriff.

Laurette und Irene Patten schufen Hunderte meisterhafter Pin-up-Originale, die von vielen der großen Kalenderverlage Amerikas veröffentlicht wurden, insbesondere von Joseph C. Hoover and Sons in Philadelphia. Hoover brachte ihre Arbeiten unter dem firmeneigenen Programm C. Moss heraus, zu dem auch die Hoovers

Superior Gift Line (Geschenke für den gehobenen Geschmack) gehörte. Im allgemeinen ähnelte der Stil der Patten-Illustrationen dem von Rolf Armstrong; ihre Motive waren sauber und nett, dennoch haftete ihnen manchmal etwas Provozierendes an.

Meistens arbeiteten die Pattens bei ihren Originalen in Pastell auf Leinwand. Normalerweise wurden große Formate verwendet; die meisten Arbeiten lagen zwischen 76 x 61 cm und 100 x 76 cm. Einige Originale waren sehr groß – bis zu 122 x 61 cm; einige klein (50 x 40 cm). Ihre Originalvorlagen verschickten die beiden Schwestern normalerweise in speziell angefertigten Holzkisten an Verleger oder Drucker, um die Vorlagen vor Beschädigung zu schützen.

Les sœurs Patten travaillèrent ensemble de 1920 à 1940, peignant des pastels de pin up et de sujets glamour d'une grande qualité. On sait peu de choses sur leur vie, si ce n'est qu'elles partageaient un atelier au 7115 May Street à Chicago. Toutefois, durant leur heure de gloire, leurs noms figurèrent parmi ceux des plus grands illustrateurs de l'édition et de calendriers.

Laurette et Irene Patten réalisèrent plusieurs centaines de superbes pin up qui furent publiées par plusieurs grands éditeurs de calendriers, notamment Joseph C. Hoover and Sons de Philadelphie. Hoover les publia dans la collection C. Moss, qui comprenait la prestigieuse ligne de calendriers «Superior Gift Line».

Les illustrations des sœurs Patten rappelaient souvent le style de Rolf Armstrong et leurs sujets allaient du plus innocent au franchement osé et provocant pour l'époque.

Elles utilisaient en priorité le pastel sur toile. Elles travaillaient généralement sur de grands formats, la plupart du temps entre 76,2 x 61 cm et 101,6 x 76,2 cm. Certains originaux étaient très grands (121,9 x 61 cm) et on en a retrouvé d'assez petits (50,8 x 40,6 cm). Les sœurs Patten envoyaient généralement leurs originaux à leurs éditeurs ou leurs imprimeurs dans des caisses faites sur mesure pour protéger leurs œuvres.

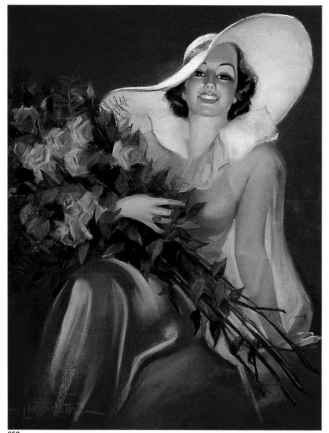

652

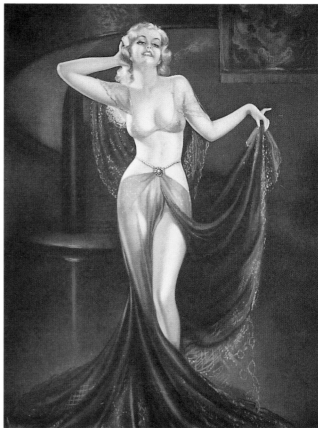

653

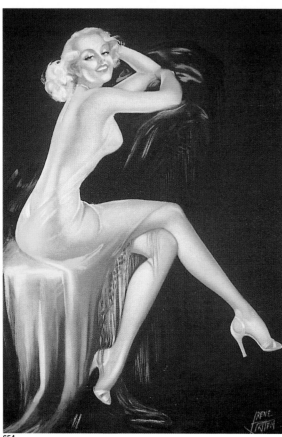

654

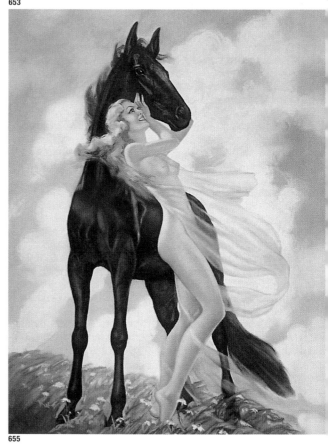

655

George Petty

The Petty Girl was an American icon who captured the nation's admiration for more than twenty-five years. From 1933 to 1956, her likeness was seen on tens of millions of calendars, magazine centerfolds, advertisements, posters, and billboards as well as on all sorts of specialty products; in 1950, *The Petty Girl* even became a major motion picture.

Petty's creation made her debut in the autumn of 1933, in a full-page cartoon accompanied by a snappy caption in *Esquire* magazine's inaugural issue. For the rest of the decade, she was featured in such popular venues as monthly advertisements for Jantzen Knitting Mills and Old Gold cigarettes (figures 663–666, 668, and 670), a print, postcard, and full-page national advertisement for Trans World Airlines (1936), *Esquire*'s deluxe hardcover Petty Folio (1937), and *Life* magazine's article, "Petty Girl … Is Feminine Ideal of American Men" (June 26, 1939). By 1940, Petty had become a national celebrity. His relationship with *Esquire* had worn thin, however, and when they secured the services of Alberto Vargas a year later, he left the magazine – but not before he had contributed a rich legacy to the history of pin-up and glamour art.

During the next ten years, the Petty Girl seemed to be everywhere. Along with the Varga Girl, she helped build morale during wartime. A 1940 advertisement for Jantzen, featuring a Petty Girl wearing a swimsuit the artist had designed himself (figure 667), ran for months in every major magazine. This image, Petty's most popular to date, led to a great number of commissions for the artist, including pin-up ads for Pepsi Cola and, on November 10, 1941, a Time magazine front cover of Rita Hayworth.

In 1945, Petty entered into a special relationship with Fawcett Publications' *True* magazine, where the Petty Girl began appearing every month as either a centerfold or full-page illustration. The magazine published best-selling Petty Girl calendars in 1947 and 1948 that contained some of the artist's finest work (figures 675, 685–697, and 699). Among his commissions for the entertainment industry were four promotional pin-ups for M-G-M's musical *Ziegfeld Follies* (1946) and, starting in 1942, seven years of front covers for the Ice Capades (figure 689).

Petty returned to *Esquire* to create two calendars in 1955 and 1956, which garnered a whole new generation of admirers for him. His other important calendar client, besides *Esquire* and *True*, was the Rigid Tool Company (figures 688–693). His innovative works for that firm were devised in a highly original way: Petty first painted an image on illustration board, then cut it out and pasted it onto a photostat of a tool, and finally painted over the background image.

The creator of the fabulous Petty Girl was born in 1894 in Abbeville, Louisiana. After his family moved to Chicago, he worked in his father's photography studio. Upon graduation from high school, he traveled to Paris to study at the Académie Julian under Jean-Paul Laurens. Back home, he worked for a printing company as a photo retoucher and became the head of the household upon his father's death. Petty married in 1918; his daughter, Marjorie, was born a year later, his son, George, in 1922.

By the mid-1920s, Petty was working full-time as a freelance illustrator, painting front covers showing children at play for *The Household* magazine and providing pretty girl images to a calendar company. After he opened his first studio in Chicago in 1926, his burgeoning client list came to include such companies as Marshall Field's (catalogue front covers; figure 661) and Atlas Beer (billboards, newspaper ads, and die-cut window display art).

The first model for the Petty Girl was the artist's wife, followed by his daughter when she became a teenager and even his son, who was enlisted to pose for the "Petty Man" in the Jantzen ad campaign. The perfectionist Petty often spent as much as two weeks on a painting. Most of his originals from the *Esquire* period (figures 656–660, 662, 680, and 681) are small, averaging 14 x 11 inches (35.6 x 27.9 cm); the works for *True* were a bit larger, 16 x 20 inches (40.6 x 50.8 cm).

Petty was a large man, often compared to Ernest Hemingway because of his rugged appearance. Like the famous author, he enjoyed big game hunting and often went on safaris to Africa. For more than ten years, he was an appreciative judge at the Miss America pageant in Atlantic City. In 1973, for *Esquire*'s fortieth anniversary, Petty created a modern-day version of his pin-up girl with gray hair and granny glasses. He died on July 21, 1975, in San Pedro, California.

The Petty Girl had a mischievous, engaging smile and a special twinkle in her eyes. Long-limbed and well endowed, she was a slick, supple, and alluring creature. She frequently wore only the barest of necessities (and sometimes not even that); she flirted with her eyes and body, but always tastefully. Like many other pin-up artists, Petty created these ideal American girls by combining the best features of several models; he further improved on nature by making their heads smaller and their legs and torsos longer. Whatever his secret, Petty certainly had the magic touch. As one critic so aptly put it, "When you touch the wrist of a Petty Girl, you almost expect to feel a pulse."

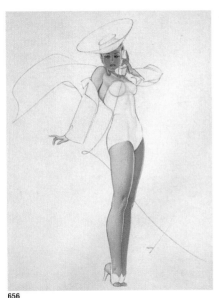

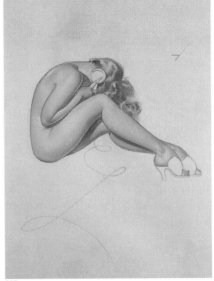

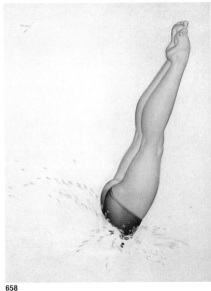

656

657

658

Das Petty Girl war über 25 Jahre lang eine bewunderte amerikanische Ikone. Zwischen 1933 und 1956 sah man ihr Abbild auf Kalendern, die in Auflagen von zehn Millionen gedruckt wurden, im Heftinnenteil von Zeitschriften als „Centerfold", in Anzeigenvorlagen, auf Postern und großformatigen Anzeigentafeln und auf diversen Spezialprodukten; 1950 wurde es sogar im Film The Petty Girl verewigt.

Das Petty Girl debütierte in einem ganzseitigen Cartoon, der von frechen Kommentaren begleitet war, in der Erstausgabe von Esquire im Herbst 1933. Den Rest des Jahrzehnts sah man es in Monatsanzeigen für Jantzen Knitting Mills und die Zigarettenmarke Old Gold (Abb. 663 bis 666, 668 und 670), als Druck oder Postkarte und in einer ganzseitigen, landesweiten Anzeige für Trans World Airlines (1936), in Petty Folio (1937), einer großzügig ausgestatteten Sonderauflage von Esquire und einem Artikel der Zeitschrift Life mit dem Titel „Petty Girl … Is Feminine Ideal of American Men" (26. Juni 1939). Nachdem die Zusammenarbeit mit Esquire 1940 nicht mehr so recht klappen wollte und sich das Magazin im darauffolgenden Jahr die Dienste von Alberto Vargas hatte sichern können, verließ Petty die Zeitschrift.

Während der nächsten zehn Jahre war das Petty Girl allgegenwärtig. Zusammen mit dem Varga Girl baute es während des Krieges die Moral der Truppen auf. In einer Anzeige für Jantzen aus dem Jahr 1940 trägt ein Petty Girl einen Badeanzug (Abb. 667). Es war zum damaligen Zeitpunkt das populärste Bild von Petty und führte zu einer ganzen Reihe von weiteren Aufträgen. Am 10. November 1941 erschien sogar ein Petty-Bild von Rita Hayworth auf dem Titel der Zeitschrift Time.

1945 begann Petty, für die Zeitschrift True von Fawcett Publications zu arbeiten. Es war eine außergewöhnliche Zusammenarbeit, die dem Petty Girl einen monatlichen Auftritt garantierte. Die Zeitschrift verlegte in den Jahren 1947 und 1948 Petty-Kalender, die Bestseller wurden und einige seiner besten Arbeiten enthielten (Abb. 675, 685 bis 697 und 699). Zu seinen Aufträgen aus der Unterhaltungsbranche gehörten vier Pin-ups für das Musical Ziegfeld Follies des Filmgiganten Metro Goldwyn Mayer (1946), und von 1942 an gestaltete er sieben Jahre lang die Titelseite der Ice Capades.

1955 ging Petty zu Esquire zurück und kreierte dort zwei neue Kalender. Zu seinen wichtigsten Kalenderkunden gehörten neben Esquire und True auch die Rigid Tool Company (Abb. 688 bis 693). Seine Arbeiten für diesen Auftraggeber waren in einer ungewöhnlichen Weise konzipiert: Petty klebte seine Bilder auf eine Kopie eines Werkzeugs der Firma und gestaltete anschließend den Hintergrund.

Der künstlerische Vater des Petty Girl wurde 1894 in Abbeville, Louisiana, geboren. Nach dem Umzug der Familie nach Chicago arbeitete Petty im Fotostudio seines Vaters. Er schloß die High School ab und ging dann nach Paris, um dort an der Académie Julian unter Jean-Paul Laurens zu studieren. Nach seiner Rückkehr in die Vereinigten Staaten arbeitete er für eine Druckanstalt als Foto-

retuscheur. Petty heiratete 1918; im nächsten Jahr wurde seine Tochter Marjorie und vier Jahre später sein Sohn George geboren. Seit Mitte der 20er Jahre arbeitete Petty nur noch als freier Illustrator und lieferte Coverillustrationen von spielenden Kindern für die Zeitschrift Household. Für einen Kalenderverlag zeichnete er Bilder von hübschen, jungen Mädchen. 1926 eröffnete er in Chicago ein eigenes Studio, und zu seiner wachsenden Liste von Auftraggebern gehörten bald Kunden wie Marshall Field's (Abb. 661) und Atlas Beer.

Die Frau des Künstlers war das erste Modell für das Petty Girl; später war es seine Tochter Marjorie. Selbst sein Sohn stand ihm Modell – als Petty Man in einer Anzeigenkampagne für die Firma Jantzen. Petty war Perfektionist und verbrachte oft zwei Wochen mit der Arbeit an einem Bild. Die meisten seiner Originale aus der Esquire-Zeit (Abb. 656 bis 660, 662, 680 und 681) sind klein (normalerweise 36 x 28 cm); die Arbeiten für True waren in einem etwas größeren Format gehalten (41 x 51 cm).

Petty wurde oft mit Ernest Hemingway verglichen, mit dem er die Vorliebe für die Großwildjagd teilte. Mehr als zehn Jahre lang war er einer der Juroren bei der in Atlantic City ausgetragenen Wahl der Miss America. 1973 schuf Petty zum 40. Geburtstag von Esquire ein neues Petty Girl. Es war nun grauhaarig und trug eine Brille. Petty starb am 21. Juli 1975 im kalifornischen San Pedro.

Das Petty Girl hatte ein schelmisches, mitreißendes Lächeln, in seinen Augen lag ein ganz besonderes Zwinkern. Es war feingliedrig, gut gebaut und ein anziehendes, geschmeidiges Geschöpf. Oftmals war das Petty Girl nur mit dem Nötigsten bekleidet (und manchmal noch nicht einmal damit). Wie auch andere Pin-up-Künstler, schuf Petty dieses Idealbild des amerikanischen Mädchens, indem er die Vorzüge mehrerer Modelle miteinander verband und der Natur etwas nachhalf: Er ließ den Kopf kleiner und Beine und Körper größer erscheinen. Trotzdem schien es lebendig zu sein, wie ein Kritiker anmerkte: „Wenn man das Handgelenk eines Petty Girls berührt, erwartet man fast, seinen Puls zu spüren".

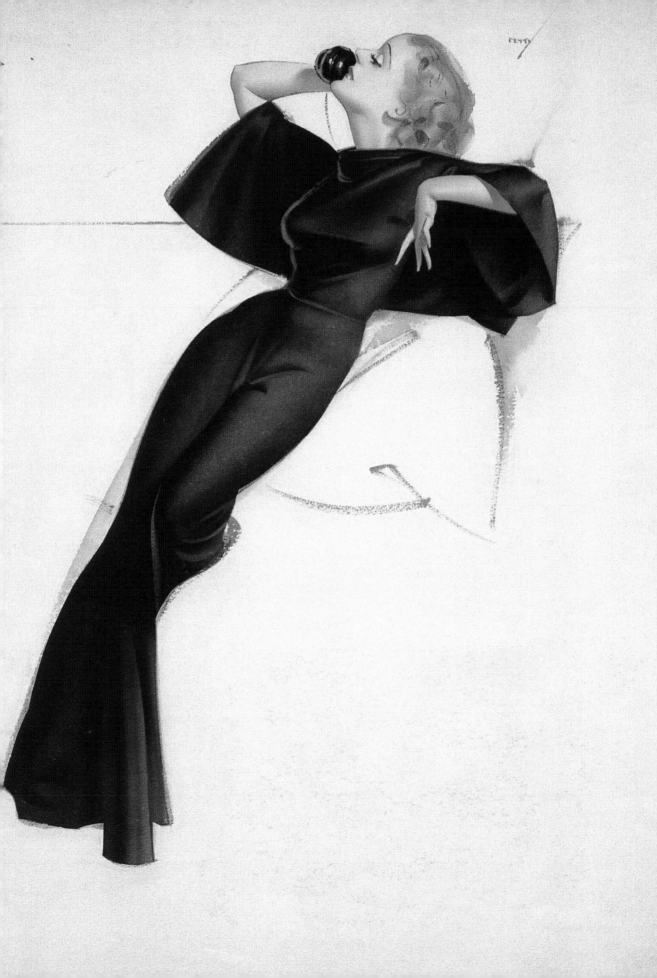

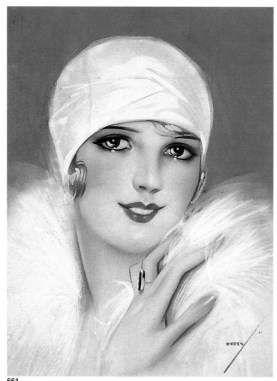

661

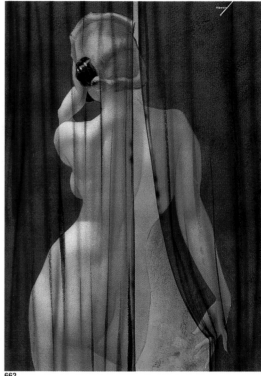

662

La Petty Girl fut une idole américaine vénérée pendant plus de vingt-cinq ans. De 1933 à 1956, ses émules fleurirent sur des millions de calendriers, posters, affiches et panneaux publicitaires ainsi que sur toutes sortes de gadgets. En 1950, Hollywood la consacra définitivement dans le film *The Petty Girl*.

La créature de Petty fit son entrée à l'automne 1933 avec le premier numéro d'*Esquire*, dans un grand dessin humoristique accompagné d'une légende croustillante. Jusqu'à la fin des années 30, elle figura dans les feuilletons publicitaires de Jantzen Knitting Mills et des cigarettes Old Gold (illustrations 663–666, 668 et 670) ; sur une reproduction, une carte postale et une publicité pleine page pour Trans World Airlines (1936) ; dans *Petty Folio*, le luxueux livre d'illustrations d'*Esquire* (1937) ; et dans un article de *Life* : «La Petty Girl … l'idéal féminin de l'homme américain» (26 juin 1939). Vers 1940, Petty était une célébrité nationale. En revanche, ses rapports avec *Esquire* étaient devenus plus que tendus et, lorsque la revue engagea Alberto Vargas l'année suivante, il mit un terme à sa collaboration, mais non sans avoir préalablement contribué amplement à l'histoire de la pin up et de l'art glamour.

Pendant les dix années qui suivirent, la Petty Girl fut partout. Avec la Varga Girl, elle aida à remonter le moral des troupes. Une publicité pour Jantzen de 1940, présentant une Petty Girl dans un maillot de bain conçu par l'artiste (illustration 667), fut republiée pendant des mois dans tous les grands magazines. Cette image, la plus célèbre de Petty, lui valut une avalanche de commandes, dont des pin up publicitaires pour Pepsi Cola et, le 10 novembre 1941, une couverture de *Time* avec Rita Hayworth.

En 1945, Petty entama une étroite collaboration avec *True* (éditions Fawcett). La Petty Girl y paraissait chaque mois sous forme de poster central ou d'illustration pleine page. En 1947 et 48, la revue publia des calendriers de la Petty Girl – des best-sellers – avec quelques-unes des plus belles créations de l'artiste (illustrations 675, 685–697 et 699). Parmi ses commandes du secteur du spectacle, on compte quatre affiches de pin up pour la comédie musicale de la M.G.M. Ziegfeld Follies (1946) et, de 1942 à 1949, toutes les couvertures des programmes d'Ice Capades (illustration 689). Petty refit deux calendriers pour *Esquire* en 1955 et 1956, qui lui valurent une nouvelle génération d'admirateurs. Il avait un autre grand client sur le marché des calendriers : la Rigid Tool Company (fabricant d'outillage ; illustrations 688–693), pour qui il conçut des œuvres très originales : il réalisait d'abord sa pin up sur un carton à dessin, la découpait, la collait sur une photographie d'outil, puis peignait le fond.

Né en 1894, le père de la géniale Petty Girl était originaire d'Abbeville, en Louisiane. Sa famille emménagea ensuite à Chicago, où il travailla dans le studio de photographie de son père. Après le lycée, il se rendit à Paris et suivit des cours à l'Académie Julian sous la direction de Jean-Paul Laurens. De retour au bercail, il travailla chez un imprimeur comme retoucheur de photos et devint le chef de famille après la mort de son père. Il se maria en 1918. Sa fille, Marjorie, vit le jour un an plus tard, suivie en 1922 de son fils George. Au milieu des années 20, Petty travaillait à plein temps comme illustrateur free-lance, peignant des couvertures montrant de joyeux bambins pour le magazine familial *The Household* et des pin up pour un éditeur de calendriers. Il ouvrit son premier atelier à Chicago en 1926, et sa liste de plus en plus longue de clients incluait les grands magasins Marshall Fields (couvertures des catalogues ; illustration 661) et la brasserie Atlas (panneaux et annonces publicitaires, mannequins en carton pour vitrines).

Sa femme fut son premier modèle pour la Petty Girl, suivie de sa fille lorsqu'elle devint adolescente, puis même son fils, enrôlé comme modèle du Petty Man lors de la campagne de publicité pour Jantzen. Perfectionniste, Petty passait parfois jusqu'à deux semaines sur une toile. La plupart des originaux de sa période *Esquire* (illustrations 656–660, 662, 680 et 681) étaient petits, 35,6 x 27,9 cm. Ses toiles pour *True* étaient un peu plus grandes, 40,6 x 50,8 cm.

Petty avait une stature imposante, et son air coriace le faisait souvent comparer à Hemingway. Comme le célèbre romancier, il aimait la chasse au gros gibier et les safaris en Afrique. Pendant plus de dix ans, il siégea au jury de Miss Amérique à Atlantic City. En 1973, pour le quarantième anniversaire d'*Esquire*, il créa une version moderne de la Petty Girl, avec des cheveux gris et des lunettes de grand-mère. Il mourut le 21 juillet 1975 à San Pedro, en Californie.

La Petty Girl avait un sourire mutin et une petite lueur malicieuse dans le regard. Avec ses longues jambes et ses formes généreuses, elle avait une silhouette élancée, souple et élégante. Elle était souvent vêtue du strict nécessaire (et parfois même pas). Elle aguichait avec ses yeux et son corps, sans jamais sombrer dans le mauvais goût. Petty créait ces beautés américaines en utilisant les meilleures qualités de plusieurs modèles. Il améliorait encore la nature en leur faisant des têtes plus petites et en rallongeant leurs jambes et leurs bustes. Bref, il avait indubitablement un doigté magique. Comme l'a déclaré un critique : «Quand on effleure le poignet d'une Petty Girl, on s'attend presque à sentir battre son pouls.»

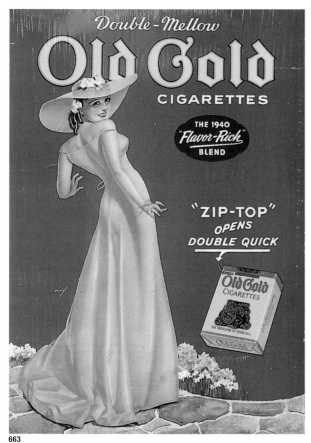

663

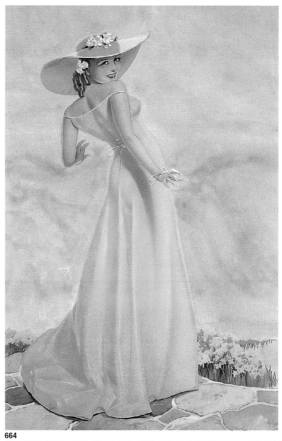

664

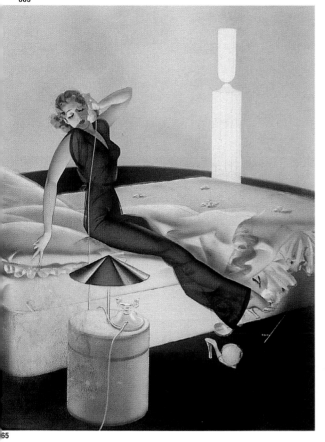

65

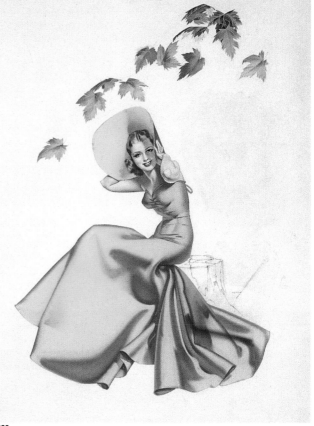

666

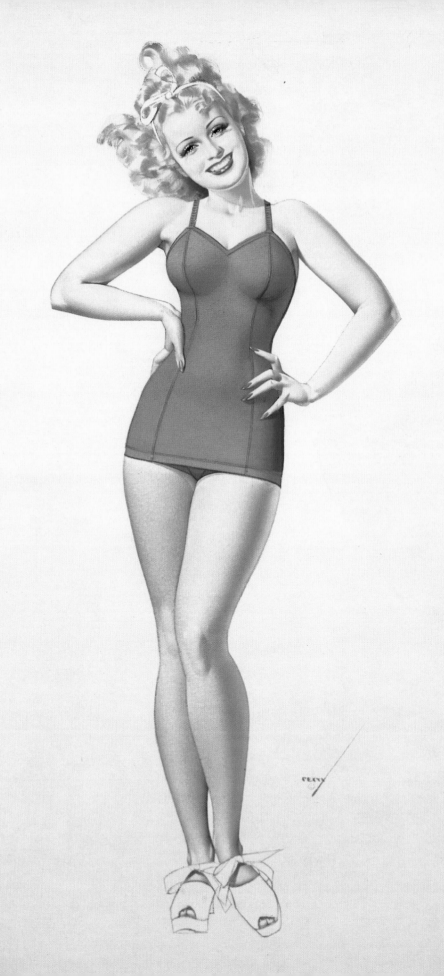

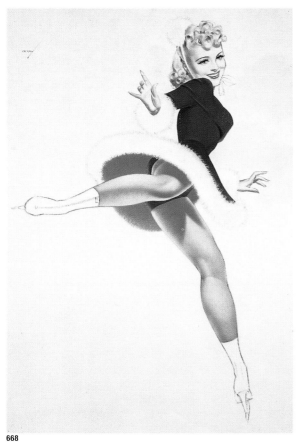

668

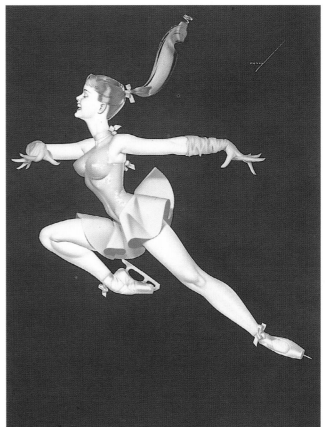

689

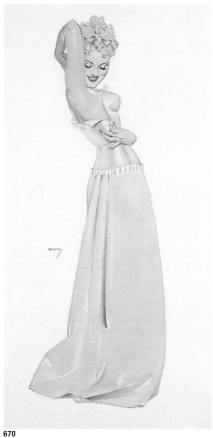

670

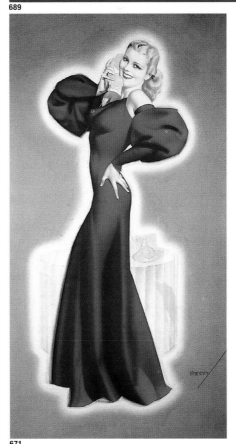

671

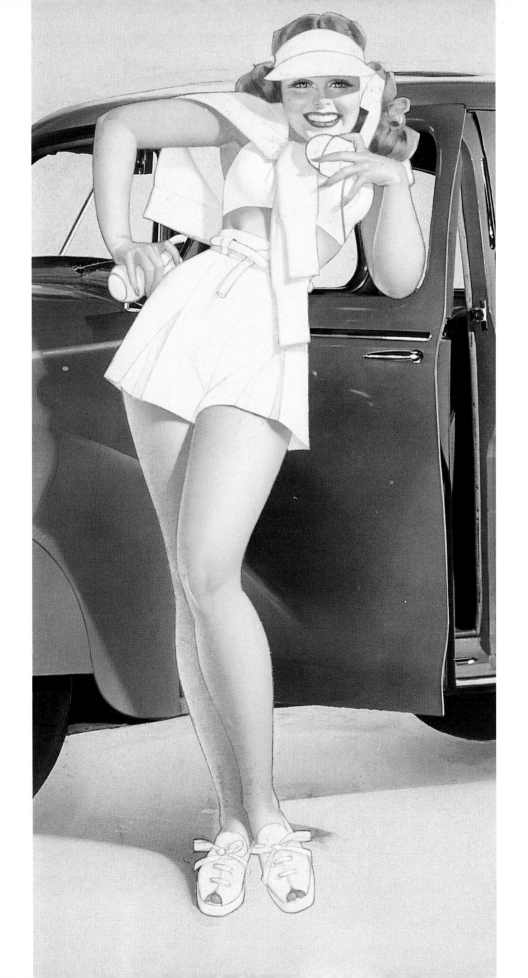

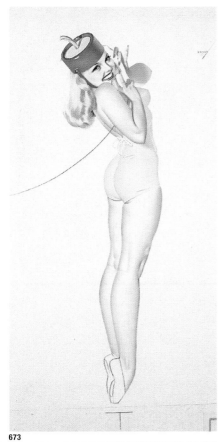

673

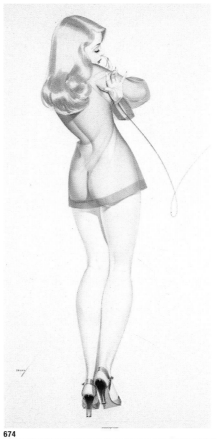

674

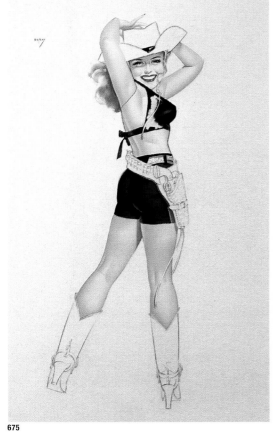

675

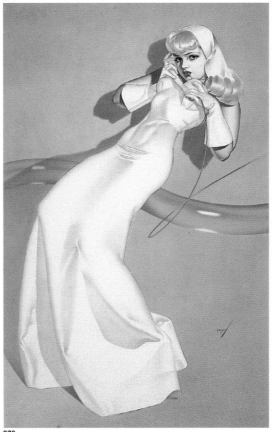

676

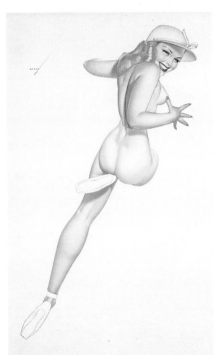

677

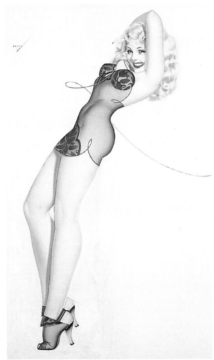

678

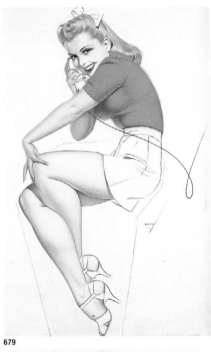

679

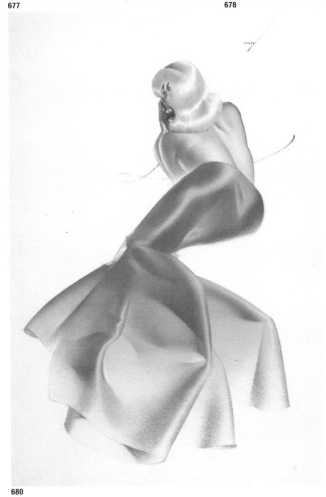

680

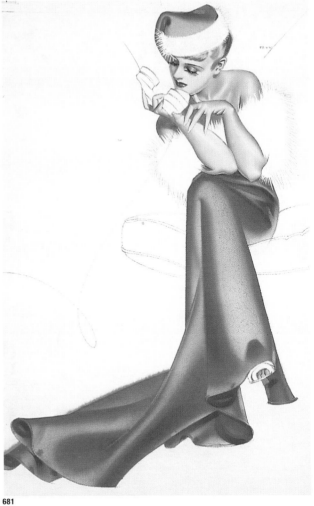

681

682 ▷

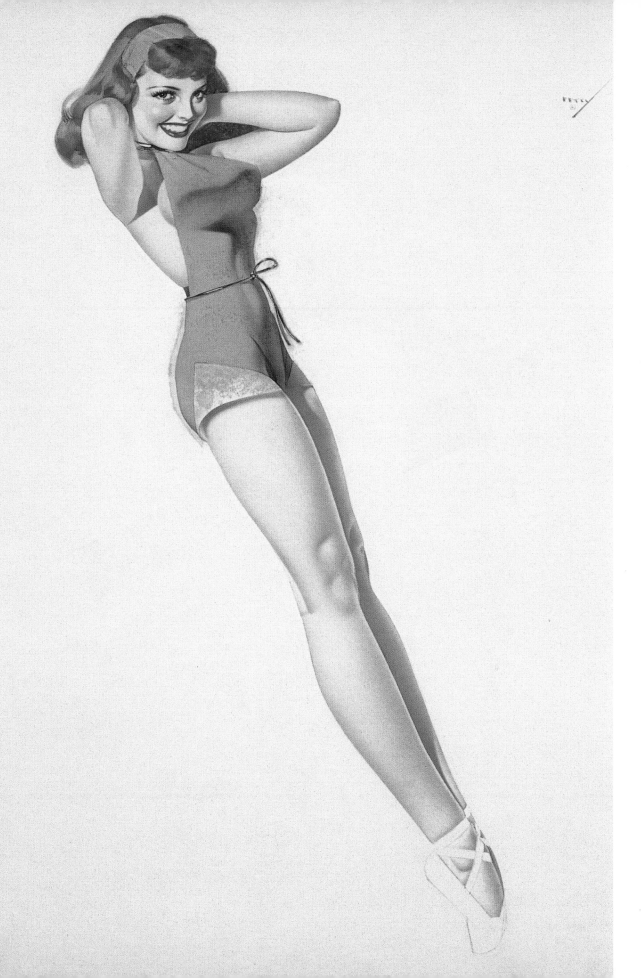

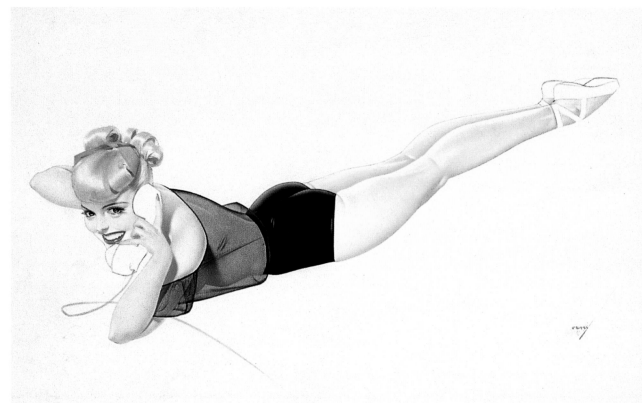

683

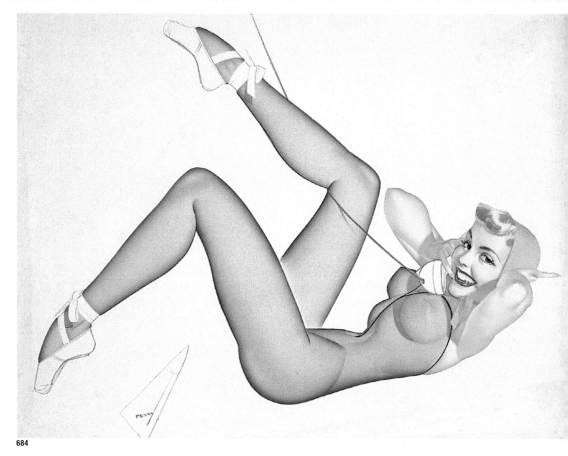

684

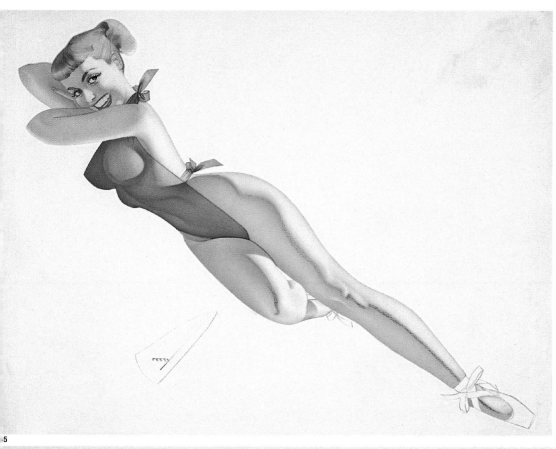

5

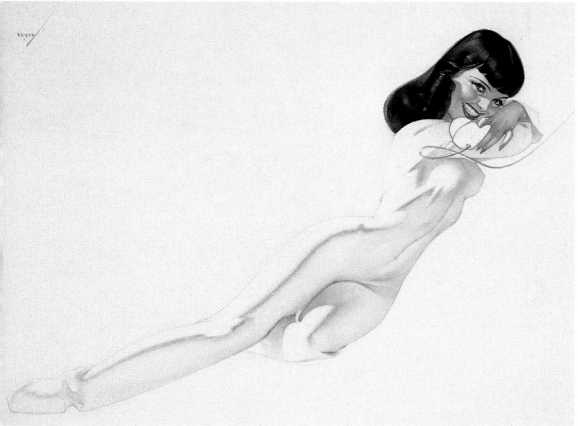

6

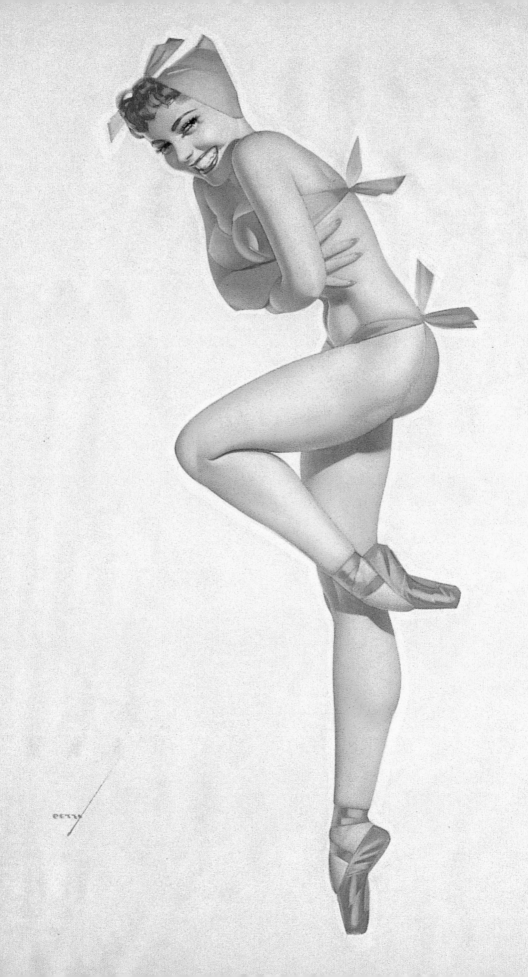

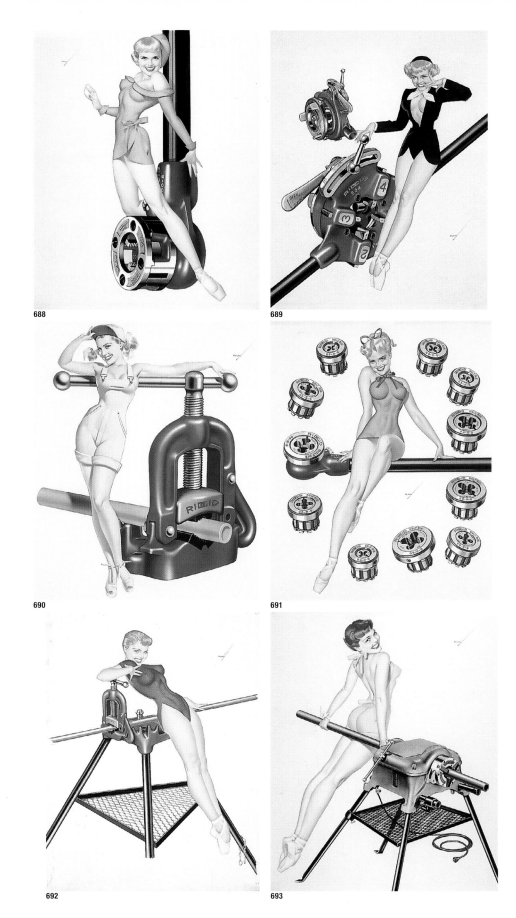

688

689

690

691

692

693

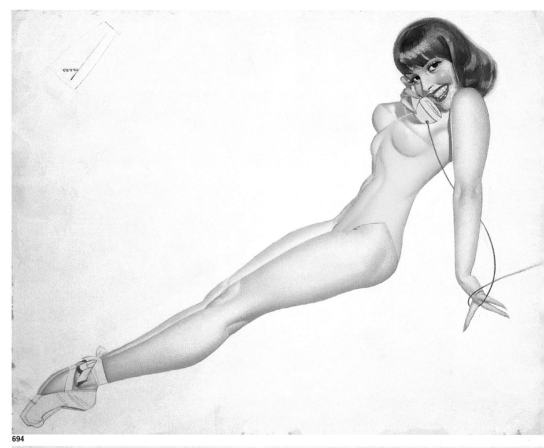

694

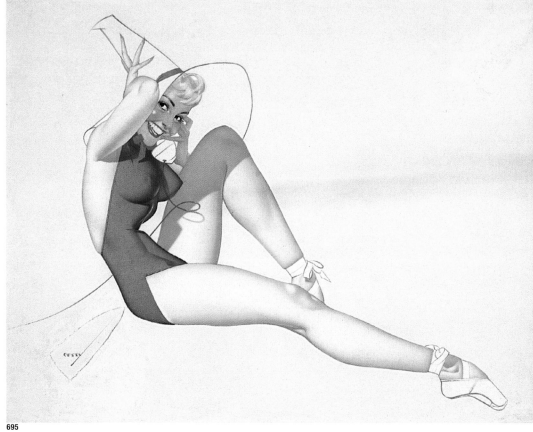

695

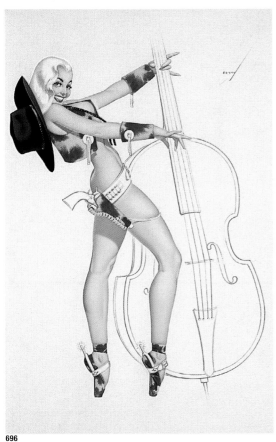

696

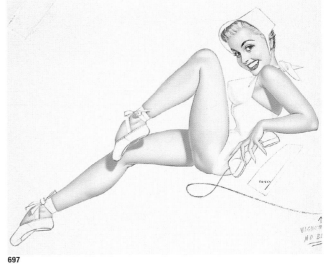

697

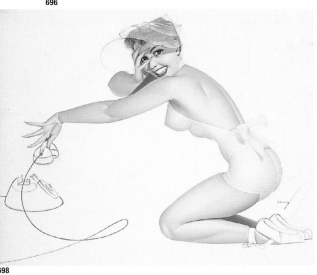

698

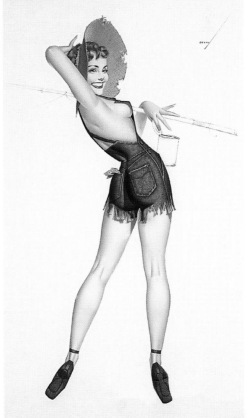

699

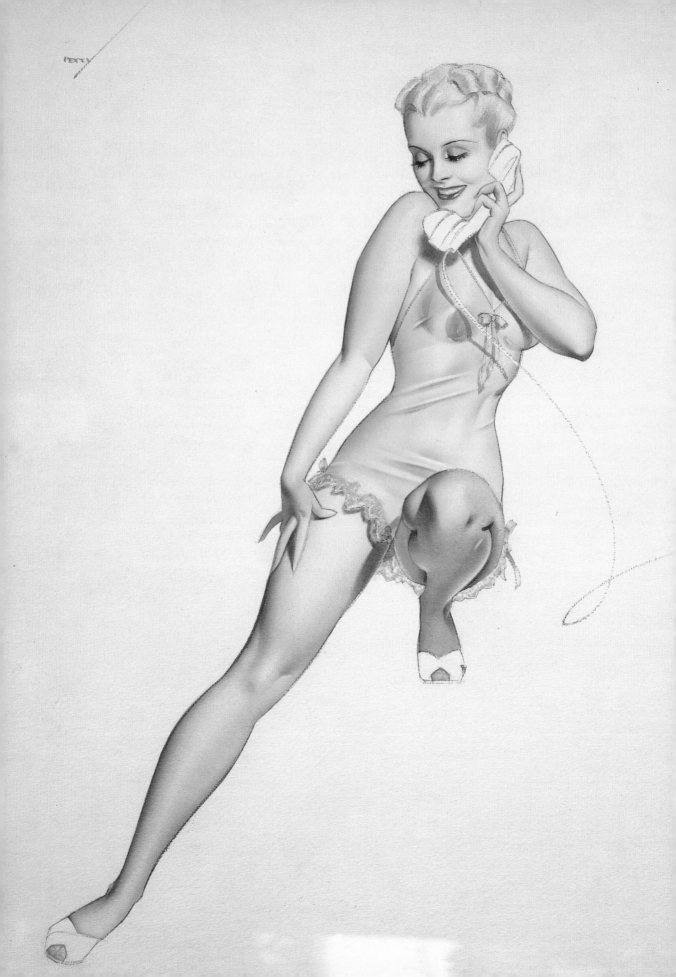

Jay Scott Pike

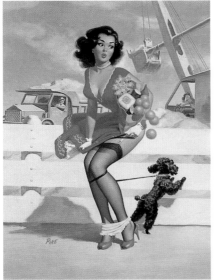

701

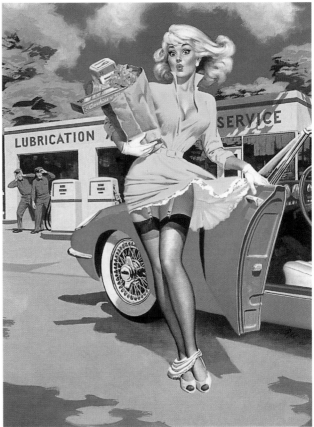

702

When the A. Fox calendar company needed an artist to complete the last two years of Art Frahm's "panties-falling-down" series, they turned to Jay Scott Pike. Among the memorable images he created for Fox are a gas station scene (figure 702) and, as the last in this important series, a picture set on a construction site entitled *Dog Tied* (figure 701).

Pike was born in Philadelphia in 1924. He enrolled at the Arts Students League in New York at the age of sixteen and, after service in the Marines, resumed his art studies at the Parsons School of Design, Syracuse University, and the Ringling

School of Art in Sarasota, Florida. Besides sexy pin-ups, he has painted award-winning illustrations for magazines and comic books as well as advertisements for major corporate clients like Proctor and Gamble, Pepsi, General Mills, Ford, Borden's, and Trans World Airlines.

Near the close of his commercial career, Pike turned to painting canvases of sensuous fine-art nudes. His exquisite pencil drawings of nudes first appeared in the Playboy clubs before being published as limited-edition graphics. In recent years, he has also accepted many portrait commissions.

Auf der Suche nach einem Maler, der die letzten Folgen von Art Frahms „Panties-Falling-Down"-Serie fertigstellen konnte, wandte sich die A. Fox Calendar Company an Jay Scott Pike. Zu den unvergeßlichen Motiven, die Pike für das Unternehmen entwarf, gehörte eine Szene an einer Tankstelle (Abb. 702) und, als letztes Bild dieser bedeutenden Reihe, eine Szene auf dem Bau mit dem Titel *Dog Tied* (Abb. 701).

Jay Scott Pike wurde 1924 in Philadelphia geboren. Im Alter von 16 Jahren schrieb er sich an der Arts Students League in New York ein. Später leistete er seinen Wehrdienst bei den Marines, einer Eliteeinheit, und nahm danach seine Kunstausbildung wieder auf: erst an der Parsons School of Design, dann an der

University of Syracuse, und schließlich an der Ringling School of Art in Sarasota, Florida. Er beherrschte „scharfe" Pin-ups genauso wie preisgekrönte Illustrationen für Zeitschriften und Comics oder auch Anzeigenaufträge für bedeutende Großunternehmen. Proctor and Gamble, Pepsi, General Mills, Ford, Borden's und Transworld Airlines zählten zu seinen Kunden.

Gegen Ende seiner kommerziellen Karriere als Werbeillustrator begann Pike, Akte in Öl zu malen. Seine exquisiten Aktzeichnungen in Kohle erschienen erst in den Playboy Clubs und wurden später in limitierter Auflage als Grafiken auf den Markt gebracht. In den letzten Jahren hat Pike auch viel im Bereich Porträt gearbeitet.

Lorsque l'éditeur A. Fox s'est trouvé en manque d'artistes pour compléter les deux dernières années de la série de jeunes filles «sans culotte» commencée par Art Frahm, il s'est adressé à Jay Scott Pike. Parmi les images mémorables que ce dernier créa pour Fox, on compte une scène dans une station-service (illustration 702) et, dernière de cette importante série, une scène sur un chantier de construction, intitulée *Dog Tied* (illustration 701).

Né à Philadelphie en 1924, Pike s'inscrivit à l'Art Students League de New York à l'âge de seize ans et, après avoir servi dans les Marines, reprit ses études d'art à la Parsons School of Design, à l'université de Syracuse puis à la Ringling School

of Art de Sarasota, en Floride. Outre ses pin up, il peignit des illustrations pour des magazines et des bandes dessinées, qui furent primées, et des affiches publicitaires pour de grands annonceurs tels que Proctor and Gamble, Pepsi, General Mills, Ford, Borden's et Trans World Airlines.

Vers la fin de sa carrière d'illustrateur, Pike s'est tourné vers la peinture de nus. Ses superbes dessins érotiques ont été dans les clubs Playboy avant d'être publiés à tirage limité. Depuis quelques années, il travaille également sur de nombreuses commandes de portraits.

Gene Pressler

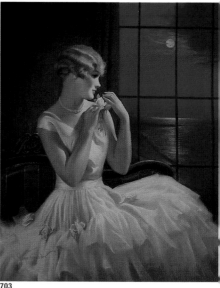

703

A prominent Art Deco artist, Pressler was born in 1893 in Jersey City, New Jersey. His teachers at the Art Students League included F. Louis Mora and Edward Dufner.

Pressler's most important work was published by the Joseph C. Hoover and Sons calendar company of Philadelphia from the 1920s to the mid-1930s. His images were mainly full-length pin-ups, but some – such as *Midnight and You* (figure 703) – were glamorous evening-gown scenes marked by Pressler's typically clever composition. By 1926, Pressler had joined Brown and Bigelow's staff and was contributing skillfully to their "girl subject" line. His highly successful Pompeian

Cream panels (tall and narrow calendar images) were eventually known from coast to coast (figure 706). Pressler also designed front covers for *The Saturday Evening Post* and other mainstream magazines. Working primarily in pastels on large-size canvas (40 x 30 inches; 101.6 x 72.2 cm), the artist insisted that his paintings be reproduced with the most up-to-date printing technology. His colors were generally rich and brilliant, like Armstrong's, but he was also adept at blending pastels in a blue-green color scale reminiscent of Maxfield Parrish's (figure 705).

Pressler retired about 1940, after a distinguished career. His original paintings are extremely rare.

Pressler, ein bekannter Künstler des Art deco, wurde 1883 in Jersey City (New Jersey) geboren. Zu seinen Lehrern an der Art Students League gehörten F. Louis Mora und Edward Dufner.

Von den 20er Jahren bis Mitte der 30er Jahre erschienen seine wichtigsten Arbeiten im Kalenderverlag von Joseph C. Hoover and Sons in Philadelphia. Meistens handelte es sich um Ganzkörper-Pin-ups, doch einige Motive, wie Midnight and Youke *(Abb. 703), waren glamouröse Abendszenen im Ballkleid. Im Jahre 1926 stieß Pressler dann zu Brown and Bigelow und steuerte dort seine kunstvollen „Thema-Mädchen" – Beiträge bei. Seine hochformatigen und*

schmalen Kalenderbilder, die an Tafelbilder erinnerten, waren sehr erfolgreich (Abb. 706).

Pressler entwarf auch Cover für The Saturday Evening Post *und andere Magazine. Hauptsächlich arbeitete er in Pastell auf großformatiger Leinwand (101 x 72 cm) und bestand darauf, daß seine Bilder nach der neuesten Drucktechnik reproduziert wurden. Presslers Farbpalette war satt und brillant, er beherrschte ebenfalls die Kunst, Pastelle in einer blau-grünen Farbskala zu mischen (Abb. 705).*

Nach einer außergewöhnlichen Karriere zog sich Pressler um 1940 ins Privatleben zurück. Von seinen Originalgemälden sind nur wenige erhalten.

Grand artiste Art déco, Pressler est né en 1893 à Jersey City, dans le New Jersey. A l'Art Students League, il eut comme professeurs, entre autres, F. Louis Mora et Edward Dufner.

Pressler eut comme principal client l'éditeur de calendriers Joseph C. Hoover and Sons, des années 20 au milieu des années 30. Il peignait surtout des pin up mais d'autres œuvres, comme *Midnight and You* (illustration 703) étaient des scènes glamour en robes du soir marquées par un grand sens de la composition caractéristique de son travail. En 1926, Pressler rejoignit l'écurie de Brown and Bigelow. Ses panneaux «pompéiens» (des images de calendriers longues et étroites) remportèrent un grand succès (illustration 706).

Pressler réalisa également des couvertures pour *The Saturday Evening Post* et d'autres grands titres. Travaillant principalement au pastel sur grandes toiles (101,6 x 72,2 cm), il insistait pour que ses œuvres soient reproduites avec les dernières techniques d'imprimerie. Ses couleurs étaient le plus souvent vives et brillantes, comme celles d'Armstrong, mais il savait aussi utiliser une gamme de pastels fondus bleu-vert qui rappelait Maxfield Parrish (illustration 705).

Pressler prit sa retraite vers 1940. Les originaux de ses œuvres sont extrêmement rares.

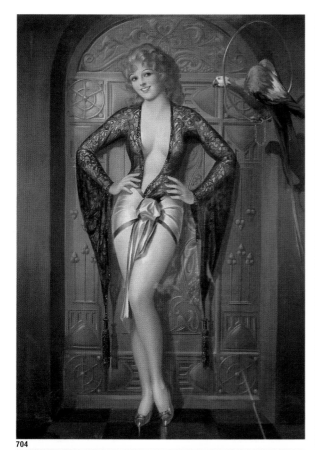

704

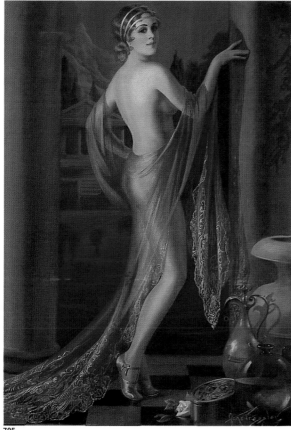

705

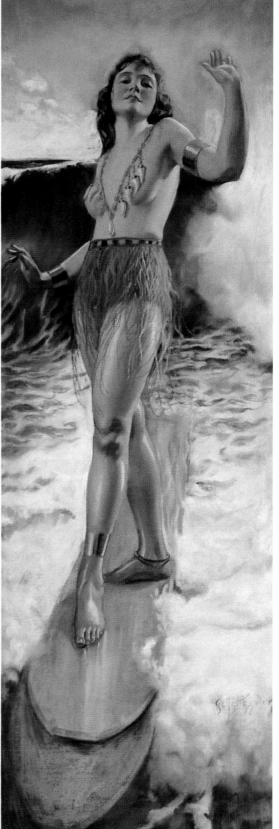

706

George Quintana

There were three artists during the 1920s and 1930s whose pin-ups appeared primarily on the front covers of magazines rather than on calendars or other advertising products: Enoch Bolles, Peter Driben, and George Quintana. Although a great deal is known about Driben's career and life, and some information exists on Bolles, very few facts are known about George Quintana.

Quintana's pin-up art was first published in late 1933 on the front covers of the pulp magazine *New York Nights*, which continued to feature his work until 1937. The first full-size pin-up magazine to carry his cover paintings was *Movie Humor*, which was modeled on *Film Fun*, the magazine that immortalized Bolles. Quintana's pin-ups appeared on the covers of *Movie Humor* from May 1934 until March 1938, when Driben replaced him as the primary cover artist. In 1935, two pulp pin-up magazines, *Tempting Tales* and *Stolen Sweets*, carried Quintana's work, as did another popular pulp, *Ginger* (from September 1935 to the end of 1939).

In den 20er und 30er Jahren gab es drei Künstler, deren Pin-ups vorrangig auf Magazintiteln erschienen und nicht in Kalendern reproduziert oder für andere Werbeprodukte eingesetzt wurden: Enoch Bolles, Peter Driben und George Quintana. Obwohl man viel über das Leben und die Karriere von Peter Driben weiß und auch einiges aus dem Leben von Enoch Bolles bekannt ist, gibt es über George Quintana nur wenige Fakten.

Seine Pin-ups wurden erstmals Ende 1933 auf Titeln des Groschenromans New York Nights *veröffentlicht und bis 1937 weiter verwendet. Das erste großformatige Pin-up-Magazin, das seine Motive als Cover einsetzte, war* Movie Humor, *ein an* Film Fun *angelehntes Magazin. Zwischen Mai 1934 und März 1938 erschienen Quintanas Pin-ups auf den Titelblättern von* Movie Humor; *dann löste ihn Driben als wichtigster Covergestalter ab. 1935 druckten mit* Tempting Tales *und* Stolen Sweets *auch noch zwei andere Billigmagazine seine Arbeiten;* Ginger, *ein bekanntes Blatt ähnlicher Machart, druckte Quintana zwischen September 1935 bis zum Ende des Jahres 1939.*

Dans les années 20 et 30, les pin up de Enoch Bolles, Peter Driben et George Quintana ornaient plutôt les couvertures de magazine que les calendriers ou affiches publicitaires. Si la vie et la carrière de Driben sont bien connues et si l'on dispose de quelques informations sur Bolles, on ne sait pratiquement rien sur George Quintana.

Les pin up de Quintana furent d'abord publiées à la fin de 1933 en couverture du pulp *New York Nights,* qui continua cette collaboration jusqu'en 1937. Le premier grand magazine de pin up à avoir des œuvres de Quintana en couverture fut *Movie Humor,* qui reprenait la formule de *Film Fun,* qui avait immortalisé Bolles. Les pin up de Quintana firent également la couverture de *Movie Fun* de mai 1934 à mars 1938, quand elles furent remplacées par celles de Driben. En 1935, deux pulps spécialisés dans les pin up, *Tempting Tales* et *Stolen Sweets,* publièrent le travail de Quintana, tout comme *Ginger,* un autre pulp populaire (de septembre 1935 à la fin de 1939).

In February 1936, a different kind of Quintana pin-up image appeared on the cover of French *Nite Life*. This keyhole-cutout, or silhouette, image was essentially identical in format to those Driben would make famous in the 1940s in Bob Harrison's pin-up magazines. Even later, Mel Ramos would parody this format in his series of Peekaboo Pop Art paintings (1964); for Ramos, however, the most immediate inspiration was an Elvgren mutoscope card, which served as an artistic link to Driben and, through him, all the way back to Quintana.

Another full-size men's pin-up magazine that Quintana painted front cover pin-ups for was *Movie Merry-Go-Round*. His work for that publication appeared in 1937, the same year that *Gay French* magazine announced that he was the highest paid artist on their staff, earning more than $50,000. Quintana also worked for the pulp title *Hollywood French* Life in 1937. The last full-size, nonpulp men's magazine for which there is a record of a Quintana front cover is the *1939 High Heel Annual*, which was similar in content to *Movie Humor* and *Movie Merry-Go-Round*.

Auf dem Cover von French Night Life *erschien im Februar 1936 eine andere Art von Pin-up. Es war eine wortwörtliche Schlüssellochszene und im wesentlichen identisch mit dem Format, das Driben in Bob Harrisons Pin-up-Zeitschriften der 40er Jahre populär machen sollte. Noch später parodierte dann Mel Ramos dieses Motiv in seiner Serie der Peekaboo Pop Art-Bilder (1964); Ramos' ursprüngliche Inspiration zu dieser Serie war allerdings eine Mutoskopkarte von Elvgren. So entstand die Verbindung zu Driben, und durch Driben geriet Ramos auf die Spuren von Quintana.*

Auch für Movie Merry-Go-Round, *ein großformatiges Männer-Pin-up-Magazin, malte Quintana Pin-ups für die Titelseite. Das war 1937, dem Jahr, in dem die Zeitschrift* Gay French *verlautbaren ließ, er sei der höchstbezahlte künstlerische Mitarbeiter ihres Magazins und verdiene mehr als 50000 Dollar. 1937 arbeitete Quintana für den Billigtitel* Hollywood French Life. *Seinen letzten Titel für ein Magazin, das nicht im Billigbereich angesiedelt war, malte Quintana 1939 für* High Heel Annual, *eine Zeitschrift, die vom Inhalt her* Movie Humor *und* Movie Merry-Go-Round *ähnelte.*

En février 1936, la couverture de *French Nite Life* arbora un type d'image différent de Quintana. Cette silhouette en «trou de serrure» avait pratiquement le même format que celui qui rendrait Driben célèbre dans les années 40 dans les magazines de pin up de Bob Harrison. Plus tard, Mel Ramos allait parodier ce format dans sa série de tableaux Pop Art «Peekaboo» (1964). Toutefois, Ramos s'inspirait alors d'une carte d'art d'Elvgren, qui servit de lien artistique avec Driben, à travers lui, avec Quintana.

Quintana réalisa également des pin up pour les couvertures d'une autre revue pour homme, *Movie Merry-Go-Round,* qui parurent en 1937. Cette même année, le magazine *Gay French* annonça qu'il était l'illustrateur le mieux payé de son équipe, avec plus de 50000 dollars. En 1937, Quintana travailla aussi pour le pulp *Hollywood French Life.* Le dernier grand magazine pour hommes qui ne soit pas un pulp et qui ait eu des couvertures de Quintana est *High Heel Annual,* dont le contenu était similaire à celui de *Movie Humor* et *Movie Merry-Go-Round.*

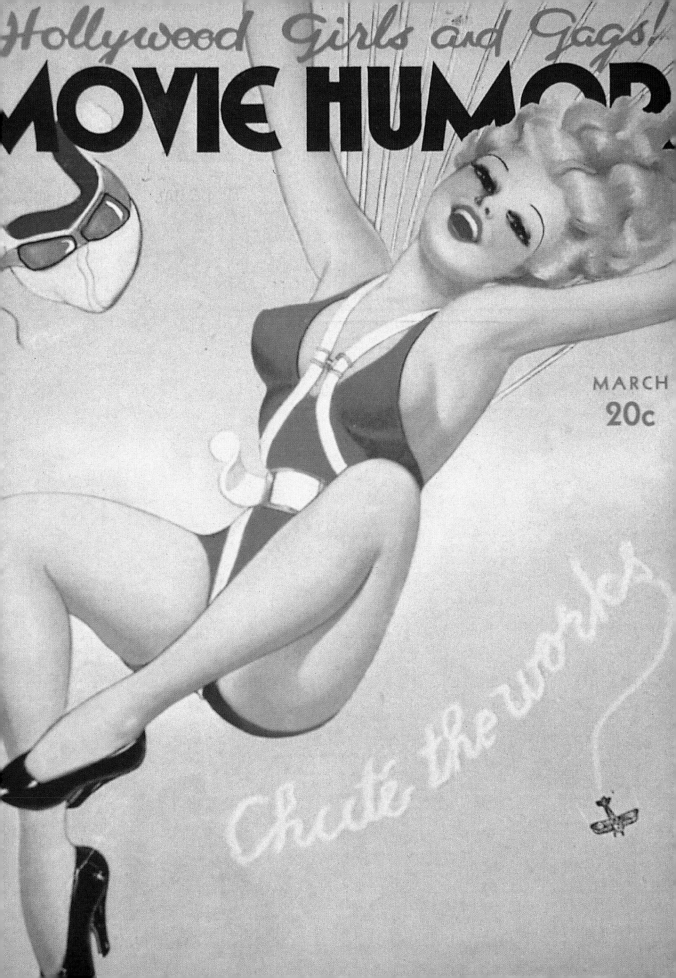

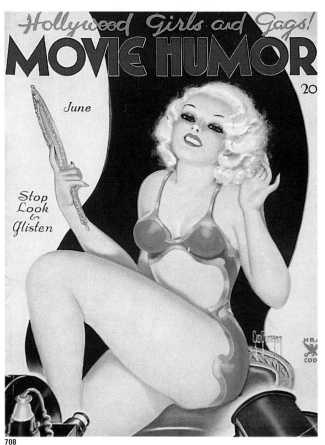

708

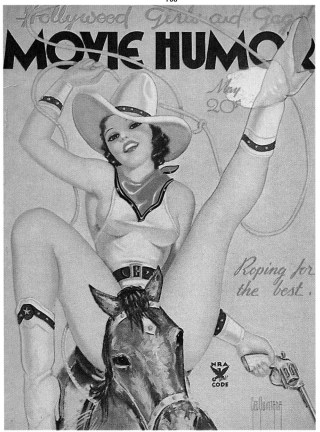

709

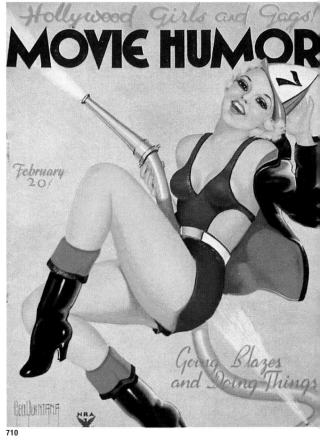

710

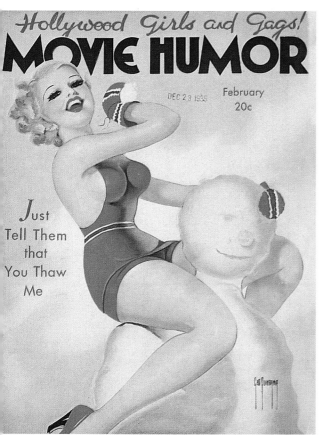

11

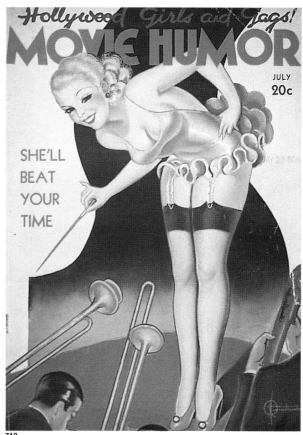

712

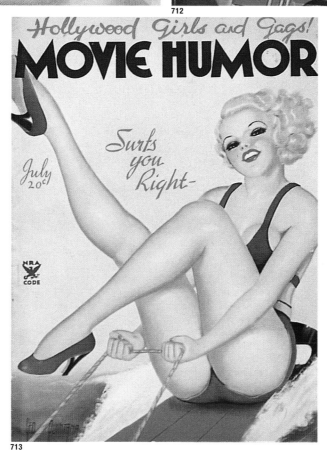

713

Bill Randall

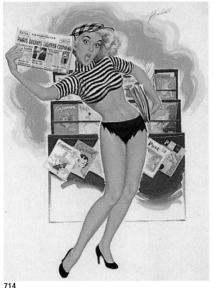

714

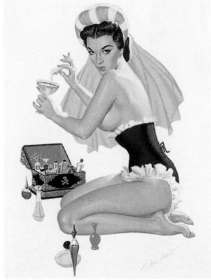

715

Noted for his phenomenally successful Date Book calendars of the 1950s and 1960s, Randall was born in 1911 and attended the Chicago Art Institute. He worked as a commercial artist until the war, when he joined with the French underground on a counterpropaganda campaign to create anti-Nazi artwork. Randall first gained notice in 1946, when *Esquire* selected him as a regular contributor to their Gallery of Glamour; he also painted centerfold pin-ups for *Esquire* and contributed ideas to their yearly calendar.

Randall also produced a great deal of advertising art for American corporations. Scotch Brand Celluose Tape, Minnesota Mining and Manufacturing, Palmolive Soap, White Rock, and General Motors were among the many mainstream companies that incorporated his pin-up images into their advertisements.

In 1950, Randall did a front-cover painting for *Parents* magazine. The same year, he also began a series of front covers for *American Weekly*, Hearst's Sunday-magazine supplement, which throughout the decade brought his pin-up themes to a larger audience of American readers than any other magazine. Ran-

dall also provided a similar set of images to Hearst's other Sunday supplement, *Pictorial Weekly*, and created a notable string of front covers for *Collier*'s from December 1952 to April 1953.

The first of Randall's Date Book calendar series was published in 1953 by the Kemper-Thomas Calendar Company in Ohio. One of the most successful in the company's history, the series is sometimes compared to the Artist's Sketch Pads published by Brown and Bigelow. However, Randall's sketches were executed in gouache rather than in pencil and were drawn on an overlay rather than on the painting itself. The result was that his calendars had a more light-hearted feeling, accented by the cartoon-like side sketches. That a photograph of Randall often appeared on the front of the calendar only enhanced his celebrity.

Though he is best remembered for the Date Book series, it should be remembered that Randall was a highly prolific, versatile illustrator who painted pin-up and glamour art for a vast range of markets; he even illustrated seven books during his multifaceted career.

Der 1911 geborene Bill Randall war Absolvent des Art Institute of Chicago. Bekannt wurde er durch seine überaus erfolgreichen Terminkalender, die in den 50er und 60er Jahren auf den Markt kamen. Bis zum Ausbruch des Zweiten Weltkriegs war Randall als Werbegrafiker tätig. Während des Krieges arbeitete er mit der französischen Résistance an der Entwicklung einer Propaganda-Kampagne mit Anti-Nazi-Bildmaterial. Erste Aufmerksamkeit erlangte Randall durch einen Auftrag der Zeitschrift Esquire, *die ihn 1946 zum ständigen Mitarbeiter an ihrer „Gallery of Glamour" machte; für* Esquire *malte er beispielsweise die ausklappbaren Pin-ups im Mittelteil des Heftes und war Ideenlieferant für den Jahreskalender des Magazins.*

Für viele amerikanische Unternehmen schuf Randall Anzeigen. Großunternehmen wie Scotch Brand Cellulose Tape, Minnesota Mining and Manufacturing, Palmolive Soap, White Rock und General Motors setzten gerne Randalls Pin-ups bei ihren Anzeigenkampagnen ein.

1950 malte Randall ein Cover für die Zeitschrift Parents. *Im gleichen Jahr begann er mit einer ganzen Serie von Covern für* American Weekly, *die Sonntagsbeilage aus dem Hearst Verlag. Mit diesem Auftrag erreichten seine Pin-ups in den nächsten zehn Jahren eine große Leserschaft in Amerika. Auch für Hearsts andere Sonntagsbeilage* Pictorial Weekly *kreierte er eine vergleichbare Serie.*

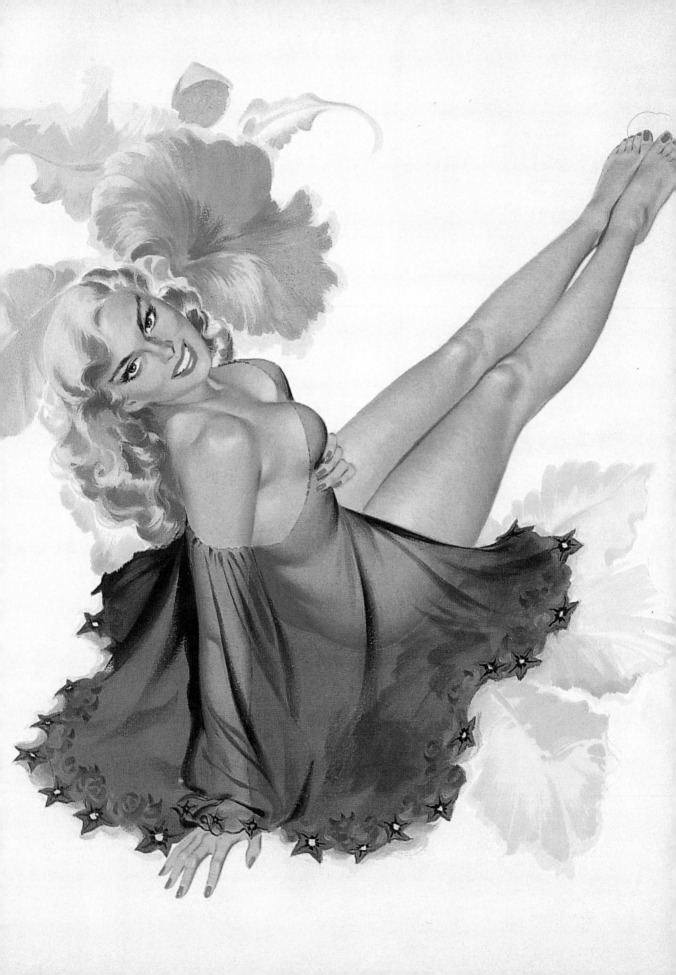

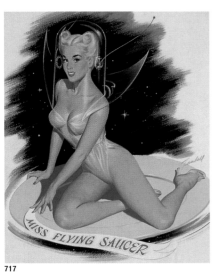

717

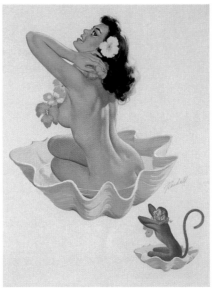

718

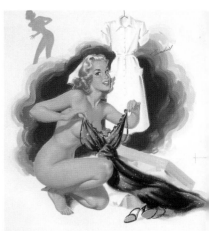

719

Zwischen Dezember 1952 und April 1953 entwarf er zusätzlich eine bemerkenswerte Anzahl von Titelblättern für die Zeitschrift Collier's.

Der erste in einer ganzen Reihe von Terminkalendern Randalls wurde 1953 von der Kemper-Thomas Calendar Company aus Ohio auf den Markt gebracht. Er wurde zu einem der erfolgreichsten in der Firmengeschichte, und die Reihe wird manchmal mit dem „Artist's Sketch Pad", dem Künstlerskizzenblock aus dem Hause Brown and Bigelow, verglichen. Randalls Skizzen wurden in Gouache anstelle von Bleistift ausgeführt und nicht auf dem tatsächlichen Bild reproduziert,

sondern auf einem aufliegenden Blatt. Das verschaffte seinen Kalendern eine gewisse Leichtigkeit, die die cartoonartigen Skizzen an den Seiten des Bildes noch verstärkten. Daß oft ein Foto von Randall auf dem Einband zu finden war, vergrößerte seine Popularität noch mehr.

Obwohl ihn vorrangig diese Kalender bekannt machten, wird man Randall auch als einem sehr produktiven und vielseitigen Illustrator begegnen, der Pin-ups und Glamourbilder für viele verschiedene Bereiche fertigte, denn er illustrierte unter anderem auch sieben Bücher.

Né en 1911 et ancien élève du Chicago Art Institute, Randall est surtout connu pour le succès phénoménal de ses calendriers Date Book dans les années 50 et 60. Il travailla comme graphiste jusqu'à la guerre, durant laquelle il travailla avec la Résistance française sur une campagne de contre-propagande, réalisant des affiches antinazies. Randall se fit d'abord connaître en 1946, quand Esquire le choisit comme collaborateur régulier à la série Gallery of Glamour. Il peignit également des posters centraux pour le magazine et fournit des idées pour son calendrier annuel.

Randall réalisa également un grand nombre de publicités pour des compagnies américaines. Scotch Brand Cellulose Tape, Minnesota Mining and Manufacturing, Palmolive, White Rock et General Motors furent parmi les grandes firmes qui incorporèrent des pin up de Randall dans leurs publicités.

En 1950, Randall peignit une couverture pour le magazine Parents. La même année, il commença une série de couvertures pour American Weekly, supplément dominical du journal de Hearst qui fut, tout au long des années

50, celui qui contribua le plus à familiariser le grand public avec les pin up. Randall fournit également une autre série de pin up pour l'autre supplément dominical de Hearst, Pictorial Weekly, et créa un grand nombre de couvertures pour Collier's de décembre 1952 à avril 1953.

Le premier calendrier Date Book de Randall fut publié en 1953 par Kemper Thomas. Cette série, l'un des best-sellers de cet éditeur, est parfois comparée à l'Artist's Sketch Pad de Brown and Bigelow. Toutefois, les esquisses de Randall étaient réalisées à la gouache plutôt qu'au crayon et n'étaient pas intégrées à la peinture principale. L'effet final était plus léger, accentué encore par l'aspect «bande dessinée» des esquisses en marge. La photographie de Randall paraissait souvent sur la couverture du calendrier, ce qui renforça encore sa célébrité.

Randall était un illustrateur très prolifique et pluridisciplinaire. Ses pin up et ses beautés glamour furent diffusées sur un grand nombre de marchés. Il illustra également sept livres.

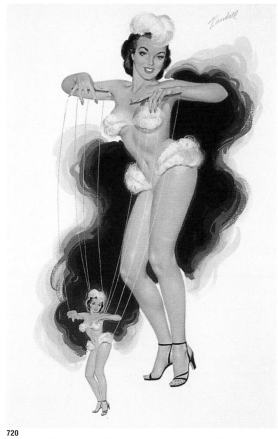

720

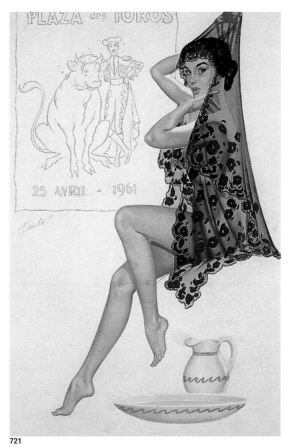

721

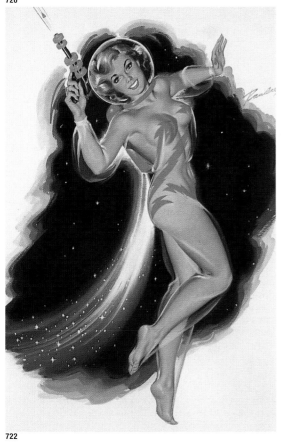

722

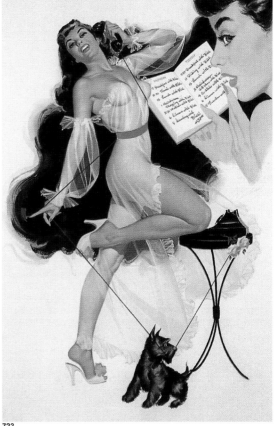

723

Edward Runci

Ed Runci was an outstanding painter of pin-ups during the 1940s and 1950s whose smooth style was much admired by his contemporaries. Unlike the other artists who came out of the Sundblom school, Runci applied his paint in thin, flat brushstrokes that created a soft-focus, Photo-Realist effect.

The child of Italian immigrants, Runci was born in the San Fernando Valley and grew up in Detroit. During World War II, he fought with the Marines at Guadalcanal. Later, his difficult convalescence from the horrors of that experience was helped by a nurse who encouraged him to draw. Back home in Detroit, he continued practicing his art and began experimenting with oil paints.

Seeking models for his work, but too shy to approach strangers, Runci enlisted his mother's help: it was she who persuaded a beautiful young woman who worked at a defense plant to pose for her son. Jeanette would become Runci's most famous model as well as a close friend. About 1947, he married an accomplished artist named Maxine and the two established a home and studio near Big Bear, an isolated spot perched high in the mountains near Santa Barbara.

After selling his first glamour painting to the Shaw-Barton calendar company in 1947, Runci teamed with Maxine to paint nine glamour images for Brown and Bigelow. Yet it was his subsequent work for Shaw-Barton that immortalized Runci's name as a pin-up and glamour artist. That firm's outstanding national marketing campaign promoted his work effectively for many years. All the spectacular pin-ups the artist delivered to Shaw-Barton shared one trait: the Runci girls were always happy, even when caught in awkward situations.

At the peak of his career, Runci finally came to terms with the trauma that had haunted him since Guadalcanal and, in gratitude, painted a portrait of Christ that went on to become a much-beloved religious calendar subject. When Maxine died, he lived for a while in Arizona, where he fulfilled a lifelong dream to paint Western scenes. He was living on the California ranch of Jeanette and her husband Frank when he died.

Runci used two different signatures on his pin-up and glamour paintings: one in a beautiful script, the other in a more printed, block style. He is known to have signed a few pin-ups with the name "Stevens" (figure 733). Maxine signed her paintings with an exaggerated block signature, using an over-size R in her last name.

Während der 40er und 50er Jahre war Ed Runci ein Star unter den Pin-up-Künstlern. Künstlerkollegen bewunderten seinen weichen, glatten Stil. Im Gegensatz zu den anderen Künstlern der Sundblom-Schule trug Runci seine Farbe in dünnen, flachen Pinselstrichen auf und erhielt so einen fotorealistischen Effekt.

Runci wurde als Kind sizilianischer Eltern in Genua (Italien) geboren, und lebte bis zum Alter von zehn Jahren in Italien. Während des Zweiten Weltkriegs war er mit den Marines in Guadalcanal stationiert. Daß er zu malen begann, hatte er der Anregung einer Krankenschwester zu verdanken, die ihm helfen wollte, die grauenvollen Kriegserlebnisse zu verarbeiten. Nach seiner Rückkehr nach Detroit beschäftigte er sich ernsthaft mit der Malerei und begann, auch mit Ölfarben zu experimentieren.

Da Runci selbst zu schüchtern war, Frauen anzusprechen, die ihm Modell sitzen sollten, bat er seine Mutter um Hilfe. Sie war es, die eine wunderschöne, junge Frau ansprach, ihrem Sohn Modell zu sitzen. Jeanette arbeitete in einem Rüstungsbetrieb und sollte bald Runcis berühmtestes Modell und eine enge Freundin werden. 1947 heiratete er die bereits arrivierte Malerin Maxine, und das junge Paar zog nach Big Bear, einem abgelegenen Bergwinkel oberhalb des kalifornischen Santa Barbara und richtete sich dort ein Zuhause und ein Studio ein. 1985 starb er in San Bernadino, Kalifornien, im Alter von 65 Jahren an einer Lungenentzündung

Nachdem er 1947 ein erstes Glamourbild an den Kalenderverlag Shaw-Barton verkauft hatte, schloß sich Runci mit seiner Frau zu einem Team zusammen, und sie malten neun weitere Glamourbilder für einen neuen Auftraggeber, Brown and Bigelow. Doch erst mit seinen späteren Arbeiten für Shaw-Barton konnte sich Runci als Pin-up- und Glamour-Künstler etablieren. Die herausragende, landesweite Marketingkampagne des Verlages förderte seine Arbeiten viele Jahre lang. Den spektakulären Pin-ups, die Runci an Shaw-Barton lieferte, war allen eines gemein: Seine Runci-Girls waren immer glücklich, auch wenn sie sich in einer prekären Lage befanden.

Auf dem Höhepunkt seiner Karriere gelang es Runci, sich endlich von den traumatischen Kriegserlebnissen zu befreien, die ihn seit Guadalcanal verfolgt hatten. Aus Dankbarkeit malte er ein Porträt von Jesus Christus, ein später sehr beliebtes Kalendermotiv. Nach dem Tode seiner Frau Maxine lebte er einige Zeit in Arizona. Dort konnte er sich einen Lebenstraum erfüllen – Westernmotive vor der Natur malen. Bis zu seinem Tod lebte er auf der Ranch seines erstes Modells Jeanette und ihres Mannes Frank in Kalifornien.

Runci verwendete für seine Pin-up- und Glamourbilder zwei verschiedene Signaturen: eine war in einer wunderschönen Handschrift gehalten, die andere erinnerte eher an Druckbuchstaben. Einige seiner Pin-ups zeichnete er auch mit dem Namen „Stevens" (Abb. 733). Maxine zeichnete ihre Bilder mit einer übertriebenen Blocksignatur, wobei das „R" ihres Nachnamens größer war als die anderen Buchstaben.

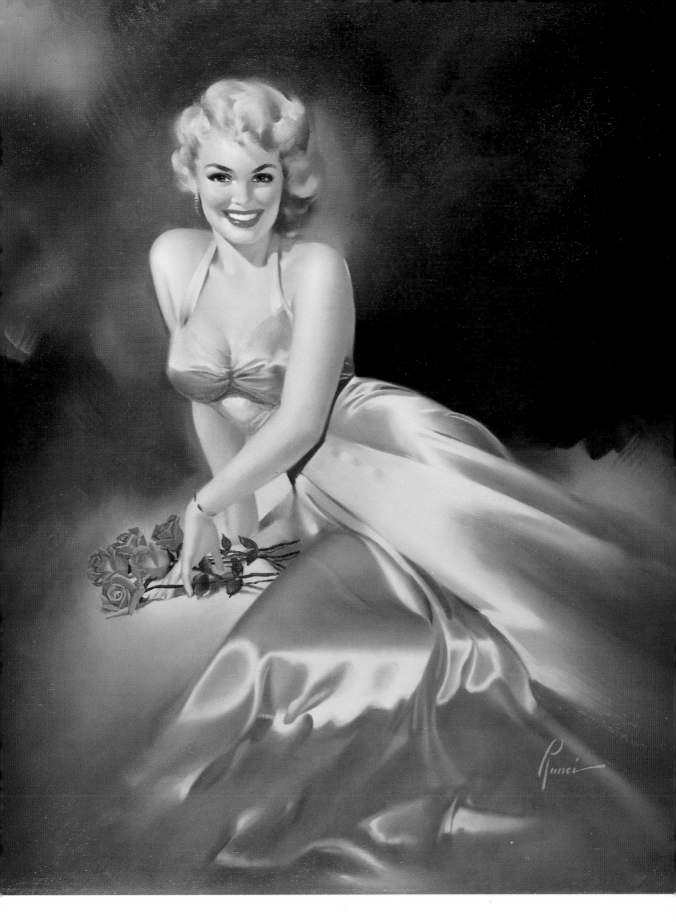

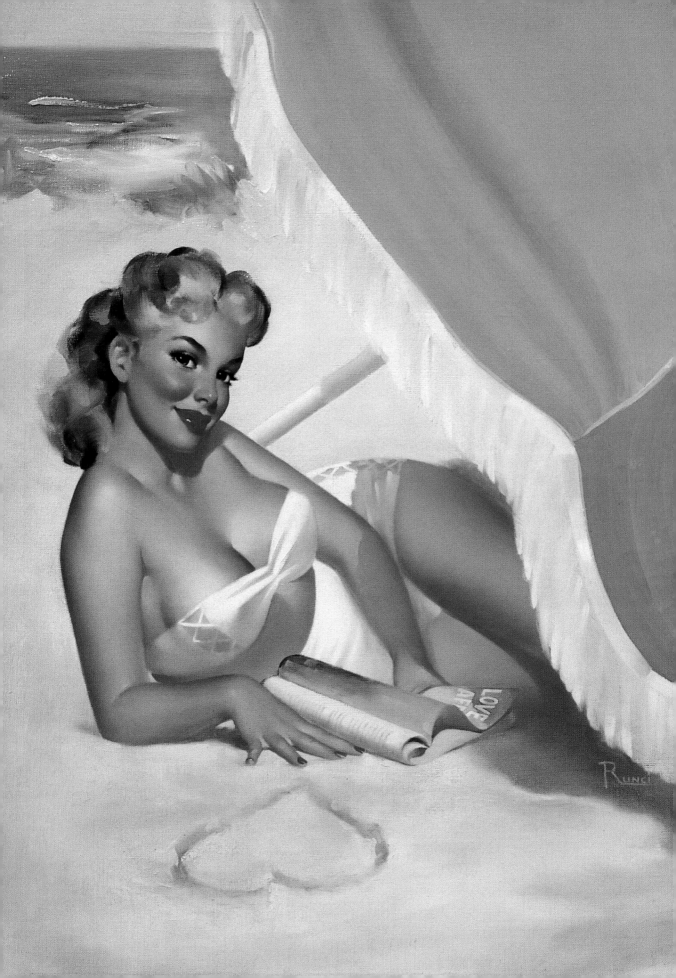

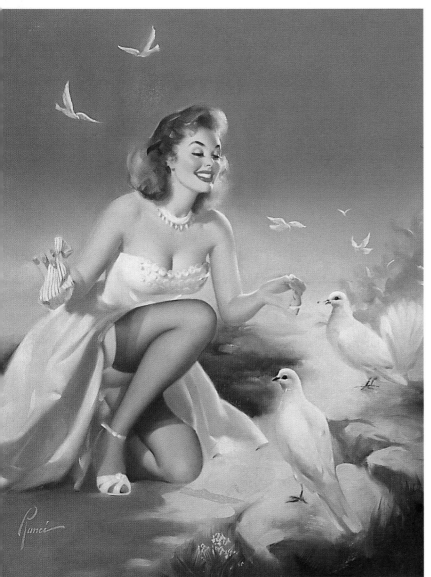

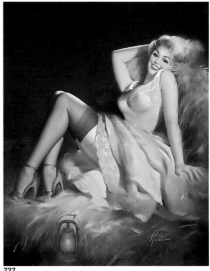

727

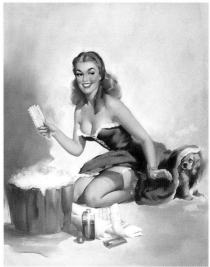

726

728

dans les années 40 et 50, le style «léché» d'Ed Runci lui valut l'admiration de ses contemporains. Contrairement à d'autres membres de l'école de Sundblom, ce grand artiste de pin up appliquait sa peinture à petits coups de pinceau légers, ce qui créait un effet lisse, d'un réalisme quasi photographique.

Fils d'immigrés italiens d'origine sicilienne, Runci est né à Gênes et a vécu en Italie jusqu'à l'âge de dix ans. Il est mort des suites d'une pneumonie à l'âge de 65 ans, à San Bernardino (Californie) en 1985. Pendant la Deuxième Guerre mondiale, il servit dans les marines et se battit à Guadalcanal. Plus tard, se remettant difficilement des horreurs vécues lors de cet épisode sanglant, il fut aidé par une infirmière qui l'encouragea à dessiner. De retour à Detroit, il poursuivit son apprentissage et s'initia à la peinture à l'huile.

Trop timide pour chercher des modèles, il se fit aider par sa mère, qui persuada une jeune et belle ouvrière d'une usine d'armement de poser pour son fils. Jeannette devint le modèle le plus célèbre de Runci et une grande amie. En 1947, il épousa une artiste accomplie appelée Maxine et, ensemble, ils établirent leur atelier et leur foyer près de Big Bear, un coin isolé haut perché dans les montagnes près de Santa Barbara.

Après avoir vendu sa première œuvre glamour à Shaw-Barton en 1947, Runci

travailla avec Maxine sur une série de neuf beautés glamour pour Brown and Bigelow. Mais ce fut néanmoins une autre œuvre plus tardive pour Shaw-Barton qui établit sa réputation. L'excellente campagne nationale de marketing de l'éditeur de calendriers promut son travail avec une grande efficacité pendant de nombreuses années. Les pin up spectaculaires que Runci réalisa pour Shaw-Barton avaient toutes un point en commun: même surprises dans les situations les plus embarrassantes, elles respiraient toujours la joie de vivre.

Au sommet de sa carrière, Runci parvint enfin à surmonter le traumatisme qui le hantait depuis la bataille de Guadalcanal et, reconnaissant, il peignit un portrait du Christ qui devint un sujet de calendrier religieux très apprécié. Après la mort de Maxine, il vécut un temps en Arizona, où il réalisa son vieux rêve: peindre des paysages de l'ouest américain. Il mourut en Californie, dans le ranch de Jeannette et de son mari, Frank, où il s'était installé.

Runci signait ses pin up et ses beautés glamour tantôt avec de belles lettres calligraphiées, tantôt avec des caractères d'imprimerie. Il aurait également signé plusieurs œuvres du nom de «Stevens» (illustration 733). Maxine signait ses toiles avec de très grosses lettres d'imprimerie, utilisant un R disproportionné pour son patronyme.

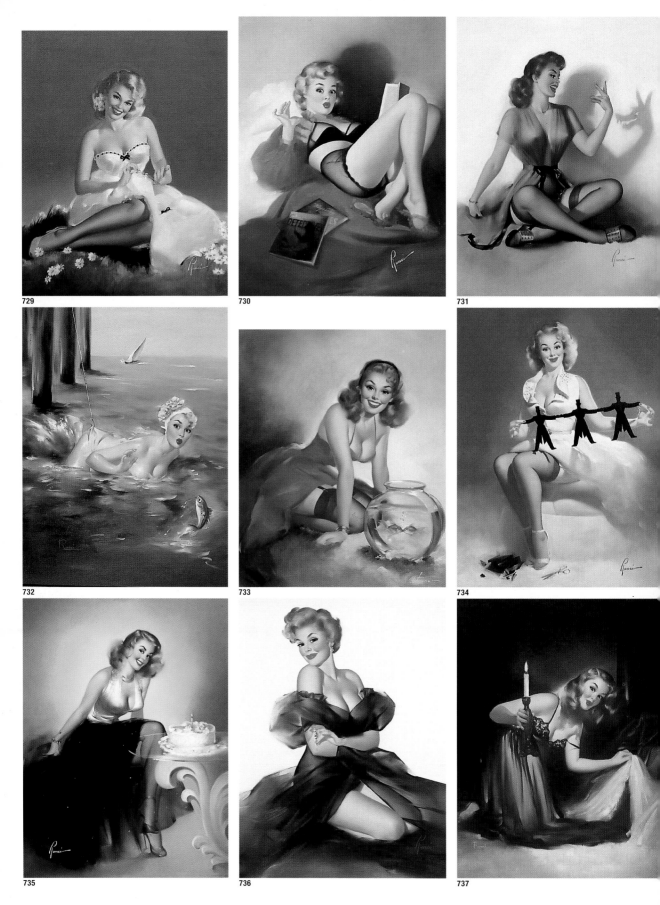

729

730

731

732

733

734

735

736

737

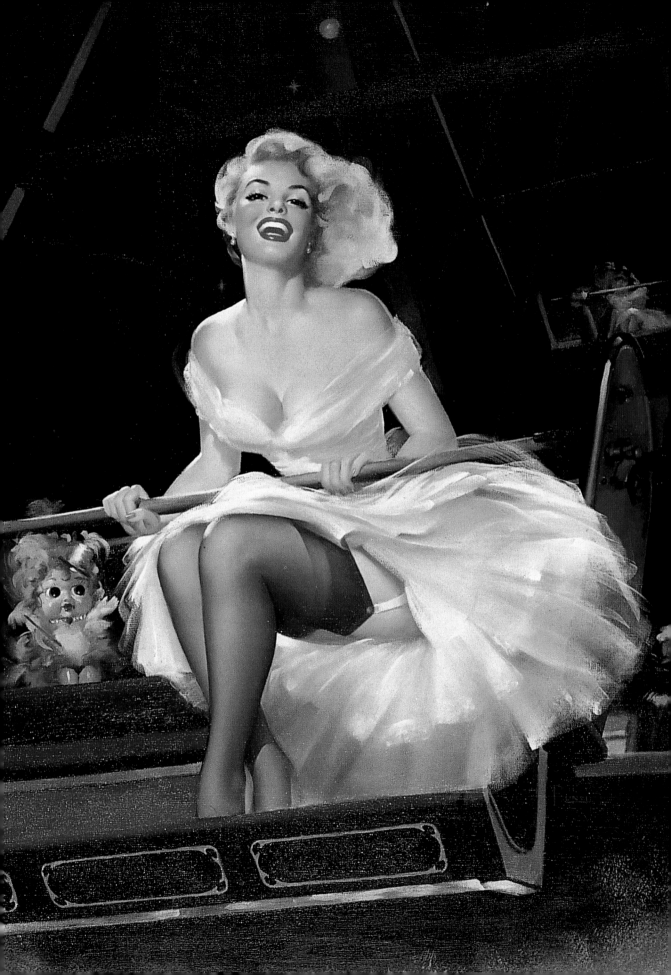

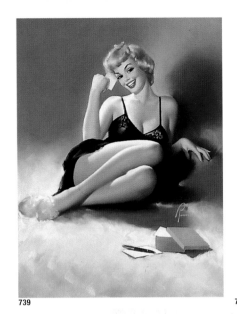

739

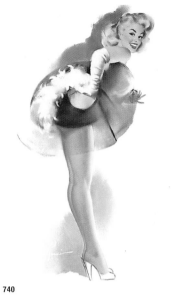

740

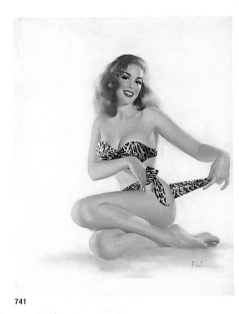

741

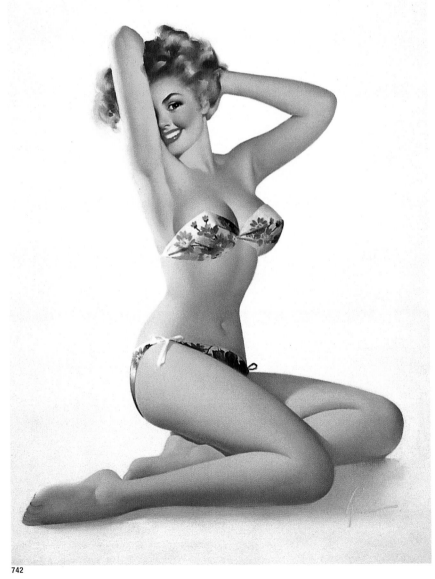

742

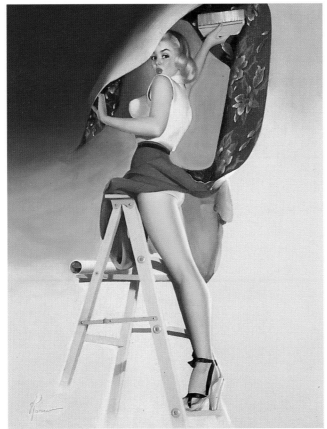

743

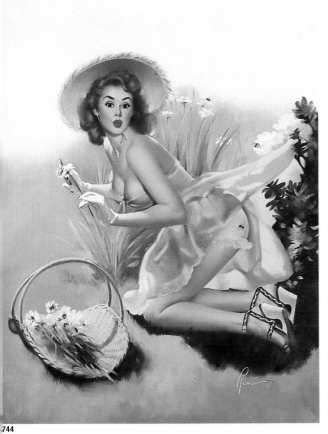

744

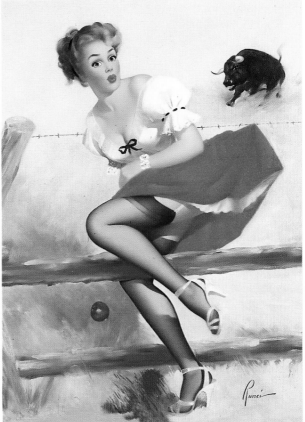

745

Arthur Sarnoff

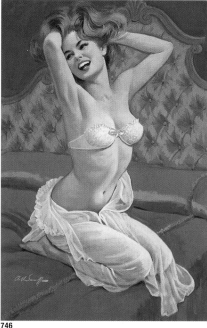

746

Sarnoff was born on December 30, 1912, in New York City and grew up in Brooklyn. At the Grand Central School of Art, he was inspired by the teacher Harvey Dunn and later studied with John Clymer and Andrew Wyeth.

During a long and prolific career, Sarnoff has been successful in a wide variety of fields. From his first pulp-magazine job in the early 1930s, he went on to create front covers and story illustrations for all the leading mainstream magazines. His more than thirty years of calendar work included glamour images, with a particularly sophisticated use of lighting, for the Kemper-Thomas Company in Ohio in the 1940s, as well as pin-ups for the U.O. Colson Company of Illinois in the 1950s and 1960s. Among the many prominent national ad campaigns he worked on were those for Karo Syrup (1940s), Lucky Strike cigarettes (1951),

and Camay Soap (1942–52); he has only recently completed a series of ads for Coors Beer.

Sarnoff, who has long admired the work of John Singer Sargent, has had a distinguished career in portraiture; his depictions of President and Mrs. John F. Kennedy are among his most accomplished. Since the mid-1960s, he has provided illustrations for lithographs to the Arthur Kaplan Company, including his phenomenally successful series of dogs playing cards and shooting pool. His pool-playing scene entitled The Hustler was the best-selling commercial print of the 1950s and one of the most famous and widely reproduced images in contemporary art.

In 1995, Sarnoff was teaching art classes in Beverly Hills, California.

Sarnoff wurde am 30. Dezember 1912 in New York geboren und wuchs in Brooklyn auf. An der Grand Central School of Art erhielt er erste Impulse von seinem Lehrer Harvey Dunn; später studierte er bei John Clymer and Andrew Wyeth.

Während seiner langen Karriere war Sarnoff auf verschiedenen Gebieten erfolgreich. Erste Aufträge in den 30er Jahren fertigte er für Groschenromane an, später folgten Coverillustrationen für alle führenden Zeitschriften. Mehr als drei Jahrzehnte war Sarnoff im Kalenderbereich tätig, wo er sich auf Glamourkunst konzentrierte, für die er eine raffinierte Lichttechnik einsetzte. In den 40er Jahren arbeitete er für die Kemper-Thomas Company in Ohio; in den 50er und 60er Jahren lieferte er Pin-ups für die U.O. Colson Company of Illinois. Zu den großen

Anzeigenkampagnen auf nationaler Ebene gehörten Aufträge von Karo Syrup, Lucky Strike Zigaretten und die Seife Camay sowie für die Brauerei Coors Beer.

Sarnoff bewunderte zeitlebens John Singer Sargent und kann selbst auf eine erfolgreiche Karriere als Porträtmaler zurückblicken; seine Bilder von John F. und Jacqueline Kennedy gehören zu seinen Glanzstücken. Seit Mitte der 60er Jahre schuf er für die Arthur Kaplan Company Illustrationen für Lithographien. Sein Billardmotiv The Hustler wurde zum erfolgreichsten kommerziellen Druck der 50er Jahre und gilt als einer der berühmtesten und meist verbreitetsten Reproduktionen in der Geschichte der Kunst. Später gab Sarnoff in Beverly Hills Kunstunterricht.

Né le 30 décembre 1912 à New York, Arthur Sarnoff grandit à Brooklyn. Il fréquenta la Grand Central School of Art, où il trouva en son professeur Harvey Dunn une grande source d'inspiration, et étudia plus tard avec John Clymer et Andrew Wyeth.

Au cours d'une longue carrière prolifique, Sarnoff perça dans de nombreux domaines. Après avoir illustré des pulps au début des années 30, il créa des couvertures et des illustrations pour tous les grands magazines de son époque. Parmi sa trentaine d'images pour calendriers (pour Kemper-Thomas dans les années 40, puis U.O. Colson dans les années 50 et 60), il y eut beaucoup de sujets glamour, caractérisés par une utilisation particulièrement sophistiquée de la lumière. Il travailla sur de nombreuses campagnes de publicité, notamment celles de Karo

Syrup (années 40), Lucky Strike (1951) et Camay (1942–1952). Plus récemment, il a réalisé une nouvelle campagne pour les bières Coors.

Grand admirateur de John Singer Sargent, Sarnoff s'est également distingué dans les portraits. Ceux de M. et Mme John F. Kennedy sont parmi les plus accomplis. Depuis le milieu des années 60, il réalise des lithographies publiées par Arthur Kaplan. Sa série représentant des chiens jouant aux cartes et au billard eut un immense succès. Sa scène de joueurs de billard intitulée *The Hustler* battit des records de ventes quand elle fut publiée dans les années 50. C'est une des images les plus célèbres et les plus souvent reproduites de l'histoire de l'illustration.

En 1995, Sarnoff enseignait encore l'art à Beverly Hills, en Californie.

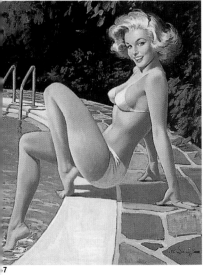

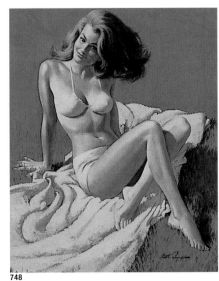

748

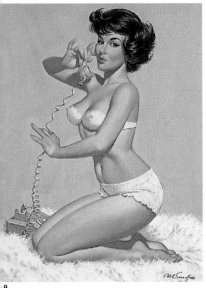

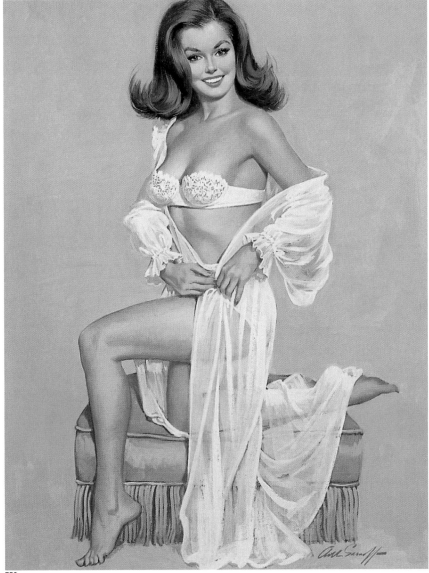

750

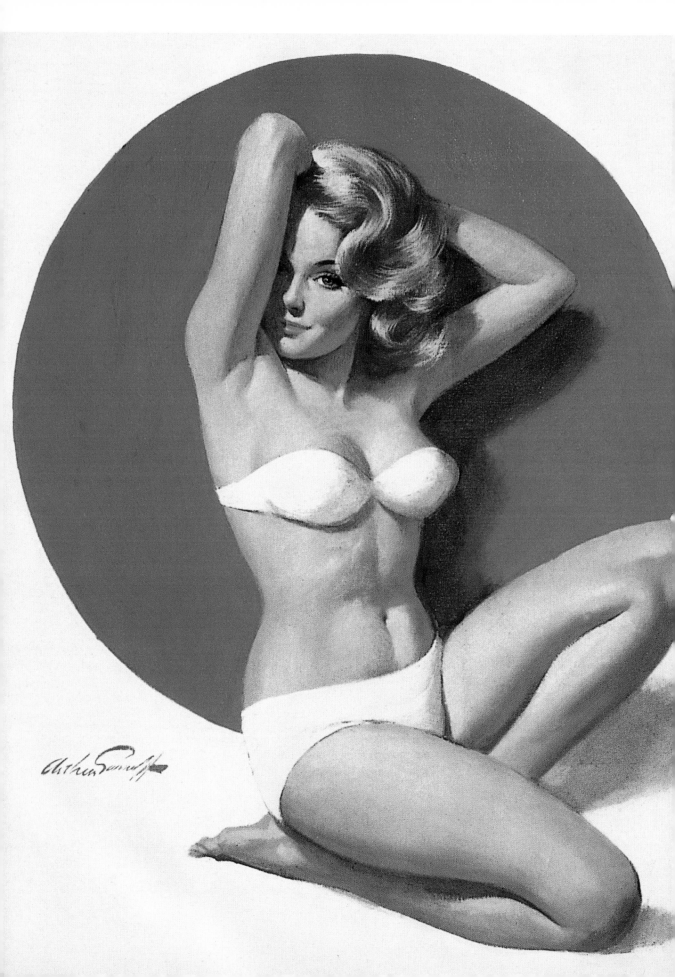

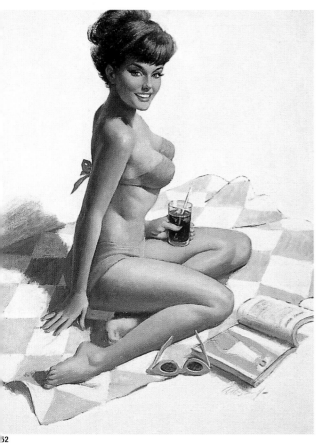

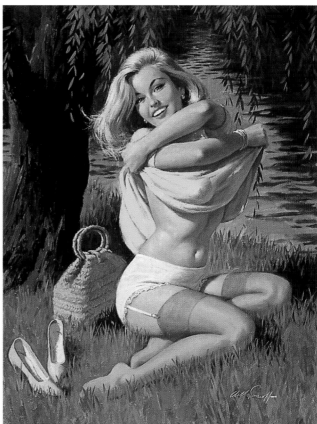

752

753

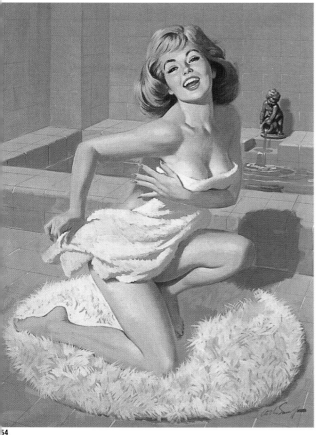

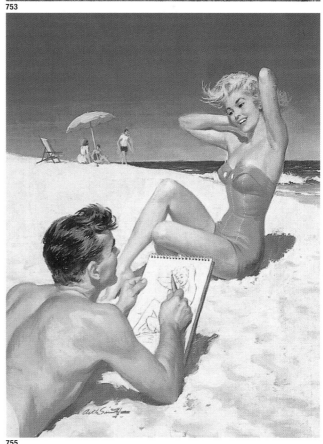

754

755

751

Mauro Scali

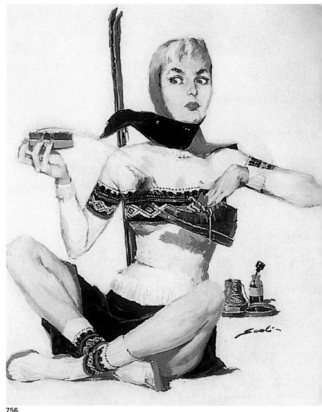

756

Scali was a pin-up and glamour artist who had the unusual ability to paint in two different styles: either "tight," with an almost photographic clarity, or "loose," with an Impressionistic freedom of form. *Esquire* was a major client for his glamour work, which first appeared as the magazine's centerfold in February 1952 and in subsequent issues was reproduced in both horizontal and vertical form. The artist also created full-page illustrations and calendar images for *Esquire*.

Der Pin-up- und Glamourkünstler Scali besaß die ungewöhnliche Fähigkeit, in zwei sehr unterschiedlichen Stilen und Techniken zu arbeiten: Seine Arbeiten waren entweder von einer „dichten", fast fotografischen Klarheit oder „locker" mit einer impressionistischen Freiheit der Form. Die Zeitschrift Esquire *war einer seiner Hauptauftraggeber für Glamourmotive, die erstmals im Februar 1952 als Centerfold erschienen und in späteren Ausgaben sowohl in vertikaler als auch horizontaler Form im Heft abgedruckt wurden. Für* Esquire *schuf Scali auch ganzseitige Illustrationen und Kalenderbilder.*

Scali était un artiste de pin up et de beautés glamour pourvu du don rare de pouvoir peindre de deux styles différents: l'un «dense», avec une précision presque photographique, et l'autre, plus libre et impressionniste. *Esquire* fut un de ses principaux clients d'œuvres glamour, qui furent publiées en poster central dans le numéro de février 1952, puis dans d'autres numéros ultérieurs sous forme horizontale et verticale. Il créa également des illustrations pleine page et des images pour les calendriers du magazine.

Scali worked in New York, where he was represented by the top-flight American Artists agency. Besides his work for *Esquire*, he illustrated many magazine stories and created numerous cover paintings for paperback novels.

Most of Scali's pin-up art was published from 1948 to 1963. He enjoyed using various mediums, and most of his pin-ups were executed either in oil on canvas averaging 30 x 24 inches (76.2 x 61 cm) or in gouache on illustration board averaging 14 x 11 inches (35.6 x 27.9 cm).

Scali arbeitete in New York und wurde von der dort ansässigen Agentur American Artists vertreten. Neben seiner Arbeit für Esquire *illustrierte er viele Geschichten im Magazinbereich und entwarf unzählige Taschenbuchcover.*

Die meisten Pin-ups von Scali wurden zwischen 1948 und 1963 veröffentlicht. Er arbeitete gerne mit verschiedenen Techniken. Die Mehrzahl seiner Pin-ups waren in Öl auf Leinwand im Format 76 x 61 cm ausgeführt oder in Gouache auf Karton, 36 x 28 cm.

Scali travaillait à New York, où il était représenté par l'excellente agence American Artists. Outre son travail pour *Esquire*, il illustra un grand nombre de nouvelles de magazines et de couvertures de livres de poche.

La plupart des pin up de Scali furent publiées entre 1948 et 1963. Il utilisait plusieurs techniques mais, le plus souvent, ses pin up étaient réalisées à l'huile sur des toiles de 76,2 x 61 cm, ou à la gouache sur cartons à dessin de 35,6 x 27,9 cm.

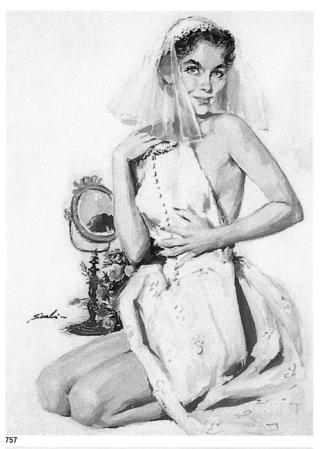

757

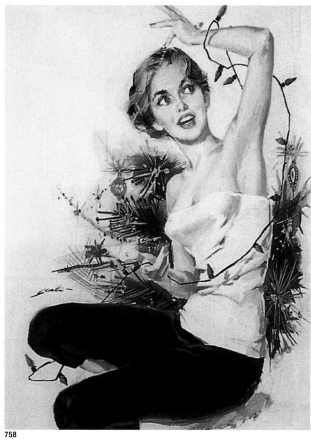

758

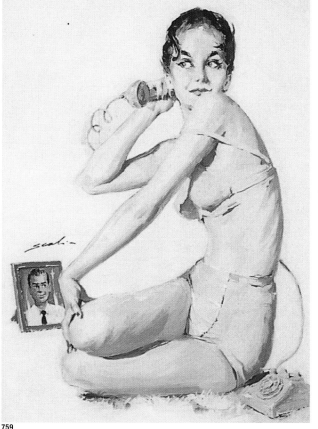

759

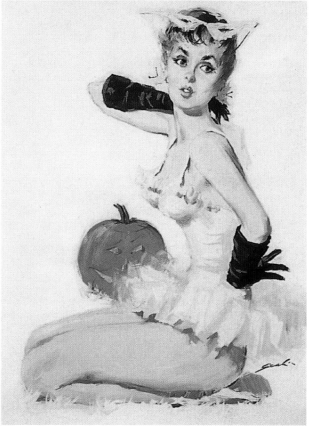

760

Lou Shabner

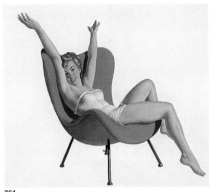

761

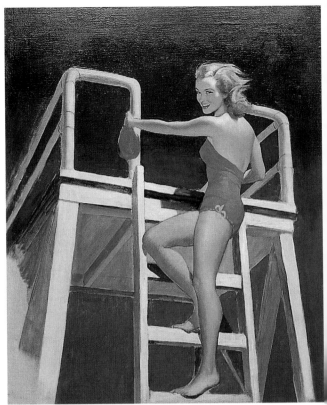

762

In 1968, Brown and Bigelow was among the last few companies to feature paintings in their pin-up and glamour calendars. Looking for new artists, the firm turned to Lou Shabner, a British painter who had been a successful glamour artist for more than twenty-five years. Responding to Shabner's reputation, the firm must also have admired the incredible Photo-Realistic effect of his exquisite paintings.

During the 1940s and 1950s, Shabner found millions of loyal English fans for his glamour portraits and classic pin-ups, which were published mainly as twelve-page calendars, first in London and then distributed throughout England and Europe. Although many of his models appeared to be British, others had a distinctly American look. There was a dream-like quality to his glamour art that sometimes

Im Jahr 1968 gehörten Brown and Bigelow noch zu den wenigen verbliebenen Firmen, die für ihre Pin-up- und Glamourkalender Gemälde als Vorlage verwendeten. Auf der Suche nach neuen Talenten wandte sich der Verlag an Lou Shabner, einen britischen Maler, der auf eine 25jährige Karriere im Bereich Glamour zurückblicken konnte. Bei Brown and Bigelow war man sich der Reputation des Künstlers bewußt und schätzte vor allem den erstaunlichen fotorealistischen Effekt seiner Arbeiten.

Während der 40er und 50er Jahre begeisterten sich Millionen von Shabner-Fans für seine Glamourporträts und klassischen Pin-ups, die vorwiegend als zwölfseitige Kalender veröffentlicht und zuerst in London und dann in ganz England und Europa vertrieben wurden. Obwohl die meisten seiner Modelle wohl Eng-

En 1968, Brown and Bigelow était l'un des derniers éditeurs à publier des calendriers avec des peintures de pin up et des beautés glamour. A la recherche de nouveaux talents, la maison se tourna vers Lou Shabner, peintre britannique qui faisait une belle carrière d'illustrateur glamour depuis plus de vingt-cinq ans. Outre sa réputation, ce sont sans doute ses superbes peintures d'un réalisme impressionnant qui séduisirent l'éditeur.

Pendant les années 40 et 50, des millions de fans britanniques adorèrent les beautés glamour et les pin up classiques de Shabner, qui étaient le plus souvent publiées sous forme de calendriers de douze pages distribués d'abord à Londres, puis en Angleterre et enfin dans toute l'Europe. Si la plupart de ses modèles étaient typiquement anglais, d'autres avaient un petit air indiscutablement améri-

left viewers almost light-headed. A printed Shabner calendar was so photographic that it was hardly ever recognized as having been reproduced from original paintings.

Shabner's pin-up girls ran the gamut of expressions – glamorous, sexy, provocative, proud, sweet, poised, joyous. Working primarily in gouache on illustration board, he occasionally painted with oil on canvas; the average size of a Shabner work was 20 x 16 inches (50.8 x 40.6 cm). Shabner often illustrated the front covers of his English calendars with a charcoal drawing of an inviting pin-up girl. No matter what medium he worked in, Shabner always attained the same strongly realistic effect.

länderinnen waren, besaßen viele von ihnen doch etwas unbestreitbar Amerikanisches. Seine Glamourbilder waren von einer zarten, fast träumerischen Qualität. Eine gedruckte Version eines Shabner-Kalenders wirkte von der Technik her so fotografisch, daß man bei ihnen nur selten auf Gemälde als Originalvorlagen schließen konnte.

Shabners Pin-up-Girls verfügten über die ganze Bandbreite der für dieses Genre typischen Posen – sie konnten glamourös sein, sexy, provokant, niedlich, fröhlich oder gelassen und selbstsicher. Vorwiegend arbeitete Shabner in Gouache au Karton, manchmal auch in Öl auf Leinwand, meistens im Format 51x41 cm. Die Titelblätter seiner Kalender für den englischen Markt illustrierte Shabner oft mit Kohlezeichnungen eines einladend wirkenden Pin-up-Girls.

cain. Ses images glamour dégageaient une atmosphère de pureté et de légèreté qui laissait parfois ceux qui les regardaient sur un petit nuage. Même reproduites, les œuvres de Shabner possédaient une qualité si réaliste qu'on les prenait facilement pour des photographies.

Les pin up de Shabner avaient toutes les expressions: sophistiquées, sexy, provocantes, fières, douces, sereines ou joyeuses. Travaillant principalement à la gouache sur cartons à dessin, il lui arrivait également d'utiliser des huiles sur toile. Les dimensions moyennes de ses œuvres étaient de 50,8 x 40,6 cm. Shabner illustra souvent les couvertures des calendriers anglais avec des pin up souriante dessinées au fusain. Quelle que soit sa technique, il obtenait toujours un effet très réaliste.

Charles
Sheldon

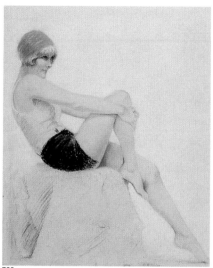

763

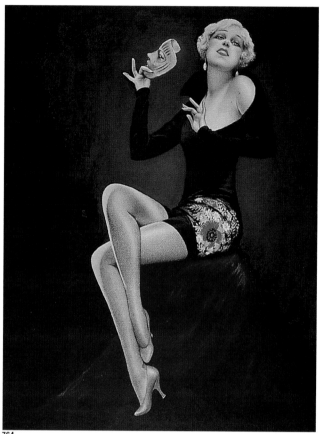

764

In 1936, Breck Shampoo asked the famous glamour artist Charles Sheldon to develop a national ad campaign for them. Forming his own advertising agency to handle the commission, Sheldon came up with the slogan "Beautiful Hair Breck" and then delivered the first of his pastel portrait illustrations. One hundred and five more legendary Breck advertisements would appear over the next twenty-five years in all the leading mainstream American magazines.

Charles Gates Sheldon was born in Worcester, Massachusetts, and grew up in Springfield. After studying with George Bridgman at the Art Students League, he went to Paris to take lessons from the great Alphonse Mucha. Sheldon received his first pin-up commission, a series of ads for La Vogue lingerie, in 1918. The same year, he married his high school sweetheart (and Charles Dana Gibson model), Grace Marchessault.

Besides a well-received series of pin-up ads for the Fox Shoe Company from 1920 to 1925 (figure 763), Sheldon had front covers published in Collier's 1924 Christmas issue and The Saturday Evening Post's October 31, 1925, Halloween issue. At the same time, he began to paint portraits of movie

and theater stars for *Photoplay* (figure 763). Mastering pastels for this assignment, which lasted from 1924 to 1933, the artist eventually painted hundreds of such portraits for magazines like *Screenland, Movie Classic,* and *Radio Digest.* The special cameras he had Eastman Kodak build helped him to create stunning images of such stars as Clara Bow, Jean Harlow, Greta Garbo, and Marlene Dietrich.

The two full-length pin-ups that Sheldon published in Brown and Bigelow's Vanities Line of 1932 (figure 764) were presented in a special marketing package with work by Rolf Armstrong. Among the highlights of the artist's varied career were his refined charcoal-and-graphite fashion illustrations for *Woman's Home Companion* and *Ladies' Home Journal* in the early 1920s and his pastels depicting family scenes for *Parents* magazine in the early 1930s.

Sheldon sometimes signed his advertising work with the names "Gates Dana" and "monte." He led a full life, enriched by frequent travel to Hollywood to visit his many friends there and by work on his exquisite summer gardens in Springfield. He died at his home there on August 4, 1961.

1936 bat die Firma Breck Shampoo den berühmten Glamourkünstler Charles Sheldon, eine nationale Anzeigenkampagne für ihr gleichnamiges Shampoo zu entwerfen. Sheldon gründete daraufhin eine eigene Agentur, lieferte den Werbeslogan „Beautiful Hair Breck" und entwarf ein passendes Porträt in Pastell. In den kommenden 25 Jahren sollten mehr als 150 weiterer solcher Anzeigen in allen Zeitschriften des Landes erscheinen.

Charles Gate Sheldon wurde in Worcester, Massachusetts, geboren und wuchs in Springfield auf. An der Art Students League studierte er unter George Bridgman und ging dann nach Paris, um Unterricht bei dem berühmten Maler Alphonse

Mucha zu nehmen. Seinen ersten Pin-up-Auftrag erhielt er 1918: eine Anzeigenserie für La Vogue Unterwäsche. Im gleichen Jahr heiratete er seine Schülerliebe Grace Marchessault, die für Charles Dana Gibson (den Schöpfer des Gibson Girl) Modell gestanden hatte.

Zwischen 1920 und 1925 schuf Sheldon für die Fox Shoe Company eine Pin-up-Anzeigenserie (Abb. 763); gleichzeitig verwendete die Zeitschrift Collier's 1924 eine seiner Vorlagen als Cover, und die Saturday Evening Post druckte 1925 sein Cover in ihrer Halloween-Ausgabe. Gleichzeitig zeichnete Sheldon für Photoplay (Abb. 765) Porträts von Film- und Bühnenstars. Er perfektionierte seine Pastell-

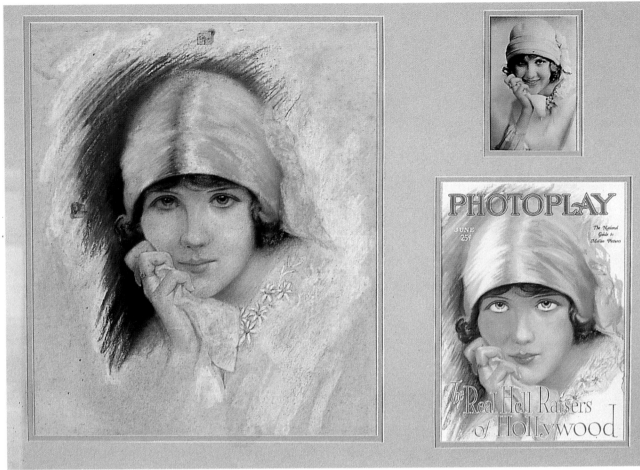

765

Technik und malte zwischen 1924 und 1933 Hunderte solcher Porträts für Zeitschriften wie Screenland, Movie Classic und Radio Digest. Speziell für ihn gebaute Kameras von Eastman Kodak ermöglichten ihm atemberaubende Porträts von Stars wie Clara Bow, Jean Harlow, Greta Garbo und Marlene Dietrich.

Zwei Ganzkörper-Pin-ups, die Sheldon 1932 (Abb. 764) in der „Vanities Line" von Brown and Bigelow veröffentlichte, wurden in einem speziellen Marketingpaket zusammen mit Arbeiten von Rolf Armstrong präsentiert. Zu den Highlights einer so breitgefächerten Karriere wie der Sheldons gehörten auch seine vornehmen Mode-

illustrationen in Kohle und Graphit, die er für Woman's Home Companion und Ladies Home Journal in den frühen 20er Jahren anfertigte oder auch Pastelle aus den frühen 30er Jahren für die Zeitschrift Parents, die Szenen aus dem Familienleben zum Thema hatten.

Seine Anzeigenentwürfe signierte Sheldon manchmal mit „Gates Dana" oder „monte". Er führte ein erfülltes Leben, war oft in Hollywood, um seine vielen Freunde zu besuchen oder kümmerte sich um seine wunderbare Gartenanlage in Springfield, wo er am 4. August 1961 starb.

En 1936, les shampooings Breck demandèrent au célèbre artiste glamour Charles Sheldon de concevoir une campagne de publicité nationale pour vanter les mérites de leurs produits. Formant sa propre agence publicitaire pour l'occasion, Sheldon inventa le slogan «Beautiful Hair Breck» (un jeu de mots sur l'homonyme «Break», qui signifie coup de chance) et livra une première série de portraits au pastel. Cent cinq autres publicités légendaires pour Breck allaient apparaître au cours des vingt-cinq ans qui suivirent dans tous les grands magazines populaires.

Né à Worcester, dans le Massachusetts, Charles Gates Sheldon grandit à Springfield. Après avoir étudié avec George Bridgman à l'Art Students League, il se rendit à Paris pour être l'élève du grand Alphonse Mucha. Sheldon reçut sa première commande de pin up en 1918, une série d'images publicitaires pour la lingerie La Vogue. Cette même année, il épousa sa petite amie d'enfance (et modèle de Charles Dana Gibson), Grace Marchessault.

Outre une autre série de pin up pour la firme Fox Shoe de 1920 à 1925 (illustration 763) qui fut bien accueillie, Sheldon réalisa les couvertures du numéro de Noël 1924 de Collier's et de celui du 31 octobre (Halloween) 1925 de The Satur-

day Evening Post. Parallèlement, il commença à peindre des portraits d'acteurs de cinéma et de théâtre pour Photoplay (illustration 765). Ce travail, qui dura de 1924 à 1933, lui permit de maîtriser la technique du pastel et de peindre ensuite des centaines de portraits similaires pour des revues telles que Screenland, Movie Classic et Radio Digest. Il se fit fabriquer un appareil-photo spécial par Eastman Kodak, grâce auquel il put créer de superbes portraits de vedettes (Clara Bow, Jean Harlow, Greta Garbo et Marlene Dietrich notamment).

Les deux pin up de Sheldon pour la collection «Vanities» de Brown and Bigelow de 1932 (illustration 764) étaient présentées dans une pochette spéciale avec des œuvres de Rolf Armstrong. Sheldon fit également des illustrations de mode à la mine et au fusain pour Woman's Home Companion au début des années 20 et des pastels de scènes de famille pour le magazine Parents au début des années 30.

Sheldon signait parfois ses publicités «Gates Dana» et «monte». Il eut une vie bien remplie, ponctuée de fréquents voyages à Hollywood pour y retrouver ses nombreux amis. Une de ses passions était de cultiver ses somptueux jardins à Springfield. C'est là qu'il mourut le 4 août 1961.

John Shilling/
Jack Whittrup

Whittrup was one of the artists to emerge from the influential Chicago-based Sundblom Circle. Under Haddon Sundblom's watchful eye, he worked with such fellow artists and friends as Gil Elvgren, Al Buell, Joyce Ballantyne, Al Moore, Al Kortner, and Coby Whitmore.

Whittrup was born in Chicago on October 16, 1912. After attending the University of Wisconsin, he studied at the Chicago Art Institute; the American Academy of Art, where his teachers included Bill Mosby, a mentor of Elvgren; and the Studio School of Art. He painted posters for the Army–Air Force Training Aids Division during the war, then briefly moved to Santa Fe and studied with Randall Davy and Theodore Van Soelen.

Whittrup opened a studio in New York in 1946 and formed the Illustrators Group, a sort of Sundblom Circle of his own. Within a year, the group was very busy indeed, Whittrup having gotten attention for his twenty-four-sheet billboard

painting for Atlas Lager Beer, commissioned by the McCann-Erickson Agency. Beginning with a shapely ballerina, his full-page ads for Lucky Strike cigarettes appeared in every national magazine in 1951.

Whittrup did a pin-up for Brown and Bigelow that was published as a single-sheet calendar for 1958. This was followed, in 1961, by another action-oriented pin-up for the firm's 1962 line: a snappy beach girl entitled *Let's Play!* that Whittrup signed with the name John Shilling. By this time the artist had a flourishing career as a painter of government and political figures, and so it is possible that he preferred his pin-up work to be credited to another name.

Whittrup's fame as a portraitist continued to grow, with many exhibitions of his work throughout the United States. He and his wife moved to Boca Raton, Florida, in the early 1970s, and he taught at that city's Center for the Arts. He died about 1990.

Whittrup war einer der Künstler, die der einflußreichen Chicagoer Schule um Sundblom entstammten. Unter Haddon Sundbloms wachsamem Auge arbeitete er mit Künstlerkollegen und Freunden wie Gil Elvgren, Al Buell, Joyce Ballantyne, Al Moore, Al Kortner und Coby Whitmore.

Whittrup wurde am 16. Oktober 1912 in Chicago geboren. Nach einem Studium an der University of Wisconsin wechselte er an das Art Institute of Chicago, ging dann an die American Academy of Art und arbeitete dort auch unter Bill Mosby, einem Mentor Elvgrens; zusätzlich besuchte er Kurse an der Studio School of Art. Während des Zweiten Weltkriegs entwarf er Poster für die amerikanische Air Force und deren Training Aids Division. Kurzzeitig zog er nach Santa Fe und studierte dort mit Randall Davy und Theodore Van Soelen.

1946 eröffnete Whittrup ein Studio in New York und gründete die Illustrators Group, eine Art Sundblom-Clique. Binnen eines Jahres wurde diese Gruppe erfolgreich, vor allem dank Whittrups überformatiger Billboards für Atlas Lager Beer – ein Auftrag der Agentur McCann-Erickson. Mit einer wohlgeformten Ballerina eröffnete er eine Anzeigenkampagne für Lucky Strike Zigaretten, die 1951 in allen landesweit erscheinenden Zeitschriften der USA geschaltet wurde.

Ein Pin-up von Whittrup für Brown and Bigelow wurde 1958 als Einzelblattkalender veröffentlicht. 1961 folgte ein Pin-up für das Lieferprogramm 1962: ein flottes Strandmädel, betitelt Let's Play, *das Whittrup mit dem Namen John Shilling signierte. Zu diesem Zeitpunkt war der Maler auch auf dem Gebiet des Porträts, insbesondere von Politikern und Regierungsangehörigen, erfolgreich geworden,*

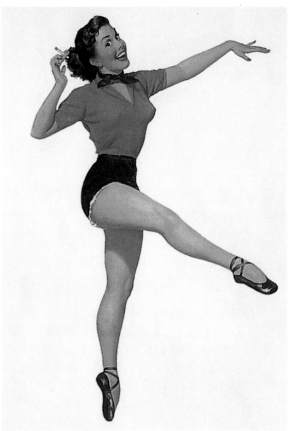

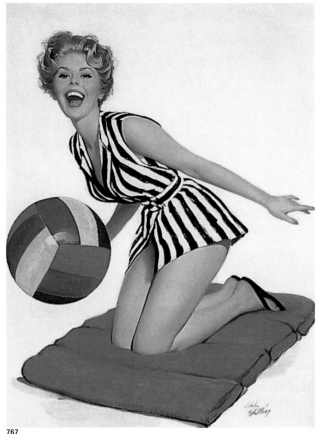

766

767

und es ist gut möglich, daß er es vorzog, seine Pin-ups unter einem anderen Namen zu veröffentlichen.

Sein Ruhm als Porträtmaler wuchs, und seine Arbeiten wurden landesweit ausgestellt. Zusammen mit seiner Frau zog er in den frühen 70er Jahren nach Boca Raton in Florida und unterrichtete am dortigen Center for the Arts. Er starb 1990.

Whittrup était l'un des artistes formés par la fameuse école Sundblom de Chicago. Sous la direction attentive d'Haddon Sundblom, il travailla avec ses collègues et amis Gil Elvgren, Al Buell, Joyce Ballantyne, Al Moore, Al Kortner et Coby Whitmore.

Né à Chicago le 16 octobre 1912, il étudia d'abord à l'université du Wisconsin, puis au Chicago Art Institute, à l'American Academy of Art (où il eut comme professeur Bill Mosby, un des mentors d'Elvgren), et enfin à la Studio School of Art. Pendant la guerre, il peignit des affiches pour l'Army-Air Force Training Aids Division, puis vécut un temps à Santa Fe, où il étudia auprès de Randall Davy et de Theodore van Soelen.

Whittrup ouvrit un atelier à New York en 1946 et fonda l'Illustrators Group, une sorte de Cercle de Sundblom de son cru. Au bout d'un an, le groupe était surchargé de commandes, Whittrup s'étant fait remarquer par ses affiches géantes pour Atlas Lager Beer, une commande de l'agence McCann-Erickson. Sa série de publicités pleine page pour les cigarettes Lucky Strike, dont la première représentait une ballerine aux formes avantageuses, parut en 1951 dans tous les grands magazines nationaux.

En 1958, Whittrup réalisa une pin up pour Brown and Bigelow qui fut publiée comme calendrier-cintre. Elle fut suivie, en 1961, par une autre pin up énergique pour le même éditeur, publiée en 1962: une dynamique baigneuse intitulée *Let's Play* que Whittrup signa «John Shilling». A cette époque, l'artiste avait une carrière florissante comme peintre de personnalités politiques, aussi préféra-t-il sans doute que ses charmantes créatures paraissent sous un pseudonyme.

La célébrité de Whittrup comme portraitiste continua de croître et il eut de nombreuses expositions dans tous le pays. Au début des années 70, sa femme et lui s'installèrent à Boca Raton, en Floride, où il enseigna au Center for the Arts. Whittrup mourut vers 1990.

Showalter

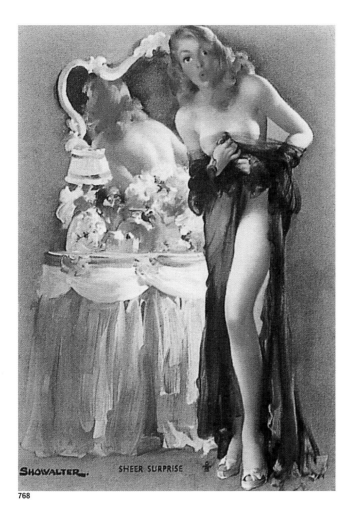

768

Nothing is known about Showalter, but the piece illustrated here (figure 768) is worth noting.

Über Showalters Leben und Werk ist nichts bekannt, aber die hier abgebildete Illustration (Abb. 768) ist sehenswert.

On ne sait rien sur Showalter, mais l'image présentée ici (illustration 768) mérite qu'on s'y arrête.

Robert Skemp

A member of the Sundblom school of illustration, Skemp first attended the Art Students League in New York in 1928–29, then went on to the Grand Central School of Art, studying in those years under George Luks, Thomas Hart Benton, and Harry Ballinger. But it was not until his association with Haddon Sundblom in Chicago that he came into his own as an artist.

Skemp and fellow Sundblom protégés like Elvgren, Buell, and Ballantyne, modeled their art in large part on that of the older artist. During his pin-up and glamour career, Skemp worked for several major publishing houses, but his original paintings are very rare today.

In the field of advertising, Skemp developed national campaigns for companies like Schlitz Beer, Studebaker Cars, the Ford Motor Company, and, most notably, for the Coca-Cola Company, where his images coordinated well with Elvgren's and Sundblom's work for the firm. He also created many story illustrations for mainstream magazines, including The Saturday Evening Post, Collier's, and Sports Afield.

Skemp often adopted Elvgren's "situation" poses in his work, depicting girls caught off-guard in various activities. The use of primary colors was another characteristic of his work. He painted in a large format, usually 40 x 30 inches (101.6 x 76.2 cm), in oil on canvas.

Skemp was a member of the Society of Illustrators and the National Arts Club. His paintings are in both public collections (the Pentagon, the United States Coast Guard, and the New York Public Library) and corporate ones (AT and T, Reynolds Tobacco, and the Franklin Mint). Between 1949 and 1953, Skemp won numerous medals from the Art Directors Club of Chicago. He was born in Scottsdale, Arizona, on August 22, 1910, and died in Westport, Connecticut, in 1993.

Skemp gehörte der Sundblom-Clique an. Zwischen 1928 und 1929 besuchte er die Arts Students League in New York und danach die Grand Central School of Art. George Luks, Thomas Hart Benton und Harry Ballinger zählten zu seinen Lehrern. Doch erst seine Verbindung mit dem Chicagoer Künstler Haddon Sundblom machte Skemp zu einem namhaften Künstler.

Skemp und anderen Protégés von Sundblom, wie Elvgren, Buell, Ballantyne und Shook, entwickelten ihre Kunst zum großen Teil nach dem Vorbild der Arbeiten des älteren Sundblom. Während seiner Karriere in der Pin-up- und Glamourkunst arbeitete Skemp für mehrere große Verlagshäuser, aber es sind kaum Originale seiner Arbeiten erhalten.

Im Anzeigenbereich entwickelte Skemp überregionale Kampagnen für Firmen wie Schlitz Beer, die Automobilhersteller Studebaker und Ford und vor allem für die Coca-Cola Company. Seine Arbeiten harmonierten mit denen von Elvgren und Sundblom für diesen gemeinsamen Auftraggeber. Für die Massenblätter The Saturday Evening Post, Collier's und Sports Afield schuf er viele Illustrationen.

Nach dem Vorbild Elvgrens zeichnete Skemp häufig Mädchen, die bei diversen Handlungen und Aktivitäten überrascht wurden. Der Einsatz von Primärfarben war ein weiteres typisches Kennzeichen seiner Arbeiten. Skemp verwendete große Formate (normalerweise 102 x 76 cm) für seine Bilder in Öl auf Leinwand.

Skemp gehörte der Society of Illustrators und dem National Arts Club an. Seine Bilder sind sowohl in öffentlichen Sammlungen (wie der des Pentagon, der United States Coast Guard und der New York Public Library) als auch in Sammlungen vertreten, die Großunternehmen wie der AT & T, Reynolds Tobacco oder Franklin Mint angegliedert sind. Zwischen 1949 und 1953 gewann Skemp unzählige Auszeichnungen des Art Directors Club of Chicago. Skemp wurde am 22. August 1910 in Scottsdale, Arizona, geboren und starb 1993 in Westport, Connecticut.

Skemp étudia d'abord à l'Art Students League de New York en 1928–1929, puis à la Grand Central School of Art, sous la direction de George Luks, de Thomas Hart Benton et d'Harry Ballinger. Mais ce n'est qu'après être passé entre les mains d'Haddon Sundblom à Chicago qu'il devint un artiste à part entière.

Skemp, comme les autres protégés de Sundblom, tels qu'Elvgren, Buell, Ballantyne et Shook, modela en grande partie son style sur celui de son maître. Au cours de sa carrière de peintre de pin up et de beautés glamour, il travailla pour plusieurs grandes maisons d'édition, mais il reste peu de ses œuvres originales aujourd'hui.

Dans le domaine de la publicité, Skemp conçut des campagnes nationales pour de grandes compagnies dont Schlitz Beer, Studebaker Cars, Ford Motor et, surtout, Coca-Cola, pour laquelle ses images se coordonnaient parfaitement avec celles d'Elvgren et de Sundblom. Il créa également de nombreuses illustrations pour des magazines à grand tirage, dont The Saturday Evening Post, Collier's et Sports Afield.

Skemp adopta souvent les images de «situation» d'Elvgren pour les adapter à son travail, montrant de jolies filles surprises dans diverses activités. Le recours aux couleurs primaires était une autre de ses caractéristiques. Il peignait à l'huile sur des toiles de grand format, généralement de 101,6 x 76,2 cm.

Skemp fut membre de la Society of Illustrators et du National Arts Club. Ses peintures figurent dans des collections publiques (le Pentagone, United States Coast Gards et la New York Public Library) et celles de grandes entreprises (AT&T, Reynolds Tobacco et Franklin Mint). Entre 1949 et 1953, il fut souvent primé par l'Arts Directors Club de Chicago. Né le 22 août 1910 à Scottsdale dans l'Arizona, il mourut en 1993 à Wesport, dans le Connecticut.

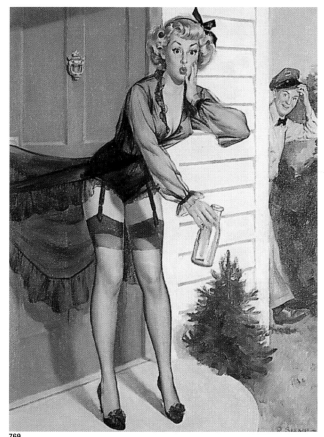

769

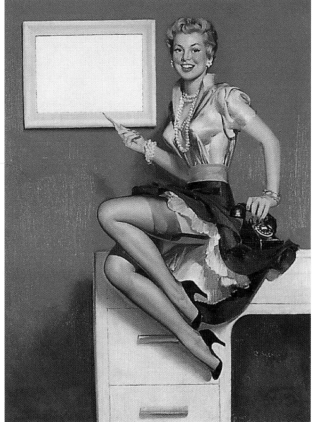

770

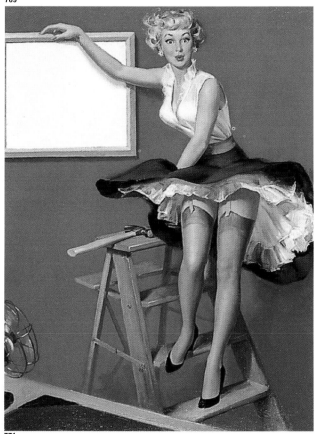

771

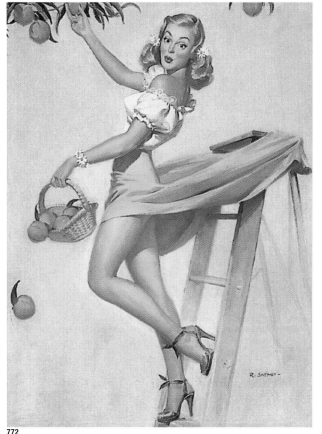

772

Francis Smilby

Francis Smilby (Francis Wilford-Smith) had been friends with Alberto Vargas through their shared publisher, *Playboy* magazine, and had had a successful career as an illustrator, providing a full-page color painting to *Playboy* for more than twenty-five years (as he continues to do today). Of all those who worked in the 1940s and 1950s in the pin-up field, he is, to the best of our knowledge, the only artist still active. Figure 775 shows an example of his current "pin-up legs," and figures 773 and 774 two Smilby cartoons.

In 1981, Smilby produced *Stolen Sweets: The Cover Girls of Yesteryear: Their Elegance, Charm, and Sex Appeal* for Playboy Press (distributed by Harper and Row, New York). Drawing on the thousands of books and magazines he had col-

lected as sources for his own work, he wrote and illustrated a history of the cover girl from the first French illustrations in the 1890s through the "U.S. Girlies" of the 1930s.

Smilby's is the best book previously available. While it focuses on an earlier period than the present volume, *Stolen Sweets* is devoted exclusively to the fine art of illustrated magazine covers. It reproduces paintings of beautiful, sexy girls in a clean, fun-loving, and celebratory spirit rather than in an exploitative or pornographic way. Smilby and his book set wonderful precedents for us when we embarked on *The Great American Pin-Up*.

Francis Smilby (Francis Wilford-Smith) und Alberto Vargas waren Freunde, die sich über ihren gemeinsamen Verleger, das Magazin Playboy *kennengelernt hatten. Smilby konnte auf eine erfolgreiche Karriere als Illustrator zurückblicken; über 25 Jahre lang hatte er* Playboy *mit ganzseitigen Farbbildern beliefert (und das tut er heute noch). Von all den Künstlern, die in den 40er und 50er Jahren Pin-up-Bilder malten, ist er unseres Wissens der einzige, der noch immer in diesem Genre arbeitet. Abb. 775 zeigt ein Paar aktueller „Pin-up-Beine" von ihm, und die Abb. 773 und 774 zeigen zwei Cartoons von Smilby.*

1981 schrieb Smilby für Playboy Press (Vertrieb durch Harper and Row, New York) Stolen Sweets: The Cover Girls of Yesteryear: Their Elegance, Charme, and Sex Appeal. *Smilby hatte Tausende von Büchern und Magazinen für seine eigenen*

Arbeiten zusammengetragen. Gestützt auf diese Sammlung schrieb und illustrierte er nun die Geschichte des Covergirls von den ersten französischen Illustrationen in den 90er Jahren des 19. Jahrhunderts bis zu den „U.S. Girlies" der 30er Jahre des 20. Jahrhunderts.

Smilbys Buch ist das beste, das bisher auf dem Markt war. Stolen Sweets *befaßt sich mit einer früheren Epoche als das hier vorliegende Buch und konzentriert sich ausschließlich auf die Kunst der Titelseitenillustration. Die in dem Buch abgebildeten jungen Frauen sind schön und sexy, aber die Art der Darstellung ist nicht pornographisch-erniedrigend, sondern harmlos-fröhlich und geradezu eine Huldigung an die Weiblichkeit. Smilby und sein Buch waren ein wunderbarer Ansporn für uns, als wir* The Great American Pin-Up *in Angriff nahmen.*

Francis Smilby (Francis Wilford-Smith) a été l'ami de Alberto Vargas à travers leur éditeur commun, le magazine *Playboy*, et a connu une belle carrière d'illustrateur en fournissant des peintures reproduites en couleurs dans *Playboy* pendant plus de vingt-cinq ans (comme il continue de le faire aujourd'hui). De tous ceux qui travaillèrent dans le domaine des pin up dans les années 40 et 50, il est, à notre connaissance, le seul encore en activité. L'illustration 775 montre un dessin humoristique de Smilby, et les illustrations 773 et 774, deux exemples de «jambes de pin up», sa production actuelle.

En 1981, Smilby a publié *Stolen Sweets: The Cover Girls of Yesteryear: Their Elegance, Charm and Sex Appeal,* chez Playboy Press (distribué par Harper and Row, New York). S'inspirant des milliers de livres et de magazines qu'il avait col-

lectionnés comme documentation pour son travail, il a écrit et illustré une histoire de la Cover Girl des premières illustrations françaises dans les années 1890 aux «U.S. Girlies» des années 1930.

Le livre de Smilby est le meilleur publié à ce jour. Bien que portant sur une période antérieure à celle examinée dans le présent ouvrage, *Stolen Sweets* est exclusivement consacré aux couvertures illustrées de magazines. Il présente des peintures de jolies filles sexy dans un esprit sain, drôle et respectueux plutôt que d'une manière insidieuse et pornographique. Smilby et son livre ont constitué pour nous un formidable précédent quand nous nous sommes lancés dans l'aventure de *L'Age d'or de la pin up américaine*.

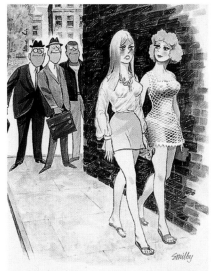

"I just hate the way men undress you with their eyes"

773

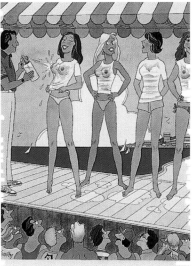

"Tell me, is this your first wet T-shirt competition?"

774

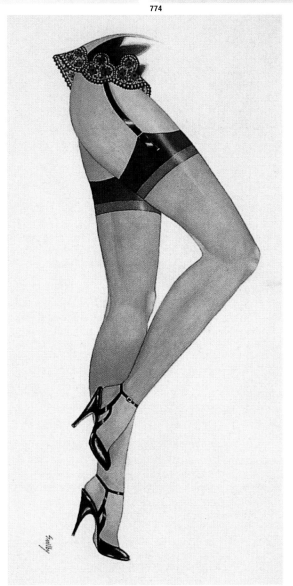

775

J. Frederick
Smith

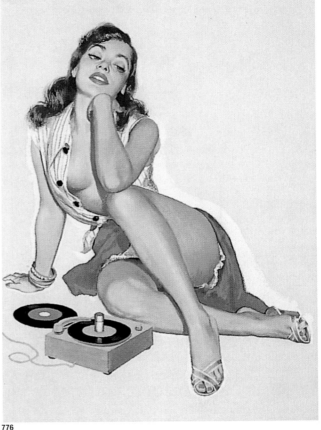

776

In 1946, when *Esquire* announced its new Gallery of Glamour series, the list of artists included the name of J. Frederick Smith, along with many of the top illustrators of the day. Working out of his New York studio, Smith was a brilliant artist who enjoyed incorporating pin-up and glamour themes into his mainstream work. His advertisements for Whitman's Chocolates, for instance, featured mothers who were as glamourous as movie stars.

Although Smith's pin-ups for the Gallery of Glamour were impressive, it was his special assignments for the magazine that distinguished him from his colleagues. His memorable three- or four-page illustrated articles, with titles like "Personal Interpretations," first appeared in 1946. He also painted pin-ups for *Esquire*'s famous two-page gatefolds as part of a relationship that was to last more than a dozen years.

From about 1945 on, Smith was represented by the well-known American Artists agency. In 1952, the firm made a deal with Brown and Bigelow whereby several prominent *Esquire* pin-up artists would combine forces to create a calendar. The result, the 1953 Ballyhoo Calendar, contained three pin-ups by Smith: a girl with a record player (figure 776), a girl holding a carnation up to her face, and a bikini-clad beach girl. All were painted in gouache on #80

Bainbridge drawing board, which imparted a special luminosity to Smith's colors.

Smith was born in Pasadena and grew up in Covina, California. He moved east in 1938 and settled in Greenwich, Connecticut, where he opened a studio for his freelance commercial art work. Many mainstream magazines immediately commissioned him to provide illustrations for their love and romance stories. After service in the Information and Education Section of the army during World War II, Smith plunged back into the glamour illustration business. He was elected an artist member of the Society of Illustrators in November 1947.

Smith attained much success as a pin-up, glamour, and mainstream illustrator in the first half of his career; he spent the last half as a highly skilled glamour and fashion photographer. He went on to receive many photographic commissions from magazines, ad agencies, and corporate clients, and his work found its largest audience in magazines like *Reader's Digest* and *The Saturday Evening Post*. In the 1960s and 1970s, several art books featuring photographs of his ideal feminine beauties were published. Whether he was working in illustration or photography, that ideal was Smith's abiding subject.

Bei der Bekanntgabe ihrer neuen Serie „Gallery of Glamour" im Jahr 1946 nannte die Zeitschrift Esquire *unter den Namen der an diesem Projekt arbeitenden Künstler neben vielen der damaligen Top-Illustratoren auch den von J. Frederick Smith. Smith arbeitete in seinem New Yorker Studio, er war ein herausragender Künstler, der Pin-up- und Glamourthemen in seine anderen Arbeiten einfließen lassen konnte. Anzeigenkampagnen für den Süßwarenhersteller Whitman's Chocolates zeigten zum Beispiel Mütter, die so glamourös waren wie Filmstars.*

Seine Pin-ups für die „Gallery of Glamour" waren beeindruckend, und seine Sonderaufträge für die Zeitschriften hoben sich durch ihre Qualität von denen

seiner Künstlerkollegen ab. Die ersten seiner unvergeßlichen Illustrationen erschienen 1946. Er lieferte auch für Esquire *'s berühmte zweiseitige Ausklapper Pin-ups: diese Zusammenarbeit sollte über zwölf Jahre dauern.*

Ab 1945 wurde Smith von der berühmten Agentur American Artists vertreten. 1952 schloß die Agentur einen Vertrag mit Brown and Bigelow, um mehreren prominenten Pin-up-Künstlern von Esquire *die Möglichkeit zu geben, gemeinsam einen Kalender auf den Markt zu bringen. Das Resultat war der Ballyhoo-Kalender (Trara und Tamtam), zu dem auch Smith drei Pin-ups beisteuerte: ein Mädchen mit einem Schallplattenspieler (Abb. 776), ein Mädchen, das eine Nelke an ihr Gesicht hält und ein Strandmädchen im Bikini. Alle drei Arbeiten wur-*

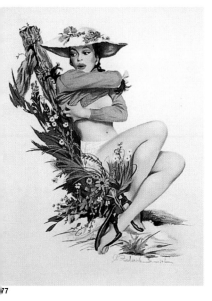

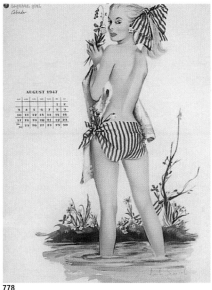

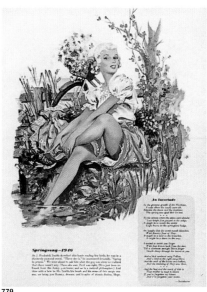

777 778 779

...en in Gouache auf Bainbridge-Karton Nr. 80 ausgeführt, der den Farben von ...mith eine besondere Leuchtkraft verlieh.

Smith wurde im kalifornischen Pasadena geboren und wuchs in Covina auf. ...938 zog er in den Osten und ließ sich in Greenwich, Connecticut, nieder. Dort ...öffnete er als frei arbeitender Werbegrafiker sein eigenes Studio. Von Anfang ...n überhäuften ihn viele der gängigen Magazine mit Aufträgen für Illustrationen ...er in den Heften erscheinenden Liebesromane. Während des Zweiten Welt- ...riegs diente er in der Abteilung Information und Ausbildung der U.S. Armee; ...anach stürzte er sich wieder in das Glamourgeschäft. Im November 1947 wur- ...e er zum künstlerischen Mitglied der Society of Illustrators gewählt.

In der ersten Hälfte seiner beruflichen Karriere war Smith als Illustrator von Pin-ups, Glamourthemen und Zeitschriften-Geschichten erfolgreich; den zwei- ten Teil seiner Karriere widmete er der Mode- und Glamourfotografie. Er erhielt viele Fotoaufträge von Zeitschriften, Anzeigenagenturen und Großunterneh- mern. Sein größtes Publikum erreichte er mit Abdrucken in Reader's Digest und der Saturday Evening Post. In den 60er und 70er Jahren wurden mehrere Kunstbücher veröffentlicht, die sein fotografisches Ideal weiblicher Schönheit thematisierten. Unabhängig von dem gewählten Medium, ob Illustration oder Fotografie, war dies Smiths bleibendes Thema.

...n 1946, lorsqu'Esquire annonça le lancement de sa nouvelle série Gallery of ...lamour, la liste des artistes incluait J. Frederick Smith, ainsi qu'un grand nombre ...es illustrateurs renommés de l'époque. Travaillant dans son atelier new-yorkais, ...mith était un brillant artiste qui aimait intégrer des pin up et des thèmes glamour ...ans ses œuvres pour la presse populaire. Ses publicités pour les chocolats Whit- ...an, par exemple, montraient des mères de famille aussi radieuses et sexy que ...es vedettes de cinéma.

Ses pin up pour la Gallery of Glamour étaient superbes, mais ce furent surtout ...es commandes spéciales pour le magazine qui le distinguèrent de ses collègues. ... partir de 1946, Esquire publia ses mémorables articles illustrés de trois ou qua- ...e pages, avec des titres du genre: «Interprétations personnelles». Au cours de ...ette collaboration qui devait durer plus de douze ans, il peignit également des pin ...p pour les posters centraux du magazine.

A partir de 1945, Smith fut représenté par American Artists. En 1952, la célèbre ...gence négocia un accord avec Brown and Bigelow qui souhaitait réunir plusieurs ...es principaux artistes de pin up d'Esquire sur un même calendrier. Le résultat, le ...allyhoo Calendar de 1953, contenait trois pin up de Smith: une fille avec un tour- ...e-disques (illustration 776), une autre sentant un œillet et une dernière en bikini

sur une plage. Toutes trois furent peintes à la gouache sur du papier Bainbridge 80 qui conférait une luminosité particulière aux couleurs de Smith.

Né à Pasadena, Smith grandit à Covina, en Californie. Il migra vers l'est en 1938, s'installant à Greenwich, dans le Connecticut, où il ouvrit son atelier. De nombreux magazines à grand tirage lui commandèrent aussitôt des illustrations pour leurs histoires sentimentales. Pendant la guerre, il servit dans le départe- ment d'information et d'éducation, avant de se replonger dans le monde des pin up et des beautés glamour. Il fut élu membre de la Society of Illustrators en novembre 1947.

Après avoir connu le succès comme illustrateur de pin up et de beautés gla- mour pendant la première moitié de sa carrière, Smith passa la seconde moitié comme photographe de mode de talent. Il continua donc à recevoir de nombreu- ses commandes de photographies de la part des magazines, des agences de publicité et des grandes entreprises. Son travail parut, entre autres, dans Reader's Digest et The Saturday Evening Post. Dans les années 60 et 70 furent publiés plu- sieurs livres d'art présentant des photographies de son idéal féminin. Que ce soit à travers les peintures ou les photographies, cet idéal fut toujours au cœur de son travail.

William Fulton Soare

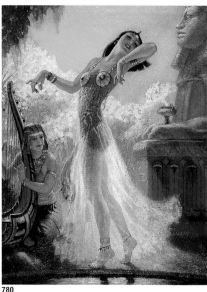

780

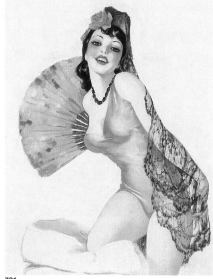

781

William Soare was the only calendar artist from the Brandywine School to paint pin-up and glamour subjects. Born on April 4, 1896, in Walden, New York, Soare moved to Leonia, New Jersey, when he was eight. Interested in art since grade school, he often drew portraits of his high school classmates as a teenager. Following service in World War I, Soare remained in Paris and studied art at the Sorbonne. He later enrolled at the Art Students League in New York, where his teachers included N.C. Wyeth and Harvey Dunn (who became lifelong friends). Along with Dean Cornwell, these artists had the most influence on Soare.

Working out of his studio in Leonia, Soare began his career in the pulp magazine market, with the major publisher Street and Smith among his clients. Soare specialized in detective, adventure, and Western subjects and always incorporated a pin-up girl into his front covers (figure 781). His work expanded to include calendars (figure 782), advertisements (Coca-Cola), and magazine front covers (*The Saturday Evening Post*, *Pictorial Review*, *Scribner's*, and *Country Gentleman*).

Soare's 1935 series for the Kemper-Thomas calendar company commemorating the bicentennial of George Washington's birth was highly successful, as was

his work the same year for Bausch and Lomb Optical Company illustrating landmark achievements in the development of optics technology. His memorable 1936 cover for *Boy's Life* depicting the musketeer D'Artagnan clearly shows the influence of Howard Pyle, while his swashbuckling sailor for *American Boy* in 1937 might have come from N.C. Wyeth's studio.

In April 1939, Soare, his wife, and their son, Thomas, moved to Englewood, New Jersey. Less than a year later, in preparing to meet with the art director of *The Saturday Evening Post* to select his first front-cover image, Soare suffered a heart attack while shoveling snow. He died two weeks afterwards, on February 29, 1940, at the age of forty-three.

Soare's career, in both the pin-up and glamour fields, was sadly curtailed, yet his art stands as a testament to his multifaceted talent. His very first pin-up for the calendar market, a stunning Egyptian dancer (figure 780), displays the masterly use of primary colors that set him apart from most of his contemporaries in the 1920s and 1930s. The same sparkling, zestful colors and richly applied paint characterize all of Soare's finest work.

William Soare war der einzige für Kalenderpublikationen tätige Künstler der Brandywine Schule, der Pin-ups und Glamourthemen malte. Er wurde am 4.April 1896 in Walden im Bundesstaat New York geboren und zog mit acht Jahren nach Leonia, New Jersey. Für Kunst interessierte er sich schon in der Grundschule; als Teenager porträtierte er oft seine Schulkameraden. Soare nahm am Ersten Weltkrieg teil, blieb in Paris und studierte Kunst an der Sorbonne. Später schrieb er sich an der Art Students League in New York ein und zählte N.C. Wyeth und Harvey Dunn (mit dem er bis zu seinem Tod befreundet war) zu seinen Lehrern. Zusammen mit Dean Cornwell übten diese Lehrer den größten Einfluß auf Soare aus.

Er arbeitete in seinem Studio in Leonia und begann seine Karriere mit

*Coverillustrationen für Groschenromane. Das bedeutende Verlagshaus Street and Smith zählte zu seinen Kunden. Soare spezialisierte sich auf Detektivgeschichten, Abenteuerromane und Western; trotzdem war immer ein Pin-up-Girl auf seinen Zeitschriftencover zu finden (Abb. 781). Soares Arbeitsbereich erweiterte sich: Es kamen Kalenderaufträge hinzu (Abb. 782), Anzeigen (Coca-Cola) und Titelblätter für Zeitschriften (*The Saturday Evening Post, Pictorial Review, Scribner's *und* Country Gentleman).

In Erinnerung an den 200. Geburtstag von George Washington schuf Soare 1935 eine erfolgreiche Kalenderserie für Kemper-Thomas; ebenso beliebt war seine im gleichen Jahr laufende Kampagne für den Optikkonzern Bausch and Lomb,

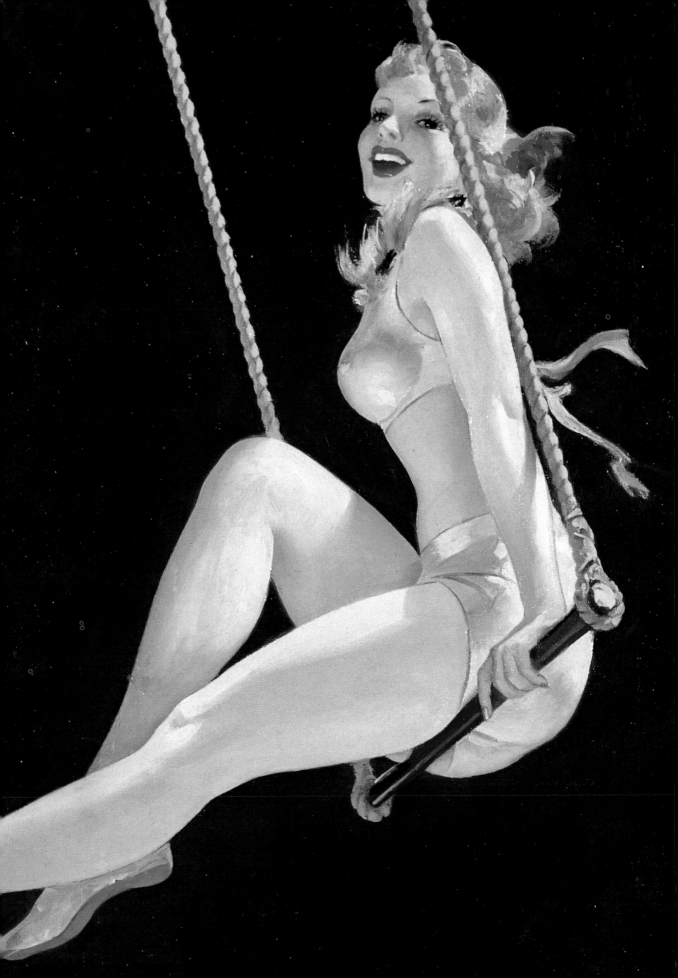

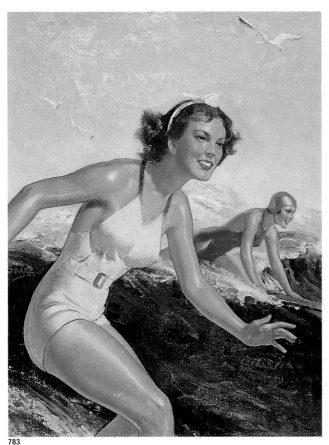

783

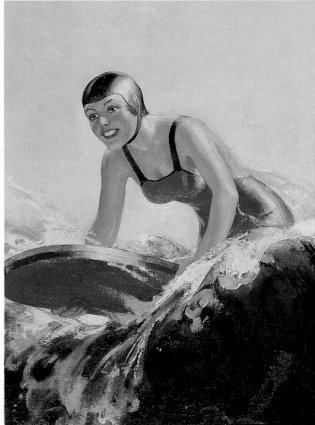

784

die die wichtigsten Errungenschaften der Optiktechnik illustrierte. Sein unvergeßliches Cover zu Boy's Life aus dem Jahre 1936 mit dem Musketier D'Artagnan zeigt Einflüsse von Howard Pyle; sein verwegener Matrose von 1937, den er für American Boy ablieferte, hätte auch aus dem Studio von N.C. Wyeth stammen können.

Im April 1939 zog Soare mit Frau und Sohn Thomas nach Englewood, New Jersey. Kaum ein Jahr später, als er sich gerade auf ein Treffen mit dem Art Director der Saturday Evening Post vorbereitete, um gemeinsam das erste Soare-Cover für die Zeitschrift auszusuchen, erlitt er beim Schneeschaufeln einen Herzinfarkt. Zwei Wochen später, am 29. Februar 1940, starb Soare im Alter von 43 Jahren.

So fand seine Karriere im Pin-up- und Glamourbereich ein jähes und frühes Ende. Doch Soares so facettenreiches Talent lebt in seiner Kunst weiter. Sein erstes Pin-up für den Kalendermarkt, eine phantastische ägyptische Tänzerin (Abb. 780), stellt seine meisterhafte Verwendung von Primärfarben unter Beweis, mit der er sich von den meisten seiner künstlerischen Zeitgenossen aus den 20er und 30er Jahren abhob. Diese Farbgebung und der pastose Farbauftrag sind für alle seine Arbeiten kennzeichnend.

William Soare était le seul artiste de calendriers de l'école de Brandywine à peindre des pin up et des sujets glamour. Il est né le 4 avril 1896 à Walden, dans l'Etat de New York. Sa famille emménagea à Leonia dans le New Jersey quand il avait huit ans. Il s'intéressa à l'art dès l'école primaire et, adolescent, dessinait souvent le portrait de ses camarades de lycée. Envoyé en France pendant la Première Guerre mondiale, il resta à Paris après l'armistice et étudia l'art à la Sorbonne. Il s'inscrivit ensuite à l'Art Students League de New York où il eut parmi ses professeurs N.C. Wyeth et Harvey Dunn (avec lesquels il noua une amitié durable). Ces deux artistes, auxquels il faut ajouter Dean Cornwell, eurent une grande influence sur son art.

Travaillant dans son atelier à Leonia, Soare commença sa carrière dans les pulps avec, parmi ses clients, le plus grand éditeur du genre, Street and Smith. Il se spécialisa dans les polars, les aventures et les westerns et incluait toujours une pin up dans ses couvertures (illustration 781). Sa sphère d'activité s'élargit ensuite aux calendriers (illustration 782), aux publicités (Coca-Cola) et aux couvertures de magazines (The Saturday Evening Post, Pictorial Review, Scribner's et Country Gentleman).

Sa série de 1935 pour le calendrier de Kemper-Thomas commémorant le bicentenaire de la naissance de George Washington remporta un vif succès. Il en fut de même pour ses illustrations de grandes réalisations technologiques dans le domaine de l'optique réalisées pour la firme Bausch and Lomb Optical. Son superbe portrait de d'Artagnan de 1936 pour la couverture de Boy's Life témoigne clairement de l'influence de Howard Pyle, tandis que son fringant marin pour American Boy en 1937 aurait pu sortir de l'atelier de N.C. Wyeth.

En avril 1939, Soare, sa femme et leur fils, Thomas, emménagèrent à Englewood, dans le New Jersey. Moins d'un an plus tard, tandis qu'il se préparait à rencontrer le directeur artistique de The Saturday Evening Post pour choisir une couverture, Soare fut victime d'une attaque cardiaque en déblayant de la neige. Il mourut deux semaines plus tard, le 29 février 1940, à l'âge de quarante-trois ans.

La carrière de Soare, tant dans le domaine des pin up que de l'art glamour, fut ainsi tristement écourtée. Toutefois, son art témoigne de ses talents multiples. Sa première pin up de calendrier, une superbe danseuse égyptienne (illustration 780), témoigne d'une grande maîtrise des couleurs primaires qui le distingue de la plupart de ses contemporains des années 20 et 30. Les meilleures œuvres de Soare sont caractérisées par ces mêmes couleurs énergiques et vives et ces touches généreuses de peinture.

Haddon Sundblom

Sundblom is recognized today as the inspiration behind the best pin-up and glamour artists from the 1930s through the 1960s. Influenced by artists like Howard Pyle, John Singer Sargent, Anders Zorn, Robert Henri, J.C. Leyendecker, Walter Biggs, Pruett Carter, and Sorolla, he himself went on to affect dozens of artists who had distinguished careers in every area of mainstream illustration. Among the many Sundblom inluenced in the pin-up and glamour art field were Elvgren, Ballantyne, Buell, Moore, Skemp, and Whittrup (Shilling), and among the second generation in the field, Bass, Brulé, D'Ancona, Frahm, Olmstead, Medcalf, Otto, Runci, Sarnoff, and Withers.

Born in 1899 in Muskegon, Michigan, Sundblom studied at the Chicago Art Institute and the American Academy of Art. Upon graduating in 1920, he served as an apprentice at the Charles Everett Johnson Studio in Chicago. In 1925, he formed a studio with Howard Stevens and Edwin Henry, and his career immediately took off. In his most important commission, from the Coca-Cola Company,

Sundblom actually set the pattern and style of the firm's long-term national advertising with his classic illustration of Santa Claus (1925). Another series of national ads, for Cashmere Bouquet soap, allowed him to develop his characteristic sunlit glow, free-spirited brushstrokes, and wholesome yet romantic imagery.

Sundblom received advertising commissions from clients like Palmolive Soap, Colgate Toothpaste, Maxwell House Coffee, and Aunt Jemima (the latter, from the late 1930s until the mid-1950s). He also worked for all the major weekly and monthly mainstream magazines and, in the mid-1930s, began to paint occasional pin-up and glamour pieces for calendars.

The artist's last assignment, in the early 1970s, was a front-cover painting for *Playboy*'s Christmas issue, showing a smiling Sundblom Girl wearing a Santa Claus hat. "Sunny" died in Chicago in 1976, but not before his priceless instruction and artistic brilliance had influenced the entire realm of American illustration.

Er gilt heute als das Vorbild für die besten Pin-up- und Glamourkünstler, die zwischen den 30er und 60er Jahren tätig waren: Haddon Sundblom. Er selbst wurde von Künstlern wie Howard Pyle, John Singer Sargent, Anders Zorn, Robert Henri, J.C. Leyendecker, Walter Biggs, Pruett Carter und Sorolla beeinflußt und prägte seinerseits Dutzende von Künstlern, die später in allen Bereichen der gängigen Illustration Karriere machten. Dazu gehörten im Bereich Pin-up und Glamour eine ganze Reihe von Malern wie Elvgren, Ballantyne, Buell, Moore, Skemp und Whittrup und, unter der jüngeren Künstlergarde, Bass, Brulé, D'Ancona, Frahm, Olmstead, Medcalf, Otto, Runci, Sarnoff und Withers.

Sundblom wurde 1899 in Muskegon im Bundesstaat Michigan geboren, studierte am Art Institute of Chicago und an der American Academy of Art. 1920 schloß er sein Studium ab. Dann begann er als Auszubildender im Charles Everett Johnson Studio in Chicago. 1925 gründete er zusammen mit Howard Stevens und Edwin Henry ein eigenes Studio und hatte damit auf Anhieb Erfolg. Bei seinem wichtigsten Auftraggeber, der Coca-Cola Company, gelang es ihm, Ausrichtung und Stil der langlebigen landesweiten Anzeigenkampagnen dieses Multis

durch sein Motiv, einen Weihnachtsmann (1925), zu prägen. Eine andere Anzeigenserie für die Seife Cashmere Bouquet, die ebenfalls in ganz Amerika lief, gab ihm die Möglichkeit, seine charakteristischen Bildelemente und -techniken zu entwickeln: ein von der Sonne gefärbter Glanz, ein beherzter Pinselstrich und frische, unverbrauchte und dennoch romantische Motive.

Zu seinen Auftraggebern im Anzeigenbereich gehörten neben anderen Palmolive Soap, Colgate, der Kaffeeröster Maxwell House und der Lebensmitteldiscounter Aunt Jemima (Ende der 30er bis Mitte der 50er Jahre). Zusätzlich arbeitete er für alle großen Wochen- und Monatsmagazine und begann in den 30er Jahren, unregelmäßig Pin-ups und Glamourkunst für Kalender zu malen.

Sein letzter Auftrag kam in den frühen 70er Jahren vom Playboy*: Er gestaltete das Cover der Weihnachtsausgabe mit einem lächelnden Sundblom Girl komplett mit einem dem Weihnachtsmann entliehenen Hut. „Sunny" starb 1976 in Chicago. Es war ihm vergönnt mitzuerleben, wie sein unbezahlbarer Einfluß als Lehrer und seine eigene künstlerische Brillanz die amerikanische Illustration in all ihren Facetten nachhaltig prägte.*

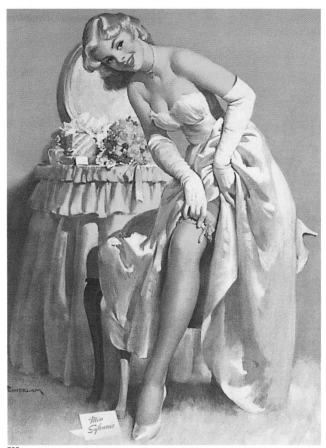

785

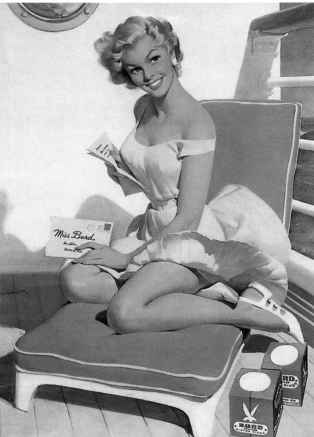

786

Sundblom est aujourd'hui reconnu comme la grande source d'inspiration des meilleurs peintres de pin up et de beautés glamour des années 30 aux années 60. Influencé lui-même par des artistes tels que Howard Pyle, John Singer Sargent, Anders Zorn, Robert Henri, J.C. Leyendecker, Walter Biggs, Pruett Carter et Sorolla, il forma des dizaines d'artistes qui connurent de belles carrières dans tous les domaines de l'illustration populaire. Parmi ceux qui se consacrèrent exclusivement aux pin up et aux beautés glamour, on compte Elvgren, Ballantyne, Buell, Moore, Skemp et Whittrup et, chez les plus jeunes, Bass, Brulé, D'Ancona, Frahm, Olmstead, Medcalf, Otto, Runci, Sarnoff et Withers.

Né en 1899 à Muskegon dans le Michigan, Sundblom étudia au Chicago Art Institute et à l'American Academy of Art. Après avoir décroché son diplôme en 1920, il fut l'apprenti de Charles Everett Johnson à Chicago. En 1925, il ouvrit un atelier avec Howard Stevens et Edwin Henry et sa carrière démarra sur les chapeaux de roues. Avec sa commande la plus importante, pour Coca-Cola, il donna le ton et le motif de la longue campagne nationale de la firme en créant l'image

désormais classique du Père Noël (1925). Une autre série de publicités nationales, pour Cashmere Bouquet Soap, lui permit de développer l'atmosphère ensoleillée, les coups de pinceau généreux et insouciants et l'iconographie bon enfant et romantique caractéristiques de son travail.

Sundblom réalisa également des images publicitaires pour des annonceurs tels que Palmolive Soap, Colgate Toothpaste, Maxwell House Coffee et Aunt Jemina (de la fin des années 30 au milieu des années 50). Il travailla pour tous les grands hebdomadaires et mensuels populaires et, vers le milieu des années 30, commença à peindre de temps à autre des pin up et des beautés glamour de calendriers.

La dernière commande de l'artiste, au début des années 70, fut une couverture pour le numéro de Noël de *Playboy*. On y voyait une Sundblom Girl souriante déguisée en Père Noël. «Sunny» mourut à Chicago en 1976, non sans avoir laissé son empreinte de génie sur le monde de l'illustration.

T. N. Thompson

From its initial publication in 1943, the Artist's Sketch Pad was a yearly institution in the calendar-publishing business. Originally created by Earl Mac Pherson for Brown and Bigelow, the calendar's format was adopted by most major pin-up publishers for almost twenty years. There were twelve one-sheet pages of pin-ups, spiral bound along the top of the calendar, that featured a central image surrounded by a group of smaller ones.

About 1948, Mac Pherson hired an assistant named Jerry Thompson, an accomplished artist who wanted an opportunity to improve his pin-ups. When Mac Pherson was stricken with polio late in 1951, Thompson found himself with the responsibility of painting the yearly Mac Pherson Sketch Book for the Shaw-Barton calendar company. He handled this project until 1958, while also creating a similar calendar for the John Baumgarth Company of Melrose Park, Illinois.

One image from the Baumgarth calendar, published in September 1952, was also sold as a single, one-sheet "hanger" calendar. Entitled *Want to See Me Swing My Baton?* (figure 798), this image of a majorette was Thompson's most popular and one of the company's best money-makers. More than a million matchbooks with this picture were sold to advertisers who wanted their products or businesses associated with its all-American baton girl.

Thompson also had pin-ups published by the Kemper-Thomas calendar company. In 1950, he did a well-received series of advertising paintings for Dodge Trucks that featured scenes on a farm with horses and shiny new pickup trucks (figure 805).

Thompson painted both on canvas and illustration board. Unlike Mac Pherson, he often combined mediums in the same painting, adding pastel, gouache, charcoal, and graphite to his oils. His paintings ranged in size from 20 x 16 inches (50.8 x 40.6 cm) to 36 x 28 inches (91.4 x 71.1 cm). Only about half of his commercial pin-ups are signed.

Seit der berühmte Künstlerskizzenblock „Artist's Sketch Pad" 1943 zum ersten Mal erschien, war er zu einer jährlich wiederkehrenden Institution in der Kalender-branche geworden. Ursprünglich hatte ihn Earl Mac Pherson für den Verlag Brown and Bigelow entworfen, doch das Format wurde während der nächsten 20 Jahre von den meisten Pin-up-Verlegern aufgenommen. Der Kalender bestand aus zwölf einzelnen Blättern im Format Din A1, die am oberen Ende von einer Spirale zusammengehalten wurden. Einige kleinere Bilder umgaben auf jedem einzelnen Blatt das zentrale Motiv.

Um 1948 stellte Mac Pherson einen Assistenten namens Jerry Thompson ein, ein ambitionierter Maler, der in diesem Job eine Möglichkeit sah, seine eigene Pin-up-Kunst zu verbessern. Als Mac Pherson Ende 1951 an Kinderlähmung erkrankte, mußte Jerry Thompson den nun jährlich erscheinenden Mac Pherson-Sketch-Book-Kalender für Shaw-Barton in Alleinregie realisieren. Jerry Thompson betreute ihn bis 1958 und entwickelte im gleichen Zeitraum einen vergleichbaren Kalender für die John Baumgarth Company, die in Melrose Park, Illinois, ansässig war.

Ein Bild des Baumgarth-Kalenders vom September 1952 wurde auch als Einzelblatt-Kalender im Format A1 auf den Markt gebracht. Want to See Me Swing My Baton *(Abb. 798)* hieß dieses Motiv eines Pin-up-Girls, das einen Stab schwenkte; es wurde zu einem der erfolgreichsten Motive in Thompsons Karriere und zu einer der lukrativsten Veröffentlichungen des Verlages.

Auch der Kalenderverlag Kemper-Thomas veröffentlichte Pin-ups von Thompson. Eine Anzeigenserie Thompsons für Dodge Trucks aus dem Jahr 1950 mit Szenen aus dem Landleben, auf denen man einen Bauernhof mit Pferden und funkelnagelneuen Pick-up-Lastwagen der Marke Dodge sah (Abb. 805), kam beim Publikum sehr gut an.

Thompson arbeitete sowohl auf Leinwand als auch auf Karton. Im Gegensatz zu Mac Pherson verwendete er oft verschiedene Techniken gleichzeitig, wie Öl, Pastell, Gouache, Kohle und Graphit. Sein Arbeitsformat lag zwischen 51 x 41 cm und 91 x 71 cm. Nur ungefähr die Hälfte seiner kommerziellen Pin-ups ist signiert.

Dès sa première parution en 1946, l'Artist's Sketch Pad devint une institution dans le monde de l'édition de calendriers. Initialement créé par Earl Mac Pherson pour Brown and Bigelow, ce format fut repris par la plupart des grands éditeurs pendant près de vingt ans. Il s'agissait de calendriers de douze pages, avec une reliure à spirale, présentant chacun une image principale entourée d'esquisses préliminaires.

Vers 1948, Mac Pherson recruta un assistant appelé Jerry Thompson, un artiste accompli qui cherchait à améliorer ses dessins de pin up. Lorsque Mac Pherson fut atteint de polio à la fin de 1951, Thompson eut la responsabilité de peindre lui-même le Mac Pherson Sketch Book pour Shaw-Barton. Il s'occupa du projet jusqu'en 1958, tout en créant des calendriers similaires pour un concurrent, John Baumgarth, de Melrose Park dans l'Illinois.

Une des images du calendrier de Baumgarth, publié en septembre 1952, fut également commercialisée sous forme de calendrier-cintre. Intitulée *Want to See Me Swing My Baton?* («Tu veux me voir manier mon bâton de majorette?» ; illustration 798), c'était la plus célèbre de Thompson et l'un des best-sellers de la maison. Plus d'un million de pochettes d'allumettes arborant cette image furent vendues à des annonceurs désireux que leur produits ou leurs services soient associés à cette belle majorette américaine.

Thompson vendit également ses pin up à Kemper-Thomas, autre éditeur de calendriers. En 1950, il exécuta une série d'affiches publicitaires pour Dodge Trucks (un constructeur de camions) montrant des scènes de ferme avec, en arrière-plan, des chevaux et plusieurs pick-up flambant neufs (illustration 805).

Thompson peignait sur toile et sur carton à dessin. Contrairement à Mac Pherson, il associait souvent plusieurs techniques, complétant ses huiles au pastel, à la gouache, au fusain et à la mine. Ses originaux mesuraient entre 50,8 x 40,6 cm et 91,4 x 71,1 cm. La moitié de ses pin up publicitaires n'étaient pas signées.

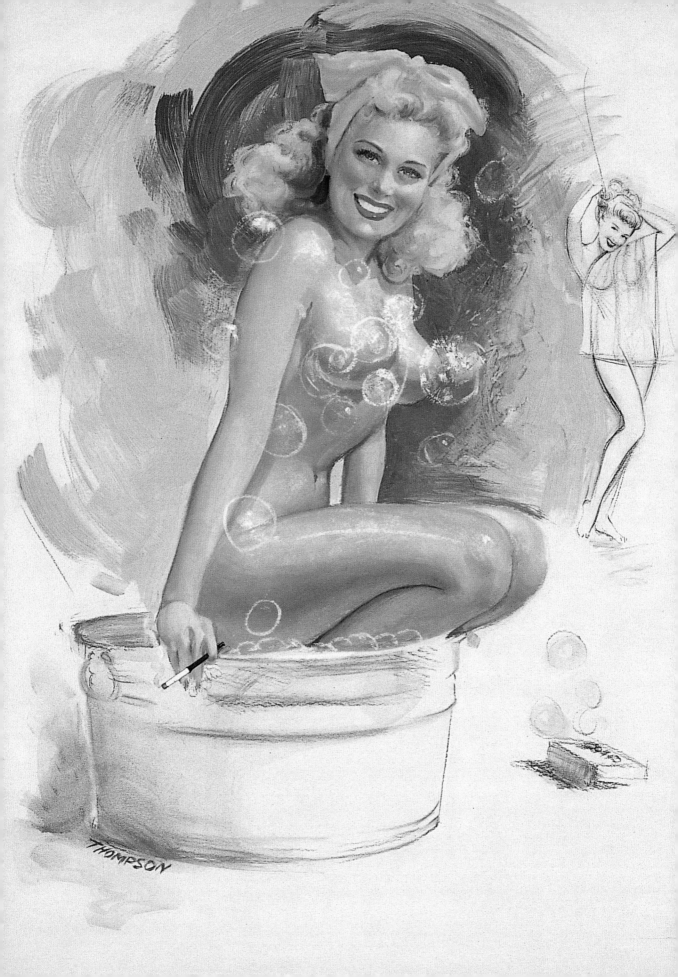

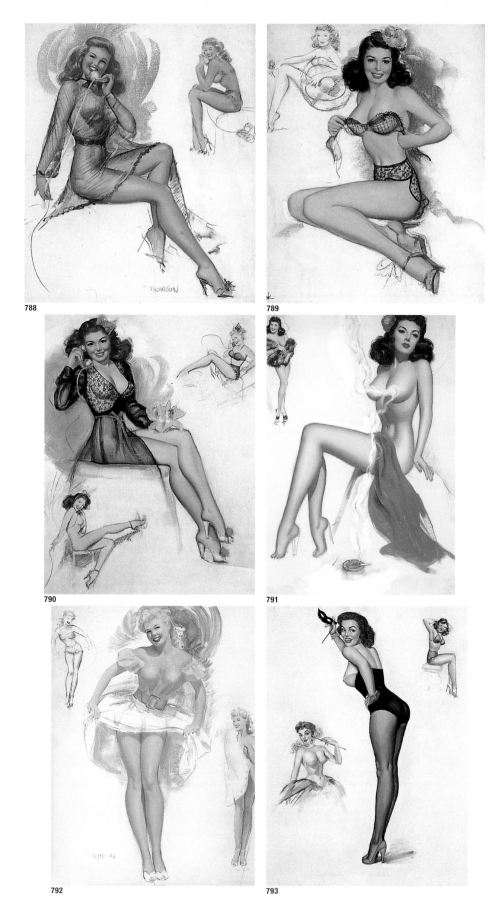

788

789

790

791

792

793

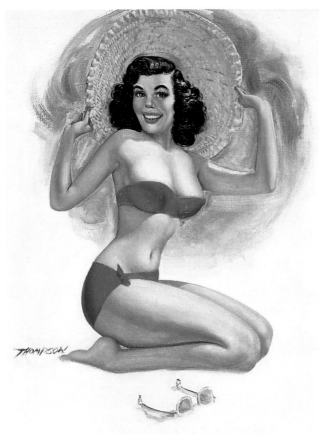

794

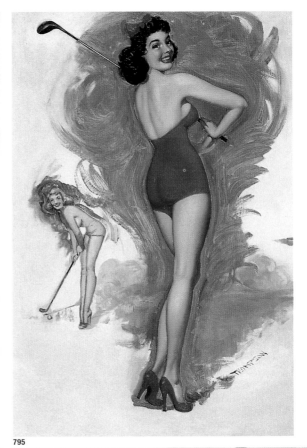

795

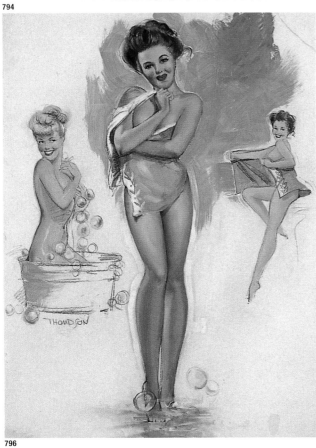

796

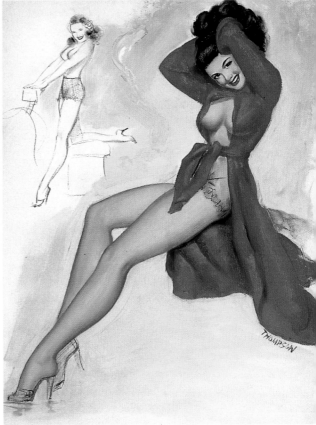

797

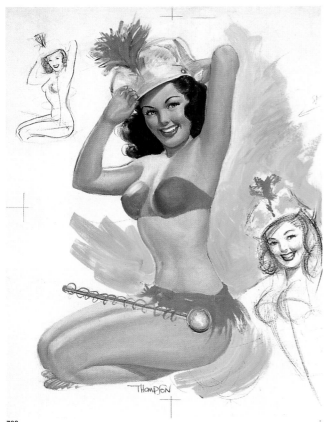

798

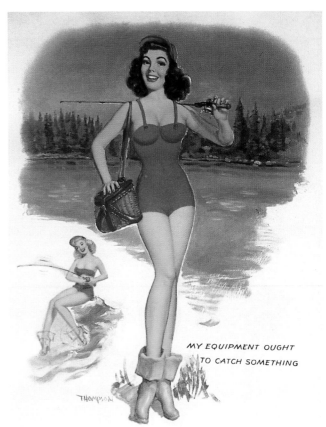

MY EQUIPMENT OUGHT
TO CATCH SOMETHING

799

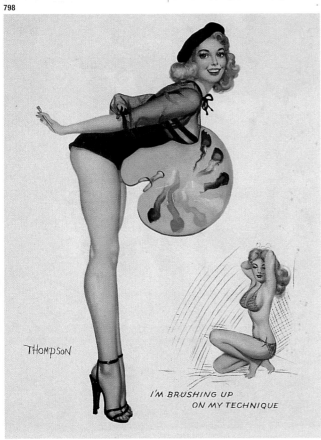

I'M BRUSHING UP
ON MY TECHNIQUE

800

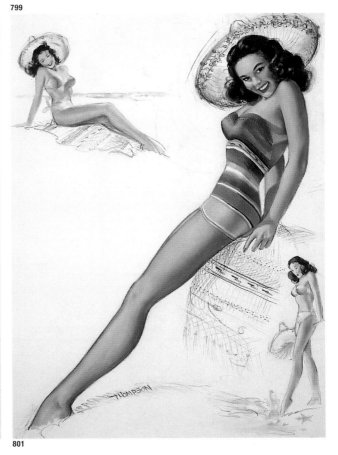

801

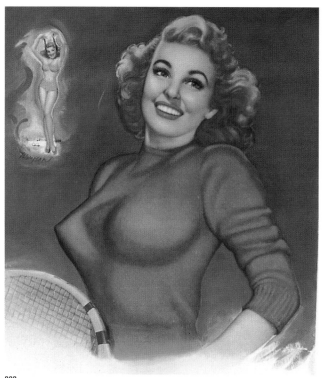

802

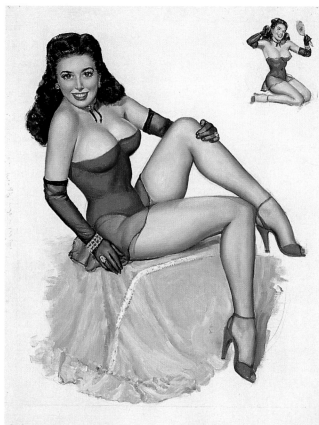

803

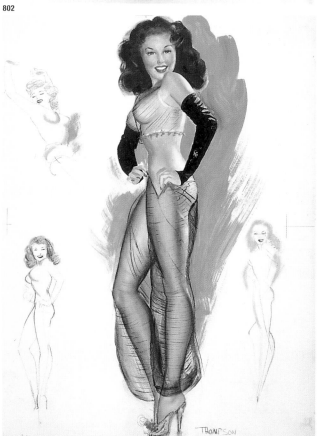

804

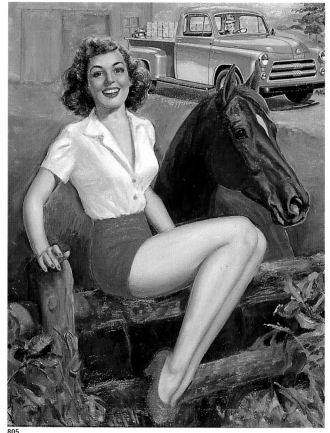

805

Si Vanderlaun

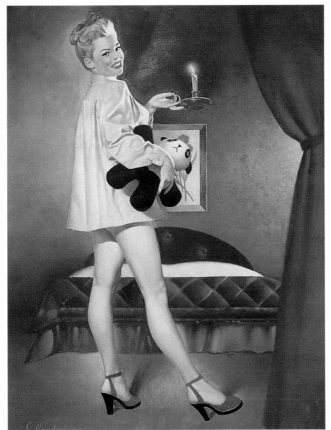

806

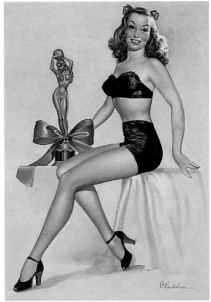

807

Vanderlaun painted works in a slick style that reproduced with photographic clarity and crispness. His entertaining pin-ups – either situation poses or narrative scenes – were published by several major calendar companies during the 1940s and 1950s.

Vanderlauns Arbeiten waren in einer glänzenden Technik gehalten, die sich mit fotografischer Klarheit und technischer Präzision reproduzieren ließen. Seine äußerst unterhaltsamen Pin-ups – entweder erzählende Szenen oder Situationen, in denen ein Pin-up vom Betrachter „überrascht" wird – wurden von einigen der großen Kalenderverlage in den 40er und 50er Jahren auf den Markt gebracht.

Les œuvres de Vanderlaun avaient un style délicat et, une fois reproduites, une précision et une netteté photographiques. Ses amusantes pin up, représentées dans des situations ou des scènes narratives, furent publiées par plusieurs grands éditeurs de calendriers pendant les années 40 et 50.

Alberto Vargas

From the time *Esquire* first introduced America to the Varga Girl, in 1940, the name Vargas has been synonymous with pin-up and glamour art. In fact, the word *vargas* has actually been applied to almost every kind of pin-up subject – a fitting tribute to the most famous and prolific glamour artist of all time.

Born February 9, 1896, in Peru, Alberto Vargas was the son of a renowned photographer, Max Vargas, who had taught him how to use an airbrush by the time he was thirteen. In 1911, while accompanying Max on a trip to Paris, Alberto came upon the famous magazine *La Vie Parisienne*, and its sensuous front covers by Raphael Kirchner made a lasting impression on him. He studied in Zurich and Geneva before leaving Europe because of the war and arriving on Ellis Island in October 1916.

Vargas's first encounter with America happened about noon at Broadway and Fourteenth Street, when he was suddenly surrounded by a lunchtime crowd of smartly dressed office workers. Mesmerized by their grace, sophistication, and beauty, the young artist decided he would spend his life glorifying the American Girl.

Vargas's first job was drawing fashion illustrations (mostly in watercolor and pen and ink) for the Adelson Hat Company and Butterick Patterns. Eventually turning to freelance commercial illustration, he was painting in a store window in May 1919 when he was asked by a representative of the Ziegfeld Follies to show his work the next day to Mr. Ziegfeld.

Within twenty-four hours, Vargas found himself commissioned to paint twelve watercolor portraits of the leading stars of the 1919 Ziegfeld Follies for the lobby of the New Amsterdam Theatre. Yet, although he was in the company of the most beautiful girls in the world, he knew there was only one woman for him: Anna Mae Clift, a showgirl with the rival Greenwich Village Follies. For the next twelve years, Vargas painted all the Ziegfeld stars, including names such as Billy Burke, Nita Naldi, Marilyn Miller, Paulette Goddard, Ruth Etting, Eddie Cantor, and W. C. Fields. He soon developed a friendship with Ziegfeld, who let the young artist call him "Ziggy," a name used only by the impresario's closest friends.

In 1927, Vargas went to work for the Paramount Pictures' art department in New York and was chosen to create the original artwork for the film *Glorifying the American Girl*, which was being produced by Ziegfeld. Working in an atmosphere of extraordinary harmony between artist, producer, and film, Vargas created advertising artwork that, aside from general distribution, also appeared in Paramount's *20th Anniversary Book*, published in 1927 for the company's stars and executives (figure 19).

Vargas maintained a full schedule throughout the 1920s, working for a diverse group of clients in addition to the Follies and Paramount. He painted front covers for *Tatler* and *Dance* magazines, did hairstyle illustrations for *Harper's Bazaar*, and even designed some countertop displays for Old Gold cigarettes. Yet he still found time to paint his favorite Ziegfeld Follies stars for his own pleasure, including the daring Shirley Vernon, whose 1927 portrait was preserved in his private collection.

Vargas and Anna May Clift were married in 1930 and moved to Hollywood four years later. Twentieth Century Fox soon hired the artist to paint pastel portraits of their stars, as did Hellman's Mayonnaise, which commissioned a series of full-length movie star portraits for their advertisements. By 1935, Vargas was working for Warner Brothers and, before the decade was over, for MGM.

Vargas's first calendar jobs were two pastel glamour pin-ups executed for Joseph C. Hoover and Sons between 1937 and 1939. He became an American citizen in 1939, the same year that he received an invitation from *Esquire* magazine to visit with publisher David Smart in Chicago to discuss the possibility of working together. Vargas was immediately hired as a replacement for George Petty, whose contract was to expire in December 1941. Agreeing to drop the s from his last name in all his work for the magazine, he had his first painting published in the October 1940 issue. Two months later, *Esquire* introduced the first Varga Girl calendar, which sold better than any other previously published up to that time.

Over the next five years, Vargas became known worldwide, and his work – both in the monthly magazine and the yearly calendar – was eagerly awaited. Although he had a full schedule of work for *Esquire* during the war years, he often accommodated special requests from soldiers to paint mascot pin-ups for their group or squadron. *Esquire* also allowed Vargas to do a series of patriotic pin-ups for

808 ▷

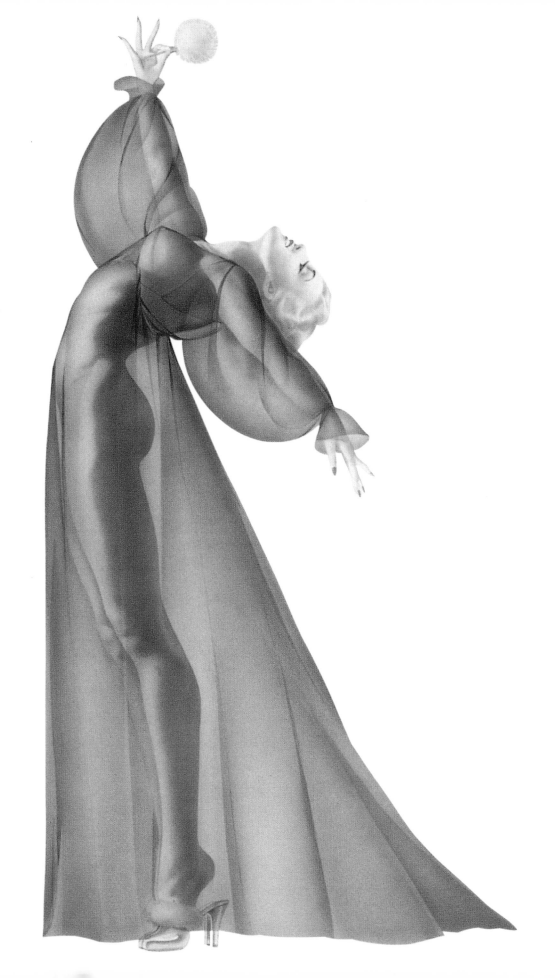

William Randolph Hearst's *American Weekly* magazine, the only other magazine work permitted him during the *Esquire* years.

Vargas continued to paint Hollywood stars while he worked for the magazine. His 1941 movie poster of Betty Grable in *Moon Over Miami* was a great success; among the other leading ladies he painted were such stars as Jane Russell, Ann Sheridan, Ava Gardner, Linda Darnell, Marlene Dietrich, Loretta Young, and Marilyn Monroe.

The most important commercial assignment of Vargas's career was the special three-page *Esquire* Girl Gatefold he created for the January 1946 issue. Planned as a special holiday gift for the magazine's readers, the original painting had to be exactly 36 inches (91.4 cm) high so that it could be reproduced in its original dimensions on three pages of the magazine. Vargas responded to this challenge with one of his most breathtaking images.

When Vargas and *Esquire* went their separate ways in 1946, the artist immediately embarked upon a project to publish his own yearly calendar. In the meantime, the magazine published an *Esquire* Calendar for 1947 that consisted completely of unsigned Vargas paintings. By the time Vargas's 1948 calendar was published, *Esquire* had a court order barring the artist from selling or distributing any product bearing the name "Varga," which the magazine had copyrighted. In 1950, a court ruled that Vargas would have to sign all his subsequent paintings with his full name.

During the early and mid-1950s, Vargas took on many commercial assignments, including a pin-up of Shelley Winters for the RKO film *Behave Yourself*, a deck of Vargas Girl playing cards called "Vargas Vanities," and a series of pin-ups for the pocket-sized British magazine *Men Only*. In 1957, *Playboy* magazine published a pictorial feature on Vargas's nudes, which drew the attention of publisher Hugh Hefner. In August 1958, Vargas and Anna Mae traveled to Lima, Peru, for a highly successful exhibition of his paintings. They were greeted upon their return with a personal invitation from Hefner to have Vargas's work appear monthly in *Playboy*.

Embarking on this momentous association in 1960, Vargas was to paint 152 works for *Playboy* during this period, adapting to new moral standards and more explicit sexuality. Vargas painted only two front-cover images for *Playboy* during his long reign as the magazine's primary artist: a cut-out figure of a girl in a bathing suit that was part of a montage created by art director Reid Austin in 1961 and the cover for the March 1965 issue.

During the *Esquire* years, from 1940 to 1946, Vargas usually prepared a total of four preliminary studies for each published painting. Three of these were drawn on a fine tissue paper, the fourth on a heavy vellum parchment paper. The three tissues showed increasing detail from one state to the next until the parchment state which, because of the paper's color and texture, was almost identical to the final painting. These studies would often be drawn with the model as a nude, Vargas simply adding the clothing to the final painting for publication. At *Playboy*, Vargas did one tissue and occasionally a few parchment studies for each published painting.

When Vargas's wife passed away in November 1974, the artist lost much of his interest in painting and in life. Toward the end of the 1970s, he worked on an autobiography with Reid Austin, *Vargas* (Harmony Books). His career was revived somewhat when he painted an album cover, *Candy-O*, for the rock-n-roll band The Cars; he also designed two other record album jackets for singer Bernadette Peters. He died on December 30, 1982, in Los Angeles.

NOTE: *Charles Martignette possesses the finest and, without doubt, the largest collection of works by Vargas, outside of the residual holdings of the artist's estate. His collection contains sparkling examples of virtually every period and facet of the artist's long, illustrious career as a pin-up artist and painter of beautiful girls and women.*

It is, therefore, very unfortunate for us, for the reader, and, in fact, for the memory of this great artist that we have been forbidden to show all this wonderful art herein. In a letter denying us reproduction rights, representatives of the estate had this to say: "With reference to your proposed 'PIN UPS' book, we have reviewed the list of illustrators and artists you intend to include. While a few are very well known, most are not. It is apparent that Vargas is the best known and would be judged by the company he keeps. The fundamental difference between you and our clients is that they do not believe it is in the best interests of the Estate to treat Vargas merely as a 'Pin Up' artist. We all know he was so much more than that."

Our reply included the following: "100% of literate people who are capable of absorbing information know that Vargas was a pin-up cartoonist for Playboy. Most people know that he was also a pin-up cartoonist for Esquire, some even that he was a pin-up calendar artist. No one knows of him as anything else."

Fortunately, through the good graces of the Esquire magazine archives, we are able to include works from a small segment of the artist's career in this volume, which we are sure will always be the single most important record of the genre. We feel certain that Playboy magazine would also have assisted us, had they been free to do so.

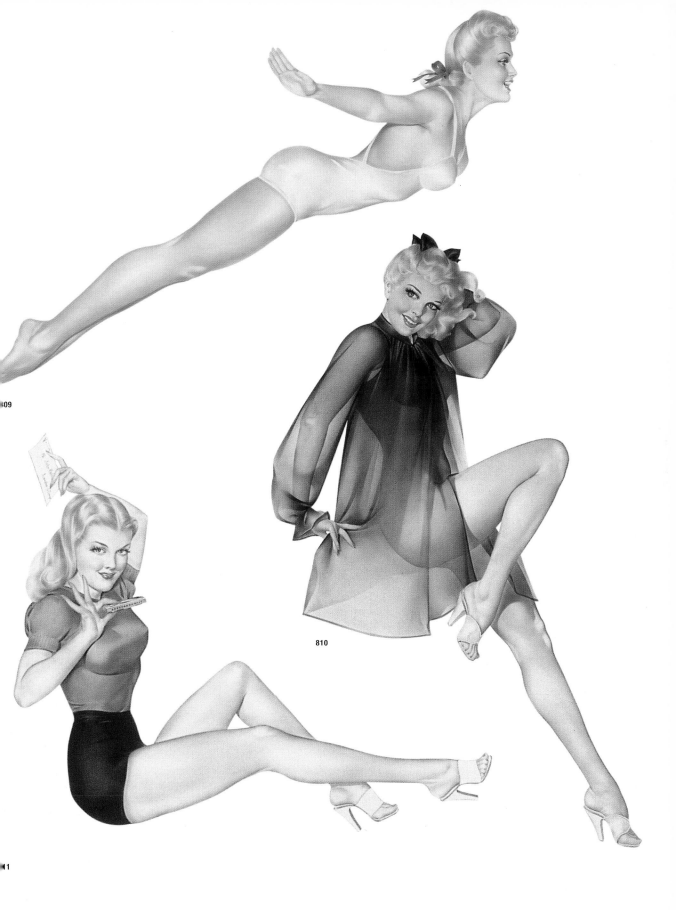

809

810

811

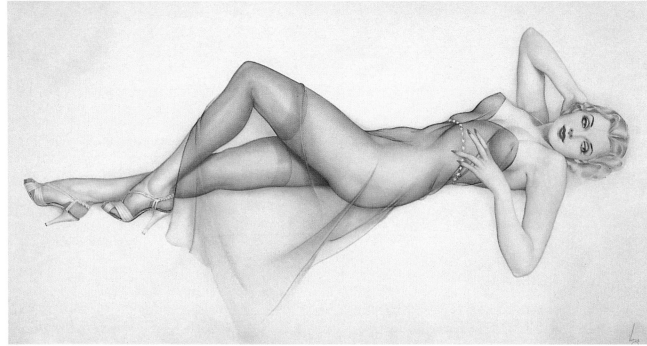

812

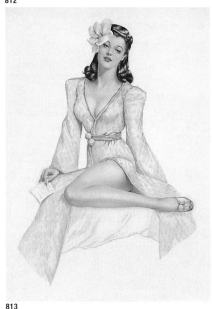

813

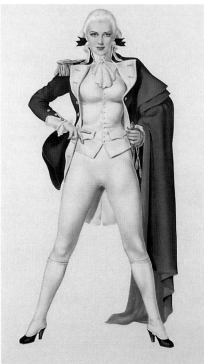

814

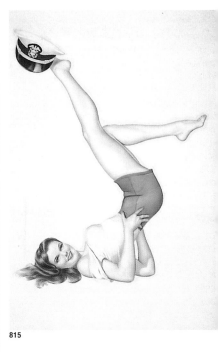

815

Seit Amerika mit Hilfe der Zeitschrift Esquire 1940 erstmals Bekanntschaft mit dem Varga Girl machte, ist der Name Vargas zu einem Synonym für Pin-up- und Glamourkunst geworden. Sein Name wurde in den USA sogar als Wort für fast jede Art von Pin-up-Thema verwendet – ein und Triumph für den berühmtesten, ideenreichsten und produktivsten Glamourkünstler aller Zeiten.

Der am 9. Februar 1896 in Peru geborene Alberto war der Sohn des berühmten Fotografen Max Vargas. Dieser brachte ihm im Alter von 13 Jahren den Umgang mit der Spritzpistole bei. 1911 begleitete Alberto seinen Vater auf einer Reise nach Paris und entdeckte dort die berühmte Zeitschrift La Vie Parisienne. Raphaël Kirchners sinnliche Titelblätter hinterließen bei dem jungen Künstler

einen bleibenden Eindruck. Alberto Vargas studierte in Zürich und Genf, verließ Europa bei Ausbruch des Ersten Weltkriegs und kam im Oktober 1916 auf der Einwandererinsel Ellis Island vor New York an.

Seine erste Bekanntschaft mit den Vereinigten Staaten machte Vargas ungefähr um zwölf Uhr mittags an der Ecke Broadway und Fourteenth Street. Dort fand er sich plötzlich von wahren Horden gutangezogener Menschen umgeben, Büroangestellten, die zum Mittagessen gingen. Er war vom Schick, der Schönheit und Anmut der New Yorker Frauen so begeistert, daß er beschloß, sein Leben in den Dienst dieser Wunderwesen zu stellen. Von nun an würde er das American Girl glorifizieren.

Vargas begann seine berufliche Laufbahn als Modellillustrator (vorwiegend in Aquarell und Tuschfeder) für die Adelson Hat Company und den Schnittmuster-hersteller Butterick Patterns. Später arbeitete er als freier Werbegrafiker. Als er gerade ein Schaufenster mit Zeichnungen dekorierte, wurde er im Mai 1919 von einem Repräsentanten der Showtruppe Ziegfeld Follies angesprochen. Herr Ziegfeld persönlich lud ihn für den kommenden Tag ein. Binnen 24 Stunden erhielt Vargas den Auftrag, zwölf Aquarell-Porträts von den Stars der Ziegfeld Follies 1919 für die Eingangshalle des New Amsterdam Theaters zu malen. Obwohl er nun plötzlich von den schönsten Frauen der Welt umgeben war, hatte Vargas sein Herz längst verloren: an Anna Mae Clift, die bei der konkurrierenden Greenwich Village Follies tanzte. In den kommenden zwölf Jahren malte Vargas alle Ziegfeld-Stars, unter ihnen Paulette Goddard, Marilyn Miller, Billy Burke, Nita Naldi, Ruth Etting, Eddie Cantor und W. C. Fields. Zwischen ihm und Zieg-feld entwickelte sich bald ein freundschaftliches Verhältnis.

1927 begann Vargas, für die künstlerische Abteilung der Filmfirma Para-mount Pictures in New York zu arbeiten. Er wurde mit den Anzeigen für den Film Glorifying the American Girl beauftragt, eines der ersten Tonmusicals, das Zieg-feld produzierte und bei dem auch viele Mitglieder seiner Truppe mitspielten. In einer für Künstler, Produzent und Filmschaffenden ausgesprochen angenehmen Arbeitsatmosphäre schuf Vargas Werbevorlagen für den Film, die nicht nur bei der späteren Promotion des Filmes eingesetzt, sondern auch im 20th Anniver-sary Book der Paramount abgedruckt wurden, mit dem der Filmgigant 1927 sich und die führenden Stars und Macher der Paramount Pictures feierte (vgl. Abb. 19).

Während der 20er Jahre arbeitete Vargas neben den Ziegfeld Follies und Paramount Pictures noch für eine ganze Reihe anderer Auftraggeber. Für die Zeitschriften Tatler und Dance gestaltete er Cover, für die Zeitschrift Harper's Bazaar Illustrationen der neuesten Trendfrisuren; für die Zigarettenmarke Old Gold entwarf er Displays für Ladentheken. Und dennoch blieb ihm noch genü-gend Zeit, seine Favoritinnen unter den Stars der Ziegfeld Follies zu malen. Zu ihnen gehörte auch Shirley Vernon, deren Porträt aus dem Jahre 1927 in seine Privatsammlung wanderte.

1930 heirateten Vargas und Anna Mae Clift. Vier Jahre später zogen sie nach Hollywood. Dort beauftragte ihn bald die 20th Century Fox, ihre Filmstars in Pastell zu porträtieren. Auch die Firma Hellman's Mayonnaise ließ Vargas Film-stars für ihre Anzeigenkampagnen darstellen. 1935 glückte Vargas der Einstieg bei Warner Brothers, und am Ende des Jahrzehnts zählte er mit Metro Goldwyn Mayer noch ein weiteres Filmimperium zu seinen Auftraggebern.

Seine ersten Aufträge für Kalender erhielt Vargas zwischen 1937 und 1939 von Joseph C. Hoover and Sons, für die er zwei Glamour-Pin-ups in Pastell mal-te. 1939 erhielt er die amerikanische Staatsbürgerschaft, und im gleichen Jahr lud ihn die Zeitschrift Esquire zu einem Gespräch mit ihrem Herausgeber David Smart ein. In Chicago sollte die Möglichkeit einer Zusammenarbeit erörtert wer-den. Vargas wurde postwendend als Ersatz für den scheidenden George Petty eingestellt, dessen Vertrag im Dezember 1941 auslaufen sollte. Vargas erklärte sich bereit, den Endbuchstaben „s" seines Nachnamens bei allen Arbeiten für die Zeitschriften wegzulassen und veröffentlichte sein erstes Bild in der Okto-berausgabe des Jahres 1940. Zwei Monate später führte Esquire mit einem Kalender bei seinen Lesern das Varga Girl ein. Dieser Kalender verkaufte sich besser als alle seine Vorgänger.

In den nächsten fünf Jahren wurde Vargas weltbekannt und seine Pin-ups – sowohl in der monatlich erscheinenden Zeitschrift als auch im jährlich publizier-ten Kalender – sehnsüchtigst erwartet. Trotz seines hohen Arbeitspensums für Esquire während der Kriegsjahre nahm Vargas oft besondere Aufträge von Sol-daten an, die für ihre Truppe oder ihr Geschwader um Pin-ups als Maskottchen baten. Mit der Erlaubnis von Esquire durfte Vargas für den Pressezaren William Randolph Hearst und seine Zeitschrift American Weekly eine Serie von patrioti-schen Pin-ups zeichnen; dieses war allerdings die einzige Zeitschrift, für die ihn Esquire je freistellte.

Vargas malte weiterhin die Hollywoodstars. Sein Filmposter zu dem Betty-Grable-Film Allotria in Florida (Moon Over Miami) aus dem Jahr 1941, einem Musical um Liebe und die Suche danach, wurde ein großer Erfolg; andere Film-diven, die Vargas malte, verkörperten ebenfalls das klassische Hollywoodideal: Jane Russell, Ava Gardner, Marlene Dietrich, Marilyn Monroe, Ann Sheridan, Linda Darnell, Loretta Young.

Der wichtigste kommerzielle Auftrag in Vargas' Karriere war ein auf drei Sei-ten ausklappbares Bild für die Esquire-Ausgabe vom Januar 1946. Dieses Var-ga-Girl war als Weihnachtsgeschenk für die Leser der Zeitschrift gedacht und mußte im Original exakt 91,4 cm hoch sein, um für den dreiseitigen Ausklapper reproduziert werden zu können. Trotz dieser schwierigen Vorgabe gelang Vargas hier eines seiner atemberaubendsten Motive.

1946 trennten sich die Wege von Vargas und Esquire, und Vargas kümmerte sich umgehend um die Publikation eines von ihm gestalteten jährlich erschei-nenden Kalenders. In dieser Zeit veröffentlichte die Zeitschrift den 1946er Esquire-Kalender, der nur aus unsignierten Vargas-Arbeiten bestand. Als sein eigener Kalender für das Jahr 1948 auf den Markt kam, ließ Esquire per Gerichtsbeschluß ein Verbot des Verkaufs oder der Verbreitung jeden Produktes mit dem Namen „Varga" erwirken, auf den die Zeitschrift das Copyright erhielt. 1950 entschied ein Gericht, daß Vargas seine Bilder künftig mit seinem vollen Namen zu signieren hätte.

Zwischen Anfang und Mitte der 50er Jahre übernahm Vargas viele Werbe-aufträge, so einen Pin-up der Schauspielerin Shelley Winters für die RKO-Film-produktion Gangster unter sich (Behave Yourself), ein Spielkartenset mit Vargas Girls, das unter dem Namen „Vargas Vanities" auf den Markt kam und eine Pin-up-Serie für das kleinformatige britische Magazin Men Only. 1957 veröffent-lichte der Playboy eine Bilderserie mit Akten von Vargas, die den Verleger des Heftes, Hugh Hefner, auf Vargas aufmerksam machte. Im August 1958 reisten Vargas und seine Frau Anna Mae zu einer sehr erfolgreichen Ausstellung von Vargas' Arbeiten in das peruanische Lima. Nach ihrer Rückkehr in die Vereinig-ten Staaten wartete eine persönliche Einladung von Hugh Hefner. Von 1960 an war Vargas jeden Monat im Playboy vertreten.

125 Arbeiten lieferte Vargas in den nächsten 16 Jahren an seinen neuen Auftraggeber Playboy. In diesem Zeitraum veränderten sich seine Bilder, wur-den moderner und orientierten sich an einer freizügigeren Einstellung gegen-über Sexualität. Während der langen Zeit als wichtigster Künstler des Blattes schuf Vargas nur zwei Cover für den Playboy: die freigestellte Silhouette eines Mädchens im Badeanzug, das zu einer von Reid Austin, dem Art Director des Playboy, entworfenen Collage gehörte, und das Cover der Märzausgabe des Jahres 1965.

Während seiner Zeit für Esquire, zwischen 1940 und 1946, legte Vargas nor-malerweise für jedes veröffentlichte Bild vier Studien an. Drei davon waren auf feinem Seidenpapier gemalt, das vierte auf festem Pergamentpapier. Die drei Variationen auf Seidenpapier zeigten von Bild zu Bild mehr Details; die Version auf Pergamentpapier war fast mit der endgültigen Fassung identisch. Bei die-sen Studien arbeitete Vargas oft mit einem Modell im unbekleideten Zustand und zog es erst im letzten Arbeitsgang an, indem er die Kleidungsstücke ergänzte. Beim Playboy gab es zu jedem veröffentlichten Bild eine Studie auf Seidenpapier und manchmal einige Varianten auf Pergamentpapier.

Nach dem Tod seiner Frau Anna Mae im November 1974 verlor Vargas das Interesse an seiner Kunst und konnte auch dem Leben nicht mehr viel abgewin-nen. Ende der 70er Jahre arbeitete er zusammen mit Reid Austin an einer Auto-biographie, die unter dem Titel Vargas bei dem amerikanischen Verlag Harmony Books veröffentlicht wurde. Ein Auftrag der US-amerikanischen Rockband The Cars, die ihn mit dem Albumcover ihrer Erfolgsplatte Candy-O betreute, gab ihm kurz neuen Auftrieb. Zwei weitere Albumcover für die Sängerin Bernadette Peters folgten. Alberto Vargas starb in Los Angeles am 30. Dezember 1982.

Depuis la première apparition de la Varga Girl en 1940 dans *Esquire,* le nom «Vargas» est devenu synonyme de pin up et de beauté glamour. De fait, il a été utilisé pour décrire toutes sortes de créatures de rêve, un bel hommage pour l'artiste glamour le plus prolifique et célèbre de tous les temps!

Né le 9 février 1896 au Pérou, Alberto Vargas était le fils d'un célèbre photographe, Max Vargas, qui lui apprit à se servir d'un aérographe quand il n'avait pas encore treize ans. En 1911, alors qu'il accompagnait son père à Paris, Alberto tomba sur *La Vie parisienne.* Les couvertures sensuelles de Raphaël Kirchner eurent sur lui une profonde impression. Il fit ses études à Zurich et à Genève avant que la guerre ne l'oblige à fuir l'Europe. Il débarqua sur Ellis Island en octobre 1916.

La vraie rencontre entre Vargas et l'Amérique se produisit vers midi, à l'angle de Broadway et de la Quatorzième rue. Là, il se trouva soudain submergé par une marée d'élégantes secrétaires sortant pour leur pause-déjeuner. Fasciné par leur grâce, leur allure sophistiquée et leur beauté, le jeune artiste décida sur-le-champ de consacrer sa vie à la gloire des belles Américaines.

Son premier emploi consista à dessiner des illustrations de mode (principalement des aquarelles et des dessins au crayon et à l'encre de Chine) pour les compagnies Adelson Hat et Butterick Patterns. Il devint ensuite illustrateur freelance. Un beau jour de mai 1919, il était en train de peindre dans la vitrine d'une boutique quand un inconnu s'arrêta et lui demanda de venir dès le lendemain montrer son travail au patron des Ziegfeld Follies. Vingt-quatre heures plus tard, Vargas avait une commande de douze aquarelles représentant les principales vedettes de la revue de 1919, destinées au hall du New Amsterdam Theatre. Bien qu'entouré des plus belles filles du monde, il n'eut d'yeux que pour une seule femme: Anna Mae Clift, une girl de la revue concurrente, les Greenwich Village Follies. Les douze années qui suivent, Vargas peignit toutes les stars de Ziegfeld: Billy Burke, Nita Naldi, Marylin Miller, Paulette Godard, Ruth Etting, Eddie Cantor et W.C. Fields. Il devint bientôt un ami du grand impresario, qui laissait le jeune artiste l'appeler «Ziggy», surnom strictement réservé à ses intimes.

En 1927, Vargas travailla pour le bureau new-yorkais du département artistique de la Paramount et fut choisi pour créer les œuvres originales figurant dans *Glorifying the American Girl,* un film produit par Ziegfeld. Dans une atmosphère de grande harmonie avec le producteur et l'équipe du film, Vargas réalisa une série d'images promotionnelles qui, outre leur distribution à l'échelle nationale, parurent la même année dans le livre commémorant le vingtième anniversaire des studios Paramount. (illustration 19).

Tout au long des années 20, en marge de son travail pour les Ziegfeld Follies et la Paramount, Vargas réalisa des commandes pour une clientèle variée. Il fit des couvertures pour *Tatler* et *Dance,* illustra des coiffures pour *Harper's Bazaar,* et dessina même des présentoirs pour les cigarettes Old Gold. Il trouva également le temps de faire, pour son propre plaisir, le portrait de quelques vedettes des Ziegfeld Follies, dont celui de Shirley Vernon (en 1927) qu'il conserva dans sa collection particulière.

Vargas et Anna May Clift se marièrent en 1930 et s'installèrent à Hollywood quatre ans plus tard. La Twentieth Century Fox engagea bientôt l'artiste pour peindre les portraits au pastel de ses stars, et Hellman's Mayonnaise lui commanda une série de portraits en pied de vedettes de cinéma pour ses affiches publicitaires. En 1935, Vargas travaillait pour Warner Brothers, et une décennie plus tard, pour M.G.M.

Les premiers travaux de Vargas pour les calendriers furent deux pin up glamour au pastel pour Joseph C. Hoover and Sons, publiés entre 1937 et 39. Il obtint la nationalité américaine en 1939. Cette même année, *Esquire* l'invita à Chicago pour rencontrer l'éditeur David Smart. Vargas fut immédiatement engagé pour remplacer George Petty, dont le contrat devait expirer en décembre 1941. Acceptant de laisser tomber le S final de son nom dans tous les travaux utilisés par le magazine, il vit sa première œuvre publiée dans le numéro d'octobre 1940. Deux mois plus tard, *Esquire* lança le premier calendrier de la Varga Girl, qui se vendit mieux que tous les calendriers précédents.

Les cinq années qui suivirent, Vargas devint célèbre dans le monde entier. Les Varga Girls, qui paraissaient tous les mois dans le magazine plus une fois par an dans le calendrier, étaient très attendues. En dépit de sa charge de travail considérable, il acceptait les demandes de soldats qui voulaient une pin up mascotte pour leur bataillon ou leur escadron. *Esquire* autorisa également Vargas à réaliser une série de pin up patriotiques pour le magazine de William

Randolph Hearst, *American Weekly,* le seul autre titre où il avait droit de publie en dehors d'*Esquire.* Pendant cette même période, Vargas continua de peindre des stars pour Hollywood. En 1941, son affiche de cinéma avec Betty Grable dans *Moon Over Miami* remporta un vif succès. Parmi ses autres portraits de grandes vedettes on compte Jane Russell, Ann Sheridan, Ava Gardner, Linda Darnell, Marlene Dietrich, Loretta Young et Marilyn Monroe.

Pour son numéro de janvier 1946, *Esquire* passa à Vargas la commande la plus importante de sa carrière: un poster géant devant faire office de cadeau de Noël pour les lecteurs. L'original devait mesurer exactement 91,4 cm de hauteur afin de pouvoir être reproduit sur un format de trois pages dans le magazine. Vargas releva le défi en créant une image époustouflante.

Lorsque Vargas et *Esquire* mirent fin à leur collaboration en 1946, l'artiste se lança immédiatement dans un nouveau projet: la publication de son propre calendrier. Parallèlement, le magazine publia un calendrier *Esquire 1947* constitué entièrement d'œuvres de Vargas non signées. Lorsque celui de Vargas sortit en 1948, la revue obtint un jugement officiel interdisant à l'artiste de vendre ou de distribuer tout produit portant le nom «Varga» dont elle possédait les droits. En 1950, le tribunal stipula que Vargas devrait désormais signer ses œuvres de son nom entier.

Pendant la première moitié des années 50, Vargas accepta un grand nombre de commandes publicitaires, notamment un portrait de Shelley Winters en pin up pour le film *Behave Yourself* de la R.K.O., un jeu de cartes intitulé «Vargas Vanities», et une série de pin up pour une revue masculine britannique, de format de poche, *Men Only.* En 1957, *Playboy* publia un reportage sur les nus de Vargas et, en août 1958, l'artiste se rendit à Lima où était organisée une exposition de ses peintures. A son retour, il fut invité à rencontrer Hugh Hefner qui souhaitait publier ses pin up tous les mois dans *Playboy.*

Cette brillante collaboration débuta en 1960 et se traduisit par 152 œuvres de Vargas publiées dans le célèbre magazine masculin au cours des seize années qui suivirent. Durant cette période, les Vargas Girls se modernisèrent, s'adaptant aux nouveaux critères de la morale et devenant plus explicitement érotiques. Au cours de son long règne comme premier artiste-maison, Vargas ne réalisa que deux couvertures pour *Playboy:* une silhouette de pin up en maillot de bain intégrée à un montage du directeur artistique Reid Austin en 1961 et la couverture du numéro de mars 1965.

Lorsqu'il travaillait pour *Esquire* de 1940 à 1946, Vargas réalisait généralement quatre esquisses préliminaires pour chaque œuvre publiée. Trois étaient exécutées sur papier de soie, la quatrième sur un vélin épais. Les trois premières étaient progressivement de plus en plus détaillées, tandis que la quatrième, du fait de la teinte et de la texture du papier, était presque identique à la peinture finale. Sur ces études, le modèle était nu, Vargas rajoutant simplement les vêtements sur la version finale. Pour *Playboy,* Il ne faisait qu'une esquisse sur papier de soie et, éventuellement, quelques études sur vélin.

Lorsque sa femme mourut en novembre 1974, Vargas cessa de s'intéresser à la peinture et à la vie en général. Vers la fin des années 70, il écrivit son autobiographie avec l'aide de Reid Austin, *Vargas* (publiée chez Harmony Books). Sa carrière fut quelque peu ravivée quand il peignit la pochette de l'album du groupe de rock The Cars, *Candy-O.* Il dessina également deux autres pochettes de disques pour la chanteuse Bernadette Peters. Il mourut le 30 décembre 1982 à Los Angeles.

Note: *Charles Martignette possède la plus belle, et sans aucun doute la plus grande, collection d'œuvres de Vargas, en dehors du fonds détenu par les héritiers de l'artiste. Sa collection compte de superbes exemples de pratiquement toutes les époques et facettes de la longue carrière de peintre de pin up et de jolies femmes de ce grand artiste.*

Il est donc regrettable, pour nous, pour le lecteur et pour la mémoire de Vargas, que nous ne puissions présenter ici ces merveilleuses images. Dans une lettre nous refusant les droits de reproduction, les représentants des héritiers nous ont déclaré: «Relativement à votre projet de livre sur les pin up, nous avons examiné la liste des illustrateurs et artistes que vous comptiez y inclure. Si quelques-uns sont connus, ce n'est pas le cas de la plupart des autres. Vargas étant de loin le plus célèbre d'entre eux, il serait jugé en fonction de ceux qui lui sont associés. Contrairement à vous, nos clients estiment qu'il n'est pa

dans l'intérêt de Vargas d'être présenté comme un simple artiste de ‹Pin Up›. Nous savons tous qu'il était beaucoup plus que cela.»

Ce à quoi nous avons répondu: «100% des personnes en âge de lire et d'emmagasiner quelques informations savent que Vargas faisait des dessins humoristiques de pin up pour Playboy. La plupart savent également qu'il faisait des dessins humoristiques de pin up pour Esquire. Certains savent même qu'il

faisait des calendriers de pin up. Personne n'en sait plus à son sujet.» Heureusement, grâce à l'aimable collaboration d'Esquire, nous sommes en mesure de présenter des œuvres illustrant un petit segment de la carrière de l'artiste dans ce volume qui, nous en sommes convaincus, restera l'ouvrage le plus complet de ce genre. Nous sommes certains que le magazine Playboy nous aurait également aidés s'il avait eu la possibilité de le faire.

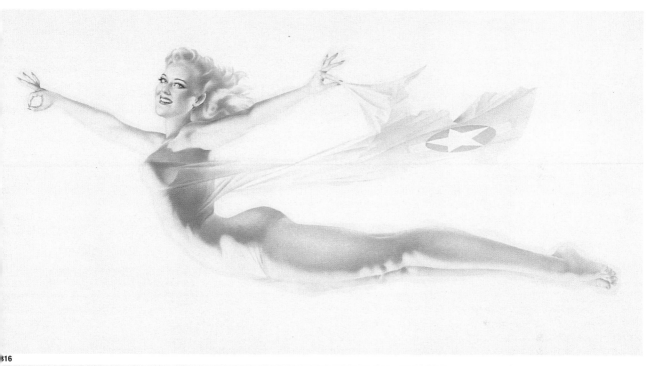

316

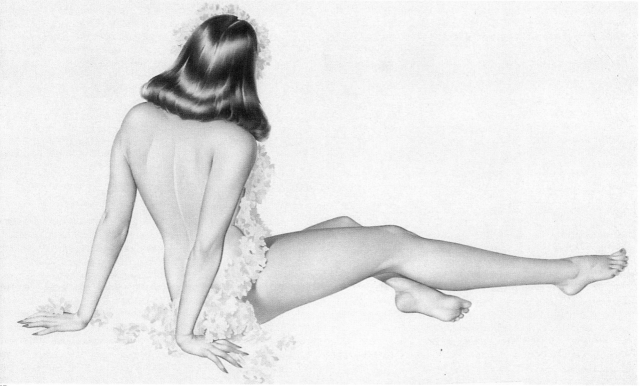

317

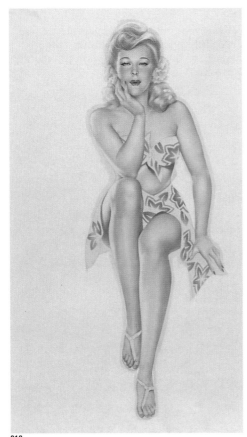

818

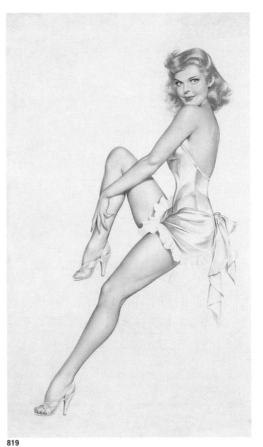

819

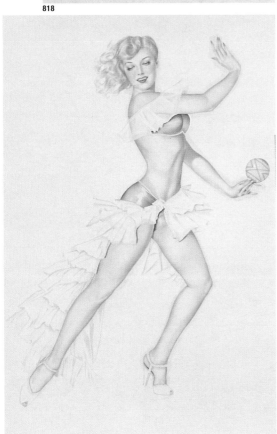

820

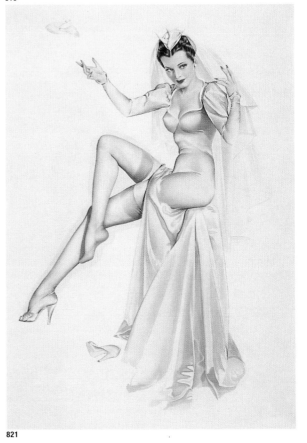

821

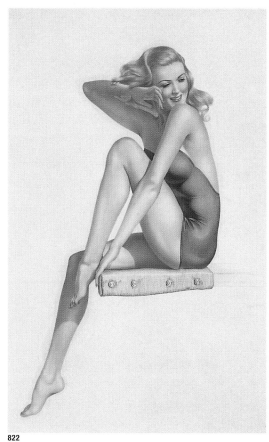

822

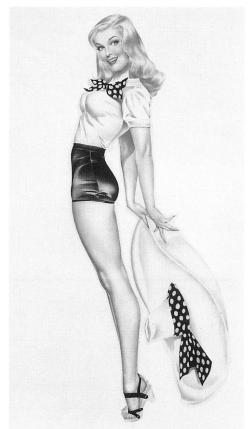

823

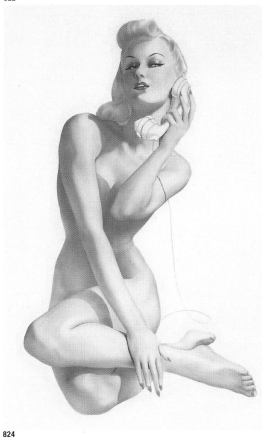

824

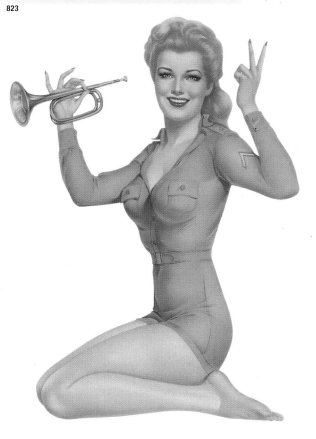

825

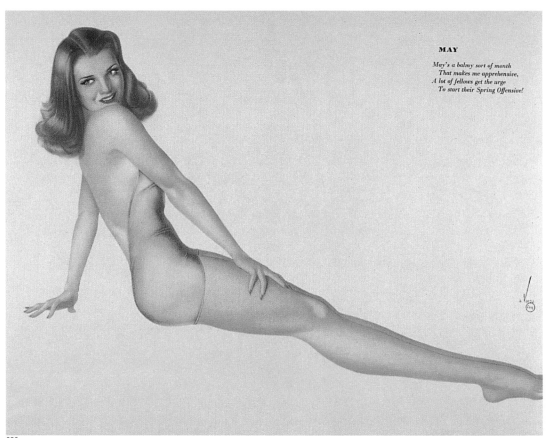

826

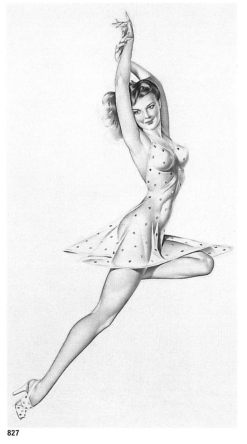

827

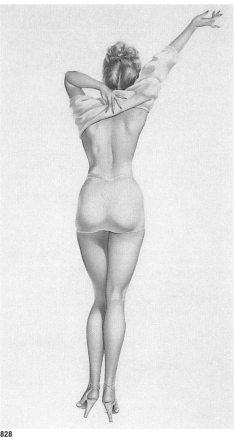

828

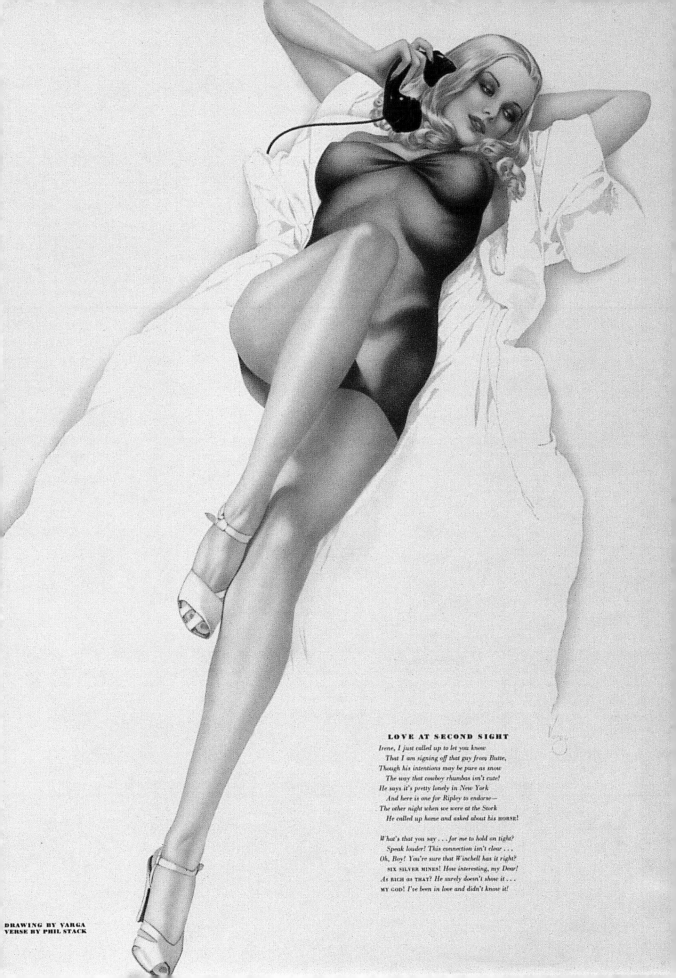

LOVE AT SECOND SIGHT

Irene, I just called up to let you know
That I am signing off that guy from Butte,
Though his intentions may be pure as snow
The way that cowboy rhumbas isn't cute!
He says it's pretty lonely in New York
And here is one for Ripley to endorse—
The other night when we were at the Stork
He called up home and asked about his horse!

What's that you say . . . for me to hold on tight?
Speak louder! This connection isn't clear . . .
Oh, Boy! You're sure that Winchell has it right?
SIX SILVER MINES! How interesting, my Dear!
As rich as THAT? He surely doesn't show it . . .
MY GOD! I've been in love and didn't know it!

DRAWING BY VARGA
VERSE BY PHIL STACK

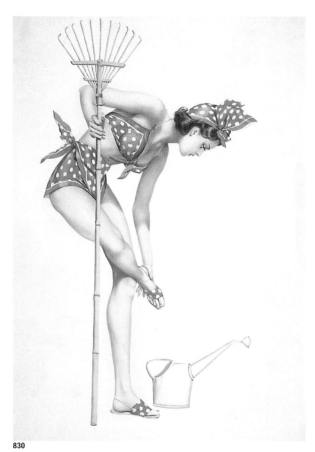

830

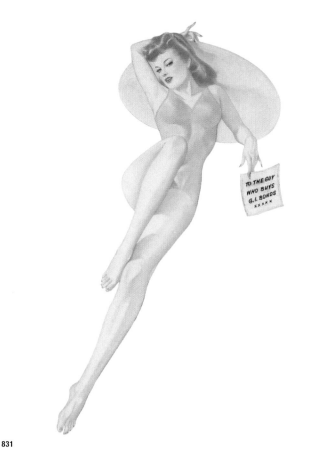

831

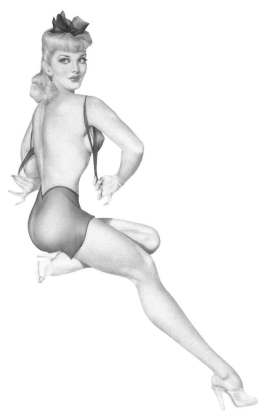

832

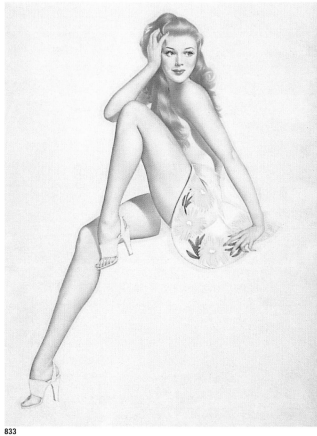

833

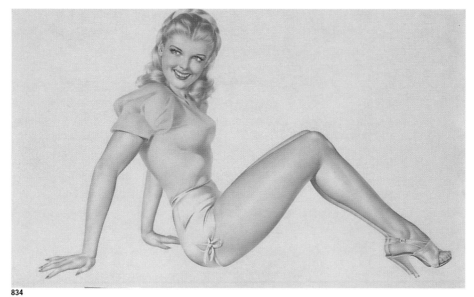

834

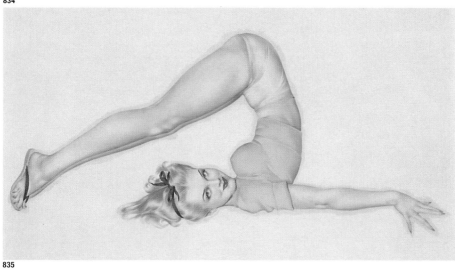

835

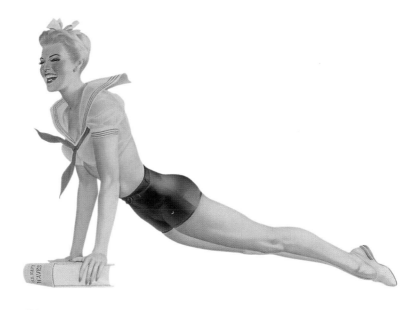

836

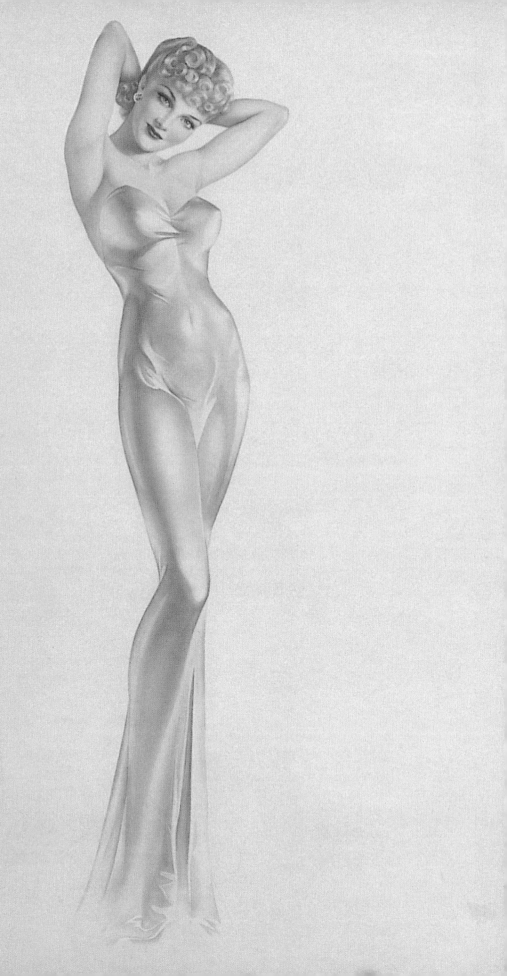

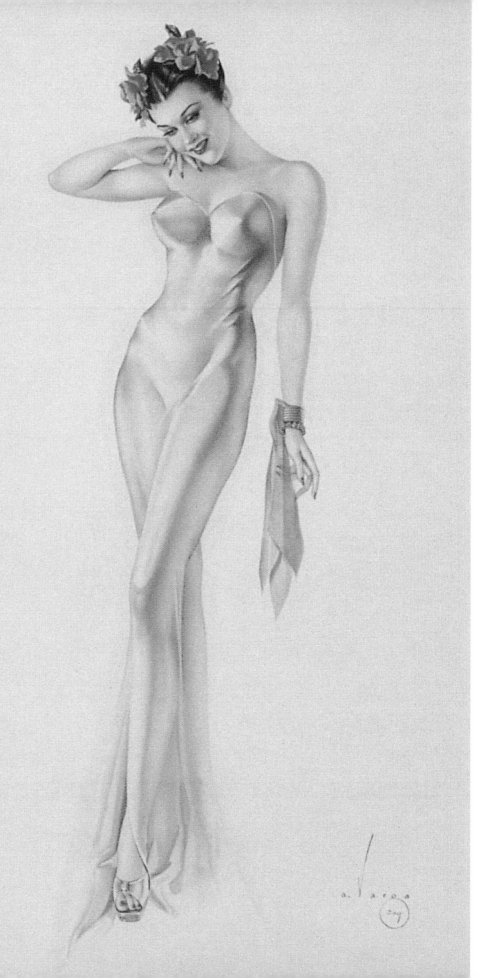

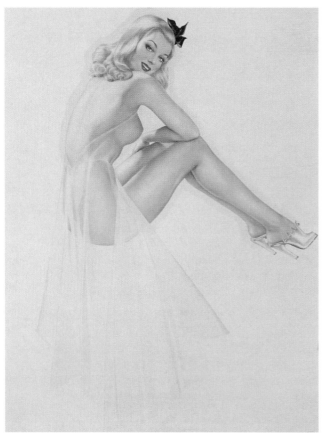

839

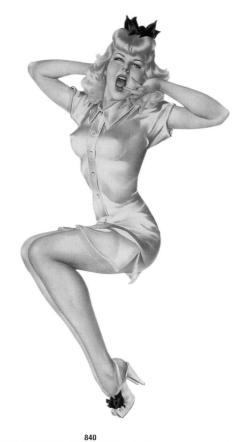

840

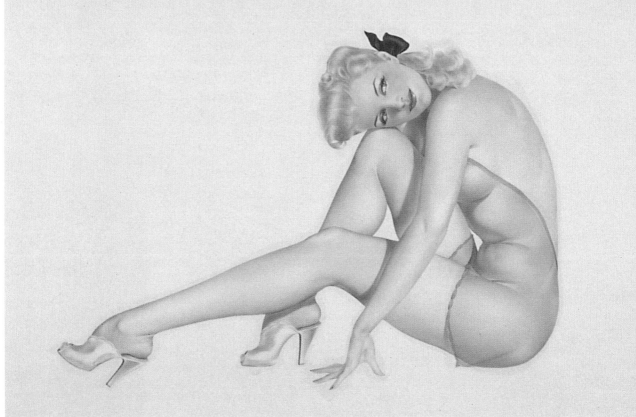

841

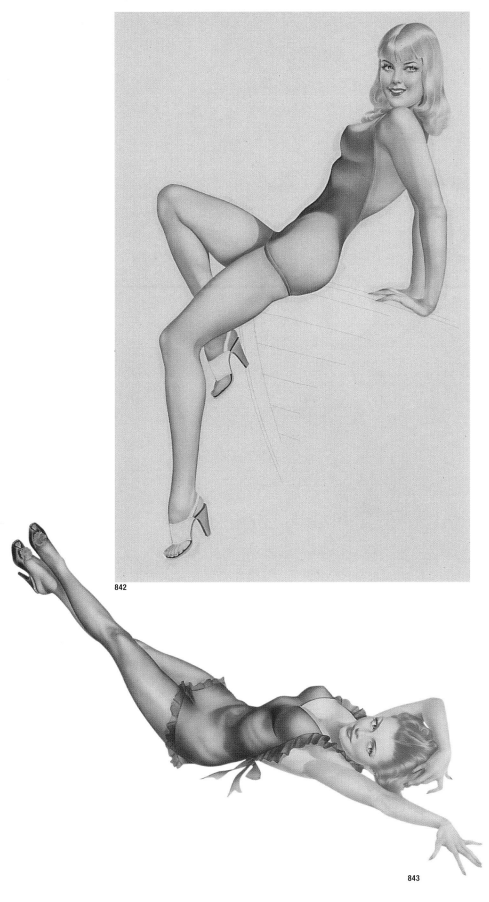

842

843

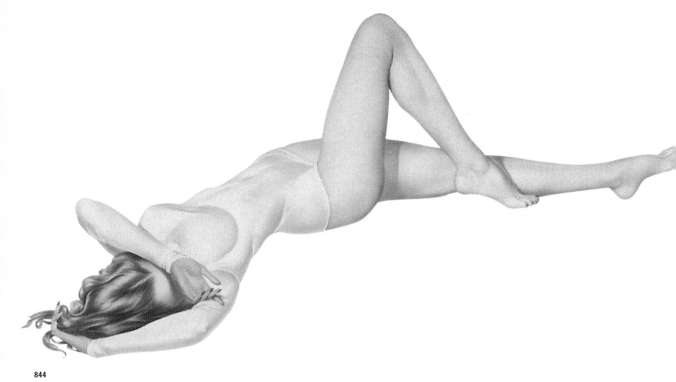

844

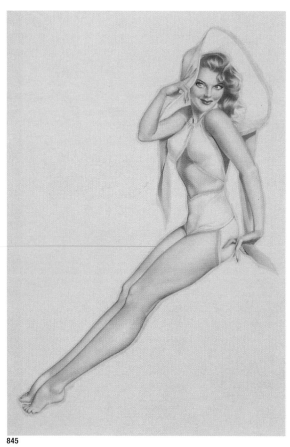

845

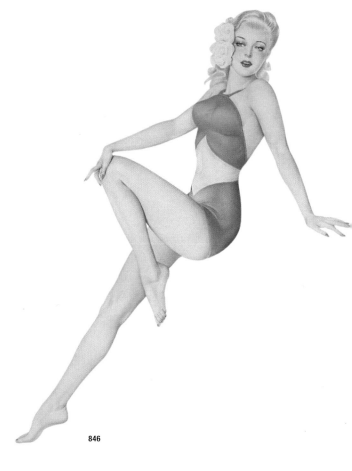

846

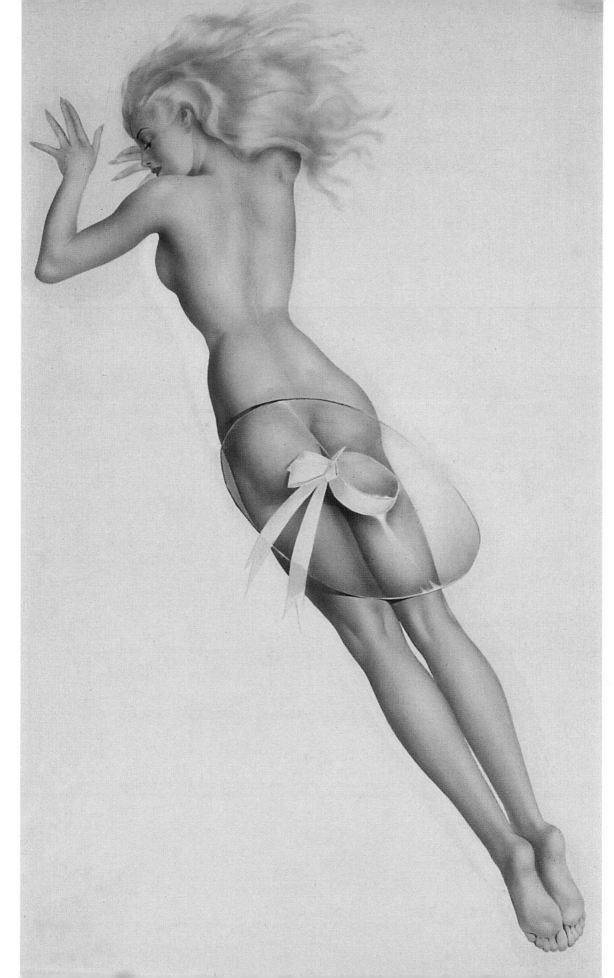

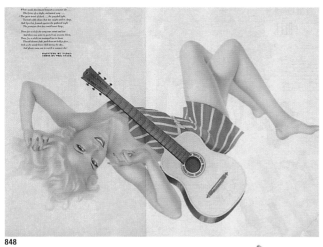

[poem text, illegible]

PAINTING BY VARGA
VERSE BY PHIL STACK

848

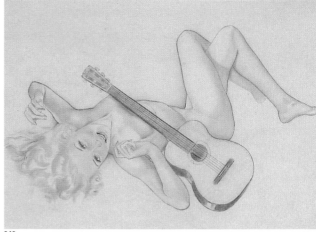

849

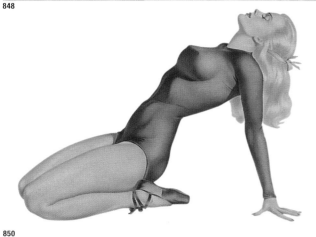

850

[poem text, illegible]

PAINTING BY VARGA
VERSE BY PHIL STACK

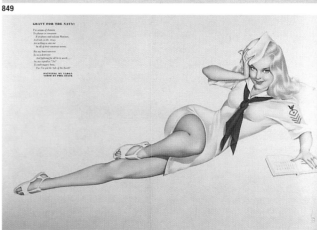

851

THE VARGA GIRL

VACATION REVERIE

It seems so strange to be here all alone,
And yet I dream that you are by my side . . .
I'm really proud, Sweetheart, the way I've grown
To think of all you do with so much pride . . .
You know the way I used to be at first—
All fears because our plans had gone astray,
All tears because a shining bubble burst—
list now I see things clearer ev'ry day;

You're nothing sure that we will hold this line!
And keep the simple things that mean so much . . .
Vacation days . . . love letters in the sand . . . ?
And summer nights when hands and hours run such . . .
And we can watch a misty moon ride high
And laugh beneath our own star-spangled sky!

PAINTING BY VARGA
VERSE BY PHIL STACK

852

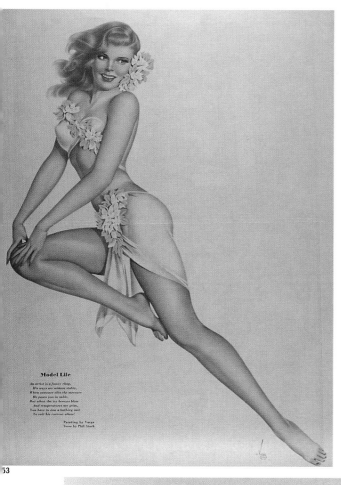

Model Life

*An artist is a funny chap,
His ways are seldom stable,
When summer tilts the mercury
He poses you in sable,
But when the ice becomes blue
And temperatures are grim,
You have to don a bathing suit
To suit his current whim!*

Painting by Varga
Verse by Phil Stack

853

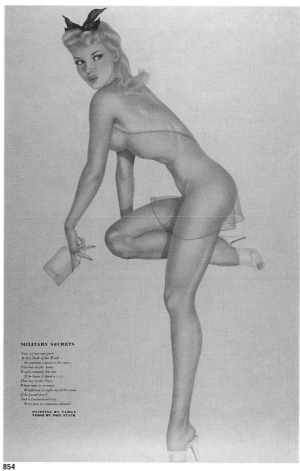

MILITARY SECRETS

*Now, no one can peek
At this Book of the Week—
In wartime's BANN to be copry,
That boy in the Army
Would certainly hire me
If he knew I dared a s. q.
That boy in the Navy
Whose hair is so wavy
Would tear it right out at the roots
If he found that I
And a Leatherneck Guy
Were too in romantic cahoots!*

**PAINTING BY VARGA
VERSE BY PHIL STACK**

854

Christmas Tidings

*It's funny that a simple telegram
Can hold the key to all my happiness,
But that's the way it is—the way I am—
The reason isn't very hard to guess,
For Jim is coming home to me again
And Christmas will be lovely as before,
And all the weary loneliness and pain
Will vanish as he smiles at me once more;*

*I prayed for this, and now that it is here,
I know that I will never let him go,
That we can look to many a happy year
When wreaths are hung and Christmas candles glow;
When laughter and contentment fill our days
And peace on earth is not an idle phrase!*

Painting by Varga
Verse by Phil Stack

855

Fritz Willis

When, in the summer of 1946, *Esquire* announced an important new feature entitled the *Esquire* Gallery of Glamour, the magazine selected Fritz Willis to supply the inaugural illustration. It was his first published pin-up, and it launched a spectacular thirty-year career.

A multifaceted talent, Willis once even acted with Katherine Hepburn, in *Alice Adams*. In the late 1930s and early 1940s, he worked for Warner Brothers as a production-design and publicity artist. At the studio, he developed a friendship with Joe DeMers, who joined him in creating pin-ups for the *Esquire* Gallery.

The year 1950 was a banner one for Willis. Not only did he begin to supply illustrations to the nation's major magazines, he was also inundated with advertising commissions from companies like Max Factor, Sunkist, and Pepsi Cola. Willis painted program covers for the Shipsteads and Johnson Ice Follies from 1952 to 1969 and once accepted a commission for a billboard for the Stardust Hotel and Casino Lounge in Las Vegas. He wrote four classic art-instruction books for the Walter Foster Company that have been in print for more than forty years.

In 1961, Willis received another important commission: Brown and Bigelow asked him to revamp their best-selling Artist's Sketch Pad calendar. He devised a fresh format and design for the calendar and, in the process, created the last of the great pin-up girls. The Willis Girl, though born in an age of rebellion, had the sophisticated air of the classic pin-up.

Willis's work was usually executed in oils on a canvas placed over illustration board; some magazine illustrations and pin-ups of the late 1940s were painted in gouache on board. Most images were about 18 x 24 inches (45.7 x 61 cm), but the major pieces could be larger.

Upon his retirement, Willis and his wife Pat, who was his model as well as his best friend, moved to San Clemente, California. He later developed Parkinson's Disease and died on January 13, 1979.

Als die Zeitschrift Esquire *im Sommer 1946 die Einführung eines wichtigen neuen Features – die* Esquire Gallery of Glamour *– bekanntgab, bat man Fritz Willis um den Startschuß zu dieser Reihe. Sie war die erste Pin-up-Veröffentlichung des Malers und stand am Beginn einer 30 Jahre dauernden beeindruckenden Karriere.*

Willis war ein vielseitig begabter Mann: Er spielte neben Katharine Hepburn eine Rolle in dem exzellenten Film Alice Adams *(1935) nach einem mit dem Pulitzer-Preis ausgezeichneten Roman von Booth Tarkington. In den späten 30er und frühen 40er Jahren arbeitete er für die Filmfirma Warner Brothers im Bereich Produktionsdesign und Pressearbeit. Dort schloß er mit Joe DeMers Freundschaft, der*

dann ebenfalls begann, für die Galerie von Esquire Pin-ups *zu malen.*

Das Jahr 1950 war das Jahr von Fritz Willis. Er belieferte die wichtigsten Zeitschriften des Landes mit Illustrationen und wurde mit Anzeigenaufträgen von Kunden wie dem Kosmetikkonzern Max Faktor und den Getränkeherstellern Sunkist und Pepsi Cola förmlich überschwemmt. Zwischen 1952 und 1969 gestaltete Willis Programmcover für die Shipsteads und Johnson „Ice Follies Revue" und nahm einen Auftrag des Stardust Hotel and Casino Lounge in Las Vegas an; für diesen Glücksspielpalast entwarf er ein Billboard, eine großformatige Reklametafel. Gleichzeitig schrieb er vier Handbücher über Malerei, die in den USA bei der Walte-

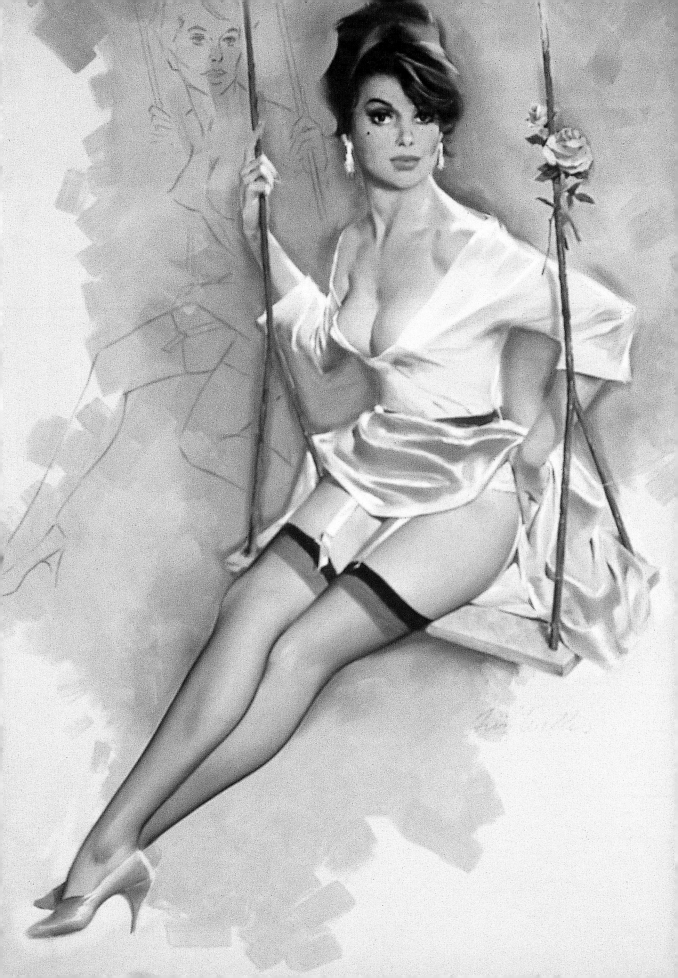

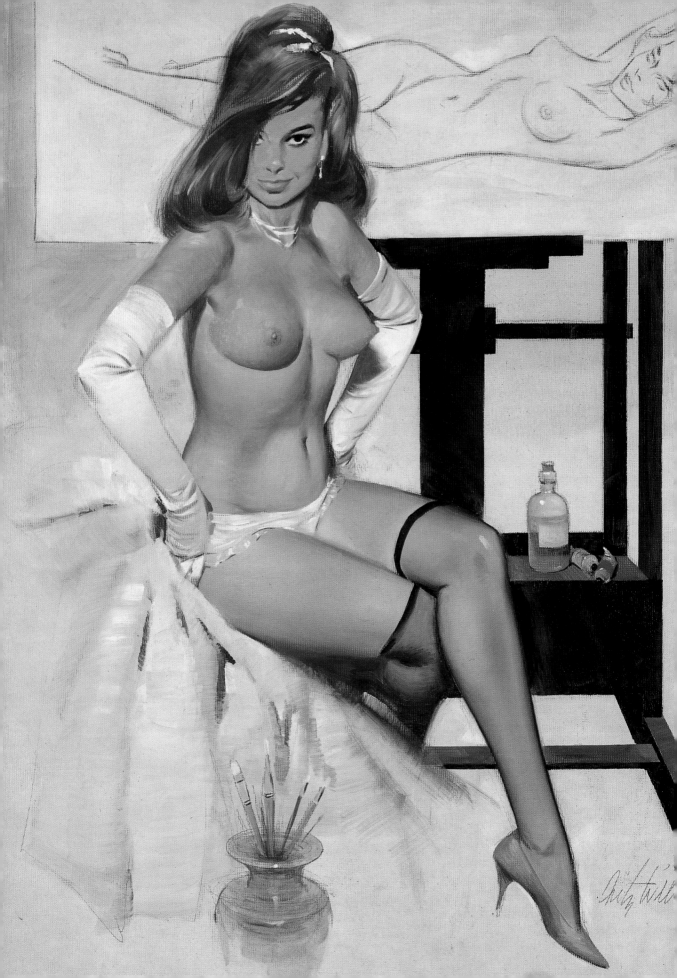

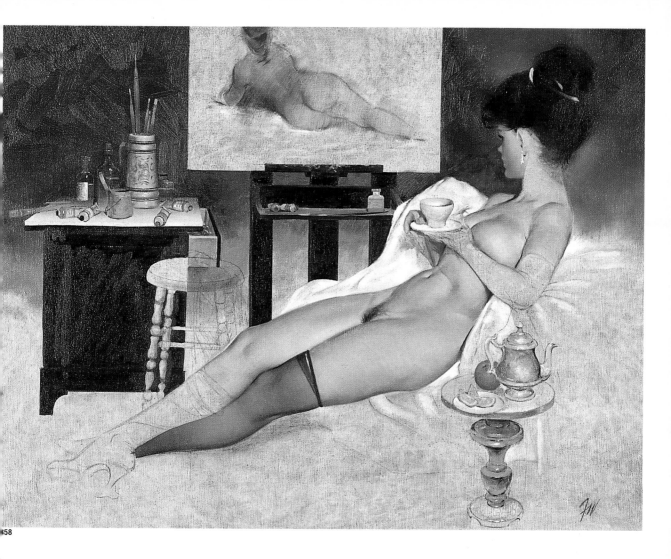

458

Foster Company erschienen. Mittlerweile sind sie zu Standardwerken geworden, die seit 40 Jahren aufgelegt werden.

1961 erhielt Willis einen weiteren wichtigen Auftrag: Der Verlag Brown and Bigelow wollte seinen Verkaufsschlager, den „Artist's Sketch Pad" „verjüngen" und in neuer Gestaltung wieder auf den Markt bringen. Das von Willis entwickelte Design wirkte neu und ungewöhnlich und bei der Arbeit an diesem Kalender schuf er das letzte in der Reihe der bedeutenden Pin-up-Girls. Sein Willis Girl entstammte war einer rebellischen Ära, besaß jedoch trotzdem die subtile Raffinesse seiner großen Vorgängerinnen, der klassischen Pin-up-Girls.

Im été 1946, *Esquire* annonça le lancement d'une nouvelle série de pin up dans le magazine, intitulée «Gallery of Glamour». Fritz Willis fut choisi pour réaliser la première illustration. C'était sa première pin up à être publiée et elle devait marquer le début d'une spectaculaire carrière de trente ans.

Talent à multiples facettes, Willis avait même donné la réplique à Katherine Hepburn dans *Alice Adams*. A la fin des années 30 et au début des années 40, il avait travaillé pour Warner Brothers comme décorateur et illustrateur publicitaire. Au cours de cette période, il avait fait la connaissance de Joe DeMers, qui devait le rejoindre plus tard pour réaliser des pin up pour la Gallery d'*Esquire*.

1950 fut une année excellente pour Willis. Non seulement il commença à fournir des illustrations pour les principaux magazines du pays, mais il fut également inondé de commandes publicitaires pour des annonceurs tels que Max Factor, Sunkist et Pepsi Cola. Il peignit la couverture du programme des revues Shipsteads and Johnson Ice Follies de 1952 à 1969 et accepta même une commande de panneaux publicitaires pour le Stardust Hotel et le Casino Lounge de Las

Meistens arbeitete Willis in Öl auf Leinwand, die auf Zeichenkarton aufgezogen war. Einige Illustrationsarbeiten für Zeitschriften und Pin-ups der späten 40er Jahre waren auch in Gouache auf Karton ausgeführt. Das gängige Arbeitsformat lag bei 46 cm x 61 cm; bedeutendere Aufträge waren jedoch auch in größerem Format gefertigt.

Nach seinem Ausscheiden aus dem Arbeitsleben zog Willis mit seiner Frau Pat, die ihm Modell und engste Vertraute in einem war, nach San Clemente in Kalifornien. Später litt Willis an der Parkinsonschen Krankheit. Er verstarb am 13. Januar 1979.

Vegas. Il écrivit également pour l'éditeur Walter Foster un manuel de dessin et de peinture devenu aujourd'hui un classique.

En 1961, Willis reçut une autre commande importante: Brown and Bigelow lui demanda de moderniser leur collection à succès, Artist's Sketch Pad. Il modifia son format, lui donna un nouveau look et, dans la foulée, créa les dernières grandes pin up. Les Willis Girls, bien que nées à un âge de rébellion, conservaient l'air sophistiqué des pin up classiques.

Willis travaillait généralement à l'huile sur des cartons à dessin entoilés. Certaines de ses images et pin up de la fin des années 40 furent peintes à la gouache directement sur carton. La plupart des originaux mesuraient environ 45,7 x 61 cm, mais certaines œuvres étaient plus grandes.

A la retraite, Willis et sa femme Pat, son modèle préféré et sa meilleure amie, s'établirent à San Clemente, en Californie. Il fut plus tard atteint de la maladie de Parkinson et mourut le 13 janvier 1979.

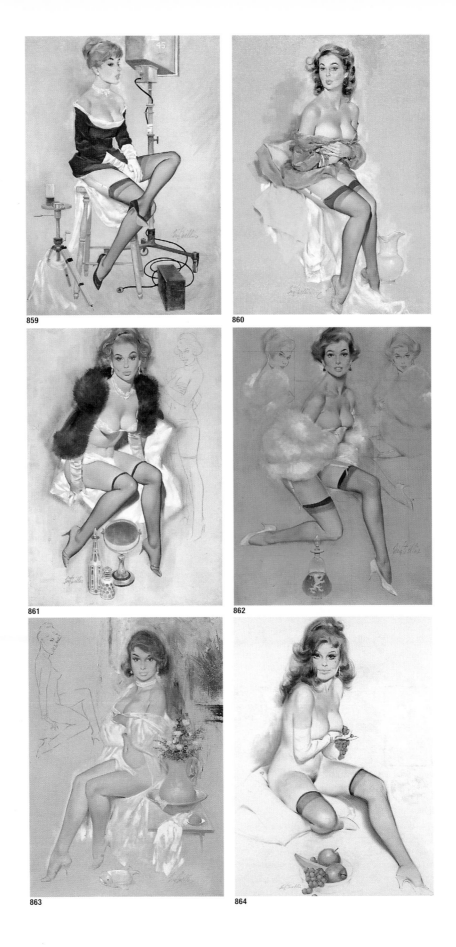

859

860

861

862

863

864

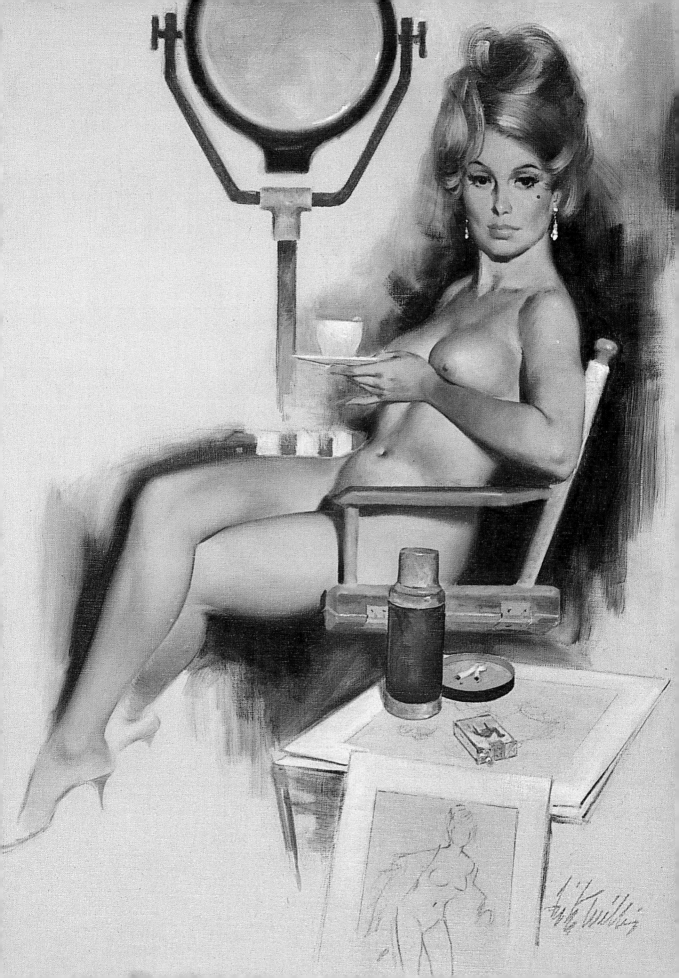

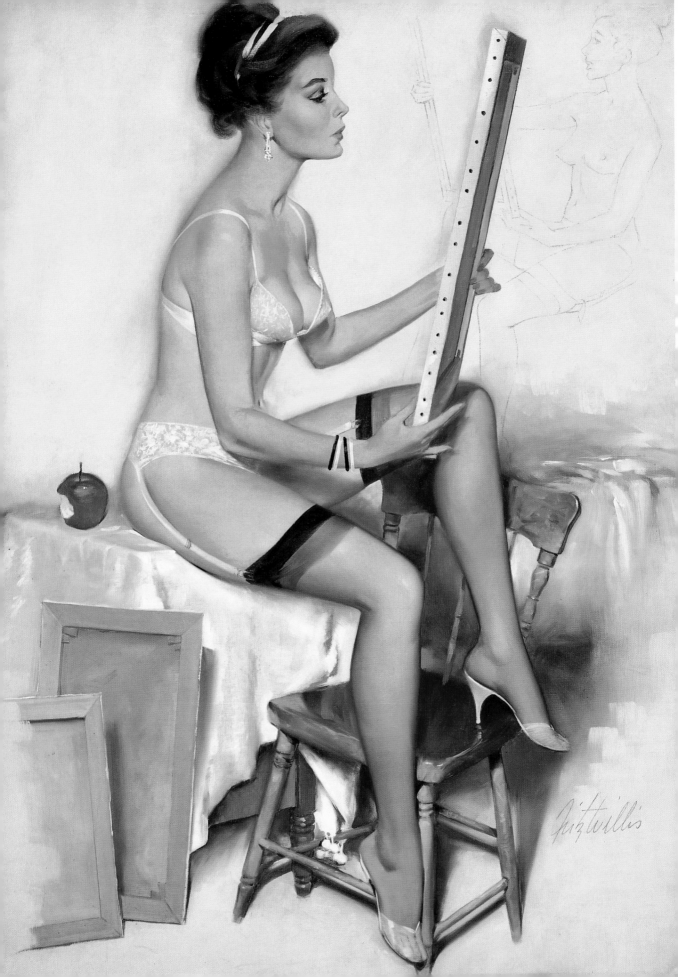

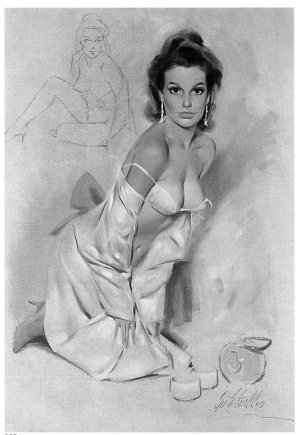

867

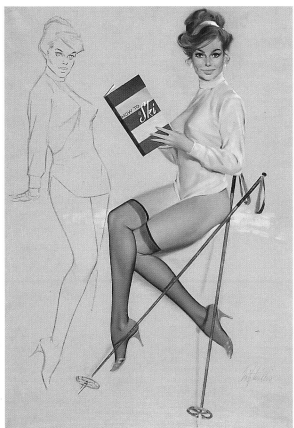

868

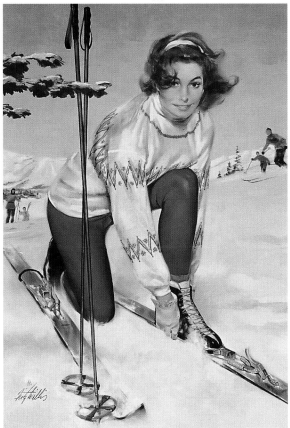

869

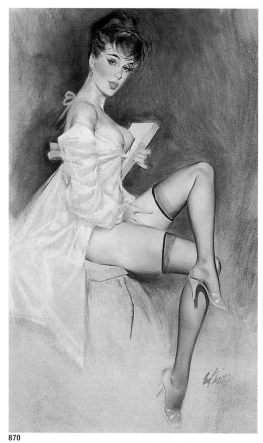

870

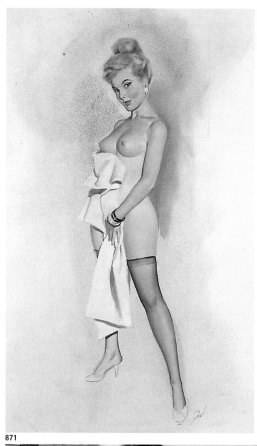

871

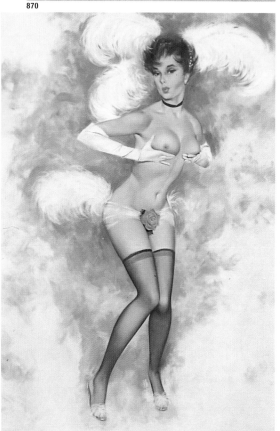

872

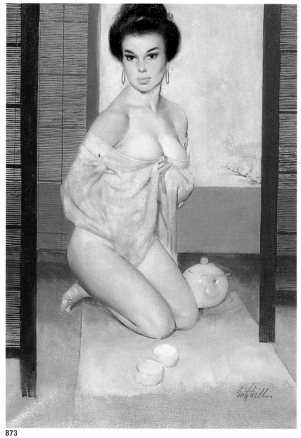

873

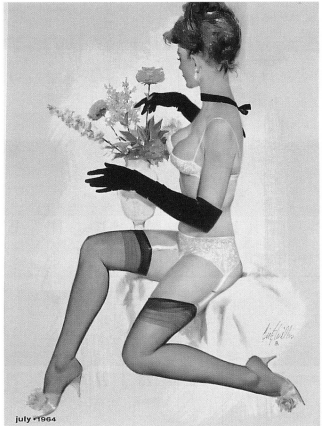

july •1964

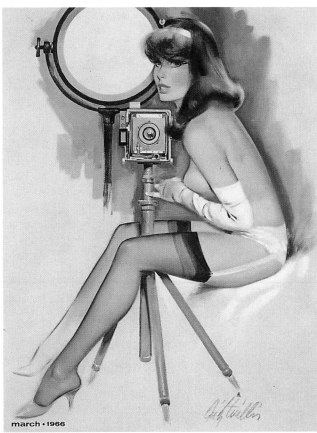

march •1966

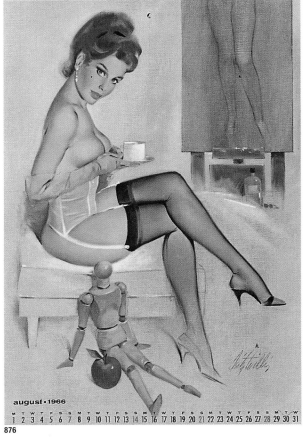

august •1966

M	T	W	T	F	S	S	M	T	W	T	F	S	S	M	T	W	T	F	S	S	M	T	W	T	F	S	S	M	T	W
1	2	3	4	5	6	7	8	9	10	11	12	13	14	15	16	17	18	19	20	21	22	23	24	25	26	27	28	29	30	31

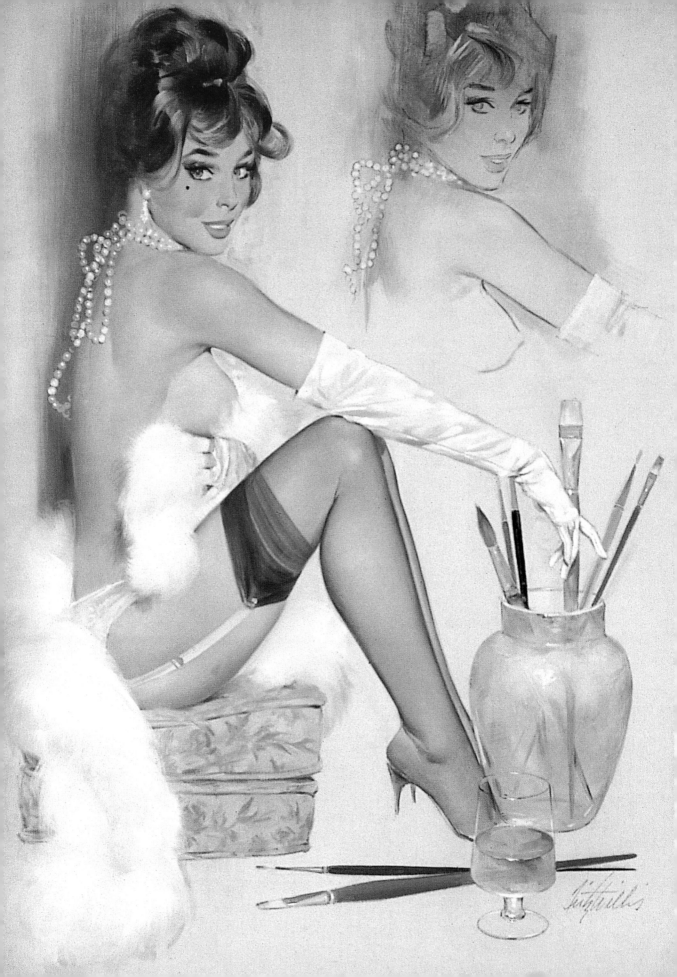

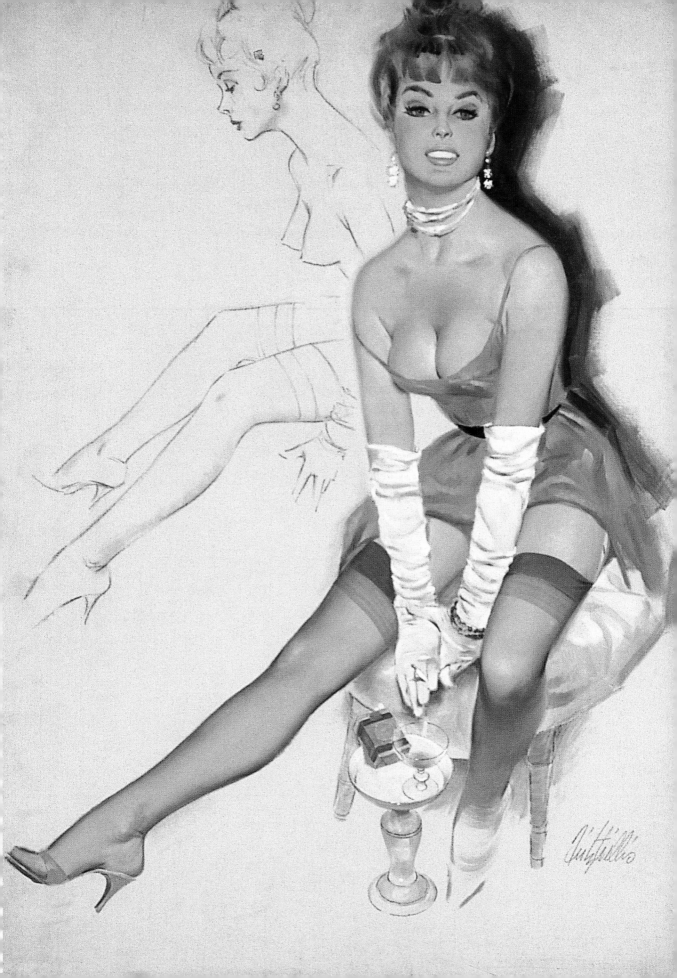

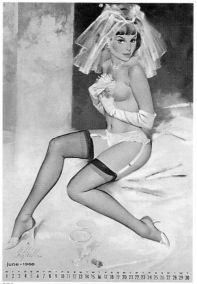

879

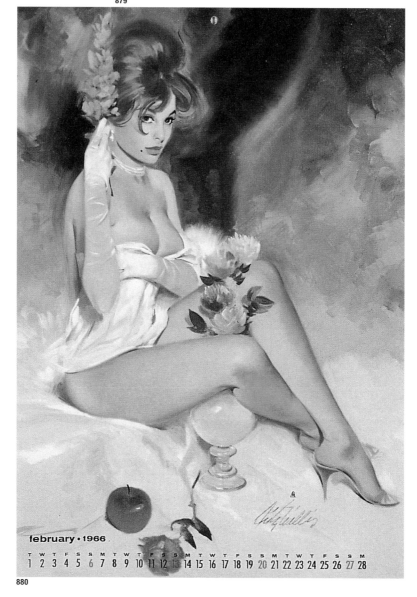

880

881 ▷
882 | 883 ▷▷

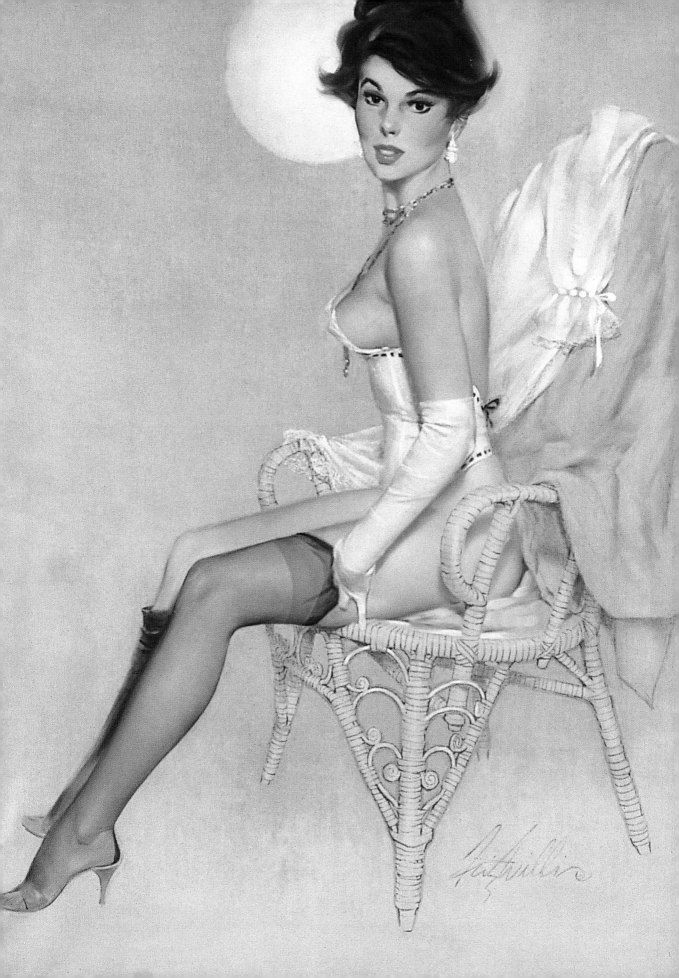

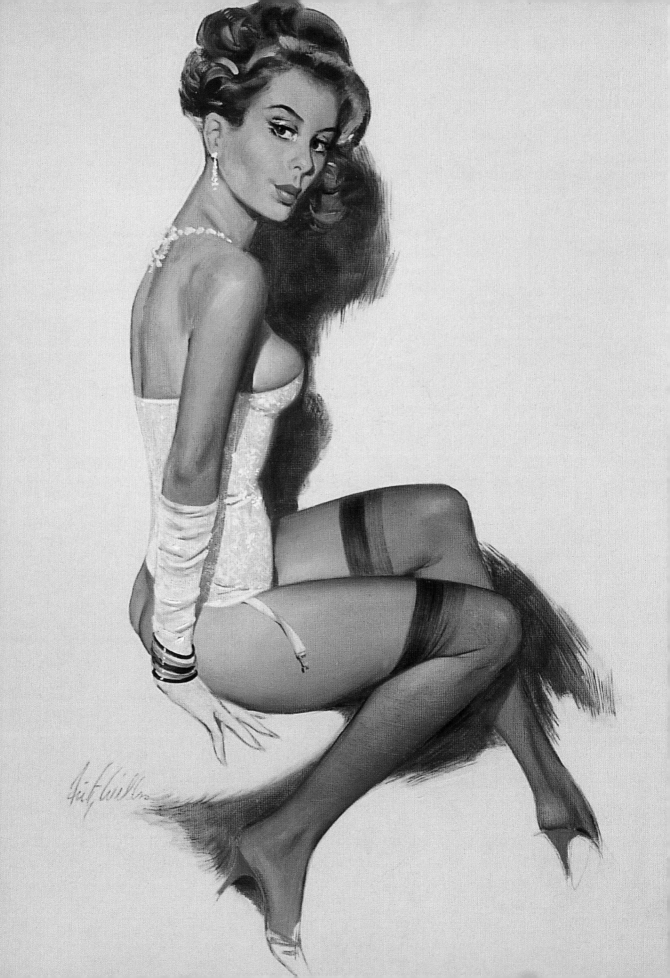

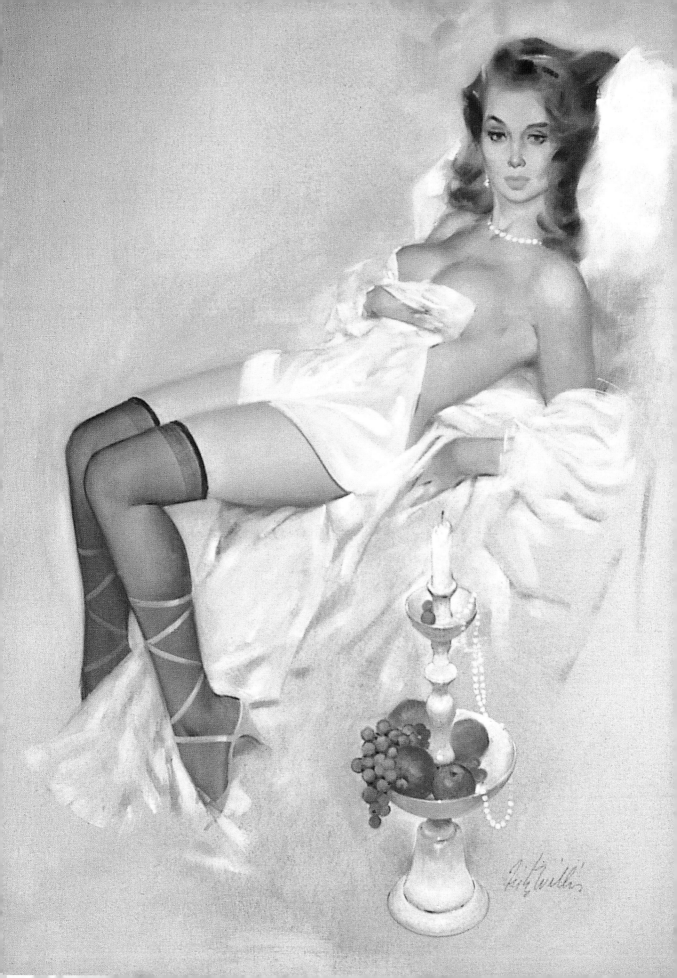

Ted Withers

When Withers began painting pin-ups for Brown and Bigelow in 1950, he had already spent twenty-five years working in the Hollywood film industry. He was ready for a change, and so was the calendar company, which assigned him the honor of painting the Artist's Sketch Pad calendar for the 1954 market. Withers's first twelve dreamy pin-ups would be followed by years more, until the calendar passed on to Fritz Willis in 1961.

Edward Withers was born in Wellington, New Zealand. After studying at Wellington College, he enrolled at the Royal Academy in London and later at the South Kensington School of Art and the Slade School of Art. Eager for more training, Withers moved to Paris and the prestigious Académie Julian. During World War I, he saw service in Samoa, Egypt, France, and Germany and received three decorations.

In 1924, Withers came to America with his wife and two children. In his Hollywood years, he did a number of celebrity portraits while employed in a series of jobs, including art director at MGM Studios, supervisor in the trick and miniature department at Universal Studios, art director for Earnshaw-Young Advertising

Agency, and art director for the Sterling Press Lithograph Company. He also paint ed fine-art works for his own enjoyment, and his award-winning landscapes were widely exhibited.

In November 1950, at his first Brown and Bigelow cocktail party, Withers was talking with Norman Rockwell when Rolf Armstrong and Gil Elvgren arrived. These two pin-up greats were introduced to Withers, who was bowled over when Armstrong praised him as "one of America's greatest, most versatile painters" and Elvgren, who had a keen interest in photography, added "one of the best photographers in the country."

Withers had an analytical mind, a great personality, and a superb sense of humor – not to mention the technical skills of a Da Vinci. In a letter to Brown and Bigelow, he once described the view from his Hollywood apartment in this way, "A night I look out on a carpet of jewels composed of neon and street lights, and her I work and am grateful that way over the eastern horizon, you nice people multipl my effort and enable me to live very well indeed." He passed away in Los Angele: in early 1964.

Als Withers 1950 mit Pin-up-Arbeiten für Brown and Bigelow begann, war er bereits seit 25 Jahren in der Filmindustrie Hollywoods tätig. Er war bereit für eine neue berufliche Herausforderung – ebenso sein neuer Auftraggeber, der ihn mit dem Auftrag für den Artist's-Sketch-Pad-Kalender für das Jahr 1954 ehrte. Die zwölf verträumten Pin-ups, die Willis für diesen Kalender zeichnete, waren die ersten in einer ganzen Serie. Erst 1962 wurde der Kalenderauftrag wiederum neu vergeben, diesmal an Fritz Willis.

Edward Withers wurde im neuseeländischen Wellington geboren. Nach einem Studium am Wellington College schrieb er sich an der Londoner Royal Academy

ein und setzte später seine Studien an der South Kensington School of Art und d Slade School of Art, beide ebenfalls in London, fort. Danach zog Withers nach Paris und studierte an der renommierten Académie Julian. Bei Einsätzen auf Samoa, in Ägypten, Frankreich und Deutschland erlebte er den Ersten Weltkrieg hautnah und wurde mit drei Orden ausgezeichnet.

Zusammen mit seiner Frau und zwei Kindern kam Withers im Jahr 1924 nach Amerika. Während seiner Zeit in Hollywood erhielt er eine Reihe von Starporträt- kommissionen und arbeitete gleichzeitig noch in verschiedenen Jobs. Er war Art Director bei den M-G-M Studios, Chef in der Trick- und Miniaturabteilung bei Un-

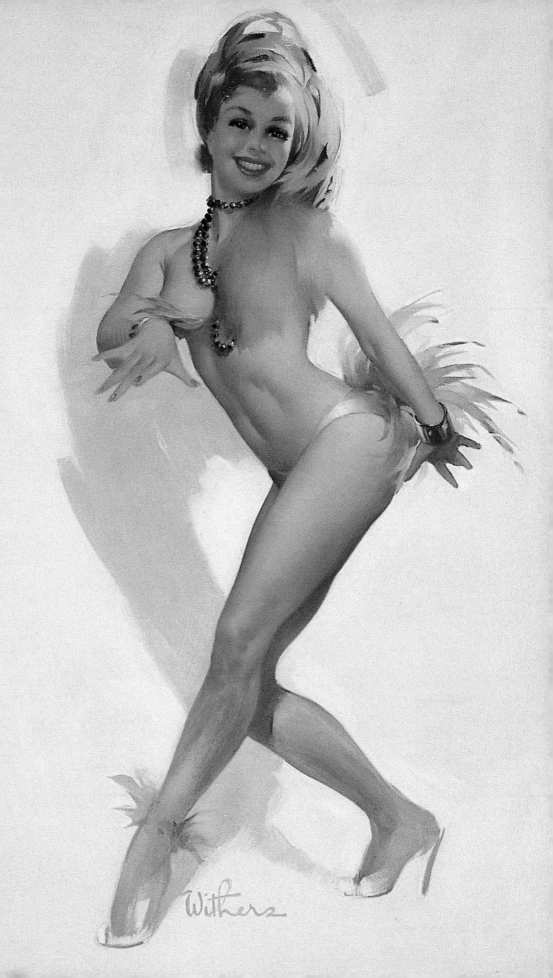

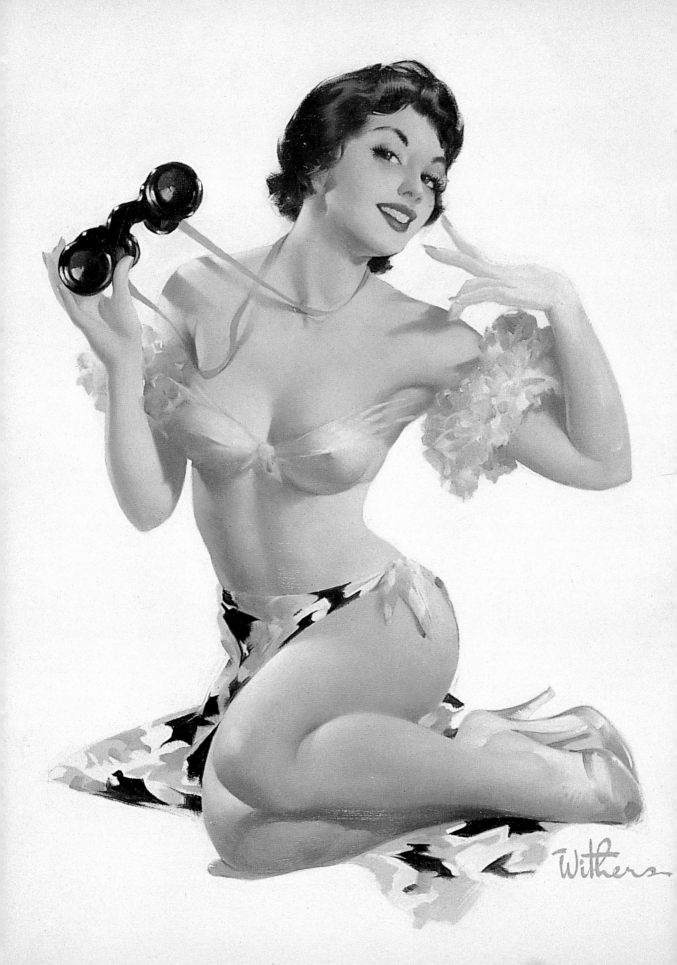

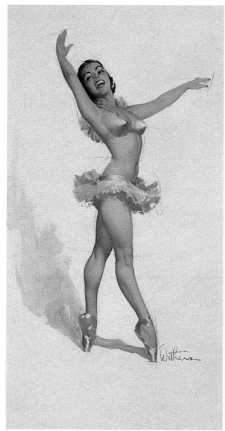

886

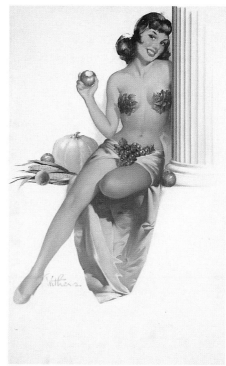

887

versal Studios, Art Director bei der Werbeagentur Earnshaw-Young und Art Director bei der Lithoanstalt Sterling Press. Zu seinem eigenen Vergnügen malte er „schöne Kunst"; seine mehrfach ausgezeichneten Landschaftsszenen wurden in vielen Ausstellungen gezeigt.

Während seiner ersten Cocktailparty bei Brown and Bigelow im November 1950 befand sich Withers gerade in einem Gespräch mit Norman Rockwell, als Rolf Armstrong und Gil Elvgren eintrafen. Diese zwei Großen des Pin-ups wurden Withers vorgestellt. Der war sprachlos, als ihn Armstrong als „einen der wichtigsten und wandlungsfähigsten Maler in den USA" bezeichnete und Elvgren, der sich selbst sehr für Fotografie interessierte, ihn „für einen der besten Fotografen

im Land" befand. Withers dachte analytisch, besaß viel Humor und war eine allseits beliebte Persönlichkeit – und verfügte über technische Fertigkeiten, die einem Leonardo da Vinci zur Ehre gereicht hätten. In einem Brief an Brown and Bigelow beschrieb er einmal den Blick aus seinem Hollywoodapartment wie folgt: „Nachts blicke ich auf einen Teppich aus Juwelen gewirkt aus Neon und Straßenlaternen. Hier arbeite ich und bin dankbar, daß Eure Truppe weit entfernt am östlichen Horizont meine Anstrengungen unterstützt und verstärkt und es mir ermöglicht, ein fürwahr angenehmes Leben zu führen." Withers verstarb Anfang 1964 in Los Angeles.

Avant de peindre des pin up pour Brown and Bigelow, Withers avait travaillé pendant vingt-cinq ans pour l'industrie cinématographique d'Hollywood. Il était donc prêt pour un changement, tout comme l'éditeur de calendriers qui lui confia la réalisation de l'Artist Sketch Pad de 1954. Ses douze premières pin up rêveuses furent suivies de nombreuses autres au fil des ans, jusqu'à ce que le calendrier passe entre les mains de Fritz Willis en 1961.

Edward Withers venait de Wellington, en Nouvelle-Zélande. Après des études à l'université de Wellington, il se rendit à Londres où il fréquenta la Royal Academy puis la South Kensington School of Art et la Slade School of Art. Toujours pas satisfait, il enchaîna avec la prestigieuse Académie Julian de Paris. Pendant la Première Guerre mondiale, il servit à Samoa, en Egypte, en France, en Allemagne et reçut trois décorations.

En 1924, Withers émigra aux Etats-Unis avec sa femme et leurs deux enfants. Lors de son séjour prolongé à Hollywood, il réalisa des portraits de vedettes tout en occupant une série de postes, dont celui de directeur artistique aux studios M.G.M., de responsable des trucages et des maquettes aux studios Universal, de directeur artistique de l'agence publicitaire Earnshaw-Young et de directeur

artistique de la Sterling Press Lithograph Company. Pour son propre plaisir, il peignait également des paysages qui étaient souvent exposés et primés.

En novembre 1950, lors de son premier cocktail chez Brown and Bigelow, Withers discutait avec Norman Rockwell lorsque Rolf Armstrong et Gil Elvgren firent leur apparition. Ces deux maîtres de la pin up lui furent présentés et Withers faillit tomber à la renverse en entendant Armstrong le louer comme «l'un des grands peintres américains et l'un des plus pluridisciplinaires», ce à quoi Elvgren, amateur de photographie, ajouta: «… et l'un de nos meilleurs photographes».

Personnage très sympathique, Withers avait un esprit analytique et un grand sens de l'humour, sans parler d'une maîtrise technique digne de Léonard de Vinci. Dans une lettre à Brown and Bigelow, il décrivit un jour la vue depuis son appartement d'Hollywood de la manière suivante: «La nuit, un tapis de joyaux composés de néons et de réverbères s'étend sous ma fenêtre. C'est là que je travaille en me réjouissant de ce que vous autres, charmantes gens qui habitez à l'est de l'autre côté de la ligne d'horizon, multipliez mes efforts et me permettiez de vivre … fort bien ma foi.» Il mourut à Los Angeles au début de 1964.

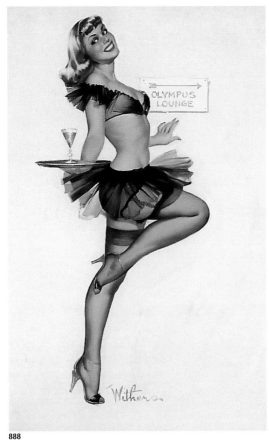

888

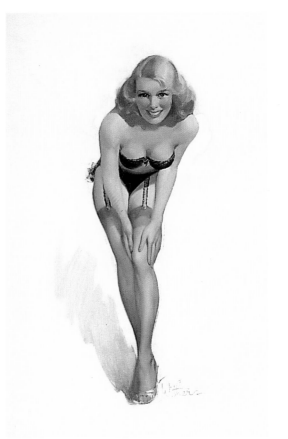

889

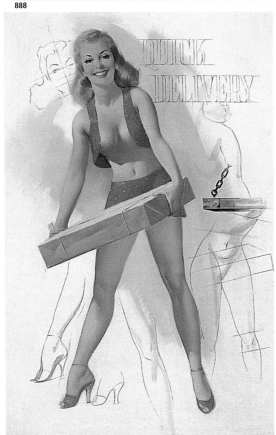

890

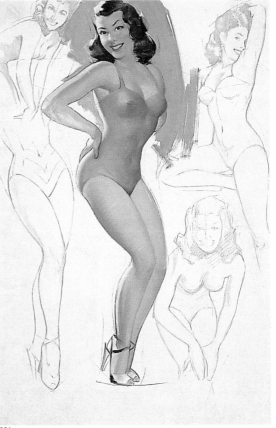

891

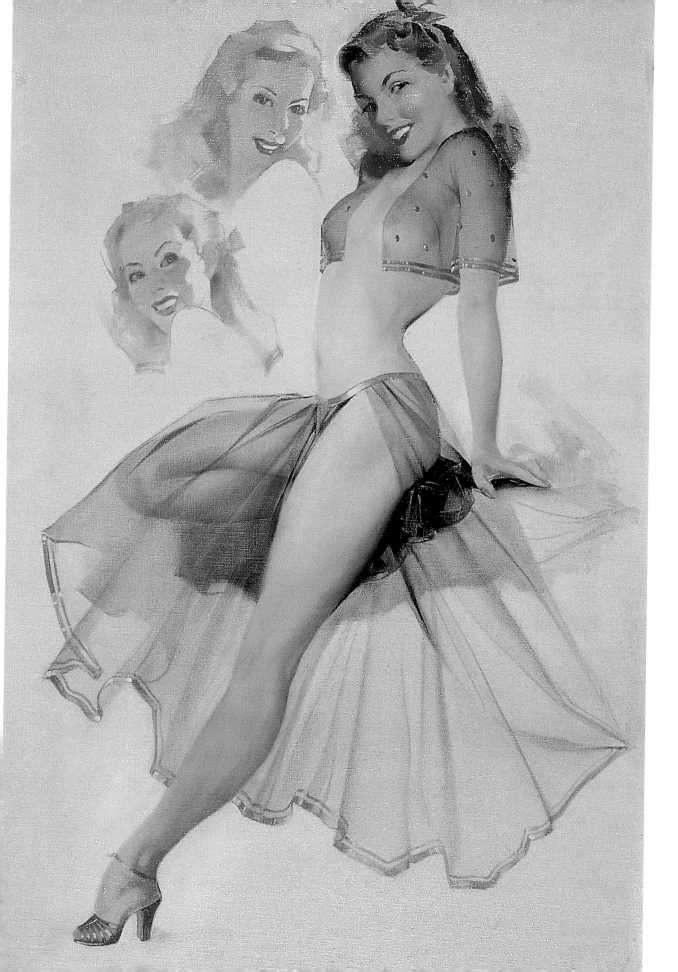

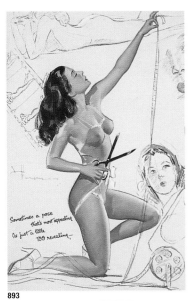

893

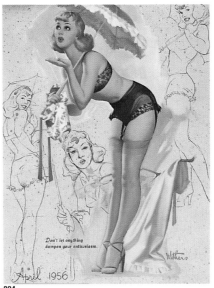

894

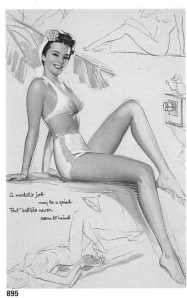

895

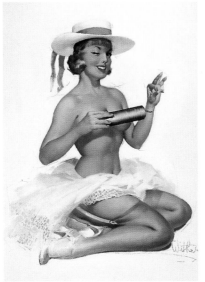

896

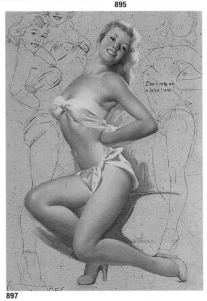

897

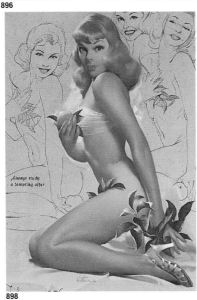

898

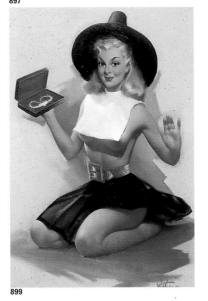

899

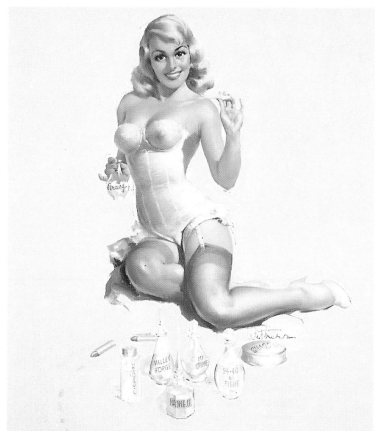

900

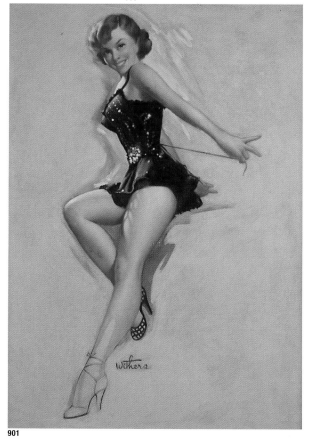

901

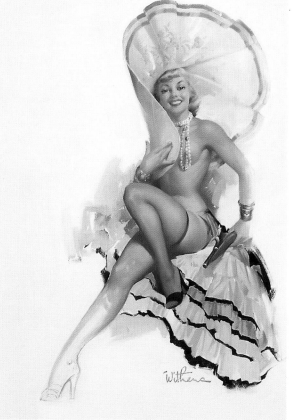

902

Index of Artists
Index der Künstler
Index des artistes

Acknowledgements

Our acknowledgments to those who have helped make this volume possible must begin with the mention of our dear friend Art (the King) Amsie. A longtime friend of Gil Elvgren and Fritz Willis, Art was for many years the only person to champion pin-up artists. He collected, documented, and preserved their works and managed to communicate to the small group of people who held the original artwork that there was value in ferreting out and saving such art. He is the single most important link to the past in this field. We thank him for making his archives, collections, and documents available to us over the past twenty years.

It would have been impossible to have a book as extensive and all-encompassing without the wholehearted support of the owners and staff of Brown and Bigelow, clearly the greatest calendar-publishing company ever. Without exception, all of the finest, most significant pin-up calendars and spin-offs were the domain of Brown and Bigelow from the turn of the century until about 1970, when the Golden Age of pin-ups ended. William Smith, Sr., and William Smith, Jr., gave us their enthusiastic support and the rare opportunity of spending days in their archives. At their headquarters in St. Paul, Minnesota, with temperatures of thirty below zero outside, we spent hour after hour with Linda Sue Johnson, Licensing Director, and Teresa Roussin, Licensing Coordinator, going through fifty years of images and other printed materials. Linda Sue and Teresa provided us with a great deal of invaluable information, some of which appears herein and some which will enhance future monographs. Then, Brown and Bigelow photographer Brad Knefelkamp shot more than three hundred printed works for possible use in this book.

An equal debt and thanks must be acknowledged to the staff at Esquire magazine, a division of Hearst Publications. David Graff, Vice President and Director of Brand Development, Lisa Kreger, Associate Licensing Manager, and Tom Robotham made it possible for us to include Alberto Vargas in the book along with all the other artists whose works appeared in Esquire, the singularly most important publication in the field of pin-up and glamour art.

LeRoy Darwin reminded us of the people in Ray Bradbury's Fahrenheit 451 who assumed the role of "talking books" to keep the classics alive in an age of book-burning. Over many years, he focused on one or two artists and amassed verbal and visual histories, while waiting for the day when someone would be able to record it all in print. Like Art Amsie, LeRoy has preserved a great deal of pin-up history, with particular interest in Earl Moran and Rolf Armstrong. He, too, generously opened his trove to us.

Other guardians of these artists' legacy include Drake Elvgren, son of the greatest of the pin-up painters, who shared personal memories and documents. Tom Skemp, San Crandall, and the Driben family, including Adrienne, Leo, and Aaron, all did the same. Zoë Mozert's brother Bruce sent a videotape showing fifty of her original paintings, and Joyce Ballantyne spoke to us about herself, Al Buell, and others.

Marianne Phillips is the "talking book" on Zoë Mozert as well as a font of information on Joyce Ballantyne and many of the other artists.

Ronald Feldman was our entrée to the George Petty Estate.

The collectors who supplied photographs of their paintings include Clarke and Janice Smith, who are among the earliest pioneering collectors of this art and whose collection is the source of much information and imagery herein. We also thank Stuart David Schiff and Barry M. Shaw for the photographs they provided.

The collection of Ray and Harriet Warkel is one of the finest, and their contribution to our efforts has been massive. In Paris, our friend Pierre Boogaertz, the only European dealer in illustration art, has been another great help. We must also thank collector and pin-up authority Max Allan Collins for his knowledge and contributions to the book.

And a special thanks to Walt Reed. Author, illustrator, historian, and founder of Illustration House, Walt is also a dealer and auctioneer with a wide-ranging collection of illustration art. We are grateful for his help0 a0nd for his lively, thoughtful overview of pin-up history.

Our gratitude also goes to staff members at the Louis K. Meisel Gallery who have aided in the preparation and publication of this book: Diane Sena, Louis's first line of research and text-editing assistant, without whom he would never get the first word on paper in any intelligible way, and Aaron Miller, researcher and traveling photographer, who along with Steven Lopez has photographed almost all of the artwork in this volume.

In addition, thanks go to Dirk Luykx and Gilda Hannah for their fine design work. We are also grateful to Margaret Donovan, Louis's editor for fifteen years and five books, for her contributions to the book. At Taschen, we thank Burkhardt Riemschneider, the project editor who brought the book to the firm; Mark Thomson, who coordinated the project; and finally Benedikt Taschen himself, who is unaffected by public opinion and prejudice and who publishes what he likes, with no holds barred.

Danksagung

Bei unserem Dank an alle diejenigen, die dieses Buch überhaupt erst ermöglicht haben, müssen wir an erster Stelle den Namen unseres Freundes Art („the King") Amsie nennen. Art war viele Jahre lang mit Gil Elvgren und Fritz Willis befreundet und lange Zeit der einzige, der sich für Pin-up-Künstler einsetzte. Er sammelte, dokumentierte und bewahrte ihre Arbeiten, und es gelang ihm, die kleine Gruppe der Besitzer von Originalen dieser Kunst davon zu überzeugen, daß es sich lohne, diese Kunstwerke aufzuspüren und zu retten. Auf diesem Gebiet stellte er die weitaus wichtigste Verbindung zur Vergangenheit dar. Wir danken ihm dafür, daß er uns im Laufe der letzten 20 Jahre sein Archiv, seine Sammlungen und seine Dokumente zur Verfügung gestellt hat.

Ein so umfangreiches und umfassendes Buch wäre gar nicht denkbar gewesen ohne die rückhaltlose Unterstützung der Inhaber und Mitarbeiter von Brown and Bigelow, zweifellos der größte und beste Kalenderverlag aller Zeiten. Die schönsten und besten Pin-up-Kalender und -Nebenprodukte waren alle ohne Ausnahme die Domäne von Brown and Bigelow, und zwar von der Jahrhundertwende bis etwa 1970, dem Ende des „goldenen Zeitalters" der Pin-ups. William Smith, Sr., und William Smith, Jr., haben unser Vorhaben mit Begeisterung unterstützt und uns die seltene Gelegenheit verschafft, ganze Tage in ihrem Archiv zu verbringen. In ihrer Zentrale in St. Paul, Minnesota, saßen wir mit Linda Sue Johnson (Leiterin der Abteilung Rechte und Lizenzen) und Teresa Roussin (Koordinatorin der Abteilung Rechte und Lizenzen) zusammen und sichteten stundenlang Bilder und andere Druckerzeugnisse aus 50 Jahren. Linda Sue und Teresa versorgten uns mit einer Unmenge von außerordentlich wichtigen Informationen. Ein Teil hat Eingang in dieses Buch gefunden; andere werden künftige Monographien bereichern. Schließlich machte Brad Knefelkamp, Fotograf bei Brown and Bigelow, über 300 Aufnahmen von Reproduktionen, die eventuell für dieses Buch in Frage kämen.

Unser Dank gilt auch den Mitarbeitern des zur Hearst-Publications-Gruppe gehörenden Magazins Esquire. David Graff (Vizepräsident), Lisa Kreger (stellvertretende Leiterin der Abteilung Rechte und Lizenzen) und Tom Robotham ermöglichten es uns, Alberto Vargas in unser Buch aufzunehmen sowie alle anderen Künstler, deren Werke in Esquire, dem mit Abstand wichtigsten Forum für Pin-up- und Glamour- Kunst, erschienen waren.

LeRoy Darwin erinnerte uns an die Menschen in Ray Bradburys Fahrenheit 451, die in einer Zeit der Bücherverbrennungen die Funktion von „sprechenden Büchern" ausübten, um die Klassiker vor dem Vergessenwerden zu bewahren. Viele Jahre lang konzentrierte er sich auf einen oder zwei Künstler, trug alle Geschichten über sie zusammen und wartete auf den Tag, an dem irgend jemand es möglich machen würde, das alles in einem Buch festzuhalten. Wie Art Amsie, so hat auch LeRoy Darwin ein großes Stück Pin-up-Geschichte bewahrt, wobei sein besonderes Interesse Earl Moran und Rolf Armstrong galt. Auch er hat uns in

großzügiger Weise die von ihm gefundenen Schätze zur Verfügung gestellt.

Zu den Hütern der Hinterlassenschaft dieser Künstler gehört außerdem Drake Elvgren, der Sohn des größten aller Pin-up-Maler, der uns von seinen Erinnerungen an seinen Vater erzählt und persönliche Dokumente zur Verfügung gestellt hat. Das taten auch Tom Skemp, San Crandall und Mitglieder der Familie Driben, darunter Adrienne, Leo und Aaron. Zoë Mozerts Bruder Bruce schickte uns ein Videoband mit 50 ihrer Originalgemälde, und Joyce Ballantyne erzählte uns von sich selbst, Al Buell und anderen.

Marianne Phillips ist das „sprechende Buch" für Zoë Mozert und auch eine Quelle der Information über Joyce Ballantyne und viele andere Pin-up-Künstler.

Ronald Feldman ermöglichte uns den Zugang zu dem Nachlaß von George Petty.

Zu den Sammlern, die Fotos ihrer Gemälde beisteuerten, gehören Clarke und Janice Smith, die zu den Pionieren unter den Sammlern dieser Kunst gehören und deren Kollektion als Quelle für einen großen Teil dieses Buches diente. Wir danken auch Stuart David Schiff und Barry M. Shaw für die Fotos, die sie uns zur Verfügung gestellt haben.

Zu den besten Sammlungen gehört die von Ray und Harriet Warkel, und auch sie haben uns außerordentlich großzügig geholfen. In Paris war unser Freund Pierre Boogaertz, der als einziger in Europa mit Illustrationskunst handelt, eine große Hilfe. Unser Dank gilt auch dem Sammler Max Allen Collins. Er ist eine Autorität auf dem Gebiet der Pin-up-Kunst, und sein Wissen und seine Unterstützung waren eine große Bereicherung für uns und dieses Buch.

Unser besonderer Dank gilt Walt Reed. Er ist nicht nur Autor, Illustrator, Historiker und Gründer von Illustration House, sondern auch Kunsthändler und Auktionator sowie Besitzer einer umfassenden Sammlung von Illustrationskunst. Wir sind ihm dankbar für seine Hilfe und für seinen lebhaften, gedankenreichen Essay über die Geschichte der Pin-up-Kunst.

Unser Dank gilt auch den Angestellten der Louis K. Meisel Gallery, die an der Vorbereitung und Veröffentlichung dieses Buches beteiligt waren: Diana Sena, Louis' „oberste Recherchiererin", ohne die er keine verständliche Zeile zu Papier bringen könnte, und Aaron Miller, Assistent und Fotograf. Fast alle Fotos der in diesem Band vorgestellten Kunstwerke stammen von ihm und von Stephen Lopez.

Außerdem schulden wir Dirk Luykx und Gilda Hannah Dank für ihr ausgezeichnetes Design. Für ihre Arbeit an diesem Buch danken wir auch Margaret Donovan, die seit 15 Jahren Louis' Lektorin ist und schon fünf seiner Bücher betreut hat. Beim Benedikt Taschen Verlag danken wir dem Lektor Burkhard Riemschneider, der den Verlag auf dieses Buch aufmerksam gemacht hat, Mark Thomson, dem Koordinator des Projekts, und zum Schluß Benedikt Taschen selbst, der, unberührt von der öffentlichen Meinung oder von Vorurteilen, verlegt, was ihm gefällt – ohne Rücksicht auf Verluste.

Remerciements

Nous tenons à remercier tous ceux et celles qui nous ont aidés à réaliser ce livre, à commencer par notre ami Art (the King) Amsie. Ami de longue date de Gil Elvgren et Fritz Willis, Art a été pendant de longues années le seul à défendre ces artistes. Il a collectionné, documenté et sauvegardé leurs œuvres et il est parvenu à convaincre le petit groupe de personnes qui détenaient des peintures originales de pin up que cet art avait de la valeur et méritait d'être recherché et préservé. Dans ce domaine, il est notre principal lien avec le passé. Nous le remercions d'avoir mis à notre disposition ses archives, ses collections et ses documents au cours des vingt dernières années.

Il nous aurait été impossible de faire un livre aussi complet sans le soutien inconditionnel des propriétaires et du personnel de Brown and Bigelow, de loin le plus grand éditeur de calendriers qui ait jamais été. Du début du siècle à 1970, qui marqua la fin de l'âge d'or de la pin up, tous les calendriers de pin up et produits dérivés les plus beaux et les plus marquants ont été édités par Brown and Bigelow, témoin irremplaçable d'un moment de l'histoire de l'art américain.

William Smith Sr. et William Smith Jr. nous ont apporté leur soutien enthousiaste et l'occasion exceptionnelle de passer des jours entiers dans leurs archives. Dans leurs locaux de Saint Paul au Minnesota, par des températures de −30° à l'extérieur, nous avons passé des heures avec Linda Sue Johnson, directrice des droits de reproduction, et Teresa Roussin, coordinatrice, parcourant cinquante ans d'images et d'articles. Linda Sue et Teresa nous ont fourni un grand nombre d'informations précieuses, dont certaines figurent dans le livre et d'autres éclaireront des monographies à venir. Brad Knefelkamp, le photographe de Brown and Bigelow, a photographié plus de trois cents illustrations de pin up afin que nous puissions éventuellement les publier dans ce livre.

Nous sommes également éternellement reconnaissants à l'équipe du magazine *Esquire,* filiale de Hearst Publications. David Graff, vice-président et directeur du développement des produits, Lisa Kregher, directrice adjointe des droits de reproduction et Tom Robotham nous ont permis d'inclure Alberto Vargas dans ce livre aux côtés de tous les autres artistes dont les travaux ont été publiés dans *Esquire,* la publication la plus importante dans le domaine de l'art glamour et des pin up.

LeRoy Darwin nous a rappelé les personnages du roman de Ray Bradbury, *Fahrenheit 451,* qui jouaient le rôle de «livres parlants» afin de préserver les classiques de la littérature à une époque où on brûlait les livres. Au fil de longues années, il a suivi de près la carrière de quelques artistes, notamment Earl Moran et Rolf Armstrong, recueillant de nombreuses anecdotes verbales et visuelles dans l'attente du jour où quelqu'un viendrait les coucher sur le papier. Comme Art Amsie, LeRoy a sauvé de l'oubli une grande partie de l'histoire des pin up. Lui aussi, il nous a généreusement ouvert les portes de son trésor.

Drake Elvgren, le fils du plus grand des peintres de pin up, veille fidèlement sur le patrimoine artistique de son père. Il a partagé avec nous ses souvenirs personnels et ses documents. Tom Skemp, San Crandall et la famille Driben, dont Adrienne, Leo et Aaron, ont fait de même. Bruce, le frère de Zoë Mozert, nous a envoyé une cassette vidéo montrant cinquante peintures originales, et Joyce Ballantyne nous a parlé d'elle-même, d'Al Buell et d'autres artistes de son temps.

Marianne Philipps a été pour nous le «livre parlant» de Zoë Mozert et une précieuse source d'informations sur Joyce Ballantyne et de nombreuses autres artistes.

Ronald Feldman a été notre passeport pour nous introduire dans le monde de George Petty.

Parmi les collectionneurs qui nous ont fourni des photos de leurs tableaux, Clarke et Janice Smith sont sans doute les premiers à avoir collectionné cet art. Un grand nombre d'images et d'informations présentées dans ce livre proviennent de leur collection. Nous remercions également Stuart David Schiff et Barry M. Shaw pour les photos fournies.

Ray et Harriet Warkel, qui ont contribué massivement à notre effort, possèdent l'une des plus belles collections. A Paris, notre ami Pierre Boogaertz, le seul marchand européen d'art illustré, nous a beaucoup aidés. Nous remercions également Max Allan Collins, collectionneur et grand connaisseur de pin up, pour ses connaissances et ses contributions au livre.

Nous remercions tout particulièrement Walt Reed. Auteur, illustrateur, historien et fondateur de Illustration House, Walt est également un marchand d'art et un commissaire-priseur possédant une vaste collection d'illustrations. Nous lui sommes reconnaissants de son aide et de son texte vivant et inspiré sur l'histoire de la pin up.

Nous tenons également à exprimer toute notre gratitude à l'équipe de la galerie Louis K. Meisel qui nous a aidés à préparer et à publier ce livre: Diane Sena, archiviste et assistante d'édition, sans laquelle nous n'aurions sans doute jamais réussi à aligner deux mots intelligibles sur le papier; et Aaron Miller, chercheur et photographe indépendant qui, avec Steven Lopez, a photographié presque toutes les illustrations de ce livre.

Merci à Dirk Luykx et à Gilda Hannah pour le beau travail de graphisme. Nous sommes également reconnaissants à Margaret Donovan, l'éditrice de Louis depuis quinze ans et cinq livres, pour ses contributions au livre. Chez Taschen, nous remercions Burkhard Riemschneider, responsable du projet qui a apporté cet ouvrage à la maison d'édition; Mark Thomson, qui a coordonné le projet; et finalement Benedikt Taschen lui-même, qui se soucie peu du qu'en-dira-t-on et des préjugés et publie ce qui lui plaît sans que rien ne l'arrête.

We have made our best efforts to contact the owners of copyrights for all the other art reproduced in this book. Most of the publishers of calendar art no longer exist, and in most cases, the art has now fallen into public domain. We acknowledge all the unidentified families and estates of these artists and thank them in absentia for their contributions.

We would like to encourage anyone with additional material on any of the artists herein to submit such information, or photographs of any original artwork, to the Archives of Pin-Up and Glamour Art. Such material will be used for historical documentation and may be included in monographs on the individual artists. Material should be submitted to either Charles G.

Martignette, P.O. Box 293, Hallandale, Florida 33008, or Louis K. Meisel, Meisel Gallery, 141 Prince Street, New York, New York 10012.

Trotz intensiver Recherche konnten die Urheberrechte nicht in jedem Fall ermittelt werden. Wir bitten ggf. um Mitteilung.

Wir möchten jeden bitten, der selbst Material und Informationen oder auch Originalabbildungen über Pin-up-Künstler besitzt, uns diese für unser Archiv über Pin-up- und Glamourkunst zugänglich zu machen. Das Material soll einer historischen Dokumentation dienen und kann evtl. Eingang finden in Monographien über die einzelnen Künstler.

Das Material können Sie senden an: Charles G. Martignette, P.O. Box 293, Hallandale, Florida 33008, USA, oder an: Louis K. Meisel, Meisel Gallery, 141 Prince Street, New York, New York 10012.

Sauf mention contraire, le copyright des œuvres reproduites se trouve chez les artistes qui en sont l'auteur. En dépit de toutes nos recherches, il nous a été impossible d'établir les droits d'auteur dans quelques cas. En cas de réclamations, nous vous prions de bien vouloir vous adresser à la maison d'édition.

Nous prions toutes les personnes en possession d'œuvres non citées dans cet ouvrage de bien vouloir communiquer leurs informations, photographies ou œuvres originales à The Archives of Pin-Up and Glamour Art. Ces informations seront utilisées pour la documentation historique ou pourront apparaître dans des monographies.

Les informations peuvent être adressées à Charles G. Martignette, P.O. Box 293, Hallandale, Florida 33008, ou à Louis K. Meisel, Meisel Gallery, 141 Prince Street, New York, New York 10012.

Imprint

Front Cover: Rolf Armstrong, *A Winning Combination*, 1947, Courtesy Brown & Bigelow, Inc.
Back Cover: Gil Elvgren, *Skirts Ahoy!*, 1967, Courtesy Brown & Bigelow, Inc.

Illustrations page 1: Al Buell / page 2: Rolf Armstrong page 3: Billy DeVorss / page 4: Peter Driben / page 5: Harry Ekman / page 6: George Petty / page 9: Earl Moran / page 14: Gil Elvgren / page 15: Art Frahm / page 30: Fritz Willis / page 31: Bill Medcalf

© 2002 TASCHEN GmbH
Hohenzollernring 53, D–50672 Köln
www.taschen.com

German translation: Elsbeth Kearful, Cologne (S. 14–39) and Gabriele-Sabine Gugetzer, Berlin
French translation: Philippe Safavi, Paris

Printed in Italy
ISBN 3–8228–1701–5